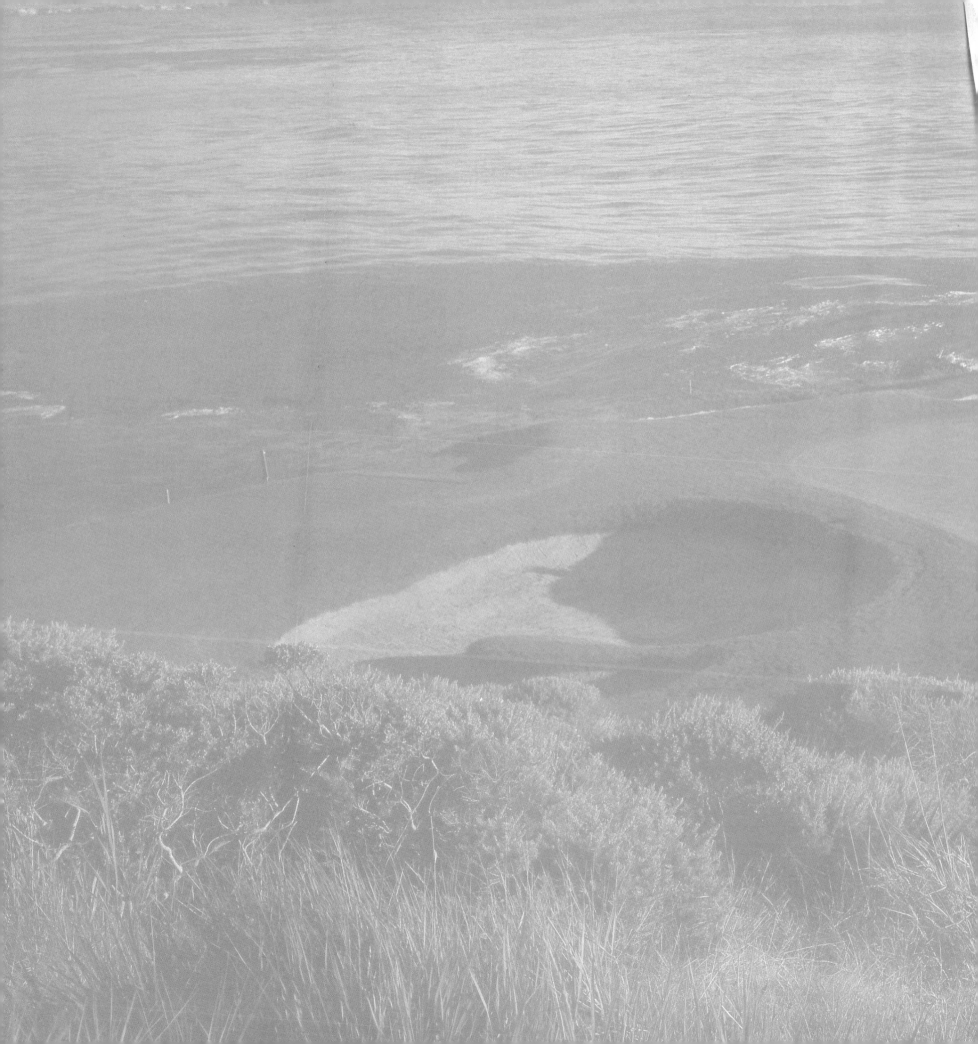

THE 500

WORLD'S

GREATEST

GOLF

HOLES

THE 500 WORLD'S GREATEST GOLF HOLES

GEORGE PEPER AND THE EDITORS OF GOLF MAGAZINE

 Artisan • NEW YORK

Published by Artisan
A Division of Workman
 Publishing Company, Inc.
708 Broadway
New York, New York 10003-9555
www.workman.com

Library of Congress Cataloging-in-Publication Data

The 500 world's greatest golf holes / by George Peper and
the editors of Golf magazine.
 p. cm.
 ISBN 1-57965-162-3
 1. Golf courses. I. Title: Five hundred world's greatest golf holes.
II. Golf magazine. III. Title.

GV975.A12 2000
796.352'06'8—dc21

 00-023068

Printed in Italy
10 9 8 7 6 5 4 3 2

Book design by Dania Davey
Layouts produced by Pamlyn Smith Design, Inc.

Number 10 at Riviera Country Club (pages 176–177)

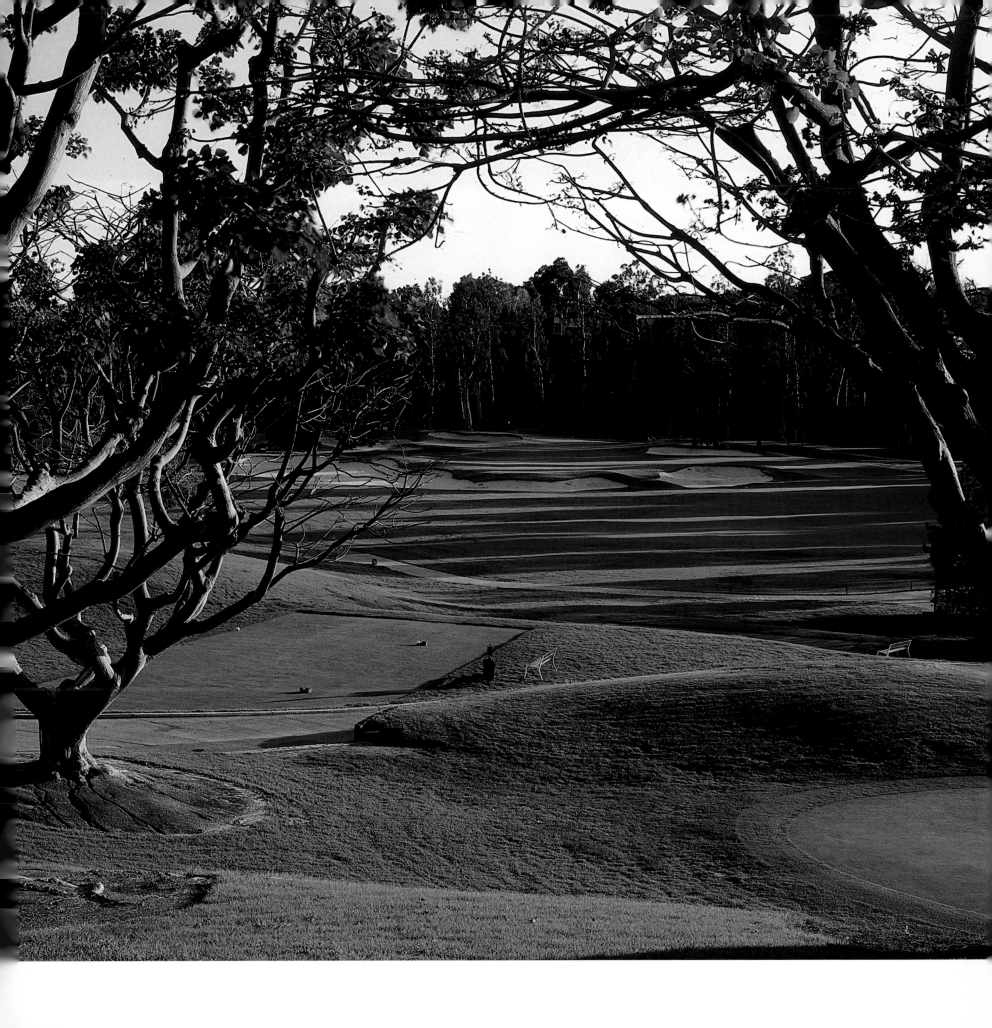

C O N T E N T S

WHAT MAKES A
GOLF HOLE GREAT?
by George Peper IX

THE EIGHTEEN
by Brian McCallen I

THE ONE HUNDRED
by Gary Galyean 79

THE FIVE HUNDRED
by Greg Midland 249

THE BEST OF THE BEST
by James A. Frank and George Peper 379

INDEX 436

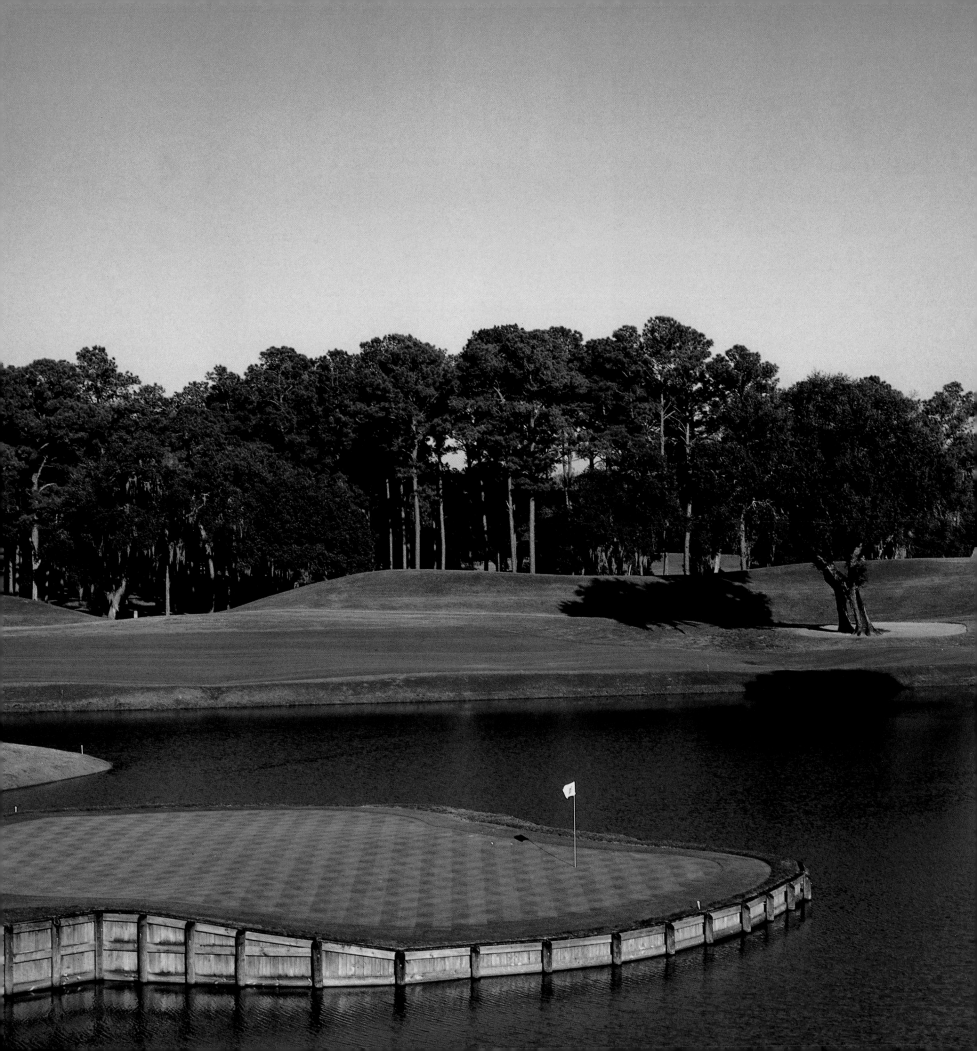

WHAT MAKES A GOLF HOLE GREAT?

George Peper

Golf in the twenty-first century is played on nearly thirty thousand courses around the world. Allow for a fair sprinkling of nine-hole layouts, and that translates to roughly five hundred thousand tees and greens—half a million holes. With this book, the editors of *Golf Magazine* designate and celebrate the best five hundred of them.

How dare we? you may ask. How can we possibly choose five hundred holes—one tenth of 1 percent of those half million—and proclaim them the best five hundred in the world?

A valid question, but so is this one: How dare we not? After all, our job is to provide content for the largest

PRECEDING PAGES: Number 18 at Edgewood Tahoe Golf Club (page 306). LEFT: Tournament Players Club at Sawgrass (Stadium) number 17 (pages 18–22).

media company in golf. As such, we have both the opportunity and the obligation to take on projects such as this—to do the legwork and research so you don't have to. The new millennium gave us the perfect moment to honor 125 par 3s, 125 par 5s, and 250 par 4s—with a total par of precisely, yes, 2,000. Besides, we had plenty of help. Nominations for the American holes came from thousands of *Golf Magazine* readers and visitors to our Web site, Golfonline.com, who checkmarked their choices on a lengthy ballot and also wrote in their favorites. For aid in certification, we enlisted the American members of *Golf Magazine*'s selection panel for the top one hundred courses in the world. Eventually, our initial list of nearly a thousand candidates was pared to just under three hundred nominees.

That, however, was just the American sector. The rest of the world remained, and we weren't about to presume international expertise. So we sought the assistance of our editorial colleagues at eleven publications around the world: *Andalucia Golf* (Spain/Portugal), *Asian Golfer* (Far East), *The Buenos Aires Times* (South America), *The Compleat Golfer* (South Africa), *Golf Européen* (France), *Golf Magazine* Australia (Australia/New Zealand), *Golf Monthly* (United Kingdom), *Il Mondo del Golf* (Italy), *Score* (Canada), *Svensk Golf* (Scandinavia), and *Wirtschafts Woche* (Germany). Each of those publications came up with a slate of home candidates, and when the contenders were consolidated, we had a global list of roughly six hundred holes.

The last cut was made at a summit conference in Carnoustie, Scotland, during the week of the 1999 British Open. It was attended by editors of the participating publications along with Sir Michael Bonallack, then-secretary of the Royal and Ancient Golf Club of St. Andrews, and David Fay, executive director of the USGA. With remarkably little bickering, we arrived at the final five hundred.

Our "500 World's Greatest" list was unveiled in the January 2000 issue of *Golf Magazine* and was reprinted in most of the other participating publications throughout the year. Meanwhile, we *Golf Magazine* editors took it upon ourselves to select the top one hundred and ultimately the top eighteen holes in the world.

So that's the *how* behind this book (along with the *who, where, when,* and *why*). Which leaves only the *what*. What makes a golf hole great?

Truth be told, there are no blueprints—literal or figurative—for great holes. They invariably are blends of art and science, nature and man, tradition and heterodoxy, stubbornness and compromise, dedicated genius and dumb luck.

That said, the world's great golf holes share certain undeniable qualities. First among them is the element of strategy, the hole's ability to call to us and say, "Play me this way."

The best holes speak several languages, inviting skilled players to take an aggressive route from tee to green while encouraging the less accomplished to follow a safer, albeit less propitious, path. For the mass of souls in the middle, they offer a dozen shades of gray, allowing each of us to calculate his own risk and reward.

Alister Mackenzie's views on the ideal golf course apply equally to the ideal hole: It "must be pleasurable to the greatest possible number . . . must give the average player a fair chance and at the same time require the utmost from the expert who tries for sub-par scores."

A classic example is the par-5 thirteenth at Augusta National, where Mackenzie has tempted generations of Masters competitors to subdue the right-to-left dogleg with a bold drive around the corner and an equally bold approach to the water-guarded green. At the same time, he allows Augusta's middle-handicap members to tack homeward safely with a trio of undistinguished shots.

Strategy is linked inextricably with quality number two—difficulty. The dean of modern architects, Robert Trent Jones, Sr., probably said it best: "Every hole should be a demanding par and a comfortable bogey." The prime determinant of difficulty is, of course, distance. There's no such thing as an easy 230-yard par 3. Indeed, for decades the USGA based its course-difficulty ratings almost entirely on yardage.

However, length alone can't predict either the sternness or the quality of a hole. Today, the USGA calculates course difficulty by looking at myriad factors on each hole—the proliferation, placement, and severity of hazards; the breadth, pitch, and path of the fairway; the size, speed, and contour of the green—the same gambits an architect uses to concoct his test.

On the tee of any good hole, two kinds of challenge face us. First is the physical assignment of propelling a ball with sufficient power and accuracy to find the fairway, find the green, and find the hole. Then there's the more subtle but equally important mental challenge, the hole's ability to mess with our heads.

In the end, we don't play the great holes—they play us. They thrill, frighten, embolden, confound, contort, support, and cajole us. They beckon our best and punish our worst, provoke our imagination, command our attention, and sometimes even improve our game.

Many of the best holes look more difficult than they actually are. Pine Valley, ranked for decades as the number one course in the world, is widely regarded as the world's most difficult as well. Its fairways and greens are lined with tall pines and acres of unraked sand and scrub—daunting prospects at every turn.

The reality, however, is that Pine Valley offers some of golf's most generous targets. They just *seem* hard to hit because the penalty for missing them is so severe. Relentless intimidation is Pine Valley's lethal weapon. The course chokes most mortals with fear, and fearing causes steering which causes veering. Or as H. N. Wethered and Tom Simpson said in *The Architectural Side of Golf,* "an impending sense of misfortune will almost certainly be reflected in the action of the club."

The most strategically compelling holes demand not just inspection but introspection. They force us to look within, to make an honest assessment of our ability, and then apply that to a plan for the hole. "It is a mental test and an eye test," according to Donald Ross. "The hazards and bunkers are placed so as to force a man to use judgment and exercise mental control in making the correct shot."

The tenth hole at Riviera Country Club is a short par 4 that coaxes all comers to gun for its green. For most mortals, however, that's a poor strategy because the slender, slanted putting surface is firm and fiercely sloped. It begs for an approach of sufficient length to allow the ball to spin and stop. It's the kind of hole Riviera's designer, George C. Thomas, had in mind when he said, "A thinker who gauges the true value of his shots, and is able to play them well, nearly always defeats an opponent who neglects to consider and properly discount his shortcomings." In this way a great hole calls us to greatness of our own, compels us to improve our course management, our ball striking, or both.

Still other holes charm us with their very inscrutability. Bobby Jones found this quality at St. Andrews, "a wise old lady . . . ready to reveal to me the secrets of her complex being if I would only take the trouble to study and to learn. . . . The more I studied the Old Course, the more I loved it, and the more I loved it, the more I studied it."

Jones later conceived his Augusta National in that mold, as a course where "there is not a hole you

can't birdie if you simply think and not a hole you can't bogey if you stop thinking."

Of course, the very first holes, on the links courses of Scotland, were not designed at all. They took their path, length, and contour straight from the lay of the land, with the architectural refinements supplied by grazing rabbits and sheep. Over the last half millennium much has changed, but a reverence for naturalness remains.

Clearly, some sites are more appealing *au naturel* than others. Jack Neville may not have been a trained architect when he was asked to design Pebble Beach, but he knew enough to take a light hand. "It was all there in plain sight," he said. Likewise, when Perry Maxwell first saw the windswept grasslands near Hutchinson, Kansas, that would become Prairie Dunes, he let the land take the lead. "There are 118 good golf holes here," said Maxwell. "All I have to do is eliminate 100 of them."

Enthralling holes such as the eighteenth at Pebble Beach and the eighth at Prairie Dunes thus owe more to the magnificence of their sites than to the brilliance of their architects. These days, such land rarely becomes available. However, advancements in earthmoving machinery have enabled the clever and well-funded architect to simulate just about any natural feature short of an ocean. No better evidence exists than the seventeenth at Shadow Creek, a pine-clad, downhill par 3 over water, set smack in the center of the Nevada desert.

In the best designs, however, the blend with the surrounding terrain is so artful, we're unable to tell where nature ends and man begins. Holes such as the tenth at Loch Lomond and the seventeenth at Sand Hills both embrace Mother Nature and amplify her charms.

Good golf swings have strong elements of balance and timing, and the same can be said of good golf holes. Balance relates to the architect's ability to counterweight the demands of the hole so that the hole is neither too easy nor too difficult. Generally speaking, extremely long holes with narrow, bowling-alley fairways lack balance as surely as short holes with airplane strips. The fairness of a fairway, or at least the width, should be commensurate with the length and other demands of the hole. Likewise, the size and receptivity of the green should be in proportion to the length of the shot to be played to it. This is why the greens of short par 5s tend to be smaller than those of long par 3s. In the same way, greens with severe contours should not be shaved so close that they run at lightning-fast speed, except perhaps in major championships.

The timing of a golf hole relates not to its topography or design but to the point at which it appears in the ebb and flow of the course. Not surprisingly, well over half of our famed five hundred are back-nine holes, and of those, well over half are numbered 16, 17, or 18. The prevalent hole is number 18, with fifty-seven representatives, while the hole with the fewest examples—just fifteen—is lowly number 1.

This stands to reason. The finishing holes decide more matches, ruin more rounds, produce more joy and suffering, and thus get more attention. Timing is everything. Yet, to dismiss these holes as mere beneficiaries of sequential positioning would be unfair. In many cases, the last holes on a course were the first holes the architect "saw" when he walked the raw terrain. He knew to save the best for last.

A couple of final elements contribute to the character of a golf hole—and perhaps unfairly. First is the reputation of the golf course on which it resides. Properly or not, famous holes tend to emanate from famous courses—courses that have hosted major events, produced historic moments, or otherwise gained the public's attention.

No aspect of our selection process made us more uneasy than the notion that, by focusing our search on the high-profile courses, we might overlook dozens of gems simply because they were hidden on courses without pedigree or publicity. That's why we sought write-in votes from our readers and Internet visitors. It's also why we limited ourselves to a maximum of three holes from any single course.

On the other hand, the quality of a golf course—famous or not—ultimately rests on the quality of its individual holes. Who would argue that the seventh, eighth, and eighteenth holes at Pebble Beach don't all belong among the best five hundred in the world? In this sense, the world's best-known courses are the logical first source of great holes.

In the same way, the reputation of a golf course architect can have a disproportionate influence on the standing of a hole. The current cadre of top-tier designers—Tom Fazio, Pete Dye, the Jones brothers (Bobby and Rees), and Jack Nicklaus—is a tough club to break into, and while several other architects are close, they remain a notch below. As a result, they and their works get slightly less notice, slightly less word of mouth, and, often unfairly, slightly less acclaim.

We trust we've been sensitive to these issues and elements, and we offer this book as testimony. If nothing else, you will find variety—holes on linksland, heathland, and parkland, in deserts and mountains, on coastlines and prairies. Holes that rise from lava and drop from cliffs. Some are fewer than five years old while others are over five hundred. They range from barely one hundred yards to more than seven hundred. Perhaps most remarkably, they represent forty countries and territories of the world.

Is our World's Greatest list definitive? We doubt it. Is it controversial? We hope so. Is it defensible? You bet it is. Have a look.

The fourteenth hole at Royal St. George's Golf Club (page 344)

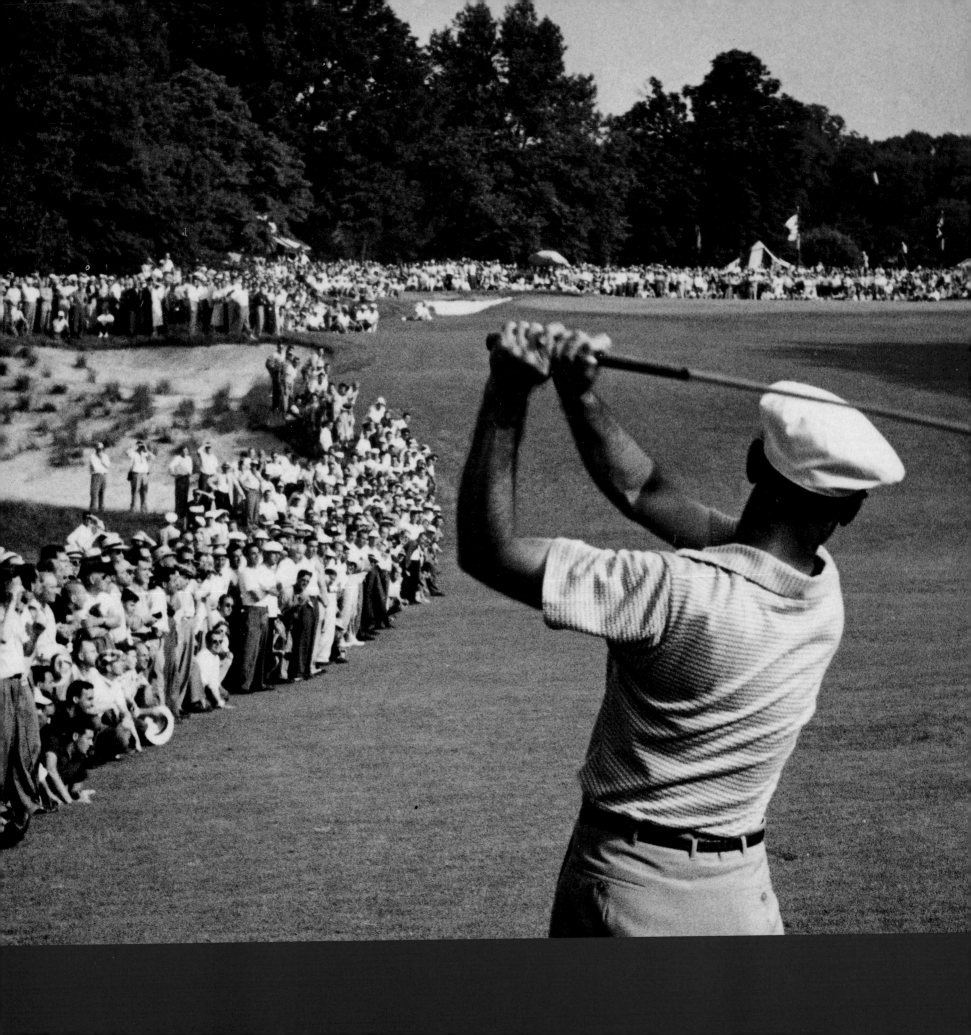

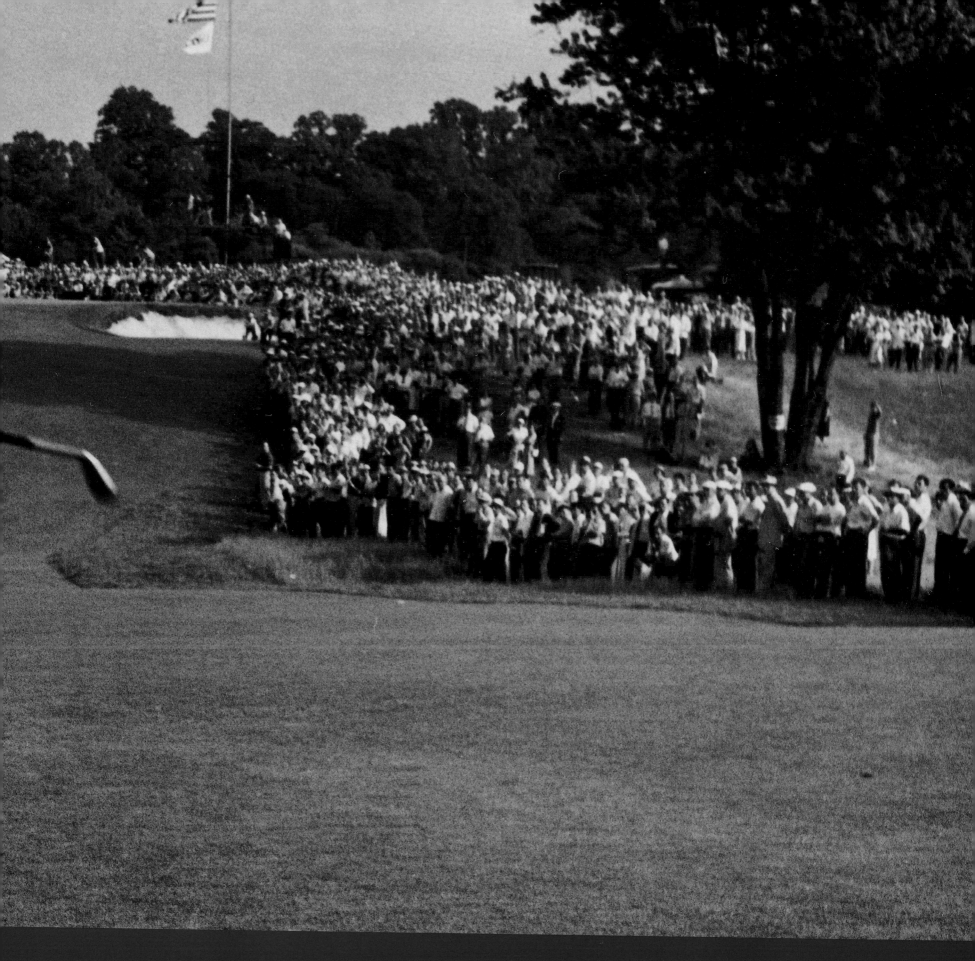

THE EIGHTEEN

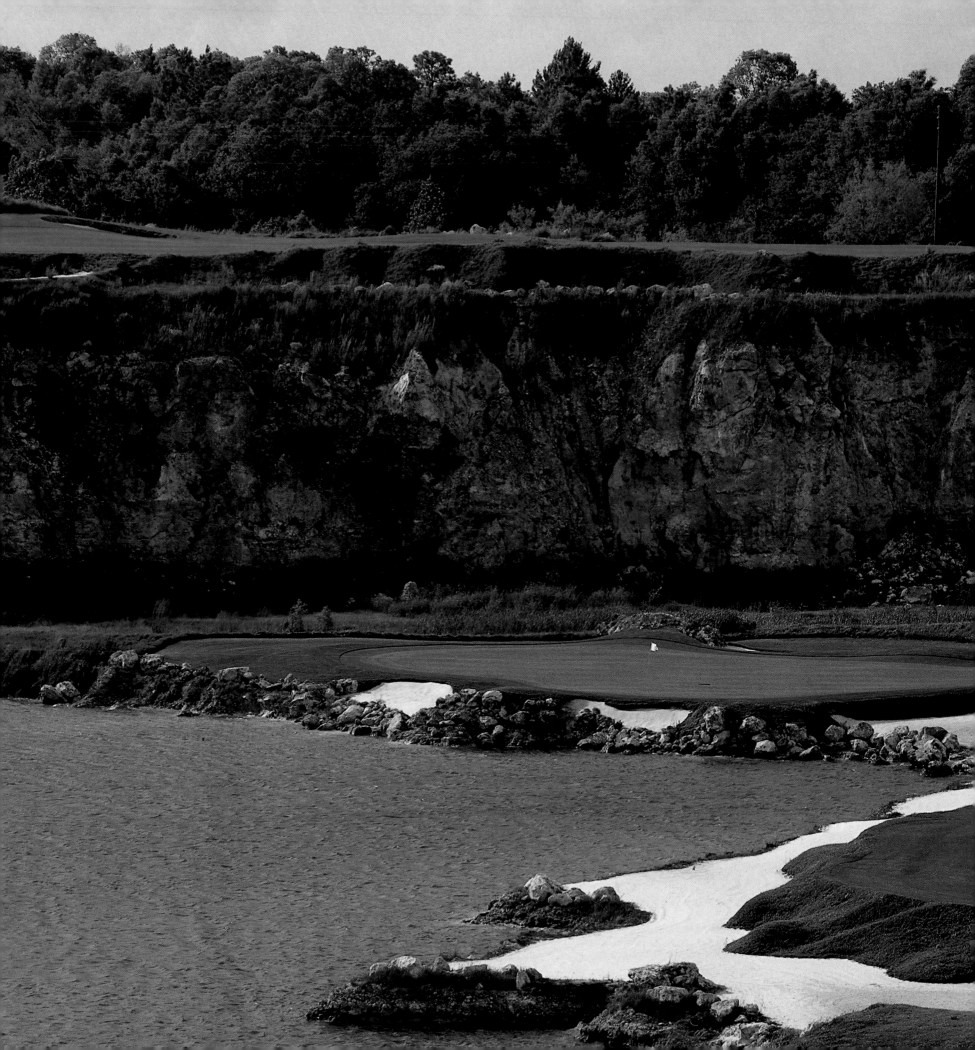

○○○

Like judges at a beauty contest, the round table of editors convened to select the top eighteen golf holes from among the five hundred chosen worldwide for the World's Greatest felt torn, besieged, even compromised, as each candidate removed its robes for closer inspection. So many high-quality choices, so few openings on the scorecard.

Knowledgeable, well-traveled golfers will have a difficult time reconciling some of our selections for the dream eighteen. After all, none of us is a course designer, a superintendent, or a golf professional. But as Alistair Cooke once remarked about duffers like himself, "We don't know much about architecture, but we know what's good." Our challenge was to make sure the final eighteen stones atop our World's Greatest pyramid truly belonged at the pinnacle.

To that end, we built our top eighteen along the lines of a classic, well-balanced layout: ten par 4s, four par 5s, four par 3s, totaling a par of 72. To be fair, only one hole per course was allowed. We sought geographic diversity

PRECEDING PAGES: Ben Hogan's 1-iron shot at the eighteenth in the final round of the 1950 U.S. Open at Merion Golf Club (page 283). LEFT: Number 15 at Black Diamond Ranch Golf and Country Club (page 267).

in our selections, and in so doing paid tribute to the seminal links of Scotland and Ireland, each of which is represented by two holes among the top eighteen. Canada and Bermuda weigh in with a hole apiece. So do South Africa and Australia. But the United States, with ten holes among the top eighteen, thoroughly dominates the list. Too many Americans on the panel? No, there's just a superabundance of great courses in America.

What did we look for in paring down the list of the world's finest to eighteen? Irrefutable, unassailable greatness. But greatness, like beauty, is in the eye of the beholder. And so shot value, design strategy, playability, memorability, and every other criterion used to gauge the merit and worth of a golf hole was employed. Still, the discussions raged on. With a few exceptions, our final selections were born of much debate and hand-wringing. It wasn't enough for a storied hole with championship pedigree to blend strategic, penal, and heroic schools of design: The hole had to fit as a capstone to our monument.

Perhaps the finest critique of what makes a golf hole individual and sound was put forth by one of

the game's finest designers, A. W. Tillinghast. "A wholesome, inspiring individuality goes a long way to make the man," he wrote. "The golf hole should have it just the same as a human."

These were the panel's guiding words. Tillinghast also wrote, "A round of golf should provide 18 inspirations—not necessarily thrills, for spectacular holes may be sadly overdone. Every hole may be constructed to provide charm without being obtrusive with it." Inside every golfer—even the most score-minded, outcome-obsessed player—lurks an appreciation of the beautiful. Think about it: No list of top holes or elite courses ever included an ugly duckling. Each of the top eighteen holes promises a memorable tussle, and each, in its own way, is visually attractive, even inspiring.

We like to think our top-eighteen roster is the result of painstaking research and studious evaluation, with a smidgen of geopolitical correctness in the mix. We did our homework, yes. But golf is art, not science. Our list, in the end, is subjective. If our dream eighteen inspires a discussion at a nineteenth hole somewhere in the world, we will have accomplished our goal.

The infamous "Church Pews" bunker at
Oakmont's third hole (pages 160–161)

COURSE:	BANFF SPRINGS GOLF COURSE
HOLE:	4
LOCATION:	BANFF, ALBERTA, CANADA
ARCHITECT:	STANLEY THOMPSON
LENGTH:	171 YARDS · PAR 3

Eighty miles west of Calgary, Alberta's flat prairie erupts into North America's most spectacular mountains. Set below massive peaks at the confluence of the Bow and Spray rivers within Canada's oldest national park is the Banff Springs Hotel, the fabled "Castle in the Rockies." Fronting this baronial fortress is the Banff Springs Golf Course, a majestic layout built by the great Stanley Thompson, a Toronto native who was among the first architects of his era to employ principles of art (balance, proportion, harmony) in his designs. He also was among the first of the big spenders: When Banff Springs opened in 1928, it became the first course in the world to cost more than $1 million to construct.

Ironically, the best-known and most photographed hole on the mile-high layout, the par-3 fourth, was not part of the original scheme. In the winter of 1927, an avalanche at the far end of the course created a small glacial lake. Thompson could not resist incorporating it into the design when he returned in the spring to finish his work. Except for the fact that the tee has been pushed back to 192 yards to keep pace with advances in equipment, the hole, formerly the eighth on the Rundle nine, is virtually unchanged today. Then as now, players emerge from the woods onto an elevated tee nearly seventy feet above a boulder-filled pond, its mottled, bluish-green cast typical of glacial lakes. The

lake gives the impression of a boiling pot—hence its name, "the Devil's Cauldron"—but its icy waters are perfectly still.

The prospect for the tee shot is daunting. The small, bowl-shaped green, ringed by six bunkers of varying depth and shape, is set on an oval terrace enclosed by spruce and fir. A steep bank runs down to the water in front of the green. Rising above the treetops are the soaring granite flanks of Mount Rundle in the distance. There are few more impressive backdrops in the game than these prodigious cliffs.

The hole's staggering beauty masks its strategic brilliance and deliberate optical illusions. When the pin is set in the back of the green, the rear bunkers, cut into an upslope, conspire to give players the impression that the hole is farther away than it really is. When the pin is in front, the forward bunkers tend to foreshorten perspective, making the target appear closer. The bunkers, then, interact with the pin placements, a neat trick. Adding to the difficulty of this glorious one-shotter is the wind, which funnels through Banff's mountain valleys and swirls between green and tee, further complicating club selection. A decent tee shot finds its reward: The concave green tends to gather slightly errant shots and funnel them to the middle. The green, canted from back to front, is flatter in back, more sloping in front. Which means

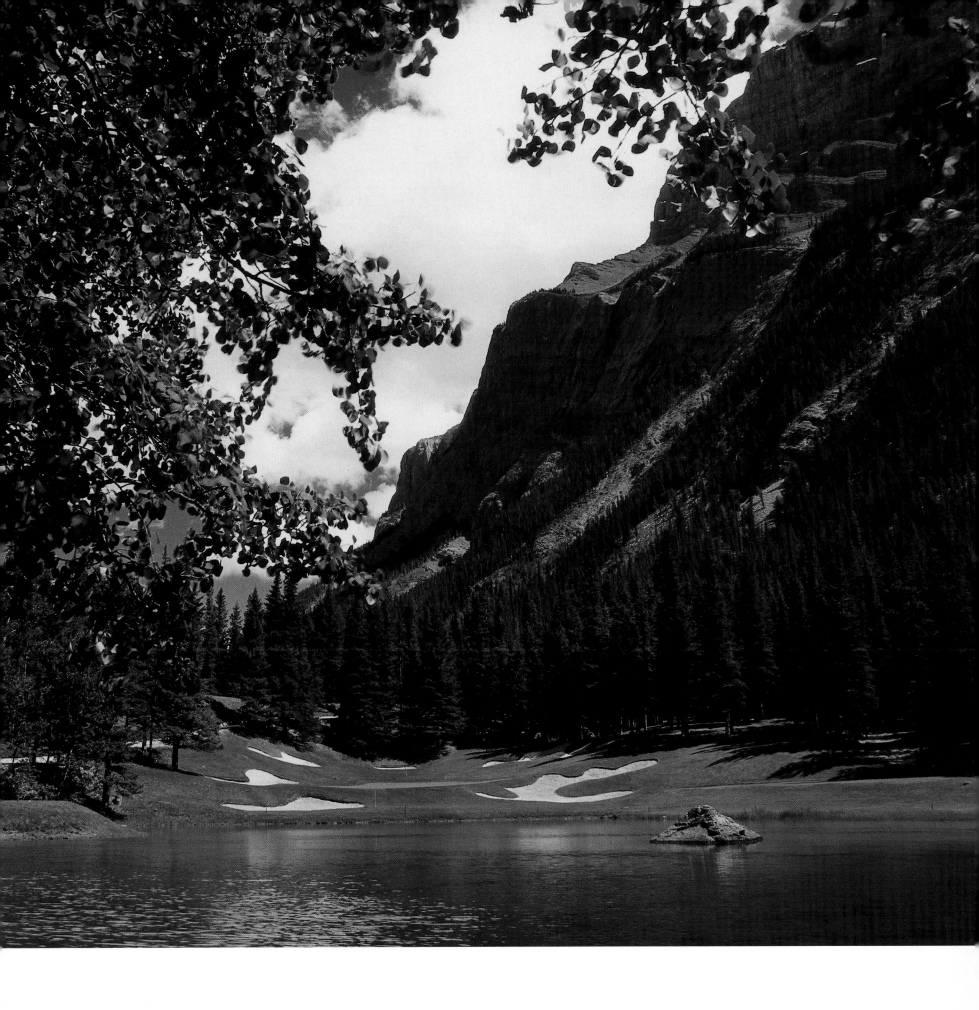

a front pin location must be approached cautiously, because a bold putt heading downhill can depart the green in a flash.

Hacked from the wilderness at great expense—trainloads of topsoil were brought to the site after tons of rock were quarried and thousands of evergreens felled—Banff Springs Golf Course is a tribute to the foresight and deep pockets of the Canadian Pacific Railway, the company that laid tracks through the Rockies. After years of neglect, the core eighteen (the Rundle and Sulphur nines) were completely restored, reopening to acclaim in 1999. The refurbished layout is an enduring monument to Thompson, a gifted landscape artist who had an uncommon ability to extract fabulous holes from rugged terrain. No par 3 on his résumé displays more subtle nuances than the Devil's Cauldron. Certainly none can match its intense beauty.

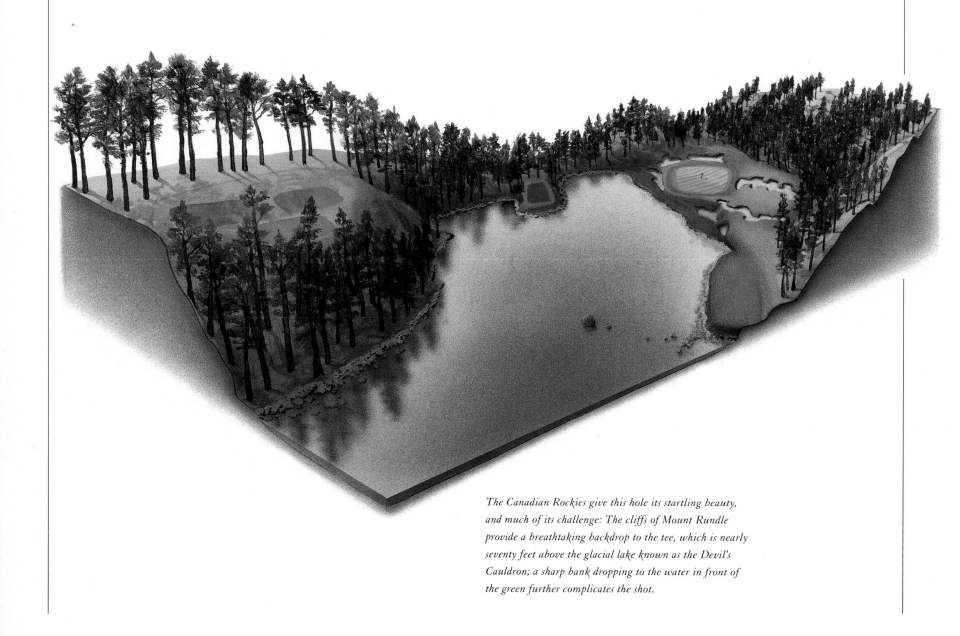

The Canadian Rockies give this hole its startling beauty, and much of its challenge: The cliffs of Mount Rundle provide a breathtaking backdrop to the tee, which is nearly seventy feet above the glacial lake known as the Devil's Cauldron; a sharp bank dropping to the water in front of the green further complicates the shot.

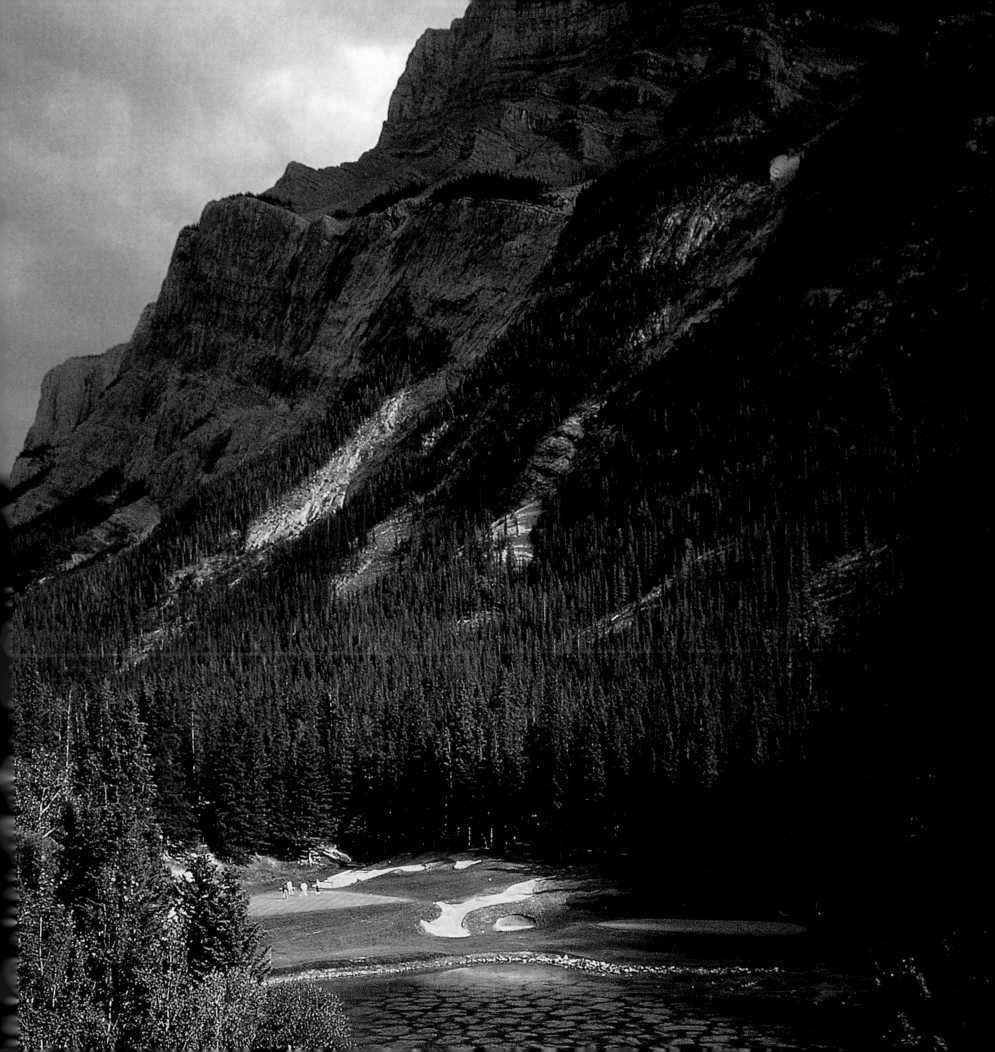

COURSE:	CYPRESS POINT CLUB
HOLE:	15
LOCATION:	PEBBLE BEACH, CALIFORNIA
ARCHITECT:	ALISTER MACKENZIE
LENGTH:	139 YARDS · PAR 3

Cypress Point, the exclusive club on California's Monterey Peninsula, has been famously described as "the Sistine Chapel of Golf." Perhaps a case could be made, at least in a golfer's mind, that Michelangelo the artist and Mackenzie the architect were kindred souls in search of perfection. The playing field was hardly level, however. Michelangelo had a bare ceiling, a balky medium (fresco), and an impatient pope to please. Dr. Mackenzie, who enjoyed a clear advantage, was able to fashion the Creator's own exquisite handiwork into a playing field unrivaled for drama and beauty.

"No one but a poet should be allowed to write of the beauties of the Cypress Point Club,"

commented Samuel F. B. Morse, the kingpin of the Monterey Peninsula and director of its early developments. Indeed, most superlatives fall short of a worthy description of the fabled links. The most scenic holes on a golf course lauded for its perfect pace and variety are the three—15 through 17—that embrace the Pacific Ocean and trace its palisades on the coastline side of Seventeen-Mile Drive. Of these, the colossal par-3 sixteenth is the most revered, but the hole preceding it, the 139-yard fifteenth, is the chapel's tabernacle.

The platform tee of the fifteenth, propped up on headlands sixty feet above a roiling sea that ebbs and flows in a narrow cove, is a good place to pause

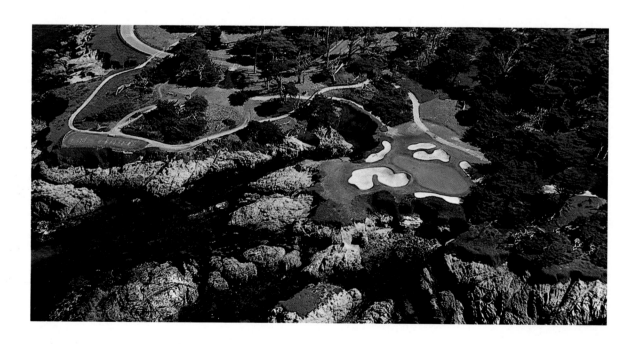

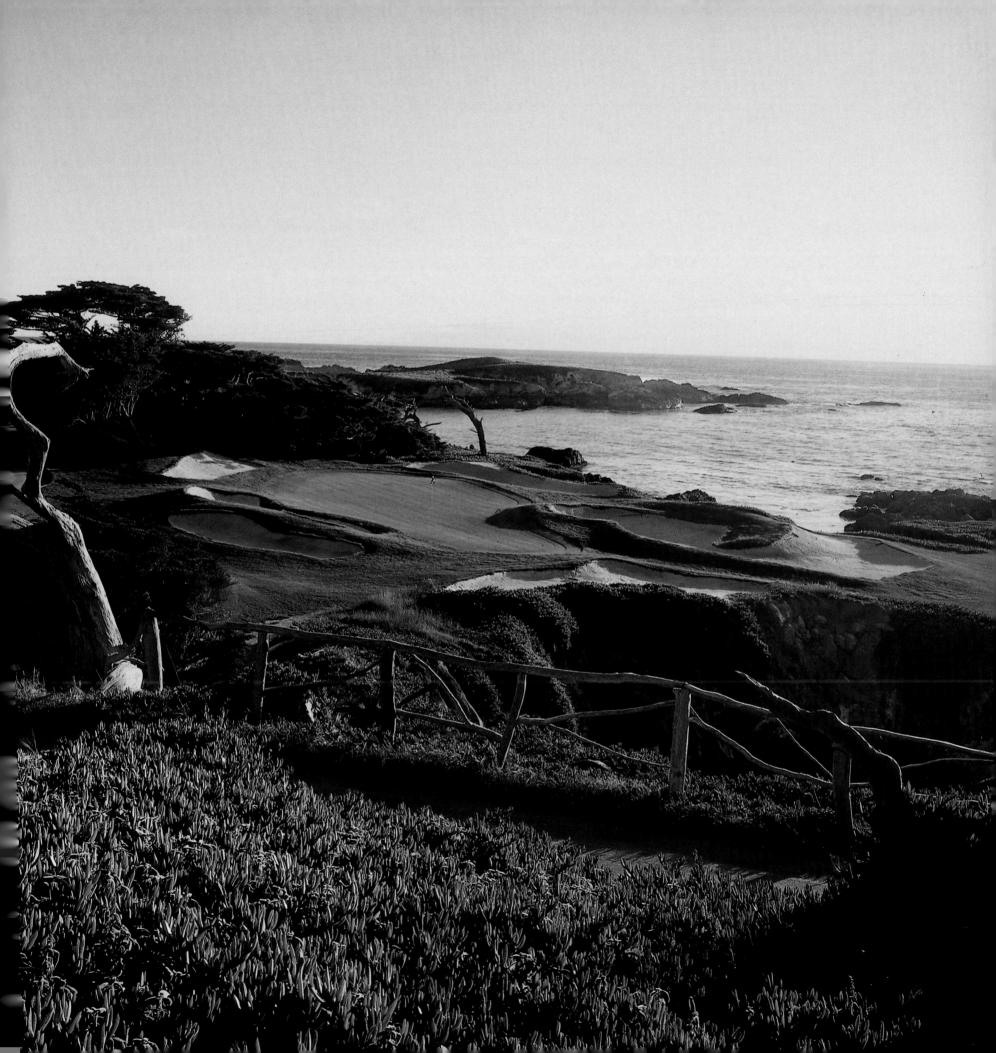

and take in the scene. The target, which can be contemplated for many minutes without danger of wearying the eye, has the aspect of a harmonious, well-proportioned landscape by a master, Homer or Corot. Working up from the sea are rocky bluffs, dull gray or dusky brown depending on the light. Above them, a fringe of tangled grass, the rubbery tentacles of ice plant abloom with pretty flowers, some sandy patches. A half-dozen bunkers of varied shape and size, each quite deep and filled with brilliant white sand, ring the gently contoured, tricorn-shaped green. The twisted, spectral trunks of spent cypress trees dot the landscape. A spindly fence of bleached wood can be seen in the left foreground. The backcloth is a thick copse of dark green

cypress trees, their tops pruned low by the wind. As far as the eye can see to the right is the turquoise-blue Pacific. Visible from the narrow sandy path leading from tee to green is the inlet below, where sea lions bask on the flatter rocks and sea otters frolic in the shallow surf. Briny salt spray fills the air, a result of the relentless pounding of the waves on the rocks. The tee shot called for, a wee pitch, is nothing compared with the monumental demands on body and soul made by the sixteenth. But more than one first-timer, besotted by the fifteenth's beauty, has foozled his tee shot here.

Mackenzie noted in his writings that the fifteenth "is at its best when the flag is placed on the little tongue of green that projects between the

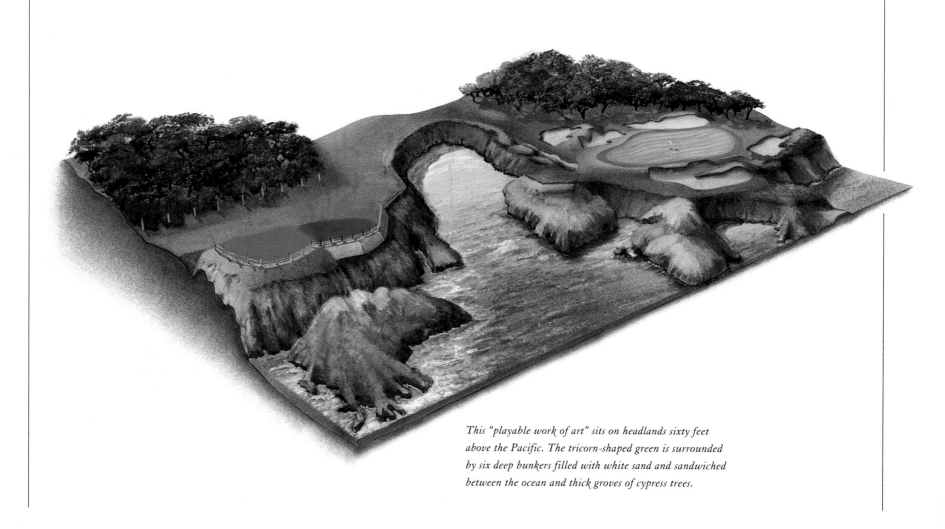

This "playable work of art" sits on headlands sixty feet above the Pacific. The tricorn-shaped green is surrounded by six deep bunkers filled with white sand and sandwiched between the ocean and thick groves of cypress trees.

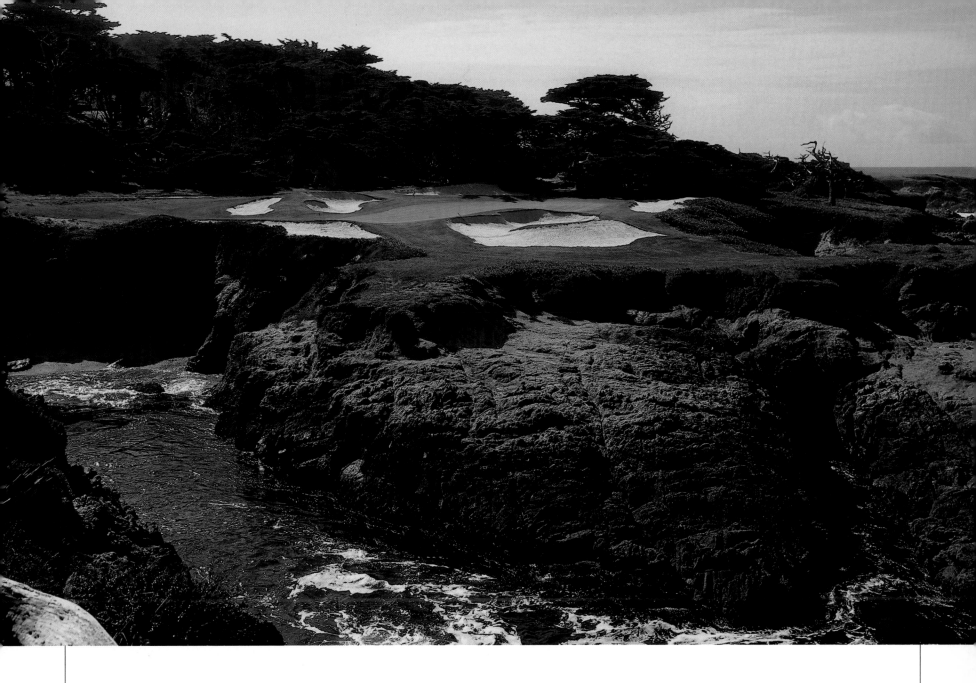

bunkers on the right. In this position, one has the alternative of playing an extremely difficult pitch with the chance of a two, or playing safe to the centre of the green and being content with a three." Ever the strategist, he nevertheless dismissed the fifteenth as "not by any means ideal, as there are not a sufficient number of alternative shots necessary to play it. The hole owes its reputation almost entirely to the beauty of the green and its surroundings."

So much for the notion that aesthetics don't really matter on a golf course: Since its debut in 1929, the splendor of Cypress Point has been reason enough to endear it to connoisseurs worldwide. The fifteenth, the first of three holes occupying a lion's paw of rock thrust into the sea, is a playable work of art. On a course renowned for its transcendent beauty, the diminutive fifteenth is the one that reaches closest to heaven.

COURSE:	THE NATIONAL GOLF LINKS OF AMERICA
HOLE:	4
LOCATION:	SOUTHAMPTON, NEW YORK
ARCHITECT:	CHARLES BLAIR MACDONALD
LENGTH:	197 YARDS · PAR 3

In cinema, it's rare for the sequel to equal the original. The same holds in golf course design. Knockoffs of famous holes rarely capture the drama and excitement of the inspiration.

The most notable exception is the par-3 fourth at The National Golf Links on the south fork of New York's Long Island, an exquisite replica of the original "Redan" hole found on the West Links at North Berwick in Scotland. The name is derived from a fortification fronted by long, deep trenches, which was assaulted by the British during the Crimean War. It is a classic line of defense that has been reproduced on one-shotters all over the world.

Architect Charles Blair Macdonald, one of the patriarchs of golf in America, wasn't interested in merely duplicating holes from the best British courses. He set out to refine them at The National, which came to be recognized as the country's first great course shortly after it opened in 1911. Located on 205 acres of tumbling land adjoining Shinnecock Hills, The National features brilliant renditions of "the Alps" hole at Prestwick as well as "the Eden" and "the Road" holes at St. Andrews. But the fourth does more than embody the strategic principles of its model; it improves upon them.

In describing the placement of classical British holes at The National—this after the land was cleared of scrub and its contours studied in earnest—

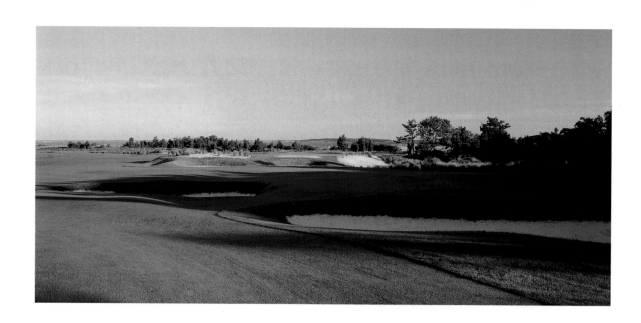

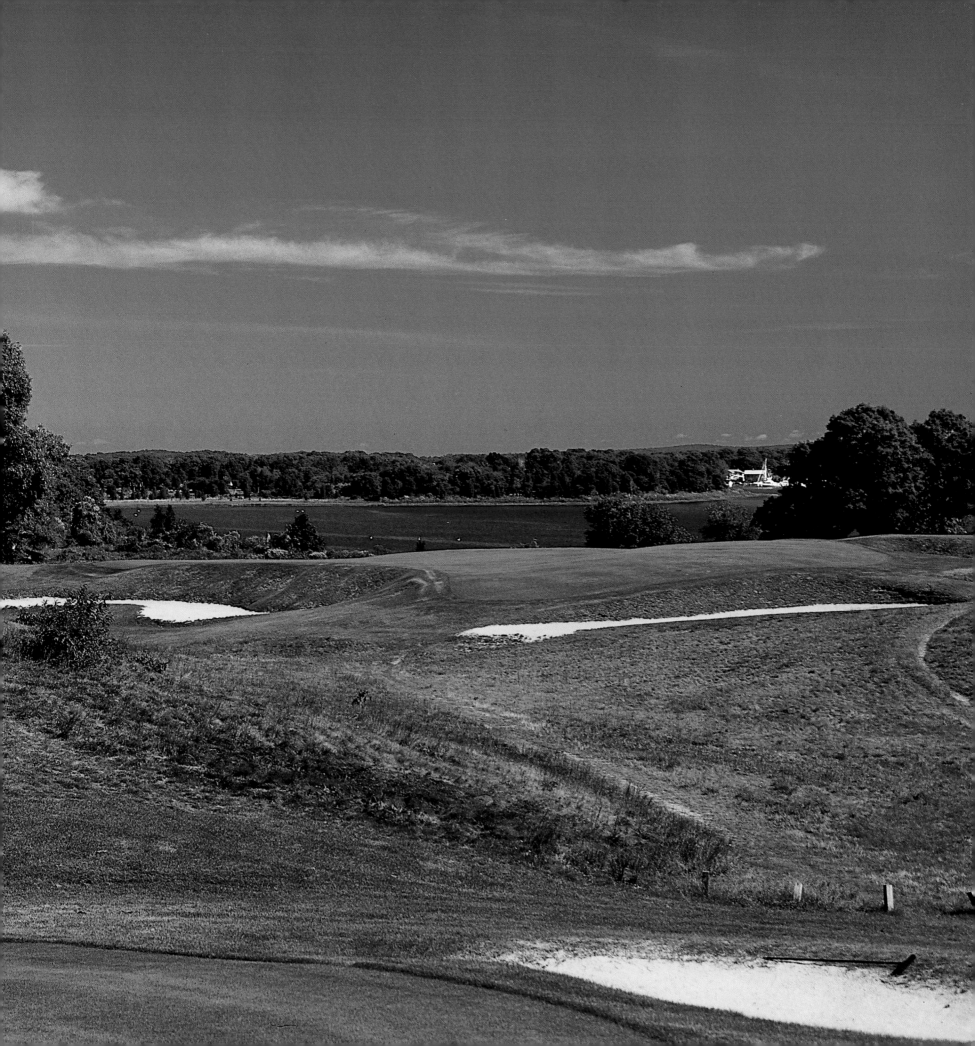

Macdonald wrote, "We [found] a perfect Redan which was absolutely natural. . . . Ben Sayers, well-known professional at North Berwick, told me he thought it superior to the original."

So has everyone who has played both. The tee shot on the par-3 fifteenth at North Berwick is semiblind, the target and its defenses obscured by a ridge. At The National's Redan, the challenge is in plain view: From an elevated perch, players gaze across a valley to a long, plateau green angled diagonally from front right to back left and set twenty-five feet above a forbidding sand pit. Deep bunkers guard the left and right flanks. Though a well-defended fortress, it will yield to a clear plan of attack.

Macdonald, who pioneered the concept of strategic golf in America, offers a multitude of options, depending upon the golfer's level of skill, the standing of the match, and the strength and direction of the wind. The hole can be played cautiously to the right of the green by the bogey shooter happy to settle for a 4. From the back tees at 197 yards, shrewd, accomplished players generally fire a mid-iron to the right corner of the green. Hit the correct distance with a draw, this tee shot will generally run onto the putting surface, leaving a long, slippery putt for birdie but a reasonable chance for par. The confident scratch player in search of glory can play the Redan heroically by shooting directly for the pin, a heart-stopping notion that brings the deep trench in front as well as a steep slope behind the green into play. There are dire consequences for a bold effort that fails. The sandy hazards defending the Redan fulfill Macdonald's edict that "the object of a bunker or trap is not only to punish a physical mistake, to punish lack of control, but also to punish pride and egotism."

Bottom line? Macdonald's Redan redux, his "transatlantic translation" of the Scottish original, is the standout creation on a course that serves as a sepia-tone highlight reel of great golf holes.

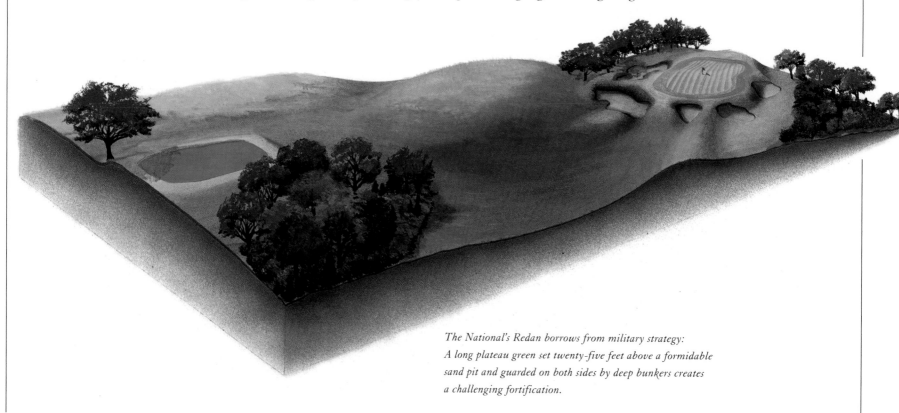

The National's Redan borrows from military strategy: A long plateau green set twenty-five feet above a formidable sand pit and guarded on both sides by deep bunkers creates a challenging fortification.

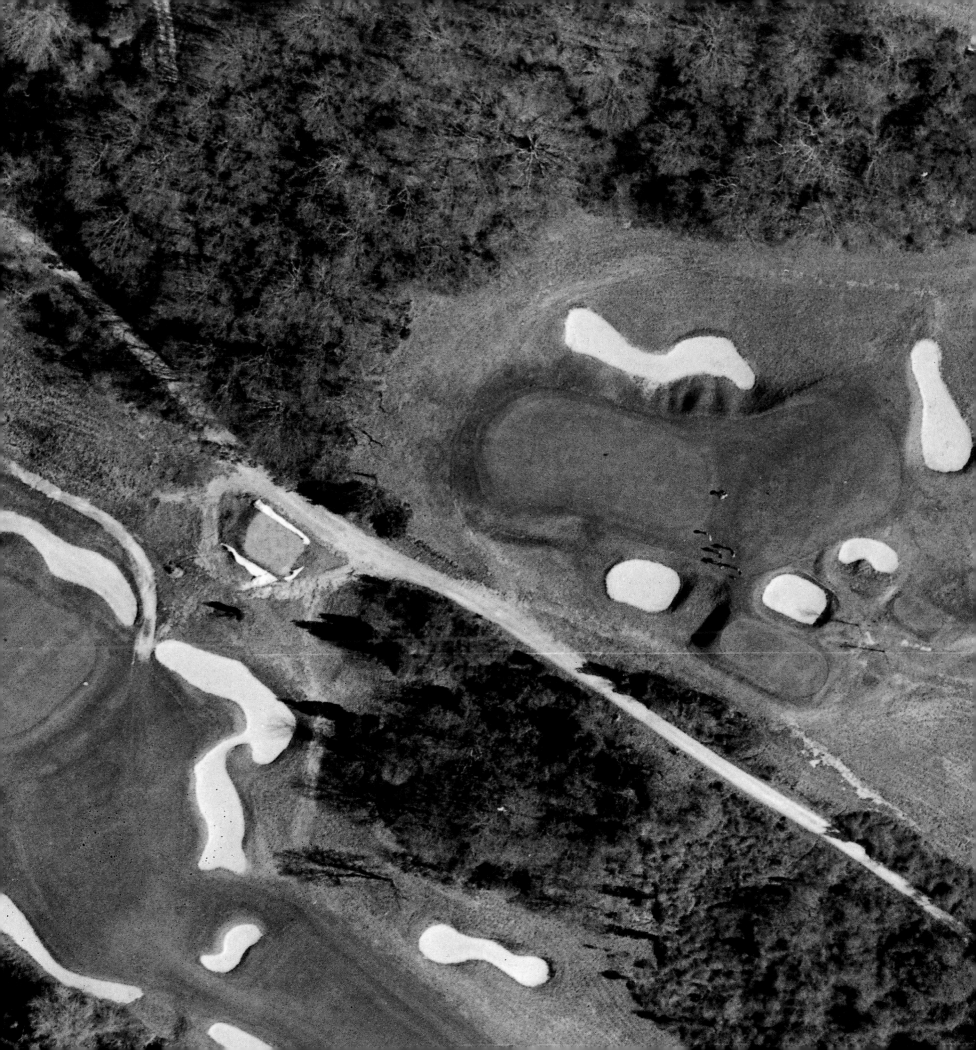

COURSE:	TOURNAMENT PLAYERS CLUB AT SAWGRASS (STADIUM)
HOLE:	17
LOCATION:	PONTE VEDRA BEACH, FLORIDA
ARCHITECT:	PETE DYE
LENGTH:	132 YARDS · PAR 3

The nation's first spectator-friendly, purpose-built stadium course is no longer the starkest examination of golf imaginable, no longer an excruciating test that had the pros kicking and screaming shortly after they first played it in 1982. Pete Dye, who conjured this grassy guillotine from swampland south of Jacksonville, had his own head put on the block by PGA Tour stars who posted sky-high scores immediately after The Players Championship moved to its new home. So Dye went back to the drawing board to flatten some of the hogback ridges in the greens, soften angles by widening landing areas, and generally ensure that most would survive his target-style prototype.

One hole he did not touch is the most vilified and notorious one-shotter in the game, an icon of a hole that lies coiled like a serpent, poised to strike at round's end. Pete Dye's cyclopean creation wasn't the first island green, but it's by far the most famous. And the most lethal. Especially on a windy day. Because there's nowhere to run, nowhere to hide on this man-eating midget. The target, a bulk-headed raft in the middle of a lake, is only 132 yards from the TPC markers, 121 yards from the blue tees, 97 yards from the white pegs. But it's not about yardage. It's about guts, inner fortitude, and that quicksilver item called confidence. "I wanted to test the best players in the world emotionally as

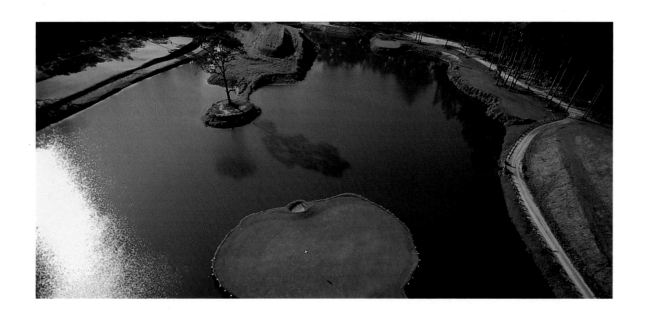

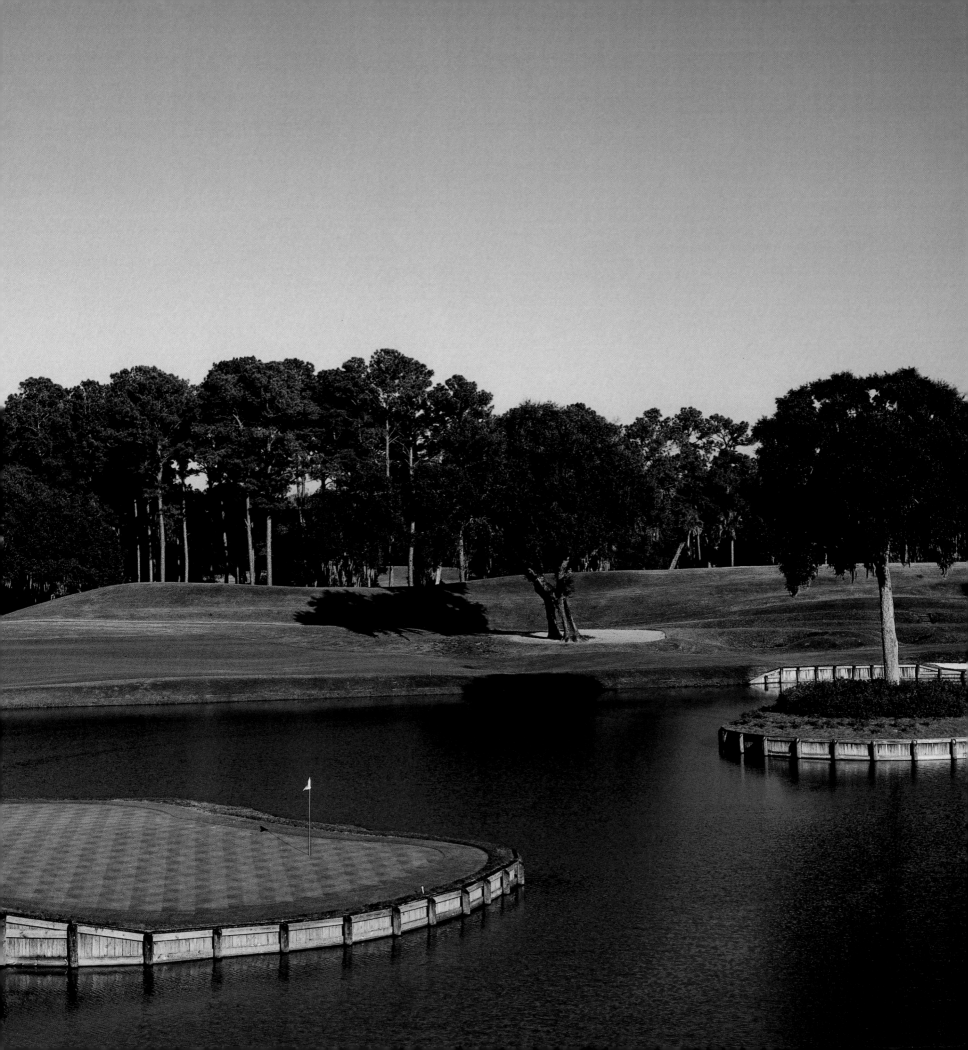

well as physically and mentally" was the Marquis de Sod's rationalization for his wicked bit of watery stagecraft. Mission accomplished.

The Stadium's seventeenth has seen its share of tragicomedy, heroics, and red-faced embarrassment. David Duval birdied the hole in the final round of the 1999 Players Championship to cement his victory. The year before, little-known Len Mattiace, on the brink of his first Tour victory, airmailed his tee shot over the green en route to an 8 on Sunday; he stumbled into a tie for fifth. In 1994, the world of golf got its first eyeful of a fiery, fist-pumping teenager named Tiger Woods, who barely caught the right edge of the island green with his tee shot, but then rolled in a birdie on the thirty-fifth hole to go one up in his match and seal the first of his three U.S. Amateur titles. Ten years previous, blustery winds up to forty miles per hour swept the course during the opening round of The Players Championship. The stroke average that day on the seventeenth was 3.79, at the time

the highest ever recorded for a par 3 on the PGA Tour. A total of sixty-four balls got splashed. From 132 yards. By the world's best players. Prompting John Mahaffey, one of its victims, to describe the hole as "one of the easiest par fives on the course."

Ironically, the seventeenth on the Stadium was not originally blueprinted for an island green. At the time Dye drained a marsh and built a moat around the 415-acre tract, the seventeenth was supposed to have water only on the right. But because sand was needed from the excavated site to create features elsewhere, Dye kept digging and eventually acted on a suggestion made by his wife, Alice (Eve handing Adam the apple?), to eliminate the bailout area. The only land to the left is a thin umbilical cord of grass, a footpath linking green to fairway.

Fear is golf's worst emotion. The slightest swing glitch, the slightest miscalculation at the seventeenth, and your hopes are drowned. And misery loves company: More than 120,000 balls end up in the lake each year. Miss the green on your second

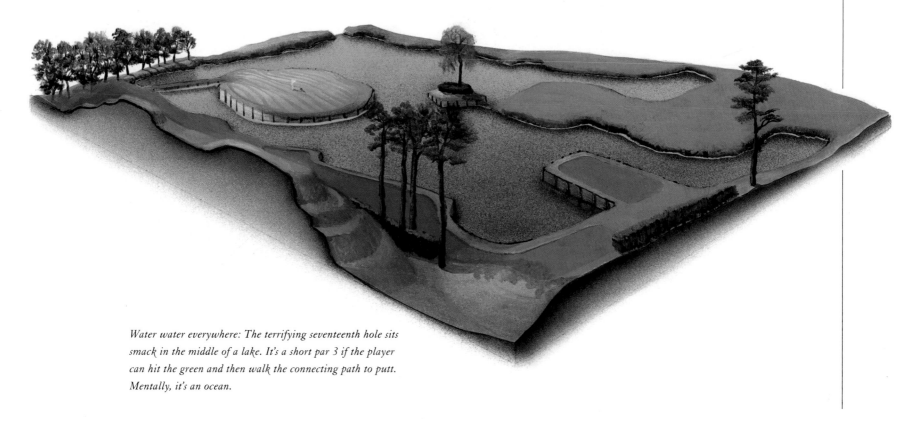

Water water everywhere: The terrifying seventeenth hole sits smack in the middle of a lake. It's a short par 3 if the player can hit the green and then walk the connecting path to putt. Mentally, it's an ocean.

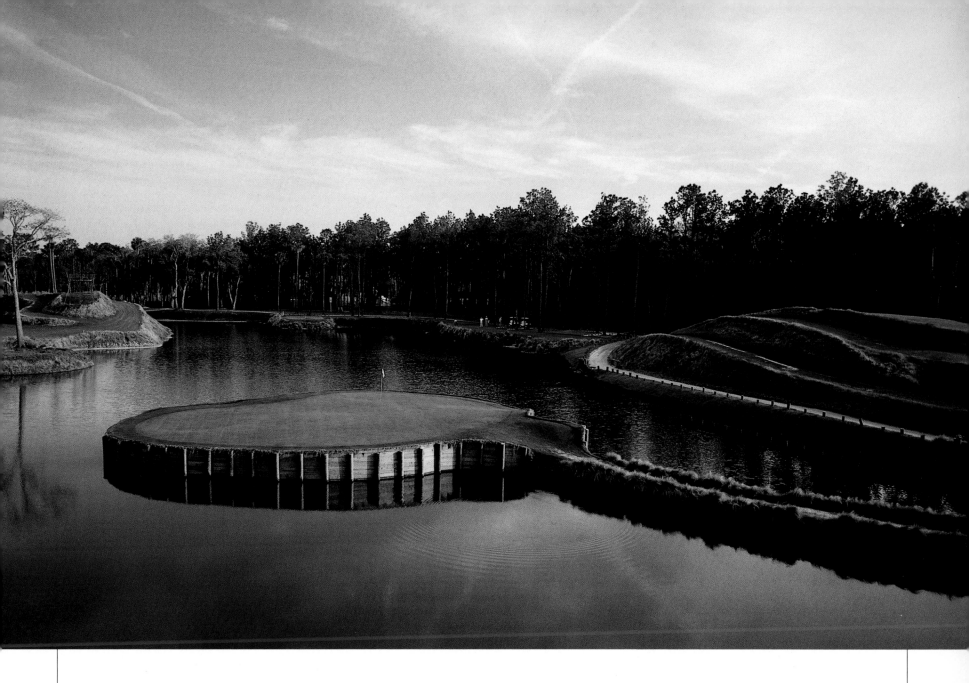

attempt, and you adjourn to a drop area to play your fifth shot from fifty yards. Hands shaking, expectations crushed, and with that bleeping water still to carry, you see it's a shot no less difficult than the tee shot itself.

Very few holes manage to get in a player's head before he tees off. The seventeenth at the TPC comes late in the round, but there isn't a neophyte or expert player anywhere who can deny at the start the psychological significance of its do-or-die outcome, the panic it can induce on a breezy afternoon, the potential it holds for failure . . . shame . . . public humiliation. With something at stake—bragging rights, a $10 Nassau, a $1.1 million payday, you name it—the wee pitch at the Stadium's seventeenth is the scariest shot in golf.

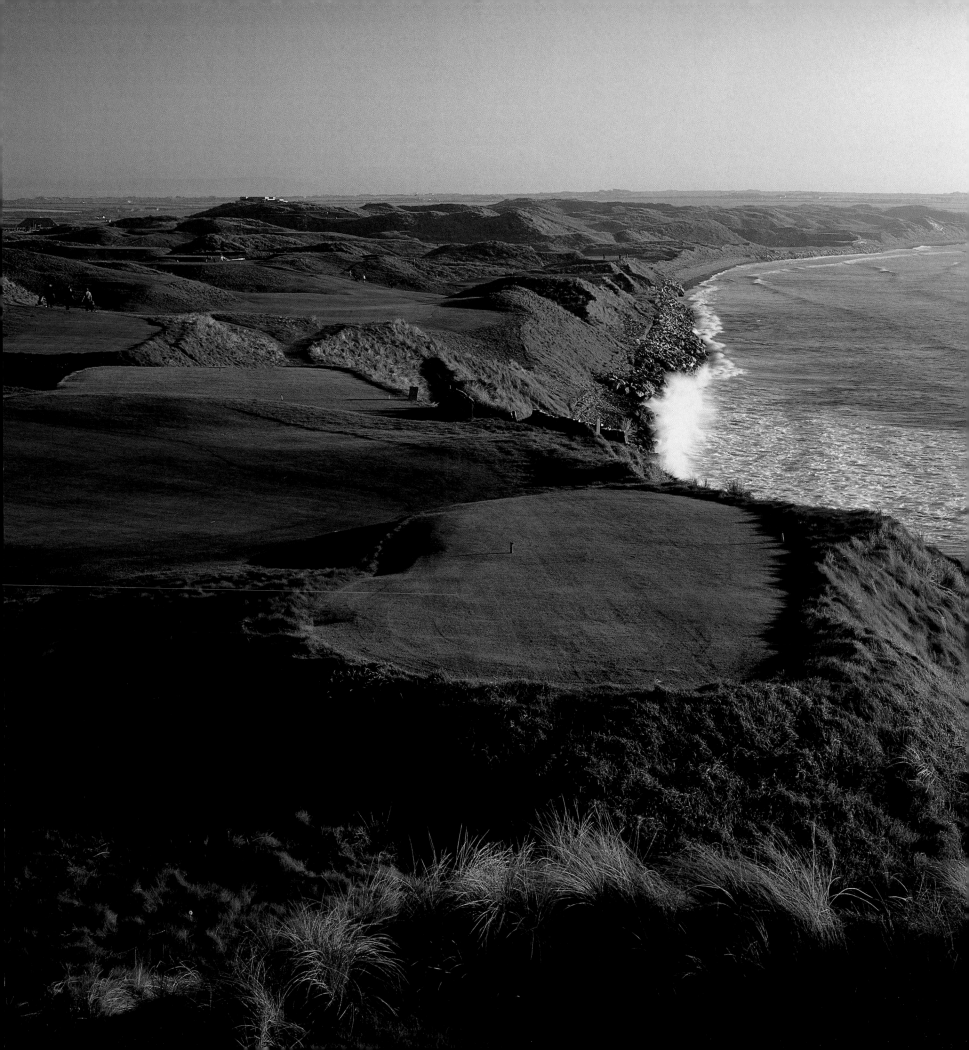

COURSE:	BALLYBUNION GOLF CLUB (OLD)
HOLE:	11
LOCATION:	BALLYBUNION, COUNTY KERRY, IRELAND
ARCHITECTS:	PATRICK MURPHY, TOM SIMPSON/MOLLY GOURLAY
LENGTH:	453 YARDS · PAR 4

Scotland is the birthplace of golf, but Ireland rocked the game out of the cradle, nourished it on creamy stout, and then set it loose upon the woolly seaside dunes. The biggest and most famous of the brood is Ballybunion.

Located in the southwest of Ireland in rural County Kerry, the links weaves through towering sand hills on the south shore of the Shannon Estuary. The original club dates to 1893. Its rudimentary layout was expanded from nine to eighteen holes in 1927. When Tom Simpson and Molly Gourlay arrived to revise the links in 1936, they applied a few brushstrokes but otherwise left well

enough alone. "The beauty of the terrain surpasses that of any course we know," Simpson wrote to the club. "Never for one moment did we imagine, or expect to find, such a really great course or such a glorious piece of golfing ground."

Herbert Warren Wind, the dean of American golf writers, put Ballybunion on the map by describing the links in 1971 as "nothing less than the finest seaside course I have ever seen." But not until Tom Watson arrived in 1981 to tackle the links and later sing its praises did pilgrims wake up to the idea that Ballybunion was well worth a detour.

Notwithstanding the fact that the first hole

borders a cemetery, Ballybunion gets off to a fairly mild start. Not until the seventh tee, perched atop a sea cliff, do players realize where they are—at the brink of Eire. By the time the clifftop tee at the eleventh is mounted, few would dispute Wind's assessment. Setting aside the formidable challenge of this 453-yard par 4 (400 yards from the regular tees), the view places the eleventh hole in a class of its own. The tiny tee clings to a flattened dune seventy feet above the beach and the mouth of the Shannon. The ocean's combers beat into the shore far below, while the eye traces the coastline as it curves to the right, the sandy bluffs extending in an arc and eventually giving way to farmland. On a clear day, mountains on the Dingle Peninsula can be seen to the south. Far offshore, schools of dolphin occasionally break the surface and leap into the air.

Now for the golf. From the championship tee, which only champions play, there's a carry of over two hundred yards to a ribbon of tumbling fairway flanked to the left by massive sand hills and to the right by the cliff edge. Depending upon the direction of the breeze—few experience Ballybunion without a taste of its salty, slanting rain driven by fierce winds—you may have to aim the drive out to sea and carry it back to safety. The twisting fairway stairsteps down through the shouldering dunes to a shelf and, farther below, a valley. Beyond the terraces at the end of the chute, a pair of sand hills pinch the entry to the raised green. There are no bunkers to defend the green. None is needed. The dunes and sea are defense enough. A pushed approach disappears over the edge of the cliff; a pulled shot may never be found in the matted dunes. Watson ranks the eleventh as one of the toughest holes in the world. Pars here are as rare as four-leaf clovers.

In his book *Emerald Fairways and Foam-Flecked Seas,* Jim Finegan said of the eleventh: "Such a combination of majesty and ferocity, of originality together with the integrity of the truly natural, is rare indeed. And so probing an examination is it that on a typically breezy day, regardless of how you choose to maneuver, you cannot guarantee a bogey." Contestants in the 2000 Murphy's Irish Open, the first national championship held at Ballybunion, came to a similar understanding after four rounds.

To succeed at the eleventh, it is not enough to advance your ball meekly down the fairway. No, the hole must be played with abandon, as the Irish do, holding nothing back. "Have a lash at it, lad"—and hope for the best.

This seaside course lies along the south shore of southwest Ireland's Shannon Estuary. Its diminutive eleventh is so well defended by dunes and sea that no bunkers are necessary. The hole is considered one of the world's most difficult.

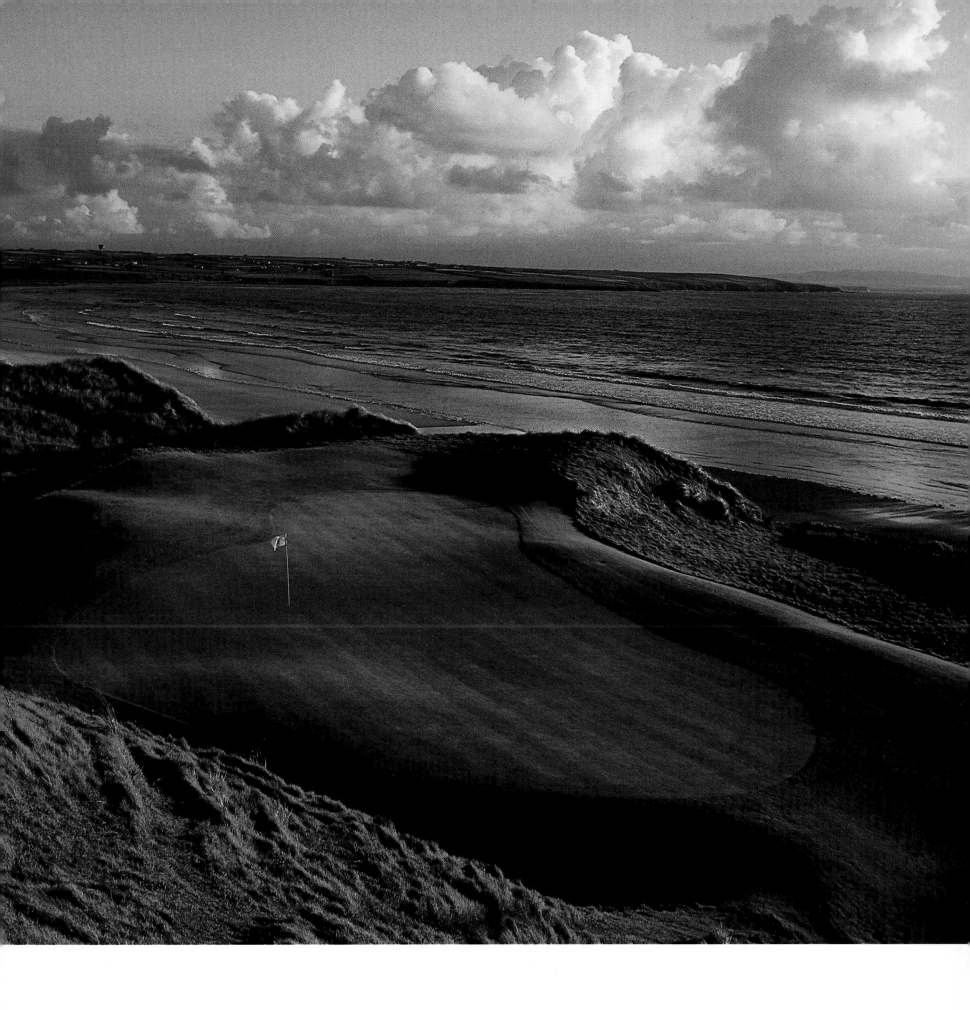

COURSE:	BETHPAGE STATE PARK GOLF CLUB (BLACK)
HOLE:	5
LOCATION:	FARMINGDALE, NEW YORK
ARCHITECTS:	A. W. TILLINGHAST, REES JONES
LENGTH:	455 YARDS · PAR 4

In the Bible, Beth'phage, or "House of Figs," is located between Jericho and Jerusalem. For the overconfident, the unprepared, or simply those easily intimidated by penal golf on a grand scale, the Black Course at Bethpage State Park on Long Island is located not an hour's drive east of New York City, but somewhere between Purgatory and Hades.

Site of the 2002 U.S. Open, the Black, the first publicly owned course to host the national championship, has reduced many top players to their knees. Sam Snead, who played an exhibition on the Black Course in 1940, is reported to have stalked off the course in disgust after his second shot sailed over the green into oblivion at the par-5 fourth.

Too bad he didn't stick around to play the fifth. It's the best hole on the course and arguably the finest two-shotter on the impressive résumé of A. W. Tillinghast, a golden age architect best known for his work at Winged Foot and Baltusrol.

Thanks to a $2.7 million overhaul completed in 1997 by "U.S. Open Doctor" Rees Jones, who donated his fee to complete the job, the 7,295-yard, par-71 layout (7,055 yards, par 70 for the Open) is better now than when it was merely the finest test of golf in the New York metropolitan area.

With work relief crews at his disposal in the post-Depression era, Tillinghast, nearing the end of his legendary career, revised a preexisting layout and sculpted three new courses from central Long Island's rolling, wooded hills. (A fifth venue was added in 1958.) The Black, opened in 1936, was "Tillie the Terror's" last hurrah, a bold manifesto clearly intended for championship play.

After touring the proposed site in 1934, Tillinghast reported: "The terrain presents infinite variety. Never quite flat but gently undulating, it grades to impressive ruggedness." With only rudimentary earthmoving machinery at his disposal,

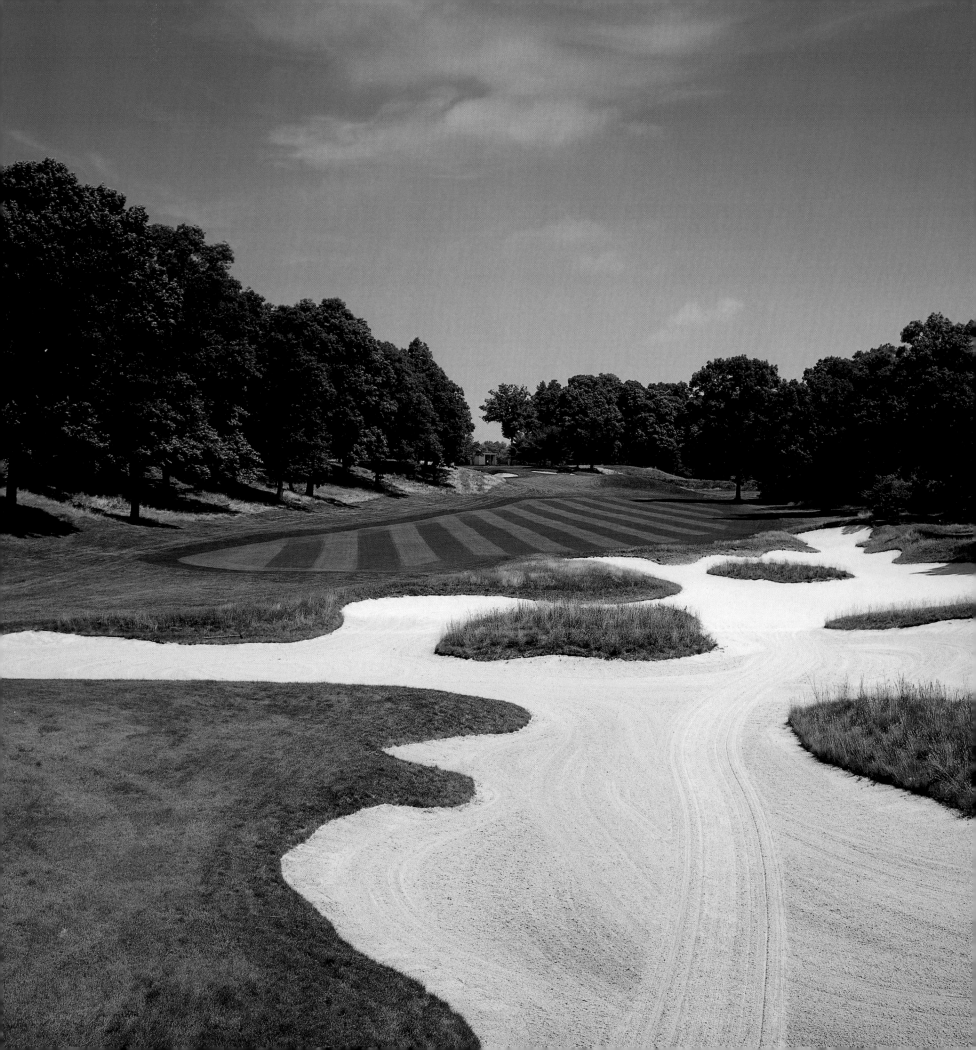

Tillinghast let the rise and fall of the land dictate the routing of the course and the shape of the holes. The result, in the hands of a master who sought to emulate nature, is a strategic tour de force, brawny yet intimate. Nearly every hole on the Black occupies its own compartment. Melded to the site's crests and swales, framed by oaks and sand, each of the holes is highly individual. None more so than the fifth.

Even in its battered state before its facelift, the fifth hole presented a heart-stopping challenge. A stunning risk-reward design stretching to 455 yards, the fifth asks for a mammoth drive from an elevated tee over sloping ground and a huge angled bunker expanded and refined by Jones. This elongated wasteland runs diagonally along the right side of the fairway. Take the bunker out of play by hitting safely to the left, and the hole is effectively turned into a par 5, because thick woods bordering the left side of the fairway block the path to the green. Better players who desire a clear shot at the green must play the hole heroically, carrying the entire length of the enormous maw in order to land the ball on the right-center portion of the fair-

way. The carry from the back tee to the far end of the trap is about 240 yards. Into the wind, only Tiger Woods and a handful of others could negotiate the direct route.

The approach at the fifth is as testing as the drive. Perched on a plateau at the end of the fairway is a small, saucer-shaped green girded by shaggy grass and three cavernous bunkers. The swept-up faces of these scalloped pits obscure the surface of the green. From the fairway thirty feet below, all a player sees is a flagstick rising from sand and tangled rough. Like most of the greens on the Black, the contours on the putting surface here are rather mild. As they should be, given the difficulty in reaching this and nearly every green on the course unscathed. Tillinghast once wrote, "I think that . . . a controlled shot to a closely guarded green is the surest test of any man's golf." The fifth at Bethpage Black is Tillie's best example.

Many a player has staggered to the snack stand behind the green to take refreshments and pause to recover from a bout with this bruiser. All can take consolation in the fact that they lasted longer than Sam Snead.

A fairway menaced by a huge bunker on the right and trees on the left demands a heroic drive. As if that's not enough, the small green sits on a plateau thirty feet above the fairway, protected by tall grass and three huge bunkers.

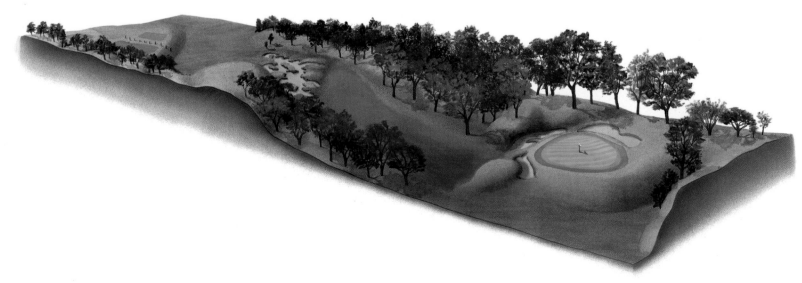

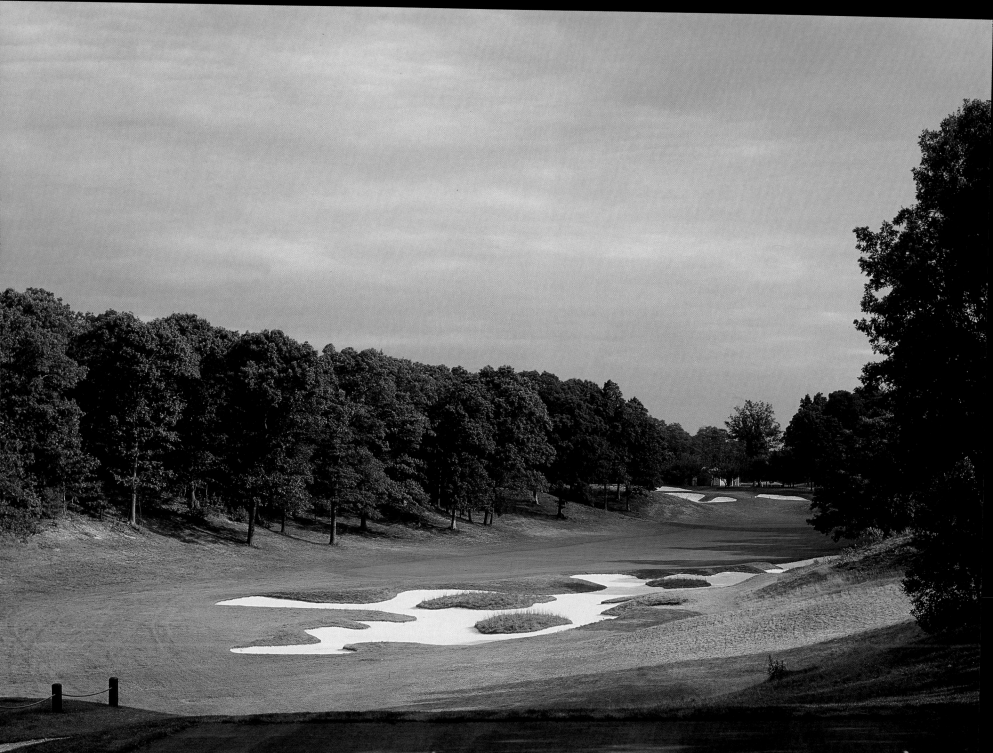

COURSE:	MERION GOLF CLUB (EAST)
HOLE:	16
LOCATION:	ARDMORE, PENNSYLVANIA
ARCHITECT:	HUGH WILSON
LENGTH:	428 YARDS · PAR 4

Golf's pantheon of elite clubs has suburban expansion along Philadelphia's Main Line and the Haskell rubber-cored ball to thank for the creation of Merion. When the lively new ball eclipsed the challenge posed by the Merion Cricket Club's original eighteen, a modest 125-acre tract of depleted, rolling farmland was acquired in nearby Ardmore for a second course. Hugh Wilson, a thirty-one-year-old insurance broker and former captain of the Princeton golf team, was appointed to design the course. Wilson, who had no formal training as an architect, traveled to Scotland and England to study the great courses. He returned after seven months and set to work.

It was not Wilson's intention to duplicate famous holes at Merion. Rather, he attempted to build a parkland course full of subtlety and nuance by fitting the holes to the land. What he came up with is the finest compact layout ever devised, a sweeping, timeless design marked by flashed-face bunkers and grade-level greens that gives no hint of limited space. What it is, according to Pete Dye, "is a wee wisp of golf's ancestral land spirited away to a Pennsylvania valley." What it has, according to Tom Doak, is "an aura of perfection." Opened in 1912, it was and is an American original.

The holes, each individual yet all of one piece, are strategic, fair, and enticing. Most memorable

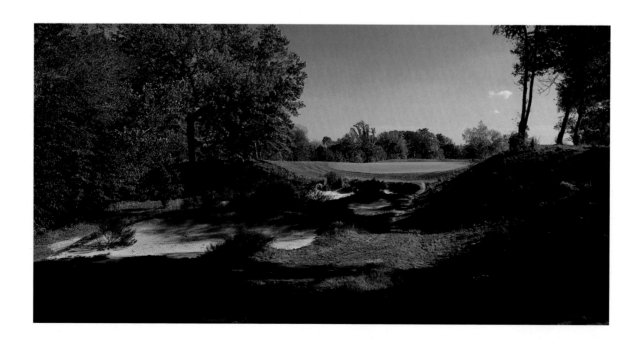

among them is the sixteenth, "the Quarry" hole. From a slim, elevated tee, the 428-yard sixteenth drops down into a valley. Approximately three hundred yards from the tee, the broad fairway ends abruptly at an old limestone quarry. The terrain in the quarry is hellish: gaping maws of sand, waist-high broom, impenetrable rough. Fifty feet above the pit is the slippery lower shelf of the giant green. The pin is usually located on the top tier, so that what a player sees from the fairway is not a waving flag but one of Merion's trademark wicker baskets set against the sky. These baskets, while charming, deny players the type of information about wind conditions that normal flags provide.

A heroic hole with penal consequences for the foolhardy, Merion's sixteenth invites attack but offers a detour around the quarry for what Henry Longhurst once called "players of lesser attainment." A tongue of fairway sweeps to the right and skirts the rim of the desolate pit. Choosing the roundabout route to the green is the safest way to secure a bogey. Taking the direct route over requires

skill and courage—not to mention a great drive.

History has been made at Merion. Bobby Jones made an appearance here as a fourteen-year-old prodigy in the 1916 U.S. Amateur but was dispatched in the quarterfinals. Eight years later, he won his first U.S. Amateur title here. Jones made a hero's journey to the club in 1930 to earn his fifth U.S. Amateur trophy and complete the fourth leg of his historic Grand Slam. Ben Hogan, competing in the 1950 U.S. Open a mere sixteen months after his near-fatal auto accident, captured the second and greatest of his four Open victories in a playoff. On a course considered by many to be too short for the modern pro, Jack Nicklaus and Lee Trevino tied for the lead at even par 280 after seventy-two holes in the 1971 U.S. Open. Trevino carded a 68 to Nicklaus's 71 in the playoff to claim the title. Despite the loss, Nicklaus said, "Acre for acre, [Merion] may be the best test of golf in the world."

The club has a storied championship tradition, and Pete Dye put his finger on why: "Merion is not great because history was made there," he wrote in

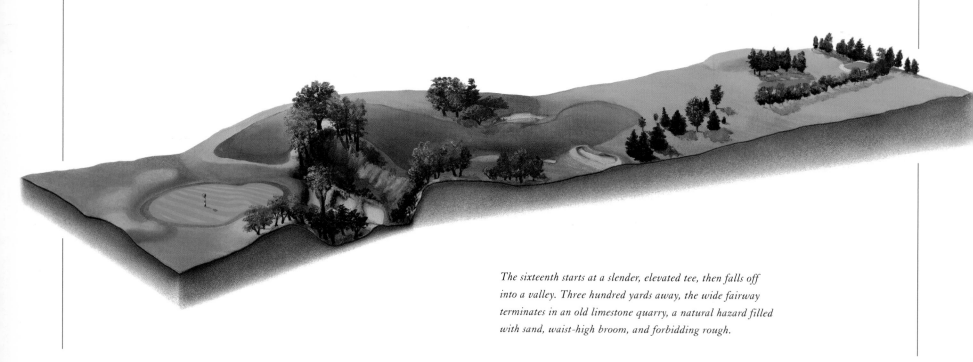

The sixteenth starts at a slender, elevated tee, then falls off into a valley. Three hundred yards away, the wide fairway terminates in an old limestone quarry, a natural hazard filled with sand, waist-high broom, and forbidding rough.

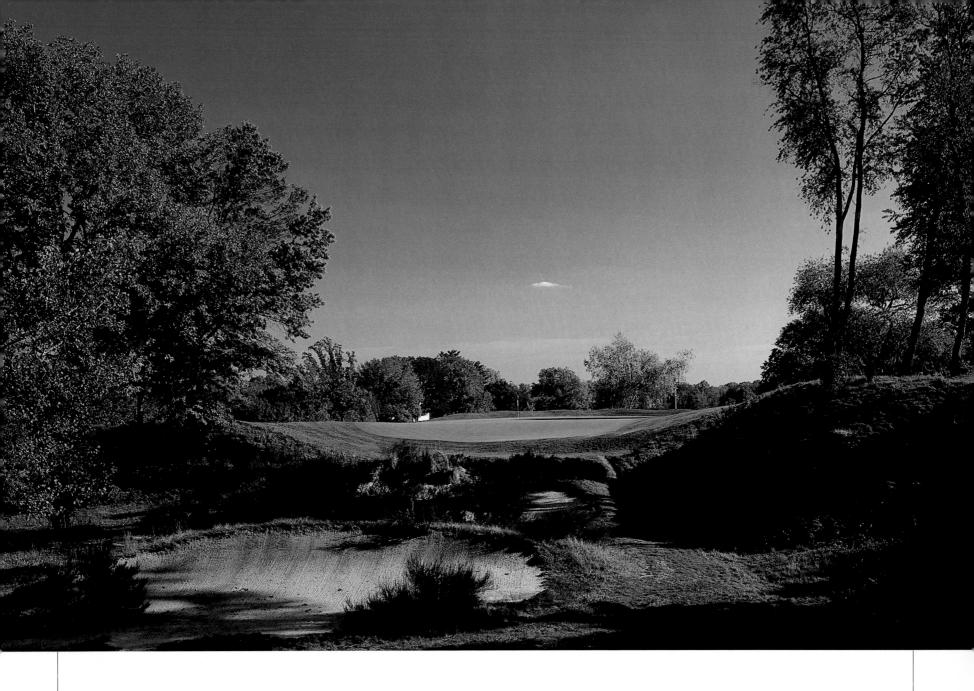

the USGA *Golf Journal* on the eve of the 1981 U.S. Open. "History was made there because Merion is great."

A. W. Tillinghast, a fellow Philadelphian, reviewed Wilson's handiwork at Merion in the *American Cricketer,* bestowing special praise on the sixteenth hole:

The old quarry, which is traversed by the last three holes, is a wonderfully effective natural hazard and makes these holes a fine finish. The 16th is a corker. . . . It is a real gem. . . . If your drive is a good one, before you stretches the old quarry, its cliff-like sides frowning forbiddingly. Just beyond, and sparkling like an emerald, is the green, calling for a shot that is brave and true. It seems almost like a coy but flirtatious maiden with mocking eyes flashing at you from over her fan, and as you measure the distance between, you are fired with the ambition to show off a bit. . . . No one will ever play Merion without taking away the memory of No. 16.

COURSE:	MID OCEAN CLUB
HOLE:	5
LOCATION:	TUCKER'S TOWN, BERMUDA
ARCHITECT:	CHARLES BLAIR MACDONALD
LENGTH:	433 YARDS · PAR 4

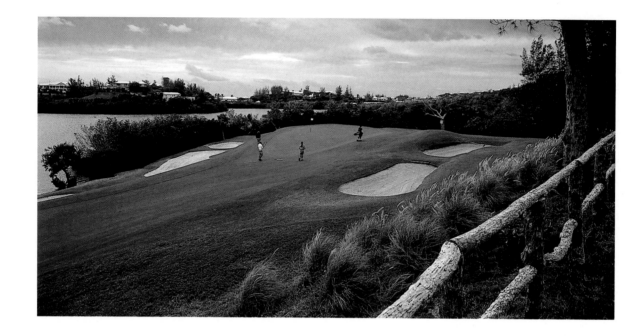

A destination unto itself, Bermuda, located 640 miles east of North Carolina, is a felicitous group of islands shielded from the arctic winds and frigid waters of the North Atlantic by the warm Gulf Stream, which flows past it. With eight golf courses distributed among its twenty-one square miles, Bermuda, a self-governing British colony, has more courses per capita than any other place on earth. But it's the quality of its most prestigious layout, Mid Ocean, that sets it apart from all other golf atolls.

Long before jets reduced travel time from the East Coast's major cities to two hours, a trip to Bermuda required a long voyage by steamship. In the early 1920s, Charles Blair Macdonald, the self-appointed patriarch of American golf, was enticed by a steamship company to visit Bermuda with the idea of building a course shortly after "the eighteenth amendment was passed and the nineteenth hole abolished," according to his memoirs. After locating desirable property in what is now the exclusive enclave of Tucker's Town—"delightful valleys winding through coral hills"—Macdonald set to work re-creating classic hole designs found on famous British links. He also made brilliant use of his own innovative ideas for strategic holes, holes that call for sound planning and occasional heroics.

"The Cape" hole was a Macdonald original: A dogleg par 4 across a body of water that invited

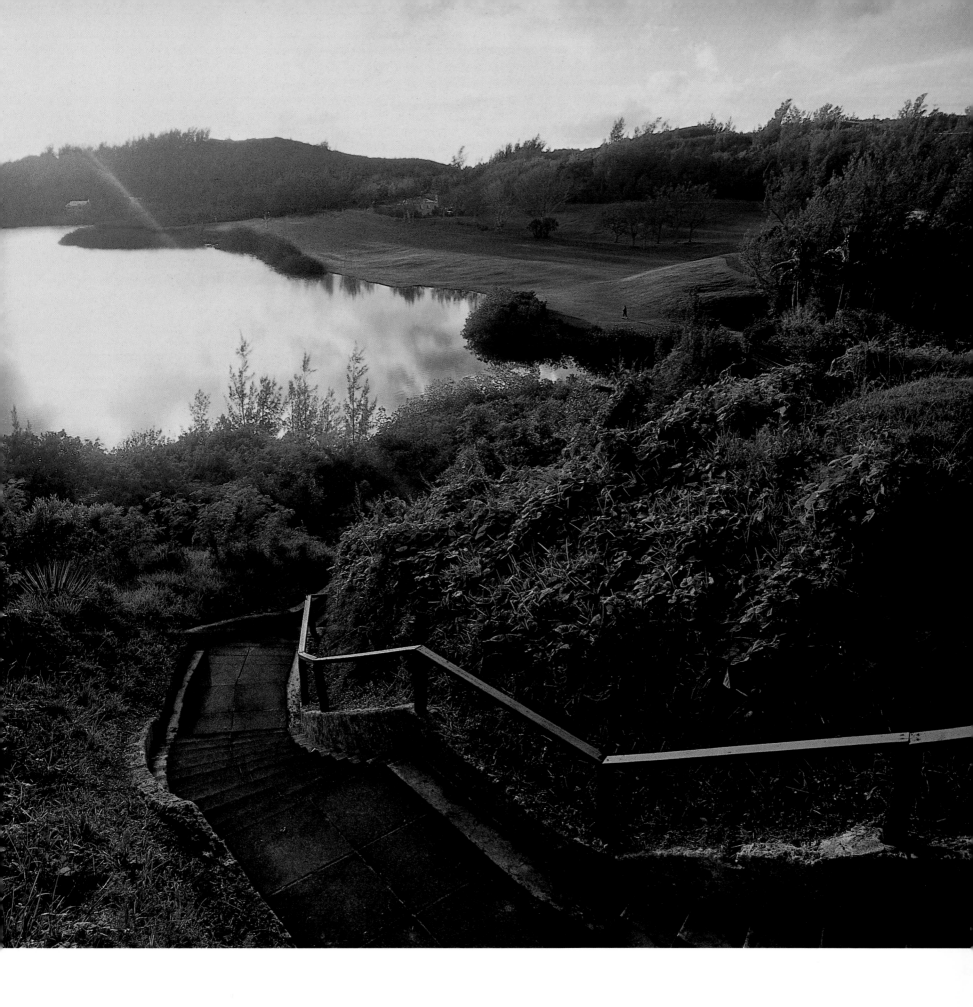

golfers to cut off as much as they dared. It is reckoned that the Cape concept has been duplicated more than any other motif in golf course design.

Macdonald built his first Cape hole at The National Golf Links in Southampton, New York. There, the carry over water is relatively short: The tee shot played to a rippling fairway that doglegs sharply to the right. The fifth at Mid Ocean, its thronelike tee notched in a hill one hundred feet above Mangrove Lake, is far grander and more dramatic than the original Cape. At 433 yards from the blue tees, it is also more difficult. In fact, it presents one of the great risk-reward scenarios in the world, as lovely as it is intimidating. The hole, in essence, is a seductress that juggles a golfer's heart and soul by trading on greed and fear.

Far below the platform tee, a broad fairway sweeps down from a wooded coral ridge and curves to the left around the irregular shore of the lake. The fairway tilts to the water as it nears the green. Those lacking skill or courage can play safely to the right over the narrowest neck of water, a carry of 150 yards, but from that vantage point there is little chance of reaching the green in regulation. Bolder players must determine for themselves how much of the lake to cut off. "One sips as much of it as one can swallow," observed the late Charles Price. There's the strength and direction of the wind to consider, and intestinal fortitude, too. The temptation to bite off a good-sized chunk of the hazard is great: From the elevated tee, the direct route over the lake, described by Robert Trent Jones, Jr., as "one of the most truly heroic tee shots ever conceived," is longer than it looks. Figure on a carry of at least 225 yards to the far shore in line with the tee box, more if one is prone to hook. Once attained, the far left edge of the fairway offers a shorter approach and a superior angle to the green. Perhaps this was Babe Ruth's line of reasoning when he made Mid Ocean's fifth hole infamous in the 1930s: The Bambino reportedly swatted eleven straight tee shots into the drink before calling it quits.

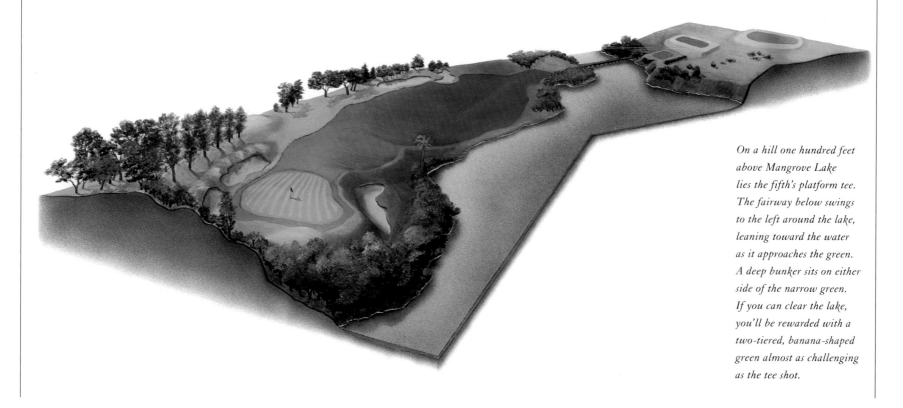

On a hill one hundred feet above Mangrove Lake lies the fifth's platform tee. The fairway below swings to the left around the lake, leaning toward the water as it approaches the green. A deep bunker sits on either side of the narrow green. If you can clear the lake, you'll be rewarded with a two-tiered, banana-shaped green almost as challenging as the tee shot.

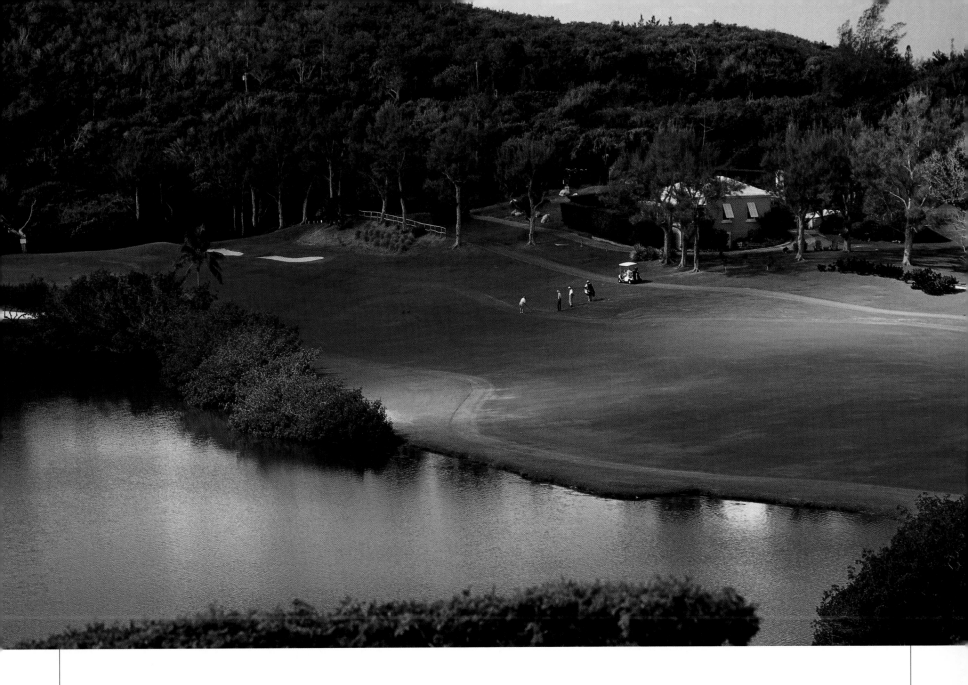

Judging the angle correctly and finding the safety of the fairway is only half the battle. The green, sited at the water's edge, is nearly a hazard unto itself. Deep, trenchlike bunkers bracket the narrow, banana-shaped green. The two-tiered putting surface, flat on bottom and wickedly contoured on top, also slopes from right to left, toward the water. The bunkers on the left are hunkered five feet below the shelflike green. A mangrove thicket stands between the traps and the lake. Bailing out to the right leaves a delicate bunker shot or a very testy pitch over a rising knoll. The club's members maintain that the green complex at the fifth is nearly as daunting as the tee shot played across the lake.

But it's the nerve-tingling prospect from the sky-box tee on Mid Ocean's toughest hole that lingers longest in the memory. The naked challenge—the huge, tempting carry over Mangrove Lake—is an affront to a golfer's ego. How irresistible is the dare, how clever the con? The club's greenkeeping staff routinely fishes about fifty balls a day from the lake.

COURSE:	PINE VALLEY GOLF CLUB
HOLE:	13
LOCATION:	CLEMENTON, NEW JERSEY
ARCHITECTS:	GEORGE CRUMP/H. S. COLT
LENGTH:	448 YARDS · PAR 4

Only an incorporated township with its own mayor and post office, and its own fire and police departments, could get away with a course like Pine Valley. It is, by popular consent, the most fiendishly difficult golf course ever built. "There is room on this earth for one Pine Valley," wrote Peter Dobereiner in *Down the Nineteenth Fairway,* "just as there is a place in the entertainment industry for the horror film, the ghost train and the chamber of horrors."

The golf course, hacked from a stricken wilderness of pine-clad sand hills in a sleepy area of New Jersey twenty miles southeast of Philadelphia, was the brainchild of George Crump, a former hotelier who spent a great deal of his own time and money to bring his iconoclastic ideas to fruition. He was ably assisted by H. S. Colt, the great English architect. Crump also welcomed input from the Philadelphia school of designers—George C. Thomas (a founding member of the club), Hugh Wilson, A. W. Tillinghast, and William S. Flynn. Hugh Wilson and his brother, Alan, completed four unfinished holes (holes 12 through 15) after Crump's sudden death in 1918. Tillinghast, a member of the first foursome to play the course with Crump, is credited with locating the Redan-like peninsula green at the thirteenth hole. For rugged grandeur, this most testing and severe of Pine Valley's par 4s stands apart from all others.

Measuring 448 yards from the back tees (445 yards from the regular tees), the thirteenth at Pine Valley is what architects like to call a par 4½. Which is a nice way of saying it's well-nigh impossible for all but a straight, fearless long-hitter to reach the green in regulation and match par on this terrifying two-shotter.

The drive, played from an upper or lower tee—there is little to choose between them and no view of the green from either—must travel uphill across a deep swale to a crowned fairway. Once safely off the tee, a decision must be made from atop the hill: Play cautiously to the lower-level fairway to the right and then pitch on to the enormous green in hopes of sinking a putt for par or at least two-putting for bogey; or take the direct route to the target by attempting a huge forced carry over a steeply pitched wasteland of stunted pines and broken ground that eats into the left side of the curving fairway, a murderous patch of no-man's-land from which there is usually no escape or return.

Implacable in its demand for distance and control, the mightiest par 4 on the world's top-ranked course is in essence no different from the other holes on the layout. Golfers must play their shots to islands girded by sandy wastelands and dense forest—first the fairway, then the green. But what gives the thirteenth its strategic value and separates it from the merely punitive is the generous bailout

area to the right of the green. Without it, the hole would be patently unfair. The bold, confident expert unconcerned about the dire consequences for a failed effort can throw caution to the wind and play a "death or glory" shot to the green. Having reached it, he is rewarded with a putt for birdie, though intricate rolls and slopes woven into the green usually warrant against it. The higher handicapper who believes discretion is the better part of valor can tack away from trouble on the approach, but by doing so he loses ground to an opponent who accepts the risk and plays the hole heroically. This is as it should be. According to golf writer Cal Brown, "There is little margin for the player who chooses to risk everything, a feature upholding the principle that a risk is not worthy of the name if you can get away with an error, however slight."

No one gets away with anything at Pine Valley.

Bernard Darwin, after a humbling round, sniffed, "The right of eternal punishment should be reserved for a higher authority." But then, the golf course asks a skilled player to execute risky shots in return for par. With a safety net or alternate route on nine of the fourteen long holes, including the brawny thirteenth, there is recourse for bogey throughout. The problem is that humility is not an emotion readily conjured by dyed-in-the-wool enthusiasts. In the end, no course in the world chips a golfer's ego down to size like Pine Valley.

George C. Thomas had the last word on the majestic Jersey behemoth: "Every true golfer loves Pine Valley," he once said. "It may be censured by some as very difficult, especially from the rough; yet its charm is the lure of diversity coupled with the thrill of surmounting its varied hardships." The thirteenth hole is a perfect example.

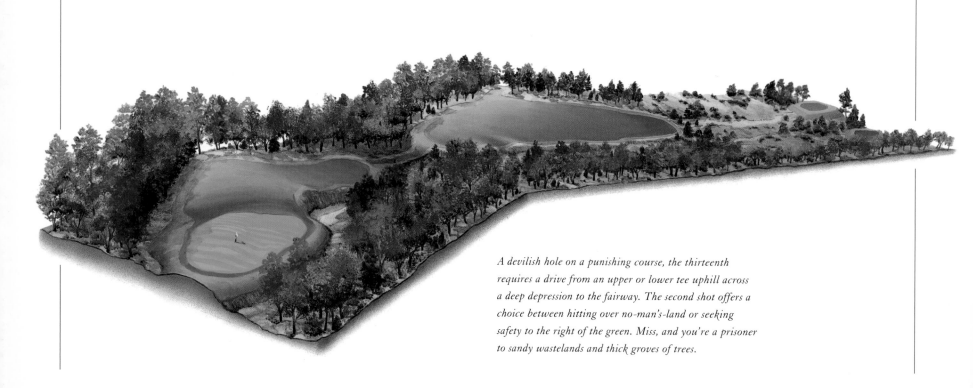

A devilish hole on a punishing course, the thirteenth requires a drive from an upper or lower tee uphill across a deep depression to the fairway. The second shot offers a choice between hitting over no-man's-land or seeking safety to the right of the green. Miss, and you're a prisoner to sandy wastelands and thick groves of trees.

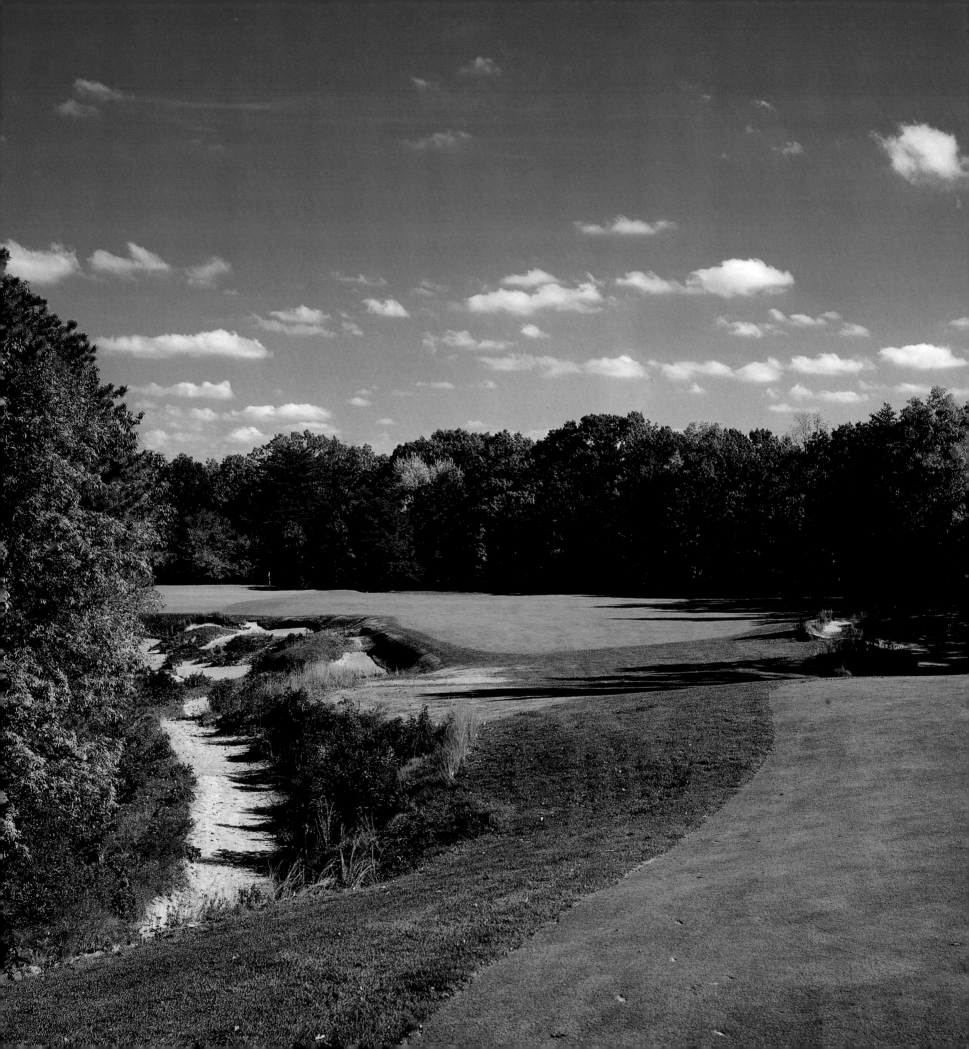

COURSE:	ROYAL COUNTY DOWN GOLF CLUB
HOLE:	9
LOCATION:	NEWCASTLE, COUNTY DOWN, NORTHERN IRELAND
ARCHITECTS:	OLD TOM MORRIS, HARRY VARDON
LENGTH:	486 YARDS · PAR 4

An English golf journalist once confessed to having a dream that he was wandering the vast galleries of the British Museum. At the end of a dark corridor, he came upon a forty-foot-high door, a fortified slab of oak held fast by giant iron hinges, the type of door that prevented easy entry to castles in olden days. The massive barricade was marked GOWF. Three knocks, and it creaked open. Beyond the threshold was the links at Royal County Down in Newcastle, Northern Ireland, its bearded bunkers and turbulent dunes unchanged from the day Old Tom Morris laid out the course in 1889 "at a cost not to exceed four guineas." (Harry Vardon revised and expanded the links in 1908 and 1919.) There is no better-preserved museum piece in the world of golf today than this lion-footed, pre-Victorian antique.

A force of nature, Royal County Down is arranged in two loops of returning nines. The hand of man is barely detectable in the wild, wind-tossed terrain. The outgoing nine, routed closer to the sea among haystack-shaped dunes rising to forty feet, is arguably the most exciting and exacting front nine in the game (the incoming nine turns away from the sea and drops the standard a bit). Capping this incomparable stretch is the most inspiring spot on the course, the "viewing hill" at the ninth.

From the prospect of the elevated tee, a long patch of rough ground runs up to a marker at the crest of a hill. A solid drive clears this heathery brow and flies down to the beautiful carpet of fairway eighty feet below. The view from the hill's summit is the reason golfers carry clubs to Newcastle: Beyond the attractive white clubhouse is the red brick steeple of the Slieve Donard Hotel. Backdropping the rooftops of town are the Mountains of Mourne, which really do sweep down to the sea. The tallest peak, Slieve Donard, is a "perpetual gazingstock" in the words of locals. The summit is often shrouded in mist, but the play of shadow and light on the flanks of the bare, rounded mountain produces shades of purple and green that change hue with each passing cloud. Closer at hand, the broad fairway, one of the widest on the course, is framed on both sides by large, irregular sand hills clad in bracken, heather, and gorse, the line of dunes nearly converging at the green. Two sentry bunkers,

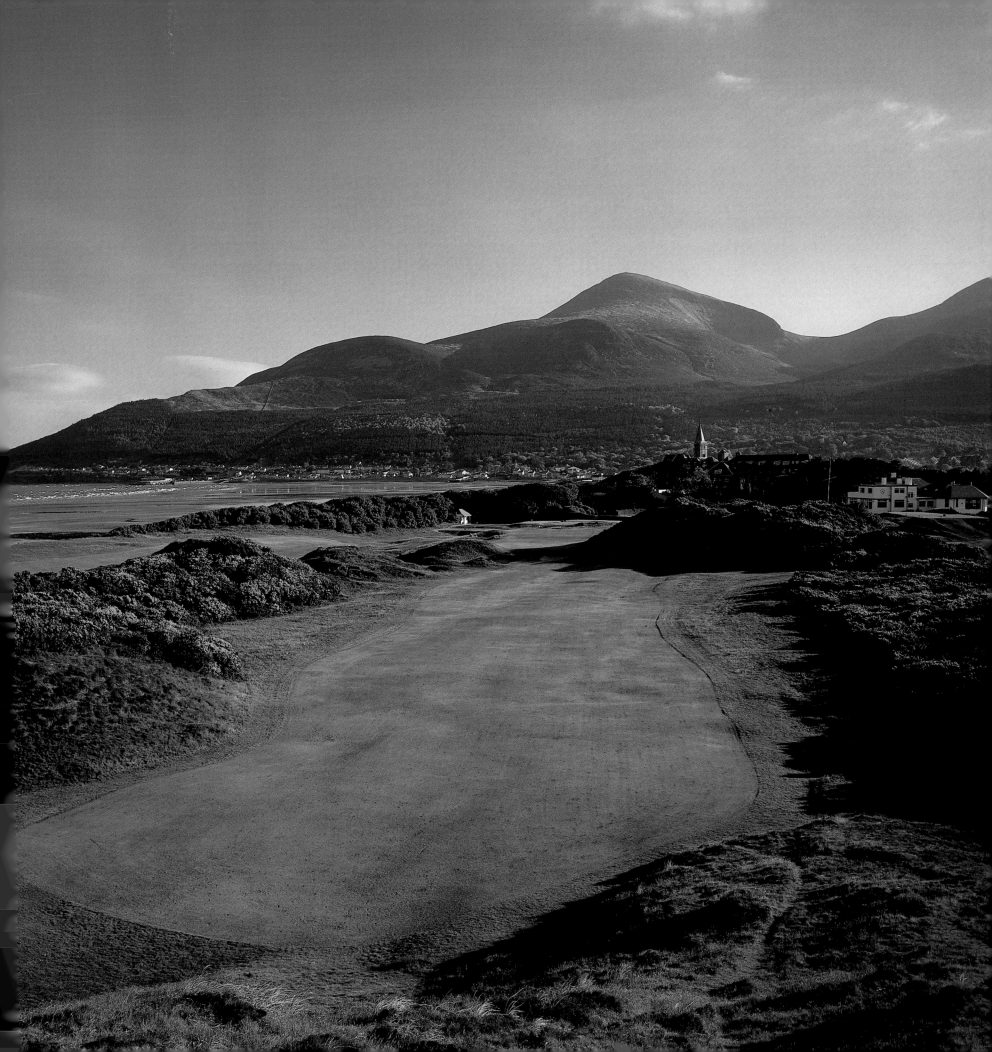

one dead center, one to the left, are cut into the face of a slope thirty yards in front of the plateau green. Carry these bunkers with your approach shot and the panorama is yours to enjoy carefree. The hole, by the way, is no mere gazingstock: It measures 486 yards from the championship tees, 431 yards from the medal and forward tees.

Curiously, Royal County Down has never hosted a major professional event. However, it does have a championship pedigree. It hosted the British Amateur Championship in 1970 and 1999, as well as the 1968 Curtis Cup matches of the best female amateurs of the United States, Great Britain, and Ireland. Also, several British Ladies Amateur championships have been contested on the storied links.

Given the splendor of its mountains, the sweeping views of Dundrum Bay to the east, and the scent of peat fires from town carried in the breeze, Royal County Down offers much more than hurly-burly golf from another era. Peter Dobereiner, the late British golf writer, once said of County Down: "This is no place for fierce concentration on card and pencil and life-or-death struggles to beat your handicap. This is not an examination paper to measure the stature of a golfer; it is an experience to be savoured, to elevate the spirits and touch the soul."

Stalwart and immutable, Royal County Down delivers "the kind of golf that people play in their most ecstatic dreams," according to Bernard Darwin, who believed the Ulster links to be unrivaled for challenge and beauty. Asleep or awake, the sight of your drive climbing high against the mountains as it crests the hill at the ninth is one of golf's most stirring experiences.

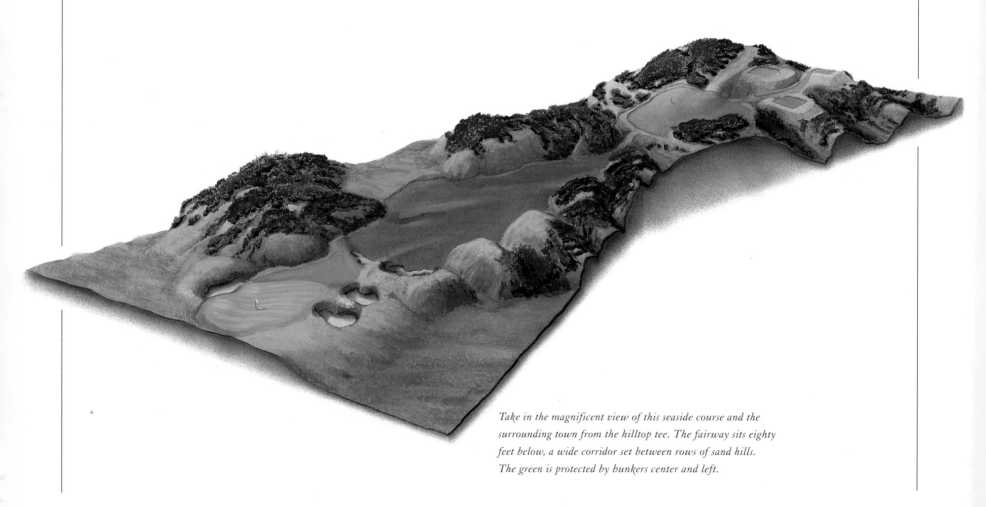

Take in the magnificent view of this seaside course and the surrounding town from the hilltop tee. The fairway sits eighty feet below, a wide corridor set between rows of sand hills. The green is protected by bunkers center and left.

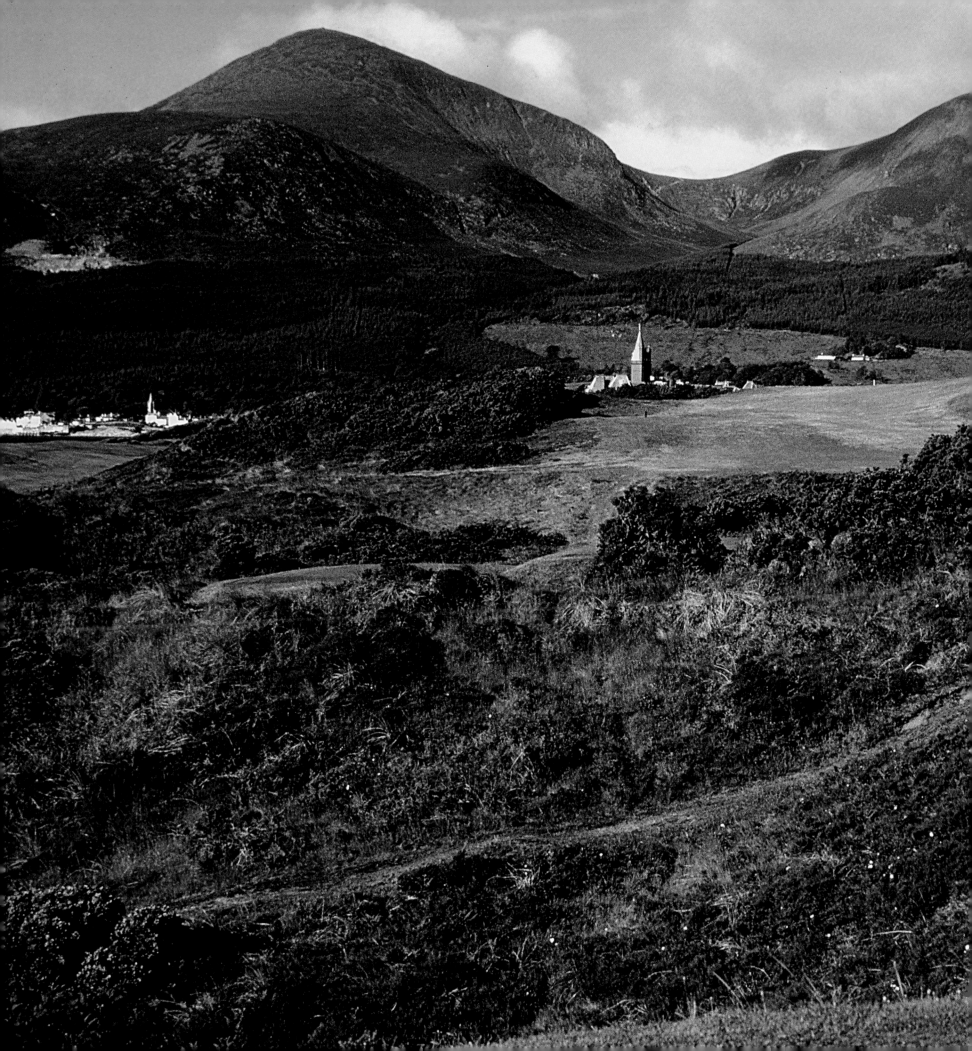

COURSE:	ROYAL MELBOURNE GOLF CLUB (WEST)
HOLE:	6
LOCATION:	BLACK ROCK, MELBOURNE, AUSTRALIA
ARCHITECTS:	ALISTER MACKENZIE/ ALEX RUSSELL
LENGTH:	450 YARDS · PAR 4

Melbourne, Australia's third-largest city, is a cosmopolitan metropolis set on a coastal plain, a tranquil city revered for its parks and gardens and culture. Southeast of town near the shores of Port Phillip Bay is a geological anomaly known as the Sand Belt, a twenty-five-square-mile area marked by undulating terrain, native scrub, and fine grasses. It is, in short, the perfect medium in which to create naturalistic, linkslike golf courses.

It was the Sand Belt that Alister Mackenzie, a Scottish physician, camouflage expert, and fledgling golf architect, was shown on his arrival by passenger steamer in 1926. Mackenzie spent only six weeks in Australia, but it could be argued that he accomplished his life's work there. Ably assisted by Alex Russell, an amateur who had won the 1924 Australian Open, and Mick Morcom, a talented greenkeeper, Mackenzie tore through the Sand Belt like a buzz saw. He laid out the nonpareil West Course at Royal Melbourne, built bunkers at nearby clubs (Victoria, Metropolitan, Kingston Heath), routed a new eighteen at Yarra Yarra, and, farther afield, improved Royal Adelaide and Royal Sydney. He also routed a spectacular new eighteen for New South Wales. Today, all eight courses (plus Royal Melbourne's East Course, laid out by Russell and built by Morcom six years after Mackenzie departed)

dominate Australia's top ten. Four of the venues are fixtures on *Golf Magazine*'s top one hundred courses in the world. Royal Melbourne is the jewel in the crown.

Since the 1959 Canada Cup (later renamed the World Cup), major events at Royal Melbourne have been played on a composite eighteen to eliminate public road crossings. Twelve holes from the west and six from the east are used. The sixth on the west is also the sixth hole in the composite configuration. It is the stand-out two-shotter in the Southern Hemisphere.

Stretched to 450 yards for the Presidents Cup in 1998, a Ryder Cup–style event that pitted a team of American pros against a talent-laden assemblage of Internationals led by Greg Norman and Nick Price (the Americans were crushed), the hole normally plays to 439 yards. From an elevated tee set in a grove of tea trees, the fairway swoops downhill and swings sharply to the right at the 220-yard mark around an untidy nest of steep-walled bunkers gouged from the land by horse and scoop. Heather and bracken fringe these punishing bunkers. Also guarding the corner of the dogleg are tall eucalyptus trees. A bold drive that flies the bunkers and rolls past the trees is in perfect position. But the game has just begun. From here, a player is left

with a clear, offensive shot to a perched green, its left flank protected by a large, fearsome bunker. Additional bunkers are positioned to the right. Golfers who take the conservative route off the tee by aiming to the left of the gaping sand pits in the crook of the dogleg are faced with a long, demanding approach, usually from a downhill or sidehill lie, to a putting surface that is none too receptive from the more cautious side of the fairway.

The tiered green, severely sloped from back to front and framed behind by tea trees and she-oaks, can be terrifyingly quick. Royal Melbourne is justly famous for its lightning-fast greens. They are comparable in speed to Augusta National's during the week of the Masters, and just as liberally contoured. An approach shot hit above the hole at the sixth may result in a three-putt. Or a four-putt. Or worse. The story is told of Sam Snead's debacle during the 1959 Canada Cup. The Slammer drove through the fairway into poor position at the sixth, put his second shot on the upper terrace of the green above the pin—and then putted his ball down the slippery slope into the front bunker!

There is also wind and weather to consider. Because of the proximity to the Tasman Sea, it is possible for a golfer to experience all four seasons in a single day in "Mel-bin," as the locals pronounce it. The weather can indeed change very quickly, especially in summer. Hot northerly winds from the desert outback can pop the thermometer at 100 degrees or more, but when a strong southerly sweeps in from Antarctica, as it often does, the mercury can drop by 40 degrees in an hour.

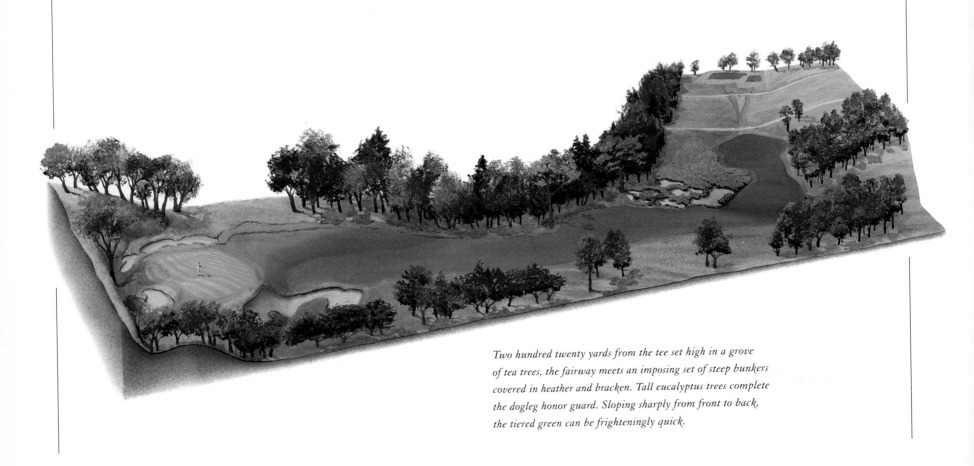

Two hundred twenty yards from the tee set high in a grove of tea trees, the fairway meets an imposing set of steep bunkers covered in heather and bracken. Tall eucalyptus trees complete the dogleg honor guard. Sloping sharply from front to back, the tiered green can be frighteningly quick.

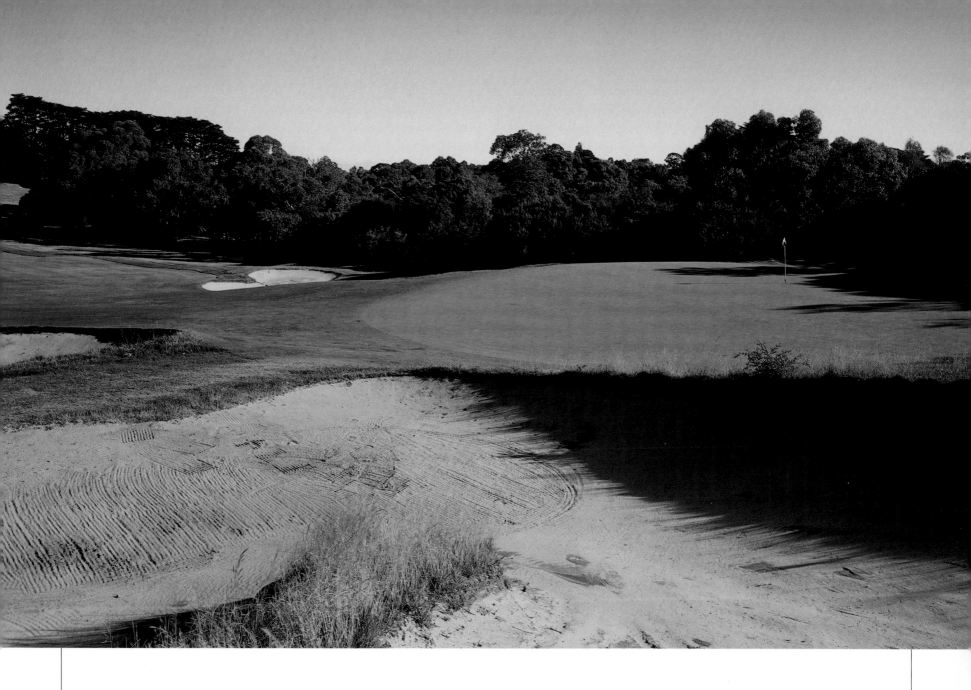

Host to dozens of national championships and major competitions over the years, Royal Melbourne is cited by many as the finest test of golf in the world. Greg Norman, who lobbied to have the Presidents Cup played in his homeland, picks Royal Melbourne as his personal favorite. "The Shark," by way of tribute, has replicated many of the club's key features, notably its bold bunkers and canted greens, in his own design projects. Native son Peter Thomson, a five-time British Open winner who served as international team captain at the Presidents Cup, once wrote that the Mackenzie masterpiece, which he rates ahead of Augusta National, "is a course to humble the giants or confirm their greatness." As for the sixth, it meets Mackenzie's own criteria for an ideal hole: "The difficulties that make a hole really interesting are usually those in which a great advantage can be gained in successfully accomplishing heroic carries over hazards of an impressive appearance, or in taking great risks in placing a shot so as to gain a big advantage for the next."

COURSE:	ST. ANDREWS (OLD)
HOLE:	17
LOCATION:	ST. ANDREWS, FIFE, SCOTLAND
ARCHITECT:	UNKNOWN
LENGTH:	461 YARDS · PAR 4

The Old Course at St. Andrews in Scotland, medieval greensward, evolutionary godsend, and undisputed birthplace of the game, has upon its ancient, rumpled links many quirky holes, among them the most notorious par 4 in creation. This is "the Road" hole, a terrifying two-shotter that has steamrolled more experts than any other hole on earth. At 461 yards from the medal (championship) tees, it is only 14 yards short of the generally accepted par-5 distance. But the angles and hazards, not the numbers, tell the story of this disaster waiting to happen.

The drive, played blind, must be essayed over dark green sheds (facsimile versions of the railway originals) arranged in the front yard of the Old Course Hotel. The destination is a ribbon of fairway that bends to the right, replete with swales and hollows. A drive flared to the right is out of bounds, irretrievably lost. But the safe route to the left, the outside turn of the dogleg, effectively turns the hole into a three-shotter (which is how most players should approach it, regardless of where their tee shot lands). In fact, until the 1950s, it *was* a par 5.

At the far end of the fairway is a long, narrow green raised a yard or so above the apron and oblique to the line of play. A cone-shaped pit, the murderous "Road" bunker, eats into the midsection of this tabletop green. To the right, the slim putting surface drops off sharply to a paved lane backed by a stone wall, all that separates the course from town. Pulled shots perish in the sand. Pushed shots end up as roadkill.

But it's the deep, sheer-sided bunker, a devil's nostril on a course strewn with pits of perdition named "Hell" and "Grave," that strikes fear into a golfer's heart. According to Patric Dickinson, the Road bunker is "so perfectly placed that it dominates play even from the tee, and by sheer force of its spidery personality drives its victims either to avoid it too carefully and chance the road, or play too safely, and so come into its parlor." An alternate view is put forth by Alister Mackenzie in *The Spirit of St. Andrews:* "Notwithstanding the abuse showered on it, this bunker has done more to sustain the popularity of St. Andrews than any feature on the course."

"Popularity" isn't the word all would choose. In 1978, in the third round of the British Open, Tommy Nakajima putted his third shot into the Road bunker, then hit sand shot after sand shot trying to get out, finally getting back on the green and recording a 9. The bunker is still known among those with memory as "the Sands of Nakajima."

To avoid calamity, the wise St. Andrews player generally plays his approach short of the bank in front of the green, hoping to get up and down for a 4 but usually happy to settle for a 5. In 1990, Nick Faldo laid up short of the seventeenth green in all

four rounds en route to a commanding victory in the Open. Conversely, Tom Watson ruined his chances of winning the 1984 Open by attacking the green with a 2-iron in the final round. His approach shot glanced off the right edge of the green, bounced across the road, and came to rest barely a foot from the wall. The best he could do was bogey, and his bid to win a sixth Open Championship was foiled.

The subtle blend of temptation and fear posed by the Old Course is brought into razor-sharp focus by the Road hole. It is the ultimate test of nerve and skill on a links that calls for more prudence than daring. In the annals of golf, no single hole anywhere has wrecked more scorecards or humbled more champions. "To label this hole harsh and inhuman would be understatement," wrote Jim

Finegan in *Blasted Heaths and Blessed Greens*. "It is an instrument of torture. It is an ogre, a monster, a villain of darkest hue."

Peter Thomson, the great Australian stylist who won the Open at St. Andrews in 1955, summed up the Road hole most accurately: "Considering what has occurred there over the last century, it is a wonder the hole still stands in its original state. As a planner and builder of golf holes worldwide, I have no hesitation in allowing that if one built such a hole today you would be sued for incompetence and your effort would be destroyed! Yet to all those who have suffered at this demon, I offer a hand of friendship, for I have suffered too, and to those who have passed its way without a mauling, I can only say, golfingly speaking, you haven't lived."

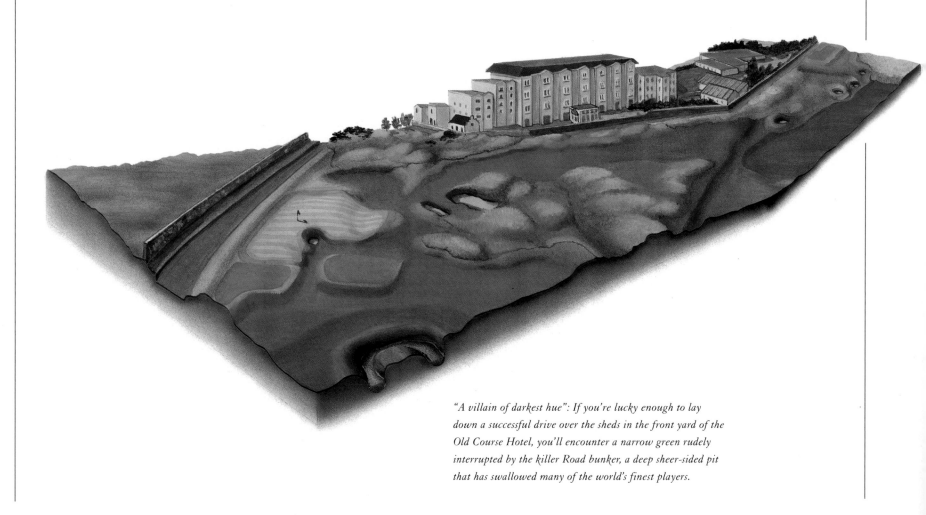

"A villain of darkest hue": If you're lucky enough to lay down a successful drive over the sheds in the front yard of the Old Course Hotel, you'll encounter a narrow green rudely interrupted by the killer Road bunker, a deep sheer-sided pit that has swallowed many of the world's finest players.

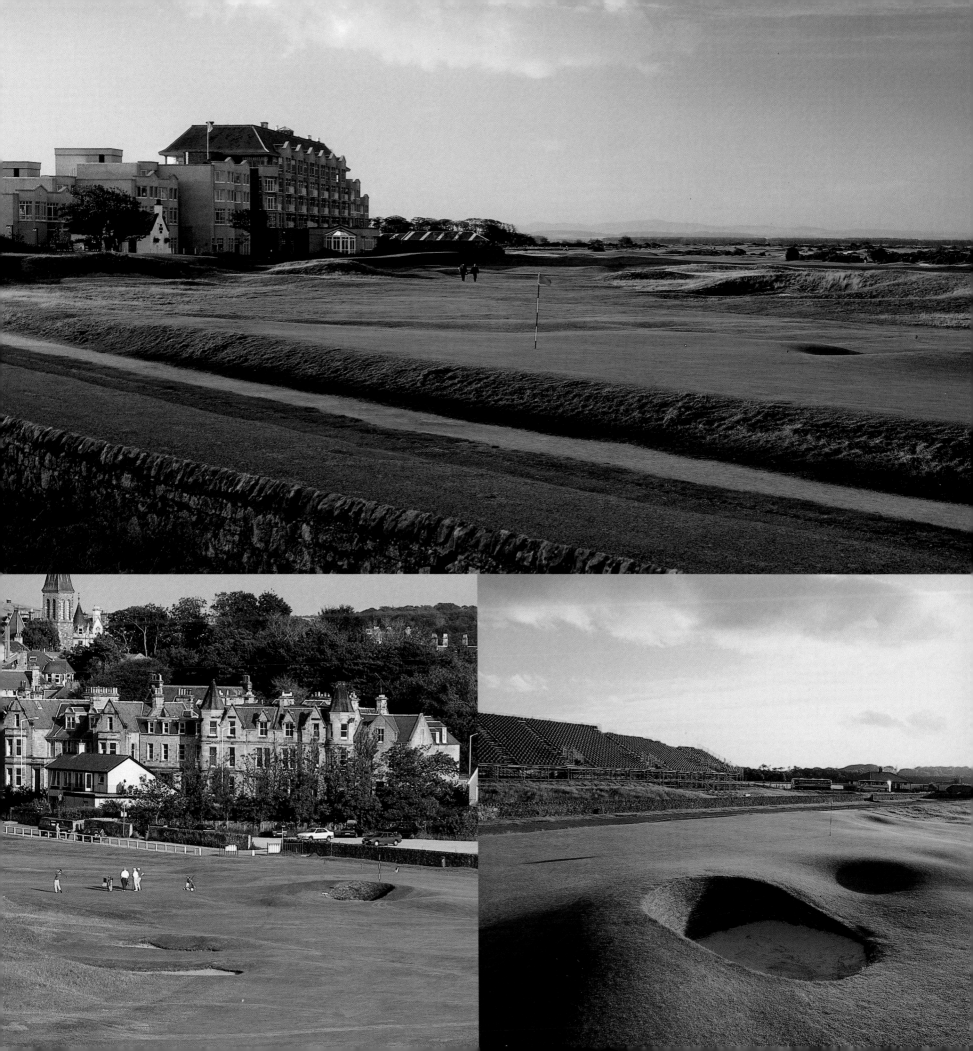

COURSE:	SHINNECOCK HILLS GOLF CLUB
HOLE:	14
LOCATION:	SOUTHAMPTON, NEW YORK
ARCHITECTS:	WILLIAM F. DAVIS, WILLIAM S. FLYNN/HOWARD TOOMEY
LENGTH:	447 YARDS · PAR 4

For the truly accomplished shotmaker, Shinnecock Hills, located on the south fork of Long Island in the fashionable summer colony of Southampton, is the most complete test of golf in America. The two U.S. Opens held there in 1986 and 1995 (it will return again in 2004) are proof positive. (The 1896 U.S. Open, only the second ever played, was held at the same club, but on a long-defunct course.) The pros, who generally grumble about the speed of the greens and the height of the rough, uttered not a discouraging word at Shinnecock Hills. The golf course is beyond reproach, its setup as straightforward and fair as any Open venue in existence.

It also has in abundance the only element that plants seeds of doubt in the minds of good golfers and forces them to create shots they wouldn't ordinarily play: wind. The prevailing breeze is from the southwest, but as architect-historian Tom Doak has pointed out, "There are two or three common winds" at Shinnecock Hills. The character of each hole changes depending upon its direction. As on a Scottish links, the wind can and often does shift around and increase in velocity as the day progresses. The holes, angled to all directions, rely on the sea breeze to provide their challenge and strategy. This is especially true on the par 4s, the backbone of the 6,813-yard, par-70 layout.

One of the five founding clubs of the USGA, Shinnecock Hills dates to 1891, but the current links was completed on a newer parcel of land in 1931. Stretched below the Stanford White–designed clubhouse that commands a hilltop overlooking Peconic Bay on one side and the Atlantic Ocean on the other, the links has often been described as a hilly version of Muirfield, rated the purest test of golf on the British Open rota. The Philadelphia design firm of Toomey and Flynn, working on the bay side of the clubhouse, made the most of their opportunity. Flynn, a skilled strategist, produced a masterpiece on undulating, sandy ground overgrown with clothes-ripping brambles and tall, wispy fescues. More than 150 bunkers, many of them gouged from hillocks and mounds, were built to signpost the holes. The routing is brilliant: No more than two holes play in the same direction consecutively. Also, most of the fairways curve to the left or right. If the wind doesn't shift, the course does. Throughout, Flynn made admirable use of the site's natural features: rolling hills, diagonal ridges, sweeping valleys.

There are many superb holes at Shinnecock, but the 447-yard fourteenth has everything a golfer could want, including a piece of club history. The hole is called "Thom's Elbow," after Charlie Thom, a Scottish professional who arrived in Southampton in 1906 as a twenty-five-year-old. Teacher, father figure, and the club's guiding light, Thom retired in 1961 after fifty-five years on the job. He continued to reside in a shingled cottage above the fourteenth tee in his capacity as pro emeritus and lived out his days overlooking one of the most naturally beautiful golf holes in the world.

From an elevated tee, players must launch their drives over a formidable stretch of prickly scrub to reach an islandlike fairway nestled in a narrow valley. Steep-faced bunkers lurk along both sides of the landing area. The hole doglegs gently to the right beyond the landing area, climbing past a smattering of pines to a circular green, its flanking bunkers pulled well back from the putting surface. The green, like most of the greens at Shinnecock, is open in front and will accept a low, running shot. Played downwind, the usual scenario, it is not the

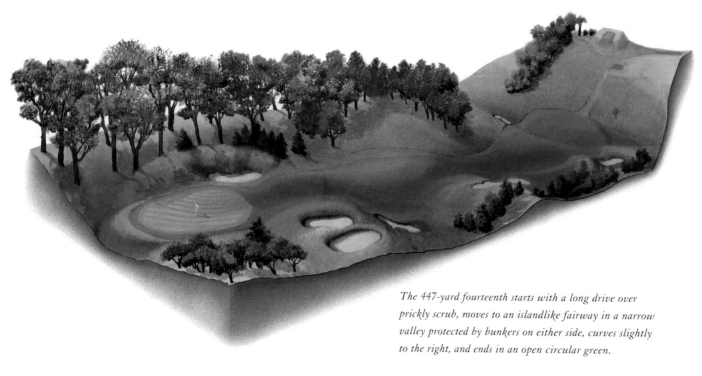

The 447-yard fourteenth starts with a long drive over prickly scrub, moves to an islandlike fairway in a narrow valley protected by bunkers on either side, curves slightly to the right, and ends in an open circular green.

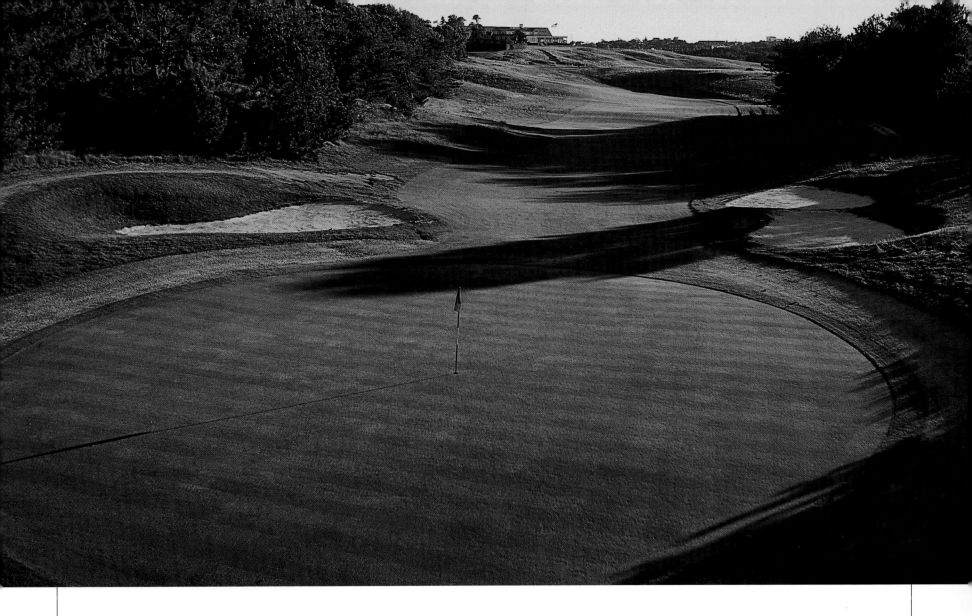

hardest hole on the course, but neither is it the easiest. Directly into the wind or even into a crosswind, the fourteenth plays as a par 5 for most members. In the crucible of a major championship, more than one contender has unraveled here.

In the 1986 U.S. Open, two-time Open champ Lee Trevino drove into the trees and bogeyed the fourteenth hole in the final round. He lost his momentum and finished fourth. Payne Stewart, paired on Sunday with eventual winner Raymond Floyd, missed a 5-foot putt for par at the fourteenth after overshooting the green. Floyd also carried over the green with his 7-iron approach. After chipping back on, he sank his 4-footer to save par and grab the outright lead for the first time in the championship. It was a lead he never relinquished.

When the U.S. Open returned to Shinnecock

Hills in 1995, the pros again saluted the storied links with the ultimate compliment: silence. No whining, no moaning about the conditions. Just a clear sense of purpose given the daunting task ahead. Corey Pavin's winning score of 280, even par, was a bit of a surprise. Except for Saturday's round, the wind never really buffeted the course as it often does in June when the ocean's waters are still cold.

Among the contenders was Greg Norman, who had led the 1986 event after fifty-four holes and who again teed off in the final twosome on Sunday before stumbling to yet another second-place finish in a major. But not everyone got burned. In the process of tying the course record with a 65 on Sunday, Neal Lancaster recorded an incredible 29 on the back nine. His heroics included a 25-foot birdie putt on the slippery fourteenth green.

COURSE:	SOUTHERN HILLS COUNTRY CLUB
HOLE:	12
LOCATION:	TULSA, OKLAHOMA
ARCHITECT:	PERRY MAXWELL
LENGTH:	445 YARDS · PAR 4

The endorsement of Ben Hogan, golf's ultimate shotmaker, could be considered reason enough to place the bruising twelfth hole at Southern Hills in Tulsa, Oklahoma, among the elite eighteen. "The Hawk," who was stationed in Tulsa during World War II and played the course hundreds of times, called the 445-yard hole "the greatest par four in the United States." High praise from a man who generally kept his opinions to himself and didn't toss around superlatives lightly.

Conceived during the depths of the Depression by a group of Tulsa businessmen and designed by Perry Maxwell, a native Oklahoman and former banker who had begun to establish himself as a golf architect by the mid-1930s, Southern Hills is perhaps a misnomer. Except for the steep incline at the ninth and eighteenth holes, there are no hills here. Most of the holes are flat or gently rolling. Tall oaks and elms line the fairways. Tee shots that depart the fairway trickle into wiry rough the consistency of steel wool. The premise here is simple: Hit it straight.

At first glance, the layout does not appear to be difficult or even special. There are, after all, no eye-catching hazards or breathtaking vistas, no roaring oceans or soaring peaks. Understated, subtle, and fair as fair can be, Southern Hills is a gray pants, white shirt, black shoes kind of golf course. No wonder Hogan loved it, despite the fact that he was forced to withdraw from the 1958 U.S. Open after

injuring his wrist while extricating one of his rare stray shots from the rough.

The 6,962-yard, par-70 layout encapsulates Maxwell's design philosophy: "It is my theory that nature must precede the architect," he once said. "First you need a suitable piece of land and then you should do as little as possible to the land to make a playable golf course. In this way you give the place character and you make it different from any other golf course in the world." It sounds easy, this business of discovering holes in the wild, but it's far more difficult to build subtleties into an existing landscape than it is to create features where they don't exist.

The ornery twelfth stands on its own as natural-born round-wrecker. The hole was there; Maxwell identified and refined it. Like nearly every par 4 at Southern Hills, the twelfth, a sweeping right-to-left dogleg, calls for a long, accurate drive to a landing area narrowed by leafy trees and thick rough. A huge, menacing bunker filled with powdery sand nestles in the elbow of the dogleg. The lengthy second shot is played slightly downhill over a blind water hazard that crosses in front of the raised green. Water also defends the right side of the approach area. A trio of deep, oval-shaped bunkers snare shots that are pulled to the left or skip over the putting surface. The green itself is very slick and tilted from back to front. Robert Trent Jones, Sr., described the view for the second shot as "spectacular

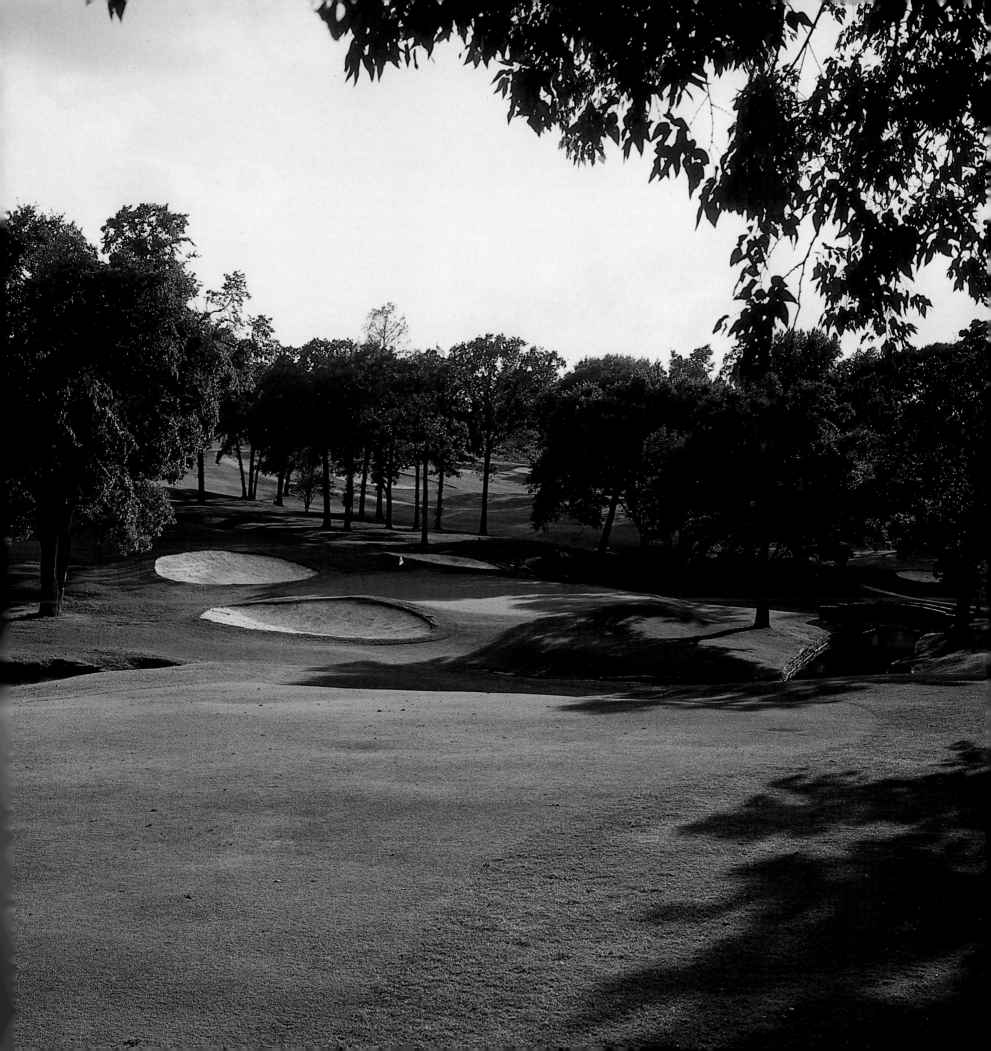

and frightening at the same time." It's a view only a Hogan could relish.

The club, a Tulsa fixture, has staged several major events—the U.S. Open in 1958 and 1977, the PGA Championship in 1970 and 1982, plus many of the USGA's top amateur championships. The U.S. Open will return to Southern Hills in 2001. In addition to a straight driver and steady nerves, the eventual champion will also need an icy disposition. The 1958 Open, won by normally hot-tempered Tommy Bolt, was labeled "the Blast Furnace Open" due to temperatures that reached 100 degrees. At the 1970 PGA Championship, held in August and won by Dave Stockton, the mercury soared to 112. The winning scores at the club's four majors have ranged from 3 under to 5 over par. For the pros, and even for the members, none of the holes at Southern Hills burns hotter than the twelfth.

Just how tough is the twelfth? Displayed over the desk of the club's former director of golf was a framed cartoon depicting a golfer hitting a ball to a tiny, jungle-choked green mired in quicksand. Beside the green was a hungry-looking crocodile. A vulture sat atop the pin. A pair of evil eyes stared from the jungle. The punch line read: "What's all this nonsense about the second shot on number 12?"

Southern Hills is calm, quiet, restrained—except for hole number 12. A vast sand-filled bunker stands at the dogleg corner, and a blind water hazard is the spoiler for the second shot. The green is slick, the view for the second shot "spectacular and frightening at the same time."

COURSE:	AUGUSTA NATIONAL GOLF CLUB
HOLE:	13
LOCATION:	AUGUSTA, GEORGIA
ARCHITECTS:	ALISTER MACKENZIE/ ROBERT TYRE JONES
LENGTH:	485 YARDS · PAR 5

The most representative hole on America's dreamiest inland course? Without a moment's hesitation or the slightest reservation, it is the par-5 thirteenth, the final leg (or prayer) of Amen Corner, an infamous trio of holes occupying the lower reaches of a course hewn from the hills and dales of a former nursery.

Bobby Jones, a Georgia native who had retired from competitive golf, and Alister Mackenzie, author of Cypress Point, Royal Melbourne, and other masterful designs, collaborated on the building of a course originally intended for seasonal play by members and their guests. Augusta National, after all, predated the Masters, an invitational event that blossomed into one of golf's four "majors" shortly after its debut in 1934. The shared goal of Jones the player and Mackenzie the architect was a flowing, strategic test that would give enjoyment to all types of golfers. According to Charles Price, "Jones wanted Augusta National . . . to be a course that would not overpower his 90-shooting members or be a push-over for his par-busting visitors."

The first hole Jones and Mackenzie "discovered" while walking the verdant, hilly site in the early 1930s was the thirteenth. Golf historian Herbert Warren Wind wrote of the discovery, "It was there in its entirety—a 465-yard par five (since lengthened to 485 yards) whose green could be reached in two if the golfer put together two

excellent shots." Reachable, yes, but danger lurks from tee to green.

The drive, played through a chute in the woods, must be rifled to a banked fairway that turns sharply left in the landing area. Tall trees define the perimeter of the fairway to the right, marking the safe route for the handicap player. Deep woods and a narrow tributary of Rae's Creek guard the entire left side. Aggressive players who turn the ball over a little too much on their tee shots in their desire to sling the ball around the corner end up in the brook or the woods. The serpentine creek eventually cuts across the fairway in front of the raised green, which lies skewed to the line of play. Set into a grassy bank behind the green are four large bunkers, each filled with brilliant white sand. Close-mown hollows in front of these bunkers give players a chance to recover if they overshoot the putting surface, but a treacherous chip down a slippery slope awaits. A front pin placement can be especially worrisome.

Nestled under the towering Georgia pines that frame the green are hundreds of pink, white, and magenta azaleas that usually burst into bloom the week of the Masters. It is the most exquisite setting on a course renowned for its horticultural perfection.

The strategic value of the thirteenth rivals its beauty. No less an authority than Robert Trent

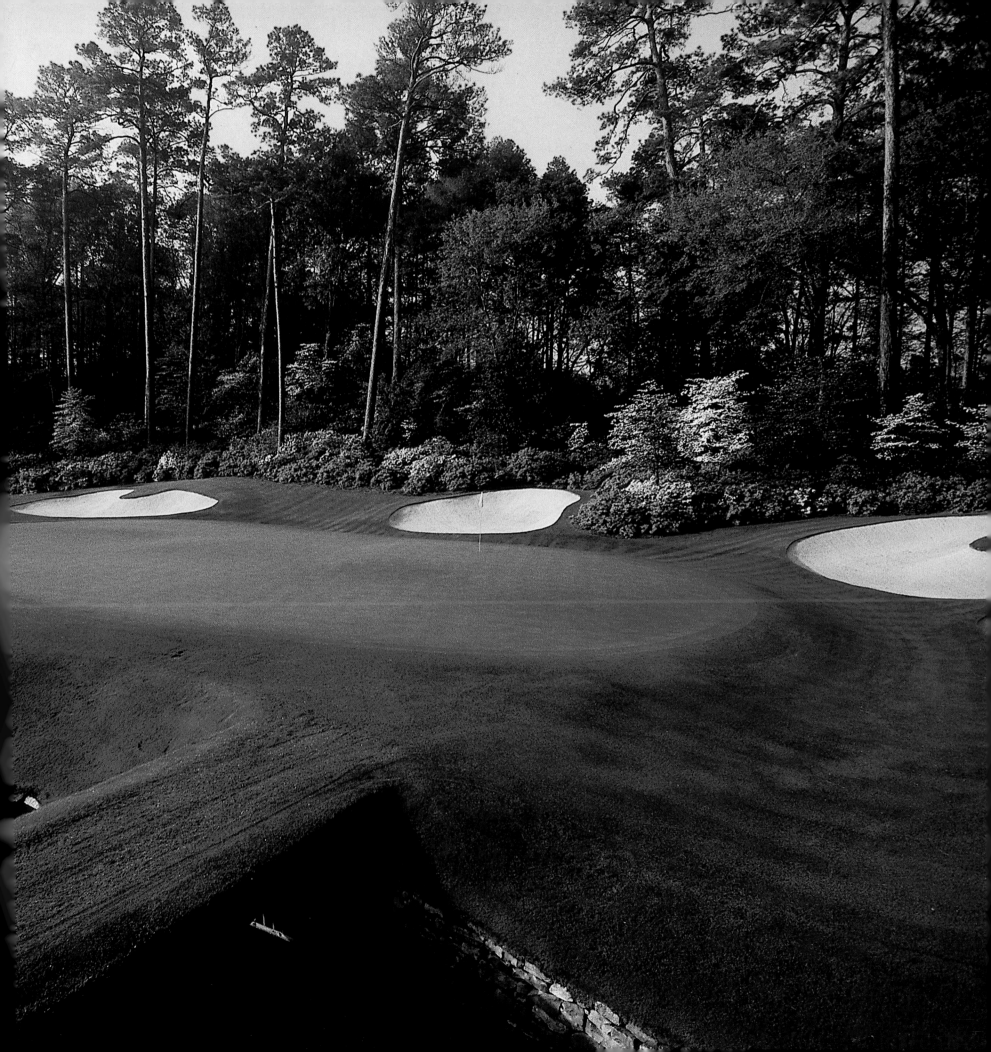

Jones, Sr. (no relation to Bobby), described the thirteenth at Augusta National as "one of the world's classic par-5 holes, perhaps the best short par five ever built. It is a superb example of a strategic hole that does not require great length to be intimidating, penal and rewarding at the same time."

As such, it has been the scene of both triumph and disaster. There was Nick Faldo's brilliant 2-iron from a sidehill lie to the green in the 1996 Masters, a shot that crushed Greg Norman's chances in their *mano a mano* duel. Fred Couples, seemingly in command, hooked his tee shot at the thirteenth into the woods during the final round of the 1998 Masters. He found his ball, pitched safely out to the fairway—and then dumped his third shot in the creek. On a hole he had eagled the previous

day, he made a 7 on Sunday, opening the door for eventual winner Mark O'Meara.

Played with care and restraint by the bogey golfer—safe drive to the right, a lay-up short of the creek, short iron onto the green, two putts—the thirteenth at Augusta National can be done in par. But experts seeking birdies or even an eagle on a par-5 hole that measures well under five hundred yards, a modest distance for today's pros, must carefully weigh risk versus reward on this seductive, hairpin-shaped hole because only two well-executed shots will find the mark. The distinctiveness of the thirteenth, the standout hole on a championship course that has become a national treasure, is best summed up by Mackenzie: "The ideal hole is surely one that affords the greatest pleasure to the greatest number, gives the fullest advantage for accurate play, stimulates players to improve their game, and which never becomes monotonous." By this and any other definition, Augusta National's thirteenth is ideal. To which legions of Masters invitees would say, "Amen."

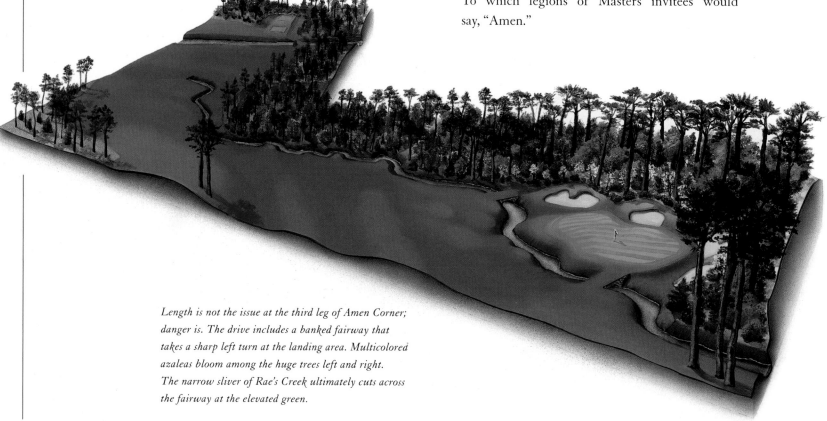

Length is not the issue at the third leg of Amen Corner; danger is. The drive includes a banked fairway that takes a sharp left turn at the landing area. Multicolored azaleas bloom among the huge trees left and right. The narrow sliver of Rae's Creek ultimately cuts across the fairway at the elevated green.

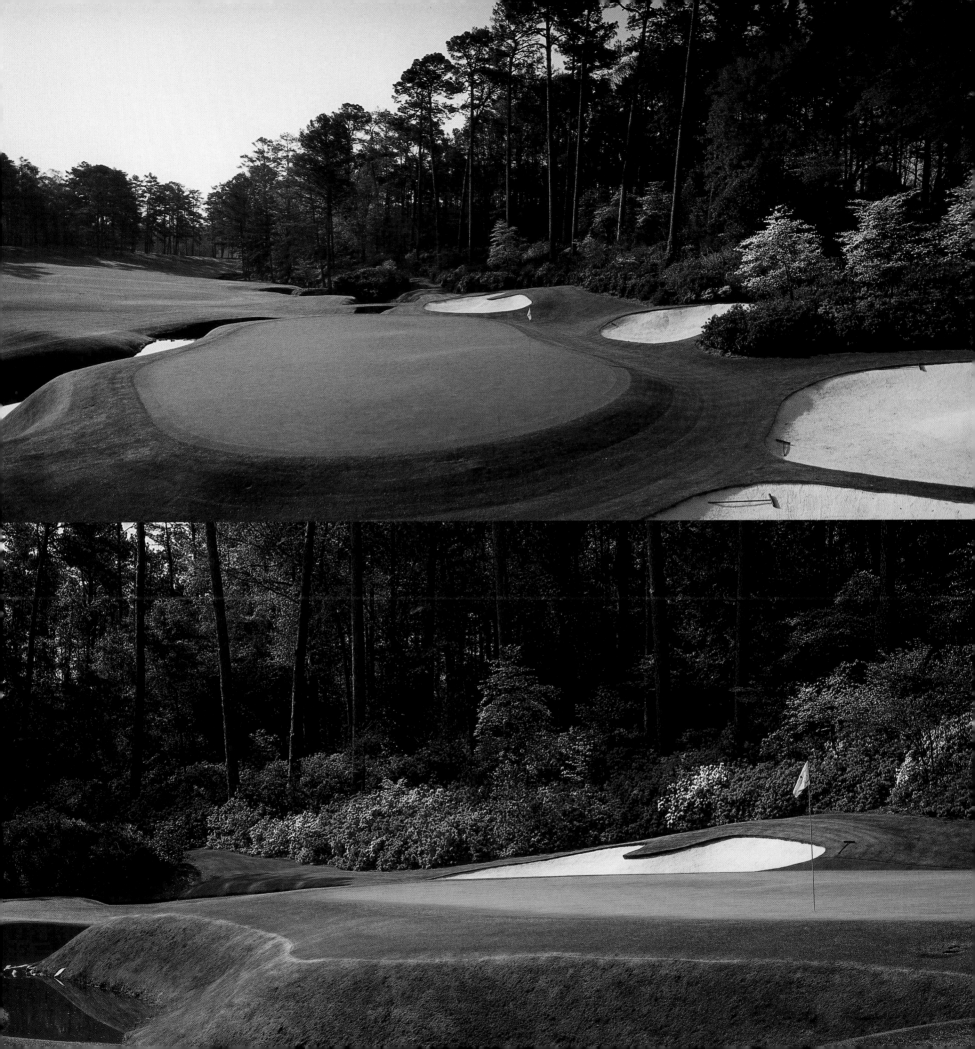

COURSE:	CARNOUSTIE GOLF LINKS (CHAMPIONSHIP)
HOLE:	6
LOCATION:	CARNOUSTIE, ANGUS, SCOTLAND
ARCHITECTS:	ALLAN ROBERTSON, WILLIE PARK, JR., JAMES BRAID
LENGTH:	578 YARDS · PAR 5

Stern and bleak, Carnoustie, hard by the North Sea above St. Andrews, is no ravishing beauty. As beleaguered players who survived the 1999 British Open can attest, the ancient Angus links, dating to 1839, is a medieval beast, Grendel with a brogue. It should be remembered that the three players tied after seventy-two holes in the 1999 Open—Paul Lawrie, Justin Leonard, and the star-crossed Frenchman, Jean Van de Velde—each scored 290, *6 over par*. (Lawrie prevailed in the four-hole playoff.)

More grueling holes await at the finish, but the strategic gem of Carnoustie is the par-5 sixth hole,

appropriately called "Long." Stretched to 578 yards by request of the Royal and Ancient before the championship in 1999, the hole measures a more accommodating 490 yards from the regular tees. The view from the tee is daunting. The hole, like most at Carnoustie, is rather flat and featureless, but staring players in the face a little over two hundred yards from the tee is a pair of cavernous bunkers, one directly behind the other, their squared-off sod faces flared like nostrils. A third bunker lurks along the right side of the fairway. Running down the entire left side of the hole (the "hooking side," as the Scots say) is a boundary

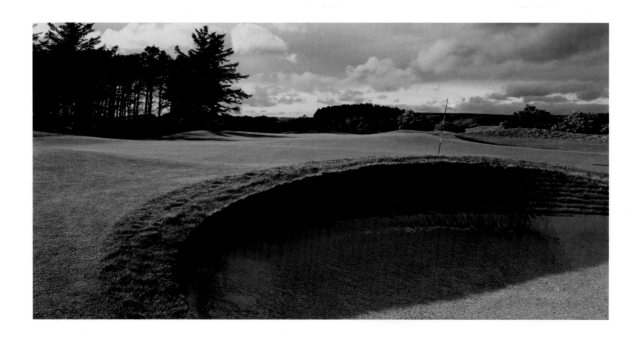

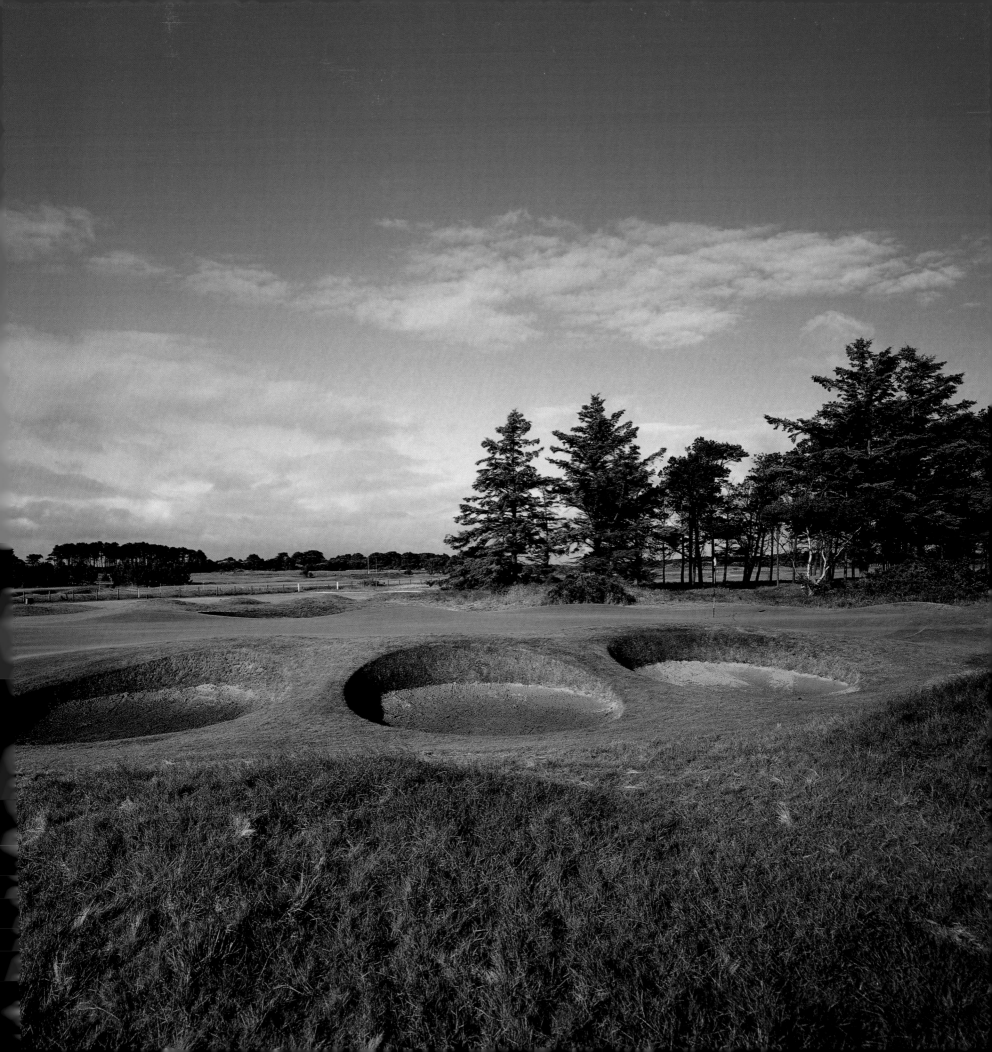

fence. Golfers are faced with three options: Fly the central bunkers to the safety of the fairway, a prodigious smack; tack safely to the right, hoping to avoid the right bunker and nettlesome rough; or flirt with out of bounds in hopes of finding the slim Elysian Fields on the left. There is historic precedent for the last, the riskiest, for this is exactly what the "Wee Ice Mon," Ben Hogan, did in the final two rounds of the 1953 British Open. Coldly calculating, Hogan rifled his trademark fade down the perilous left side and cut the ball back to a thirty-yard-wide landing area between the fence and the bunkers. Each time, he capitalized on his perfectly positioned tee shot by ripping a 4-wood to the green and two-putting for birdie. These many years later, this narrow strip of fairway, wedged between perdition and disaster, is still referred to as "Hogan's Alley."

The sixth hole was less than kind to Jack Nicklaus in the 1968 British Open. In the final round, Jack uncharacteristically hooked his drive over the fence, out of bounds. The penalty—two shots—was Gary Player's margin of victory.

Positioning the drive is only half the battle. Protruding halfway into the right side of the fairway about two hundred yards ahead of the fairway bunkers is "Jockie's Burn," a tributary of the feared Barry Burn that coils through the finishing holes.

The gap between the terminus of this watery ditch and the boundary fence is about twenty-five yards. But unless the second shot is aimed to the left center portion of the fairway, players may topple into the ditch or, seventy yards beyond it, catch one of two cleverly sited bunkers short of the green. The green itself, while wide, is shallow and oblique to the line of play. Ghastly sand pits defend the right front portion of the green; a big, deep bunker, invisible from the fairway, gobbles shots that fly too far.

Like every hole at Carnoustie, the sixth is not necessarily penal—"just depressingly efficient at exposing the weaknesses of one's game," according to architect Tom Doak. Adds Scotsman Sandy Lyle, "Remember, [the sixth] is an extremely powerful golf hole and any system you employ to score five, especially in any kind of wind, is the right one."

Ah, the wind. Wind is the unseen hazard at Carnoustie. Rare is the day when a freshening breeze doesn't whip in off the Firth of Tay. Because the sixth tacks directly to the west, the wind more often than not is in a player's face. In one blustery round during the 1995 Scottish Open, Colin Montgomerie needed two drivers and a 1-iron to reach the green. For the average handicapper, sound tactics, solid hitting, and a little bit of luck are required to conquer this, the longest and most dangerous hole on the most forbidding links of all.

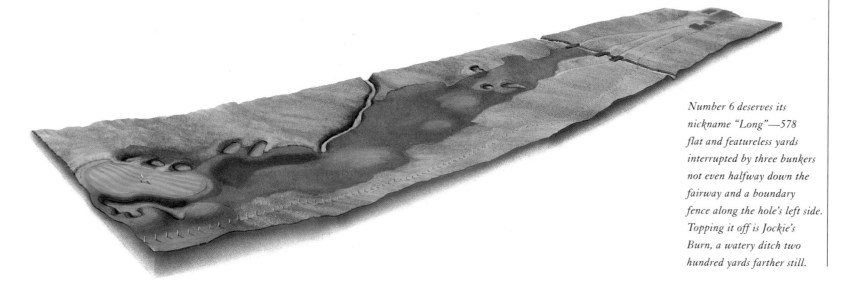

Number 6 deserves its nickname "Long"—578 flat and featureless yards interrupted by three bunkers not even halfway down the fairway and a boundary fence along the hole's left side. Topping it off is Jockie's Burn, a watery ditch two hundred yards farther still.

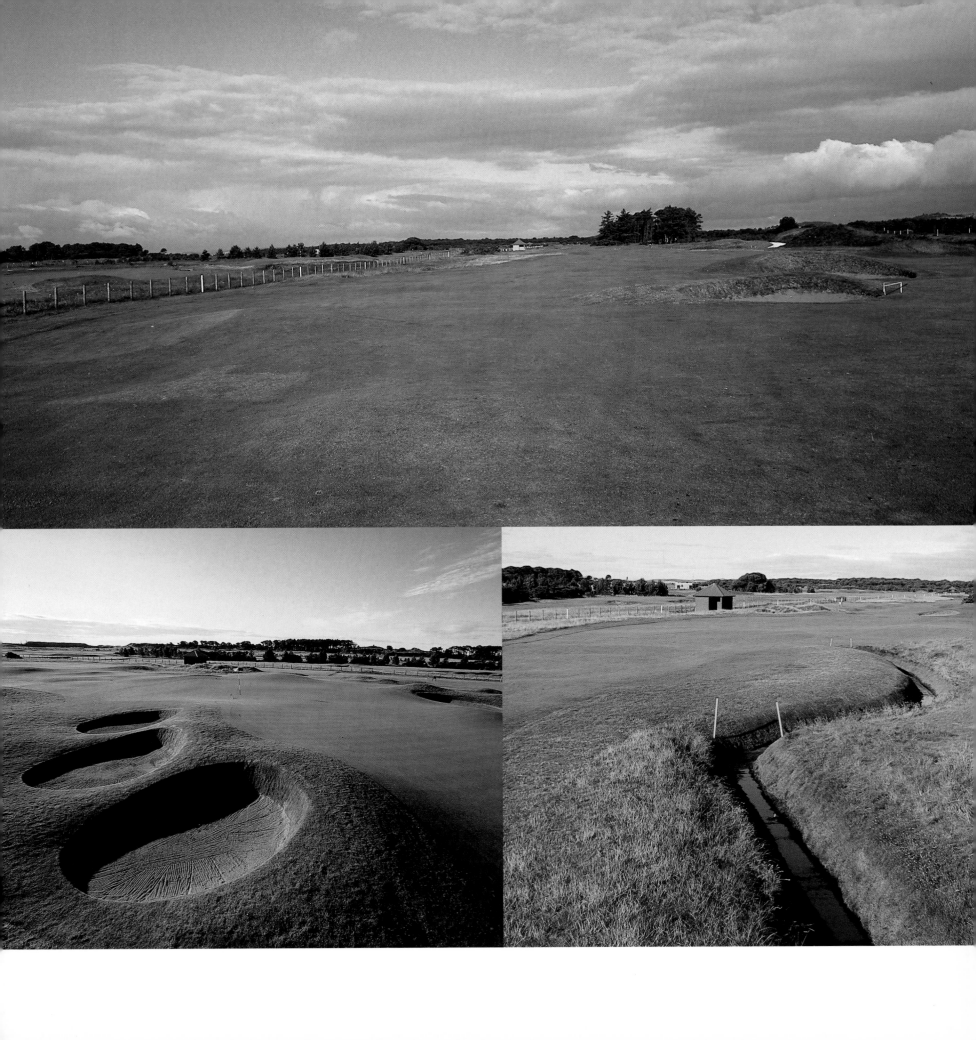

COURSE:	DURBAN COUNTRY CLUB
HOLE:	3
LOCATION:	DURBAN, NATAL, SOUTH AFRICA
ARCHITECTS:	GEORGE WATERMAN/ LAURIE WATERS
LENGTH:	513 YARDS · PAR 5

Shadowed for years by the veil of apartheid, South Africa, after turning the page on its unfortunate past in the mid-1990s, enters the millennium as a thriving golf destination. Dozens of new projects by the game's top architects are taking shape across what is known in the tourism industry as "a world in one country." The ingredients for superlative golf are here: a salubrious year-round climate, breathtaking natural beauty, and, like most nations where the British exerted their presence, a strong golf heritage. The South African Open, after all, is older than the U.S. Open. South Africa has produced many great champions, including Bobby Locke, Gary Player, David Frost,

and Ernie Els, to name a few. It follows that players of this caliber must have had exceptional playgrounds on which to hone their skills.

South Africa's most highly regarded layout is Durban Country Club. Going one better, it is the only course on the African continent currently ranked among *Golf Magazine*'s top one hundred courses in the world. Laid out by George Waterman and Laurie Waters—the latter a native of St. Andrews who apprenticed under Old Tom Morris, emigrated to South Africa, and later won the national championship four times—the course, opened in 1922, was built along the sunny Natal coast on the outskirts of what was then a small port

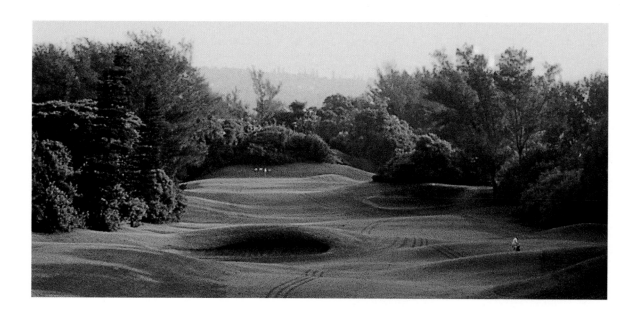

settlement. Durban today is a dynamic harbor city, its Indian markets, Zulu galleries, and British government buildings offering cultural diversity.

As befits its stature, Durban has many first-rate holes. Most famous among them is the 513-yard third, which occupies a valley in the dunes and is screened from the Indian Ocean and its white sand beaches by dense vegetation. In common with the world's best strategic holes, it favors sound judgment and shot placement over brute strength. The tee at the third, perched on a dune high above the fairway, gives players a bird's-eye view of the challenge that lies ahead. Far below, the fairway appears as a rumpled green rug, its mounds and swales parted between grassy dunes on the left and thick bush to the right. The prospect from the tee, according to Tom Doak, is "like looking down the barrel of a gun." A straight drive is a prerequisite to playing the hole successfully, but brisk ocean winds can play havoc with tee shots. A large, deep bunker eats into the left side of the fairway, leaving a narrow gap on the right for even long hitters.

The drive, however, is merely the pawn's first move. The aggressive golfer seeking to get home in two must be far and sure with his approach, for the raised green, backdropped by a tree-covered dune, tends to shrug off run-up shots. Only a perfectly struck, high-flying shot will do. A pushed or pulled effort is irretrievably lost in the impenetrable bush.

The more cautious player has his own obstacles to overcome. Two kidney-shaped bunkers, each perfectly positioned to either side of the fairway some forty yards from the green, were clearly intended to snare the careless lay-up. Like all well-crafted bunkers set back from the green, these two sand pits can play tricks with depth perception.

Even from the safety of the fairway 100 yards from the green, the pitch to the small, elevated putting surface is not easy. The hole may look easy on the scorecard at 513 yards, but Durban's third is a thorough test of any player's skill, regardless of whether birdie, par, or even a bogey is the goal.

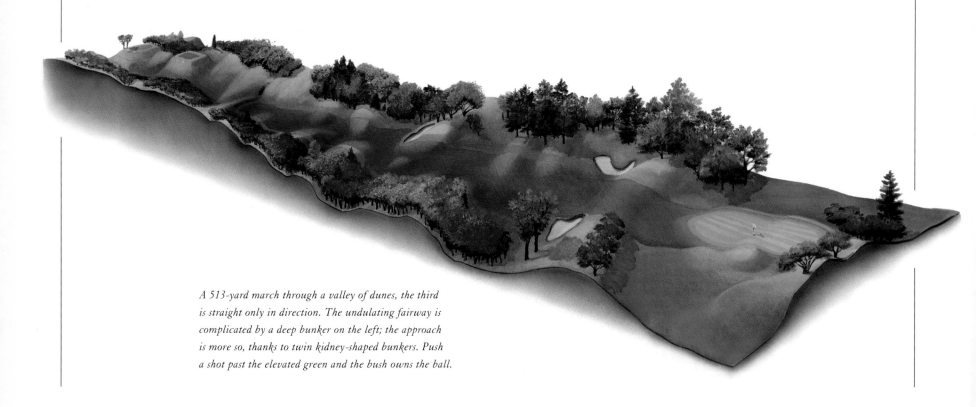

A 513-yard march through a valley of dunes, the third is straight only in direction. The undulating fairway is complicated by a deep bunker on the left; the approach is more so, thanks to twin kidney-shaped bunkers. Push a shot past the elevated green and the bush owns the ball.

The best index of a layout's pedigree is its roll call of champions. Every great South African player has competed at Durban. Most successful among them was Gary Player, who captured the first of his *thirteen* South African Open victories at the club in 1956. He returned to post the course record, a 64, in 1969.

Durban Country Club has changed very little since its debut, though a few alterations were made on the advice of Colonel S. V. Hotchkin, a British architect, in 1928; and again in 1959 by Robert Grimsdell, a devotee of H. S. Colt, the great English designer. Grimsdell summed up perfectly Durban's enduring appeal: "The player is not shown everything at a glance, but is given the thrill of anticipation and uncertainty." On a typically breezy day, the sly and potentially ruinous third at Durban is a shining example.

COURSE:	PEBBLE BEACH GOLF LINKS
HOLE:	18
LOCATION:	PEBBLE BEACH, CALIFORNIA
ARCHITECTS:	JACK NEVILLE/DOUGLAS GRANT, H. CHANDLER EGAN
LENGTH:	548 YARDS · PAR 5

The most spectacular finishing hole in the game, the one that nearly atones for all the damage to psyche and scorecard that might have occurred on the epic journey preceding it, is better now than when it was merely great. Which is saying something, because the stunning par-5 eighteenth at Pebble Beach, set along the curved shore of Carmel Bay, is universally regarded as the game's ultimate heroic hole. In 1998, a major coastal reconstruction project intended to repair damage and prevent further erosion caused by the insistent pounding of the Pacific was completed, thereby preserving for generations to come the quintessential hole on America's most cherished links. The clifftop thrills available on holes 4 through 10 are incomparable, but as a closer, Pebble's eighteenth is in a class of its own, the climax to top all finales.

It wasn't always so. The original eighteenth hole laid out by Jack Neville and Douglas Grant in 1919 was a rather mundane par 4, but it was converted to its present look and par in 1928 by H. Chandler Egan, a two-time U.S. Amateur champion. Save for a few refinements, the hole today is essentially the same as it was then. Robert Hunter, who joined forces with Egan to revise and improve Pebble Beach, wrote in his design treatise, *The Links,* "When we build golf courses we are

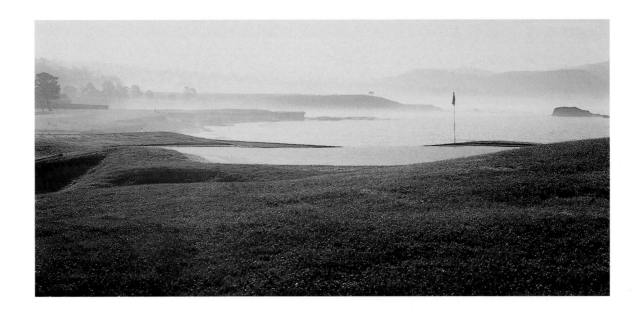

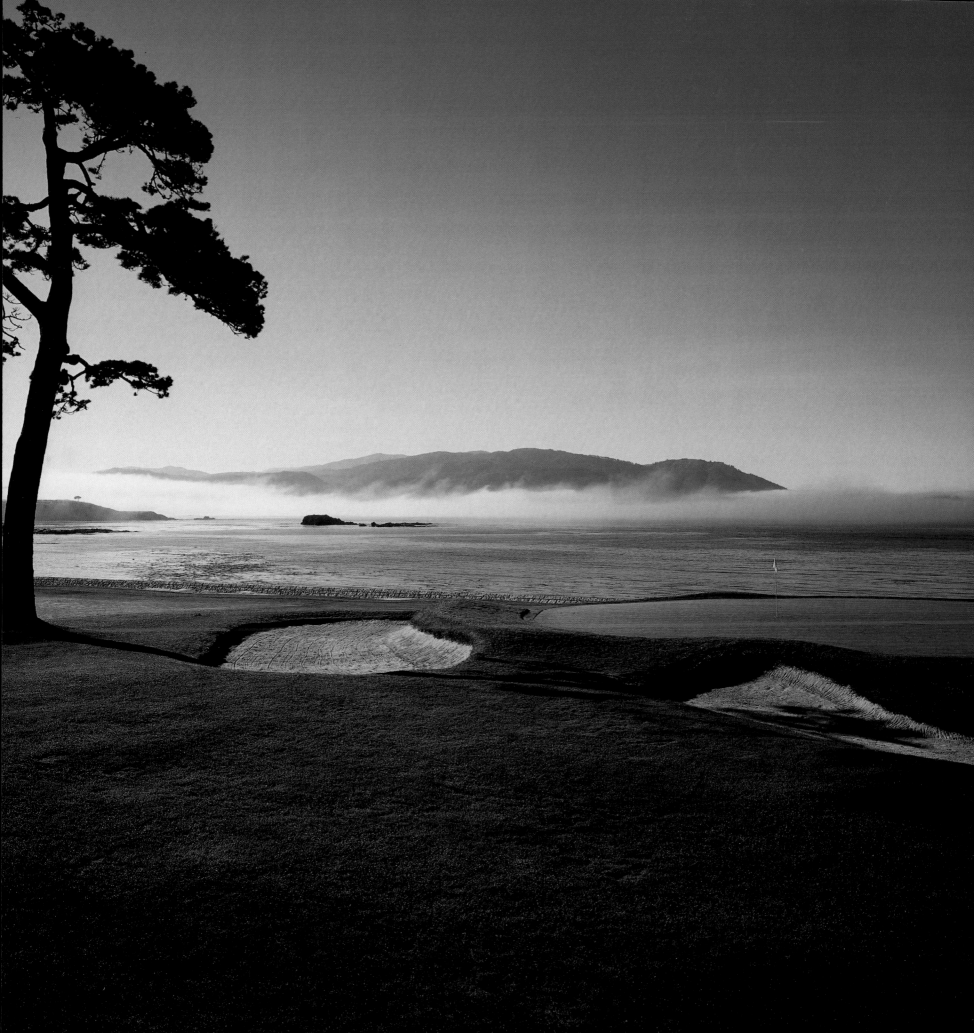

remodeling the face of nature; and it should be remembered that *the greatest and fairest things are done by nature and the lesser by art,* as Plato truly said" (emphasis added). Of course, Plato never played the eighteenth on a breezy day with a match on the line, but he did put his finger on the timeless appeal of Pebble Beach.

In the wake of the recent bulwarking, Pebble's majestic eighteenth, all 548 yards of it, runs along the ocean's shore a mere eight feet above the high-tide mark. The left side of the fairway is now buttressed by a formidable seawall capped with sandstone-colored blocks. Imitation rock formations attached to the base of the wall blend in with the existing coastline. The rebuilt tee, tripled in size, now projects into the ocean on its own self-supporting concrete bulkhead. As a consequence, the right-to-left arc of the dogleg is a little sharper and the scenario for the drive more tantalizing than before, as aggressive players are now dared to bite off more of the ocean with their tee shots.

There is plenty of bailout room to the right, but a drive played too cautiously away from the sea is in danger of rolling into a bunker, leaking out of bounds, or ending up behind a pair of trees in the right-center portion of the fairway. The second shot also can be aimed over water, setting up the most favorable angle for the approach to the green. (Only long-ball artists like Tiger Woods have any chance of reaching the green in two.) The safer route to the right not only lengthens the hole, it brings into play a large, overhanging pine and a pair of deep greenside bunkers, lending credence to Ken Venturi's opinion that the eighteenth cannot be played timidly.

Whichever line is chosen for the drive—safe or risky—neither option should be exercised before taking a moment to observe the scene behind the tee. Beyond a shelf of weathered rock, canopies of the bay's kelp forests gently rise and fall with the waves. Sea otters show their whiskers among the thick strands of kelp. Leopard seals

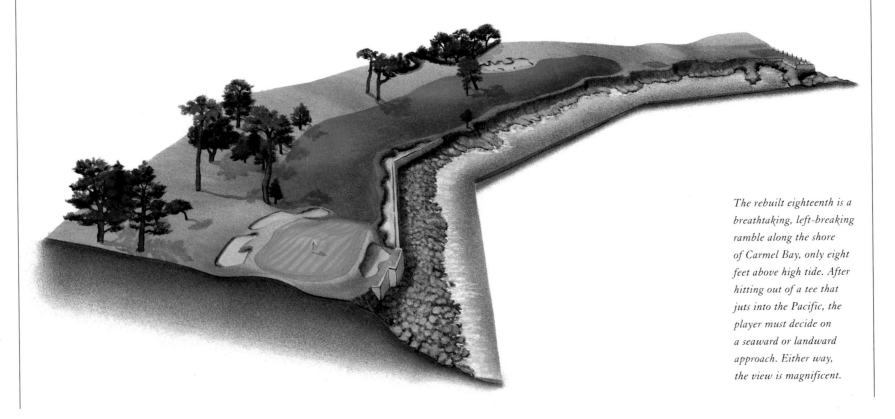

The rebuilt eighteenth is a breathtaking, left-breaking ramble along the shore of Carmel Bay, only eight feet above high tide. After hitting out of a tee that juts into the Pacific, the player must decide on a seaward or landward approach. Either way, the view is magnificent.

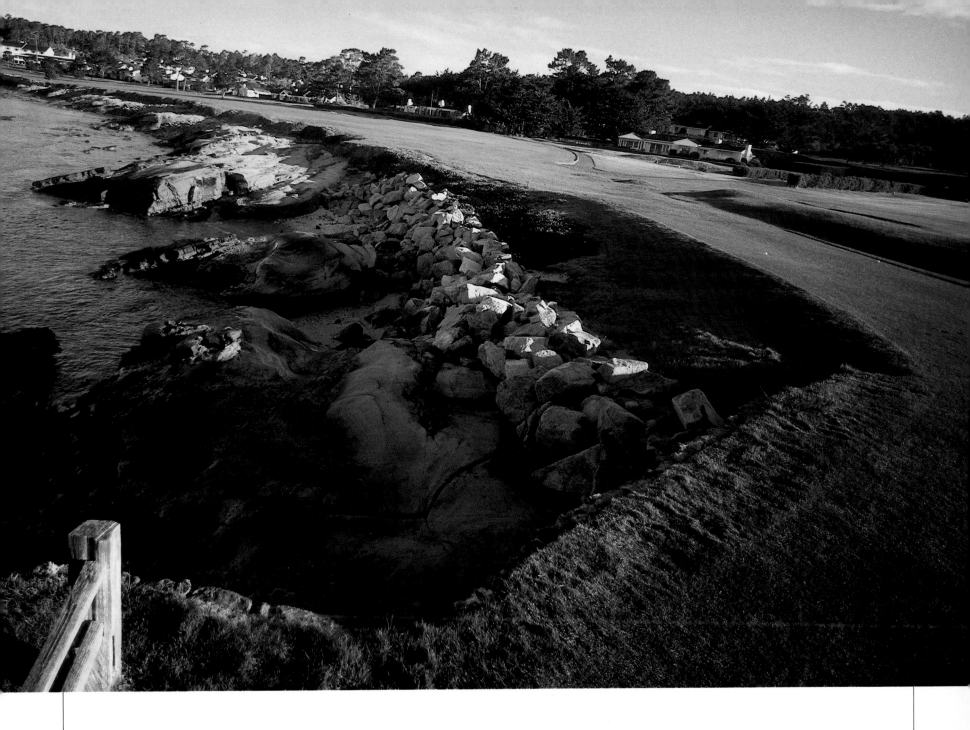

bask on the rocks. Occasionally, a school of dol-phins breaks the surface. Offshore, migrating whales spout in winter. Far to the south is Big Sur, its misty shore giving way to rounded peaks in the Santa Lucia Range. And that's the rear view. The view ahead is a boomerang-shaped fairway, the ocean's combers beating in from the left and low-rise white buildings, the resort's accommodations, set well back from the line of play on the right. It is the most inviting and also the most difficult drive a player is asked to make at Pebble Beach.

After holing out on a sizable green that slopes from back to front, most first-timers head to the resort's Tap Room (the perfect nineteenth hole) to tally their score and assess the holes and fix them in memory. Birdie or bogey, no recalled vision is more pleasurable than that of the eighteenth, because no hole entwines beauty and challenge better.

THE ONE HUNDRED

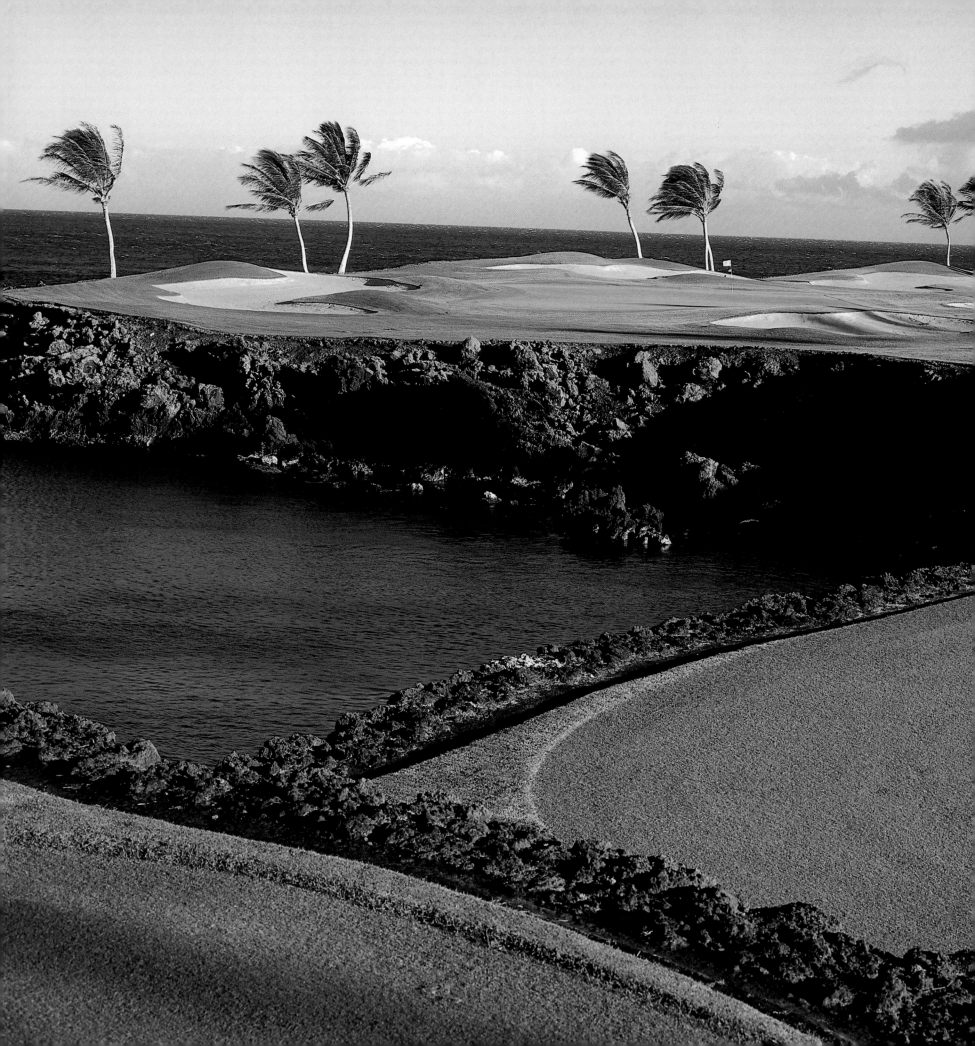

○○○

How many extraordinary holes would satisfy a lifetime of golf? Eighteen, no matter how remarkable, would not be enough. Five hundred might be too many to fully absorb and understand. However, nearly six courses, comprising the one hundred best holes in the world, would suffice very nicely in their variations of setting, challenge, and puzzlement.

The one hundred best holes in the world—the ones of "alarming excellence," as Bernard Darwin put it a century ago—present tests of evaluation, judgment, control, and difficulty. Like good theater, they have the ability to beguile, confound, fulfill, and drain us. They "draw us across the footlights," A. W. Tillinghast said.

Very often these great holes appear more difficult than they are, which was a trait Alister Mackenzie admired. Their intricacy is more baffling than hard. They present multiple defenses and multiple solutions. It is within this range of flexibility that challenges and approaches for players of all abilities can be found.

PRECEDING PAGES: *Bobby Jones's final playoff putt at 18 to win the 1929 U.S. Open at Winged Foot (page 300).* LEFT: *The fifteenth hole at Mauna Lani Resort (South) (page 257).*

George C. Thomas, the rose-growing Philadelphian and architectural genius behind Bel-Air, Riviera, Los Angeles North, and Ojai, had a nice way of putting it. "Golf is a game of balance. A thinker who gauges the true value of his shots, and is able to play them well, nearly always defeats an opponent who neglects to consider and properly discount his shortcomings."

We have all felt such justice won or lost when a combination of the elements at work in the hundred best holes in the world converges. We realize how fortunate we are to be standing on a tee at one of the world's most beautiful places and asked to respectfully accept the result of our effort and judgment. Each of the holes that follow offers this satisfaction and intrigue.

The bunker at PGA West (Stadium)'s sixteenth hole (page 312)

COURSE:	AUGUSTA NATIONAL GOLF CLUB
HOLE:	12
LOCATION:	AUGUSTA, GEORGIA
ARCHITECTS:	ALISTER MACKENZIE/ ROBERT TYRE JONES
LENGTH:	155 YARDS · PAR 3

Augusta National's twelfth is perfect theater. From the tee, the player is at the center of a balanced dramatic scene for both himself and those who watch from behind him.

On the left, catastrophe or elation unfold at the eleventh green, to the right the thirteenth tee makes its demands, and Rae's Creek ties each to the other. It is nearly impossible to picture "Golden Bell," as the club has named it, without seeing the azaleas in bloom behind the green, and hearing the cheers and moans of Masters' spectators as shots are played and scores posted on the leader board behind the eleventh.

By design and location, the twelfth's foremost demand is judgment. The swirling breezes, barely revealed by the tops of the pines, add an invisible defense to the three bunkers, narrow green, and water that place a premium on the discernment of distance.

How many times have we watched Jack Nicklaus look upward, pondering the sway of the pines, left to see if a threatening putt is made at the eleventh, or wait for the crowd to calm themselves after an important birdie or double bogey is posted on the scoreboard in the distance?

In the heat of moments such as these, the strategic elements of Augusta's twelfth are magnified and the thoughtfulness of the player is weighed in microns as he determines which club will see the ball safely to the green.

At just 155 yards, a short iron is all that is required, but it must be exactly measured. Too much and Greg Norman is walking back across the Ben Hogan bridge to play again; too little and Fred Couples wonders if his ball will hold on the bank or run into the creek; just right and Curtis Strange makes a hole in one. Not only theater, but award-winning theater.

COURSE:	BEL-AIR COUNTRY CLUB
HOLE:	10
LOCATION:	LOS ANGELES, CALIFORNIA
ARCHITECTS:	GEORGE C. THOMAS/JACK NEVILLE
LENGTH:	200 YARDS · PAR 3

The fortune that funded Bel-Air Country Club and the innovation that was wrought in the design of its golf course, particularly the tenth hole, are starlike tales of success and fame arriving when most needed and least expected.

Like Marion Hollins's drive that was the impetus for Cypress Point's sixteenth, so did the blows of Jack Neville and George C. Thomas with a putter across a Bel-Air canyon open the way for the short tenth and the course's demanding back nine.

Thomas had been retained to design the course. As a wealthy Philadelphian with an interest in gardening and landscape design, he had worked with Donald Ross and A. W. Tillinghast as well as observing what his friends Hugh Wilson and George Crump had done at Merion and Pine Valley respectively.

Following service in World War I as a pilot, Thomas moved to Los Angeles, presumably for its promise as a prime rose-growing climate. However, within a short period of time, he was practicing golf course architecture, which would eventually include Riviera, Los Angeles North, Stanford, Ojai Valley, and Bel-Air.

The funding for Bel-Air came from Alphonzo Bell, who was a produce farmer and devoted Christian. When a shortage of water threatened his farm's survival and necessitated a new well, the drill bit found oil rather than water. The resulting windfall provided the capital for developing the club. Bell sought out Thomas and Neville, a multiple winner of the California Amateur, who had also been instrumental in the design of Pebble Beach.

During planning, the land where Thomas hoped to build the second nine was bought by the state for the campus of UCLA. The designers were forced to look elsewhere to build the inward nine. The story is told that, while searching for an alternate site, Thomas, Neville, and Thomas's construction foreman, Billy Bell, came to the precipice of the canyon where the original clubhouse was to be built.

They decided that if the 150-yard carry across the canyon could be successfully negotiated, it would open a whole tract of land on the other side that could be used for the back nine. Neville produced a ball and with a putter, the only club that could be found, he struck the ball across the canyon. When Thomas did the same, the second nine was born.

A suspension bridge was erected to get the players across the deep canyon to the green—hence the hole's name "Swinging Bridge." Four underground tunnels and an elevator were added to route golfers under and through the clubhouse and around the circuitous course.

COURSE:	CABO DEL SOL GOLF CLUB
HOLE:	17
LOCATION:	LOS CABOS, MEXICO
ARCHITECT:	JACK NICKLAUS
LENGTH:	178 YARDS · PAR 3

Sometimes compared with Cypress Point's six-teenth, lauded as the center of the "best three finishing holes in the world," and touted by the game's greatest player as sitting on the best golf property on the planet, Cabo del Sol's seventeenth is an intoxicating combination of beauty and strategy that demands performance and judgment.

As all golf architects are inclined to do, Jack Nicklaus is often heard praising the positive aspects of his courses. However, the words that he has used to describe this work at the tip of Mexico's Baja California peninsula are extraordinary—words you can accurately use only once. He called it the best golf property he has ever seen.

The seventeenth justifies Nicklaus's superlatives with its flexibility of length, which provides a test for all levels of play, and astounds even the most currish by its beauty and strategic allure. The arrangement of tees is so well conceived that distances between 115 and 178 yards can be configured without losing the threat or beauty of the Bay of Whales.

Like Hawaii's Mauna Kea and Lanai's Manele Bay, Cabo del Sol's seventeenth and the rest of the course provide seaside golf in a desert climate. The combination is fascinating by its contrast and can also be infuriating when assailed by the forces of the Pacific Ocean winds.

"My experience of really first class holes," Alister Mackenzie wrote, "is that, like the famous 'Road Hole' at St. Andrews, they at first sight excite the most violent spirit of antagonism. It is only after the holes have been played many times that the feeling of resentment disappears and the former critics become the strongest supporters."

COURSE:	CASA DE CAMPO GOLF CLUB (TEETH OF THE DOG)
HOLE:	7
LOCATION:	LA ROMANA, DOMINICAN REPUBLIC
ARCHITECT:	PETE DYE
LENGTH:	225 YARDS · PAR 3

"This course will come out of nowhere and it will throw you down and stomp on your head," said Gary Koch following his play at Teeth of the Dog during the 1974 World Amateur Team Championship.

The short seventh is an oceanside jewel cut and set within a Dominican masterpiece that is as much a testament to Pete Dye's will as it is to his imagination.

The hole consists of little more than the tee perched at the ocean's edge, a stretch of aqua water, and the green set slightly back and surrounded by the white sand beach. Off to the left is the eighth tee jutting thirty yards into the sea, to the right a simple stand of palms rustling in the prevailing sea breeze.

It all seems so correct, so wonderfully fit for where it is. And yet without the dogged presence of Dye and Bruce Mashburn, a North Carolinian who learned course building at the hand of Donald Ross, this course would never have been ripped from the *dientes del perro,* which is the local name for the coral that also gives the course its name.

As in a medieval public works project, three hundred local workers pounded the coral with sledgehammers, pickaxes, and chisels. A large steel bar was tied behind one of the small bulldozers so the workers could smash the bar into the coral and smooth it before the topsoil arrived one square yard at a time in sugarcane carts pulled by oxen.

"Patience," Dye has said, "can be a great virtue, and I learned firsthand that land responds more positively to the raw-boned hands of the laborer than to the steel-faced jolt of heavy machinery. Whatever delicate features Teeth of the Dog possesses are a direct result of the hard work of those Dominicans who took such pride in their work."

COURSE:	CYPRESS POINT CLUB
HOLE:	16
LOCATION:	PEBBLE BEACH, CALIFORNIA
ARCHITECT:	ALISTER MACKENZIE
LENGTH:	233 YARDS · PAR 3

The view leaves one in awe of the task at hand and the beauty of such a setting. It also makes one wonder if the whole thing isn't more than a good, even great, hole should ask.

Seth Raynor and Alister Mackenzie posed those same questions before Marion Hollins, the founder of Cypress Point, who demonstrated that the examination at the sixteenth would be presented as a par 3 rather than a short 4.

From the tee—and there is only one—the carry is 233 yards over surging ocean surf to a putting green framed by gray, craggy rocks, circled by bunkers and backdropped by the horizon of the Pacific Ocean. On a sunny day, it is awesome; on a stormy day, overwhelming; and on any day, never to be forgotten.

Miss Hollins was the quintessential sportswoman of the 1920s, the golden age of sport. A U.S. Women's Amateur champion, the greatest horsewoman of her day, and the number one–ranked women's polo player in the world, she founded Cypress Point with the same drive and vision with which she played all her sports.

Initially it was Raynor she consulted about the routing and design. His plans situated the sixteenth green on the point where it was eventually built, but the hole was a short par 4. Following his death in 1926, the job fell to Mackenzie, who agreed that it was more presentable as a two-shot hole with a two hundred-yard carry.

Hollins would have none of it. She wanted it to provide the elation of a heroic hole when successfully negotiated. In his autobiography, Mackenzie gives Hollins full credit: "I must say that, except for minor details in construction, I was in no way responsible for the hole. It was largely due to the vision of Miss Marion Hollins (the founder of Cypress Point). It was suggested to her by the late Seth Raynor that it was a pity the carry over the ocean was too long to enable a hole to be designed on this particular site. Miss Hollins said she did not think it was an impossible carry. She then teed up a ball and drove to the middle of the site for the suggested green."

Mackenzie worried that the sixteenth was less than ideal because there was not a sufficiently easy route for the weaker player. His fear was assuaged a few years later when a friend, who had played two balls into the ocean, was beaten by his opponent who used a putter to play around the water, reaching the green in four shots and winning both the hole and $200.

COURSE:	EL RINCON GOLF CLUB
HOLE:	7
LOCATION:	BOGOTÁ, COLOMBIA
ARCHITECT:	ROBERT TRENT JONES, SR.
LENGTH:	179 YARDS · PAR 3

Among his many trademarks and accomplishments, Robert Trent Jones, Sr., has demonstrated a talent for using water hazards in a way that accentuates the heroic aspects of his best holes. Augusta's eleventh and sixteenth, Baltusrol's fourth, Mauna Kea's third, the Dunes's thirteenth, Hazeltine's sixteenth—each of these exacts, as Jones has said, "an easy bogey, tough par."

In the middle of the Andes Mountains, Jones found a site where he could present this recurring theme in a different context. El Rincon's seventh hole is a respectable 179 yards in length. However, a golf ball hit a mile and a half above sea level travels 13 percent farther. Necessarily, the course is designed to play at a length of 7,542 with the par-3 holes averaging 210 yards in length.

Therefore, the delicacy of the seventh falls contrary to the premise that longer must be tougher at such an altitude. This "short" hole is the only major revision Jones made to the course he designed originally in 1963. Prior to the 1980

World Cup, Jones redesigned the hole to mirror changes he had made to Baltusrol's fourth in 1954.

A small lake completely separates the teeing ground from the putting green. The lengthy teeing ground, another Jones trademark, offers a variety of perspectives to the hole. A stone wall protects the front of the green, adds a crisp line, and accentuates the severity of the hazard. A ball played too long will find one of three sand-faced bunkers clearly visible from the tee. Recovery from the sand must contemplate too long a shot finishing in the water. Finally, the diagonal positioning of the green disguises the length to the hole.

This is a captivating short hole that demands good judgment and distracts with great beauty. Bounded to the east by the Bogotá River, El Rincon's climate is described as eternal spring. The average temperature of 57 degrees produces eucalyptus groves, bushy spruce, and conical pines, all of which surround Jones's masterpiece of flexibility and variation.

COURSE:	MAUNA KEA GOLF CLUB
HOLE:	3
LOCATION:	KAMUELA, HAWAII
ARCHITECT:	ROBERT TRENT JONES, SR.
LENGTH:	210 YARDS · PAR 3

The world's great holes are defined by location and strategic design. In the case of the Mauna Kea's par-3 third, what appears to be a naturally situated, strikingly beautiful short hole is the result of a collision of genius in vision and engineering that gave birth to golf on Hawaii's black lava fields.

As bizarre as it must have seemed that Laurance Rockefeller chose the Big Island's barren lava fields as the site for a five-star hotel, it must have seemed even more outrageous when he explained to Robert Trent Jones, Sr., that he wanted guests to play golf on a course so demanding and visually spectacular that it would instill memories strong enough to warrant their return to the island.

With such an assignment, Trent Jones developed the technique for grinding and pulverizing the omnipresent black lava so it could be shaped into a beautifully flowing golf course. Topsoil was layered on top of the lava, grass grown, and for the first time golfers could feel the exhilaration of playing golf in an environment where it had never before been played. This was golf in a lava desert.

Of the world's thirty-five climates, thirty-three are reputed to be present on the Big Island of Hawaii and all are, more than likely, visible somewhere between the third tee at the ocean's edge and the snow-capped Mauna Kea volcano, which rises 13,796 feet in the distance.

The tee shot must be played over the pounding Pacific surf to a diagonally placed green, which, depending on where the hole is cut, can be 182 to 234 yards in length. The conditions are rarely benign. A missed calculation of wind direction or speed will leave the tee shot in either of the guarding bunkers or rebounding off the rocks and into the surf below.

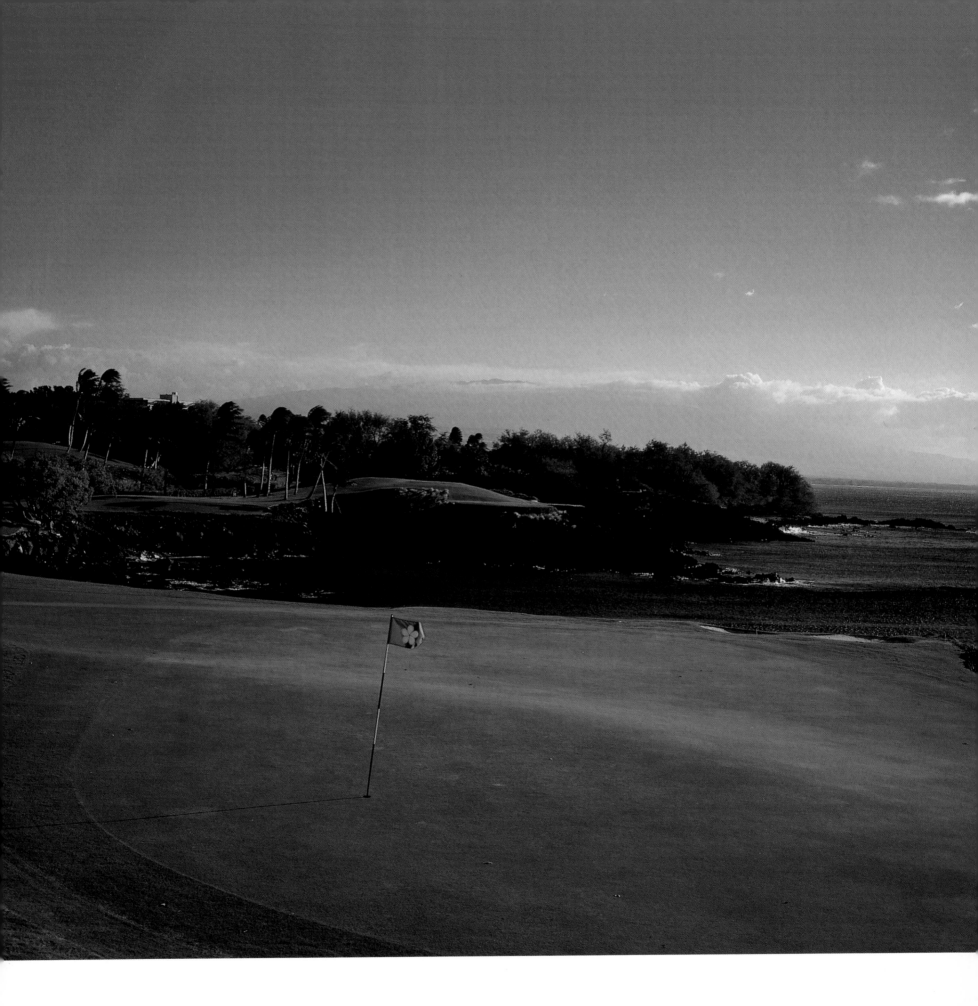

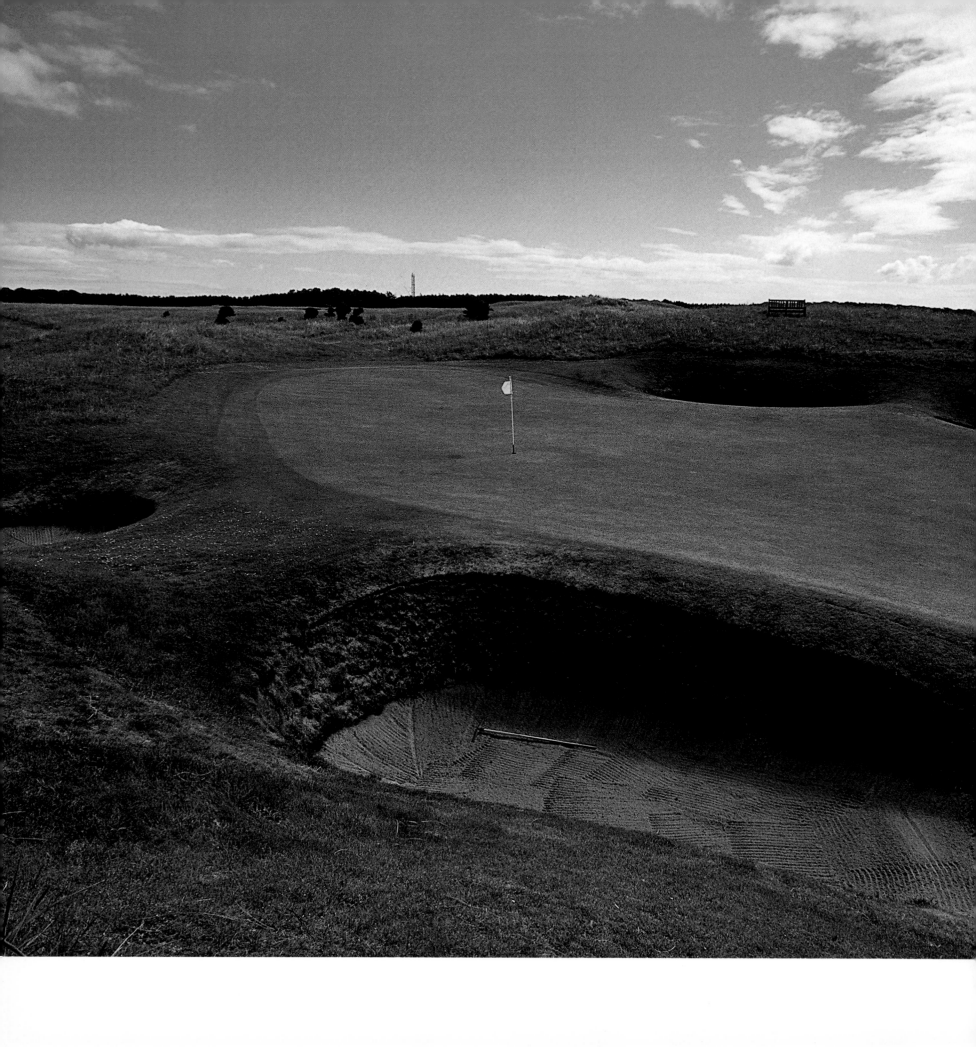

COURSE:	MUIRFIELD (HONOURABLE COMPANY OF EDINBURGH GOLFERS)
HOLE:	13
LOCATION:	GULLANE, EAST LOTHIAN, SCOTLAND
ARCHITECTS:	OLD TOM MORRIS, H. S. COLT/ TOM SIMPSON
LENGTH:	159 YARDS · PAR 3

Of the twelve British Open champions to have captured the claret jug at Muirfield, it was Jack Nicklaus, in 1966, who seemed to relish it most, and his summation of the short thirteenth was as to the point as the hole itself.

"A gem," he called it.

Playing 159 yards uphill to a long, narrow green, the thirteenth is nestled "in a basket of dunes." While the inward nine at Muirfield flows generally counterclockwise—just as the out nine flows clockwise—this formula is interrupted at the thirteenth, which runs 180 degrees away from the twelfth and fourteenth. Under windy linksland conditions, such a change requires a focused recalculation that interrupts prevailing conditions and considerations.

The green is gracefully contoured and jealously guarded by three deep bunkers to the right and two to the left. The club's history book describes the diabolical nature of these hazards. "The bunkers to either side up the green sire satanic permutations of stance and lie, aim and elevation . . ."

The putting surface presents its own defense by the long, fast putt that results from being above the hole. Legend has it that Walter Hagen, en route to his 1929 Open Championship here, intentionally drove into a bunker rather than risk being left with such a putt.

With his victory here in 1966, Nicklaus joined Gene Sarazen, Ben Hogan, and Gary Player as the only players to have won all four major championships. By the time the Open Championship was again held at Muirfield in 1980, Nicklaus needed to win the Open once more to have completed the modern grand slam for the fourth time (this before anyone else had been around twice). Nicklaus made a spirited try—he finished tied for fourth—however, it was to be Tom Watson's victory, the third of his five Open championships.

COURSE:	NEW SOUTH WALES GOLF CLUB
HOLE:	6
LOCATION:	LA PEROUSE, SYDNEY, AUSTRALIA
ARCHITECTS:	ALISTER MACKENZIE, ERIC APPERLY
LENGTH:	193 YARDS · PAR 3

Falling as it does between Alister Mackenzie's work at Royal Melbourne (1926) and Cypress Point (1928), New South Wales provided an important developmental link in his career, and an instructional link in the career of Eric Apperly.

There are few courses in the world that provide such raw, natural scenery. The coastal courses of the Monterey Peninsula and Northern Ireland would offer similar settings. Located on the rocky, exposed seaside of eastern Australia, all but five holes have views of the Pacific Ocean where it touches the Cape Banks, the turning point for Captain Cook as he sailed into Botany Bay.

While the sixth is foremost among New South Wales's stunning array of holes, there is evidence that the sixth was not the work of Dr. Mackenzie in 1928, but rather to be credited to Eric Apperly's postwar work in 1947.

According to Ran and John Morrissett, aerial photographs of the course following Mackenzie's only visit to Australia show that the fifth hole was followed by today's seventh. It was after World War II that Apperly, an Australian amateur golfer, added the famous sixth. Clearly he had learned to emulate Mackenzie and saw that the rocky cove provided a natural and stirring spot for a short hole.

To get to perhaps the most photographed hole in Australia you must cross a bridge to the reef where the back tee is located. The temptation is to avoid the pounding ocean to the left and play safely to the right. However, the right-to-left pitch of the green makes recovery from the right side extremely difficult.

The combination of setting and strategic tomfoolery makes Apperly's efforts at New South Wales's sixth true to Mackenzie's belief that "one of the objects in placing hazards is to give the players as much pleasurable excitement as possible."

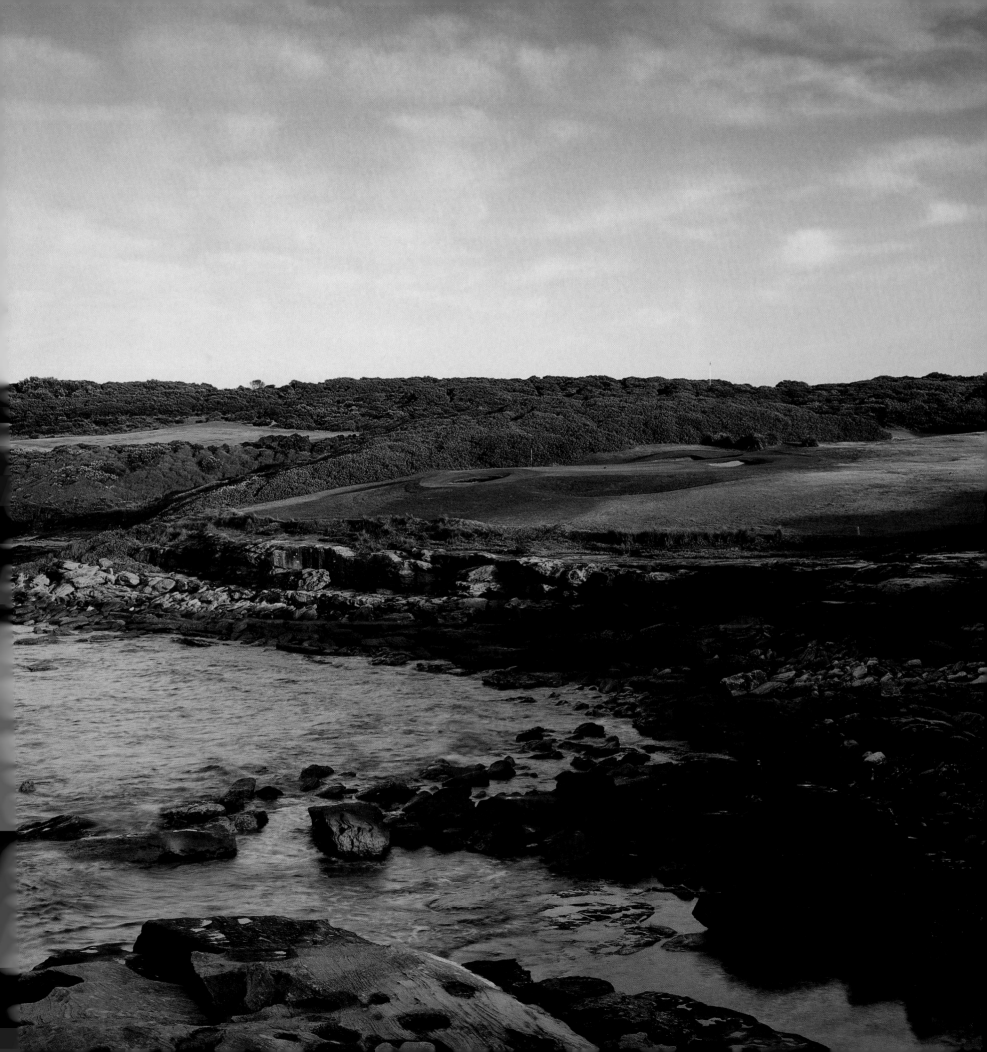

COURSE:	NORTH BERWICK GOLF LINKS (WEST)
HOLE:	15
LOCATION:	NORTH BERWICK, EAST LOTHIAN, SCOTLAND
ARCHITECT:	DAVID STRATH
LENGTH:	192 YARDS · PAR 3

Generally regarded as the most copied hole in the world, North Berwick's "Redan" was perhaps the first to present a specific formula of defense against a player making par.

The term "redan," in military parlance, refers to a type of guarding parapet with two faces or two lines of works pointing away from the fortification and reduces the enemy's points of assault.

The redan defense at this 192-yard hole is, indeed, twofold: The green is set at a 45-degree angle, with the back left angled away and set behind a deep bunker. Furthermore, the green falls gradually away to the rear. Except for the bunker, its elements of defense are largely invisible from the tee and are obscured by a ridge about forty yards short of the green.

The trick here is to judge the distance, clear the bunker, and make the ball stop on a green that is sloping away from you. Depending on the prevailing wind, a successful tee shot may require a fade, a draw, or a low, running approach.

"The ideas embodied in the hole are excellent," wrote Alister Mackenzie, "and these ideas give an architect great opportunities of making interesting holes. . . . We frequently construct holes that may be played with a swing from right to left, left to right, or even from either side according to the position of the hole in the green."

Charles Blair Macdonald's Redan hole at The National Golf Links on Long Island (No. 4) is considered better than North Berwick's original, which is why you will find it, and not this, among the top eighteen in the world.

North Berwick was very much the golf destination for the wealthy and powerful in the early years of the twentieth century. While Winston Churchill is better known for his disparaging remarks about golf than for his playing of it, he was probably on the links at North Berwick when he received the summons that would result in the thirty-seven-year-old becoming First Lord of the Admiralty in 1911.

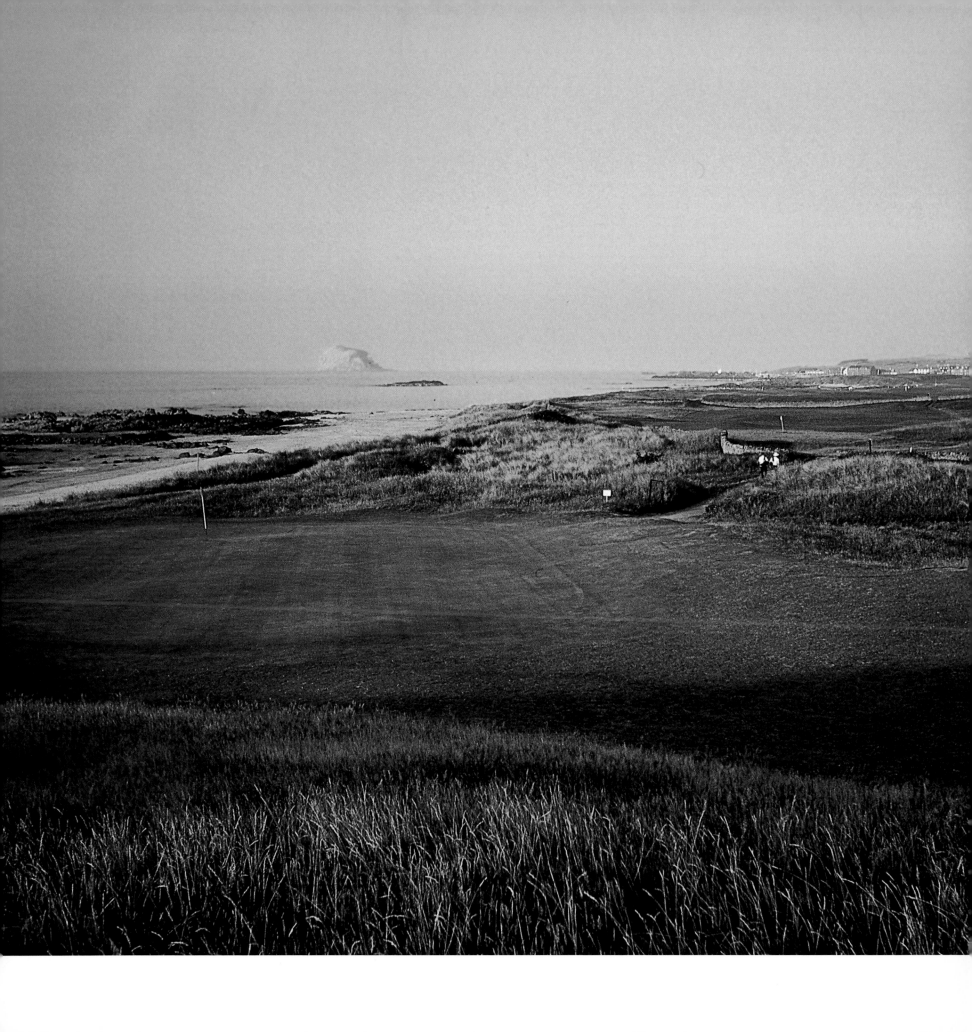

COURSE:	PEBBLE BEACH GOLF LINKS
HOLE:	7
LOCATION:	PEBBLE BEACH, CALIFORNIA
ARCHITECTS:	JACK NEVILLE/DOUGLAS GRANT, H. CHANDLER EGAN
LENGTH:	107 YARDS · PAR 3

Having climbed Pebble Beach's long sixth, the player stands on the tee at the seventh exposed on three sides to the magnificence of this eloquently contrasted short hole. All aspects of its demands are either overwhelming or absent, and therein lies its greatness.

Behind you, below you, to the right, and behind the green lies the pounding surf of Monterey Bay. Just one hundred yards away lies a two thousand-square-foot green, eight yards wide, surrounded by bunkers and protected by a massive dollop of rock over which waves are breaking.

The shortest of any hole where major championships are played, the seventh at Pebble Beach is a change-up. Full power gives way to judgment and strategic consideration. In benign conditions, the player stands tall, selects a short iron, and flips his ball casually to the quaint green below.

As the storm rises, just peering at the green from beneath your rain hat can be painful. Such a moment may require a 3-iron, an intentional but safe play to one of the greenside bunkers, or something truly bizarre as a putter. (Despite the myth, Sam Snead did not play the hole this way, but has watched others roll the ball down the walking path to the green, pitch on, and one-putt, besting those with less imagination.)

Set in the middle of the most dazzling seaside series of holes in the world, the seventh at Pebble Beach is an ever-present paradox of contrasting questions and conditions, which enthrall and perplex players of all abilities.

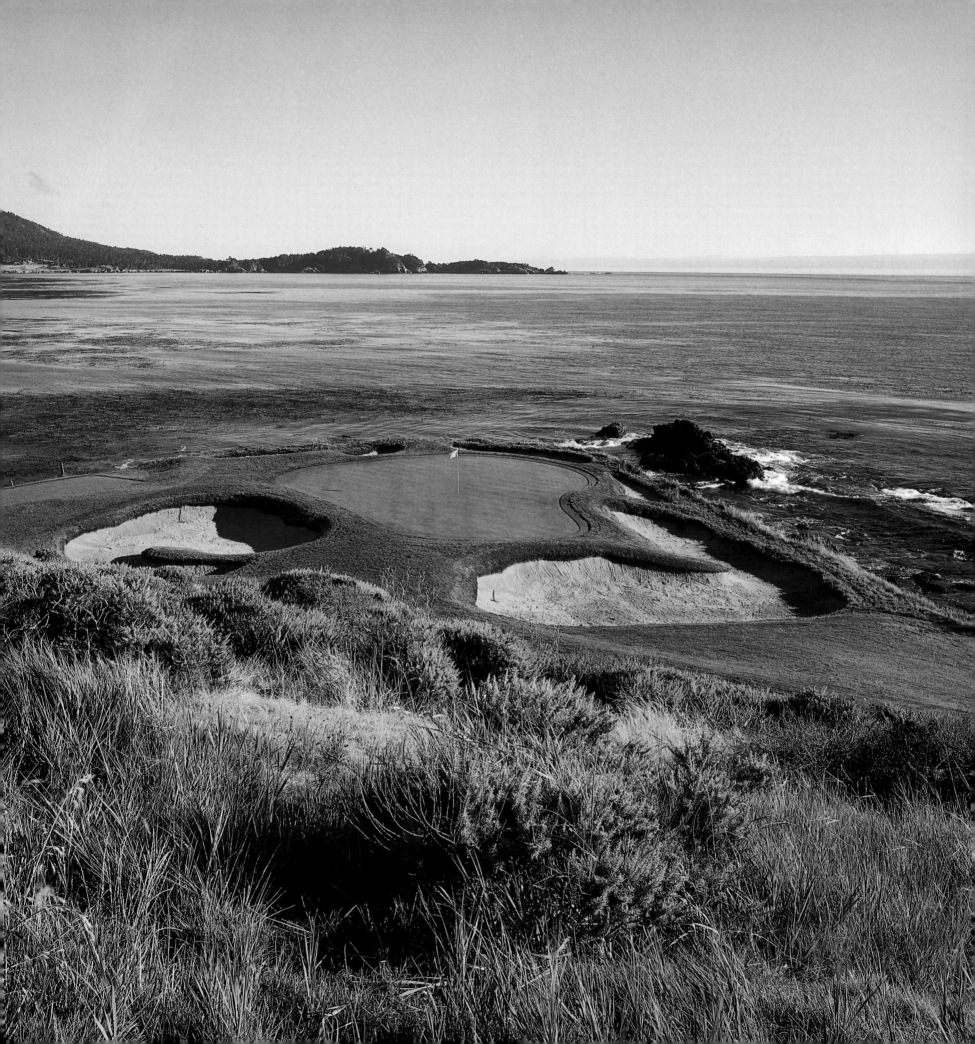

COURSE:	PINE VALLEY GOLF CLUB
HOLE:	10
LOCATION:	CLEMENTON, NEW JERSEY
ARCHITECTS:	GEORGE CRUMP/H. S. COLT
LENGTH:	146 YARDS · PAR 3

The nearly chimerical golf problems the Pine Valley course exemplifies are present in all aspects at the infamous tenth.

Played normally, it is a simple 7- or 8-iron. As the shortest hole on the course, delectable issues and danger surround it. The undulating green is small and falls precipitously on all sides to the ragged sand pit that surrounds it. In full view at the right front corner is its most dangerous element: a deep pot bunker into which the front of the green slopes and from which backward is the only means of escape. And from which the hole gets its nickname, "the Devil's Asshole."

Why, in 1919, did such an exaggerated design almost instantly garner praise from course architects who were generally interested in promoting only their own designs? Because nothing like it had ever been built before. It is a course unafraid to be difficult. It does not offer weaker players an alternative line to the hole and feels no reason to apologize for making such demands.

George C. Thomas, an early Pine Valley mem- ber and noted designer of Riviera, Los Angeles North, and Bel-Air, had this view of golf generally, which may shed a light on his admiration for Pine Valley specifically. "Pars are for nearly perfect play, not for puny drives or wild tee shots, unless, after such, the player makes fine recoveries, or holes out in one putt, or by a very accurate and difficult shot reaches the green after his first ineffectual effort."

"Pine Valley," wrote Alister Mackenzie, "is, with the possible exception of Cypress Point, by far the most spectacular course in the world. I have never seen a course where the artificial bunkers have such a beautiful and natural appearance, and the undulations on the greens are excellent."

Unafraid to be difficult and unimaginably beau- tiful, Pine Valley offers targets and islands of grass in a sea of sandy wasteland. As at the tenth, nearly every hole requires a forced carry, while recovery can be injurious to even the most accomplished player. No course before or since has been both as strategi- cally demanding and beguiling. Nowhere is this more obvious than at the short tenth.

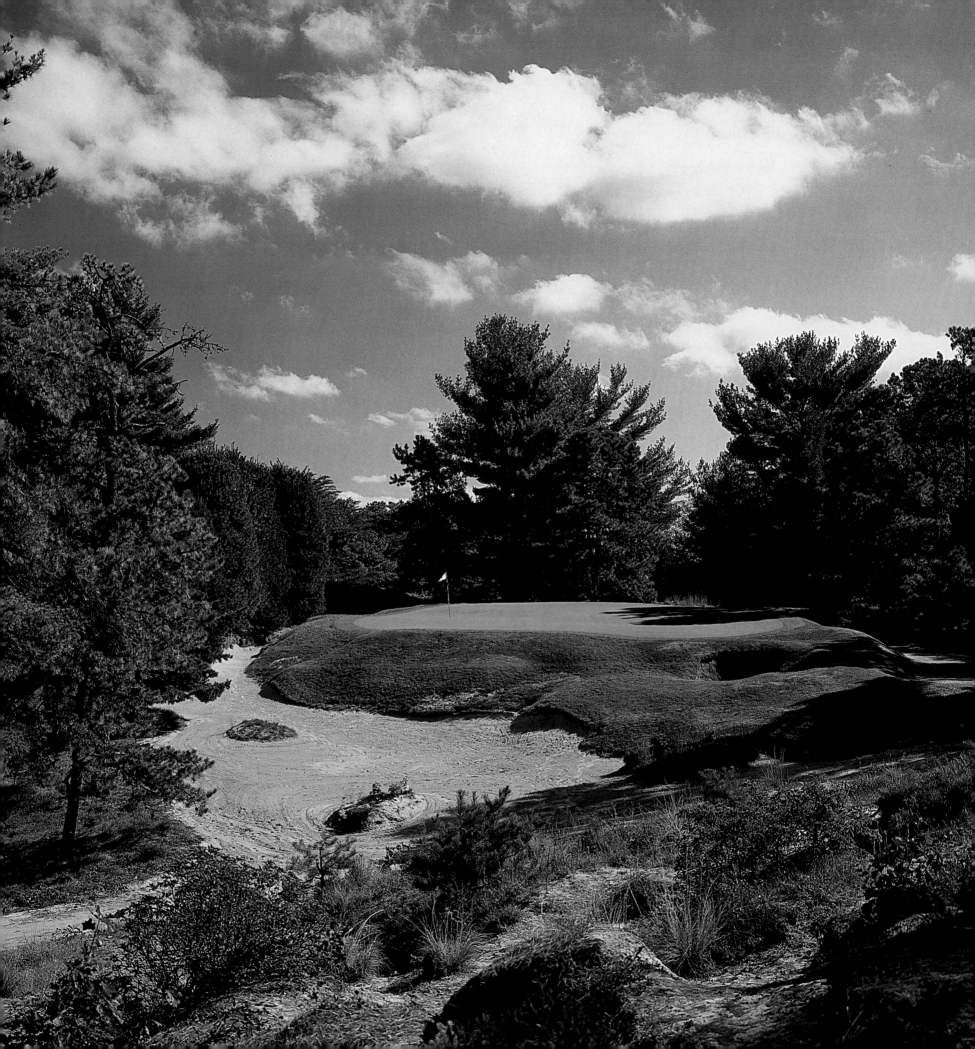

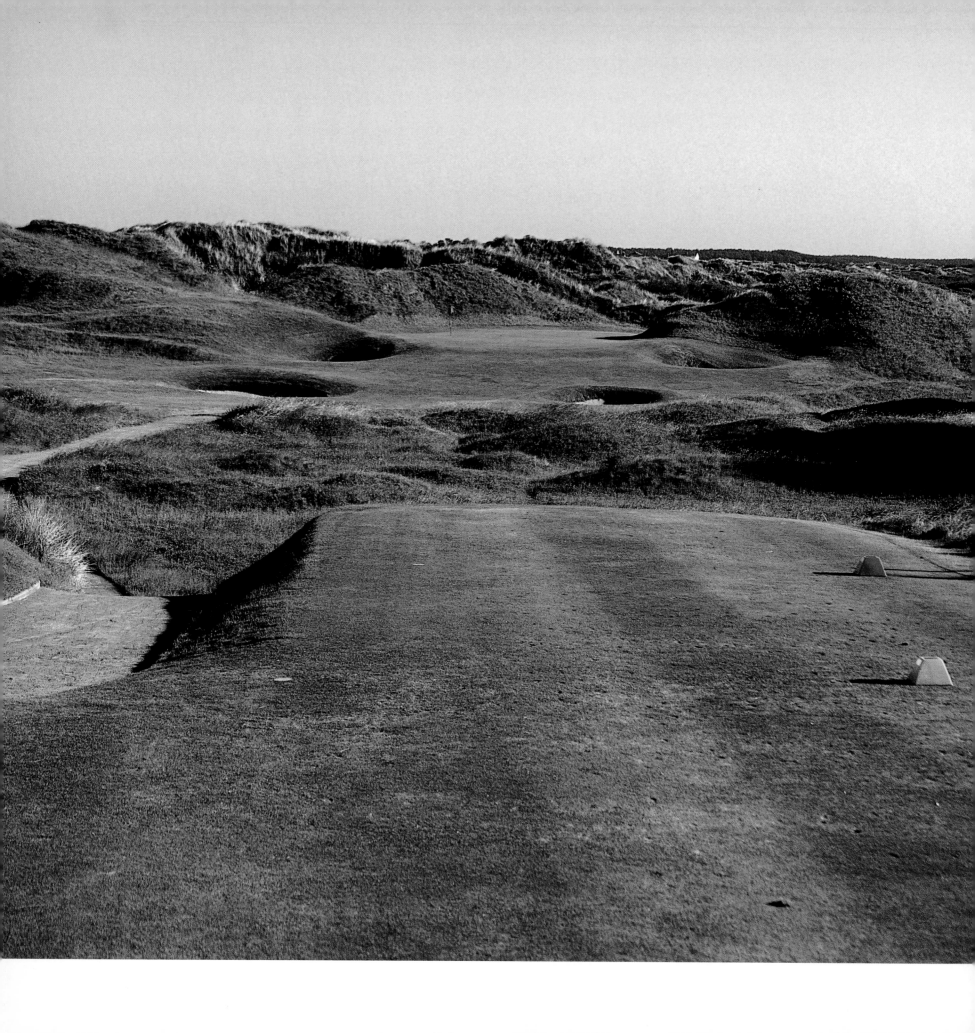

COURSE:	ROYAL BIRKDALE GOLF CLUB
HOLE:	12
LOCATION:	SOUTHPORT, MERSEYSIDE, ENGLAND
ARCHITECTS:	GEORGE LOWE, F. W. HAWTREE/ J. H. TAYLOR
LENGTH:	181 YARDS · PAR 3

Reaching 111 years of age at the turn of the millennium, Royal Birkdale was late in coming to its championship responsibilities. Scheduled to host the 1940 British Open Championship, which was postponed due to World War II, Birkdale would not realize that honor until 1954, when Peter Thomson won the first of his five.

But late though it might have been, Birkdale caught up in a hurry. Over the past thirty years, no club has hosted more major events, including two Ryder Cups, the Walker Cup, the British Amateur, the Ladies Open twice, and eight Open Championships, including the one hundredth in 1971.

Twice the Open champion here, Thomson has said, "Birkdale lacks nothing. It is a man-size course but not a monster. It is testingly narrow but not absurd, certainly not artificial."

There is nothing unnatural about the short twelfth. From the tee, situated in the hills, the shot must carry across a narrow valley to the green up in the next row of hills. Even from this relatively short distance the green appears narrow and small. Four deep bunkers and the flanking sand hills accentuate and define the target, but do nothing to make it seem closer—or easier to hit.

The rough, which frames Birkdale's fairways and greens at every turn, is a colorful combination of creeping blackberry, willow scrub, and a yellow evening primrose that tickles a subconscious memory of Scottish heather in bloom.

COURSE:	ROYAL DAR-ES-SALAAM (RED)
HOLE:	9
LOCATION:	RABAT, MOROCCO
ARCHITECT:	ROBERT TRENT JONES, SR.
LENGTH:	199 YARDS · PAR 3

Eighty-three years after it appeared at Royal Ashdown Forest, and seven years after his introduction of the concept at the Golden Horseshoe in Williamsburg, Virginia, in 1971 Robert Trent Jones, Sr., took the island green to Morocco and made an indelible impression.

The Red Course at Royal Dar-es-Salaam was the first eighteen of forty-five holes Jones designed, with the assistance of Cabell Robinson, for the late King Hassan II of Morocco. This was literally a course fit for the king, undoubtedly the most enthusiastic golfing royal in the world at the time.

The short ninth accentuates the demands made by great short holes while simultaneously heralding the elements of the game that have enticed participation all over the world.

The tee is placed on the crescent-shaped bank of a large lake 199 yards from the green. As the seventeenth at TPC has shown, there is nothing quite as intimidating as a target green completely surrounded by water. Anticipation of disaster shrinks, in the mind's eye, what is an adequately sized green. Also distracting is the beauty of the setting: At this sanctuary in Rabat, ducks, geese, and flamingos add to the effect. Leading to either side of the green are two humpback, wooden bridges creating a setting that has been described as a scene taken from a piece of willowware china.

If Alister Mackenzie was correct when he said, "One of the objects in placing hazards is to give the players as much pleasurable excitement as possible," then Dar-es-Salaam's ninth is electrifying.

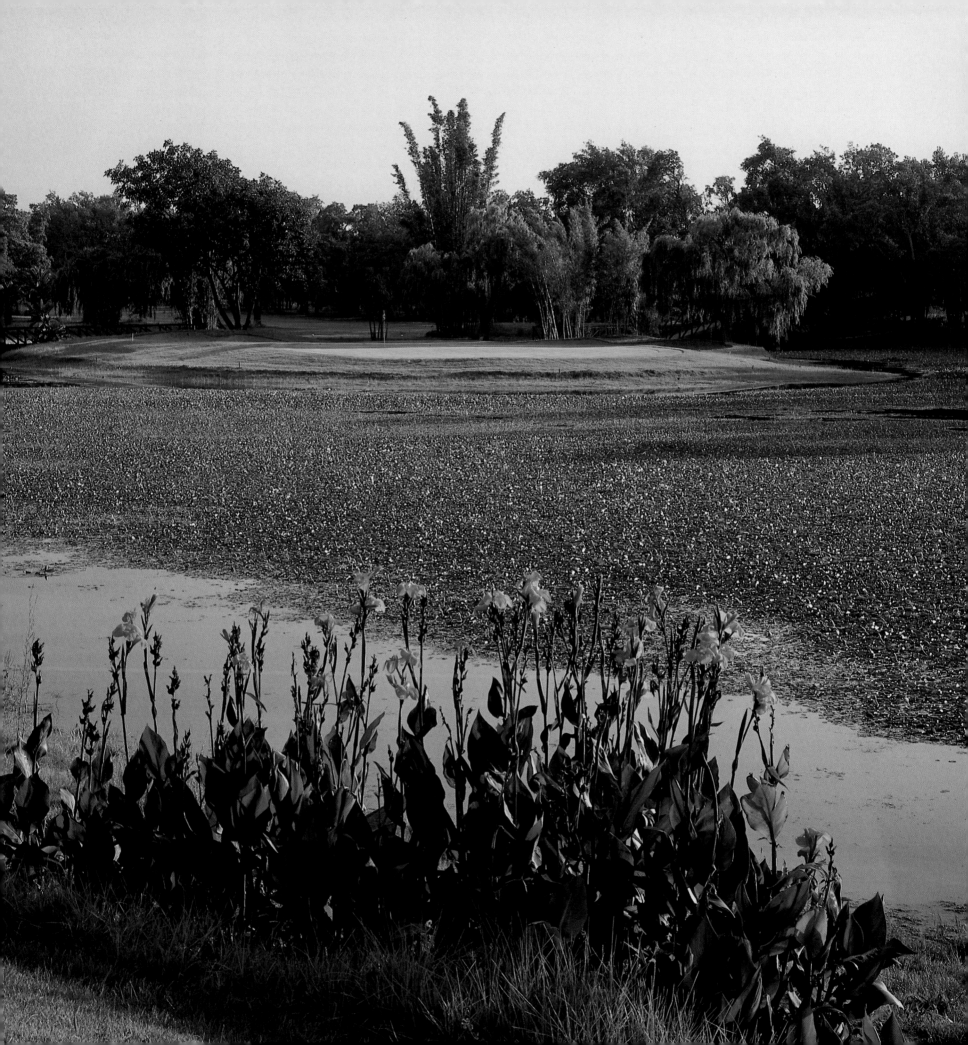

COURSE:	ROYAL MELBOURNE GOLF CLUB (WEST)
HOLE:	5
LOCATION:	BLACK ROCK, MELBOURNE, AUSTRALIA
ARCHITECTS:	ALISTER MACKENZIE/ ALEX RUSSELL
LENGTH:	176 YARDS · PAR 3

Remarkably similar in its design elements to Pine Valley's tenth, the fifth at Royal Melbourne is the first of the course's short holes—and the first that sets the course apart.

Four years after Pine Valley's opening in New Jersey in 1922, Alister Mackenzie was requested to come to Australia for the purpose of building the finest course possible with no limit to the expense. The result is a course that has tested world champions and continually pleases its members.

Having abandoned his medical practice after working with H. S. Colt at Alwoodley in Leeds and the Eden at St. Andrews, Mackenzie was at the beginning of a career that would define him as a citizen of the world. He took what he had learned at Colt's side to new heights with designs in Uruguay, Canada, Argentina, Ireland, Australia, California, and, of course, Augusta.

With the 1924 Australian Open champion, Alex Russell, as his design partner, Mackenzie went about the task of creating Royal Melbourne with an eye for strategy as well as shaping. The fifth employs one of "the good doctor's" most common devices at a short hole, a sharp downslope at the front of the green so that a ball landing short will roll back toward the golfer and off the putting surface.

The shot from the tee requires a 170-yard carry across a small valley to a green surrounded by sand, heather, and bracken. The slope just in front of the green is generally shaved and so steep that balls will run to the bottom. Should the hole be cut in the right front portion, a short shot may easily find one of the beautifully shaped bunkers. A backdrop of native oaks and tea trees emphasizes the hole's striking silhouette.

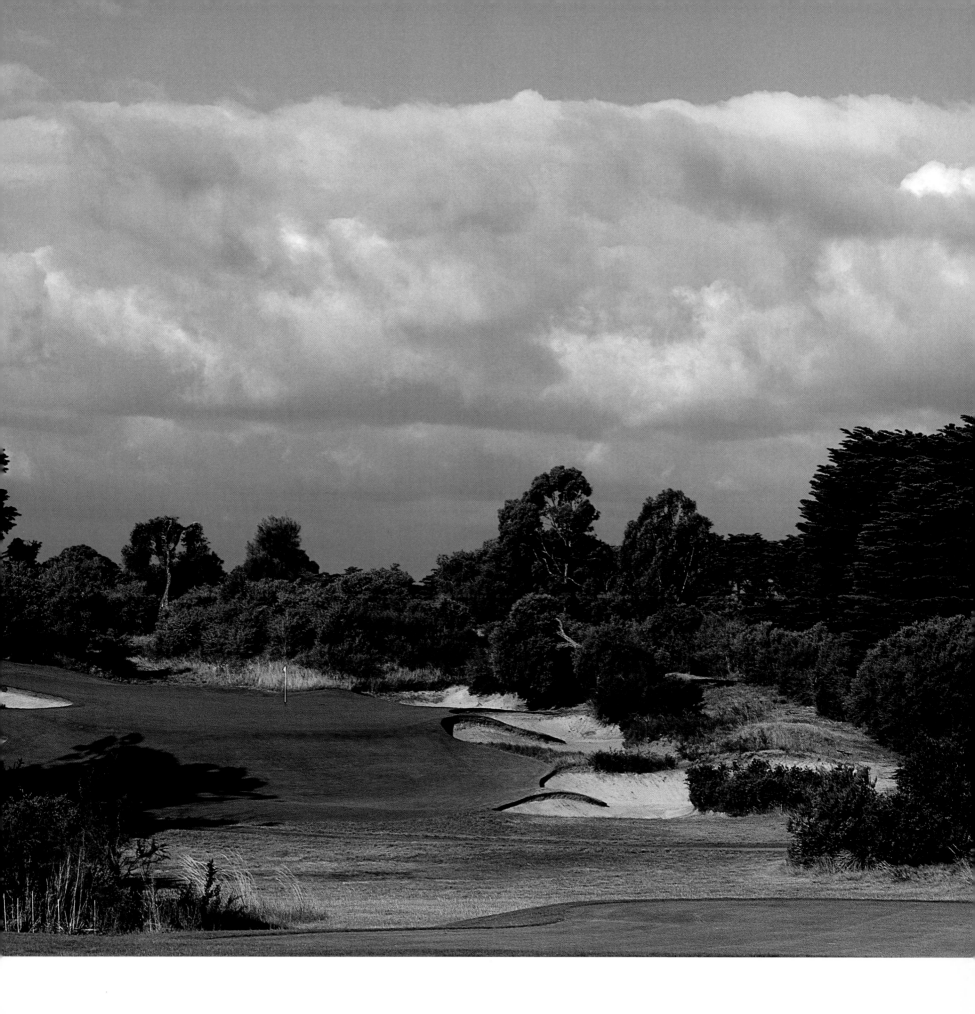

COURSE:	ROYAL PORTRUSH GOLF CLUB (DUNLUCE)
HOLE:	14
LOCATION:	PORTRUSH, COUNTY ANTRIM, NORTHERN IRELAND
ARCHITECTS:	OLD TOM MORRIS, H. S. COLT
LENGTH:	210 YARDS · PAR 3

"Calamity Corner," abbreviated to "Calamity," is the appropriate name given to the short fourteenth at Royal Portrush. With a violent, seventy-five-foot chasm to the right of the green and defining hillocks along the left, only an exact shot will find the putting green. All of this is made more complicated by the diversity of wind and weather from the Irish Sea, and the distracting beauty of another of golf's magnificent settings.

"The air is so fine," wrote Bernard Darwin, "that the temptation to play three rounds is very hard to overcome, while I may quote, solely on the authority of a friend, this further testimonial to it, that it has the unique property of enabling one to drink a bottle of champagne every night and feel the better for it."

The magnificence of the course's architecture is nearly overwhelmed by its setting. The names resonate like an Irish poem. To the east are the tall limestone cliffs, the White Rocks, leading to Dunluce Castle and the headlands of the Giant's Causeway. To the west are the hills of Inishowen, beyond which lie Portsalon and Buncrana. Close to the shore are the Skerries. Farther out lie the Paps of Jura, the distant shapes of the outer isles of Scotland and the silhouette of the hills of Donegal.

The fourth oldest golf club in Ireland, the County Club, as it was originally called, was opened in 1888 after Tom Morris laid out the course. Eleven years later, the club was made royal by the Prince of Wales (later King Edward VII) and came to be called Royal Portrush.

Darwin praised the remodeling in 1933 by H. S. Colt and observed that Colt had "built himself a monument more enduring than brass."

The competitive world has echoed Darwin's sentiment. More than fifty important championships have been held on these links. The first Irish Open was conducted here in 1892, and Joe Carr won his third and last British Amateur here in 1960. He stood on the ninth tee dormie 10 in the final.

The only British Open to be held in Ireland was played at Royal Portrush in 1951 and won by Max Faulkner. After thirty-six holes, he was signing propitious but presumptuous autographs as "Max Faulkner, Open Champion 1951." The only Irishman to have won the British Open, Fred Daly in 1947 at Hoylake, spent his early years at Royal Portrush as a caddie.

Frenchwoman Catherine Lacoste won the 1969 Ladies British Open Amateur Championship here in the same year she won the U.S. Women's Amateur.

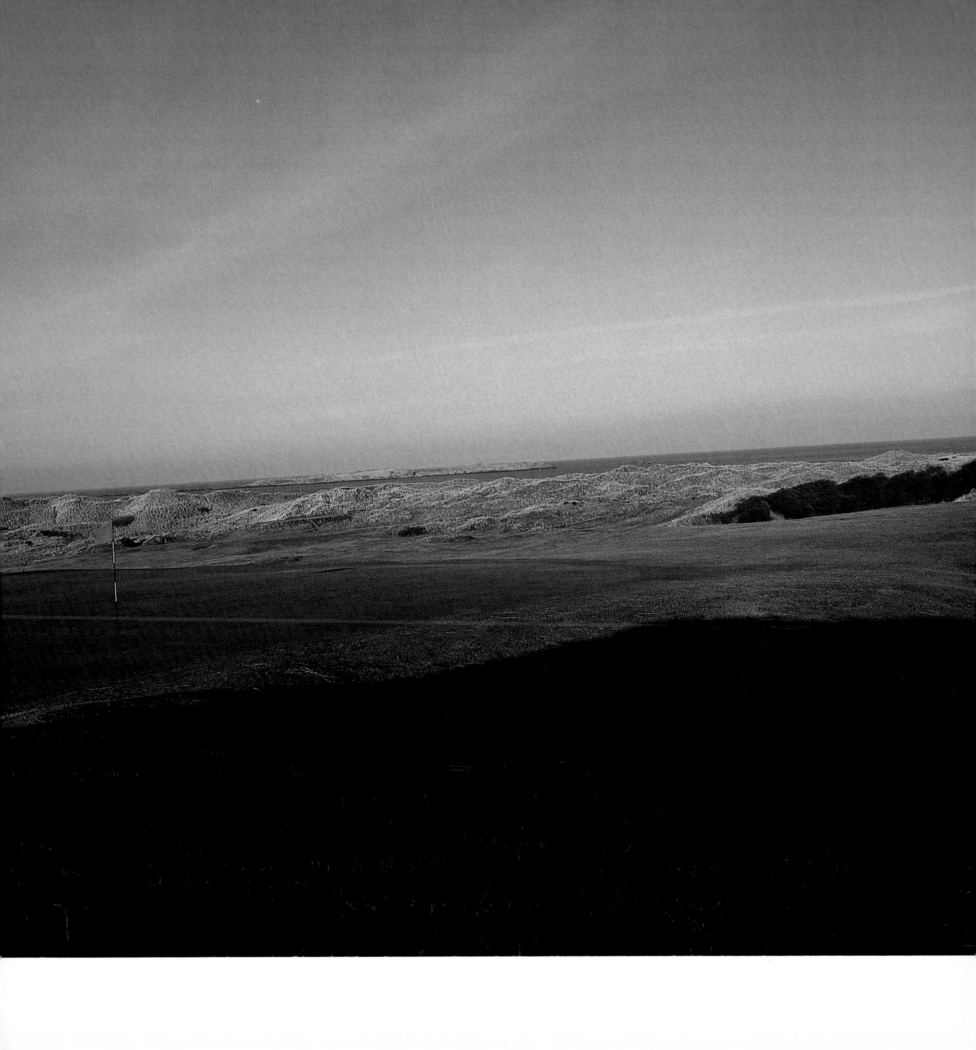

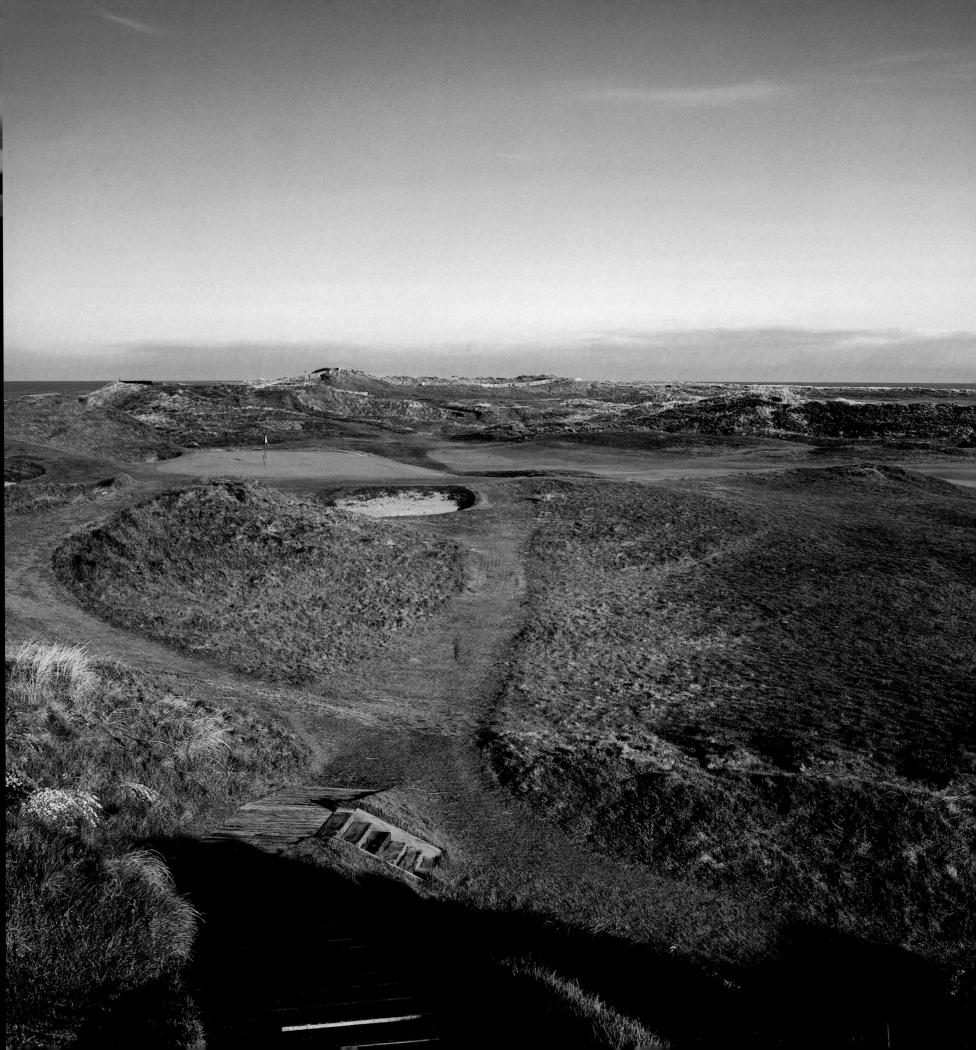

COURSE:	ROYAL TROON GOLF CLUB (OLD)
HOLE:	8
LOCATION:	TROON, AYRSHIRE, SCOTLAND
ARCHITECTS:	WILLIE FERNIE, JAMES BRAID
LENGTH:	129 YARDS · PAR 3

"The hardest stamp in the world to lick." So it has been said about Royal Troon's eighth, known to all as "the Postage Stamp."

At 129 yards, it is the shortest hole on the British Open Championship rota, and comes just two holes behind the longest—Troon's 577-yard sixth.

It can be described as a deceptively simple, organic hole. Shaving the tops from and into neighboring dunes created both tee and green. The resulting effect is an enticing hole, which under linksland conditions presents the difficulty of discerning wind conditions that severely affect the short, high shot.

There is no safe play. If par or better is to be attained, the ball must be played in the air and must find the green. To the left, a large dune shelters the green, making the wind's effect more difficult to read; to the right, a crater bunker and rough gully fall steeply away; and the putting surface is surrounded by five bunkers that can result in a poorly played ball going from one to another (and to another).

With its green measuring just twenty-five feet in width, its small size and the invisible wind are the Postage Stamp's strongest defenses. The contrast of the hole's innocent distance and calamitous penalty is infatuating—a difficult circumstance in a beautiful setting.

In 1923, Walter Hagen lost the Open Championship by 1 stroke after being muddled by the eighth. In 1973, forty-one years after his British Open victory, seventy-one-year-old Gene Sarazen made a hole in one with a 5-iron. Interesting contrasts, indeed.

COURSE:	ST. ANDREWS (OLD)
HOLE:	11
LOCATION:	ST. ANDREWS, FIFE, SCOTLAND
ARCHITECT:	UNKNOWN
LENGTH:	172 YARDS · PAR 3

"The eleventh hole at St. Andrews," wrote Alister Mackenzie, "requires a greater variety of shots under different conditions of wind and changes in position of the flag than any other short hole. It also produces more interest, excitement, and thrills than any other hole, and for these reasons I consider it the greatest of all short holes."

Coming at the end of the four-hole loop that turns the Old Course homeward, the eleventh shares its green with the seventh; thus homeward players cross with those playing the out nine.

While the outward groups must yield to those who have turned for home, it presents an unusual moment in the world of golf. This is a moment when, in the normal course of events, players have an opportunity to intersect with one another and exchange a quick, polite greeting while in the process of continuing about their business.

The Old Course's eleventh is one of the most copied short holes in the world because of the diabolical perplexity of its charms—the deep Hill bunker (left), the estuary of the Eden River (long),

and a severely tilted putting surface that must be deciphered once reached. To make par here demands avoidance of the various hazards while also avoiding a slippery downhill putt. Putting from above the hole with the wind at your back can result in three-putts at best or finding the bunker at worst.

The stories of disaster at the eleventh are legend. In 1933, Gene Sarazen took a 6 here, including three from the bunker, and finished out of the playoff by one stroke.

It was also at "the High-in," as it is named (the seventh is "High-out"), that Robert Tyre "Bobby" Jones performed what he called "one last superbly childish gesture by picking up—that is, withdrawing—in the British Open championship at St. Andrews [1921].

"And often I have wished I could in some way offer a general apology for picking up my ball on the eleventh green of the third round, when I had a short putt left for a horrid six," wrote Jones in *Down the Fairway.* "It means nothing to the world of golf. But it means something to me."

COURSE:	VALE DO LOBO GOLF CLUB
HOLE:	7
LOCATION:	ALMANSIL, PORTUGAL
ARCHITECT:	HENRY COTTON
LENGTH:	196 YARDS · PAR 3

When Sir Henry Cotton came to Vale do Lobo in 1966, he was regarded as the finest British golfer of his time as well as an accomplished architect. His three British Open victories had come on either side of World War II (1934, 1937, and 1948); one could only wonder what the six-year hiatus might have shown Cotton given the chance.

Portugal generally and the Algarve specifically beguiled Cotton in his later years, and the architecture he produced for the region was reputedly his favorite. The original course he designed at Vale do Lobo has been seriously altered and split to make the cores of two courses. While these were redesigned by Rocky Roquemore, the Yellow Course's par-3 seventh (now the sixteenth of the championship eighteen) remains unchanged and one of the most photographed holes in Europe.

In all the world of golf, there is nothing like what lies before you on the seaside tee. Serenely, the vast Atlantic washes onto the beach far below while the quiet violence of its erosive power blares from the vast cliff faces before you. There are three rock faces to be negotiated. Just walking onto the tee can be a challenge if you consider fully the geological events that have occurred in order to present such a breathtaking spot.

If this were not enough, a necklace of hazard stakes running the length of the hole is a reminder that, although on the tee, you are in effect in the hazard. Negotiating the wind and the chasms is a perilous and exhilarating task that tends to minimize the danger of the greenside bunkers and windswept green.

On a placid day, it all appears gorgeous and invigorating. On a stormy day, with the wind howling from the left, it takes a great deal of nerve to play the ball over the cliffs and hope the gale blows it home.

COURSE:	WINGED FOOT GOLF CLUB (WEST)
HOLE:	10
LOCATION:	MAMARONECK, NEW YORK
ARCHITECT:	A. W. TILLINGHAST
LENGTH:	190 YARDS · PAR 3

"The character of the one-shot or par 3 holes," wrote A. W. Tillinghast, "has more to do in checking the assault of the 70 breakers than any other factor." Tillinghast considered the tenth at Winged Foot's West Course, named "the Pulpit," as the finest par 3 he ever built. Similar to North Berwick's Redan hole in multiple defenses, it is dissimilar in that all hazards are in plain view from the tee.

The deep, wide green slopes from back left to front right and is flanked by two perfectly shaped bunkers, more than six feet deep. A third bunker lies just before the throat of the green and serves to confuse the discernment of distance to the flag.

Once reached, the green itself presents a severe test. When the hole is cut in the front, a misplayed downhill putt can find one of the greenside bunkers or require a chip back from off the throat. When the hole is at the back of the green, a shot played too far may run out of bounds.

"Every player who does something more than slog a ball, who thinks as he plays, appreciates why greens are built in this manner," reasoned its designer.

A house located behind the green provoked Ben Hogan's description of the tenth as "the 3-iron into some guy's bedroom."

COURSE:	YALE UNIVERSITY GOLF COURSE
HOLE:	9
LOCATION:	NEW HAVEN, CONNECTICUT
ARCHITECTS:	CHARLES BLAIR MACDONALD/ SETH RAYNOR
LENGTH:	211 YARDS · PAR 3

The legend of Seth Raynor is inseparable from that of Charles Blair Macdonald, who introduced Raynor to the game and its architecture as the young engineer held the survey stakes during construction of The National Golf Links in 1908.

Raynor had opened a surveying and landscaping business in Southampton, New York, after graduating from Princeton University with a degree in engineering. Macdonald was impressed with the thirty-seven-year-old's engineering skill and hired him to oversee construction of The National.

Following that success, Macdonald and Raynor conspired at Sleepy Hollow, Piping Rock, The Greenbrier, Mid Ocean, and Lido. By the time Raynor came to the job at Yale University, his designs had appeared in Honolulu, Pebble Beach, Palm Beach, Shoreacres, Cincinnati, Newport, and points in between. He had carried forward what Macdonald had willingly relinquished.

As odd as it was during this golden age of flourishing wealth and sports, there was not a university in the world, outside St. Andrews, that could boast an outstanding golf course. Coaxed out of his self-imposed retirement by friends who had attended Yale, Macdonald agreed to work again on a consulting basis with Raynor to build the Yale course.

The Yale alumni bulletin of 1929 gives Raynor credit for "what is today considered by many to be the outstanding inland golf course of America. Mr. Macdonald, who served on the advisory committee, was familiar with the plans from the outset, but Mr. Raynor was the real genius of this masterpiece who made the layout, designed the greens, and gave the work of construction is supervision from start to finish."

The ninth is considered to be the finest "Biarritz" hole in the world. The name, derived from Willie Dunn's design of the third hole at France's Golf de Biarritz, refers to the deep (five feet at Yale), trenchlike gully that runs through the middle of the green. The green is sixty yards deep and may seem like a large target, but the drive must be played from a tee sixty feet above Greist Pond, which seems to change all the bets.

"I know of no golf course where the water holes are as wonderful as those in New Haven," wrote Macdonald. This was high praise for Raynor, who had learned at Macdonald's knee.

COURSE:	BAY HILL CLUB
HOLE:	18
LOCATION:	ORLANDO, FLORIDA
ARCHITECTS:	DICK WILSON, ARNOLD PALMER
LENGTH:	441 YARDS · PAR 4

Bay Hill's eighteenth is notable among golf's dramatic final acts. Arnold Palmer's tenacity and Dick Wilson's strategic eye converge at this home hole to induce adrenaline flow even among the game's best players.

The course was laid out in 1961, the same year Palmer won his first British Open at Royal Birkdale and the throngs of Arnie's Army were being enlisted. On the low silhouette of central Florida's sandy terrain, Dick Wilson designed a demanding course that reaches its ultimate climax with the second shot to the final green.

Wilson had honed his design skills by observation and osmosis as a water boy on the construction crew at Merion West in Philadelphia. After college, he worked with Toomey and Flynn's crew on the revision of Merion's East Course.

Akin to Alister Mackenzie's experience with camouflage during World War I, Wilson served during World War II constructing and camouflaging airfields. What lessons were brought from hiding airports to his golf designs can only be imagined, but the dangers of Bay Hill's eighteenth are anything but hidden. Indeed, they stand bold, obvious, and demanding much like the championship play Palmer exhibited throughout his competitive career. By 1980, Palmer had purchased Bay Hill and added his architectural insights to the course.

The approach into the crescent-shaped green must be judged precisely when the hole is cut in front, where it flirts with the edge of the water and greenside bunkers.

In 1990, Robert Gamez electrified a live television audience and on-course spectators by holing a 7-iron shot from 176 yards for an eagle 2 on the final hole of the Nestlé Invitational. It was enough to win by one stroke over Greg Norman and would lead Gamez to PGA Rookie of the Year honors.

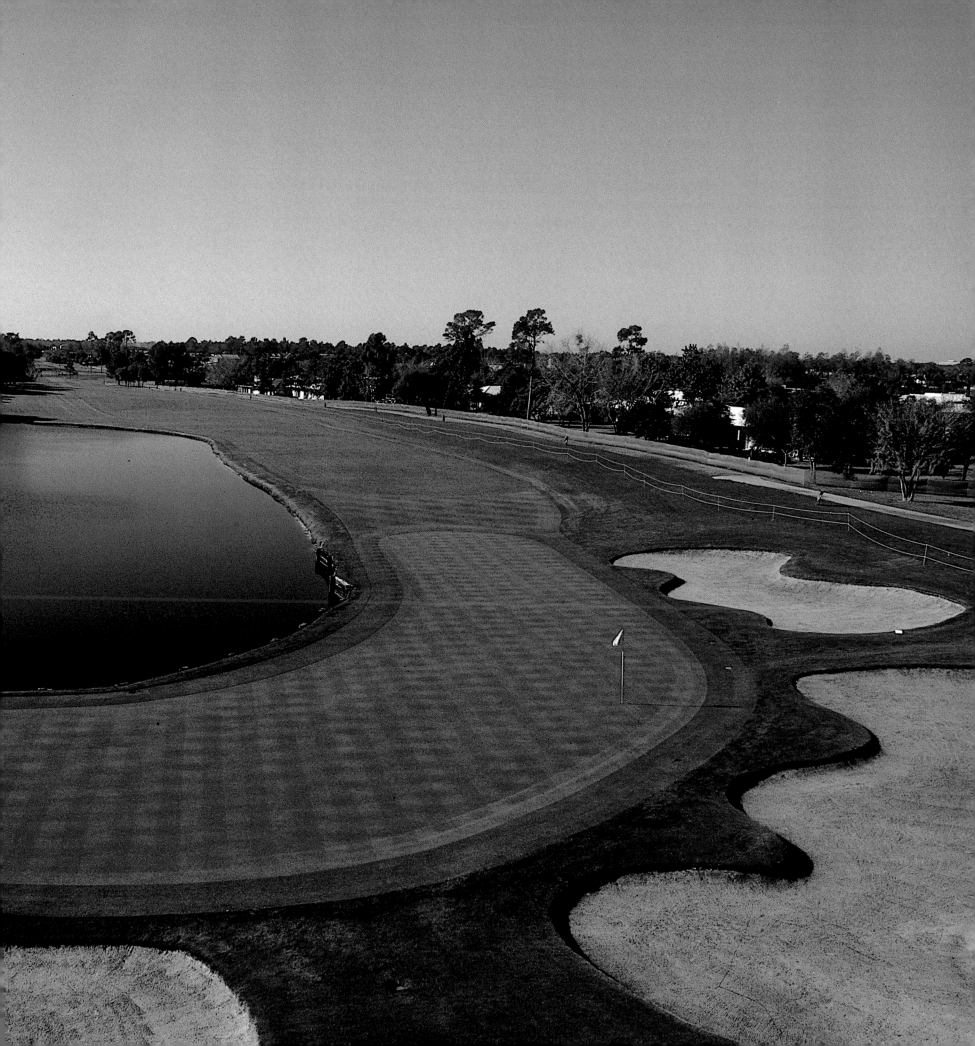

COURSE:	CARNOUSTIE GOLF LINKS (CHAMPIONSHIP)
HOLE:	17
LOCATION:	CARNOUSTIE, ANGUS, SCOTLAND
ARCHITECTS:	ALLAN ROBERTSON, WILLIE PARK, JR., JAMES BRAID
LENGTH:	459 YARDS · PAR 4

At times described as a strand of spaghetti, and at other times as a boa constrictor in search of prey, the serpentine Barry Burn winds its way through the final few holes of Carnoustie, along the way creating the quasi-island from which the seventeenth derives its name—"the Island"—and a good deal of its drama.

The burn demands precise execution at a critical point near the end of the round. At 459 yards, it is not an overly demanding length for the highest caliber of player. However, it can be transformed into a three-shot hole when playing into the teeth of a North Sea wind.

As is the case at the world's greatest strategic holes, control and good judgment are rewarded. Because of the critical point where the burn diagonally crosses the fairway, the tee shot must be placed short of the water. Only the longest players, under the best conditions, may be enticed, in a moment of desperation, to attempt to cross the burn with their drive.

Whatever disadvantage may be experienced by wind direction at the seventeenth, it is counteracted at the eighteenth, which plays in the exact opposite direction. Of course, the reverse is also true. The easier the seventeenth might play downwind, the eighteenth will answer with strict severity.

Carnoustie is considered by many to be as tough a test of golf as can be found anywhere in the world. Its closing holes substantiate that opinion, and the intricacy and changing face of the seventeenth exemplify it. The names of those who have won here are a testament to the excellence the course demands. Tommy Armour, Henry Cotton, Ben Hogan, Gary Player, Tom Watson, and Scotland's own Paul Lawrie had to demonstrate the highest level of tenacity and performance in order to become one of Carnoustie's champions.

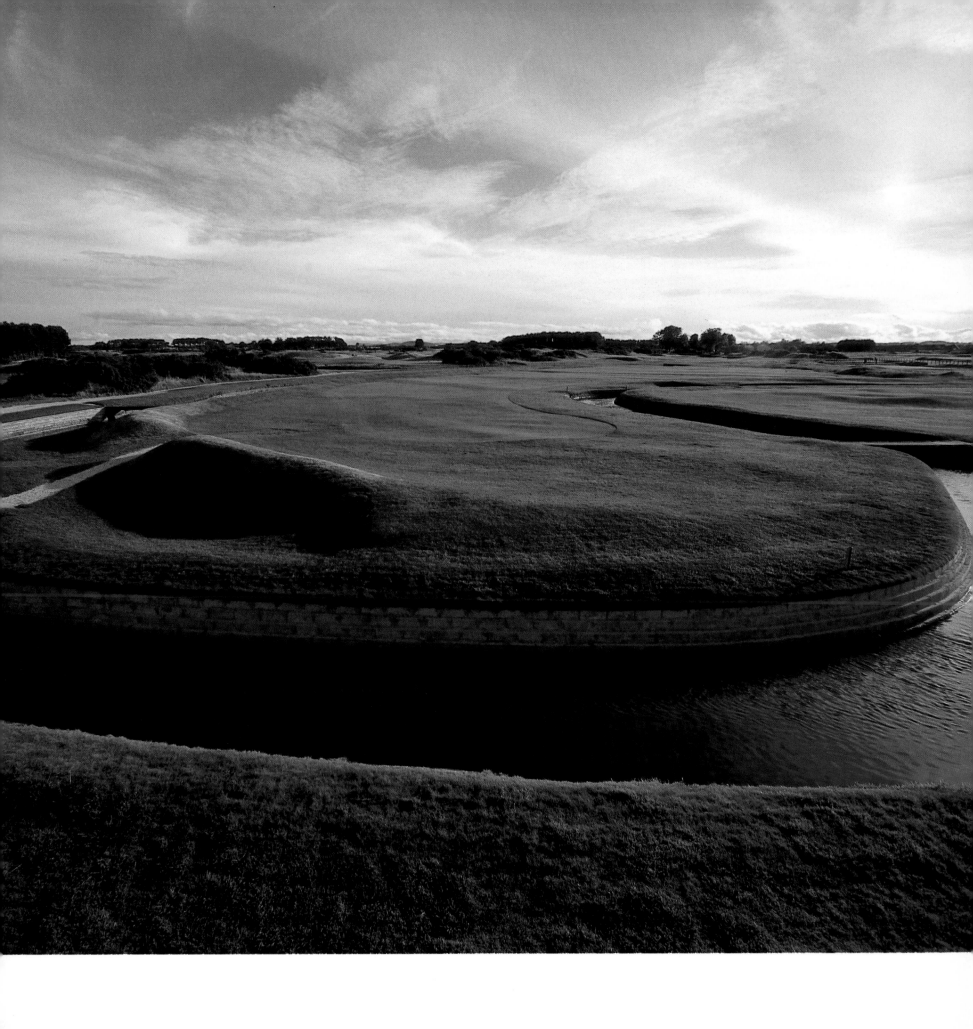

COURSE:	COLONIAL COUNTRY CLUB
HOLE:	5
LOCATION:	FORT WORTH, TEXAS
ARCHITECTS:	JOHN BREDEMUS, PERRY MAXWELL
LENGTH:	466 YARDS · PAR 4

Rated the hardest par 4 on the PGA Tour in a *Golf Magazine* 1983 survey, the fifth at Colonial best illustrates Ben Hogan's assessment of the entire course. "A straight ball will get you in more trouble at Colonial than any course I know."

Nicknamed "Death Valley," the fifth drew this strategy from Cary Middlecoff: "First I pull out two brand-new Wilson balls and throw them into the Trinity River. Then I throw up. Then I go ahead and hit my tee shot into the river."

Such a disorienting assessment is an ironic reflection of the life of John Bredemus, the eccentric designer responsible for Colonial's original layout in 1935. Working only in Texas and Mexico, he was reputed to hate shoes and new golf balls, and to consider the tops of trees as ideal for gaining the best view when planning a new course.

Colonial's fifth is a 466-yard dogleg-right tightly guarded by a tree-lined ditch on the left, more trees on the right, and the Trinity River farther right. The prevailing wind blows from left to right, accentuating the dangers. The narrow landing area calls for a controlled fade with something less than a driver, which leaves a long approach to the well-guarded green.

During the 1941 U.S. Open, Craig Wood was 3-over after playing just four holes of the second round. The reigning Masters champion's agony was further stressed by a chronic back ailment that required him to play wearing a corset. Heavy rains during the second round had waterlogged the course and the corset. At the fifth, Wood had pulled his drive into the ditch just before the USGA suspended play.

During the rain delay, Wood decided he would withdraw but was dissuaded by Tommy Armour. Everyone was struggling, Armour pointed out. When play was resumed, Wood bogeyed the fifth and then played the next forty-nine holes in even par. His 4-over 284 was good enough to win the Open by 3 strokes.

Perry Maxwell is credited with the refinement of Colonial five years after its creation. As a retired banker and latecomer to golf, Maxwell is one of those who simply had the knack. With his three-year apprenticeship under Alister Mackenzie in the early 1930s, Maxwell's reputation bloomed. Following their work at Crystal Downs, Maxwell added his touches to Pine Valley, The National, Maidstone, Augusta National, and Colonial.

During the final round of the 1975 Players Championship, Al Geiberger hit both his drive and approach into the rough at the fifth. The resulting bogey, as Dave Stockton was making birdie at the sixth, made for a horserace that eventually ended with Geiberger as the leader. His four rounds in the 60s (66-68-67-69) set a Colonial record of 270.

"If anybody had told me I'd finish at seven-under and not win," said Stockton, "I wouldn't have believed them."

COURSE:	CONGRESSIONAL COUNTRY CLUB (BLUE)
HOLE:	17
LOCATION:	BETHESDA, MARYLAND
ARCHITECTS:	DEVEREUX EMMET, ROBERT TRENT JONES, SR., GEORGE COBB, REES JONES
LENGTH:	480 YARDS · PAR 4

Congressional's seventeenth derives its greatness from intrinsic strategic demands. The discernment of those elements is the means by which champions are identified. This certainly was the case during the final round of the 1997 U.S. Open.

Although a long hole, it plays downhill, so the premium is placed on the approach. The fairway slopes from right to left, the green extends into the water, two blind bunkers guard the rear of the green (plus there are two others to the right), and the green itself is placed on a diagonal.

At the tee, your inclination is to power the ball as far as possible down the hill. However, as Colin Montgomerie and Tom Lehman discovered in the final round of the 1997 Open, the side of the drive is perhaps more important than its size.

When Rees Jones rebuilt this green for that championship, he placed it on a diagonal that runs from right front to back left. This results in a narrower target when approached from the right side, wider from the left. Jones also built up a roll in the center of the green, dividing the surface in half. To avoid three-putting, it is necessary that the approach finish in the same half as the hole.

Both Lehman and Montgomerie drove to the right half of the fairway. That meant they were playing from a sidehill, downhill lie to a narrow target with the hole cut on the left—the side nearer the water. Lehman's 7-iron was just slightly pulled, but, because of his acute angle into the green, the ball bounded off the bank and into the water hazard. He finished third.

Montgomerie, playing his third as a small pitch from right and short of the green, was unable to gauge the proper pace. His ball failed to release and left him a very difficult 8-footer for par. He missed and finished as the runner-up.

Ernie Els played his drive to the left half of the fairway and, from an essentially level lie, had a straight-in approach to the hole from an angle that gave him the widest target. His 5-iron was struck with just the right weight. When the ball stopped near the hole on the proper side of the green, the Open champion had been identified. It had been twenty-three years since Ken Venturi, dehydrated and distraught, walked the same fairway to become the Open champion.

"Congressional's seventeenth is the culmination of a series of very strong holes which begins at the thirteenth," said Rees Jones. "The seventeenth is really where the U.S. Open was decided, and the strategic elements of the hole's design did that. It is the quintessential championship hole, and what a dramatic setting."

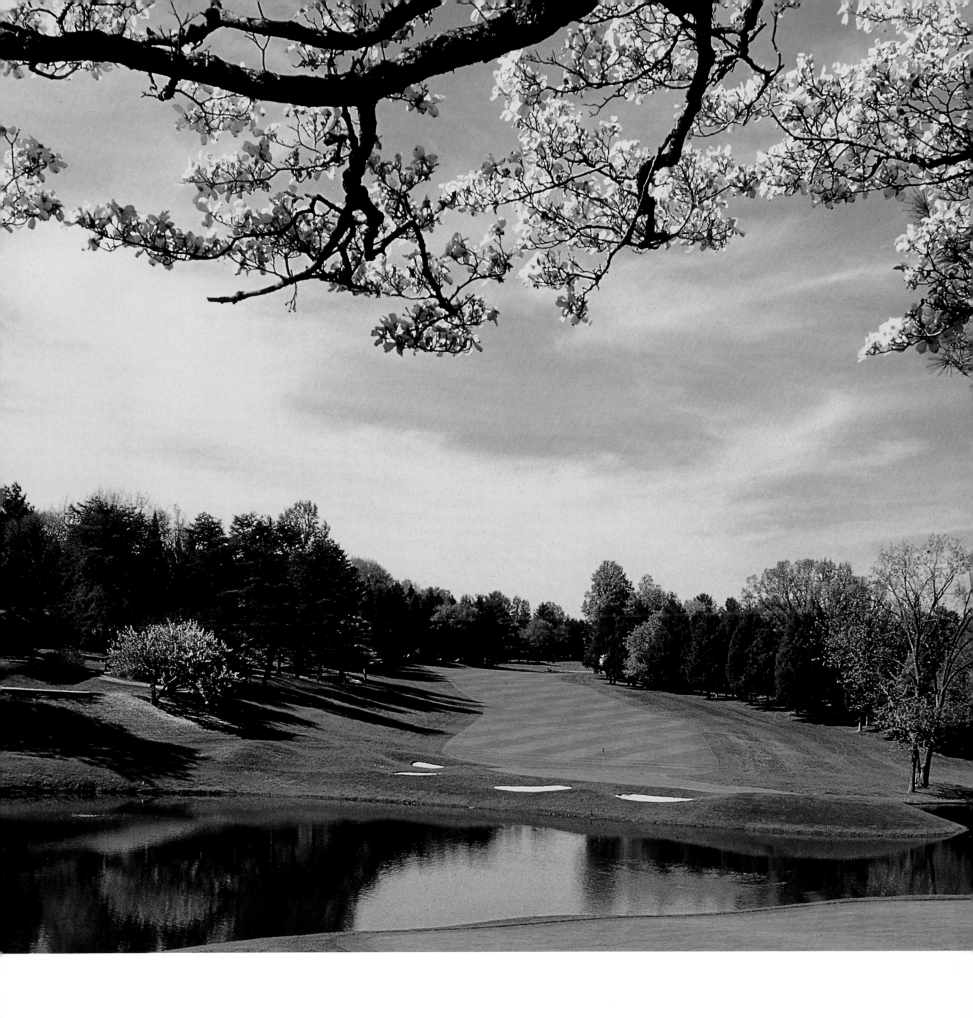

COURSE:	THE COUNTRY CLUB (OPEN)
HOLE:	3
LOCATION:	BROOKLINE, MASSACHUSETTS
ARCHITECTS:	WILLIE CAMPBELL, WILLIAM S. FLYNN, REES JONES
LENGTH:	444 YARDS · PAR 4

Of all those who have touched The Country Club with their creations, renovations, or restorations—including William S. Flynn, Geoffrey Cornish, and Rees Jones—none has found a better way around the rocks at the third than Willie Campbell and Mother Nature did originally.

Like the Old Course at St. Andrews, Royal Dornoch, Cruden Bay, and others, the features of the terrain at Brookline left few lines to be created and most simply to be found. The 444-yard third is a key example of how an intriguing and exacting path could be located, indeed enhanced, by winding its way through the heavy rock outcroppings and mounds of the eastern Massachusetts terrain. This is truly a New England hole.

The third is a dogleg-right that leads to a small canted green that cannot be seen from the elevated tee. From that perch, the landing area looks to be a narrow V-shaped opening defined on the left by a fairway bunker at the base of a rough-covered mound and, on the right, by another mound with more rough and rock outcroppings.

Longer players choose to club down at the third in order to find the best spot from which to play their second. Their temptation is to attempt to carry the rocky mound on the right in order to gain a short approach to the green. Part of such a decision is the height of the rough atop the mound. For the 1988 U.S. Open, the fescue was left long, thus increasing the penalty for failure. During the 1999 Ryder Cup matches, the grass was clipped in order to give the longer players more incentive to attempt a carry.

As with so many courses of this era, bunkers guard the green's approach as well as both sides of the green itself. This is a similar design element to Maidstone's ninth, where a second shot made in recovery must negotiate an approach bunker on the left and short of the green's throat.

Also a trait of the era, the greatest disaster is to be found when missing the green long. A shot played too strongly can run through the green, over the road, and possibly into a pond.

In the three U.S. Opens at The Country Club, all of which were decided by playoffs (1913, 1963, and 1988), the eventual winners (Francis Ouimet, Julius Boros, and Curtis Strange) each equaled or took the low score at the third.

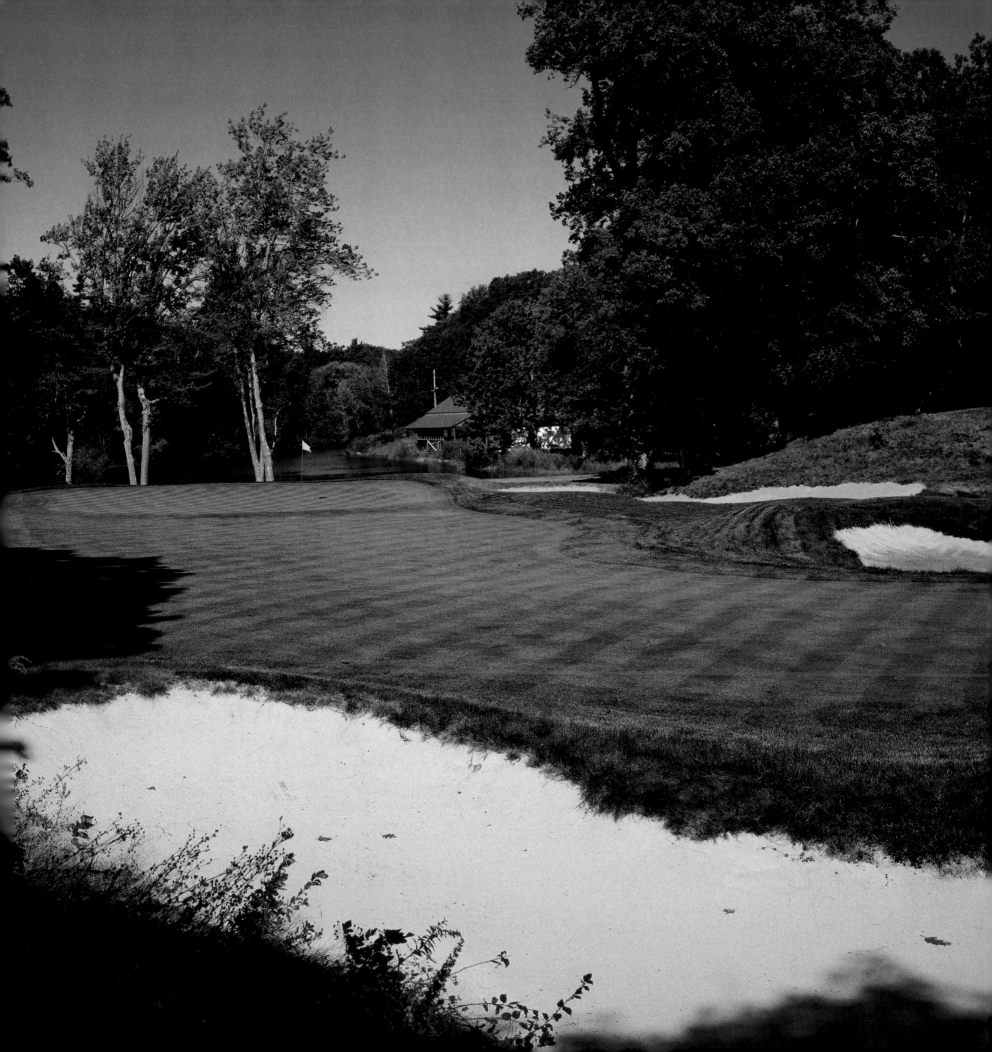

COURSE:	CRYSTAL DOWNS COUNTRY CLUB
HOLE:	5
LOCATION:	FRANKFORT, MICHIGAN
ARCHITECT:	ALISTER MACKENZIE
LENGTH:	353 YARDS · PAR 4

The fifth at Crystal Downs illustrates an array of Alister Mackenzie's strategic necessities for making a short par 4 appear impenetrable in our imagination, achievable in reality, and exhilarating when attained.

"It is of vital importance to avoid anything that tends to make the game simple and stereotyped," said Mackenzie. "On the contrary, every endeavor should be made to increase its strategy, variety, mystery, charm and elusiveness so that we shall never get bored with it."

From the tee, the top of the flag can just be seen in line with the bunker at the top of the ridge, which is surrounded by rough. While this bunker provides a landmark, the carry is too great and would result in a rough lie short or long. The ideal line is over the large maple, right of "the Three Sisters" bunker that divides the fairway, to the top of the hogback ridge. A well-struck drive runs along that ridge and down into the undulating fairway. Pulled drives find the rough below the distant bunker, and pushed drives usually run off the ridge into the rough on the far side. Farther right there is out of bounds beyond the entrance drive.

Mackenzie had learned during his 1924 survey of the Old Course at St. Andrews that alternative routes infuse intrigue to great holes. He described the fourteenth at St. Andrews as a long hole in which the tilt of the green, placement of the hole, and wind determine which of the four routes a player should attempt.

"It is slopes of this kind that are so often overlooked in designing a golf course, and it is one of the most difficult things imaginable to construct them really well," he wrote.

Faced with the hogback at Crystal Downs's fifth, Mackenzie used the slope to require a discernment of the proper path to the green. Stronger players must negotiate the hogback to gain their advantage, while less powerful hitters can use the left fairway to gain their shorter but more precarious, blind entrance to the green.

The putting surface slopes left to right toward four bunkers that protect an errant shot from running down a slope to the road below. A flat, bowllike area at the right center of the green attracts imprecise approaches and can make two putts elusive.

COURSE:	DORAL RESORT AND COUNTRY CLUB (BLUE)
HOLE:	18
LOCATION:	MIAMI, FLORIDA
ARCHITECT:	DICK WILSON
LENGTH:	443 YARDS · PAR 4

After earning high marks as a construction superintendent for Toomey and Flynn's 1931 design at Shinnecock Hills, Dick Wilson was forced by the Great Depression to take a job as the professional and greenkeeper at Delray Beach Country Club in Florida.

Eight years before and also in Delray, Donald Ross had designed the Gulf Stream Golf Course. During his years there, Wilson no doubt played Gulf Stream and it was perhaps the fifteenth hole that gave him the concept for what would eventually become regarded as one of the toughest finishing holes on the PGA Tour.

Doral's eighteenth is an expanded rendition of Gulf Stream's fifteenth. Water must be negotiated on the left by the drive and the approach. The closer a player's line falls to the water, the better the angle into the green. The water is left, trees right, and the green is tiered and pitches away from the approach. While Gulf Stream's hole is just 312 yards long, Wilson stretched the home hole at Doral to a daunting 443 yards.

The hole is set up with the drive. Water runs along the left of the landing area and then eats back into the fairway. Long hitters must calculate carefully in order to gain their advantage on the left but without finding the water by going too long. Either a long fairway bunker or palm trees scattered along the right will penalize those shying too far away from the water.

Similarly, those going right of the green, in order to avoid the water that nearly surrounds it, will be left with a pitch or a bunker shot to a green that falls away from them and toward the water beyond.

It was in 1962 that Wilson and Robert von Hagge created Doral and shortly it came to be called "the Blue Monster" because of its strategic (and watery) demands. This was a year after their success at Bay Hill and the same year they built the Lakeside course at the Greenbrier. Doral demonstrated without confusion that flat Florida terrain could provide just as rigorous a test as those courses with more topographical relief.

The Tour's arrival at Doral each spring marks the beginning of the run-up to the Masters, and their arrival at Doral's eighteenth reminds the world's best players of how exacting their performances must be in order to gain the game's major prizes.

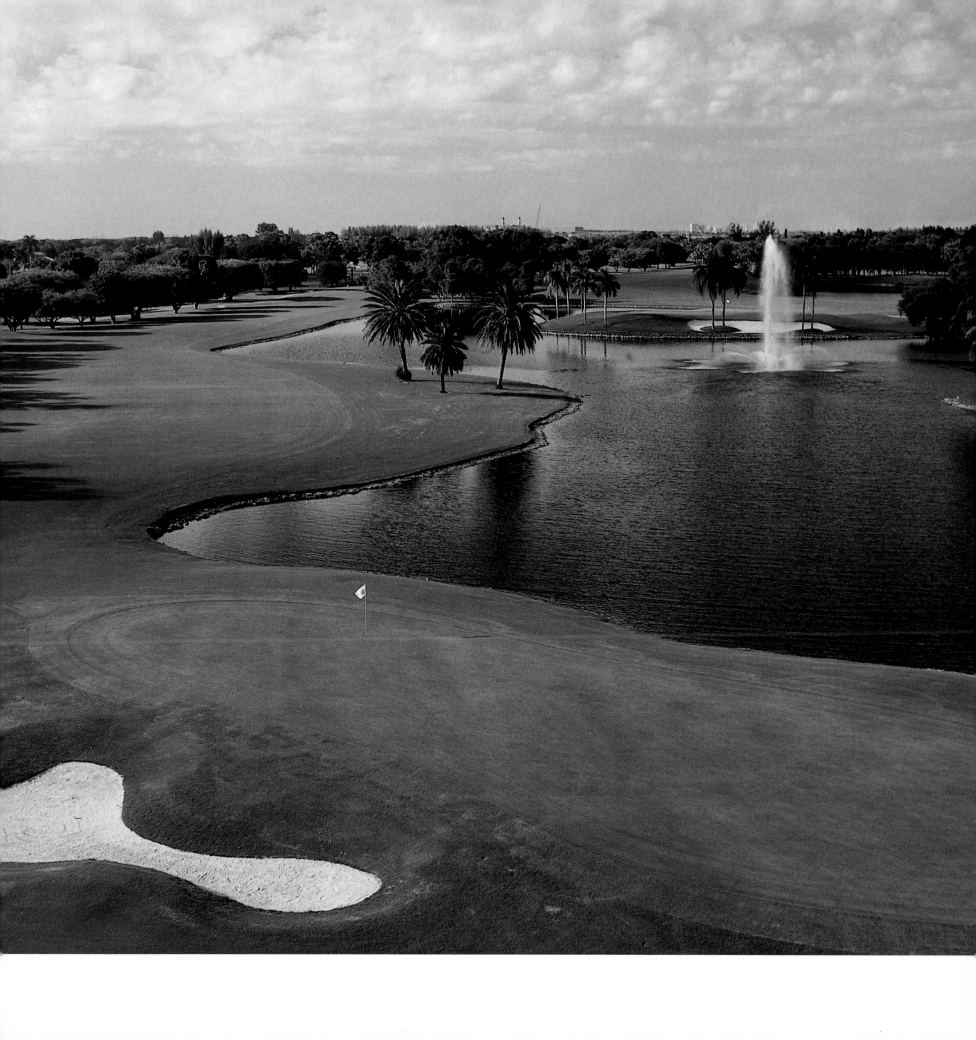

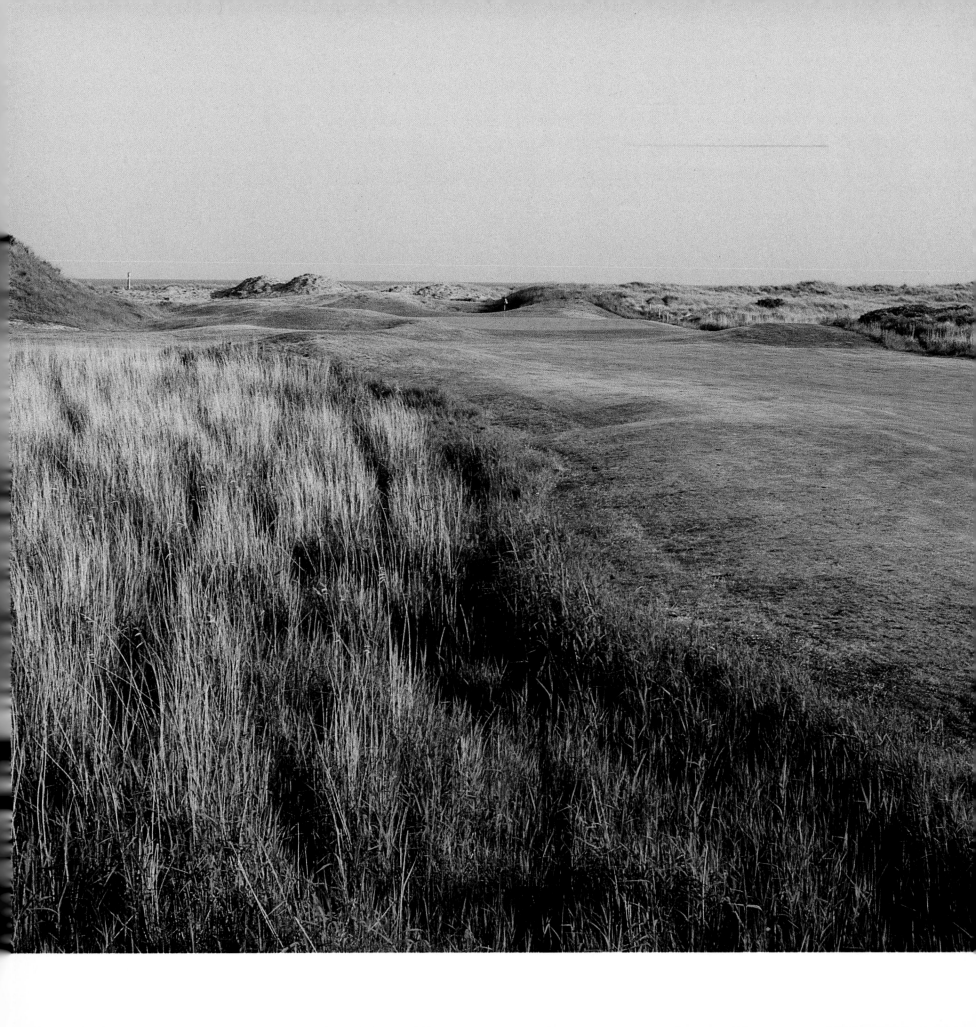

COURSE:	THE EUROPEAN CLUB
HOLE:	7
LOCATION:	BRITTAS BAY, COUNTY WICKLOW, IRELAND
ARCHITECT:	PAT RUDDY
LENGTH:	470 YARDS · PAR 4

"All modern golf is merely a copy of the original with mounding, bunkering, and the other main features of golf's landscape borrowed and adapted from dunesland golf," says Pat Ruddy, the course's developer, designer, and builder. "What I'm trying to do at the European Club is accelerate evolution. To do what St. Andrews did in 400 years, what Royal Dublin and Portmarnock did in 100 years, and do it in 15."

Like the notable designers, players, greenkeepers, and architects before him, Ruddy has drawn his lessons from the marram grass, gorse, and sand of the linksland, and from the uplifting spirit such ground has always offered to golf.

At the seventh hole, Ruddy has used the most effective visual devices that have developed at the best holes in the world. Care has been taken to eliminate blindness, or at least total blindness. Portions of the fairway are concealed behind reeds, valleys, and hillocks inducing claustrophobia. Length, danger, and green size are also visually exaggerated while, in fact, the hole offers generous landing zones and ample room to bail out.

The seventh is situated on a sandbank that runs through a reed bed. A burn runs the entire length of the right side, beyond which there lie a hundred acres of unspoiled land with no structure in sight. On the left are dunes covered with tall grass, a marsh filled with reeds, and more sand hills up by the green. Brittas Bay glimmers behind the green, and beyond lies the confluence of the Irish Sea and St. George's Channel.

What Ruddy refers to as the "reverse view telescope effect" is employed at the tee to make everything seem more distant. The marsh on the left appears to be about 190 yards out but in fact it is 300. The tendency is to take a long iron and lay up, but that leaves a second shot that must be played with a returning angle toward the river.

"The question at the seventh," says Ruddy, "is can you hit the ball twice in a straight line while ignoring the straight line of the river hugging the fairway and the green all the way on the right?

"It is my theory that state of mind is just as important as state of ground or state of wind. Even a 5 percent stray thought wandering through the gray matter sets the seeds for disaster. On hole seven we inject a 25 percent stray thought between the challenging setup of the hole and the distracting beauty of the place."

COURSE:	HARBOUR TOWN GOLF LINKS
HOLE:	18
LOCATION:	HILTON HEAD ISLAND, SOUTH CAROLINA
ARCHITECTS:	PETE DYE/JACK NICKLAUS
LENGTH:	478 YARDS · PAR 4

Harbour Town's home hole is one of golf's instantly recognizable icons. Its trademark red-and-white-striped lighthouse stands guard beyond the green. Lowcountry marsh borders the left, and towering pines define the right.

As is true of Pete Dye's best work, what appears to be natural at Harbour Town's eighteenth is, in fact, the product of an organic but artificial evolution that only takes place because Dye is physically present during the construction of his courses.

George Cobb, the architect who originally laid out Harbour Town, intended the eighteenth to parallel the tenth. With that goal in mind, he eventually had enough sand dumped on the marshy coastline that dikes had to be built to hold it.

"The dikes kept breaking," Dye wrote about Harbour Town, "the sand kept flowing outward into the sound, increasing the width. Pretty soon there was enough workable land to build not only the par-three seventeenth but also the par-four eighteenth."

With the wide-open vista of Calibogue Sound and the lighthouse marking the way home, it was left to Dye to fashion the route. At 478 yards, the eighteenth is long enough to tempt a strong player to play straightaway and ignore the longer, safer route offered to the right. The tee, the landing area, and the green are all built on promontories that, when used, demand that the marsh must be carried by both the drive and the approach to the green.

The marsh side of the green and its throat are guarded by a one hundred-plus-yard, flat bunker that actually affords safety in preventing errant shots from finding the water. It was at Harbour Town that Dye and his design consultant, the thirty-five-year-old Jack Nicklaus, invented the low-profile style with multiple tees and small greens that became so popular. The eighteenth best illustrates the style's strategic strengths and visual appeal.

COURSE:	HAZELTINE NATIONAL GOLF CLUB
HOLE:	16
LOCATION:	CHASKA, MINNESOTA
ARCHITECTS:	ROBERT TRENT JONES, SR., REES JONES
LENGTH:	396 YARDS · PAR 4

Through a persistent series of events, one of the great medium-length par 4s in the world was uncovered among the trees and undergrowth on the shore of Hazeltine Lake in Chaska, Minnesota.

Since Tony Jacklin won the U.S. Open at Hazeltine National in 1970—the only British-born U.S. Open champion in the last eighty years of the twentieth century—the club and USGA officials had been working to perfect the course for a return engagement. Specifically, they wanted to make the par-4 seventeenth a par 3, and the par-3 sixteenth a par 4.

On a snowy winter day, after considering a location near the fifteenth green, members Bob Fischer, Warren Rebholz, and Reed MacKenzie walked down the steep hill behind the fifteenth green.

"No one had been down there before," Mac-Kenzie remembers, "and we found a flat area from the bottom of the hill to the lake shore that was perfect for a tee.

"This was presented to Robert Trent Jones, who agreed it would work. Trent decided on the green's general location and character. A minimum of work was needed for the rest of the hole. The original green was a little severe with two very small decks. A green revision in 1985–86 produced the present surface." The green requires a very precise approach because it is narrow and steep

banks fall to the water from its peninsular shape.

Prior to the 1991 U.S. Open, Rees Jones was retained to further tune his father's original design. At the sixteenth, the younger Jones converted a shallow drainage ditch bordering the fairway on the left into a stream. "We came to the conclusion that the hazard on the 70th hole of the number-one championship in the world should be a definite penalty, not left to chance," he said. "This made the 16th more of a 'white knuckle golf hole.'"

In the 1991 U.S. Open, Scott Simpson never unscrambled the secret of the sixteenth. Leading Payne Stewart by 2 strokes in the final round, Simpson played a 1-iron from the tee to the left rough, failed to reach the green on his approach, and made bogey, which led to the eighteen-hole playoff with Stewart the following day.

In the playoff, Simpson led Stewart by 2 strokes coming to the sixteenth. Both players made the fairway. Simpson played first with an indecisive 7-iron that just reached the front of the green. Stewart was partially blocked on the right by the large white ash, which has since been replaced with a new tree.

Stewart played an 8-iron over the tree to within twenty feet of the back-right hole location. Simpson three-putted. Stewart holed, and the championship was tied. When Simpson's ball found the water on the seventeenth and Stewart's found the green, the victory was Stewart's.

COURSE:	LOCH LOMOND GOLF CLUB
HOLE:	10
LOCATION:	LUSS, DUMBARTONSHIRE, SCOTLAND
ARCHITECTS:	TOM WEISKOPF/JAY MORRISH
LENGTH:	455 YARDS · PAR 4

Were it not for the astonishing beauty of its setting, Loch Lomond would probably be best known as the first of Scotland's courses to be designed by American architects rather than one of the most beautiful in the land. Tom Weiskopf and Jay Morrish's gifted design on the shores of this dazzling lake and in the shadow of Ben Lomond's looming, distant peak creates an impression as unforgettable as any in the world of golf.

Backdrops of water, mountains, and forest enhance the course's strategic elements. At the tenth, they are artfully balanced. "[The tenth is] a great hole, in fact, a truly phenomenal hole in my opinion," said Tom Lehman, who won the Loch Lomond tournament, a European Tour event, in 1997. "You face a tough, downhill tee shot with 'stuff' both left and right—bad stuff. It's usually a 3-wood for me from the tee to stay short of Arn Burn [from which the hole derives its name], which runs right across the fairway at the foot of the hill. That leaves a 7-iron approach to a green which funnels from the front right to the back left."

As with Donald Ross's seventh at Oak Hill in Rochester, New York, water crossing at a diagonal in the landing area presents a strategic question as to how much risk a player is willing to take from the tee in order to gain an advantage with the second shot. "Should you be so fortunate as to have a creek running through your property," wrote Ross, "a very interesting treatment is that of having it run across the line of play. Don't, however, make the creek the only hazard."

The second hazard may be the distraction of watching your ball suspended against the foothills of the Grampian Mountains and knowing that on the other side they descend into the mouth of the Clyde. From there the vista opens to the Firth of Clyde and runs to the shores of the Island of Arran, the Mull of Kintrye, and the rocky crags of Northern Ireland.

"I consider Loch Lomond my lasting memorial to golf," said Weiskopf. "The opportunity of designing the golf course at Loch Lomond carried with it an awesome sense of responsibility for Jay and me. It is one of the most beautiful places on earth, endowed with mature trees and breathtaking views with the history of Scotland lingering in the stones and waters of the loch."

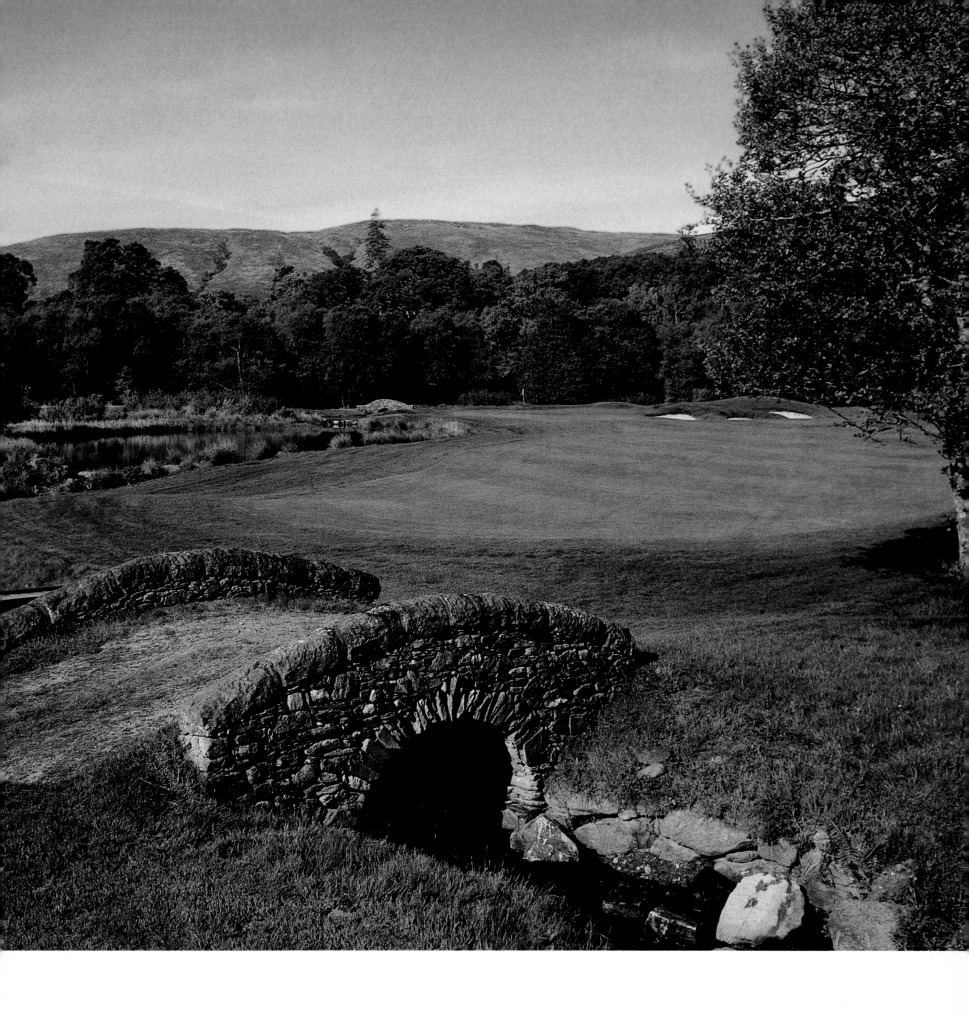

COURSE:	THE MAIDSTONE CLUB
HOLE:	9
LOCATION:	EAST HAMPTON, NEW YORK
ARCHITECTS:	WILLIE AND JOHN PARK, WILLIAM H. TUCKER
LENGTH:	402 YARDS · PAR 4

In assessing Frederick Law Olmsted's approach to landscape design, the point has been made that while an architect strives to create order out of chaos, Olmsted wanted order *and* chaos.

The same point can be made about the preeminent linksland golf course designers from Old Tom Morris onward. From rough, scrubby land, good for little more than grazing sheep and goats, a game of intricate order, demanding execution, and patient judgment was fashioned. Desolate, windblown places are where these qualities are best exemplified.

"Maidstone's 9th is the purest links hole in America," opines Rees Jones, the notable architect, U.S. Open doctor, and Maidstone member. "It plays from an elevated tee to a flat fairway that is sheltered on both sides by major dunes. The ocean can be seen and heard to the right, and it ends at an elevated green that is naturally protected by a strategic and penal bunker."

The elevated tee provides no shelter and the ball must be played up into the wind, which can make the fairway difficult to hit. As the windblown boundary to the sea, the dune to the right allows fluffy lies and is less densely covered with grass than the one on the left. The high grass covering the left dune usually means that a ball landing there is lost.

Should the ball be found, recovery from the left is treacherous. A hacking shot back to the fairway must be accepted. Those attempting to overpower the recovery from the left rough with a go for the green must avoid a cross bunker about eighty yards short of the putting surface. To the right of the green is an extremely deep natural bunker with the sobriquet "Yale Bowl."

The fairway rises to a sizable green that is well pitched back to front with subtle contours. Its exposure to the wind can affect the putting.

In all conditions, it is invigorating, as Mr. Olmsted might have observed, to search for order among the handsome chaos at Maidstone's ninth.

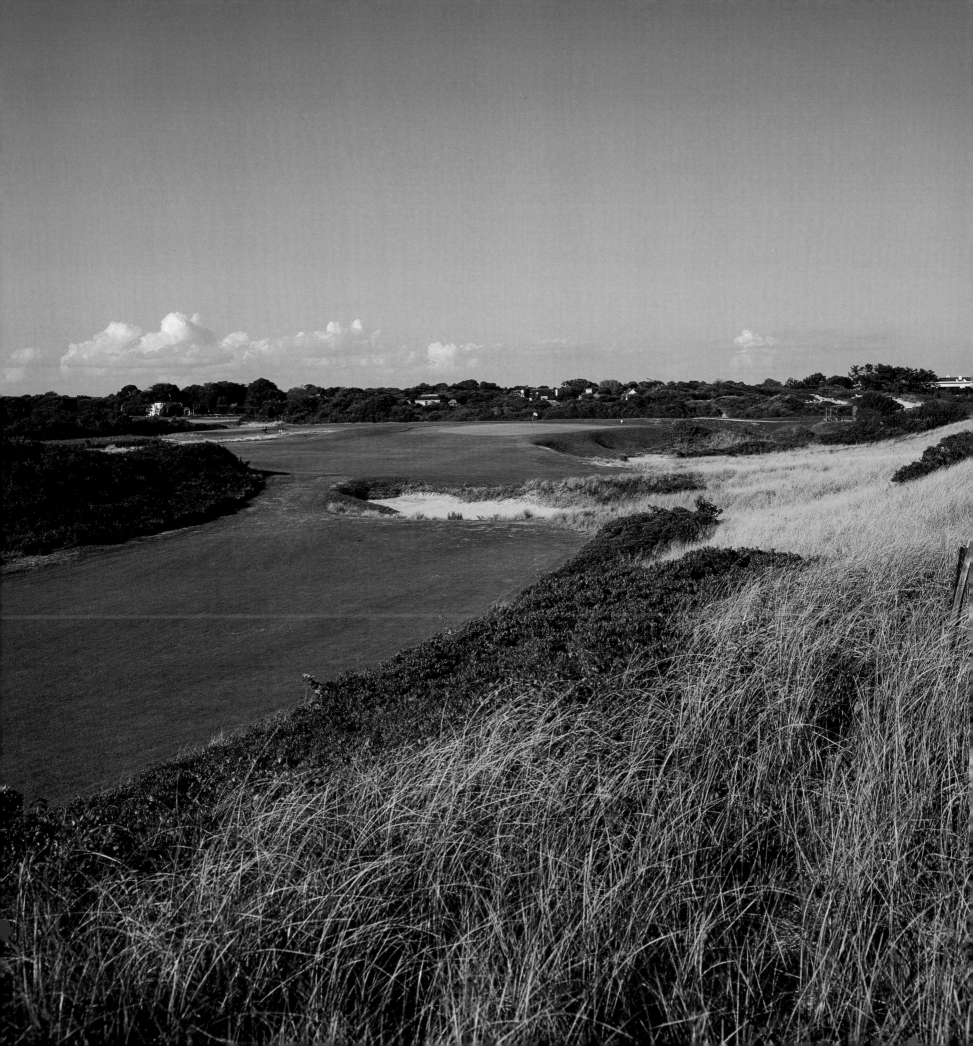

COURSE:	MUIRFIELD VILLAGE GOLF CLUB
HOLE:	14
LOCATION:	DUBLIN, OHIO
ARCHITECTS:	JACK NICKLAUS/ DESMOND MUIRHEAD
LENGTH:	363 YARDS · PAR 4

Muirfield Village's shortest two-shotter is its most beguiling. It often plays toughest in relation to par during the numerous, important championships that have been played here.

"In holes of this length," said Donald Ross, "both the drive and approach should be difficult. Otherwise, they are usually very uninteresting."

There is nothing boring about the fourteenth. A player's patience and judgment are quietly tested. The view is all so quaint from the teeing ground. At just 363 yards, the issues can be clearly identified: the gorgeous, little stream running at a diagonal in front and to the right of the green, the sand that guards the left, the willow trees and undulating fairway. On a calm day, there might even be a moment's contemplation of attempting to carry the stream.

When better judgment prevails, a long iron or fairway wood is played to the heart of the fairway. It is at this point that the game is on. As you walk to your ball, however perfectly placed it might be in the fairway, the provocative danger that must be negotiated becomes evident.

The fourteenth's approach is complicated by the visual distractions that contemplate the disaster awaiting should the golfer become too greedy. "Most players who come unglued on the second shot," says course co-designer Jack Nicklaus, "do so because they have let the narrowness and the length of the green relative to the severity of the hazards—water right, sand left—overintimidate them. Avoid that tendency and your good approach will be rewarded with a relatively easy birdie putt."

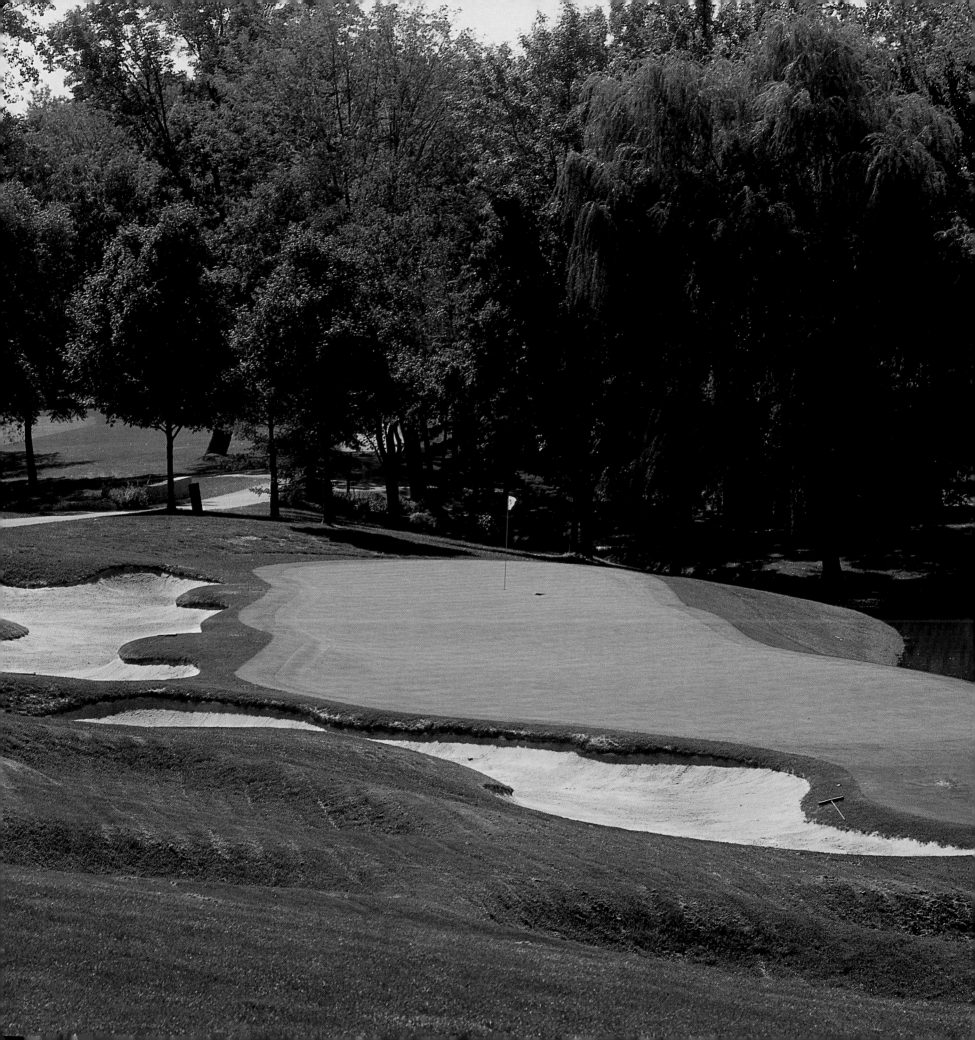

COURSE:	THE NATIONAL GOLF LINKS OF AMERICA
HOLE:	17
LOCATION:	SOUTHAMPTON, NEW YORK
ARCHITECT:	CHARLES BLAIR MACDONALD
LENGTH:	368 YARDS · PAR 4

"When playing golf you want to be alone with Nature," wrote Charles Blair Macdonald, the first U.S. Amateur champion and creator of The National.

At The National's seventeenth, Macdonald welds strategic golf questions to one of the world's most gorgeous backdrops, a downhill view of the Peconic Bay and Long Island Sound.

Since it is one of the world's best-conceived short par 4s, from the tee there is a false sense of security afforded by the generous width of the fairway. However forgiving this fairway may at first appear, the drive is critical. For maximum effect, it must be played long and left in order to gain the best angle of approach to the green.

Yet the overwhelming temptation is to play a drive to the right. From the tee, the right is a shorter carry over the sandy area that separates the tee and the fairway. However, wind conditions and the alignment of the fairway bunkers on the right mean that such attempts often end in the sand.

The bunker that embraces the entire rear of the green appears adversarial but is, in fact, intended to save long shots from hitting the entrance road.

In its alluring deception, The National's seventeenth is much like the sixth at New South Wales: What appears to be safer can actually result in greater difficulty. And vice versa.

The National is regarded as Macdonald's masterpiece. "How good a course it is," Bernard Darwin wrote in 1913, "I hardly dare trust myself to say . . . but this much I can say: Those who think that it is the greatest golf course in the world may be right or wrong, but are certainly not to be accused of any intemperateness of judgment."

Alister Mackenzie observed, "At The National there are excellent copies of classic holes, but I think the holes, like the 14th and 17th, which C. B. Macdonald has evolved, so to speak, out of his own head, are superior to any of them."

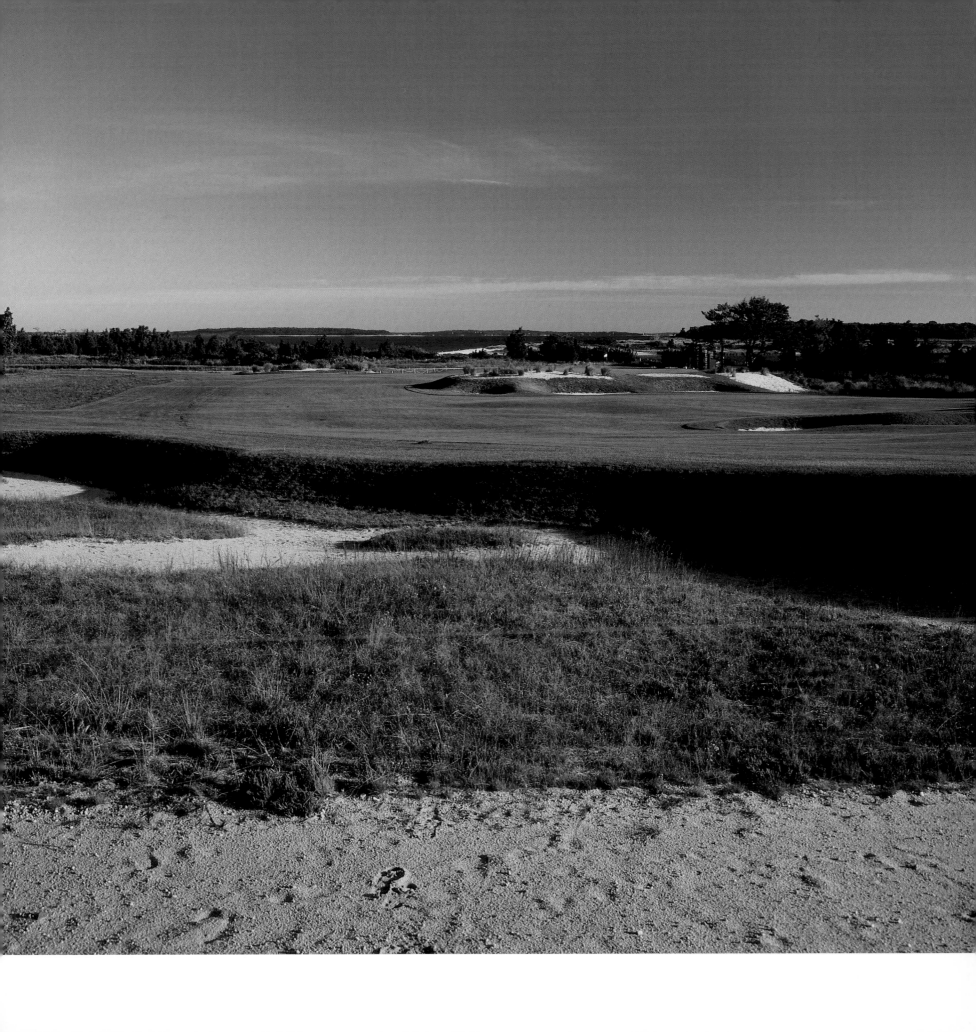

COURSE:	NEW ST. ANDREWS GOLF CLUB
HOLE:	18
LOCATION:	TOCHIGI, JAPAN
ARCHITECT:	JACK NICKLAUS
LENGTH:	428 YARDS · PAR 4

The home hole at New St. Andrews is exhilarating in its demonstration of how an uncomfortable combination of length and terrain can constrict the most powerful player. Judgment and restraint will win over brute length at the final hole of Jack Nicklaus's first design in Japan.

After playing an exhibition round with Nicklaus, Tom Weiskopf put it this way: "The par-4 18th is almost as tough as the 1st and 13th holes, and will definitely decide many tournaments. Normally, I'll take a 3-wood from the tee to avoid going over the crest of the hill that would present a sharp downhill lie. Then a 4- or 5-iron over the very deep bunkers right in front of the green to a sharply angled putting surface. Make four fours here and you deserve to win any tournament."

If you hadn't been told where or when it was built, the look of New St. Andrews's eighteenth is more like one of Donald Ross's midwestern designs. The dark trees that line the fairway and the natural severity of the slopes that define the plateau landing area look as though they have been played upon for years.

The hole sits comfortably within these established natural elements. The slope that falls at the beginning of the plateau cants the fairway from left to right. The second canting, between the plateau and the green, runs from right to left.

The narrow landing area, guarded by a fairway bunker on the right, runs from about 200 yards away from the green to about 130 yards before dropping steeply and then rising again to the green complex.

Six bunkers guard the front of the green, making it clear that the putting surface must be reached. Their sprawling, comfortable shapes define the depth of the approach. From the tee, the bunkers are not visible as the plateau landing area blocks them from view. There is a lurking feeling, however, that something treacherous must lie just out of view.

COURSE:	OAK HILL COUNTRY CLUB (EAST)
HOLE:	7
LOCATION:	ROCHESTER, NEW YORK
ARCHITECTS:	DONALD ROSS, ROBERT TRENT JONES, SR., GEORGE AND TOM FAZIO
LENGTH:	432 YARDS · PAR 4

In its presentation of length, water, sand, and contour, "the Creek's Elbow" is as fine a hole as Donald Ross ever designed.

When you are standing in the landing zone near the stream, it is easy to imagine that with a little touch here or there, Ross was simply lucky enough to find a natural golf hole, bunker it, and go on his way. His design notes tell a different story:

> Note carefully the lowering of the ridge at 400 yards so as to form a valley entrance 30 yards wide to the green. . . . The line of the creek must be changed from 250 yards to approximately 300 yards relieving the sharp curves. . . .

Two exacting shots must be struck in order to find the green and attempt par. With the stream crossing at a gentle diagonal running from short right to long left, a long hitter can gain a shorter route to the hole by playing to the left half of the fairway, but should his driver err to the right it will find water and a line to the green that is crowded by large trees.

The safer play from the tee is with a fairway wood that avoids the stream. The trade-off is a longer approach into the well-bunkered green. While Ross's original design presented an open-throated green allowing for a running shot, Jones's 1955 work choked the entrance with two bunkers requiring a full carry.

In the 1941 Times-Union Open, the top ten finishers, who included Sam Snead, Ben Hogan, and Gene Sarazen, together averaged 4.25 strokes at the seventh. In the 1995 Ryder Cup, Curtis Strange and Jay Haas lost this hole to a par during the foursome competition.

COURSE:	OAKLAND HILLS COUNTRY CLUB (SOUTH)
HOLE:	16
LOCATION:	BLOOMFIELD HILLS, MICHIGAN
ARCHITECTS:	DONALD ROSS, ROBERT TRENT JONES, SR.
LENGTH:	405 YARDS · PAR 4

"Water hazards always lend welcome variety and test of skill to a course," wrote Oakland Hills's creator Donald Ross. "They are pleasant breaks that can generally be made into charming beauty spots."

Gary Player might disagree, at least regarding the sixteenth hole and the 1972 PGA Championship.

Great holes present demands and reward heroics just as great champions define themselves by finding necessary answers to unlikely situations.

The 150-yard 9-iron Player struck for his approach to the sixteenth was heroic in the gamble he accepted in going for the green and the successful accomplishment of what he achieved.

It was the final round. Player was attempting to win the PGA Championship for the second time. With three holes to play, he was tied with Jim Jamieson, who was on the eighteenth green.

The sixteenth doglegs sharply to the right and in the elbow of the bend is a water hazard that protrudes into the fairway guarding the front and right of the green. The inside corner of the dogleg is further delineated by some weeping willows that discourage any player (Gary included) from attempting a shot to cut the corner over the water.

Player's tee shot was sliced to a position in the right rough where the willows blocked a regular approach over the water to the green. He would have to go up and over. The question was whether Player had the strength to play a club that would provide the necessary loft to clear the trees and sufficient distance to carry the water.

Twenty years earlier, Robert Trent Jones, Sr., had toughened Oakland Hills for the 1951 U.S. Open. "The game had outrun architecture," Jones said, and he decided the world's best players needed "the shock treatment."

Plainly identifying the demands that were being asked of him, Player pulled a 9-iron from his bag realizing that a mis-hit would result in a wet bogey or worse for him and the championship for Jamieson.

The 9-iron was struck perfectly, the ball climbed over the willows, carried the water, and settled four feet from the hole. Player made his putt for birdie, Jamieson missed at the eighteenth, and the South African became the PGA champion for the second time.

COURSE:	OAKMONT COUNTRY CLUB
HOLE:	3
LOCATION:	OAKMONT, PENNSYLVANIA
ARCHITECTS:	HENRY AND WILLIAM FOWNES
LENGTH:	425 YARDS · PAR 4

There are a few pairs of consecutive holes in this list of top one hundred holes in the world (including the seventeenth and eighteenth at the TPC at Sawgrass, sixteenth and seventeenth at Carnoustie, twelfth and thirteenth at Augusta), and most share a common feature. This certainly is true of Oakmont's third and fourth holes, which share the one hazard that is inextricably linked to the course's history—the legendary "Church Pews" bunker.

While sharing a church pew can be an uplifting and fulfilling experience, contrition and punishment seem to have been more on the mind of this hazard's creators.

Opened in 1903, fifteen years before Pine Valley was completed, Oakmont was conceived and built as the first of America's truly penal courses. Club founder Henry C. Fownes and his son, William C. Fownes, shared a passion for the kind of exacting golf that, to this day, rewards excellence and penalizes shortcomings.

"A shot poorly played should be irrevocably lost," the younger Fownes is attributed as saying. As the 1910 U.S. Amateur champion, first captain of

the Walker Cup team (1922), and past president of USGA (1926–1927), W. C. Fownes's extensive experience had brought him to a deliberate point of view about competitive golf, which is reflected across Oakmont's eighteen holes and epitomized here.

The two-acre Church Pews bunker is shared by the adjacent fairways of the third and fourth holes, which run in opposite directions. It is a short-iron shot from front to back and sectioned by eight grass-covered ridges three feet tall and seventy-five feet wide. Advancing the ball is not always an option from the Church Pews, nor is playing backward or sideways necessarily easy. Because grass is grown only on the tops of the ridges, a lie too close to one may allow too limited a backswing, too steep an up-slope, or too contorted a stance from above or below.

Three severe bunkers to the right of the fairway balance the potential for penalty for an errant drive. From the fairway, the approach is made to an elevated green, which is relatively flat by Oakmont standards, and guarded on both sides by more deep bunkers. As an added consequence to the uphill shot, the green slopes slightly away from the line of play.

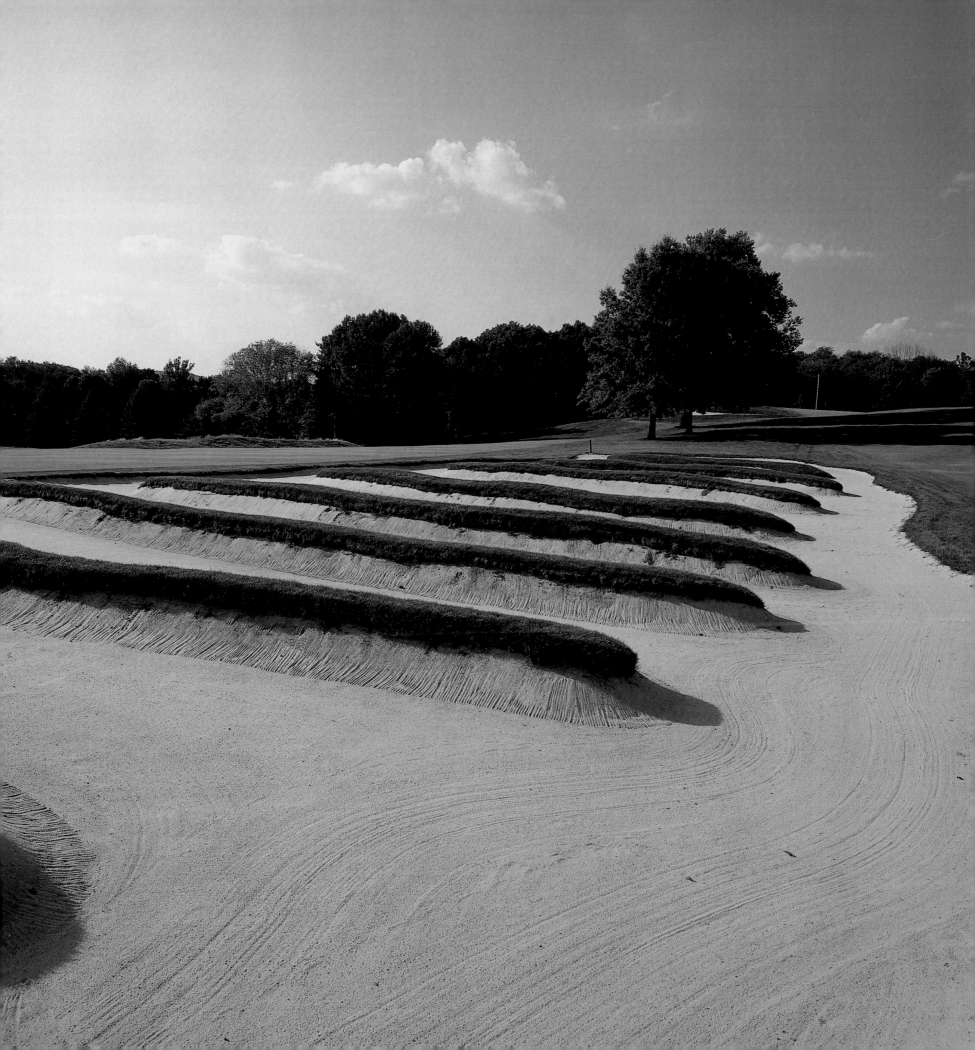

COURSE:	OLIVOS GOLF COURSE
HOLE:	15
LOCATION:	BUENOS AIRES, ARGENTINA
ARCHITECTS:	LUTHER KOONTZ/EMILIO SERRA
LENGTH:	480 YARDS • PAR 4

It has been nearly a half century since Luther Koontz envisioned the design for Olivos. The idea was to create a course comprising holes that were not difficult in the sense that they required long, powerful shots, but were demanding in judgment, the ability to work the ball from both directions, and the demonstration of an effective short game emphasized by the natural undulations of the terrain. Over the years, the strategic elements matured and Koontz's vision became a reality, best exemplified today at the fifteenth hole.

It is easy to be beguiled by the beauty of this short, dogleg-right par 5 (it's a par 5 for the members, but a par 4 in the Argentine Open and Masters), but succumbing to its charms usually leads to the commission of fatal errors. From first shot to last (however that may be), the fifteenth is a demanding mistress.

Tall deciduous trees define both sides of the fairway and have eliminated a direct line across the dogleg, a route sometimes taken during Olivos's early days.

The positioning and shape of a greenside pond demarcate the line of entry to the putting green.

The oval-shaped pond juts almost completely across the fairway from the right rough. It leaves a small piece of dry ground, perhaps five yards, that provides a meager runway into the green but is nearly indiscernible from the fairway. For this reason, the approach must fly all the way to the putting surface, and must do so accurately: Bunkers right and left punish an errant approach.

Argentina's greatest player, Roberto De Vicenzo, characterizes the hole as one of country's most stunning and demanding, "especially if one plays it the regular way," he says. "I like to hit a good drive of some 270 yards to the left of the fairway. Then I go for the middle of the green with a 3- or 4-iron, because whatever is the position of the flag, it is a small green and there are few possibilities of leaving the ball close to the hole."

The daring De Vicenzo was not always so pragmatic, and the trees were not always so tall. In the early 1960s, he knew that if his drive strayed to the right, he would be able to play over the young trees on a direct and shorter line. Such an approach largely disarmed the constraints of water, trees, and rough that the hole presents today.

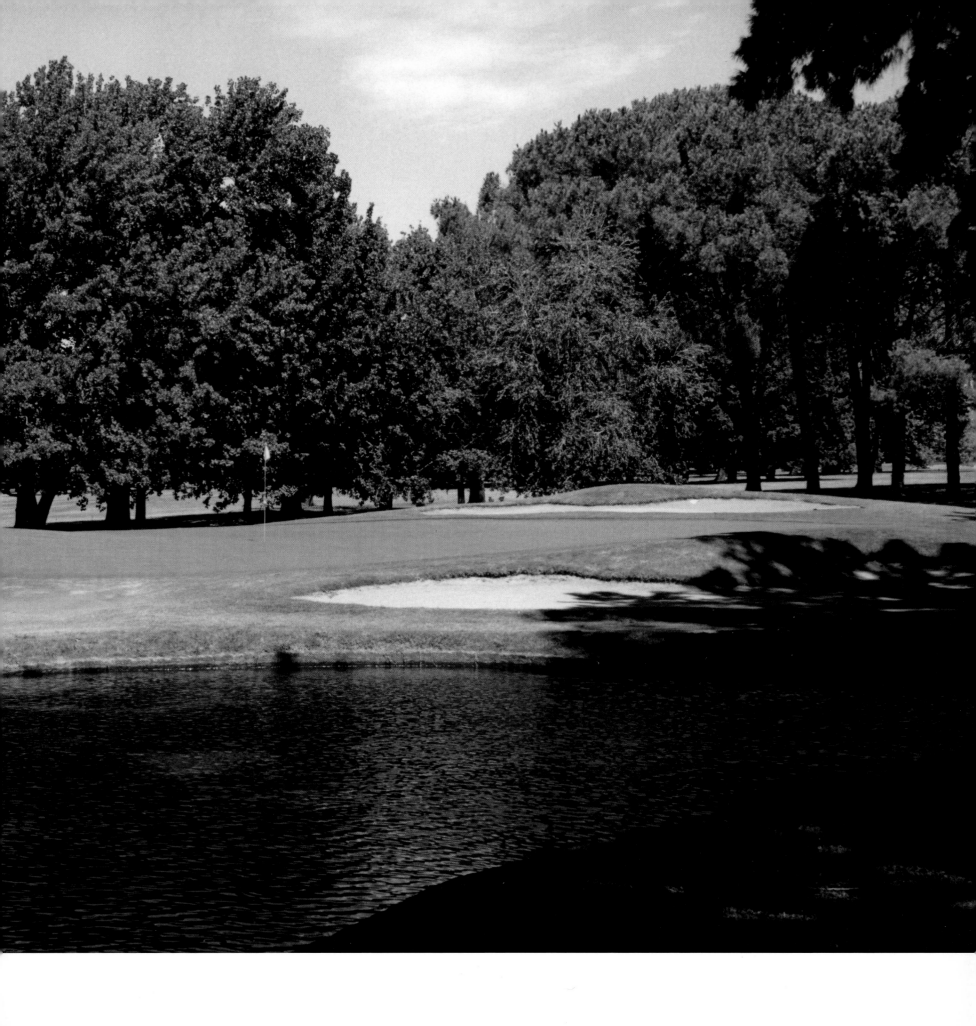

COURSE:	PARAPARAUMU BEACH GOLF CLUB
HOLE:	17
LOCATION:	WELLINGTON, NEW ZEALAND
ARCHITECT:	ALEX RUSSELL
LENGTH:	442 YARDS · PAR 4

Alister Mackenzie's abilities as a student of medicine, camouflage, and course design must have honed his facility for design instruction. His one visit to Australia and New Zealand left in its wake not only several of the world's best designs, but also the talents of those who had learned under him and would continue after he was back in America.

Alex Russell won the 1924 Australian Open as an amateur. Two years later, he helped Mackenzie lay out the original course at Royal Melbourne. Other collaborations with Mackenzie followed. Twenty-three years later, his individual design talent was exercised for the last time at Paraparaumu Beach, on the North Island of New Zealand overlooking the Cook Strait and the Tasman Sea.

Russell had learned from Mackenzie not to force his imprint on the land but rather to let the land dictate where the holes would run and what their character would be. Such is the nature of Paraparaumu.

The seventeenth is a par 4 of notable length, which, when played into the wind, presents difficulties of distance and, when played downwind, presents difficulties of accuracy. Its demands are made more diabolical by a split fairway. The lower tier is easier to find from the tee and provides a shorter route to the green. However, two bunkers short and right of the green guard its entrance and demand that the approach be put up into the wind and dropped precisely on the putting surface.

The upper fairway tier is more difficult to hit and hold from the tee. In addition to its narrowness, a steep slope falls off the left side and is generally shaved to exaggerate the punishment for inaccuracy. However, if a place can be found on the left-hand fairway tier, a generous approach is offered to the green through the air or along the ground.

Like so many of the world's great holes, the seventeenth offers a dilemma that must be solved by balancing the natural elements of the terrain and wind in a manner commensurate with the abilities of the player. In such cases, a lesser player who chooses well will overcome a better player who has chosen badly.

Paraparaumu is a links course of medium length that under firm conditions plays much shorter. Its defense is found in the windy conditions that are often present and that make the course's small greens more elusive. The massive backdrop of snowcapped mountains adds dramatic contrast to undulating terrain.

COURSE:	PASATIEMPO GOLF CLUB
HOLE:	16
LOCATION:	SANTA CRUZ, CALIFORNIA
ARCHITECT:	ALISTER MACKENZIE
LENGTH:	395 YARDS · PAR 4

"I think the 16th hole [at Pasatiempo] is the best two-shot hole I know. I certainly do not know of any hole which gives so great an advantage for length and accuracy," wrote Alister Mackenzie in *The Spirit of St. Andrews.*

Mackenzie's words are unequivocal. Of all the superb holes he designed in various parts of the world and on all the important courses that he created, Pasatiempo's sixteenth was his favorite. What an astounding thing to contemplate.

From the tee the hole calls for a blind shot over the indicator flag. It takes a couple of times around to cultivate a plan of attack for such a shot. A draw is required for precise placement. There is out of bounds to the right and a barranca on the left.

Following a well-executed drive, the player is left with a long, downhill second shot to a three-tiered green that is elevated and guarded by a group of magnificently shaped greenside bunkers. The green is positioned behind another deep barranca and there is a stream below.

"I have always wanted to live where one could practice shots in one's pajamas before breakfast," said Mackenzie. In the temperate climate of Santa Cruz his wish came true, and he and his wife built a cottage to the left of the sixth fairway.

Pasatiempo was the brainchild of Marion Hollins, who pursued it following her formation of Cypress Point. Pasatiempo was to be more than a private club. In addition to Mackenzie, Hollins retained the Olmsted brothers, nephews and business associates of Frederick Law Olmsted, to master plan a residential community around the golf course.

Fueled by Hollins's remarkable energy, connections, and personal wealth, Pasatiempo became a focal point for film stars and important golfers. On opening day, Cyril Tolley (the British Amateur champion), Bobby Jones (the U.S. Open champion), Glenna Collett (the British Ladies Open Amateur champion), and Hollins (the U.S. Women's Amateur champion) played the inaugural round. Regular visitors included Mary Pickford, Babe Didrikson Zaharias, Will Rogers, and Joyce Wethered.

A few days before, Bobby Jones had been knocked out of the first round of the U.S. Amateur Championship, which was being played at Pebble Beach. That left him free to play other courses in the area including Cypress Point and Pasatiempo. These exposures to Mackenzie's work are given credit for Jones's decision to hire the good doctor to design Augusta National.

COURSE:	PINEHURST COUNTRY CLUB (NO. 2)
HOLE:	5
LOCATION:	PINEHURST, NORTH CAROLINA
ARCHITECT:	DONALD ROSS
LENGTH:	482 YARDS · PAR 4

"Pinehurst Number Two is the kind of course where every bunker could be removed and you'd never know it," wrote its creator, Donald Ross. The fifth hole at Pinehurst No. 2 best exemplifies his argument.

From the back tee, which was constructed for the 1999 U.S. Open, the player is beguiled by an enormous landing area and a gently turning dogleg-left to the green. To take maximum advantage, the tee shot must be played to the right half of the fairway. This sets up one of the most exacting approaches in golf. A long iron must be played with the ball above your feet to a green that slopes from right to left.

While the green appears large and receptive, its undulations, sloping shoulders, and tilted throat are designed to deflect mismeasured shots. The bunkers in the landing area and to either side of the green add important definition. However, as Ross maintained, they could be removed and the strategic intricacy of the hole would remain intact.

During the first round of the 1999 U.S. Open, the fifth predictably played as the most difficult hole on the course. The reason for that, while hidden in the scoring statistics, illustrates the magnificence of the hole's architecture.

Typically at the U.S. Open, the cost of hitting a ball in the rough is about half a stroke. At the fifth hole, the cost of rough was only .419, but the average score was 4.494. This was despite the fact that 64 percent of the players hit the fairway from the tee and did not have to play from the rough.

The missing piece of the puzzle was that of the shots played from the fairway only 24 percent finished on the green (the eighteen-hole average was 52 percent), and this still resulted in a staggering 1.54 average putts. Normally, fewer balls on the green would result in more chips shots and fewer putts. Ross's design spoke in eloquent silence about the demands it would eventually make on the forthcoming champion.

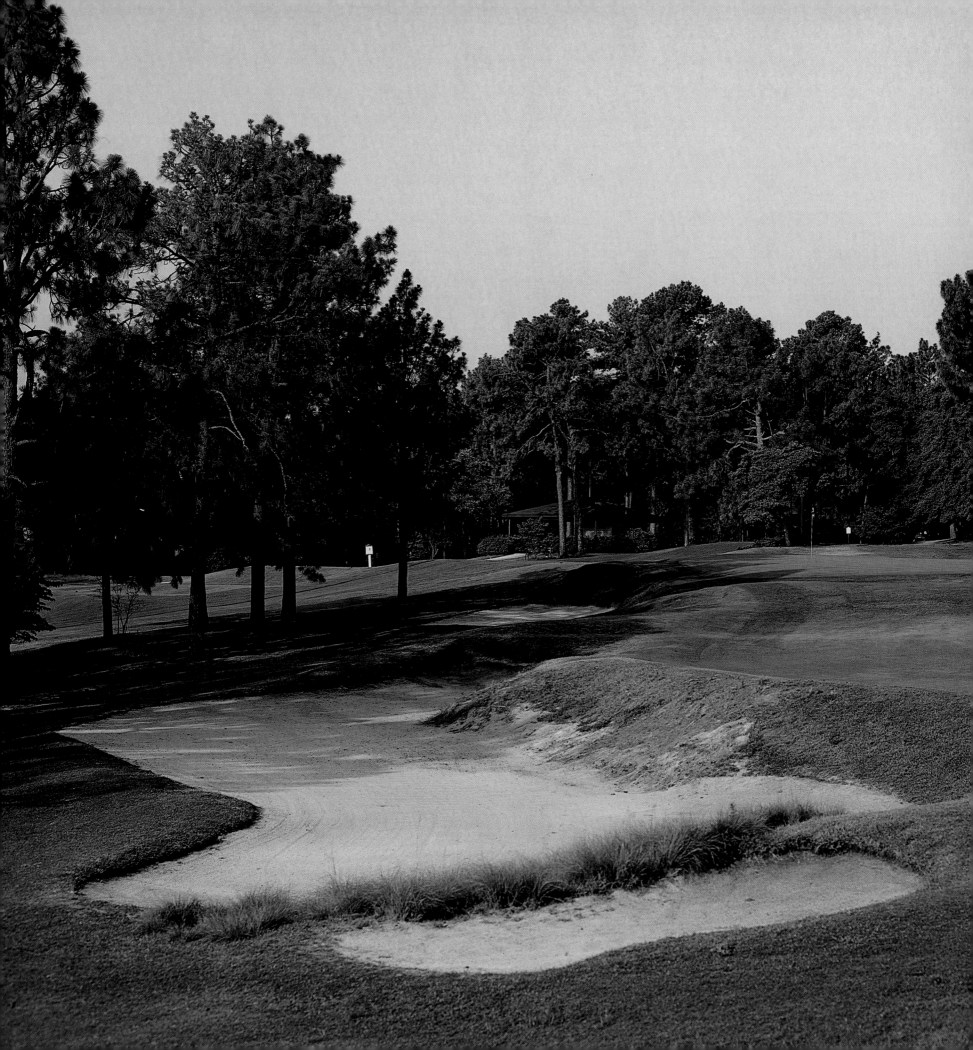

COURSE:	PRAIRIE DUNES COUNTRY CLUB
HOLE:	8
LOCATION:	HUTCHINSON, KANSAS
ARCHITECT:	PERRY MAXWELL
LENGTH:	430 YARDS · PAR 4

By 1937, Perry Maxwell had assimilated—from Alister Mackenzie and a study of the world's great courses—a style of architecture that was uniquely his own and quintessentially American. It was at just that moment of his life that Maxwell was presented with the canvas that would become Prairie Dunes.

On the outskirts of Hutchinson, Kansas, the Carey family invited him to build a golf course. An area twenty-three miles long and ten miles wide—baked by the sun, blown by the wind, inhabited by clumps of odd plants, waist-high grass, rattlesnakes, sand plum trees, yucca, crowfoot grass, and milkweed—seemed by some odd coincidence to have much in common with the great windblown linksland courses of Great Britain and Ireland.

An artist in much the same style as Ansel Adams and Georgia O'Keeffe, Maxwell admired the rugged beauty of the land and felt a need to get out of nature's way rather than impose his will.

"The site of a golf course should be there, not brought there," he said. Clearly when he scoured the Kansas sand hills for what would become Prairie Dunes, he was challenged by what not to do. "There are 118 good golf holes out here," he said after days of walking the land, "all I have to do is eliminate a hundred of them."

The par-4 eighth doglegs right and offers no percentage for those attempting to cut the corner. Gently the hole rises from the tee and, in the span of its 430 yards, runs over and around four sand dunes that traverse the fairway. The first is just 165 yards from the tee and is named for Ray Hockady, the man who promoted the idea of numbering our highway system and whose golf ball always seemed to come to rest at this first dune.

Each successive dune becomes gradually higher with the last rising more than forty feet 140 yards from the green. The green is protected on the right by four bunkers edged by yucca plants and another bunker on the left. Fear of the sand may bring a harsher penalty into play as a slope behind the green drops into high grass.

Maxwell was best known for his undulating greens, and the two-tiered plateau green offers its own placid puzzles.

Born in Kentucky, Maxwell moved to Oklahoma for health reasons and did not take up the game until age thirty. Ten years later, following the death of his wife, he toured the great American courses, brought the first grass greens to Oklahoma, and began an architectural career that produced or refined seventy designs.

In the early 1930s, Maxwell worked with Mackenzie at Crystal Downs, the University of Michigan, and Ohio State University. His talent was so admired that he worked at Pine Valley, Augusta National, The National Golf Links, Maidstone, Merion, Colonial, Saucon Valley, and Gulph Mills.

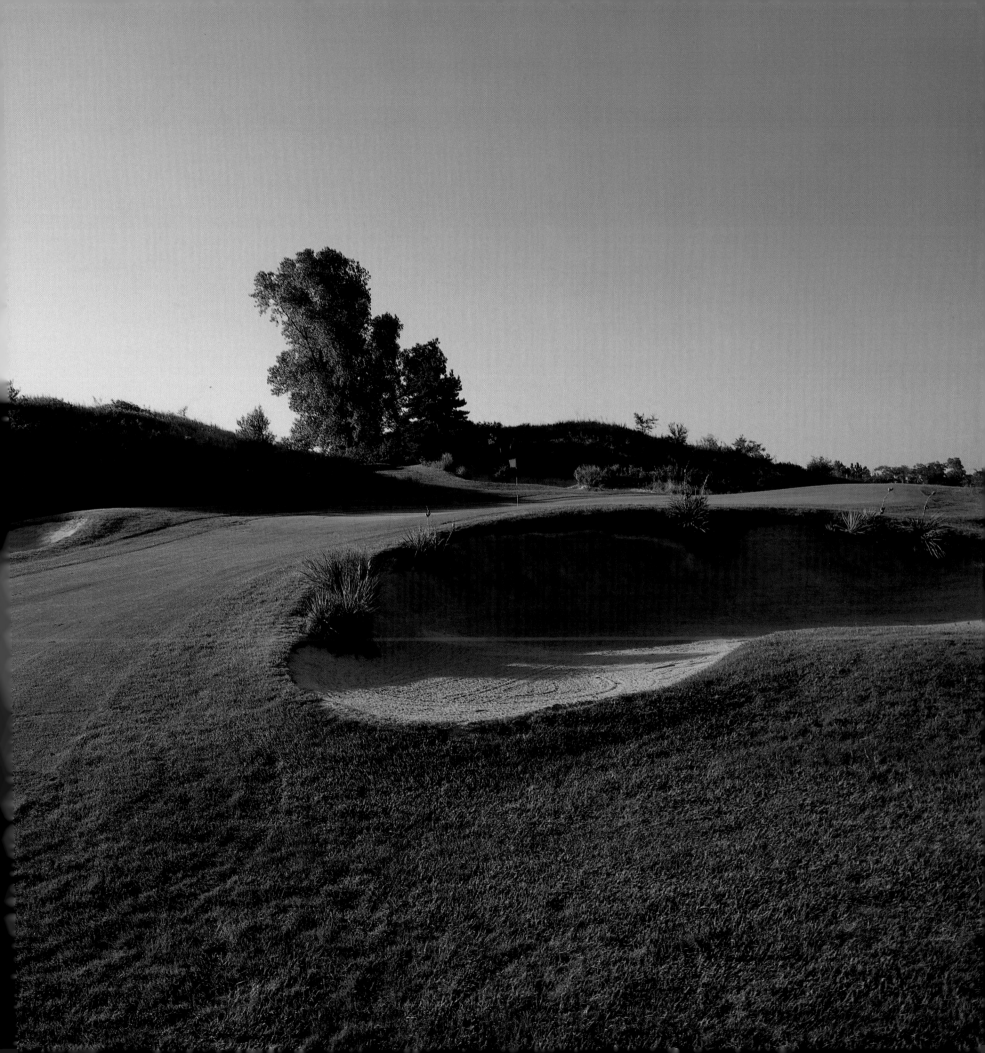

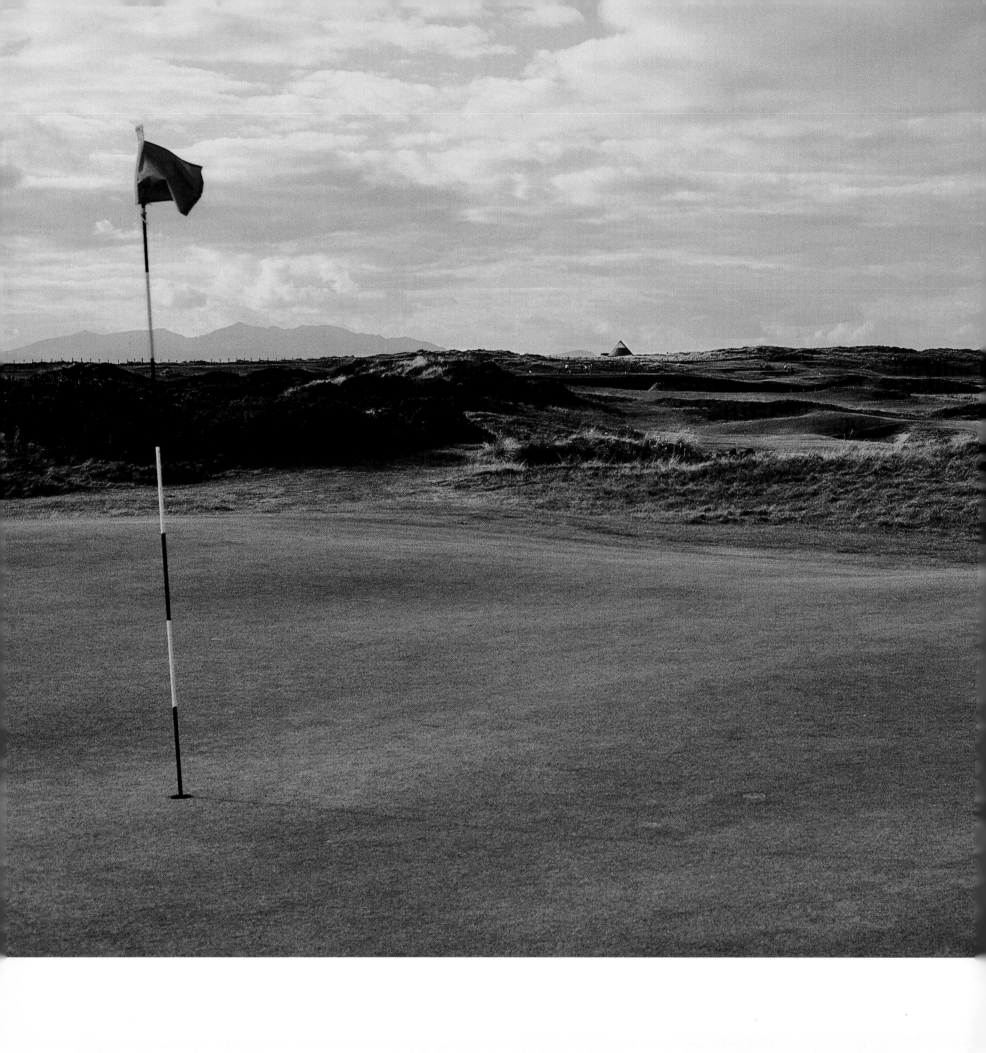

COURSE:	PRESTWICK GOLF CLUB (OLD)
HOLE:	1
LOCATION:	PRESTWICK, AYRSHIRE, SCOTLAND
ARCHITECT:	OLD TOM MORRIS
LENGTH:	346 YARDS · PAR 4

"A man is probably less likely to be contradicted in lauding Prestwick," wrote Bernard Darwin in 1910, "than in singing the praises of any other course in Christendom."

Darwin was the finest golf writer who ever lived, and this is his description of Prestwick's first, "the Railway." Although these words are nearly a century old, such is the uniqueness of a course that wasn't so much designed by Old Tom Morris as uncovered in the duneland of western Scotland that they are still almost perfectly accurate today.

The first hole is so good that, as with the first at Hoylake, it is a pity that we have to play it while we are still, perhaps, a little stiff and nervous. The crime against which we have chiefly to be on our guard is that of slicing, for the railway runs along the entire length of the hole on the right-hand side, quite unpleasantly near us.

We must not hook either, for rough country awaits the ball hit unduly far to the left, and, indeed, the shot is such a narrow one that there are some strong hitters who advocate the taking of a cleek [fairway wood] from the tee.

The second shot may be described on a calm day as a longish pitch, and there is a big bunker in front of the green, rough ground and a sandy road behind, the railway to the right, and tenacious undergrowth to the left. There is apt to be an engine snorting loudly on the other side of the wall just as we are playing a critical and curry putt, and the said putt is none the easier from the engine having liberally besprinkled the green with cinders.

Altogether, we shall have done good work if we get a four, and what a hole to do in three.

COURSE:	QUAKER RIDGE GOLF CLUB
HOLE:	6
LOCATION:	SCARSDALE, NEW YORK
ARCHITECT:	A. W. TILLINGHAST
LENGTH:	446 YARDS · PAR 4

"Any theatrical producer will tell you that the successful performer must possess talent primarily, and to an almost equal degree personality," wrote A. W. Tillinghast. "Without an appealing personality, a magnetism which draws the audience across the footlights, the actor must be endowed with rare ability to 'get his stuff'—as they say. But with talent, plus personality, the reward of spontaneous, sincere applause is assured."

Quaker Ridge stirs such spontaneity and the sixth is exemplary of its theater. At 446 yards, it is the narrowest and longest par 4 on a course known for two things: its long par 4s and its demand for accurate driving.

The fairway is just 22 paces wide, pitches from right to left, and bends from left to right. Overhanging trees on the left, high grass on the slope to the right, and the plateau fairway require longer players to club down to assure finding the fairway off the tee and the best spot from which to advance to the small green.

After a well-placed drive, the second shot is generally played with a middle or long iron with the ball above the player's feet. For a right-handed player this is a hook stance for a shot that requires a fade. No wonder Tillinghast was lovingly referred to as "Tillie the Terror."

In 1969, Jimmy Demaret observed, "Quaker Ridge is the most underrated golf course in the New York area because it has never been host course for a major championship. I'd like to go on record as saying it would be a tough test of golf for any tournament, the U.S. Open and PGA [Championship] included."

Rebunkered by Rees Jones before the 1997 Walker Cup matches, Quaker Ridge reflects Tillinghast's magnetism of design, "which draws the audience across the footlights."

COURSE:	RIVIERA COUNTRY CLUB
LOCATION:	PACIFIC PALISADES, CALIFORNIA
ARCHITECT:	GEORGE C. THOMAS
LENGTH:	311 YARDS · PAR 4

HOLE: 10

The histories of Ben Hogan, George C. Thomas, and Riviera merge in the Santa Monica Canyon about two miles from the Pacific Ocean.

It was here that Thomas created his most acclaimed design, and where Hogan won the first of his four U.S. Open Championships, and two years later signaled his return to competition after a nearly fatal automobile wreck.

Hogan played upon a masterpiece created by Thomas, whose first impression of the site was less than enthusiastic. However, being instructed to spare no expense, he hired two hundred men to clear the canyon, install irrigation, and haul nineteen thousand pounds of grass seed and topsoil from the San Fernando Valley. When it opened in 1927, Riviera was the most expensive course ever built ($675,000) and it is still regarded as the most inspired example of Thomas's philosophy.

The short par-4 tenth accentuates the intricacy of Thomas's creative mind and Hogan's ability to unravel it. At a length of just 311 yards, it tempts the player to drive the green but the risk is substantial. Thomas used elements of two classic holes, Tillinghast's Reef and North Berwick's Redan: The fairway is split by two bunkers, forcing the player to choose between carrying one at 210 yards on the right or 255 yards on the left, while the green is inhospitable to receiving a drive and slopes severely from right to left.

"Unless the wind is at my back," says Nick Price, "I prefer to hit a 230-yard lay-up on the left side, but you've got to stay out of the thick, matty rough . . . Most of the guys are thinking birdie three on the tee; but you'd be surprised at how many of us walk away with a six."

"The strategy of the golf course is the soul of the game," wrote Thomas. "The spirit of golf is to dare a hazard, and by negotiating it reap a reward, while he who fears or declines the issue of the carry, has a longer or harder shot for his second . . . yet the player who avoids the unwise effort gains advantage over one who tries for more than in him lies, or who fails under the test."

COURSE:	ROYAL ADELAIDE GOLF CLUB
HOLE:	14
LOCATION:	SEATON, ADELAIDE, AUSTRALIA
ARCHITECT:	ALISTER MACKENZIE
LENGTH:	447 YARDS · PAR 4

The oldest of Australia's golf clubs, Royal Adelaide's present site at Seaton is its third location since 1870. Because a railway line transected the land for the golf course, several of the original holes negotiated the tracks in one way or another. It took the visit of Alister Mackenzie in 1926 to eliminate the railway's interference: After Mackenzie's redesign, the fourteenth became one of six holes—the first and the last five—to fall on one side of the line with the other twelve on the other side.

This long par 4 doglegs to the right and finds its defense in the small plateau that is the landing area. That plateau is guarded within the right elbow of the dogleg by three bunkers that run consecutively from the edge of the fairway farther into the rough. The plateau can also produce a downhill lie for well-struck drives that do not travel quite far enough.

Royal Adelaide is known for its tussocky marram grass, which generally requires a chopping shot for recovery to the fairway or green. The fourteenth's fairway is unsheltered by trees and open to the wind. In addition, the fairway approach to the green complex is interrupted by rough about fifty yards from the green. This makes the green a target surrounded by rough and guarded by three bunkers.

The club has hosted all the major Australian championships many times, and Gary Player won the second of his seven Australian Open titles here in 1962.

All of Australia's eight royal clubs are located on the coastal rim of the continent, an area that provides the sandy soil and regular winds that produce the best conditions for golf, while putting them in relatively easy reach of the majority of the country's population.

The long arm of Scotland's golfing influence found Royal Adelaide in the form of "Des" Soutar and Jack Scott. Both learned their golf at Carnoustie and, just after the beginning of the twentieth century, found their way to Australia. Soutar designed courses in Australia and New Zealand and competed widely. Scott was appointed as Royal Adelaide's first professional. Australian Peter Thomson, five-time British Open champion, added his touches to Royal Adelaide's design later in the century.

COURSE:	ROYAL BIRKDALE GOLF CLUB
HOLE:	18
LOCATION:	SOUTHPORT, MERSEYSIDE, ENGLAND
ARCHITECTS:	GEORGE LOWE, F. W. HAWTREE/ J. H. TAYLOR
LENGTH:	476 YARDS · PAR 4

The demands made at Royal Birkdale's home hole have been answered in the historic events that have taken place there.

In former days, four of the last six holes could be played as par 5s. For the Open Championship, however, the thirteenth and eighteenth are configured as long 4s. The geography at the eighteenth illustrates the course's uniquely flat fairways flanked by gorgeous, rough sand hills. Indeed, the dunes here are more ornamental than hazardous, placing a greater strategic responsibility on length and bunkering to provide the championship examination.

The sand hills provide a comfortable hint of shelter that is not always present on linksland courses. Also, they are not to be played over in the way they are at other Open venues, such as Royal St. George's.

At 476 yards, well bunkered and bordered by two small ridges on either side of the fairway, the eighteenth requires two exacting shots to reach the green.

Tom Watson's closing par in 1983, to win his fifth Open Championship in nine years, is a sterling example of how the final hole must be negotiated. Watson's drive was long and perfectly placed clear of the fairway bunkers. From there, it was reported, he aimed his 2-iron at the dining room window, which was packed with onlookers, and sent his ball safely to the green. It was his fifth British Open victory in nine years.

Eighteen years before, Peter Thomson won his fifth Open Championship here and joined the elite group of those who have done so twice on the same course. His first Open victory had been attained at Royal Birkdale in 1954.

It was also here that one of the century's great acts of sportsmanship took place during the 1969 Ryder Cup.

In the closest contest to date in Ryder Cup history, seventeen of the thirty-two matches had gone to the last hole. Tied going into the last day, the British won five of the eight morning singles. The United States won four of the first six afternoon matches and tied one. That left the Ryder Cup to be determined by the last group of Tony Jacklin and Jack Nicklaus. They were tied going to the home hole.

On the final hole and playing in his first Ryder Cup, Nicklaus conceded a 2-foot putt to Jacklin after making a 4-footer for par. The concession resulted in the first tie in Ryder Cup history and an act of goodwill that will live long after the score is forgotten.

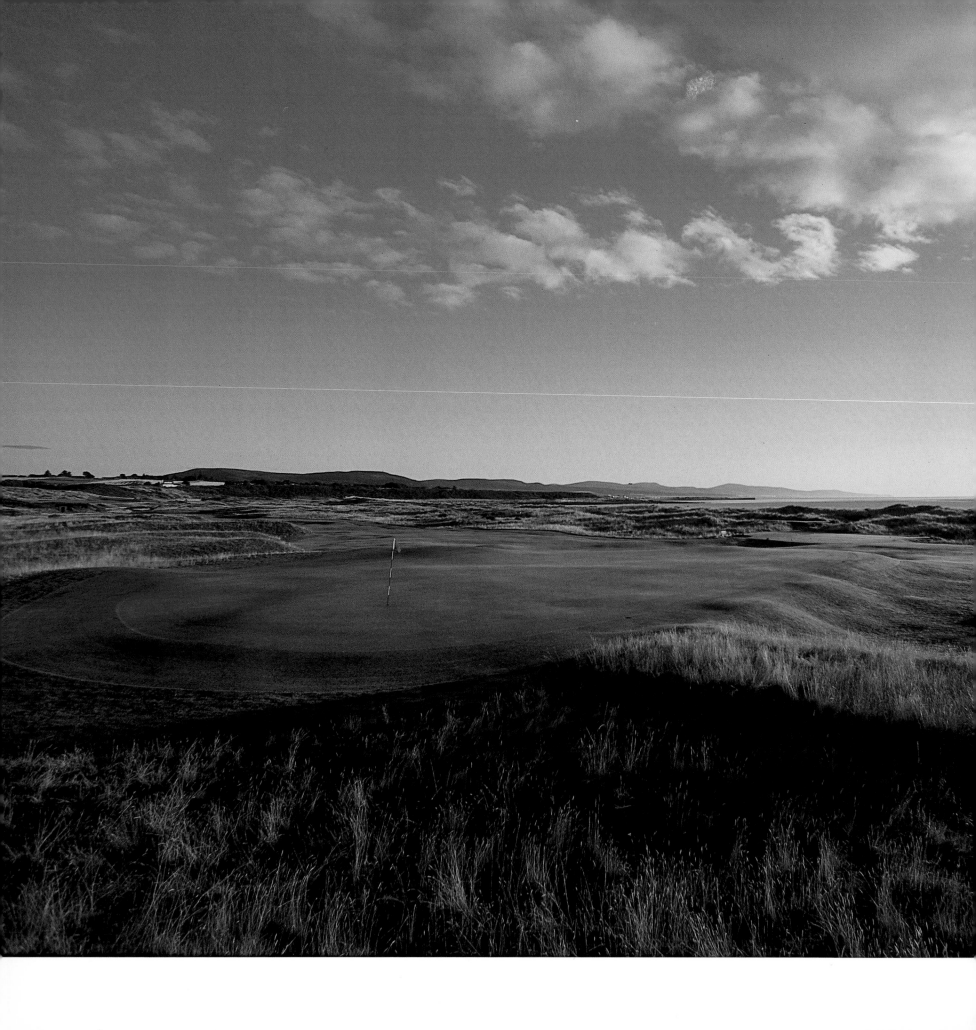

COURSE:	ROYAL DORNOCH GOLF CLUB
HOLE:	14
LOCATION:	DORNOCH, SUTHERLAND, SCOTLAND
ARCHITECTS:	OLD TOM MORRIS, JOHN SUTHERLAND, GEORGE DUNCAN
LENGTH:	459 YARDS · PAR 4

Royal Dornoch's fourteenth, which carries the sobriquet "Foxy," is the purest example of using the land, just as God left it, to optimize golf strategy without artificial hazards or superficial shaping.

Or as six-time British Open champion Harry Vardon unequivocally described the fourteenth, "It is the finest natural hole I have ever played."

At 459 yards, the double dogleg is forced by a major hummock of dune that runs along the right side of the hole. The drive requires a slight draw as the fairway makes its first turn to the left about 230 yards from the tee. The second shot then requires a fade to access the green raised about four feet above the fairway. Only two exact shots will find the putting surface.

The natural shape of the hummock and the hole's length made bunkers unnecessary. This may be the only one of the world's best holes to demand so much without the use of artificial hazards.

Donald Ross acquired his disciplined view of golf course design here as Royal Dornoch's golf professional and greenkeeper. He learned the elegantly simple principles that were later reflected in his best work in America.

The fourteenth's defense, as well as its key, is that a slightly errant shot will roll off the plateau green, necessitating a delicate chip shot to recover par. A second shot played along the ground must find the exact entryway.

Golf was played on the shores of Embo Bay at the mouth of Dornoch Firth as early as 1616, making it the third-oldest course in the world, after the Old Course at St. Andrews and Leith. Six hundred miles north of London, it is the northernmost of the world's championship courses.

COURSE:	ROYAL LYTHAM AND ST. ANNES GOLF CLUB
HOLE:	17
LOCATION:	ST. ANNES-ON-SEA, LANCASHIRE, ENGLAND
ARCHITECT:	GEORGE LOWE
LENGTH:	462 YARDS · PAR 4

The antithesis of the all-natural Dornoch, at Royal Lytham and St. Annes all the hazards are artificial and so placed as to punish any imprecision. The seventeenth—a flat, tough dogleg to the left with a sea of bunkers guarding the bend—is emblematic of a course that is impossible to force. "It is a beast," wrote Bernard Darwin, "but just a beast."

Bob Jones struck one of the most famous shots in golf history while playing the seventeenth at Royal Lytham and St. Annes en route to his first British Open victory in 1926.

Jones pulled his drive into a rough, sandy area in the corner of the dogleg about 175 yards from the green. His opponent, Al Watrous, had driven to the center of the fairway and played his second to the front to the green.

Having selected his "Old Equaliser," a mashie iron that is the equivalent of today's 4-iron, Jones struck the ball perfectly and it flew to the center of the green. "A teaspoon too much sand," it was said, "would have ruined the shot."

The perfection of the recovery disheartened Watrous, who reportedly uttered, "There goes a hundred thousand bucks."

A plaque was installed at the spot in the rough from where Jones played his miraculous stroke, and the mashie hangs in the upstairs lounge in the clubhouse.

Of the nine Open champions who have won at Royal Lytham and St. Annes, all but one came from overseas. In 1969, Tony Jacklin became the first British-born player to win here and the first British-born to win the British Open since 1951.

In 1996, Tom Lehman became the second American and the first American professional to win at Lytham. Other Open champions at Lytham include Bobby Locke, Peter Thomson (for his fourth), Bob Charles, Gary Player, and Seve Ballesteros (twice).

Arnold Palmer made his Ryder Cup debut here in 1961, and it was the site of the last playing of the Cup matches (1977) before players from continental Europe were invited to compete.

COURSE:	ROYAL ST. DAVID'S GOLF CLUB
HOLE:	15
LOCATION:	HARLECH, GWYNEDD, WALES
ARCHITECTS:	HAROLD FINCH-HATTON, F. W. HAWTREE
LENGTH:	435 YARDS · PAR 4

Sitting under the imposing Harlech Castle and the mountains of Snowdonia, Royal St. David's is as dramatic and historic a setting one could imagine for golf.

Edward I built the castle in 1299 after conquering Wales and proclaiming his son the first Prince of Wales. Six hundred years later, the then Prince of Wales became a patron of the golf club whereon some "overkeen members proudly and promptly assumed the prefix 'Royal.'" Once coronated King Edward VII, the former prince sanctioned the proper use of the prefix.

At 435 yards and playing into the prevailing wind, the fifteenth demands two precisely struck shots to reach the green. With Mount Snowdon in the distance, the scale and definition of the hole are perfectly balanced with the task at hand. The fairway curves to the right at an oblique angle to the line from the tee. Rough sand hills frame the smooth fairway.

Like Royal Dornoch's fourteenth, there are no bunkers here. The hole finds its defense from the sand hills, the wind, and a hollow just short of the green. A running approach must negotiate the hollow, and a high, pitched second is left to the uncertainties of the Snowdonian wind.

The Harlech Town Bowl is the most important of regional events that have been played here. Harold Hilton, the great turn-of-the-century amateur, once won playing off a handicap of plus eight.

COURSE:	ROYAL ST. GEORGE'S GOLF CLUB
HOLE:	4
LOCATION:	SANDWICH, KENT, ENGLAND
ARCHITECTS:	DR. LAIDLAW PURVES, ALISTER MACKENZIE, J.J.F. PENNINK
LENGTH:	470 YARDS · PAR 4

No less an authority than six-time British Open (and onetime U.S. Open) champion Harry Vardon considered Royal St. George's—known to members as "Sandwich"—the best course in the world, for reasons that are exemplified at the 470-yard fourth.

An exact tee shot is demanded in order to achieve success. A poorly struck ball from the tee, he once said, presents "grave difficulties, demanding an unusually brilliant recovery and sterling play" if the player "is to have any chance of getting on level terms with his opponent again, assuming that the latter is playing the proper game."

However, Vardon added later, "you are always satisfied that virtue is properly rewarded at Sandwich, and that if your tee shot is hit truly and well you are certain to be nicely situated for your second." Hence the name "Elysian Fields," which is given to the landing area at the fourth and meant to reflect the peace a player feels having successfully negotiated the massive bunker from the tee.

The fairway bunkers down the left are so placed that a well-played shot must be executed to carry the first. Indeed, from the medal tee even long hitters often avoid a direct line over the red flag atop the thirty-foot dune, preferring to fade the ball to a strategic position in the fairway. In poor weather, shorter hitters often play the hole as a par 5, seeking comfort in the narrow fairway left of the bunker, and then laying up with a wooden club for a fifty-yard pitch into the green. Finally, the green is well protected and, said Vardon, "abounds in character and variety."

The fourth is reflective of the demands the course has presented to the game's great champions who have won there. Vardon, Hilton, Hutchinson, Travis, Hagen, Cotton, Locke, Beman, Jacklin, Lyle, and Norman demonstrated the patience and tenacity necessary to read the puzzle, unravel the solution, and play the shots.

The club was founded in 1887 during golf's last great British expansion. Congestion on the course at London's Wimbledon Common forced Dr. Laidlaw Purves to find space and peace elsewhere. Sunday golf was also one of the doctor's chief objectives. H. G. Hutchinson reported in 1891 that at Sandwich "play is permitted on Sundays, but no caddie is allowed because carrying one's own clubs fulfills some of the conditions of a religious observance."

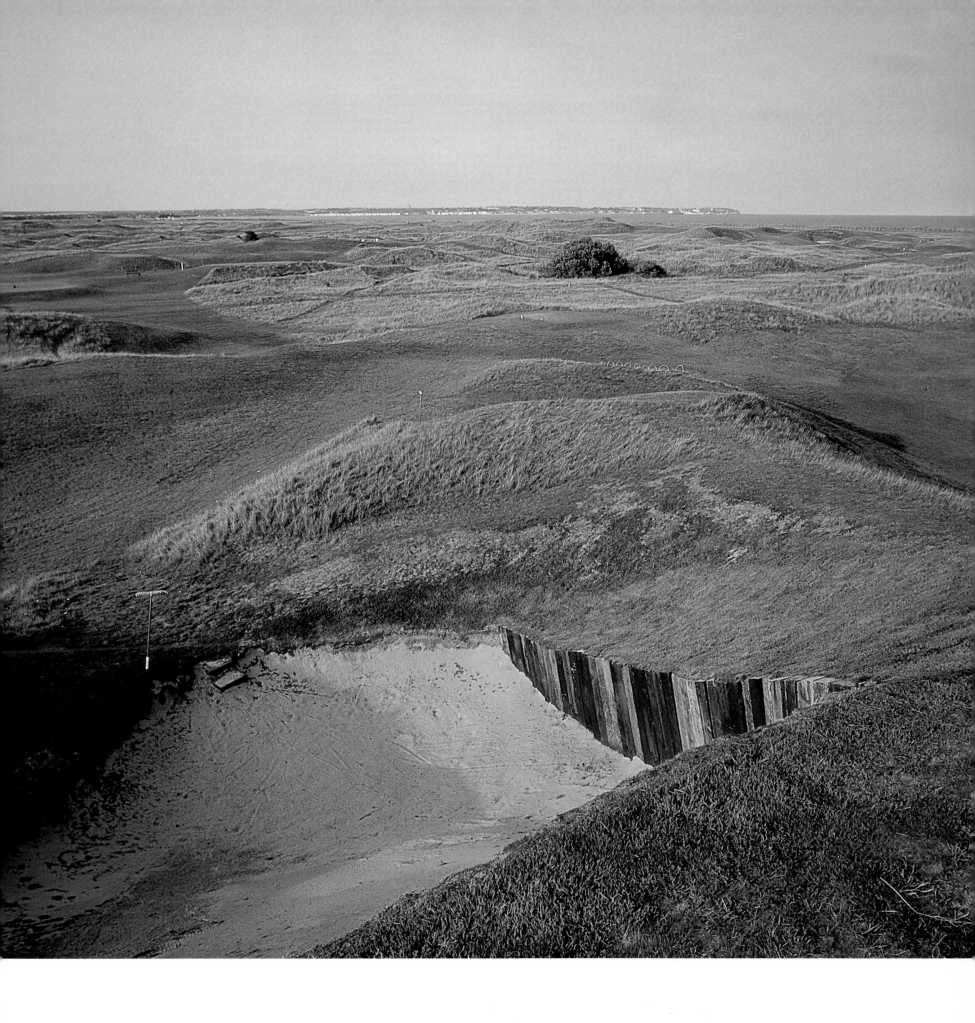

COURSE:	ROYAL TROON GOLF CLUB (OLD)
HOLE:	11
LOCATION:	TROON, AYRSHIRE, SCOTLAND
ARCHITECTS:	WILLIE FERNIE, JAMES BRAID
LENGTH:	481 YARDS · PAR 4

At 481 yards, it's short as par 5s go (which is how its members play it), and long as a par 4, which is what it is when the British Open comes to Troon. At either par, it is regarded as the toughest hole on the course. Thick gorse grows hard along the left of the fairway. But the real hazard is the train tracks to the right. Indeed, the Glasgow-to-Ayr railroad line plays such a factor here that the hole is named "the Railway."

The rail line runs hard by the right side of the hole, and the stone wall that marks the out of bounds lies uncomfortably close to the approach to the green. Trains running southward—against the line of play—seem to move closer as you play toward the small green.

Disaster at the Railway can be incited by the seaside wind, which pushes the ball toward the tracks. However, overcalculation of the wind can be equally damaging as there is no safety to the left of the fairway, either.

Many are those who have met disaster at the eleventh. Jack Nicklaus made an 11 here on his first attempt, as did the great English champion Max Faulkner. The astounding success here of Arnold Palmer in the 1962 Open Championship is magnified by others' shortcomings. During his four rounds, Palmer had one par, two birdies, and an eagle. It was at the eleventh that he separated himself as a champion.

Many club members have made the turn in the Saturday Medal and gladly taken one over par for the tenth, eleventh, and twelfth knowing that they have escaped the holes they refer to as the "card wreckers."

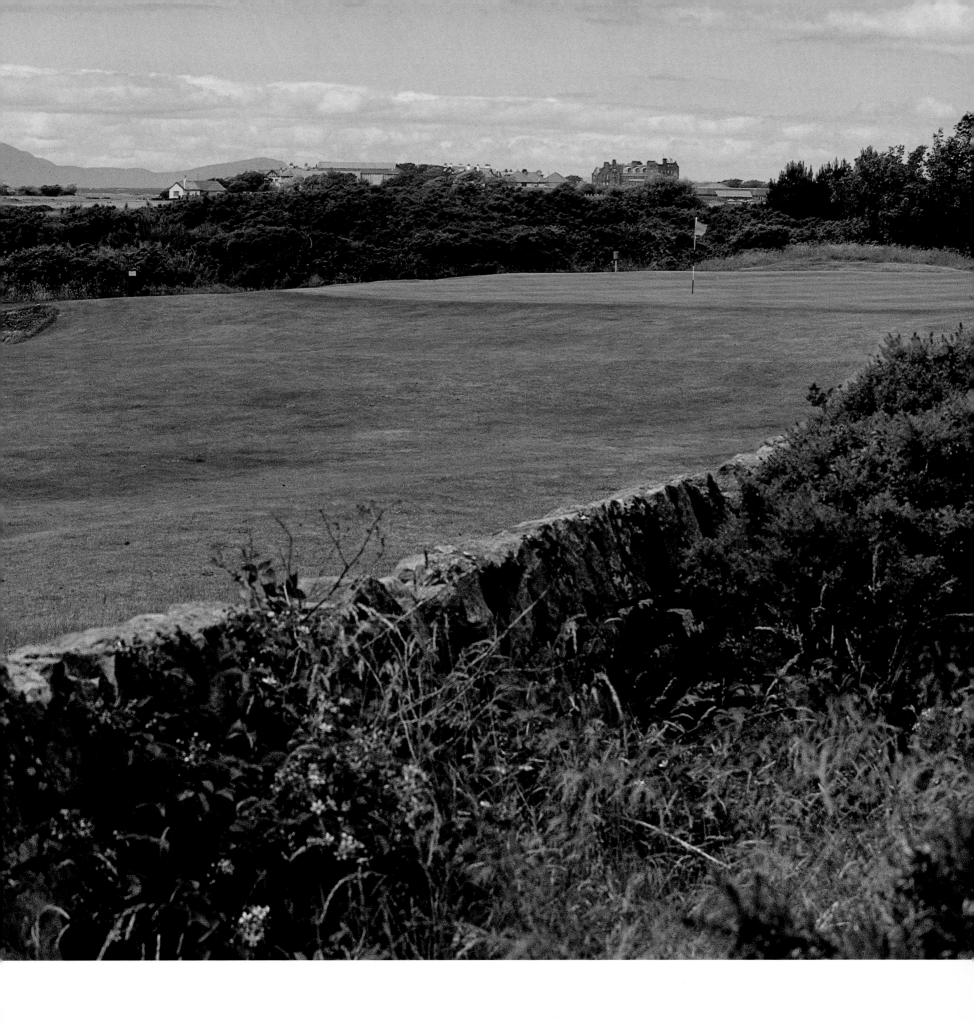

COURSE:	SAND HILLS CLUB
HOLE:	7
LOCATION:	MULLEN, NEBRASKA
ARCHITECTS:	BEN CRENSHAW/BILL COORE
LENGTH:	283 YARDS · PAR 4

It has been said that the Old Course at St. Andrews is the only naturally evolving golf course in the world because it was the first, and because the game and the course evolved there simultaneously.

Sand Hills, Prairie Dunes, and Ballybunion could make the same argument from an architectural perspective. The holes were always there. Indeed, they are so naturally plentiful that the artistry was in discerning which not to use. It is no wonder, then, that architects Ben Crenshaw and Bill Coore took two years to select the routing Sand Hills would take, and that only two thousand cubic yards of material were moved in its construction.

Golf came to Sand Hills in 1995, nearly half a millennium after being discovered at St. Andrews. And yet, like the Old Course, it had been evolving here for thousands of years. The striking difference is the absence of the sea. The undulations that sweep Sand Hills were not left behind by a receding ocean, but rather shaped by the erosive winds of the High Plains and the basin of the Middle Loup as it reaches for the Missouri.

At an elevation three quarters of a mile higher than that of St. Andrews, the vegetative contrasts of the plains are nonetheless similar to the linksland of Fife. The high, golden grasses of Nebraska lend contrast, definition, and soul as they cover the sand hills through which the fescued fairways and bent-grass greens course.

Sand Hills's seventh is the shortest par 4 of the world's one hundred best holes. It is strange indeed that a hole of such length, in the midst of an eight-thousand-acre ranch and eighteen thousand square miles of grassy dunes, garners such attention. Perhaps it is here that the minimalist elements of this design are most accentuated.

The fairway, bunkers, and green are perfectly shaped to present the dilemma: to go, to get close, or to play short. How much advantage can be squeezed from the drive before disaster rears its head? Whether as confusing, swirling gusts or discernible prairie gales, the wind offers either a solution or further temptation.

This hole exemplifies the transference of all that has evolved at St. Andrews. Sand Hills's seventh demonstrates that when the right piece of ground presents itself, a disciplined, informed mind will turn off the earthmovers, inject strategy in lieu of length, and marvel at the result, which, in this case, stretches under the big sky to the horizon of the vast prairie.

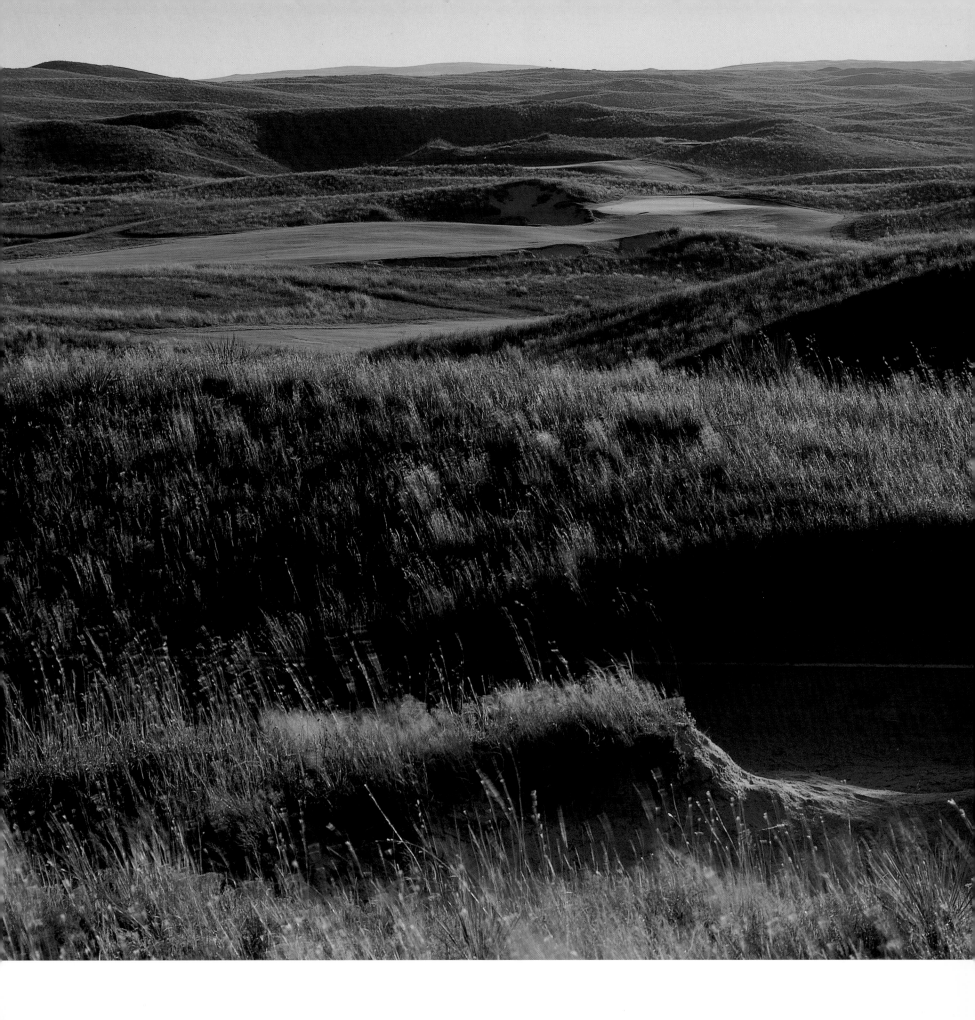

COURSE:	SEMINOLE GOLF CLUB
HOLE:	6
LOCATION:	NORTH PALM BEACH, FLORIDA
ARCHITECT:	DONALD ROSS
LENGTH:	383 YARDS · PAR 4

Whether or not you agree that Ben Hogan was the best to have ever played the game, there is no question that "the Hawk," as he was sometimes called, had an eye for everything golf and anything phony.

Therefore, when Hogan described the sixth at Seminole as "the best par four in the world," it wasn't just another line for the newspaper. Everyone knew he wouldn't say such a thing unless he believed it.

In his prime, Hogan spent the month of March at Seminole preparing for his annual competitive debut at the Masters. Sometimes alone, sometimes with members, but always with intensity, Hogan would hone at Seminole what had been struck years before in the Texas dirt. His praise of the sixth came after spending hundreds of hours playing this Donald Ross masterpiece.

The sixth is to architecture what Hogan was to the rest of the game—demanding, relentless, and stylish.

The drive must be played to the right in order to avoid the bunkers that run to the left of the driving zone. However, the closer the first shot is to the fairway bunkers, the better will be the line into the green.

From the fairway, the player must discern the distance to the elevated green, which is made deceptive by the four bunkers that lie to the right of the green and extend back into the fairway. Shortfall bunkers, particularly to an elevated green, cloud the discernment of distance.

"It is a very simple matter to furnish a line of play on every hole that can be taken without ever having to negotiate bunker carries," wrote Ross, "but at the same time will force the player to sacrifice one or more strokes, should he choose to take the easy way."

The easy way at Seminole's sixth would be a route that makes use of the open-throated approach to the green. However, such a placement by the second calls for an exacting pitch to a green confounded by subtle ripples and the grain of tropical grass.

This is by way of saying there is no easy way. Perhaps reflective of his personality, the subtlety and style with which Seminole's sixth demands par may be the reason Hogan regarded it so highly.

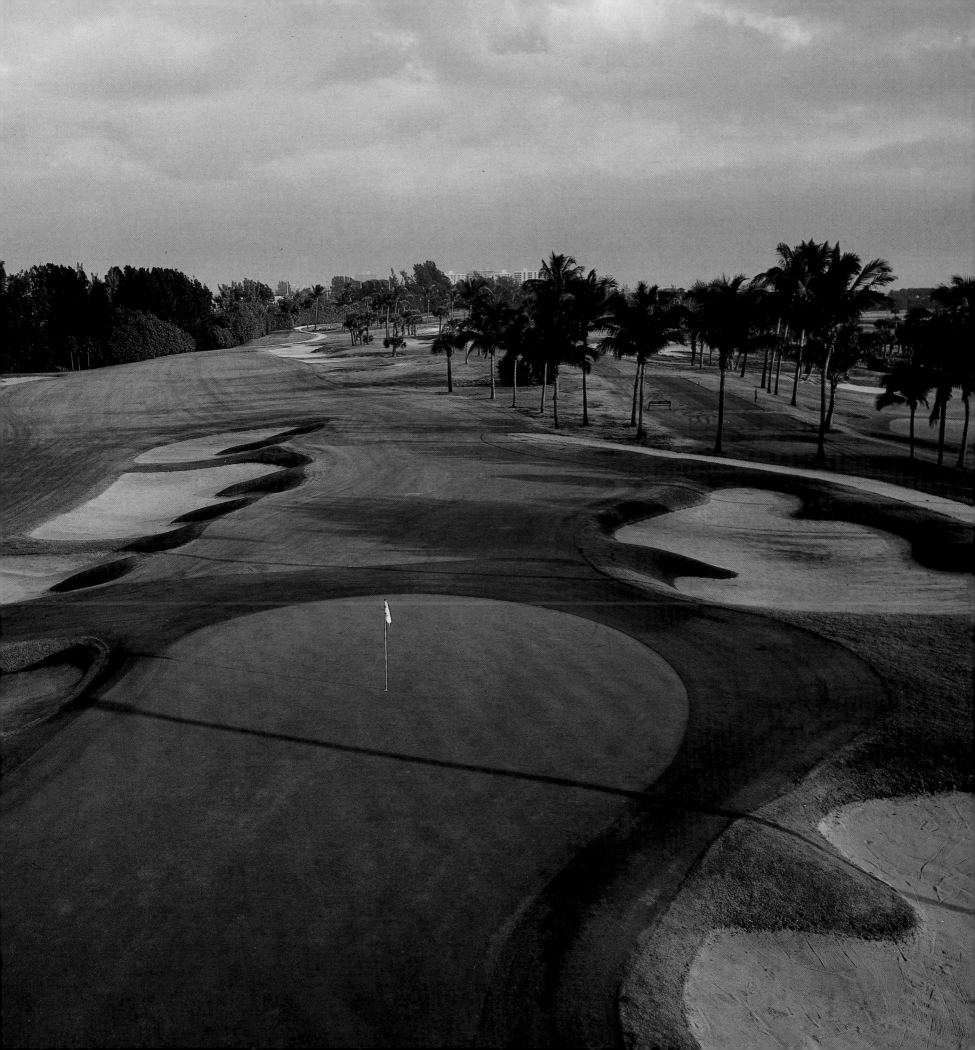

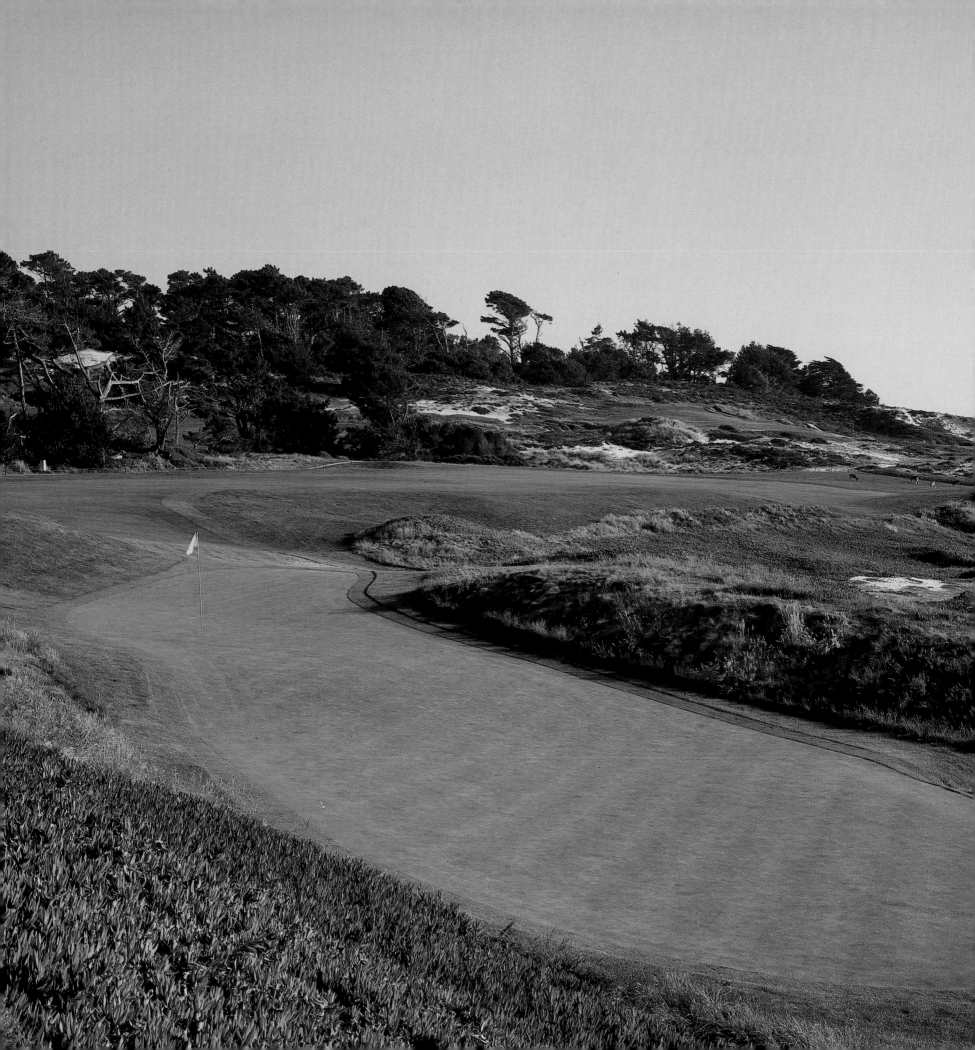

COURSE:	SPYGLASS HILL GOLF CLUB
HOLE:	4
LOCATION:	PEBBLE BEACH, CALIFORNIA
ARCHITECT:	ROBERT TRENT JONES, SR.
LENGTH:	365 YARDS · PAR 4

The first six holes at Spyglass Hill make a loop that begins and ends in the pines of Del Monte Forest, plays to all four points of the compass, and meets the linksland elements of sand and seaside weather straight on.

Like Maidstone's ninth, the fourth at Spyglass Hill is as sincere and effective an interpretation of natural linksland golf as can be found in America.

A short dogleg of 365 yards, the hole falls naturally downhill as the fairway tilts away from the higher ground to its right toward the ocean at its left. As on the linksland of Ireland and Scotland, there are no trees. The borders are the rough edges of untouched sand where ice plant, sea oats, and brackenlike scrub hold tenaciously to the windswept dunescape.

On the tee, weather may determine how much advantage will be gained by playing tightly to the left side of the fairway. Under benign conditions, a well-placed drive to that side will allow the bold player to flirt with a delicate second shot over the intruding sand and scrub and onto the small green slightly below. While the target of the green is smaller from this line, the perpendicular approach to it lessens the danger of its hazards.

A drive less bold, to the wider part of the fairway, provides a better line for acceptance of the approach shot into the green. However—and there is always one of those with Robert Trent Jones, Sr.'s best work—this better line to the green is complicated by bringing the danger of sand and ice plant closer to the line of play.

Reminiscent of Ireland's Ballybunion, the green is small but accepting, placed at a diagonal, and offers a cozy, nestled feeling of fitting into the undulating waves of sand that surround it. However (there's that word again), as at all the great linksland courses, any feeling of comfort is fleeting when the ocean's storm pounds its unprotected flank.

COURSE:	SUNNINGDALE GOLF CLUB (OLD)
HOLE:	5
LOCATION:	SUNNINGDALE, SURREY, ENGLAND
ARCHITECTS:	WILLIE PARK, JR., H. S. COLT
LENGTH:	410 YARDS · PAR 4

It was not until the late nineteenth century that golf courses began to be built in places other than on linksland. The sandy belt of soil that took the name heathland, and lies just west of London, begat a number of magnificent inland courses. As John de St. Jorre elegantly put it, Sunningdale can be found in the same "magical swath of Bagshot sand as Swinley, Wentworth and The Berkshire."

The fifth on Sunningdale's Old Course exemplifies the topography, strategy, and elation of heathland golf. From an elevated tee, the hole is clearly defined. Over a colorful belt of heather, the fairway is bordered on both sides by more heather, golden long grass, and dark green forest. There are two fairway bunkers in the right half of the fairway.

It is exhilarating to stand on the tee and view the task at hand with clarity and perceived possibility that a par can be had. Farther out, the water of a small pond is reflected to the right, and four bunkers guard the green. Two pure shots must be struck. The drive must find the left half of the fairway to avoid the bunkers. The second shot must be either pitched over the pond or run up to the right of the large, greenside bunkers.

It was here, in qualifying for the 1926 Open Championship, that Bob Jones played the perfect round. In scoring 66, Jones made 33 full shots and 33 putts. His twelve 4s and six 3s were described by Bernard Darwin as "incredible and indecent."

As quintessential among London golf clubs, Sunningdale has its share of characters. In the bar one afternoon, one member greeted, perhaps apocryphally, another member who was holding a handkerchief to his face to stop a nosebleed.

"Good heavens!" exclaimed the first. "What happened to you?"

"I got punched on the nose by the fellow I was playing with," said the bleeding member.

"That's awful! Did you punch him back?"

"Of course not," replied the bleeder.

"Oh," retorted the first, "if I'd known that I would have punched you years ago!"

COURSE:	TOURNAMENT PLAYERS CLUB AT SAWGRASS (STADIUM)
HOLE:	18
LOCATION:	PONTE VEDRA BEACH, FLORIDA
ARCHITECT:	PETE DYE
LENGTH:	440 YARDS · PAR 4

Significant finishing holes demand precision and dangle catastrophe. Exacting sports performance of a world-class nature requires endurance as well as execution.

While the TPC at Sawgrass reaches its crescendo at the seventeenth, it is on the eighteenth tee that the player must maintain his composure, channel the adrenaline flow, and strike one last series of strokes before he can hoist The Players Championship crystal. The names of those who have won here are a testament to the architecture of the course generally and the final hole specifically.

Never one to shy away from asking the essential questions, architect Pete Dye presented them all at the first of the PGA Tour's Tournament Players clubs. The ideal drive at the home hole is dangerously down the left, leaving a shorter, better-angled approach to the green. The less heroic play is to the right, avoiding the water that runs the entire length of the left side. However, a position too far right will find trees and rough and an angle making it necessary to aim at the water and cut the second shot back into the green. Besides the water, the triple-tiered green is guarded by sand on the left as well as deep, irregular mounds and grass bunkers on the right.

Since The Players Championship moved to its new home in 1982, the eighteenth hole has figured prominently. That first year, Jerry Pate played his second with a 5-iron—just as he had done to win on the last hole of the 1976 U.S. Open—and the ball finished 18 inches from the hole. The resulting 18-under-par was the winning score predicted by Dye. As a final christening of the course's first championship, Pate pushed PGA Tour Commissioner Deane Beman and Dye into the water off the eighteenth green's bulkhead and then dove in himself.

While half a dozen ensuing TPC victories have been determined at the eighteenth, it was 1991 that provided the greatest drama as Steve Elkington stood on the final tee needing birdie to win. He drove safely to the fairway, but the ball finished on a sand-filled divot 200 yards from the green. Calmly, the Australian selected a 3-iron and played a slight draw that finished 12 feet from the hole. When Elkington's putt fell, Fuzzy Zoeller, still playing the eighteenth, needed a birdie to tie, which was not to be.

British writer Peter Dobereiner summed up the strenuous nature of Dye's designs. "While I have never met Pete Dye, I know him well. He is 500 years old and has absorbed the wisdom of the ages. He wears a pointed hat and a flowing robe embroidered with occult symbols. When he speaks, he becomes extremely animated, and gesticulates a lot, with flashes of blue static crackling from his long fingernails."

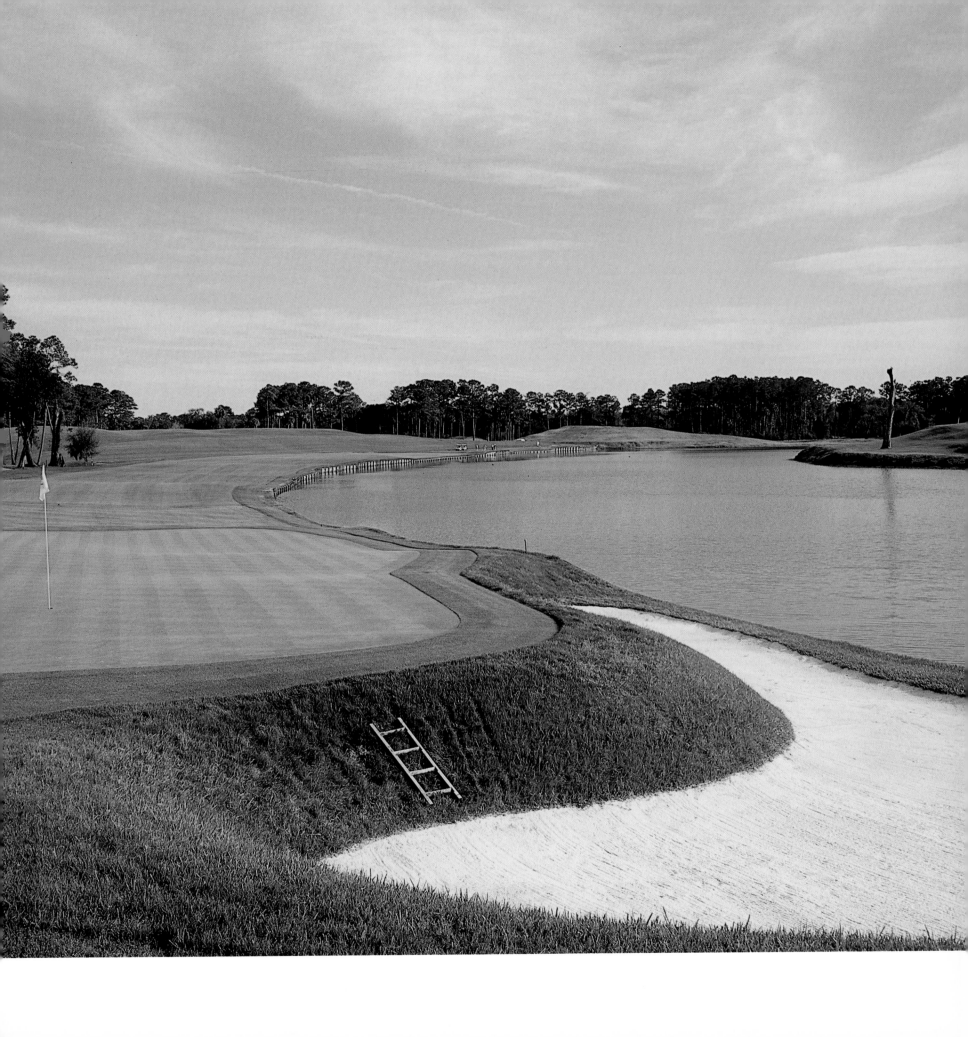

COURSE:	TURNBERRY GOLF CLUB (AILSA)
HOLE:	9
LOCATION:	TURNBERRY, AYRSHIRE, SCOTLAND
ARCHITECTS:	WILLIE FERNIE, P. M. ROSS
LENGTH:	455 YARDS · PAR 4

Because of its lighthouse and rocky outcroppings, the ninth hole at Turnberry is one of the most recognizable pieces of golf property in the world. It's also played its part in many British Open championships.

The elegant, strategic demands "Bruce's Castle" presents pale in contrast to its natural setting and historical import. It has been suggested that such settings are the frames that display golf's greatest holes. If that is so, Turnberry's ninth is unsurpassed. Like Pebble Beach, Cypress Point, and Ballybunion, this is a meeting of land and sea that baffles description. It is in such places that golf's best moments are remembered and, indeed, framed.

The championship tee is perched above a rocky peninsula that juts into the sea. A two hundred-yard carry is needed to find the safe fairway on the line marked by a stone cairn. The shot's difficulty is emphasized by the hogback fairway, which falls off to rough on the right or rough and rocks to the left.

Behind the tee lies the rock promontory Ailsa Craig; farther on and to its right the silhouette of the Mull of Kintrye can be discerned, and beyond them all the looming shores of Ulster.

As on many linksland courses in pleasant weather, the drive and approach may not seem too demanding for the better players; but the target grows narrower and smaller when the rain and wind come ashore. Without bunkers here, the entrance to the small green provides for a running approach to a surface tending to gather well-struck shots.

On a line beyond the green and pointing skyward is the simple, stately memorial to those lost while serving from the Royal Naval Air Station at Turnberry. During World War II, the course was transformed with miles of concrete runway from which sorties were flown to monitor enemy activity in the North Atlantic. Scars of runway can still be seen on the course, serving as a sober reminder of the sacrifices made in order that we might enjoy such magnificent times at so breathtaking a spot.

COURSE:	YALE UNIVERSITY GOLF COURSE
HOLE:	4
LOCATION:	NEW HAVEN, CONNECTICUT
ARCHITECTS:	CHARLES BLAIR MACDONALD/ SETH RAYNOR
LENGTH:	443 YARDS · PAR 4

"Although the students of various colleges and universities in the United States have been devoted to the game of golf, in 1925 there was no college which had an outstanding golf course," wrote Charles Blair Macdonald. "Strange as it might seem, St. Andrews has been the only university in the world that can boast of one."

When Yale University Golf Course opened in 1926, Seth Raynor and Macdonald had remedied that situation. Raynor had learned to emulate Macdonald's successful hole designs, which Macdonald had imitated from the originals he sought out in the British Isles before his building The National Golf Links.

Yale's fourth is a variation on the Road hole design Macdonald had used at The National fifteen years before. Similar to the Road hole (No. 17) at the Old Course at St. Andrews, the closer you drive toward the pond (or on the original, the railway sheds), the more advantaged is your entrance to the green. On the approach, the center of the green is defended by a deep bunker (the Old Course's Road bunker).

Raynor was unafraid to use again what he knew Macdonald had made work before. "I used to think that my ears would grow to be like asses' ears, for I was always stretching them to take in every word that Mr. Macdonald uttered on the subject of golf," Raynor said.

On the subject of copying the best golf architecture he could find, Macdonald was undaunted by those who suggested he should be more original:

I read a golf article not long since in which the writer called a "fetish" the copying of holes from the classical courses of Great Britain, holes that have the testimony of all great golfers for more than a century or two past as being expressive of the best and noblest phases of the game.

Architecture is one of the five fine arts. If the critic's contention is true, then architecture must be a "fetish," as the basis of it is the copying of Greek and Roman architecture, Romanesque and Gothic, and in our own times among other forms, Georgian and Colonial architecture. One must have the gift of imagination to successfully apply the original to new situations. Surely there is nothing "fetish" about this. I believe in reverencing anything in the life of man which has the testimony of the ages as being unexcelled, whether it be literature, paintings, poetry, tombs—even a golf hole.

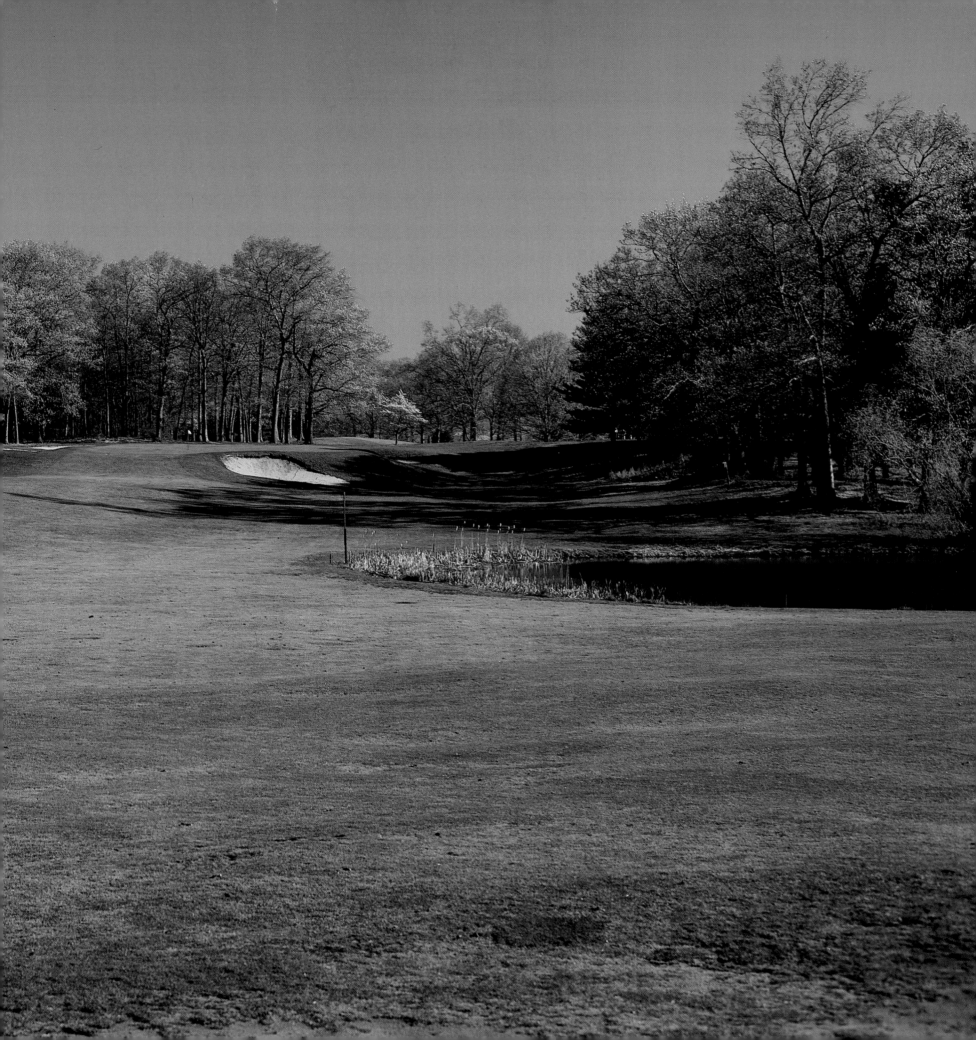

COURSE:	ALWOODLEY GOLF CLUB
HOLE:	3
LOCATION:	LEEDS, ENGLAND
ARCHITECTS:	H. S. COLT/ALISTER MACKENZIE
LENGTH:	510 YARDS · PAR 5

It could be argued that the absence of a nemesis or protagonist makes the greatest demands on a player's discipline and concentration. Perhaps this is why Bobby Jones taught himself to play against par regardless of the course or the competition. At Alwoodley's par-5 third, it is the near absence of hazards that is disorienting.

This long, fairly straight, sweeping hole begins with a drive that transects the sixteenth fairway in order to find its own, which cants from right to left. At 213 yards from the tee, and just inside the left rough, the hole's one and only bunker adds definition and depth to the landing area, as do the long-grass rough to the left and the heather along the right. Pines and silver birch also frame the first third of the hole.

Initially, it appears that finding the fairway with the drive is the hole's most demanding shot. However, with the prevailing wind following and the putting green steeply sloped from right to left, it is the nondescript second shot that must be precisely executed and positioned to leave a manageable ground stroke to the hole.

This kind of subtlety is a hallmark of Alister Mackenzie, who collaborated with H. S. Colt on the plan for Alwoodley. Giving it an additional fillip of notoriety, this course it was Mackenzie's first design.

Mackenzie had returned to Leeds after graduating with a medical degree from Cambridge and serving with the military during the Boer War. Back home, his interest in golf and golf course design began to grow. By 1907, he joined with other Yorkshire gentlemen as a founding member of Alwoodley and was elected its first secretary. Colt, a noted architect who also was the secretary of the newly formed Sunningdale, was hired to design the course. He traveled from London to Leeds and spent the night at Mackenzie's home, where they consulted on the new course.

Colt was so taken with Mackenzie's understanding of course design that he invited him to collaborate at Alwoodley. Born just one year apart, both men had attended Cambridge, received professional degrees (Colt had studied law), shared a passion for golf, and were secretaries of emerging golf clubs.

Following his heart, Mackenzie left his medical practice and over the next twenty-five years created an unmatched array of inspired designs from Ireland to Australia to California and South America. He wielded arguably the greatest influence on contemporary golf course design of any of those during this golden era of design. And it was here, at Alwoodley, that his journey began.

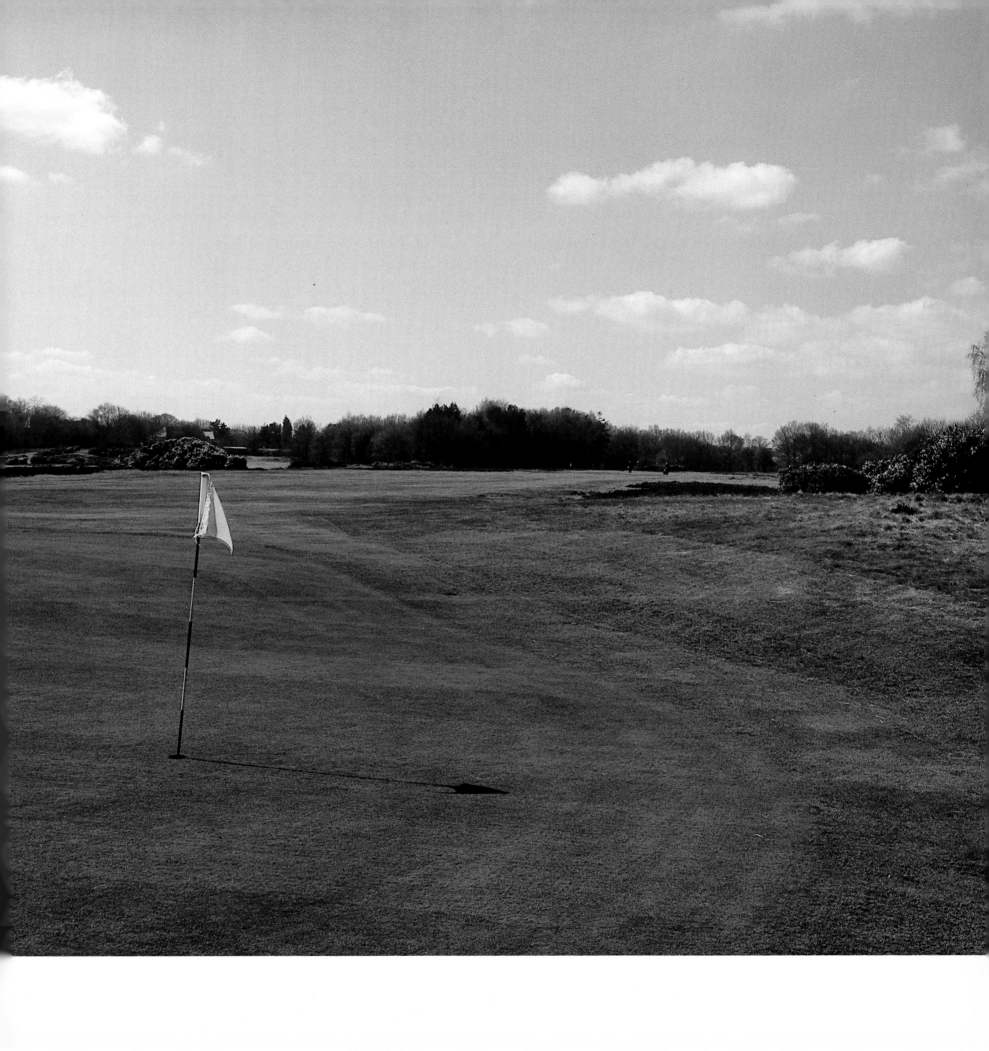

COURSE:	BALTUSROL GOLF CLUB (LOWER)
HOLE:	17
LOCATION:	SPRINGFIELD, NEW JERSEY
ARCHITECTS:	A. W. TILLINGHAST, ROBERT TRENT JONES, SR.
LENGTH:	630 YARDS · PAR 5

"If I reach seventeen," John Daly told his caddie during the 1993 U.S. Open, "at least I'll make history."

At 630 yards, Baltusrol's seventeenth on the Lower Course is the longest hole in U.S. Open competition. It requires an accurately placed drive to have any chance of the second carrying the cross bunkers—sometimes referred to as "the Sahara Desert"—at the 400-yard mark. A successful third requires an uphill approach to a circular green, which is "as high as a house" and guarded left and to the front by a half-dozen bunkers.

Until the second round of the 1993 U.S. Open, the seventeenth had never been reached in two. During the previous ninety-eight years, Baltusrol hosted a dozen national championships and every major male and female player from around the world, yet the seventeenth green remained untouched.

And so the opportunity fell to Daly, the 1991 PGA Champion, who, in 1995, also would win the British Open at St. Andrews. At the seventeenth tee on the second day, Daly realized the moment was now or never. He knew that because of the always vacillating score needed to make the cut, he might not be around for the weekend.

"You're going to do it!" someone shouted from the gallery.

"I'm going to try," replied Daly before launching his drive 325 yards down the left side of the fairway. From that point, what remained was a 290-yard uphill carry from a point perfectly positioned for entry onto the green. Selecting a 1-iron, Daly swung hard enough to lose his balance and fall forward as the ball leapt off the club face toward the green.

It landed with enough momentum to carry through the rough, one of the bunkers, and onto the green. The air literally shook with the spectators' adulation. Dave Anderson of *The New York Times* described the noise as similar "to the roars that once responded to a moonshot home run by Mickey Mantle or Reggie Jackson."

Baltusrol's seventeenth is exemplary of A. W. Tillinghast's late-recognized genius for golf course design: strong, demanding, and strategic. In addition to the Lower Course at Baltusrol, the middle years of Tillinghast's life reflected a list of breathtaking accomplishments including the other course at Baltusrol (the Upper), Ridgewood, Winged Foot, Baltimore (Five Farms), Bethpage, San Francisco, and Brook Hollow.

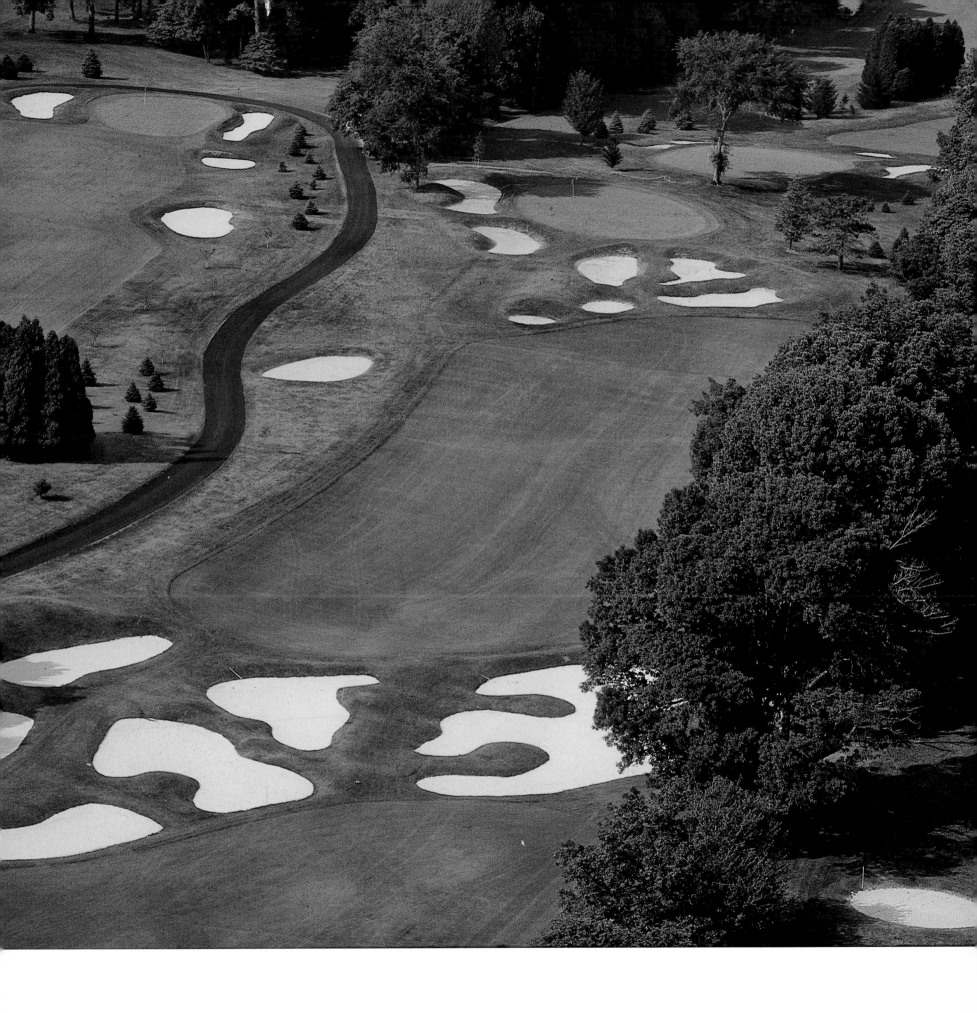

COURSE:	BETHPAGE STATE PARK GOLF CLUB (BLACK)
HOLE:	4
LOCATION:	FARMINGDALE, NEW YORK
ARCHITECTS:	A. W. TILLINGHAST, REES JONES
LENGTH:	522 YARDS · PAR 5

Bethpage's Black Course was A. W. Tillinghast's answer to the penal notoriety that was being heaped upon Pine Valley. When it opened in 1936, all the best players, and those who wanted to be, ventured to Long Island to try their hand.

"Without doubt," Tillinghast wrote, "were the other courses at Bethpage as severe as Black the place would not have enjoyed the great popularity it has known since it was thrown open to the public. Yet thousands of 'weak sisters' undoubtedly will flock there insisting on at least one tussle with the Black Leopard, just to show that they can 'take it.'"

The fourth hole is one of the most gorgeous of all inland par 5s. From an elevated tee, it stretches before you properly proportioned, aesthetically balanced, and strategically questioning, in large part due to the massive, sculptured bunkering.

"The bunker at the fourth is the ultimate cross bunker," says Rees Jones, who is remodeling the Black for the 2002 U.S. Open. "Most of Tillinghast's courses had one major cross bunker. . . . It was a typical concept of his."

Jones points out that the bunker facing the green forces the player to contemplate how he will ultimately approach the green with his second or third shot. "The best angle into the green is a short pitch with the third shot from the right, which means the drive does not have to be so long. However, if an attempt to reach the green in two is to be made, a longer drive must be played. The line for a long second is over the bunker fronting the green. The angle of approach into the green is more exacting on this line."

The green is a narrower target from the left; the slope behind falls away quickly. In addition, the green is twenty-five to thirty feet higher in elevation than the first landing area, which makes it more difficult to hold a long approach shot.

"No green that is to receive a pitched iron shot from short to medium length should offer the same degree of welcome from both sides," wrote Tillinghast. This element of strategy is justifiably magnified here for those wishing to "show that they can take it," and, they hope, make birdie.

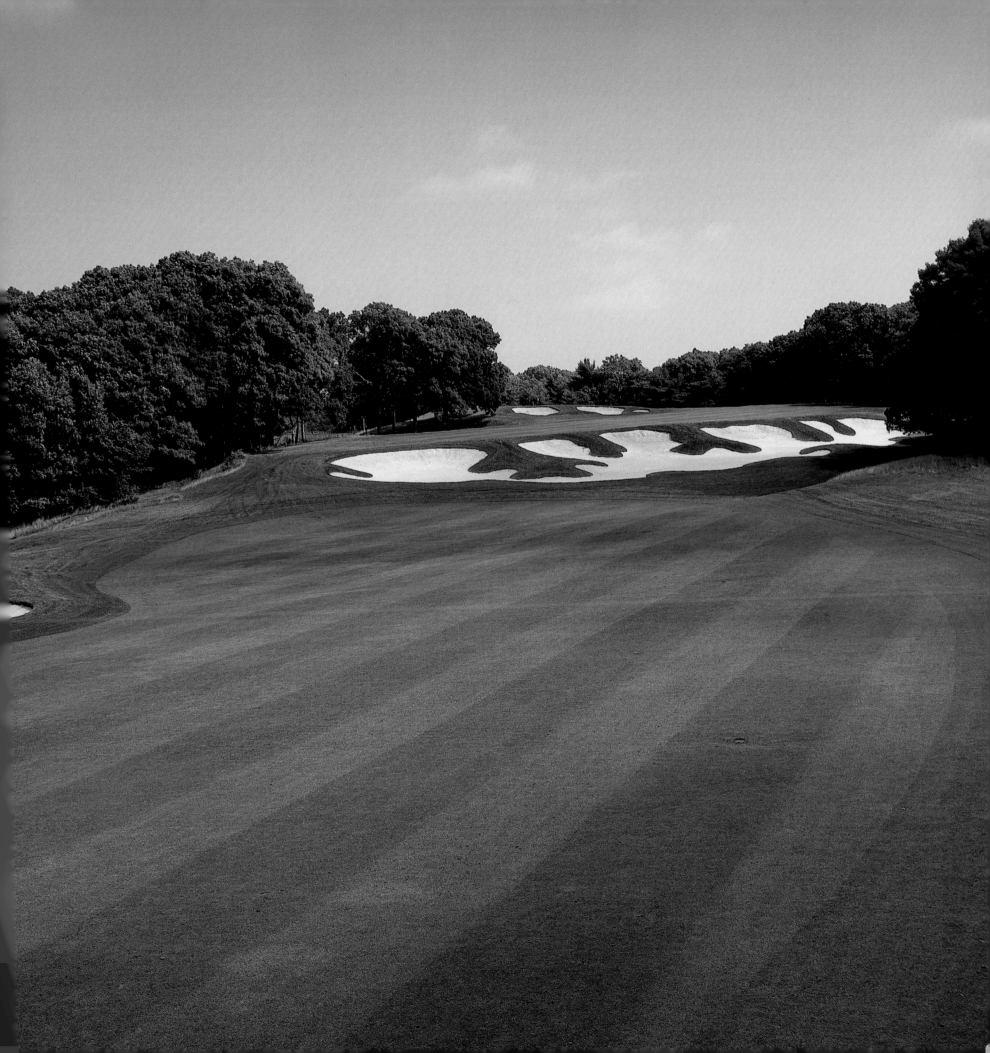

COURSE:	CRYSTAL DOWNS COUNTRY CLUB
HOLE:	8
LOCATION:	FRANKFORT, MICHIGAN
ARCHITECT:	ALISTER MACKENZIE
LENGTH:	550 YARDS · PAR 5

A true three-shot par 5, the eighth at Crystal Downs derives its distinguishing characteristics not from its hazards or extraordinary length, but rather from the abnormalities of its undulations and the increased precision it demands as you draw closer to the green.

These are elements that Alister Mackenzie may have discerned from Pine Valley's fifteenth and later perfected at Augusta National's eighth.

From the back tee, the line is directly over the forward tee to a fairway that undulates like a sea. Those able to place their drive precisely attempt to find a small slot just left of the maple tree that stands in the right rough. At this spot there is some flat relief to be found from what Mackenzie called "subtleties of this nature which make all the difference between a good course and a bad one."

As at Pine Valley's last par 5, the farther a player plays toward the green, the narrower become that player's options. On the left, the fairway slides off into fair but awkward stances that result in a blind, uphill approach to the green.

Should caution have resulted in placement of the second shot for an easy third, the green presents its own riddle. A very narrow neck on the right requires precision for running ground-strokes. Bunkers guard both sides. The putting surface pitches steeply from back to front, and this danger is accentuated by a drop in front of the green, which is experienced by putts too strongly played or overconfident pitches when the hole is front left.

It is always invigorating to negotiate those holes where the hazards are perilous, such as many found at Pine Valley, Cypress Point, Royal Melbourne, St. Andrews's Old Course, or Seminole. And it is fascinating to see how golf's great architects go to the other end of the spectrum to make the same strategic demands using almost no hazards.

Time and again, hole after hole, Mackenzie demonstrated that he could make his point either way but never simply with brute length.

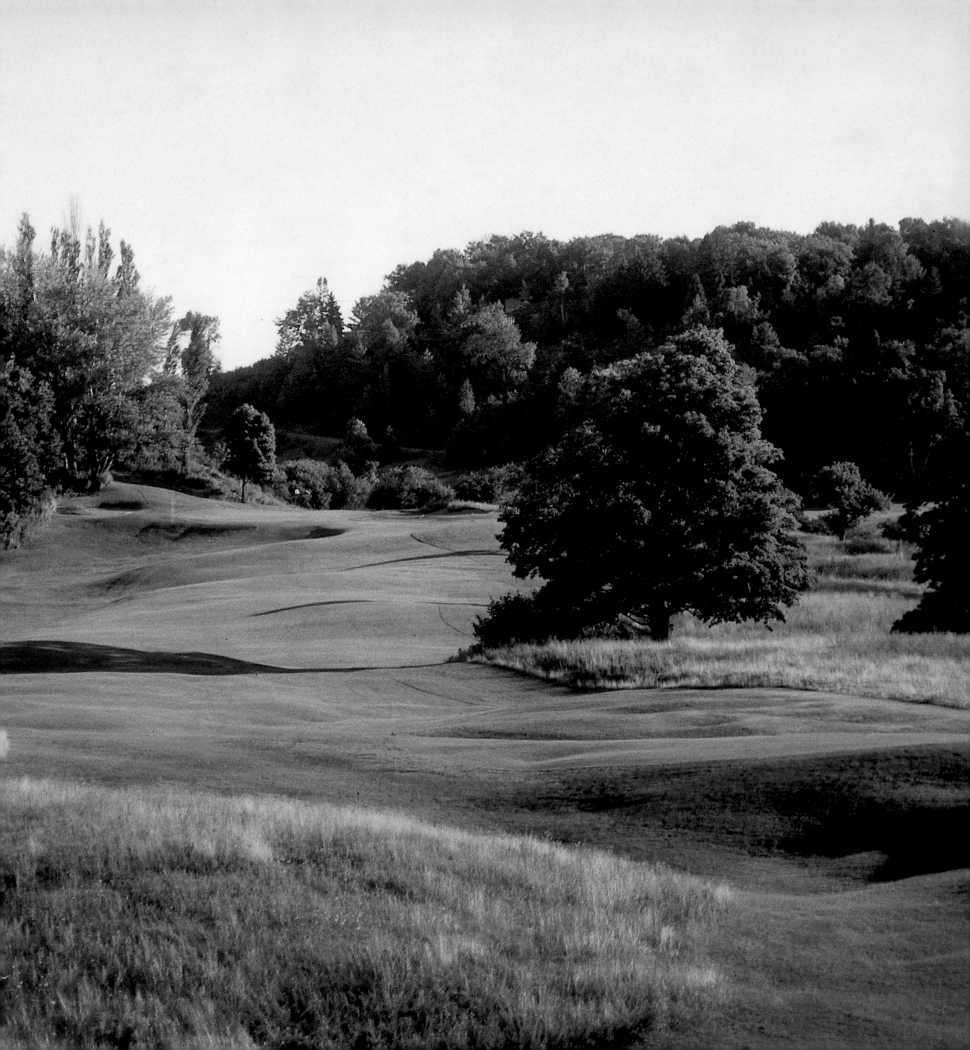

COURSE:	DORADO BEACH HOTEL AND GOLF CLUB (EAST)
HOLE:	13
LOCATION:	DORADO, PUERTO RICO
ARCHITECT:	ROBERT TRENT JONES, SR.
LENGTH:	540 YARDS · PAR 5

As is often the case at the world's most notorious heroic holes, Robert Trent Jones, Sr.'s intentional obfuscation of the line of instinct by the line of charm is the primary design element at Dorado Beach's par-5 thirteenth.

"It is fair to all," Jones has said, "demanding all to be sure, but it demonstrates clearly all the rewards and penalties that should be innate to all great golf holes."

This sort of design is called a zigzag hole or a double dogleg. To work your way around two water hazards, which are located on opposite sides of the fairway, four or five alternate paths can be taken in finding success or failure.

An accomplished player can choose to carry both the water hazards and thereby shorten the distance to the elevated green by nearly one hundred yards. Alternatively, with a strong wind blowing off the Atlantic from behind the green, it may be wiser to avoid the long carry over either water hazard and leave a short pitch into the green.

The lesser player may accomplish par by playing to the right of the first hazard, left of the second, and then either pitching over the water and sand for the third or laying up with the third for a pitch into the green, the rear portion of which slopes to the ocean less than forty yards away.

In all cases, the talent, accomplishment, and good sense of the player is challenged in kind by the strategic elements of the hole. Add to this a warm winter Caribbean day, palm fronds rustling in the breeze, surf on the beach, the subtle glow of a winter tan, and the promise of five more exacting holes before finding the terrace at the clubhouse, and Dorado's thirteenth is an indelible memory.

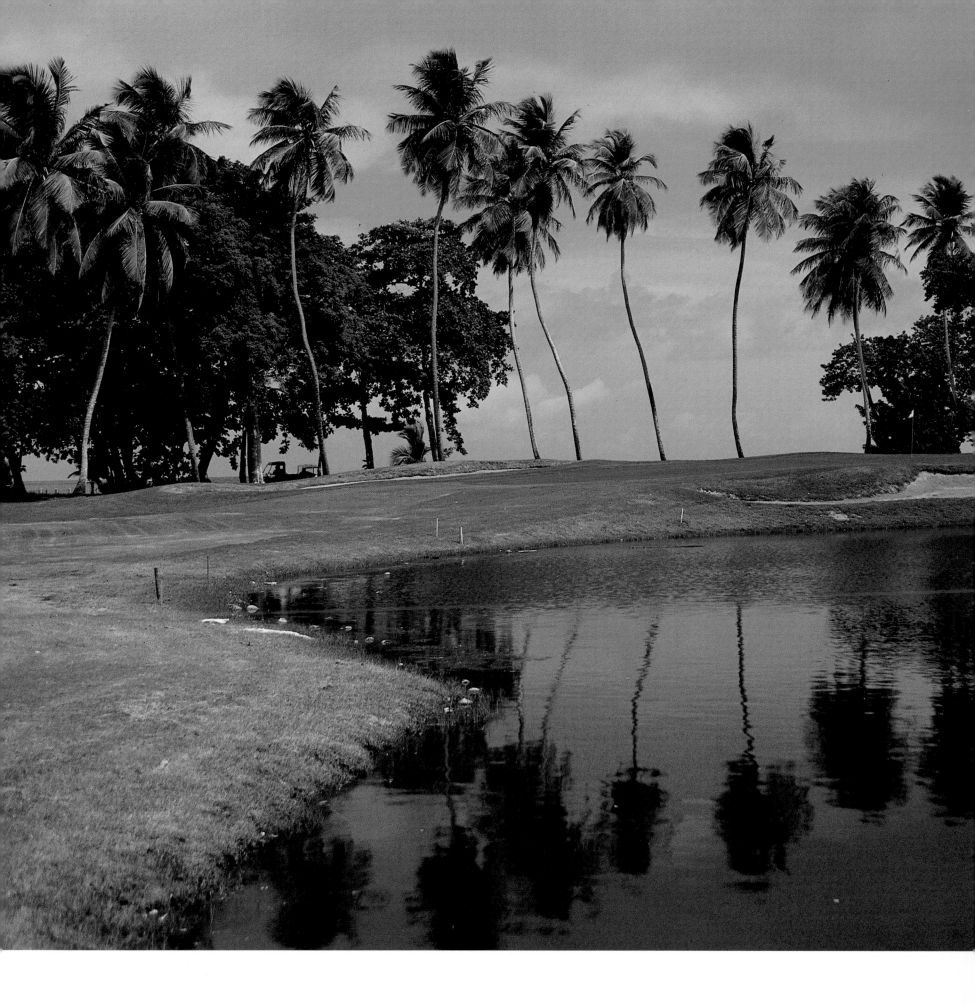

COURSE:	THE DUNES CLUB
HOLE:	13
LOCATION:	MYRTLE BEACH, SOUTH CAROLINA
ARCHITECT:	ROBERT TRENT JONES, SR.
LENGTH:	590 YARDS · PAR 5

Near the midpoint of the last century, Robert Trent Jones, Sr., introduced his interpretation of the heroic hole, which has served as one of the essential identifiers of his innovation in course design.

In 1949, at Myrtle Beach's Dunes Club, Jones shaped the par-5 thirteenth with a variety of tees and approaches that can be configured to tempt the most accomplished player and accommodate the lesser. The sharp dogleg-right around water offers three alternative routes to the well-protected green.

"The difficulties that make a hole really interesting," wrote Alister Mackenzie, "are usually those in which a great advantage can be gained in successfully accomplishing heroic carries over hazards of an impressive appearance, or in taking great risks to place a shot so as to gain a big advantage for the next."

The adjustability of the Dunes's thirteenth adds to its versatility. From the back tee, the better player may see no alternative but to take three in reaching the green. From a forward tee, that same player may be beguiled into attempting more than he or she is able to accomplish. By allowing its length to be adjusted by the position of the teeing ground, the hole maintains its respect even in the face of modern players' prodigious length.

To have foreseen, in 1949, the advancements that golf equipment and physical fitness would make, and the course adjustments such changes would necessitate, is further evidence of Jones's notable place in the past century's practice of golf course architecture. Notable refinements of his heroic hole were built at Dorado Beach—the zigzagging thirteenth—and Las Brisas with its alternate-fairway approach.

COURSE:	EL SALER GOLF CLUB
HOLE:	3
LOCATION:	OLIVIA, VALENCIA, SPAIN
ARCHITECT:	JAVIER ARANA
LENGTH:	534 YARDS · PAR 5

At many of the world's best courses, the third hole provides a nearly indiscernible strategic enticement that can determine the outcome of the competition. Examples that come to mind include Seminole, Carnoustie, Southern Hills, Royal Liverpool, and The National Golf Links.

This lesson was not lost on Javier Arana, who designed El Saler as a tribute to Scottish golf. Located on the Iberian Peninsula's more temperate Costa Blanca, this linksland design jockeys with Valderrama for top honors among all European courses.

Eight of its holes are situated on the coast of the Golfo de Valencia (which means "gulf" of Valencia, not "golf") and gaze eastward toward the Balearic Islands. The remaining ten run through sandy soil and coastline forest.

The par-5 third winds northward through the woodlands. Its 534 yards provide an ideal length for presenting the better player with the dilemma of whether or not to attempt the green in two. The higher handicapper will face enough in the way of length, dogleg, hazards, and trees to demand three precise shots needed for a successful approach to the putting green.

From the tee, the hole begins its sweeping dogleg to the left early. Straightaway, framing the first landing area at the edge of the right rough, two well-shaped fairway bunkers lend definition and a target for the shorter player. The long hitter must drive long and left to carry over the trees on the left and avoid the fairway's bunkers to the right.

The second shot by the weaker player needs to be placed on the left half of the fairway to ensure that the third will avoid the threat of a long bunker guarding the entrance and entire right side of the green. The stronger player is left with a decision: With approximately 250 yards to the hole, a long accurate stroke must be played to thread the green's throat, guarded at the left front by a small bunker and on the right by the long one.

Placement of the hole on the oblong green—running at a slight diagonal to the entry line—can place additional demands on both short and long approaches. The attendant bunkers make precision the primary concern of hole locations toward the front. A rear-left location places the premium on length; rear-right requires length and accuracy.

El Saler's third asks a number of questions in a variety of combinations. How the golfer discerns what is required and formulates an answer within his or her abilities will have a major effect in determining what tone the remainder of the round may take and who will be the eventual champion.

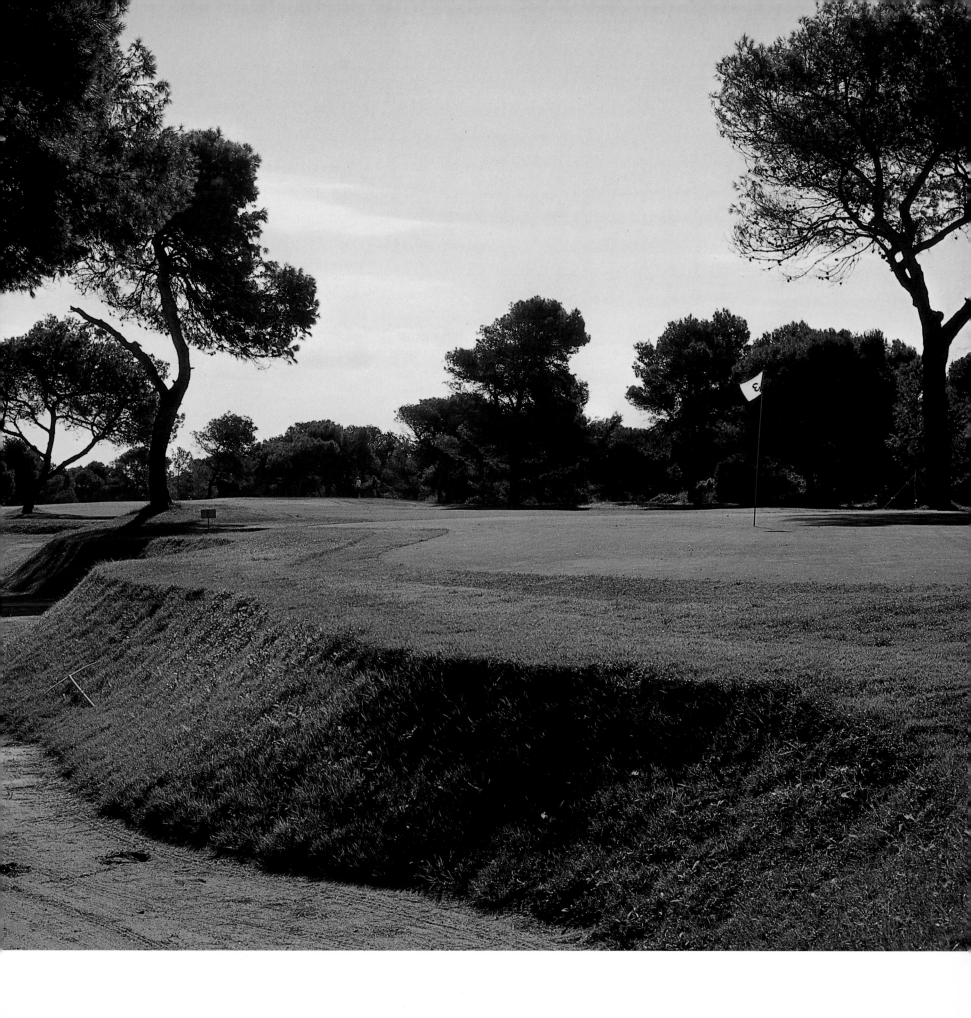

COURSE:	FIRESTONE COUNTRY CLUB (SOUTH)
HOLE:	16
LOCATION:	AKRON, OHIO
ARCHITECTS:	W. H. WAY, ROBERT TRENT JONES, SR.
LENGTH:	625 YARDS · PAR 5

Fueled by the exuberance of Charles Blair Macdonald—Chicago native, the first U.S. Amateur champion, and self-proclaimed originator of golf course architecture—America's Midwest took to golf with gusto, and throughout the twentieth century created many of the world's greatest courses.

Emblematic of the midwestern approach is the sixteenth at Firestone, a strong, strapping, demanding hole requiring strength as well as finesse. The course was a gift to the employees of Firestone Rubber from Harvey Firestone and arrived just before the Great Depression in 1928.

The course's original designer was Englishman W. H. "Bert" Way, who had worked on course construction crews in Europe and was brought to America by Willie Dunn of Shinnecock Hills fame. Before the creation of Firestone's South Course, Way had already made a substantial mark on other important midwestern courses. He built Detroit Golf Club before Donald Ross redesigned it; The Country Club of Detroit before H. S. Colt and Charles Alison redesigned it; and Mayfield Country Club in Cleveland. It was Mayfield where John D. Rockefeller was introduced to his lifelong enthusiasm for golf.

While Firestone has always been regarded as a major test of golf, it was not until Trent Jones's redesign for the 1960 PGA Championship that it earned its reputation for requiring both brains and brawn. When he was finished, Firestone was the longest championship course in America.

The sixteenth is an icon of Jones's work at this time and reflects the questions asked by the course's other seventeen holes. At 625 yards, it is long—so long that Arnold Palmer dubbed it "the Monster" after taking a triple bogey 8 during the 1960 PGA Championship.

The view from the tee is daunting. Even though the hole runs downhill, 625 yards is still a long way. The drive must be struck accurately and with power if one hopes to achieve par. Having to recover from a poor shot usually takes par out of play.

The second stroke is the most difficult because another long shot is required, this time from a downhill lie to a fairway split by a large fairway bunker. If success has been achieved to this point, the third shot requires a pitch to a wide green guarded right and front by a pond, right and rear by two bunkers. When the green is firm and fast and the hole is cut on the right, it is a perilous approach. A par at Firestone's sixteenth signifies that the examination has been successfully passed and the leading players identified.

COURSE:	HIGHLANDS LINKS GOLF CLUB
HOLE:	6
LOCATION:	INGONISH, NOVA SCOTIA, CANADA
ARCHITECT:	STANLEY THOMPSON
LENGTH:	537 YARDS · PAR 5

Mucklemouth Meg, a Scottish lass from Hawick who could reputedly swallow a whole "Bubbly Jock's Egg" (a turkey egg), won golf immortality by giving her name to the sixth at Highlands Links.

This rugged, natural course is regarded by many as the Cypress Point of Canada. At the outermost tip of Cape Breton Island, in the shadow of Mount Franey and within sight of the Atlantic Ocean and the Clyburn River, Stanley Thompson built Highlands Links, which he referred to as his "mountain and ocean course."

Highlands Links's sixth, by the creator of Capilano, Banff Springs, and Jasper Park, reflects Thompson's instinct for the natural and strategic elements of good course design.

"Stanley Thompson in his early days sometimes would use little more than instinct in laying out his courses," wrote John La Cerda in a 1946 edition of *The Saturday Evening Post*. "The most beautiful courses, he is convinced—the one where the greens invite your shots—are the ones which hew most closely to nature."

As a relatively short par 5, the sixth finds its defense among the hazards, undulations, and the oblique angles at which they are positioned. A pond guards the right landing area, which is constricted on the left by trees that line the entire length of the hole. The second shot is played over a belt of rough. While advantage is to be gained by playing a long shot that runs closer to the green, penalty is more likely, as the approach is choked and well bunkered. The entire line of the hole appears completely natural and pleasing to the eye. "Nature must always be the architect's model," Thompson once said. Mucklemouth Meg would be flattered.

COURSE:	HIRONO GOLF CLUB
HOLE:	15
LOCATION:	KOBE, JAPAN
ARCHITECT:	CHARLES ALISON
LENGTH:	565 YARDS · PAR 5

Charles Alison took what he and H. S. Colt had learned on the heathland belt west of London and in 1932 transported it intact to Hirono's fifteenth hole, 250 miles west of Tokyo in the Osaka-Kobe area of Japan.

Parts of Hirono's terrain bear a striking resemblance to the heathland of Sunningdale, Worplesdon, and The Berkshire with its dark, pine woodlands, ravines, and intricate undulations. The frame of golf at Hirono is ideal, and Alison's use of these natural elements was epitomized by his course routing generally and the fifteenth hole specifically: The layout over and around its natural assets forces it to be played as a three-shot hole. It was thirty years before anyone would reach the green with two shots, and it took Jack Nicklaus to do it.

As it's a dogleg-left, any attempt to shorten the hole by taking a line across the corner is thwarted by the placement of a fifty-year-old, one-hundred-foot Kuromatsu (black pine) that stands in the left half of the fairway. In the rough to the right side of the landing area, three bunkers punish drives that leak in that direction. This forces all tee shots to the right half of the fairway and ensures that the hole's 565 yards will be directly confronted and negotiated.

From the tee, the first of two natural ravines faintly appears in the distance defined by characteristically ragged Colt and Alison bunkers cut into its facing. While the crossing bunkers may appear more threatening than they actually are, their primary purpose is to indicate the course of the hole as it turns to the left 175 yards from the green. The second ravine is gentler and its slope provides the defining front lines to the putting green, as do its two bunkers. Two additional bunkers lend depth perception and guard the rear of the green.

During a 1963 exhibition round at Hirono, using persimmon woods with steel shafts, Nicklaus struck a perfect drive of 285 yards to the right half of the fairway. While contemplating his second shot, Nicklaus was told by Hirono's captain that the fifteenth green had never been reached with just two strokes. "Okay," Nicklaus replied with a grin, "I'll try."

A spectator standing only ten yards away remembers the ball leaving Nicklaus's 3-wood "like a jet fighter taking off!" The ball cleared the two bunkers that guard the upslope in front of the green and stopped short of the right-rear hole position.

For the ensuing moments, the spectators stood in stunned silence. Then they erupted into clapping, cheering, and jumping. While Nicklaus had accomplished the impossible, Alison's strategic use of the ravines and bunkers, and the addition of the Kuromatsu, continue to require even the best players to approach the green with three shots. During the 1999 Japanese Amateur Championship, no one reached the fifteenth with just two shots.

COURSE:	LAS BRISAS GOLF CLUB
HOLE:	8
LOCATION:	MÁLAGA, SPAIN
ARCHITECT:	ROBERT TRENT JONES, SR.
LENGTH:	507 YARDS · PAR 5

The golf world has always been enamored with Robert Trent Jones, Sr.'s major presentations of the heroic three-shot hole. The thirteenth at the Dunes, the thirteenth at Dorado Beach, and the eighth at Las Brisas are the best examples.

In each case, the hole is just long enough for the better player's judgment to become clouded and tempted by the lure of reaching the green with two strong shots. Alternatively, the shorter, and sometimes more sagacious player, is offered a less dangerous line that still requires three precise shots.

Opening in 1968, Las Brisas followed Jones's work at Sotogrande. A few miles from Marbella, the course is located in a valley that flows out of the Sierra Blanca and toward Puerto Banus. The sharp peak of La Concha rises above the course providing a sense of scale and drama.

At the eighth, the drive is over a stream that runs up the right side of the wide fairway. The green is back across the water, as is a stand of trees some distance short of it.

The heroic play is to aim the second directly for the green, avoid the stand of trees, and carry the water. A slight opening is available to the right of the left greenside bunker. A more conservative approach is to play a shorter second to the right of the trees and over the water. This must then be followed by a pitch to the green, which is guarded left and right by sand.

Trent Jones was the first of the great American "Okay, show us what you've got" architects. In the 1950s, as improvements in equipment and physical prowess lengthened the distance better players hit the ball, Jones was not content to concede them any advantage. There are other holes, such as Oak Hill's thirteenth, where Jones demands length and judgment. At Las Brisas, and his other heroic three-shotters, he requires length tempered by an acceptance of personal limitation.

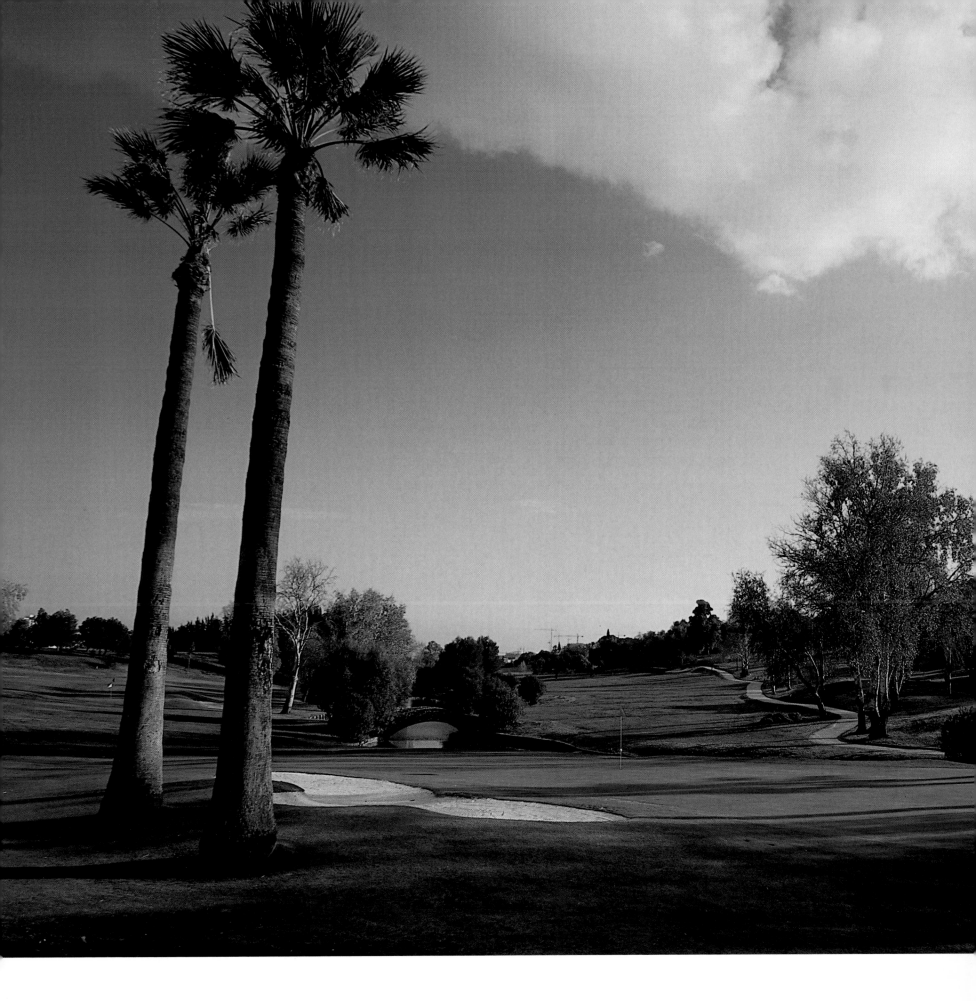

COURSE:	LOS LEONES GOLF CLUB
HOLE:	4
LOCATION:	SANTIAGO, CHILE
ARCHITECT:	ALISTER MACDONALD
LENGTH:	560 YARDS · PAR 5

Upon first glance, this hole seems striking in its simplicity. However, its demand for precision quickly becomes apparent.

The hole runs in a dead straight line for 560 yards. There is just one bunker, placed to the right of the putting green. Entry from the left is guarded by an enormous, perfectly placed tree.

Throughout this list, contrast often draws us to the world's best holes. When catastrophe lingers just yards from an immaculate fairway—such as on Pebble Beach's eighteenth or Royal County Down's first—it is titillating. When the pastoral nature of golf is set side by side with an urban element, as can be found at Los Angeles Country Club or St. Andrews's Old Course, it can be enticing.

Los Leones's fourth has both of these elements. Just outside the course boundary and running the length of the hole's right side is one of Santiago's major boulevards. Walking up the fairway, the player has the unmistakable impression that this wonderful golf course is smack in the middle of one of the world's most vibrant and cosmopolitan cities. The sight of the skyscrapers on the other side of the busy thoroughfare and so close to play is strangely pleasing. The water hazard and out of bounds that come between the fairway and the outside world are not so invigorating.

While the green is reachable with two strong shots, they must be played to exact positions. The best line from the tee is to the right half of the landing area. Of course, this is also the riskiest line because of the out of bounds, lateral water hazard, and trees that tightly insulate the border of the course from the outside world.

From the right side of the fairway, an entrance for the second shot is gained to the green. From the left side of the fairway, such an entrance is closed by the majestic tree, parked left front off the putting surface. On the right, the bunker proves a benevolent hazard, saving errant shots from running out of bounds.

Los Leones's fourth tantalizes the player with a difficult but clear opportunity for birdie or double bogey. In match play, such as 1998 World Amateur Team Championship, the gain or loss can be sustained early enough in the round to permit recovery. In stroke play, discretion may be the better part of valor.

COURSE:	MUIRFIELD (HONOURABLE COMPANY OF EDINBURGH GOLFERS)
HOLE:	9
LOCATION:	GULLANE, EAST LOTHIAN, SCOTLAND
ARCHITECTS:	OLD TOM MORRIS, H. S. COLT/ TOM SIMPSON
LENGTH:	504 YARDS · PAR 5

Muirfield's ninth is ingenious and unusual in that it plays with as much difficulty into the wind as it does with it. Of all the demands Muirfield makes of the championship player, perhaps no hole asks more.

As with all the holes at the club known formally as the Honourable Company of Edinburgh Golfers, everything that is expected of the golfer can be seen from the teeing ground. The fairway chokes gradually from a generous 50 yards, at about 250 yards from the tee, to only half that at the 300-yard mark.

To the right is high fescue rough; to the left, the fescue pinches the landing area. Also to the left are two strategically placed bunkers, which present still another hazard to any attempt to overpower the hole from the tee. Beyond the bunkers and the fescue on the left, a five-foot-high greystone wall marks the boundary and runs the length of the hole. Adding still more drama, if not trouble, behind the tee stand the Archerfield Woods, which Robert Louis Stevenson made famous as the Garden Sea Wood in "Pavilion on the Links."

When a player is playing into the wind, the danger is that an extra effort will produce a hooking shot over the wall and out of bounds. Such was the fate of Peter Thomson in 1959 while in quest of his fifth Open Championship. The combination of the wind, rough, and bunkers makes careful play from the tee a necessity and, therefore, the likelihood slim of reaching the green in two.

Downwind the prospects are even more dangerous. Indeed, it is downwind when the dilemma of the ninth is fully presented. The landing area for a downwind drive is half the width of that when playing into the wind. Hence, downwind promises a greater likelihood of finding the rough left or right. Should the drive be successfully played to the narrowing neck in the fairway, the result is that the second shot will have a line to the green interrupted by five diagonal bunkers that lie right and short of the putting surface. Beyond the green and also on this line, the greystone wall marks the out of bounds.

Like so many of the world's great holes, Muirfield's ninth requires patience and does not respond well to being pressured or overpowered. Arnold Palmer learned this in 1966 when, rather than laying up off the tee, he used a driver and finished with a 6.

COURSE:	OAK HILL COUNTRY CLUB (EAST)
HOLE:	13
LOCATION:	ROCHESTER, NEW YORK
ARCHITECTS:	DONALD ROSS, ROBERT TRENT JONES, SR., GEORGE AND TOM FAZIO
LENGTH:	596 YARDS · PAR 5

"Oh my!" Gary Player is reported to have cried out when he first came to Oak Hill's thirteenth. "Have you fellows ever seen anything like this?"

"Never!" responded Jack Nicklaus and Arnold Palmer.

Unlike some of the long, notable par 5s that play downhill, this is a full, three-shot hole playing nearly 600 yards uphill with a slight dogleg to the right. While it may seem that only brute length is required, the changes that Robert Trent Jones, Sr., made to the hole in 1955 penalize those who are only strong and not cautious.

Allen's Creek crosses the fairway at a perpendicular about three hundred yards from the tee, thus becoming a concern for longer hitters. The second shot requires a fairway wood that avoids the fairway bunkers on the right and sets up a proper line of approach to the green.

The steepest climb comes after a medium or short iron is played to the green, which is set in a natural bowl that slopes dramatically from back to front and is guarded by two bunkers at its entrance and six more at the rear.

The club's magnificent oak trees, whence it derives its name, form a scenic backdrop, and in a grove that towers over the green from the left is "the Hill of Fame." This hillside provides the best vantage point on the course and can accommodate several thousand spectators. It was from this place that the deafening roars came in 1980 when Jack Nicklaus tied Walter Hagen with his fifth PGA Championship, in 1989 as Curtis Strange was en route to winning two consecutive U.S. Opens, and when Fred Couples chipped in at the 1995 Ryder Cup.

The Hill of Fame also is the spot that the club uses to honor golf's notable men and women by affixing brass plaques to the huge trees. Honorees include Dwight D. Eisenhower, Bob Jones, Bill Campbell, Arnold Palmer, Jack Nicklaus, Babe Didrikson Zaharias, Joe Dey, and many others who are cited for "their fine qualities of heart and mind and their personal contributions to some phase of human welfare and uplift."

COURSE:	OAKMONT COUNTRY CLUB
HOLE:	4
LOCATION:	OAKMONT, PENNSYLVANIA
ARCHITECTS:	HENRY AND WILLIAM FOWNES
LENGTH:	564 YARDS · PAR 5

Oakmont may be the archetypal U.S. Open course. Penal in its conception, it has identified champions—Tommy Armour, Sam Parks, Ben Hogan, Jack Nicklaus, Johnny Miller, and Ernie Els—who are more than adequate proof of the course's relentless premise that precision will be rewarded while anything less will be necessarily estranged.

It is tied with Baltusrol for most U.S. Open championships, but it is only at Oakmont that all seven have been played over the same course. (Baltusrol has used three courses to accomplish the same feat.)

Not content for a competitor to have but one encounter with "the Church Pews" bunker, the three-shot fourth hole returns us to it, this time on the left. As at the third, the Church Pews is balanced on the opposite side of the driving area by a cluster of five severe bunkers. Playing downhill at 564 yards, this is a birdie opportunity for long hitters. However, at the fairway's elbow, before dipping down and right to the green, a multitude of bunkers continues to demand the need for precision.

Sixteen of Oakmont's 180 bunkers are seen at the fourth. Founder Henry C. Fownes and his son, William C. Fownes, wanted to create a links-type course. However, since the course was situated three hundred miles inland in the clay soil of western Pennsylvania, pot bunkers were an impossibility. With Yankee ingenuity, they invented an original alternative, the shallow, furrow-raked bunker, in hopes that it would make the same competitive demands as the linksland pot bunker.

A century ago, there were 350 bunkers at Oakmont. To compensate for the shallowness required by the clay, the Fowneses had each bunker raked with a heavy implement that created two-inch furrows, two inches apart. Like corporal punishment, this practice was abandoned in the late 1950s. However, the intervening forty years and numerous championships had been clearly defined by the practice.

By 1953, the bunker count at Oakmont had been reduced to 250; by 1973, there were 187; and at the time of Els's victory in 1994, there were 180. Every one difficult, but only one Church Pews.

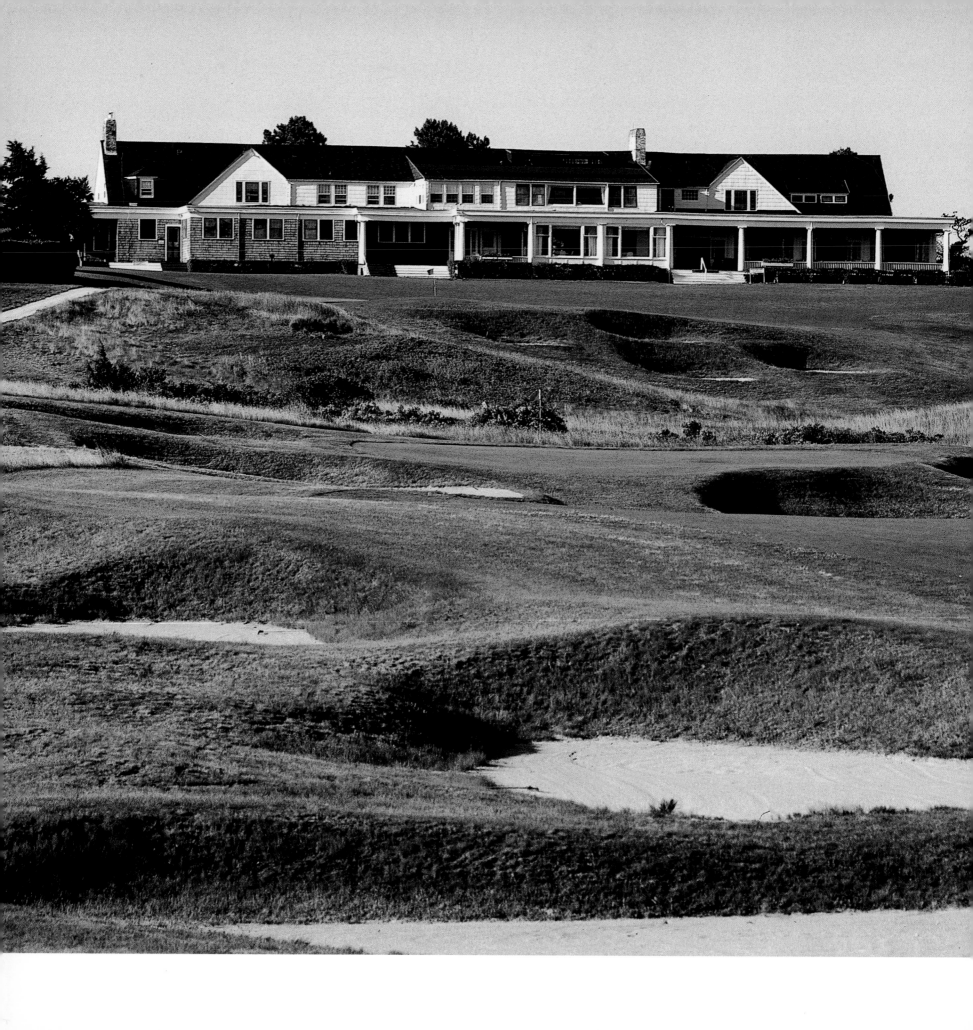

COURSE:	SHINNECOCK HILLS GOLF CLUB
HOLE:	16
LOCATION:	SOUTHAMPTON, NEW YORK
ARCHITECTS:	WILLIAM F. DAVIS, WILLIAM S. FLYNN/HOWARD TOOMEY
LENGTH:	542 YARDS · PAR 5

Strategy, beauty, and historical importance are the usual qualities that determine golf's greatest holes. Shinnecock's sixteenth exemplifies all three.

At 542 yards, it is short among the world's notable par 5s. But any "lack" of length is compensated for by the fact that it plays into the prevailing wind, and that bunkers and heavy rough prevent its being overpowered. The wise player does not attempt to reach the green with 2 strokes. The ribbon of fairway undulates in the driving area and again before reaching the green, so a premium is placed upon leaving the ball in a relatively flat spot from which to play the next shot.

Bunkers left and right guard each turn of the S-shaped fairway. Beyond the sand lies the defining golden fescue, which is grown to knee height. Five bunkers guard the front of the green, and long shots easily run through the putting surface and down the slope to its rear.

Quietly enthroned on the hill above and behind the green is the stately and beautifully proportioned clubhouse in gray shakes and white trim. An icon of golf worldwide, it is America's first golf clubhouse and was designed in 1892 by Stanford White.

This is one of the game's great stages, and just like a premier theater of London's East End or New York's Broadway, it accomplishes the desired effect of elevating the player's game and the spectator's experiences to the highest level. In 1930, when William S. Flynn and Howard Toomey reworked Willie Davis's original design, Shinnecock was destined to attain (and consistently retain) preeminent status among the world's great courses.

In the shadow of its great clubhouse, the second U.S. Amateur and U.S. Open Championships were played in 1896. During the following century, Shinnecock hosted two more U.S. Open Championships (1986, 1995), the 1900 U.S. Women's Amateur, the 1967 U.S. Senior Amateur, and the 1977 Walker Cup. The U.S. Open will return in 2004.

COURSE:	SOUTHPORT & AINSDALE GOLF CLUB
HOLE:	16
LOCATION:	SOUTHPORT, MERSEYSIDE, ENGLAND
ARCHITECT:	JAMES BRAID
LENGTH:	510 YARDS · PAR 5

A sleeper, or sleeper-faced, bunker is not something that one sees much of these days. But in 1923, when James Braid laid out a "proper eighteen" at Southport & Ainsdale, it was really quite the thing.

A "sleeper" is how the British refer to a railroad tie. The stout wooden beam was laid beneath the tracks to absorb shock, thus making it easier to sleep while traveling by rail. On sandy, wind-blown golf courses around Great Britain and Ireland, sleepers were used to reinforce the banks of hazards, helping them retain their shape and, therefore, their menace. Southport & Ainsdale's sixteenth, with the sobriquet "Grumbley's," has as fine an example of a sleep bunker as one could hope to find.

The hole plays 510 yards directly into the prevailing wind, and the drive must be hit on a line between the tight fairway bunkers. Out of bounds guards the right side.

The second shot then must clear the towering sand hills and the enormous, sleeper-faced bunker, which actually is two. The hill is fortified by a long wall of black sleepers below which, and blind to the second shot, lie two round bunkers.

It was at S & A in 1933 that Samuel Ryder, the English seed merchant who endowed the competition, watched his last Ryder Cup match and the last British victory for twenty-four years. This was just the fourth such meeting and neither side had yet won on the other's turf.

During the two-day competition, Grumbley's yielded eleven birdies, one eagle, and two bogeys. The eagle was taken on day one by the British team of Abe Mitchell and Arthur Havers in the second foursomes match. It resulted in a 3 and 2 victory over Olin Dutra and Denny Shute. Great Britain's 1-point margin of victory was the smallest until 1953.

The Ryder Cup returned to S & A in 1937 and the result was the first U.S. victory on British soil. This was the last Ryder Cup match to be played for ten years, as World War II and its resulting hardships nearly extinguished interest in this international rivalry of professional golf and goodwill.

COURSE:	SPERONE GOLF CLUB
HOLE:	16
LOCATION:	BONIFACIO, CORSICA, FRANCE
ARCHITECT:	ROBERT TRENT JONES, SR.
LENGTH:	580 YARDS · PAR 5

As we have become more mobile and better informed regarding the world's great golf courses, the ability to find treasured enclaves has lessened. So often, after driving hours to a remote course, one finds some Tour bus in the car park. Not so at the southern tip of Corsica, where Sperone oversees the Strait of Bonifacio.

Although some lament the difficulty of reaching such a spot, therein lies its protection from the peering world. The sense of discovery is heightened by the excellence of the golf. The ubiquitous and talented Robert Trent Jones, Sr., exercised his eye for the strategic and beautiful on its rocky shore.

Similar to Pebble Beach's eighteenth and Casa de Campo's eighth, Sperone's sixteenth is bordered by the sea and one-hundred-foot cliffs for the entirety of its left side. The tee is built upon a narrow piece of craggy shoreline that challenges the player to balance his greed against his better judgment. While the landing area is wide, Jones employs his always successful par-5 strategy of demanding a more dangerous line be taken in order to reach the green with a long second shot.

Trent Jones has often stated that every hole should be a hard par but an easy bogey. Such is the case at Sperone's sixteenth. No matter how well placed the drive, the longer players stand in this magnificent setting, with the glittering Lavezzi Islands and Sardinia in the distance, and ponder their mortality. Can the second shot be struck perfectly? Will it fall against the cliffs? Will the bunkers save it? Will the wind push it to the gorse-like rough? Is it worth the risk?

With a good round going, the questions might best be answered conservatively by playing short. But how often will you stand in this place and have such an opportunity?

As the most widely known of golf's architects, and perhaps the most influential, Trent Jones always had an innate sense of timing. He knew just when to present the problems and could not resist confounding them with gorgeously distracting settings. Sperone's sixteenth epitomizes the premise of an easy bogey and a difficult par.

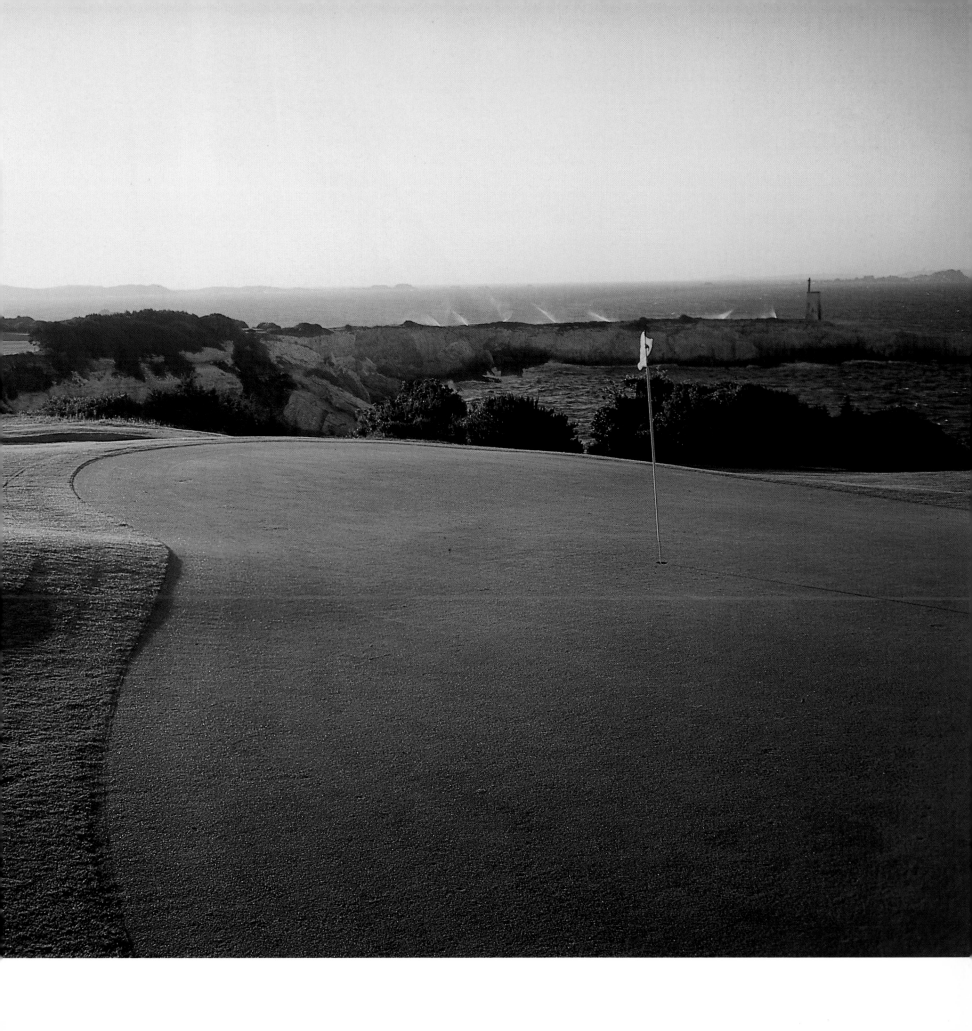

COURSE:	SPYGLASS HILL GOLF CLUB
HOLE:	1
LOCATION:	PEBBLE BEACH, CALIFORNIA
ARCHITECT:	ROBERT TRENT JONES, SR.
LENGTH:	600 YARDS · PAR 5

Great golf courses do not always open with great holes. Spyglass Hill does, its first a fearsome gateway signaling the test that lies ahead. Such an opening leaves an impression: The word "breathless" comes to mind.

Beginning with a par 5 is a device sometimes used by golf course architects to afford a better pace of play. It gives the player a bit more time to acquire a pace or rhythm before being asked to putt.

This opening hole, however, does not communicate a kindness of pace or be a concern for comfort. Indeed, as is so often the case with Robert Trent Jones, Sr.'s best work, strong questions are asked immediately and without disguise.

Reminiscent of Jones's sixteenth at Firestone, the first at Spyglass Hill plays very long and downhill. The sweeping dogleg to the left must be negotiated with a drive from a tee chuted by Monterey pines and flanked by the clubhouse. When you stand upon this tee, nothing is particularly clear except that something major lies ahead. The drive must find the center or right half of the fairway to set up the sec-

ond: Too far right will mean pitching out from under more pines; too far left and the rough may also allow nothing more than a less than full recovery.

When originally constructed in 1966, the hole played around a lone great pine in the left half of the fairway about 150 yards from the green. When it met its demise, it was replaced by three smaller trees. The closer that one plays to them, the better the resulting line to the green. However, it is too easy for an imperfectly struck ball to be stopped or deflected by one of those sentinels. Hence, a decision has to be made to go left or right, either easing and lengthening the third, easing and shortening it, or shortening and penalizing it with nasty rough. This is classic Trent Jones strategic design.

Having found a spot from which to approach, the player then finds a plateau green guarded by a huge bunker and scrappy, sandy scrub. As reward for the troubles that have been contemplated or endured so far, a panorama of the deep blue Pacific Ocean falls as a backdrop and runs to the horizon. This is a momentous beginning.

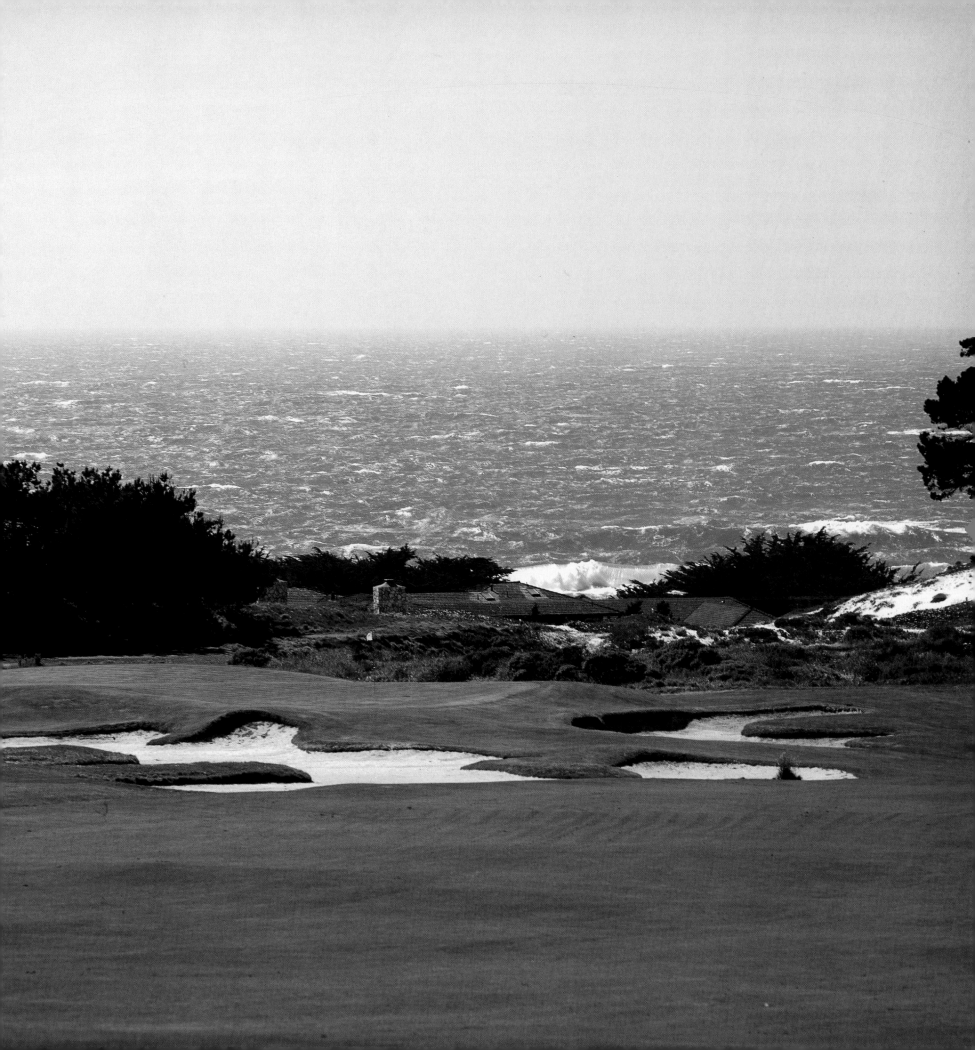

COURSE:	VALDERRAMA GOLF CLUB
HOLE:	4
LOCATION:	CÁDIZ, SPAIN
ARCHITECT:	ROBERT TRENT JONES, SR.
LENGTH:	535 YARDS · PAR 5

As the venue for the Ryder Cup matches' first visit to continental Europe, in 1997, Valderrama presented the world's best players with the requisite match-play dilemmas. At no hole was this more evident than the par-5 fourth.

Robert Trent Jones, Sr.'s first European design was Sotogrande, completed in 1965. Success there sowed the seeds for a second course, Sotogrande (New) in 1980, a Trent Jones combined design with Cabell Robinson. Shortly thereafter, Sotogrande (New) was spun off to become Valderrama.

Valderrama has steadfastly established itself as the renowned golf course on the continent of Europe. Since the late 1980s, it has annually hosted the Volvo Masters. The 1997 Ryder Cup put it firmly in a position of leadership that was cemented in 1999 when it held the WGC American Express Championship.

The fourth hole is widely considered the best on the course. From its high tee, everything lies before you with nothing hidden. Essential to Trent Jones's best par-5 architecture, there is risk and reward to be contemplated even before the drive is struck.

Beautifully framed by oak and cork trees, the landing area is beguiling in its generosity as it offers wide reception to the right. However, any thought of making birdie must take advantage of a line that runs along the left side of the fairway, close to the shaded white sand bunkers.

After you reach the fairway with a well-placed drive played into the prevailing wind, the ante goes up. The long, two-tiered green is provocatively guarded on the right and behind by water, and on the left by sand. A narrow throat at the left front provides limited ground entrance to the putting surface.

Only a perfectly played fairway wood will find the green. In most cases, the better part of valor is a strategically placed lay-up that results in a nervous half wedge to the difficult green.

Valderrama's fourth demands all that a great three-shot hole must ask. Visually, everything seems possible from the tee. Careful judgment and well-executed strokes will result in reward, it can be imagined. But miss by inches and what might have been birdie will easily exceed par.

COURSE:	WENTWORTH GOLF CLUB (WEST)
HOLE:	17
LOCATION:	VIRGINIA WATER, SURREY, ENGLAND
ARCHITECTS:	H. S. COLT/CHARLES ALISON
LENGTH:	571 YARDS · PAR 5

The intrigue of the heathland golf courses that lie close to London is fully demonstrated at Wentworth's seventeenth. H. S. Colt's extensive influence over golf architecture during the early part of the last century was honed in this part of England. It was here that he found the grand isolation that is exhilarating in its contrast to the bustling environs of London's outskirts.

It is one thing to feel such isolation on the shores of Scotland's firths or along the Irish coast. But to experience it within a short train ride of London's center offers its own unique contrast.

Walking over the small hill to Wentworth's seventeenth tee, the player is taken by the juxtaposition of these elements. Behind you sits a large country house similar to so many in this part of England. Before you lies rough heathland intersected by a walking path from the tee to the fairway. The hole is bordered on both sides by tall trees, often swept by mist and fog.

Out of bounds runs the entire length of the hole's left side. Strategic advantage is gained by taking a line to the left of center. However, Colt was very clever here in that the line to the left flirts with the danger of out of bounds while the left-to-right canting of the fairway emphasizes the difficulty of finding such an advantage. The risk and reward of this hole is beguiling.

The second shot is played over the brow of the hill to a blind green. A large oak behind the putting surface offers a target. The downhill slope of the fairway, as it runs to the entrance of the green, adds temptation for those wishing to reach with their second. The tightness of the target is made more so by the out of bounds on the left and the steep slope that runs from the right of the green down to the walking path. There are no bunkers, but definition is provided by the trees and bunker-like undulations cut at the right rear of the green.

By the time Colt and his partner Charles Alison came to Wentworth, their work was well known and widespread. Among a list too numerous to record here, Colt had built Alwoodley (1907) and County Sligo (1922) with Alister Mackenzie, the Eden at St. Andrews (1912), The Country Club of Detroit (1914), and had performed numerous important renovations from Biarritz to Belfast.

The 1953 Ryder Cup, which was the most hotly contested in twenty years, was held here with the Americans eking out victory by just 1 point. In his greatest year, Ben Hogan did not play in this event because he had limited his schedule to four-day, seventy-two-hole, stroke-play events. At this time, both the Ryder Cup and the PGA Championship included thirty-six-hole days that Hogan, just four years after the near-fatal car crash, chose to avoid.

FOLLOWING PAGES: *Soon-to-be 1913 U.S. Open champion Francis Ouimet*
surveys his putt at the eighteenth green at The Country Club (page 273).

THE FIVE HUNDRED

THE AMERICAS

Golf may not have been invented in North America, but there's no question the game has flourished there more than anywhere else. It's the stage for the world's most highly competitive professional tour, and also boasts more *Golf Magazine* top one hundred golf courses than any other region. The various settings lend themselves to a wealth of great golf holes, with terrain ranging from the Canadian Rockies to the shores of the Caribbean.

In the early twentieth century, British-born architects such as Donald Ross, Alister Mackenzie, and Stanley Thompson came to North America, bringing their knowledge of course design and passing along the secrets of the trade to the next generation of homegrown apprentices. This process has resulted in a thrilling variety of golf designs throughout the continent.

South American golf has historically been concentrated within the borders of Argentina, Brazil, and Venezuela, but as our list demonstrates, that is changing: Colombia, Uruguay, and Chile have holes in the top five hundred.

UNITED STATES

PAR 3

Augusta National Golf Club ✦ 12

LOCATION: AUGUSTA, GEORGIA

ARCHITECTS: ALISTER MACKENZIE/ROBERT TYRE JONES

LENGTH: 155 YARDS · PAR 3

It is nearly impossible to picture "the Golden Bell," as the club named it, without the azaleas in bloom and the crowd at the Masters. This hole is perfect theater. A short iron is all that is required, but it must be exactly measured as the green is narrow and bracketed by trouble—Rae's Creek in front, the beautiful azaleas and other vegetation behind. The foremost demand here is judgment. • This hole is showcased on pages 84–85.

Baltusrol Golf Club (Lower) ✦ 4

LOCATION: SPRINGFIELD, NEW JERSEY

ARCHITECTS: A. W. TILLINGHAST/ROBERT TRENT JONES, SR.

LENGTH: 194 YARDS · PAR 3

Robert Trent Jones, Sr., who redesigned this hole after the 1954 U.S. Open, made the most improbable ace in history while trying to convince the members that "the hole is not too tough." Others would disagree. The courageous tee shot is all carry over the pond, while two deep bunkers lurk behind the sadistically sloping green. Imagine how much more dramatic the fourth would be if it came toward the end of the round.

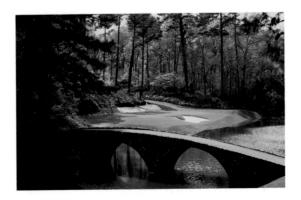

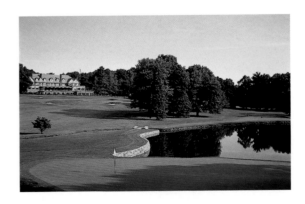

Bay Hill Club ✦ 17

LOCATION: ORLANDO, FLORIDA

ARCHITECTS: DICK WILSON, ARNOLD PALMER

LENGTH: 223 YARDS · PAR 3

When the pin is cut on the back-right portion of this green, even the best players in the world hesitate to fire at it. To the player with a long iron in hand and the Bay Hill Invitational on the line, the green looks about as deep as a kiddie pool, and equally hospitable. But it's not impossible. During a casual round, Arnold Palmer once dunked a 3-iron shot in the pond before switching to a 2-iron and holing out for a routine 3.

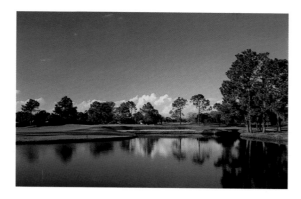

Bel-Air Country Club ✦ 10

LOCATION: LOS ANGELES, CALIFORNIA

ARCHITECTS: GEORGE C. THOMAS/JACK NEVILLE

LENGTH: 200 YARDS · PAR 3

Having laid out the front nine, Thomas and Neville had to find new land for the back nine after the original site was sold. The story is told that the architects came to the edge of a canyon and decided that if the 150-yard carry could be negotiated, they would have found their way. With a putter, the chasm was flown and a dramatic all-or-nothing par 3 was born. Players cross via the "swinging bridge" that gives the hole its name.

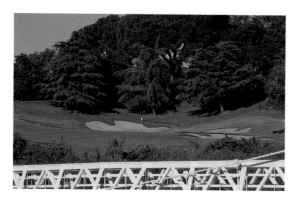

Brook Hollow Golf Club ✦ 16

LOCATION: DALLAS, TEXAS

ARCHITECTS: A. W. TILLINGHAST, BEN CRENSHAW/BILL COORE

LENGTH: 220 YARDS · PAR 3

Ben Crenshaw tried to take pity on the average golfer, shortening this hole by 15 yards during a 1992 course renovation. But Tillie built this to be a one-shotter for the ages, and that is how it remains. It plays uphill and into the prevailing wind, with a large, sloping green that makes putting a survival test. Greats from Ben Hogan (1946 Dallas Open) to Crenshaw (1972 Trans-Mississippi Cup) to Jay Sigel (1987 U.S. Mid-Amateur), all winners on this layout, happily escaped with pars.

The Challenge at Manele ✦ 12

LOCATION: LANAI, HAWAII

ARCHITECT: JACK NICKLAUS

LENGTH: 202 YARDS · PAR 3

It's ironic that on Jack Nicklaus's friendliest public-access design you'll find one of the scariest tee boxes in golf. Vertigo sufferers beware: The tiny clifftop back tee on this dramatic one-shotter may have you clinging to the ball washer. Hitting the green requires clearing a 150-foot-high chasm of Pacific waters, and that's after settling your nerves enough to just make contact.

Champions Golf Club (Cypress Creek) ✦ 12

LOCATION: HOUSTON, TEXAS

ARCHITECT: RALPH PLUMMER

LENGTH: 213 YARDS · PAR 3

The first of a superb three-hole stretch at this former Ryder Cup, U.S. Open, and Tour Championship site, Cypress Creek's twelfth normally isn't too intimidating for the pros unless the wind is swirling. For mere mortals, even famous ones, it's another matter. The water guarding the green was christened Bob Hope Lake, as he was the first person to hit a ball into it shortly after the course's opening in 1959.

The Creek Club ✦ 11

LOCATION: LOCUST VALLEY, NEW YORK

ARCHITECTS: CHARLES BLAIR MACDONALD, SETH RAYNOR

LENGTH: 195 YARDS · PAR 3

"The Island" is just that, surrounded by a tidal inlet out of which players can sometimes hit their off-line tee shots. Reminiscent of Macdonald's design at Yale University's ninth hole, the green at the eleventh is massive (84 paces long) and has a deep swale bisecting its surface. Until a 1992 course renovation, the grass in front of the swale was fringe, but it was then shaved down to become part of the green, creating a host of interesting pin positions.

Crooked Stick Golf Club ✦ 13

LOCATION: CARMEL, INDIANA

ARCHITECT: PETE DYE

LENGTH: 182 YARDS · PAR 3

Crooked Stick will always hold a place in golf's collective memory as the site where we got our first real glimpse of John Daly, who overpowered the monstrous course to win the 1991 PGA Championship. The thirteenth was not exempt from his astounding length, as he hit an 8-iron on this tee all four days while most other players were hitting 6-irons. On Sunday, Daly drained a 25-foot birdie putt here to pull 5 strokes ahead of Bruce Lietzke.

Cypress Point Club ✦ 15

LOCATION: PEBBLE BEACH, CALIFORNIA

ARCHITECT: ALISTER MACKENZIE

LENGTH: 139 YARDS · PAR 3

Less famous, perhaps, than the colossal par 3 to follow, number 15 at the "Sistine Chapel of Golf" is in many ways more beautiful, dramatic, and playable. It is the first of three holes occupying a lion's paw of rock thrust into the Pacific, and the platform tee is propped up on headlands sixty feet above a roiling sea that ebbs and flows in a narrow cove. A half-dozen bunkers ring the gently contoured tricorn-shaped green. • This hole is showcased on pages 10–13.

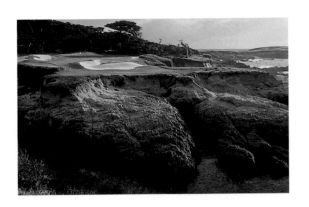

Cypress Point Club ✦ 16

LOCATION: PEBBLE BEACH, CALIFORNIA

ARCHITECT: ALISTER MACKENZIE

LENGTH: 233 YARDS · PAR 3

From the tee, the carry is 233 yards over a surging ocean surf to a putting green framed by gray, craggy rocks, circled by bunkers, and backdropped by the horizon of the Pacific Ocean. The sixteenth is truly memorable. However, it initially worried architect Alister Mackenzie because there did not appear to be a sufficiently easy route for the weak player. He needn't have worried: He later saw one player beat another by using a putter to get around the water. • This hole is showcased on pages 92–93.

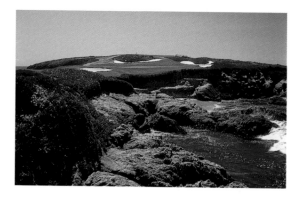

Desert Mountain Golf Club (Geronimo) ✦ 18

LOCATION: SCOTTSDALE, ARIZONA

ARCHITECT: JACK NICKLAUS

LENGTH: 197 YARDS · PAR 3

Requiring one last, solid swing, the eighteenth puts an exclamation point on a course full of dramatic forced carries. It's a do-or-die tee shot, as the intervening canyon is fit only for rattlesnakes and a full assortment of desert flora—not for golf balls. Mounds ring the two-tiered green, which is also guarded by sand traps both short and long. A shot not staying on the green here will test the short game abilities of just about anyone.

East Lake Golf Club ✦ 18

LOCATION: ATLANTA, GEORGIA

ARCHITECTS: TOM BENDELOW, DONALD ROSS, GEORGE COBB, REES JONES

LENGTH: 232 YARDS · PAR 3

Who says par-3 finishing holes are second-rate? It didn't seem to bother Bobby Jones, who once made East Lake his home course, or Hal Sutton, who defeated Vijay Singh in a playoff during the 1998 Tour Championship. After hitting a 4-wood shot into the greenside bunker on the last hole of regulation, Sutton went with the same club again in the playoff—and stuck the ball 5 feet from the hole for the winning birdie.

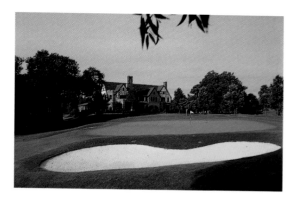

Essex County Country Club ✦ 11

LOCATION: WEST ORANGE, NEW JERSEY

ARCHITECTS: A. W. TILLINGHAST, SETH RAYNOR, CHARLES BANKS

LENGTH: 202 YARDS · PAR 3

This nerve-rattling tee shot is a prime example of why Essex County's back nine is often referred to as the toughest in the state. The elevated property is subject to winds, making the multiple hazards between tee and green look virtually unavoidable. A snaking gully must be carried twice, while a ten-foot-deep bunker short and right of the green is like a magnet for errant shots. The green itself has a ridge separating the right and left portions, adding difficulty to lag putts.

Fox Chapel Golf Club ✦ 6

LOCATION: PITTSBURGH, PENNSYLVANIA

ARCHITECT: SETH RAYNOR

LENGTH: 192 YARDS · PAR 3

An abundance of trees and an incredibly difficult green present the main challenges on this hole, whose character reflects the famous Redan hole at North Berwick in Scotland. The oblong green is bisected by a mound that steadily rises toward the back, tilting the putting surface from back to front and side to side. Pins cut on the severely sloping left portion are virtually inaccessible, and one bunker on each side penalizes shots that stray too far off target.

Garden City Golf Club ✦ 2

LOCATION: GARDEN CITY, NEW YORK

ARCHITECTS: DEVEREUX EMMET, WALTER TRAVIS

LENGTH: 137 YARDS · PAR 3

You might say the second hole is a direct result of suburban sprawl. Though a short hole, the tee shot plays over the gaping "Bottomless Pit," an excavation site that provided sand and gravel for the roads of Garden City, a suburb of New York City, in the late nineteenth century. (Does that qualify a shot hit into the pit as roadkill?) If that's not enough to think about, three additional, albeit smaller, bunkers guard the right and rear of the green.

Golden Horseshoe Golf Club (Gold) ✦ 16

LOCATION: WILLIAMSBURG, VIRGINIA

ARCHITECT: ROBERT TRENT JONES, SR.

LENGTH: 169 YARDS · PAR 3

The seventeenth at the TPC at Sawgrass may get more publicity, but this island green is just as intimidating. Built in 1963—a full fifteen years before Pete Dye designed the TPC—the sixteenth hole is thirty yards longer than its more famous cousin. Two sets of tees provide various playing angles—the green is longer but narrower from the blue tees, and shallower but wider from the white tees.

The Golf Club ✦ 3

LOCATION: NEW ALBANY, OHIO

ARCHITECT: PETE DYE

LENGTH: 185 YARDS · PAR 3

This hole doesn't have an immediate "Dye-like" appearance—it's just an across-the-pond par 3 to a small, circular green. Upon reaching the green, however, players discover a mammoth complex of interconnected bunkers, subtly submerged in the humps and mounds. The sand stretches in an almost uninterrupted semicircle, extending twenty-five yards to the left and fifteen yards behind the green. Small logs bolster lips of the traps, while narrow ribbons of grass serve only as a pathway through the tumult.

Harbour Town Golf Links ✦ 17

LOCATION: HILTON HEAD ISLAND, SOUTH CAROLINA

ARCHITECTS: PETE DYE/JACK NICKLAUS

LENGTH: 192 YARDS · PAR 3

Don't be fooled: Just because the green is shaped like a lightbulb doesn't mean it inspires great ideas on how to hold a long tee shot on its firm surface. Success here takes guts, which many a player coming down the stretch during the MCI Classic has shown through the years. It plays into the setting sun as well as the prevailing wind, so making a 3 on Sunday often leads to a victory march up the eighteenth.

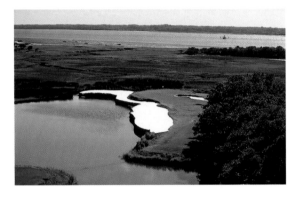

The Hills of Lakeway Golf Course ✦ 7

LOCATION: LAKEWAY, TEXAS

ARCHITECT: JACK NICKLAUS

LENGTH: 195 YARDS · PAR 3

This twenty-five-foot cataract can look more like Niagara Falls when the prevailing headwind is blowing. The green is tucked directly behind the signature waterfall, which flows down from a creek on the right. Two more bunkers stand guard behind the long, shallow green, which angles away from left to right. Players who come up short and hope to find their balls might need scuba gear or a spelunking helmet, as the waterfall empties into a cavern.

Jupiter Hills Club (Hills) ✦ 9

LOCATION: TEQUESTA, FLORIDA

ARCHITECT: GEORGE FAZIO

LENGTH: 192 YARDS · PAR 3

George Fazio must have thought he was George Crump, as this hole would look right at home at Pine Valley. The green is perched atop one of the property's surprisingly high sand dunes, equaling a rise of about forty feet from tee to green. But what's more important is what lies between tee and green—an unrecoverable scrub and sand waste area that may as well be a chasm to nowhere. There's some room to miss the green to the right, but anyone who's counting on that is in trouble.

Kemper Lakes Golf Club ✦ 17

LOCATION: HAWTHORN WOODS, ILLINOIS

ARCHITECTS: KEN KILLIAN/DICK NUGENT

LENGTH: 203 YARDS · PAR 3

You might expect the seventeenth, flanked by water on two sides and bunkers on the right, to benefit a straight hitter. However, its position, in the midst of Kemper's three treacherous finishing holes, has provided some surprises. None more so than the 1989 PGA Championship, when Mike "Radar" Reid held a 3-stroke lead over Payne Stewart with three to play. A costly double bogey at the seventeenth dropped him one behind Stewart, who won.

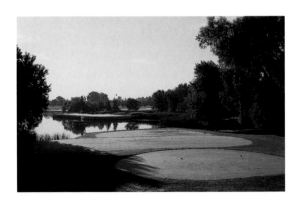

The Kittansett Club ✦ 3

LOCATION: MARION, MASSACHUSETTS

ARCHITECTS: FRED HOOD, WILLIAM S. FLYNN, HUGH WILSON

LENGTH: 165 YARDS · PAR 3

Some might see a long stretch of beach and think, "sunbathing." Kittansett's architects thought, somewhat maliciously, "golf hole." Tee shots not safely reaching the small "island" green will either end up in the waters of Buzzards Bay or find a sand-encrusted fate in the hole's main feature—the Sahara-like bunker that completely surrounds the heavily contoured putting surface. The fickle ocean winds only add to the intimidation factor, making this early-round challenge a formidable one.

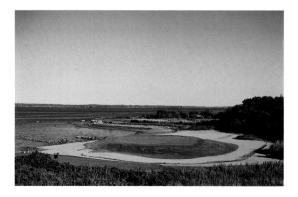

La Quinta Resort and Club (Mountain) ✦ 16

LOCATION: LA QUINTA, CALIFORNIA

ARCHITECT: PETE DYE

LENGTH: 168 YARDS · PAR 3

Reflecting the course's target-style desert personality, the sixteenth hole is a dry version of Dye's seventeenth hole at the nearby PGA West Stadium Course. Instead of building an island green surrounded by water, Dye built this one amid native scrub brush and several hundred large rocks, making the green look like a lonely oasis. The mountain backdrop tends to make this hole look longer than it is, so club selection is tricky.

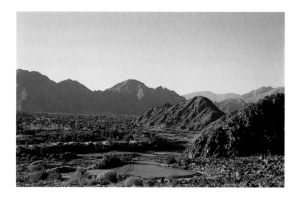

Los Angeles Country Club (North) ✦ 11

LOCATION: LOS ANGELES, CALIFORNIA

ARCHITECTS: GEORGE C. THOMAS/WILLIAM P. BELL, ROBERT MUIR GRAVES

LENGTH: 244 YARDS · PAR 3

This downhill stunner is a feast for the senses. Views of Los Angeles abound from the elevated tee, and the hole is a mirror-image of a traditional Redan (although with an additional forty yards). The left bunker, looking greenside, is actually a false front, about forty yards short of the surface. Shots missing right will roll down an embankment and result in a blind pitch to the green, over an artfully shaped right bunker that rises level with the putting surface.

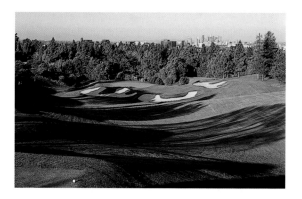

The Maidstone Club ✦ 14

LOCATION: EAST HAMPTON, NEW YORK

ARCHITECTS: WILLIE AND JOHN PARK, WILLIAM H. TUCKER

LENGTH: 140 YARDS · PAR 3

Scotsman Willie Park was largely responsible for Maidstone's back nine, so it's not a stretch to say that he may have been thinking of Royal Troon's "Postage Stamp" eighth hole when building this one. Though not an exact replica of that famed par 3 across the Atlantic, this short beauty requires the same type of precision. The small, exposed green is encircled by pot bunkers and thick gorselike bushes, with the Atlantic Ocean as a backdrop.

Mauna Kea Golf Club ✦ 3

LOCATION: KAMUELA, HAWAII

ARCHITECT: ROBERT TRENT JONES, SR.

LENGTH: 210 YARDS · PAR 3

Mauna Kea offers strikingly beautiful golf in a black lava desert. Snow-capped Mauna Kea volcano rises in the distance. At its fabulous third, the tee shot must be played over pounding surf to a diagonally placed green, which, depending on where the hole is cut, can be 182 to 234 yards. Conditions are never benign; a missed calculation of wind direction will leave the tee shot in one of the guarding bunkers or rebound it off the rocks into the surf below. • This hole is showcased on pages 96–97.

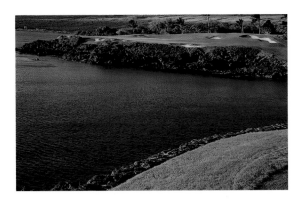

Mauna Lani Resort (South) ✦ 15

LOCATION: KOHALA COAST, HAWAII

ARCHITECTS: ROBIN NELSON, RODNEY WRIGHT

LENGTH: 196 YARDS · PAR 3

Every January, when the Senior Skins Game visits Mauna Lani, there are two things always shown on television: whales frolicking off the coast and players hitting tee shots on the par-3 fifteenth. The cameras love to follow a ball's path as it gets battered by the trade winds, then linger on the contrast among the various possible landing areas—lush green grass, white sand bunkers, blue ocean waters, and coarse black lava.

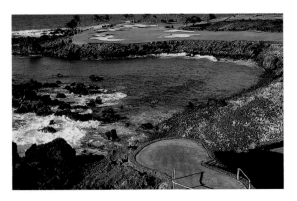

Medinah Country Club (No. 3) ✦ 2

LOCATION: MEDINAH, ILLINOIS

ARCHITECTS: TOM BENDELOW, ROGER PACKARD, ROGER RULEWICH

LENGTH: 184 YARDS · PAR 3

The first of a trio of par 3s that crosses Lake Kadijah, this is the only one of the three to have been spared a complete renovation. Yet architect Roger Rulewich did come in before the 1999 PGA Championship to rebuild the putting surface: Since there are no bunkers separating the green from the lake, putts hit too hard had nothing to stop them from rolling into the water. Rulewich leveled the green to create some more reasonable pin positions, but kept the front bunker-free.

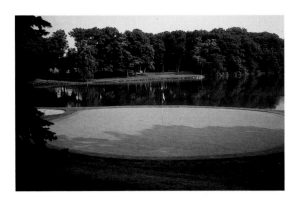

Muirfield Village Golf Club ✦ 12

LOCATION: DUBLIN, OHIO

ARCHITECTS: JACK NICKLAUS/DESMOND MUIRHEAD

LENGTH: 152 YARDS · PAR 3

On Jack Nicklaus's most highly regarded design, the six-time Masters champion built the twelfth hole to resemble the twelfth at another of his favorite tracks, Augusta National. The winds don't swirl nearly as much, but as at Augusta, this is a hole where players are happy to take a 3 and leave quietly. It doesn't always happen: During the first playing of the Memorial, Nicklaus himself hit two shots in the water and took a 7.

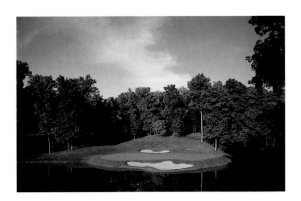

The National Golf Links of America ✦ 4

LOCATION: SOUTHAMPTON, NEW YORK

ARCHITECT: CHARLES BLAIR MACDONALD

LENGTH: 197 YARDS · PAR 3

An exquisite replica of the original Redan hole, number 15 on the West Links at North Berwick in Scotland, this par 3 is a sequel equal to or greater than the original. This hole embodies the strategic principles of its model—and improves upon them. The fourth offers a multitude of options, depending on the golfer's skill, the standing of the match, and the strength and direction of the wind. • This hole is showcased on pages 14–17.

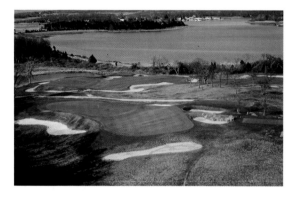

Newport Country Club ✦ 14

LOCATION: NEWPORT, RHODE ISLAND

ARCHITECTS: WILLIAM F. DAVIS, DONALD ROSS, A. W. TILLINGHAST

LENGTH: 212 YARDS · PAR 3

Extending down from the lavish clubhouse, the fourteenth was the opening hole in Davis's original 1893 design. It is called "Plateau," and its treeless expanse is subject to devilish winds blowing in off the Atlantic. The green is delicately perched between a huge bunker complex above and to the right, and a thirty-foot fall-off and lone deep bunker to the left. The green surface runs hard from right to left and is difficult to hold.

Oakland Hills Country Club (South) ✦ 17

LOCATION: BLOOMFIELD HILLS, MICHIGAN

ARCHITECTS: DONALD ROSS, ROBERT TRENT JONES, SR.

LENGTH: 201 YARDS · PAR 3

During the 1996 U.S. Open, Davis Love III came to this tee on Sunday tied for the lead with Steve Jones, but he missed the green with his 5-iron and failed to make par, the first of two closing bogeys. The day before, South African Wayne Westner double-hit a pitch shot at the seventeenth, reminding everyone of T. C. Chen's disastrous double-chip in the 1985 U.S. Open, also at Oakland Hills.

Oak Tree Golf Club ✦ 4

LOCATION: EDMOND, OKLAHOMA

ARCHITECT: PETE DYE

LENGTH: 200 YARDS · PAR 3

In the days leading up to the 1988 PGA Championship, the fourth hole was referred to as the scariest hole on the course. A stand of large trees sits to the right, affecting right-to-left shots, and the green is all carry over water. All this made Paul Azinger's third-round hole in one that much more exciting. His 6-iron took two bounces and dove in the cup, and as Azinger remarked afterward, "I've never gotten a roar like that."

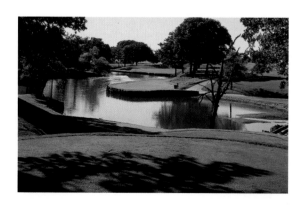

Olympic Club (Lake) ✦ 3

LOCATION: SAN FRANCISCO, CALIFORNIA
ARCHITECTS: WILLIE WATSON, SAM WHITING,
　　　　　　ROBERT TRENT JONES, SR.
LENGTH: 223 YARDS · PAR 3

Experts often speak of Olympic's last four holes as its killer stretch, but holes 3 through 6, a formidable quartet known as "Earthquake Corner," have also seen their share of drama. In the Ben Hogan-Jack Fleck playoff for the 1955 U.S. Open, Hogan striped his 2-iron tee shot to 3 feet, while Fleck's rested 20 feet away. Fleck calmly sank his putt, while a stunned Hogan missed his, giving Fleck an early edge in what would prove to be one of golf's great upsets.

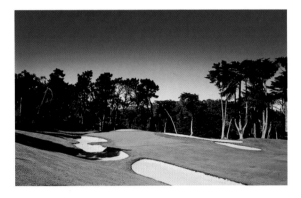

Pebble Beach Golf Links ✦ 7

LOCATION: PEBBLE BEACH, CALIFORNIA
ARCHITECTS: JACK NEVILLE/DOUGLAS GRANT, H. CHANDLER EGAN
LENGTH: 107 YARDS · PAR 3

On the tee at Pebble Beach's seventh, behind you, below you, to the right, and behind the green lies the pounding surf of Monterey Bay. Just one hundred yards away lies a two-thousand-square-foot green, eight yards wide, surrounded by bunkers and protected by a massive dollop of rock over which waves are breaking. This hole is a paradox of contrasting questions and conditions, which enthrall and perplex players of all abilities. • This hole is showcased on pages 104-105.

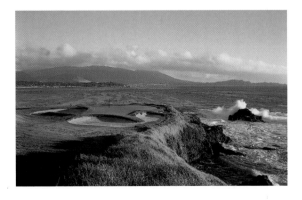

Pine Needles Lodge and Golf Club ✦ 3

LOCATION: SOUTHERN PINES, NORTH CAROLINA
ARCHITECT: DONALD ROSS
LENGTH: 134 YARDS · PAR 3

This is a hole that, true to Ross's design philosophy, can yield equal amounts of birdies and bogeys. A short-iron tee shot for most players, many are tempted to fire straight at the pin, but the nature of the green—long, narrow, and very undulating—can make that decision a poor one if the shot is not precise. Five bunkers flank all sides of the green, a pond guards the front, and the slight downhill terrain can make depth perception tricky.

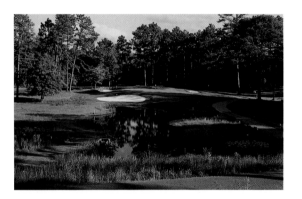

Pine Valley Golf Club ✦ 10

LOCATION: CLEMENTON, NEW JERSEY
ARCHITECTS: GEORGE CRUMP/H. S. COLT
LENGTH: 146 YARDS · PAR 3

The nearly chimerical golf problems Pine Valley exemplifies are present in all aspects at the infamous tenth, its shortest hole. Normally, it is a simple 7- or 8-iron. The small undulating green falls precipitously on all sides to the ragged sand pit surrounding it. The most dangerous element is a deep pot bunker into which the front of the green slopes and from which backward is the only means of escape. It is this pit that gives the hole its nickname, "the Devil's Asshole." • This hole is showcased on pages 106–107.

Point O'Woods Golf and Country Club ✦ 9

LOCATION: BENTON HARBOR, MICHIGAN
ARCHITECT: ROBERT TRENT JONES, SR.
LENGTH: 197 YARDS · PAR 3

Rows of mature trees line the corridor for the tee shot on this superior one-shotter, where the green is just about the only safe place to be. A flooded ravine provides the first obstacle to carry, but even that wouldn't be so bad were it not for what lies on the other side. A twelve-foot bank, covered with untamed long grass and topped by a bunker, serves to swallow up most weak attempts. Three more bunkers are found to the rear of the wide, shallow green, which has only the tiniest sliver of bailout room to the right.

Prairie Dunes Country Club ✦ 2

LOCATION: HUTCHINSON, KANSAS
ARCHITECT: PERRY MAXWELL
LENGTH: 161 YARDS · PAR 3

Perry Maxwell's widely known admiration of the Kansas sand dunes is reflected in this hole. Though it is his creation, it truly belongs to the landscape. Named "Willow," the hole plays to a green neatly chiseled into a hillside, with thickets of vegetation to the right and three well-placed bunkers to the left. The prairie wind plays tricks on club selection, so those players finding this green with their tee shots will have earned their chance for par.

Riviera Country Club ✦ 4

LOCATION: PACIFIC PALISADES, CALIFORNIA
ARCHITECT: GEORGE C. THOMAS
LENGTH: 236 YARDS · PAR 3

This is one of the few "dogleg" par 3s on the PGA Tour, and is one of the reasons players at Riviera know a birdie or eagle on the welcoming first hole is a must for a low round. This long, uphill hole routinely averages a half stroke over par during the Nissan Open. Ben Hogan, who won three times at Riviera (including the 1948 U.S. Open), called the fourth "the greatest par 3 in America."

Sahalee Country Club ✦ 17

LOCATION: REDMOND, WASHINGTON
ARCHITECTS: TED ROBINSON, ROBERT MUIR GRAVES
LENGTH: 215 YARDS · PAR 3

The hole is set like an amphitheater among a magnificent cathedral of trees. Appropriate, then, that it was here, during the 1998 PGA Championship, that the pivotal strokes were played catapulting Vijay Singh to the ranks of major champion. Singh and playing partner Steve Stricker both hit their tee shots into the back-right bunker, but Singh charged his 18-footer in the cup for par, while Stricker missed his 11-footer, leaving Singh with a 2-stroke cushion that he rode to victory.

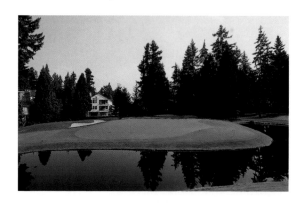

St. Louis Country Club ✦ 3

LOCATION: CLAYTON, MISSOURI

ARCHITECTS: CHARLES BLAIR MACDONALD, SETH RAYNOR

LENGTH: 203 YARDS · PAR 3

Between the uphill terrain and plateau green, this tee shot likely required a driver or brassie at the time of its construction in 1914. Even today, the shot is nerve-racking, as the ball must first carry the water just in front of the tee and then avoid the phalanx of bunkers short and to the sides of the green. The most notable of these is short and right, and marked by a steep drop-off that sees plenty of balls rolling backward into the sand.

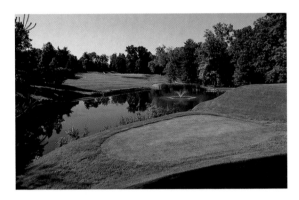

Sand Hills Club ✦ 17

LOCATION: MULLEN, NEBRASKA

ARCHITECTS: BEN CRENSHAW/BILL COORE

LENGTH: 168 YARDS · PAR 3

This hole displays the unparalleled naturalness of Sand Hills, and demonstrates how minor design touches can alter a shot's visual complexion. The green is completely encircled by bunkers and wispy native grasses, leaving a high, soft tee shot as the only sensible option. Complicating matters is the downhill terrain and deceivingly high lips of the sand traps, which make club selection perplexing. Add in the Great Plains winds, and hitting the green becomes a difficult proposition.

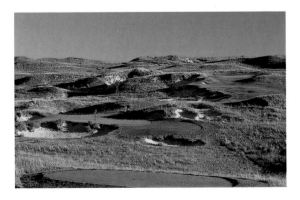

San Francisco Golf Club ✦ 7

LOCATION: SAN FRANCISCO, CALIFORNIA

ARCHITECTS: A. W. TILLINGHAST, WILLIAM P. BELL

LENGTH: 190 YARDS · PAR 3

It was christened "the Duel" hole, because the current green was the site of the last known duel on American soil a century ago. Fifteen years later, Tillinghast crafted the land into a downhill par 3 that he later called his favorite hole. The contours of the putting surface show Tillie's brilliance: A ridge bisects the green, presenting players with a tough decision off the tee when the pin is placed in back.

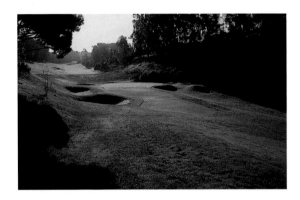

Shadow Creek Golf Club ✦ 17

LOCATION: NORTH LAS VEGAS, NEVADA

ARCHITECT: TOM FAZIO

LENGTH: 164 YARDS · PAR 3

When you look at the lush, exquisitely landscaped arena that contains this devilish little par 3, it's hard to believe the property was once nothing more than desert scrub. The seventeenth hole's multiple tee boxes, set on a ridge thirty feet above the level of the green, allow for play from a variety of different angles. The objective, however, always remains the same—to find a small patch of green amid large rocks, four-deep bunkers, and a thirty-foot waterfall that leads to a greenside creek.

Shinnecock Hills Golf Club ✦ 11

LOCATION: SOUTHAMPTON, NEW YORK
ARCHITECTS: WILLIE DAVIS, WILLIAM S. FLYNN/HOWARD TOOMEY
LENGTH: 158 YARDS · PAR 3

Glancing at the scorecard, you might think a shortish par 3 that usually plays downwind would offer a breather on a course of this caliber. In the case of Shinnecock's eleventh, you'd be wrong. The putting surface slopes away from the player, but playing short for safety brings into play four nasty bunkers that guard the front of the green. It was here in 1986 that a forty-three-year-old Raymond Floyd curled in an 18-foot birdie on Sunday to surge to victory in the U.S. Open.

Shoreacres Golf Club ✦ 12

LOCATION: LAKE BLUFF, ILLINOIS
ARCHITECT: SETH RAYNOR
LENGTH: 127 YARDS · PAR 3

In an area replete with great golf holes, this one stands out because of one major difference: a very un-Chicago-like elevation change. The green sits at the bottom of a jungly ravine one hundred feet below the tee. Tall trees line both sides of the hole, and provide only a narrow opening to the green. Though reachable with a short iron for most players, the drop in elevation makes club selection tricky.

Sleepy Hollow Country Club ✦ 16

LOCATION: SCARBOROUGH-ON-HUDSON, NEW YORK
ARCHITECTS: CHARLES BLAIR MACDONALD, A. W. TILLINGHAST, REES JONES
LENGTH: 150 YARDS · PAR 3

You can almost hear the Headless Horseman galloping through the woods on the tee of this downhill beauty. Now let's see him come out and try to make a 3! Strong crosswinds, a plateau green guarded by six bunkers, and the Hudson River backdrop conspire to make this tee shot an adventure. Considering the site's literary pedigree, maybe it's more of a mystery.

Somerset Hills Country Club ✦ 12

LOCATION: BERNARDSVILLE, NEW JERSEY
ARCHITECT: A. W. TILLINGHAST
LENGTH: 144 YARDS · PAR 3

Though Tillinghast was famously skeptical of using water on his designs, he had almost no choice on this hole, which sits at the lowest point of the property. As it turned out, the site yielded a lovely peninsula green, jutting into the lake on the left. The mechanics of this hole are slightly reminiscent of the sixteenth at Augusta National (though the hole precedes Augusta by seventeen years), as the tee shot must carry a sliver of water, and the green slopes hard from right to left, funneling balls toward the lake.

Tournament Players Club at Sawgrass (Stadium) ✦ 17

LOCATION: PONTE VEDRA BEACH, FLORIDA
ARCHITECT: PETE DYE
LENGTH: 132 YARDS · PAR 3

Pete Dye conjured this grassy guillotine from swampland. Easily the most vilified and notorious one-shotter in the game, the seventeenth was redesigned by Dye after PGA Tour stars posted sky-high scores when The Players Championship moved to its new home. Its target is a bulkheaded raft in middle of a lake 132 yards from the TPC markers—nowhere to run, nowhere to hide. In 1984, John Mahaffey, one of its victims, described it as "one of the easiest par fives on the course." • This hole is showcased on pages 18–21.

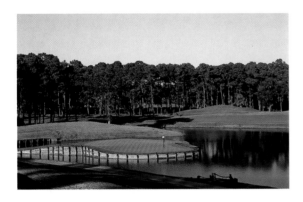

Troon Golf and Country Club ✦ 15

LOCATION: SCOTTSDALE, ARIZONA
ARCHITECTS: TOM WEISKOPF/JAY MORRISH
LENGTH: 139 YARDS · PAR 3

Called "Troon Mountain," this short but testy hole incorporates all the surrounding desert elements into a mural of naturalistic golf. The well-bunkered, triple-tiered green is an oasis of green amid a desert moonscape. The green's position, backdropped by a red rock hillside and ringed by cacti, makes the distance hard to judge from the tee. Thinking the green is closer than it is, players have been known to underclub and find themselves in the deep front-left bunker, or worse, among the prickly desert fauna.

Valley Club of Montecito ✦ 8

LOCATION: SANTA BARBARA, CALIFORNIA
ARCHITECTS: ALISTER MACKENZIE/ROBERT HUNTER
LENGTH: 154 YARDS · PAR 3

Ocean breezes often blow through this serene landscape of hills, creeks, and mature trees, but it's the genius of Mackenzie's bunkering that provides the true character of the course. Though only a short- or mid-iron for most players, their tee shots must carry a valley to a lightning-fast, two-tiered green. Dramatic bunkers surround the putting surface, their steep faces rising right up to the edges. Shots pushed too far right will find an even worse fate—a steep drop-off leading to an oak tree grove.

Wannamoisett Golf Club ✦ 3

LOCATION: RUMFORD, RHODE ISLAND
ARCHITECT: DONALD ROSS
LENGTH: 136 YARDS · PAR 3

The setting for this historical hole is pure New England, with a small creek on the right and leafy oak trees surrounding the greensite. The green itself has a classic Ross look—in fact, it served as the model for the Donald Ross Society's logo. Its surface is elevated and subtly undulating, though the slope off the hill and toward the creek is frighteningly noticeable, especially at midsummer green speeds. Bunkers, both grass and sand, ring the green's outer edge.

Whistling Straits Golf Club (Straits) ✦ 12

LOCATION: HAVEN, WISCONSIN
ARCHITECT: PETE DYE
LENGTH: 166 YARDS · PAR 3

The fog rolls in, the temperature drops, and the sheep graze along the hillside. Scotland? No, Wisconsin. But you'd be forgiven if you mistook the twelfth hole at Whistling Straits for a bit of the "Auld Sod." Depending on the tee location and the wind, the player can hit anything from sand wedge to 5-iron. With the right side falling precipitously into Lake Michigan, the hillside on the left is the only hope for an off-line shot to avoid disaster.

Winged Foot Golf Club (East) ✦ 6

LOCATION: MAMARONECK, NEW YORK
ARCHITECT: A. W. TILLINGHAST
LENGTH: 194 YARDS · PAR 3

Former Masters champion and onetime Winged Foot assistant pro Jackie Burke, Jr., once said, "The East is absolutely one hell of a hard golf course." This sentiment certainly embraces the par 3s, of which the sixth is king. Tillinghast named this hole "Trouble," and it often is. Hitting the raised green with a mid- to long iron takes equal parts skill and luck, while Tillie's infamous splash-sand bunkers await those who miss.

Winged Foot Golf Club (West) ✦ 10

LOCATION: MAMARONECK, NEW YORK
ARCHITECT: A. W. TILLINGHAST
LENGTH: 190 YARDS · PAR 3

A. W. Tillinghast considered the tenth at Winged Foot's West Course, named "the Pulpit," as the finest par 3 he ever built. The deep, wide green slopes from back left to front right (and continues to slope off the front of the green and back toward the green) and is flanked between two perfectly shaped bunkers, both of which reach a depth of more than six feet. • This hole is showcased on pages 122–123.

Yale University Golf Course ✦ 9

LOCATION: NEW HAVEN, CONNECTICUT
ARCHITECTS: CHARLES BLAIR MACDONALD/SETH RAYNOR
LENGTH: 211 YARDS · PAR 3

The ninth at Yale University is considered to be the finest "Biarritz" hole in the world. Biarritz refers to the deep trenchlike gully (five feet at Yale) that runs through the middle of the green. To get there, players must carry the pond with their tee shots and avoid bookend bunkers on each side of the green. The rumpled, natural qualities of this hole only add to its charm. • This hole is showcased on pages 124–125.

Yeamans Hall Club ✦ 6

LOCATION: HANAHAN, SOUTH CAROLINA
ARCHITECTS: SETH RAYNOR, TOM DOAK
LENGTH: 180 YARDS · PAR 3

This Redan hole has many similarities to its contemporary at The National Golf Links on Long Island, but adds a southern twist. Instead of open linksland, the green is encircled by live oaks and magnolias, which create a devious swirling wind. Doak's recent renovation has replaced nearly ten yards of green that had been lost over the years, bringing the two existing rear bunkers back into play and ensuring that the surface's slope, which is both front to back and right to left, funnels balls away from front pin positions.

PAR 4

Aronimink ✦ 1

LOCATION: NEWTOWN SQUARE, PENNSYLVANIA
ARCHITECT: DONALD ROSS
LENGTH: 432 YARDS · PAR 4

Donald Ross once wrote, "I consider the ability to play the longer irons as the supreme test of a great golfer." He gets right to the point at Aronimink, where the final 250 yards of this opening hole play uphill, often requiring a long-iron approach. Though the hills at Aronimink are mostly subtle, the drop-off from the elevated tee to the first fairway is the greatest on the course.

Augusta National Golf Club ✦ 10

LOCATION: AUGUSTA, GEORGIA
ARCHITECTS: ALISTER MACKENZIE/ROBERT TYRE JONES
LENGTH: 485 YARDS · PAR 4

This majestic hole, framed by Carolina pines, slopes gradually left and features a drop of nearly one hundred feet from tee to green. It has been the scene of two bitter disappointments in Masters playoffs. After taking a bogey to fall out of a playoff with Larry Mize and Greg Norman in 1987, Seve Ballesteros left a trail of tears as he slogged back up the long hill to the clubhouse. In 1989, Scott Hoch had a 2-foot putt on this green to beat Nick Faldo—he missed, and Faldo won on the next hole.

Baltusrol Golf Club (Lower) ✦ 3

LOCATION: SPRINGFIELD, NEW JERSEY
ARCHITECTS: A. W. TILLINGHAST, ROBERT TRENT JONES, SR.
LENGTH: 466 YARDS · PAR 4

Players returning to Baltusrol for the 1993 U.S. Open saw a third hole that was lengthened by 24 yards since the course last hosted the event in 1980. The downhill tee shot, played from within a chute of trees, must find the sloping, dogleg-left fairway surrounded by still more trees. A creek crosses the fairway about fifty yards short of the green, but the three well-placed bunkers guarding the large putting surface are of far greater concern.

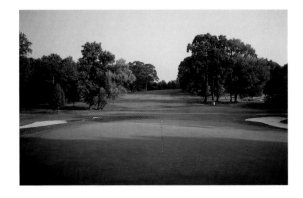

Baltusrol Golf Club (Upper) ✦ 16

LOCATION: SPRINGFIELD, NEW JERSEY

ARCHITECTS: A. W. TILLINGHAST, REES JONES

LENGTH: 435 YARDS · PAR 4

This tee shot presents an interesting dilemma. The fairway falls off gently to the right, while a set of bunkers guards the left. Trying to avoid the bunker, many players end up in the right rough, where they find their line to the green blocked by a huge oak tree. The sloping, well-bunkered green is normally fearsome, but it was conquered by Tony Manero in the 1936 U.S. Open. Beginning the round 4 strokes behind Harry Cooper, Manero rolled in a 12-foot birdie putt here on his way to a remarkable comeback victory.

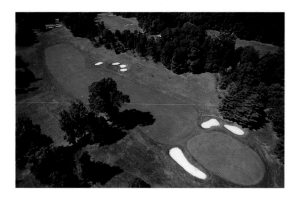

Bandon Dunes Golf Club ✦ 4

LOCATION: BANDON, OREGON

ARCHITECT: DAVID MCLAY KIDD

LENGTH: 415 YARDS · PAR 4

The fourth marks the beginning of one of the finest stretches of public-access linksland in America. Though the sea is never too far away when you are playing Bandon Dunes, this hole gives you your first true glimpse at what lies ahead. It stretches downhill but into the teeth of the prevailing wind, with knee-high heather grass lining both sides of the winding fairway. Two small pot bunkers guard the left side of the two-tiered green.

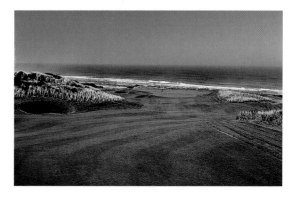

Barton Creek Country Club (Fazio) ✦ 16

LOCATION: AUSTIN, TEXAS

ARCHITECT: TOM FAZIO

LENGTH: 420 YARDS · PAR 4

Tom Fazio is well known for providing golfers with holes that play tougher than they look. It seems as if he decided to abandon that theory on this one—the view from the sixteenth tee offers up enough hazards to keep most players on edge. A cluster of six fairway bunkers guards the left side of the fairway, and a snaking creek curves in front and to the right of the green. As the number two handicap hole, it obviously plays just as tough as it looks.

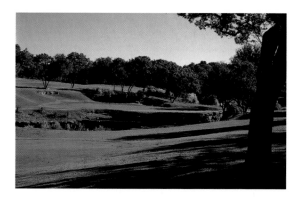

Bay Hill Club ✦ 18

LOCATION: ORLANDO, FLORIDA

ARCHITECTS: DICK WILSON, ARNOLD PALMER

LENGTH: 441 YARDS · PAR 4

Bay Hill's eighteenth is notable among the game's dramatic final acts. The approach to the crescent-shaped green must be judged precisely when the hole is cut in front, where it flirts with the edge of the water and greenside bunkers. In the 1990 Nestlé International, Robert Gamez electrified spectators on the final hole by sinking a 7-iron shot from 176 yards for an eagle 2. It was enough to win by 1 stroke over Greg Norman, and would propel Gamez to PGA Rookie of the Year honors. • This hole is showcased on pages 126–127.

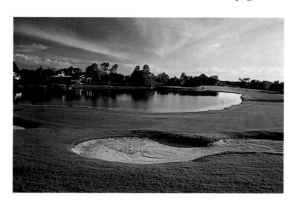

Bel-Air Country Club ✦ 17

LOCATION: LOS ANGELES, CALIFORNIA
ARCHITECTS: GEORGE C. THOMAS/JACK NEVILLE
LENGTH: 468 YARDS · PAR 4

Ben Hogan called the seventeenth "one of the finest par fours I've played," which is no surprise, because it rewards the accurate shotmaker. The hole doglegs right and slopes right, but the crowned fairway landing area can send shots ricocheting into the rough. That's not a good position for the delicate approach, which is played to a peninsulalike green with steep drop-offs left, right, and rear. A large bunker guards the front left, and beyond, the UCLA campus fills the background.

Bethpage State Park Golf Club (Black) ✦ 5

LOCATION: FARMINGDALE, NEW YORK
ARCHITECTS: A. W. TILLINGHAST, REES JONES
LENGTH: 455 YARDS · PAR 4

Bethpage's Black Course's fifth hole is arguably the finest two-shotter on the impressive résumé of architect A. W. Tillinghast, a golden age architect best known for his work at Winged Foot and Baltusrol. The fifth asks for a mammoth drive from an elevated tee. Its stunning risk-reward design stretches to 455 yards. The approach is as testing as the drive, with three cavernous bunkers girding the green. • This hole is showcased on pages 26–29.

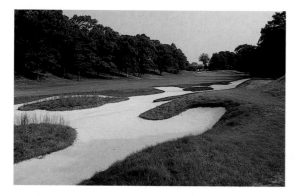

Bethpage State Park Golf Club (Black) ✦ 10

LOCATION: FARMINGDALE, NEW YORK
ARCHITECTS: A. W. TILLINGHAST, REES JONES
LENGTH: 474 YARDS · PAR 4

After nine holes of wooded parkland golf, the tenth begins Bethpage's emergence into a heathland that would look at home in southern England. Wispy long grass frames the fairway, and the driving area is protected by large bunkers left and right. The green is fronted by a deep hollow, negating the chance for a run-up approach. When the pros arrive for the 2002 U.S. Open, this hole will surely be talked about as the beginning of a tortuous back nine.

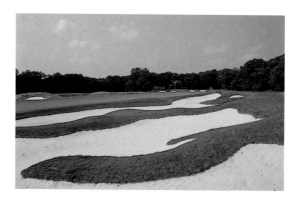

Black Diamond Ranch Golf and Country Club (Quarry) ✦ 15

LOCATION: LECANTO, FLORIDA
ARCHITECT: TOM FAZIO
LENGTH: 371 YARDS · PAR 4

It almost looks too pretty to play. Fazio took full advantage of his extraordinary opportunity and created one of golf's most beautiful inland holes by running it through a former dolomite quarry. A lake stands guard all the way down the left, but many draws and hooks find the serpentine bunkers that border the hazard. The lake ends just in front of the green, in the form of a four-foot rocky precipice that must be carried on the approach.

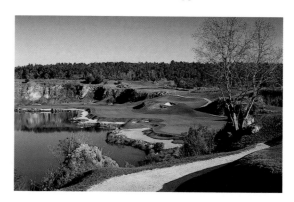

Blackwolf Run Golf Club (Meadow Valleys) ✦ 18

LOCATION: KOHLER, WISCONSIN

ARCHITECT: PETE DYE

LENGTH: 458 YARDS · PAR 4

It's called "Salmon Trap," and its waters can be trouble for fish and golfers alike. Trees down the right side block players' view of the Sheboygan River, but they know it's there. The hole actually has two alternate greens; the one that gives it teeth sits along the banks of the Sheboygan. For all players except those hitting off the red tees, this green is the target, and the approach shot must carry the final 50 yards over the swift-moving tributary.

Blackwolf Run Golf Club (River) ✦ 5

LOCATION: KOHLER, WISCONSIN

ARCHITECT: PETE DYE

LENGTH: 419 YARDS · PAR 4

The beauty of this hole, especially when viewed from the tee box as the early-morning light casts shadows across the fairway, is enough to distract players from the tasks at hand. Namely, to avoid a series of unyielding fairway bunkers lining both sides of the hole, and then hit an exacting approach shot to an uphill, blind green. The prevailing westerly wind also figures into the mix, but is often not felt from the tree-sheltered tee box.

Butler National Golf Club ✦ 18

LOCATION: OAK BROOK, ILLINOIS

ARCHITECTS: GEORGE AND TOM FAZIO

LENGTH: 466 YARDS · PAR 4

When Butler National hosted the Western Open from 1974 through 1990, this hole was one of the most feared on the PGA Tour. The tight, double-dogleg finisher calls for a long fade off the tee, after which the approach must avoid a snaking creek and a large oak tree 70 yards short of the green. En route to a course-record 64 during the 1982 Western Open, Bob Gilder posted 10 birdies and an eagle on the first seventeen holes, then double-bogeyed 18.

The Camargo Club ✦ 12

LOCATION: INDIAN HILL, OHIO

ARCHITECT: SETH RAYNOR

LENGTH: 415 YARDS · PAR 4

Here, players either drive it straight or prepare for an "X" on the scorecard. To the right of the fairway is a fifty-foot, tree-lined drop to a creek; on the left is a shorter drop but a similar fate. A deceiving cross bunker sits sixty yards in front of the green. That, combined with the subtle but significant uphill terrain, results in many players coming up a club or two short. The green is large at 10,000 square feet, but has a hogback running from front to back that cuts down on the available area for approach shots.

Canterbury Golf Club ✦ 18

LOCATION: CLEVELAND, OHIO

ARCHITECTS: HERBERT STRONG, GEOFFREY CORNISH

LENGTH: 438 YARDS · PAR 4

A fearsome finishing hole, and one that has been a factor in three professional major championships. The hole runs entirely uphill, and the second shot is partially blind to a green ringed by eight snarling bunkers. In the 1946 U.S. Open, Byron Nelson seemed poised to capture his sixth major title. But coming off a three-putt bogey at the seventeenth, Nelson hooked his drive into the rough at 18 and made a double bogey 6. He lost in a playoff, and never won that sixth major.

The Cascades Golf Club ✦ 12

LOCATION: HOT SPRINGS, VIRGINIA

ARCHITECT: WILLIAM S. FLYNN

LENGTH: 476 YARDS · PAR 4

The view from the tee, tucked into the hillside, is enough to dry the mouth of even the most seasoned veteran. Trees lining both sides of the undulating fairway seem to engulf the hole, but there's actually a little more room than it appears. Still, the prospect of having to stripe a solid drive with the mountain looming close on the right can be intimidating. The hole bends gently left, with two cross bunkers interrupting the fairway about one hundred yards short of the long, narrow green.

The Cascades Golf Club ✦ 13

LOCATION: HOT SPRINGS, VIRGINIA

ARCHITECT: WILLIAM S. FLYNN

LENGTH: 438 YARDS · PAR 4

Cascades's thirteenth tends to lull players into a sense of comfort and confidence that often leads to calamity. The rounded, majestic peak in the distance is the ideal aiming point for this dogleg-left fairway, but a wide creek runs down the left side to punish those who try to take a shortcut. From the landing area, the approach is played slightly downhill to a small green ringed by bunkers. The right-to-left slope in the fairway promotes a hook, bringing the creek into play again by the green.

Castle Pines Golf Club ✦ 10

LOCATION: CASTLE ROCK, COLORADO

ARCHITECT: JACK NICKLAUS

LENGTH: 485 YARDS · PAR 4

With a terrain that would rival some of the intermediate trails on the nearby ski slopes, the tenth hole is a prime example of Nicklaus's love of sweeping, downhill holes. Between the thin mountain air and extra-long roll players get off the tee, the approach shot here is often no more than a mid- or short iron for the pros during the Sprint International. But that shot must be played off a sidehill/downhill lie, to a green guarded in front by a pond and in back by two bunkers.

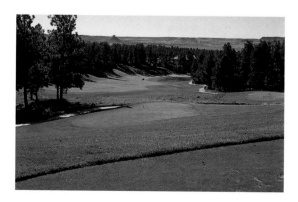

Champions Golf Club (Cypress Creek) ✦ 14

LOCATION: HOUSTON, TEXAS

ARCHITECT: RALPH PLUMMER

LENGTH: 430 YARDS · PAR 4

For a hole that's nearly dead straight and absent any fairway hazards, it's incredible to hear Jack Nicklaus calling this hole "consistently the toughest to par." Champions resident Steve Elkington concurs, calling it one of his favorite holes. What gives? The answer is at the green, which is heart-shaped and guarded more closely than a bank vault by three bunkers, offering a selection of cumbersome pin positions.

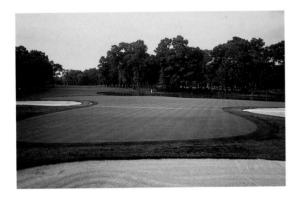

Cherry Hills Country Club ✦ 14

LOCATION: ENGLEWOOD, COLORADO

ARCHITECT: WILLIAM S. FLYNN

LENGTH: 480 YARDS · PAR 4

This hole played the hardest during the 1960 U.S. Open, with an average of nearly 4.6 strokes. A superb dogleg-left fairway demands a good drive, which means avoiding the snaking creek on the left. The creek continues up the left side near the round, crowned green, causing many players to bail out in the direction of the large bunker on the right. From there, the green slopes hard toward the creek, making up-and-downs a rare occurrence.

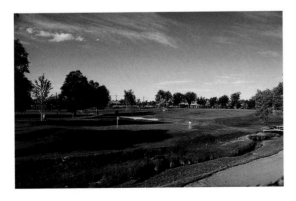

Cherry Hills Country Club ✦ 16

LOCATION: ENGLEWOOD, COLORADO

ARCHITECT: WILLIAM S. FLYNN

LENGTH: 433 YARDS · PAR 4

Esteemed by many, reviled by one—that just about sums up the history of the sixteenth. Running diagonally across this dogleg-right fairway, Little Dry Creek appears to be out of play, and for most, it is. But in the 1938 U.S. Open, Ray Ainsley's second shot hooked into the stream (which apparently wasn't that dry). He proceeded to slash at the ball through the shallow water before finally hacking it onto the green, in the process setting the U.S. Open record for most strokes taken on a hole—19.

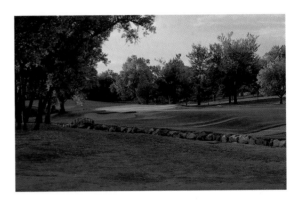

Chicago Golf Club ✦ 2

LOCATION: WHEATON, ILLINOIS

ARCHITECTS: CHARLES BLAIR MACDONALD/SETH RAYNOR

LENGTH: 440 YARDS · PAR 4

The architects paid homage to the birthplace of golf with this hole, which is called "Road" and is a re-creation of the famous seventeenth hole at St. Andrews. But instead of a railway shed to carry at the inside corner of the dogleg-right, there is a series of three bunkers (four more are placed on the left side). The wide green is set at a left angle to the fairway, encouraging a draw on the approach. There is even a small pot bunker short and left of the green, resembling St. Andrews's famous "Road" bunker.

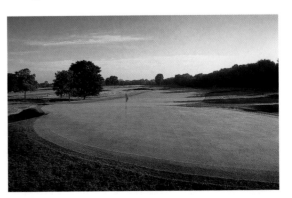

Chicago Golf Club ✦ 12

LOCATION: WHEATON, ILLINOIS

ARCHITECTS: CHARLES BLAIR MACDONALD/SETH RAYNOR

LENGTH: 415 YARDS · PAR 4

Named "Punch Bowl," this hole remains tough despite the advances of the modern game. Both longer and shorter hitters will have to contend with any of five fairway bunkers, placed at varying locations from tee to green. One final hazard comes into play for all players—a wide, deep bunker just short and right of the green. Approaches carrying this will sometimes funnel toward the hole on the punch bowl green, while those missing the surface will be left with a testing chip.

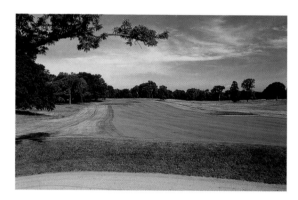

Cog Hill Golf Club (Dubsdread) ✦ 16

LOCATION: LEMONT, ILLINOIS

ARCHITECTS: DICK WILSON/JOE LEE

LENGTH: 397 YARDS · PAR 4

Though not very long by today's PGA Tour standards, the sixteenth often manages to trip up its share of leaders during the annual Western Open. The trouble here is that the fairway slopes from right to left—the same direction of the hole's dogleg—thereby funneling even some good-looking drives toward the left rough. From that position, it's an awkward, uphill approach to a green guarded by overhanging trees and two front bunkers.

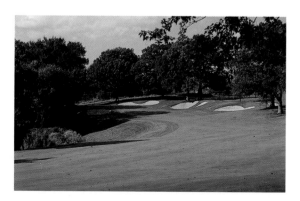

Colonial Country Club ✦ 5

LOCATION: FORT WORTH, TEXAS

ARCHITECTS: JOHN BREDEMUS, PERRY MAXWELL

LENGTH: 466 YARDS · PAR 4

The fifth hole at Colonial best illustrates Ben Hogan's assessment of the entire course: "A straight ball will get you in more trouble at Colonial than any course I know." Nicknamed "Death Valley," the fifth is a 466-yard dogleg-right tightly guarded by a tree-lined ditch on the left, more trees on the right, and the Trinity river farther right. • This hole is showcased on pages 130–131.

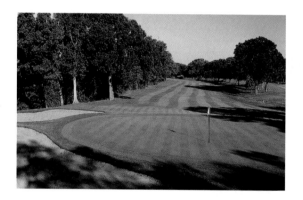

Colonial Country Club ✦ 18

LOCATION: FORT WORTH, TEXAS

ARCHITECTS: JOHN BREDEMUS, PERRY MAXWELL

LENGTH: 434 YARDS · PAR 4

The Colonial tournament holds the PGA Tour record for the longest-running event still played at its original site. Why would they leave? The eighteenth is a fantastic finisher, a gentle dogleg-left that ends at a green tucked between two bunkers, with a pond farther left. The famous Texas wind also can be a factor, as George Bayer found out one year: His second shot got caught in the wind and found not the green, but the roof of the clubhouse.

Congressional Country Club (Blue) ✦ 14

LOCATION: BETHESDA, MARYLAND

ARCHITECTS: DEVEREUX EMMET, ROBERT TRENT JONES, SR.,
GEORGE COBB, REES JONES

LENGTH: 439 YARDS · PAR 4

This stern par 4 has four bunkers guarding the right side of the landing area, and from there the second shot is steeply uphill to a narrow, angled green also protected by four bunkers. During the final round of the 1964 U.S. Open, Ken Venturi was walking through the hollow just short of the green when the temperature hit 115 degrees, and for a moment he thought he had stopped breathing. It would be the only back-nine bogey in his remarkable win.

Congressional Country Club (Blue) ✦ 17

LOCATION: BETHESDA, MARYLAND

ARCHITECTS: DEVEREUX EMMET, ROBERT TRENT JONES, SR.,
GEORGE COBB, REES JONES

LENGTH: 480 YARDS · PAR 4

When Rees Jones rebuilt this green for the 1997 U.S. Open by placing the peninsula green on a right-to-left diagonal, he had a hand in altering history. But he could not have foreseen the drama that unfolded. In this natural amphitheater, Tom Lehman's chances for victory evaporated with his 7-iron approach into the water, while Ernie Els calmly made par en route to his second Open win. • This hole is showcased on pages 132–133.

The Country Club (Open) ✦ 3

LOCATION: BROOKLINE, MASSACHUSETTS

ARCHITECTS: WILLIE CAMPBELL, WILLIAM S. FLYNN, REES JONES

LENGTH: 444 YARDS · PAR 4

The third winds its way through heavy rock outcroppings and mounds. The result is a dogleg-right leading to a small, canted green invisible from the elevated tee. The temptation is to carry the mound on the right to set up a shorter approach, but long rough and bunkers in the fairway and guarding the green play havoc if the shot is not perfect. In three U.S. Opens and the 1999 Ryder Cup, the third was a hole played with caution. • This hole is showcased on pages 134–135.

The Country Club (Open) ✦ 4

LOCATION: BROOKLINE, MASSACHUSETTS

ARCHITECTS: WILLIE CAMPBELL, WILLIAM S. FLYNN, REES JONES

LENGTH: 334 YARDS · PAR 4

A gambler's delight, this hole proved itself to be a match-play beauty during the 1999 Ryder Cup matches. Several players went for the green off the tee, despite the fact that it's a blind shot over a ridge, and the green is not much bigger than half a basketball court. A cluster of six bunkers surrounds the green, but it's the thick rough that usually makes players think twice about pulling out their driver on this one.

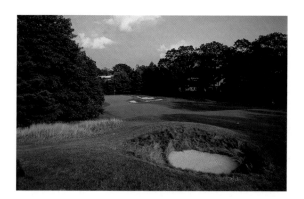

The Country Club (Open) ✦ 18

LOCATION: BROOKLINE, MASSACHUSETTS

ARCHITECTS: WILLIE CAMPBELL, WILLIAM S. FLYNN, REES JONES

LENGTH: 436 YARDS · PAR 4

When people speak of the 1988 U.S. Open, they refer to "the Shot." Curtis Strange's courageous recovery from the front-right bunker, to about 2 feet, saved his par and forced a playoff with Nick Faldo, which Strange won the next day. Three fairway bunkers taken out before the 1963 U.S. Open were rebuilt by Jones in 1988, and the unmistakable yellow clapboard clubhouse stands sentinel behind the green.

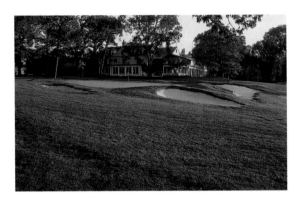

Country Club of Detroit ✦ 18

LOCATION: GROSSE POINTE FARMS, MICHIGAN

ARCHITECTS: H. S. COLT/CHARLES ALISON

LENGTH: 425 YARDS · PAR 4

The very essence of a precise finishing hole. A thick line of trees guards the left side of the tight landing area, while a small cluster of bunkers sits to the right. The green is slightly elevated and slopes hard from back to front, favoring those with an uphill putt—usually. In the semifinal match of the 1954 U.S. Amateur, Arnold Palmer hit a wonderful pitch from behind the slick green, saving par and eventually beating Ed Meister, who missed a 15-foot uphill birdie putt to win.

The Creek Club ✦ 6

LOCATION: LOCUST VALLEY, NEW YORK

ARCHITECTS: CHARLES BLAIR MACDONALD/SETH RAYNOR

LENGTH: 453 YARDS · PAR 4

The waters of Long Island Sound provide an ideal backdrop at the sixth, beautifully displaying a course that is renowned for its brilliant combination of links- and parkland features. Both characteristics manifest themselves at the downhill sixth, with trees down the left and brown-top heather grass on the right. The punch bowl green complex, shallow and difficult to hit, sits behind a massive, mounded front bunker.

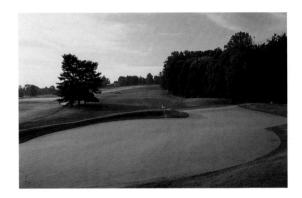

Crooked Stick Golf Club ✦ 18

LOCATION: CARMEL, INDIANA

ARCHITECT: PETE DYE

LENGTH: 457 YARDS · PAR 4

With a final holed putt here, John Daly became a household name, but the eighteenth had a history long before the 1991 PGA Championship. More than twenty years after his original layout of the course, Dye redesigned number 18 in preparation for the PGA, combining two smaller lakes into the massive inland sea that now runs down the right side. The large green sits precariously close to the water, and is guarded on the left by two pot bunkers along with one more to the rear.

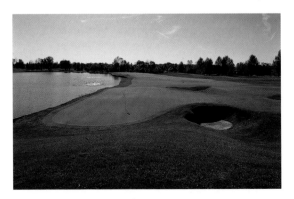

Crystal Downs Country Club ✦ 1

LOCATION: FRANKFORT, MICHIGAN
ARCHITECT: ALISTER MACKENZIE
LENGTH: 460 YARDS · PAR 4

So much for easing players into a round. The first hole at Crystal Downs combines native beauty with a formidable challenge, signaling the difficulty that awaits. Standing on the elevated first tee, players can view up to eight different holes and the tall grasses and artfully shaped bunkers that characterize the layout. A good drive will still leave a long approach to a medium-sized, well-bunkered green. The tallest grass on the hole awaits on the left, which just happens to follow the direction of the prevailing wind.

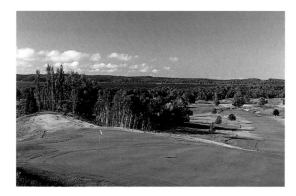

Crystal Downs Country Club ✦ 5

LOCATION: FRANKFORT, MICHIGAN
ARCHITECT: ALISTER MACKENZIE
LENGTH: 353 YARDS · PAR 4

Crystal Downs's fifth illustrates an array of Alister Mackenzie's strategic necessities that make a short par 4 appear impenetrable. From the tee, the top of the flag can just be seen in line with the bunker at the top of the ridge, surrounded by rough. While this bunker provides a landmark, the carry is too great and will result in a rough lie short or long. Mackenzie knew that alternative routes infuse intrigue to great holes. • This hole is showcased on pages 136–137.

Cypress Point Club ✦ 17

LOCATION: PEBBLE BEACH, CALIFORNIA
ARCHITECT: ALISTER MACKENZIE
LENGTH: 393 YARDS · PAR 4

Back when Cypress Point was one of the three courses used during the annual Pebble Beach National Pro-Am, this hole was consistently admired by the pros as one of the most strategically exquisite in golf. The drive is over an inlet of Pacific to a wide, but slanting, fairway that doglegs right. A perfectly placed fairway pine sits about sixty yards in front of the shallow green, affecting approach shots hit from the ocean side of the fairway.

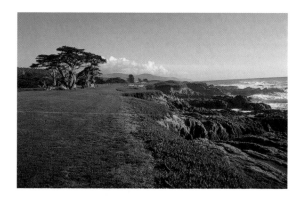

Desert Forest Golf Club ✦ 13

LOCATION: CAREFREE, ARIZONA
ARCHITECT: RED LAWRENCE
LENGTH: 440 YARDS · PAR 4

There are no fairway bunkers at Desert Forest—and none is needed. The microscopic, twenty-yard-wide fairway landing area on this hole transitions quickly to native desert terrain and saguaro cacti, a more intimidating fate than any bunker. The green, sitting at the course's highest point, is guarded by two front bunkers and is extremely deep, with three tiers back to front. Shots hitting the front tier with too much backspin often end up twenty to thirty yards back down the fairway.

Desert Highlands Golf Club ✦ 1

LOCATION: SCOTTSDALE, ARIZONA
ARCHITECT: JACK NICKLAUS
LENGTH: 356 YARDS · PAR 4

Players looking to swing away with the driver to start their rounds should look elsewhere: This is a superb finesse hole, not one for reckless driving. The elevated tee affords a great view of the mountains to the north and the tight landing area below. A long iron is the club of choice off the tee, a decision bolstered by a narrowing fairway and a group of bunkers 225 yards out on the right. The small, three-tiered green demands a precise short-iron approach, and is surrounded by desert and rock formations.

Doral Resort and Country Club (Blue) ✦ 18

LOCATION: MIAMI, FLORIDA
ARCHITECTS: DICK WILSON, RAYMOND FLOYD
LENGTH: 443 YARDS · PAR 4

The course, known as "the Blue Monster" because of its strategic (and watery) demands, demonstrates that flat Florida terrain can provide just as rigorous a test as those courses with more topographical relief. Architect Dick Wilson designed a punishing finish, with water all the way down the left side, and a mix of sand and trees right. No wonder it is always among the toughest closing holes on the PGA Tour. • This hole is showcased on pages 138–139.

Double Eagle Golf Club ✦ 17

LOCATION: GALENA, OHIO
ARCHITECTS: TOM WEISKOPF/JAY MORRISH
LENGTH: 355 YARDS · PAR 4

The listed yardage on this hole is somewhat deceiving—it's 355 only when played as a dogleg-right. The straight line from tee to green is more like 302, presenting a tempting gamble. For most, the play is a long iron, staying short or left of the mid-fairway bunker. From there, the 12,000-square-foot green is receptive. Those daring to drive the green will be faced with a 250-yard carry over the right-hand bunker, threading their shots between the water on the right and the huge expanse of sand and scrub on the left.

The Estancia Club ✦ 2

LOCATION: SCOTTSDALE, ARIZONA
ARCHITECT: TOM FAZIO
LENGTH: 375 YARDS · PAR 4

Three fairway bunkers, all in a row, provide the perfect line for the riskier of two tee shot options, this one requiring a 240-yard carry over the traps. It offers a shorter approach to the green, but also brings into play the desert terrain on the left side, marked by cacti and large boulders where coyotes are often sighted. The safer play is a shorter drive between these bunkers and one farther right. From either place, the three-tiered green ringed by four deep bunkers provides a stiff putting challenge.

Fishers Island Club ✦ 4

LOCATION: FISHERS ISLAND, NEW YORK
ARCHITECT: SETH RAYNOR
LENGTH: 397 YARDS · PAR 4

You might expect a course marooned in the middle of Long Island Sound to have some compelling, quirky holes, and Fishers Island doesn't disappoint. Even if the drive finds the plateau fairway of the fourth hole, the blind second shot still produces plenty of tense moments. It must be played over a hill to a small green at the water's edge and, depending on the wind, can demand either a quick-stopping short-iron or a low-flying knockdown shot.

Forest Highlands Golf Club ✦ 9

LOCATION: FLAGSTAFF, ARIZONA
ARCHITECTS: TOM WEISKOPF/JAY MORRISH
LENGTH: 478 YARDS · PAR 4

This hole is as beautiful as it is strategic. The tee sits ninety feet above the fairway, meaning the eighty-foot Ponderosa pine on the right can be carried by the better player. This is the preferred route to the green, since a creek and superbly placed bunker on the left are equally intimidating. That creek runs parallel to the hole before emptying into a lake a hundred yards short of the green. The double green is shared with the eighteenth hole, and is also guarded by two bunkers.

Forest Highlands Golf Club ✦ 17

LOCATION: FLAGSTAFF, ARIZONA
ARCHITECTS: TOM WEISKOPF/JAY MORRISH
LENGTH: 390 YARDS · PAR 4

Believe it or not, this hole was designed to tempt players to drive the green (and at seven thousand feet above sea level, it's possible). It is a tantalizing prospect: A raggedy creek bed crosses the fairway diagonally, and though laying up short of it may seem smart, pulling out a mid-iron on a par 4 just seems silly. Shots headed for the green must avoid the pines on the left, while starting far enough left to counteract the rightward slope of the fairway. This is a thrilling, heroic hole where anything from eagle to triple bogey is a possibility.

Four Seasons Resort and Club
(TPC at Las Colinas) ✦ 14

LOCATION: IRVING, TEXAS
ARCHITECTS: JAY MORRISH/BEN CRENSHAW
LENGTH: 409 YARDS · PAR 4

The last of the six holes on which the property's small river comes into play, the fourteenth is the most exacting hole on the course. While many of the previous holes provide ample fairways and generous greens, the fourteenth demands a strong drive in order to leave a short iron into its long, narrow green. Though not long by today's distance standards, the fourteenth often comes in as the third-toughest hole during the PGA Tour's Byron Nelson Classic.

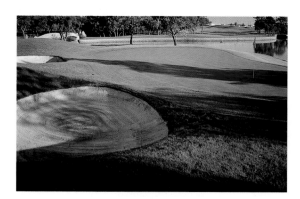

Galloway National Golf Club ✦ 15

LOCATION: GALLOWAY TOWNSHIP, NEW JERSEY

ARCHITECT: TOM FAZIO

LENGTH: 409 YARDS · PAR 4

Sandy soil and thick forest provide the perfect setting for a hole that emphasizes placement over power. The fifteenth's fairway slopes upward just in front of a massive sand pit, about 270 yards from the tee, and drives finishing short will find a flat lie. But the priority is to be in the left side of the fairway, as a large cedar tree short and right of the green blocks approaches from the right side. A steep downhill slope fronts the green, causing weak shots to roll back up to twenty yards.

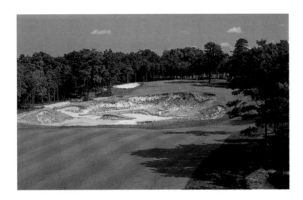

Garden City Golf Club ✦ 11

LOCATION: GARDEN CITY, NEW YORK

ARCHITECTS: DEVEREUX EMMET, WALTER TRAVIS, ROBERT TRENT JONES, SR.

LENGTH: 416 YARDS · PAR 4

A fair test for the average player, a significantly tougher one for low handicappers, this hole has a left-to-right angle to the fairway that encourages a fade off the tee. But the prime landing area is narrow and dangerous—deep bunkers down the right and nasty rough creeping in from the left. Missing the fairway on either side will almost surely lead to a bogey. On the green, a barely noticeable swale creates a two-tiered surface that produces large breaks on most long putts.

Golden Horseshoe Golf Course (Gold) ✦ 17

LOCATION: WILLIAMSBURG, VIRGINIA

ARCHITECT: ROBERT TRENT JONES, SR.

LENGTH: 435 YARDS · PAR 4

Golden Horseshoe is a fine example of a resort course giving average amateurs a taste of major-championship-caliber holes, at a slightly lower degree of difficulty. The narrow seventeenth is reminiscent of a classic U.S. Open finishing hole, meaning the objective is clear and the artificial hazards are few. Lined by trees on both sides, the fairway appears narrow from the tee, though in reality it's fairly generous. An uphill second shot, to a green guarded by two front bunkers, demands a good swing.

Golf Club of Oklahoma ✦ 3

LOCATION: BROKEN ARROW, OKLAHOMA

ARCHITECT: TOM FAZIO

LENGTH: 417 YARDS · PAR 4

The prevailing wind conditions place extraordinary demands on this tee shot. A clump of overhanging trees 265 yards down the right rough blocks the path to the green from that side, so keeping the drive left is crucial. One problem—the wind blows steadily from left to right, and a large bunker on the left-hand landing area doesn't help. The green has a four-foot swale in the right-front portion that seems to have a magnetic effect on approach shots, while bunkers guard the front left and back right.

Grand Cypress Resort (North) ✦ 7

LOCATION: ORLANDO, FLORIDA
ARCHITECT: JACK NICKLAUS
LENGTH: 432 YARDS · PAR 4

The toughest hole on Grand Cypress's toughest nine, the seventh is a classic Nicklaus par 4, which, of course, means it's a dogleg-right! Yes, the most famous fader in history loves holes that suit his game, and this is no exception. The seventh winds around a lake to the right, with a fairway bunker lining the water's edge. From there, it's at least a mid-iron to a mounded green encircled by bunkers—and when the pin is back right, the approach must carry the water a second time.

The Greenbrier (Greenbrier) ✦ 2

LOCATION: WHITE SULPHUR SPRINGS, WEST VIRGINIA
ARCHITECTS: GEORGE O'NEIL, JACK NICKLAUS
LENGTH: 403 YARDS · PAR 4

A renovation by Jack Nicklaus just prior to the 1979 Ryder Cup matches here resulted in this becoming an important early-round hole. Birdies are a good possibility, but aggressive approach shots carry a high degree of risk. The lake on the right pinches the fairway on the drive, and must also be carried to reach the green. Nicklaus angled the green away from the players, creating a few pin positions where shots missing their targets will find one of three bunkers, or roll helplessly backward into the water.

The Greenbrier (Old White) ✦ 1

LOCATION: WHITE SULPHUR SPRINGS, WEST VIRGINIA
ARCHITECTS: CHARLES BLAIR MACDONALD/SETH RAYNOR
LENGTH: 449 YARDS · PAR 4

Things get off to a roaring start on Old White, with the hole local legend Sam Snead considers to be the toughest on the course. The drive is played from an elevated tee over the babbling stream far below, with the clubhouse porch providing space for a gallery to the left. The majestic peaks of the Allegheny Mountains offer a postcard quality to this dogleg-right fairway, leading to a large green flanked by three bunkers. An opening par is a big boost to the round.

Half Moon Bay Golf Club (Links) ✦ 18

LOCATION: HALF MOON BAY, CALIFORNIA
ARCHITECTS: ARNOLD PALMER/FRANK DUANE
LENGTH: 435 YARDS · PAR 4

The land was there, just waiting for a spectacular finishing hole. With the ocean glimmering to the right, golfers will have to summon enough concentration to avoid the barranca, which crosses the fairway and can be reached from the tee. That thirty-yard-long canyon must be carried to reach the two-tiered, bunker-encircled green. Misses to the right can wind up on the beach (which is in play), while those flying over the green will likely be swallowed by rubbery ice plant.

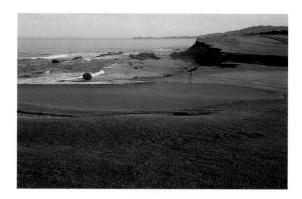

Harbour Town Golf Links ✦ 18

LOCATION: HILTON HEAD ISLAND, SOUTH CAROLINA

ARCHITECTS: PETE DYE/JACK NICKLAUS

LENGTH: 478 YARDS · PAR 4

Harbour Town's home hole is one of golf's instantly recognized icons. It is long enough to tempt a strong player to play straightaway and ignore the longer, safer route. It was here that architect Pete Dye and his design consultant, the thirty-five-year-old Jack Nicklaus, invented the low-profile style with multiple tees and small greens that became so popular in their wake. The eighteenth best illustrates the style's strengths and visual appeal. • This hole is showcased on pages 142–143.

Hazeltine National Golf Club ✦ 16

LOCATION: CHASKA, MINNESOTA

ARCHITECTS: ROBERT TRENT JONES, SR., REES JONES

LENGTH: 396 YARDS · PAR 4

Rees Jones has called the sixteenth a "white knuckle golf hole," referring to the pond and stream on opposite sides of the fairway. For Scott Simpson, the color might well be blue, as in how he felt after leaving the green. Twice during the 1991 U.S. Open, he came to the sixteenth with a 2-stroke lead over Payne Stewart, and twice he bogeyed: first in the final round, second in the eighteen-hole playoff, when Stewart holed a long birdie putt to tie and later win. • This hole is showcased on pages 144–145.

The Honors Course ✦ 15

LOCATION: OOLTEWAH, TENNESSEE

ARCHITECT: PETE DYE

LENGTH: 443 YARDS · PAR 4

Knowing many players will overcompensate on their tee shots to avoid the lake on the left, Pete Dye resisted the temptation to place bunkers or other hazards on the right. Lest anyone mistake this sign of compassion for surrender, he then proceeded to design a green complex that makes the second shot downright frightening. The small green slopes toward the lake and is guarded on the right by two bunkers, leaving little margin for error.

The Honors Course ✦ 18

LOCATION: OOLTEWAH, TENNESSEE

ARCHITECT: PETE DYE

LENGTH: 451 YARDS · PAR 4

This noble finishing hole recalls the eighteenth at Augusta National, with two bunkers guarding the left corner of the gradual dogleg-right. However, instead of playing sharply uphill, this hole's tee, landing area, and green are all roughly the same elevation, but separated by two ravines. The narrow, 60-yard-long green is guarded by one sand and three grass bunkers, as well as two large trees. Of the eighteenth, Pete Dye gushes, "As natural a piece of ground as you will find to build a golf hole."

Huntingdon Valley Country Club ✦ 18

LOCATION: ABINGTON, PENNSYLVANIA

ARCHITECTS: WILLIAM S. FLYNN/HOWARD TOOMEY

LENGTH: 434 YARDS · PAR 4

At the end of a round, the last thing a tired player wants to see is the sixty-foot rise of the eighteenth fairway, making this dogleg-right hole among the toughest finishers anywhere. Players are tempted to bite off as much as they can to shorten the approach, but must carry thick rough and bunkers in the process. The hilltop green sits majestically as four bunkers run up the right side, with one more to the left. The slick putting surface has been known to send downhill putts careening back off the green toward the fairway.

Huntsville Golf Club ✦ 2

LOCATION: SHAVERTOWN, PENNSYLVANIA

ARCHITECT: REES JONES

LENGTH: 391 YARDS · PAR 4

This tee is perched more than one hundred feet above the tree-lined, dogleg-left fairway, a height that may tempt players to take the unnecessary risk of cutting the corner. Better to aim at the rustic barn in the distance and drop the tee shot between the first of four bunkers to the left and the wooded slope on the right. The path to the small, slightly elevated green is a sweeping ramp of fairway lined with still more bunkers, while a final large bunker catches most pulled approach shots.

The Inverness Club ✦ 7

LOCATION: TOLEDO, OHIO

ARCHITECTS: DONALD ROSS, DICK WILSON, GEORGE AND TOM FAZIO

LENGTH: 452 YARDS · PAR 4

With no bunkers and a relatively wide, accepting fairway, the seventh hole may appear incapable of eliciting big numbers. Not exactly. First of all, it's long. And once players reach the green, it's a whole different game. The raised, slanted green is the most feared on the course. During the 1986 PGA Championship, both Bob Tway and Greg Norman had 15-foot downhill birdie putts on this hole; both players' putts kept rolling right off the green.

The Inverness Club ✦ 18

LOCATION: TOLEDO, OHIO

ARCHITECTS: DONALD ROSS, DICK WILSON, GEORGE AND TOM FAZIO

LENGTH: 354 YARDS · PAR 4

Jack Nicklaus calls it "the hardest hole I ever played," but that's not why Inverness's eighteenth will forever be remembered. Rather, this is where Greg Norman's improbable string of final-round heartbreaks truly took hold. On Sunday at the 1986 PGA Championship, Norman and Bob Tway were tied. While Norman was safely on the fringe at 18, Bob Tway's ball lay in a difficult spot in the right-hand greenside bunker. Tway holed the spectacular bunker shot, beating a stunned Norman.

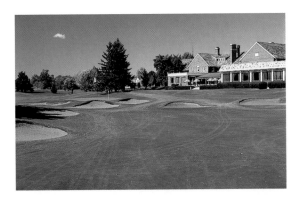

Kiawah Island Resort (Ocean) ✦ 4

LOCATION: KIAWAH ISLAND, SOUTH CAROLINA

ARCHITECT: PETE DYE

LENGTH: 432 YARDS · PAR 4

Pete Dye has been known to say, "Golfers love abuse." It's obvious he was thinking along those lines when he created this beast of a par 4. On a treeless expanse of property at the mercy of the seaside winds, Dye created a hearty early-round challenge. The split fairway calls for two carries over wetlands, while the shallow green, backed by sand dunes, has enough humps and bumps to resemble an off-road driving course.

Laurel Valley Golf Club ✦ 18

LOCATION: LIGONIER, PENNSYLVANIA

ARCHITECT: DICK WILSON

LENGTH: 470 YARDS · PAR 4

Conventional wisdom suggests that to par number 18, the drive must be straight and long so that the second shot can carry the huge lake and reach this elevated, well-bunkered green. Unless you're able to repeat the performance of Dave Marr. Coming to the eighteenth with a 2-stroke lead over Jack Nicklaus in the 1965 PGA Championship, a nervous Marr drove into the left bunker, laid up short of the lake, and then hit a 9-iron 2 feet from the hole to save par and capture victory.

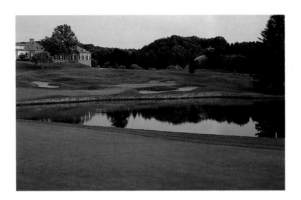

Lake Nona Golf Club ✦ 7

LOCATION: ORLANDO, FLORIDA

ARCHITECT: TOM FAZIO

LENGTH: 450 YARDS · PAR 4

It almost seems cruel, that long ridge running down the middle of the fairway. Anything landing to the right of it risks bounding off into the lake, while leftward shots could find themselves getting kicked into the rough. If hitting the fairway is tough, the second shot is certainly no cakewalk. The narrow green is fronted by a bunker, while deep grass collection areas stand guard left and right. It's not uncommon to see players putt from off the green to avoid a testy chip shot.

Linville Golf Course ✦ 3

LOCATION: LINVILLE, NORTH CAROLINA

ARCHITECT: DONALD ROSS

LENGTH: 455 YARDS · PAR 4

A sublime site in the midst of North Carolina's Blue Ridge Mountains provided a perfect topographic canvas for this supremely challenging hole. The semiblind tee shot is played over a hilltop to a valley landing area surrounded by thick pine trees. Even more formidable is the uphill approach, which must carry the property's ubiquitous creek—twice. Adding to the difficulty is the small, sloping green, which demands that the ball be kept below the hole to avoid an almost certain three-putt.

Long Cove Club ✦ 1

LOCATION: HILTON HEAD ISLAND, SOUTH CAROLINA

ARCHITECT: PETE DYE

LENGTH: 400 YARDS · PAR 4

At first glance, this may look like yet another diabolical Pete Dye hole. But look closely—the fairway is reasonably wide, with a gentle dogleg-right (helping slicers to a good start). The sandy waste bunker down the right side actually stops some tee shots from ending up in the large lake. Sure, the green is hard by the water on one side and has a deep pot bunker just short, but the overall design of this hole is in keeping with the fairness and aesthetic standards at Long Cove.

Los Angeles Country Club (North) ✦ 16

LOCATION: LOS ANGELES, CALIFORNIA

ARCHITECTS: GEORGE C. THOMAS/WILLIAM P. BELL, ROBERT MUIR GRAVES

LENGTH: 433 YARDS · PAR 4

This is the first in an infamous stretch of closing holes—all long par 4s. A large bunker on the left is perfectly placed 220 yards from the tee. Players often try to carry the bunker, because four trees on the right further reduce the available landing area. The green slopes precipitously from back to front, so the large bunker about 10 yards short of the green catches plenty of weak approach shots from players trying to avoid ending up above the hole.

The Maidstone Club ✦ 9

LOCATION: EAST HAMPTON, NEW YORK

ARCHITECTS: WILLIE AND JOHN PARK, WILLIAM H. TUCKER

LENGTH: 402 YARDS · PAR 4

At the Maidstone Club, rough, scrubby land good for little more than grazing was fashioned for a game of intricate order, demanding execution and patient judgment. The ninth begins from an elevated tee with no shelter, and the ball must be played up into the wind, which can make the fairway difficult to hit. Exposure to the wind on the green can affect putting. According to Rees Jones, "Maidstone's ninth is the purest links hole in America." • This hole is showcased on pages 148–149.

The Maidstone Club ✦ 10

LOCATION: EAST HAMPTON, NEW YORK

ARCHITECTS: WILLIE AND JOHN PARK, WILLIAM H. TUCKER

LENGTH: 382 YARDS · PAR 4

A three-shot par 4? When you are playing into the prevailing wind, the answer is yes. The hole features a landing area that abruptly ends at a huge, rough-strewn hill of bayberry bushes and coastal scrub. This monstrosity must be carried to reach the green—if the drive is not long enough with the second shot, laying up is the smart play. One of the most intimidating green sites in golf awaits, with a five-bunker complex on the left, twenty-five-foot drop-offs back and right, and a mound in the center that affects nearly every putt.

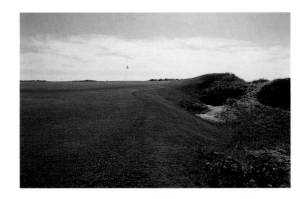

Mauna Kea Golf Club ✦ 6

LOCATION: KAMUELA, HAWAII

ARCHITECT: ROBERT TRENT JONES, SR.

LENGTH: 344 YARDS · PAR 4

When Laurance Rockefeller first spied the land for his resort venture, he said, "This is the place." Any golf architect worth his salt likely would agree, as the property allows for holes like this one, which seem to have designed themselves. The fairway follows the natural contours of the hill, playing down toward the ocean backdrop. Thick vegetation and lava line the left side, and the green, guarded by two front bunkers, is perched on a small plateau.

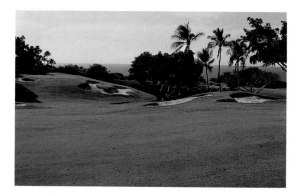

Merion Golf Club (East) ✦ 16

LOCATION: ARDMORE, PENNSYLVANIA

ARCHITECT: HUGH WILSON

LENGTH: 428 YARDS · PAR 4

Merion's creator, Hugh Wilson, attempted to build a parkland course full of subtlety and nuance by fitting the holes to the land in what was once at 125-acre tract of rolling farmland. The sixteenth hole, called "the Quarry" hole, has a broad fairway ending abruptly at an old limestone quarry. The terrain in the quarry is hellish, with gaping maws of sand, waist-high broom, and impenetrable rough. The sixteenth is a heroic hole with penal consequences for the foolhardy. • This hole is showcased on pages 30–33.

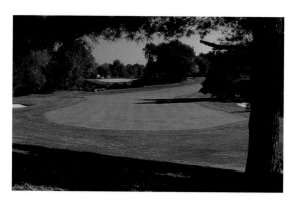

Merion Golf Club (East) ✦ 18

LOCATION: ARDMORE, PENNSYLVANIA

ARCHITECT: HUGH WILSON

LENGTH: 463 YARDS · PAR 4

A picture-perfect finish—literally. The drive must carry an old, overgrown quarry that actually comes more into play on the two previous holes. In the case of a well-struck drive, the long approach will be played near the spot of one of the most famous shots in golf history, Ben Hogan's 1-iron in the final round of the 1950 U.S. Open. That shot, and the eighteenth green, are immortalized in a photograph showing Hogan's unmistakable follow-through from behind (see pages xiv–1).

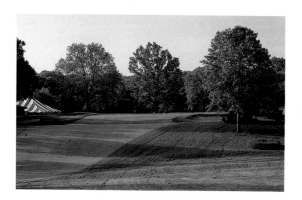

Metacomet Golf Club ✦ 14

LOCATION: EAST PROVIDENCE, RHODE ISLAND

ARCHITECT: DONALD ROSS

LENGTH: 459 YARDS · PAR 4

A bunker on the left sits at the crest of a fairway hill 215 yards from the tee. This rolling terrain produces a slingshot effect—drives that reach the right side of the hill are propelled some thirty yards down and to the left, into a valley landing area. A second large hill leading up to the green obscures the flag, leaving a blind approach. The green's front-left side is guarded by a double bunker, while steep drop-offs on the right, rear, and left create a plateau effect.

Metropolis Country Club ✦ 6

LOCATION: WHITE PLAINS, NEW YORK

ARCHITECTS: HERBERT STRONG, A. W. TILLINGHAST

LENGTH: 423 YARDS · PAR 4

Typical of many Westchester County par 4s, this sharp left-bending, down-hill hole is tight off the tee, with only about 20 yards of level fairway for the drive. In addition, the fairway slopes hard left and down the hill, making for awkward lies. The approach needs to be precise, avoiding a small but troublesome creek to the right, and a gaping front bunker that guards the tricky, two-tiered green.

Milwaukee Country Club ✦ 9

LOCATION: MILWAUKEE, WISCONSIN

ARCHITECTS: H. S. COLT/CHARLES ALISON, ROBERT TRENT JONES, SR.

LENGTH: 332 YARDS · PAR 4

This is one of the most demanding short holes in America. The narrow landing area is defended on the right by three bunkers; the second shot, deceptively uphill, looks closer thanks to the fearsome, ten-foot-deep bunker short and right of the green that creates a false front. The subtle slopes in the green and slight dogleg-right were primarily the work of Trent Jones, who reworked the hole in preparation for the 1969 Walker Cup matches.

Monterey Peninsula Country Club (Dunes) ✦ 12

LOCATION: PEBBLE BEACH, CALIFORNIA

ARCHITECTS: SETH RAYNOR/CHARLES BANKS, REES JONES

LENGTH: 415 YARDS · PAR 4

After a redesign by Rees Jones, this hole is longer and tougher than the original, but still among the most scenic holes on the Monterey Peninsula. The tee was moved back and three fairway bunkers were built on the left. The approach is played uphill to a contoured green whose right portion is the most desirable, and also the most guarded—the sharp right fall-off is marked by two deep bunkers. A clear view of the Pacific greets players upon arriving at the green, and also allows the wind to harass approach shots.

Muirfield Village Golf Club ✦ 14

LOCATION: DUBLIN, OHIO

ARCHITECTS: JACK NICKLAUS/DESMOND MUIRHEAD

LENGTH: 363 YARDS · PAR 4

The shortest par 4 on the course is its most beguiling, and usually its toughest when championships come to call. The smart play is a long iron or fairway wood to the heart of the undulating fairway. A stream runs diagonally in front and to the right of the green, while sand sits along the left. The green is long and narrow—a difficult target to hit set among ingeniously placed trouble. • This hole is showcased on pages 150–151.

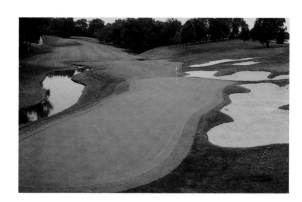

Myopia Hunt Club ✦ 4

LOCATION: SOUTH HAMILTON, MASSACHUSETTS

ARCHITECTS: H. C. LEEDS, GEOFFREY CORNISH/BRIAN SILVA

LENGTH: 392 YARDS · PAR 4

During the 1905 U.S. Open, an unidentified competitor hit a downhill putt on the fourth green directly into an adjacent pond. He eventually took nine putts to hole out, and the pond was filled in and replaced by a bunker. The narrow, dogleg-left fairway rambles down to the infamous green complex, which has seen some changes over the years, except for one constant. On certain days, it's still possible to roll a putt off the green and into that historical—although now sand-filled—hazard.

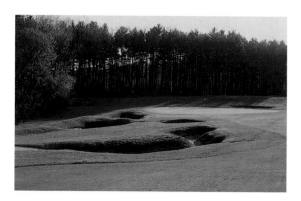

The National Golf Links of America ✦ 3

LOCATION: SOUTHAMPTON, NEW YORK

ARCHITECT: CHARLES BLAIR MACDONALD

LENGTH: 426 YARDS · PAR 4

"The Alps" hole is modeled after the famous seventeenth hole at Scotland's Prestwick. After a drive that must avoid a long fairway cross bunker, the second shot is played blind over a rough-hewn hill—the Alps—to a huge green 20 yards past a long bunker. Players must ring a bell after holing out to advise those waiting on the other side of the Alps that the green is clear. Unlike Prestwick's version, this hole offers the option of playing around the hill as a par 5, but where's the fun in that?

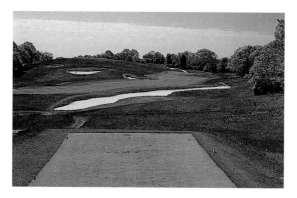

The National Golf Links of America ✦ 17

LOCATION: SOUTHAMPTON, NEW YORK

ARCHITECT: CHARLES BLAIR MACDONALD

LENGTH: 368 YARDS · PAR 4

The name of the game here is strategy, as this is one of the best-conceived short par 4s anywhere. From the tee, the fairway looks generous, but the drive is critical: The right side seems to offer the shorter approach, but the tee shot should be long and left to leave the best angle into the green. There is also sand to contend with—in the fairway on the right and behind the green. What solace exists is the beautiful view of Peconic Bay and the Long Island Sound. • This hole is showcased on pages 152–153.

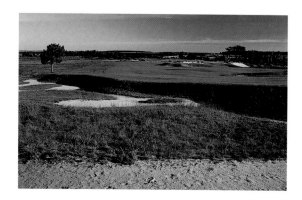

Newport Country Club ✦ 9

LOCATION: NEWPORT, RHODE ISLAND

ARCHITECTS: WILLIAM F. DAVIS, DONALD ROSS, A. W. TILLINGHAST

LENGTH: 448 YARDS · PAR 4

Rising up to the clubhouse, the majestic ninth usually offers the benefit of the prevailing wind, a comforting thought when you are staring at the cross bunker 235 yards from the tee on the right—hit in it, and it's nearly impossible to reach the green. Even those finding the fairway aren't out of the woods; there's virtually no background behind the flag, making depth perception difficult. The green is angled away from right to left, and a nasty bunker hugs the short-left side, awaiting those who misjudge distance and direction.

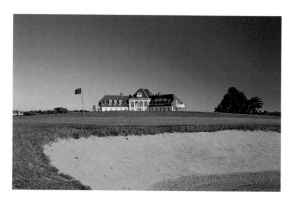

Oak Hill Country Club (East) ✦ 7

LOCATION: ROCHESTER, NEW YORK

ARCHITECTS: DONALD ROSS, ROBERT TRENT JONES, SR.,
GEORGE AND TOM FAZIO

LENGTH: 432 YARDS · PAR 4

"The Creek's Elbow," as the seventh is called, is as fine a hole as Donald Ross ever designed. Its presentation of length, water, sand, and contour is excellent. Two exacting shots must be struck in order to find the green and attempt par. In the 1995 Ryder Cup matches, Curtis Strange and Jay Haas lost this hole to a par during the foursomes competition. • This hole is showcased on pages 156–157.

Oakland Hills Country Club (South) ✦ 11

LOCATION: BLOOMFIELD HILLS, MICHIGAN

ARCHITECTS: DONALD ROSS, ROBERT TRENT JONES, SR.

LENGTH: 411 YARDS · PAR 4

This hole doesn't sound long for today's elite players, but whenever a major comes to Oakland Hills the competitors are happy to escape with a par. The tumbling, twisting fairway is difficult to hit, with balls often caroming into the rough. The second shot plays uphill to a narrow green that is not completely visible from the fairway. A chipping area was recently added to give more short-game options to players who overshoot the green.

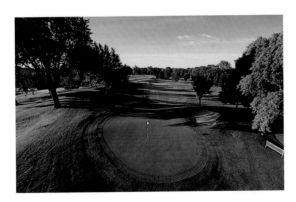

Oakland Hills Country Club (South) ✦ 16

LOCATION: BLOOMFIELD HILLS, MICHIGAN

ARCHITECTS: DONALD ROSS, ROBERT TRENT JONES, SR.

LENGTH: 405 YARDS · PAR 4

Oakland Hills's sixteenth doglegs sharply to the right, and in the elbow of the bend is a water hazard that protrudes into the fairway, guarding the front and right of the green. Great holes present demands and reward heroics, just as great champions define themselves by finding necessary answers to unlikely situations. • This hole is showcased on pages 158–159.

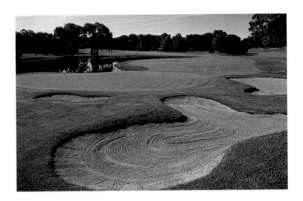

Oakmont Country Club ✦ 3

LOCATION: OAKMONT, PENNSYLVANIA

ARCHITECTS: HENRY AND WILLIAM FOWNES

LENGTH: 425 YARDS · PAR 4

Opened in 1903, Oakmont was the first of America's truly penal courses. First and foremost among its hellish hazards is the "Church Pews" bunker that hugs the left side of this fairway: It's two acres of sand striped with eight grass-covered ridges three feet tall and seventy-five feet long. Once you enter this pew, often the only escape is prayer. Three bunkers balance the right side of the fairway, and the green, relatively flat for Oakmont, is elevated and book-ended by more deep sand pits. • This hole is showcased on pages 160–161.

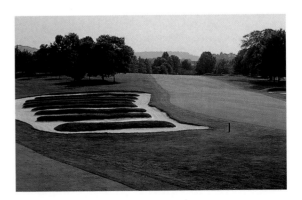

Oakmont Country Club ✦ 18

LOCATION: OAKMONT, PENNSYLVANIA

ARCHITECTS: HENRY AND WILLIAM FOWNES

LENGTH: 453 YARDS · PAR 4

Emotion and drama have marked the history of this formidable finishing hole. In the 1973 U.S. Open, a young Johnny Miller shocked the golf world with a final-round 63, lipping out an 18-foot birdie putt on the eighteenth. In 1994, the roar was enormous as Arnold Palmer played his last hole in a U.S. Open. A bunker was added in 1983 to toughen up the drive for big hitters, but many would say the narrow fairway, already guarded by four other bunkers, was tough enough already.

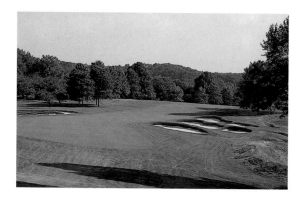

Ocean Forest Golf Club ✦ 16

LOCATION: SEA ISLAND, GEORGIA

ARCHITECT: REES JONES

LENGTH: 394 YARDS · PAR 4

On a pristine parcel of Georgia barrier island that few people are likely to see (the club is intensely private), Rees Jones has crafted a beauty where players will have to account for the area's fresh breezes. The hole doglegs left out of a chute of trees, revealing a second shot that, though not overly long, must contend with a small green guarded by five bunkers in front and unrecoverable marsh behind. This should be an exciting hole when the Walker Cup matches are held at Ocean Forest in 2001.

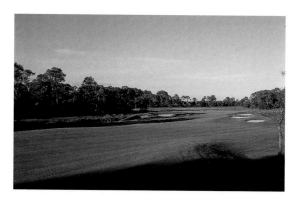

Ojai Valley Inn Golf Club ✦ 11

LOCATION: OJAI, CALIFORNIA

ARCHITECT: GEORGE C. THOMAS

LENGTH: 358 YARDS · PAR 4

This hole was built on the type of land architects dream about, where the inherent natural features dictate the level of challenge. Though a short par 4 by today's standards, the eleventh is a precise hole whose main feature is a barranca running down the right side and crossing the fairway past the dogleg. The tee shot must avoid a large bunker at the corner of the dogleg, leaving an approach over the barranca through a narrow gap in the trees to reach the long green, guarded in back by two more bunkers.

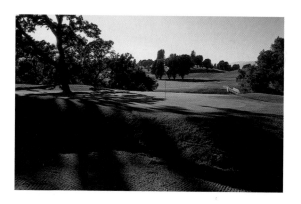

Old Memorial Golf Club ✦ 18

LOCATION: TAMPA, FLORIDA

ARCHITECT: STEVE SMYERS

LENGTH: 451 YARDS · PAR 4

Gnarly swaths of palmetto bushes pinch the landing area of this classically styled finishing hole, creating a golf ball graveyard for those missing the fairway. Tee shots should favor the left side, both to avoid a large oak on the right and provide the best angle into an artfully bunkered green. But a wide, high-lipped bunker short and right comes first, quickly followed by a smaller bunker that is invisible from the fairway. Other potential pitfalls include two more bunkers on the left and one behind the green.

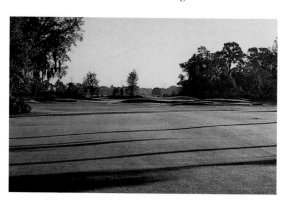

Old Warson Country Club ✦ 14

LOCATION: ST. LOUIS, MISSOURI
ARCHITECT: ROBERT TRENT JONES, SR.
LENGTH: 360 YARDS · PAR 4

The carry from the championship tee over the lake ranges from 200 to 250 yards, but the tightness of the landing area causes the most trouble. Three well-placed bunkers, one on the left and two on the right, see plenty of action as players tend to steer shots away from the water. More trouble is found on the approach, as three more bunkers flank a sloping, narrow green. A fine example of a hole presenting numerous hazards to offset lack of length.

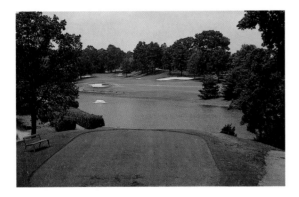

Olympia Fields Country Club (North) ✦ 14

LOCATION: OLYMPIA FIELDS, ILLINOIS
ARCHITECT: WILLIE PARK, JR.
LENGTH: 444 YARDS · PAR 4

This is sure to be a pivotal hole down the stretch when the 2003 U.S. Open is held at Olympia Fields. From the sunken tee, players must carry their drives over Butterfield Creek, which then flows into the woods—but only temporarily. It makes a return appearance short of the green, this time with a ten-foot rocky embankment that must be carried. The approach is uphill to a green whose narrow front is guarded by two bunkers dug into the hillside.

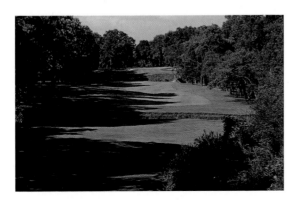

Olympic Club (Lake) ✦ 7

LOCATION: SAN FRANCISCO, CALIFORNIA
ARCHITECTS: WILLIE WATSON, SAM WHITING,
ROBERT TRENT JONES, SR.
LENGTH: 288 YARDS · PAR 4

This hole's length makes it almost irresistible for long hitters, who may be looking for birdies after the difficult holes 2 through 6. But as John Daly demonstrated in the 1998 U.S. Open, be careful what you wish for. Daly drove the green with a 3-wood in the second round en route to a two-putt birdie, then made an 8 the next day after his drive found the trees.

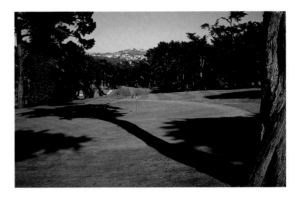

Olympic Club (Lake) ✦ 18

LOCATION: SAN FRANCISCO, CALIFORNIA
ARCHITECTS: WILLIE WATSON, SAM WHITING,
ROBERT TRENT JONES, SR.
LENGTH: 338 YARDS · PAR 4

The hole itself is no more than a long iron and wedge for many players, but from the fairway the elevated green is barely visible behind a set of deep bunkers. It was here in 1955 that relative unknown Jack Fleck rolled in a 7-foot birdie putt—with a Ben Hogan model putter—to tie Hogan and force a playoff in the U.S. Open. It was also the scene of a controversial tough pin placement during the second round of the 1998 U.S. Open.

Pablo Creek Club ✦ 9

LOCATION: JACKSONVILLE, FLORIDA

ARCHITECT: TOM FAZIO

LENGTH: 448 YARDS · PAR 4

Birdies on this hole are about as rare as used cars in this exclusive club's parking lot. Lined by trees on both sides, the fairway extends to a landing area guarded on the left by three bunkers. Though only 185 yards from the green, these bunkers are not the ideal place from which to attack this oval-shaped, elevated green. Four deep-faced bunkers surround the putting surface, which is sloping and very quick. Severely pushed shots may find a watery fate in the marsh that lies beyond the right bunker.

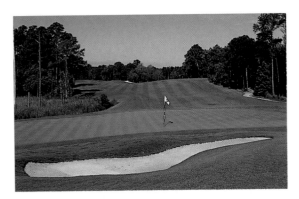

Pasatiempo Golf Club ✦ 2

LOCATION: SANTA CRUZ, CALIFORNIA

ARCHITECT: ALISTER MACKENZIE

LENGTH: 442 YARDS · PAR 4

Mackenzie originally laid out this hole as a par 5, with the tee directly behind the first green. That changed when a service road was built, but the result is a strong early test. The mounded, uneven fairway tumbles along the same fall line as the first hole, with the ocean in the background. Downhill lies in the fairway are common, making the approach—to a green originally built for short-iron third shots, so it slopes away from the player—that much tougher.

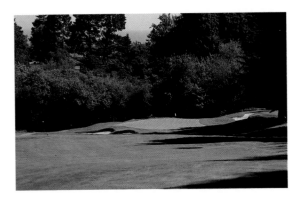

Pasatiempo Golf Club ✦ 16

LOCATION: SANTA CRUZ, CALIFORNIA

ARCHITECT: ALISTER MACKENZIE

LENGTH: 395 YARDS · PAR 4

This course was Mackenzie's longtime home, and this hole his most beloved par 4. It follows the land's contours all the way to the elevated, three-tiered green, which is guarded by expertly carved bunkers, and a deep barranca in front. The approach is played off a downhill lie, further complicating distance control. Complementing the challenges of the course are the hillside surroundings, which include a plethora of cypress, pine, and oak trees along with views of Monterey Bay. • This hole is showcased on pages 166–167.

Pebble Beach Golf Links ✦ 8

LOCATION: PEBBLE BEACH, CALIFORNIA

ARCHITECTS: JACK NEVILLE/DOUGLAS GRANT, H. CHANDLER EGAN

LENGTH: 431 YARDS · PAR 4

The second shot on this hole is the make-or-break swing at Pebble. A successful carry of the 180-yard chasm can propel players to a good round; skulling one into the Pacific often has the opposite effect. Jack Nicklaus called it the greatest second shot in golf, played to a difficult green that was refurbished by Alister Mackenzie in the 1920s. The small putting surface, ringed by bunkers, is lightning-fast and slopes toward the ocean.

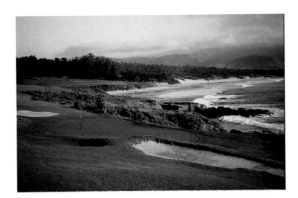

Pete Dye Golf Club ✦ 2

LOCATION: BRIDGEPORT, WEST VIRGINIA

ARCHITECT: PETE DYE

LENGTH: 435 YARDS · PAR 4

Tee shots must carry Simpson Creek, which continues up the left side to the green. In summer, unmanicured native grasses sprout on the creek banks, snagging and concealing errant shots. An aiming bunker in the right rough signals the best position to fire at the deep, undulating green. Two sunken greenside bunkers sit ominously to the left, with the creek directly behind them. A closely mown swale to the right offers some bailout room, but pitches from there require a deft touch.

PGA West (Stadium) ✦ 9

LOCATION: LA QUINTA, CALIFORNIA

ARCHITECT: PETE DYE

LENGTH: 452 YARDS · PAR 4

Ending the front nine with a bang, this intimidator—the course's number one handicap hole—offers all of the elements that make PGA West's Stadium the most feared track in America. A massive waste bunker comes into play off the tee, catching some errant shots that would otherwise go in the pond. However, when faced with extracting a ball from this Sahara-like creation, many players might prefer their ball be wet.

Philadelphia Country Club ✦ 17

LOCATION: GLADWYNE, PENNSYLVANIA

ARCHITECTS: WILLIAM S. FLYNN/HOWARD TOOMEY

LENGTH: 446 YARDS · PAR 4

Trees that once stood at the inside corner of this dogleg-right have been removed, giving big hitters a chance to cut the corner—if they dare—in order to leave as little as an 8-iron approach into this undulating green. A large bunker guards the right side of the plateau fairway, and most players choose to hit safely out to the left. That's what Byron Nelson did in the 1939 U.S. Open, when he hit a 1-iron into the hole (then played as the fourth) for an eagle 2, en route to a playoff win over Craig Wood.

Philadelphia Cricket Club ✦ 9

LOCATION: FLOURTOWN, PENNSYLVANIA

ARCHITECT: A. W. TILLINGHAST

LENGTH: 472 YARDS · PAR 4

The ninth is exceptional for its precisely guarded landing area and dangerously close right-hand out of bounds, marked by an old railroad embankment. Players trying to bail out left meet a tight fairway area confined by a stream and two troublesome bunkers, from which bogey is nearly inevitable. The approach is uphill to a two-tiered, well-bunkered green, where even a slightly pushed shot can end up on the wrong side of the white stakes.

Pinehurst Country Club (No. 2) ✦ 2

LOCATION: PINEHURST, NORTH CAROLINA
ARCHITECT: DONALD ROSS
LENGTH: 441 YARDS · PAR 4

It doesn't take long for Pinehurst to show its teeth. Donald Ross's penchant for "inverted saucer" greens is on full display, as any approach shot not hitting the correct portion of the green will likely roll off the sides. Early in the round, with at least a mid-iron in your hand, that's a tall order—there were only thirty-one birdies on this hole during all four rounds of the 1999 U.S. Open.

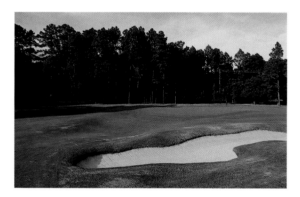

Pinehurst Country Club (No. 2) ✦ 5

LOCATION: PINEHURST, NORTH CAROLINA
ARCHITECT: DONALD ROSS
LENGTH: 482 YARDS · PAR 4

From the back tee at Pinehurst's fifth, the player is beguiled by an enormous landing area and a gently turning dogleg-left to the green in the distance. A tee shot played to the right half of the fairway sets up one of the most exciting approaches in the world of golf, to one of Donald Ross's trademark raised, rolling greens. • This hole is showcased on pages 168–169.

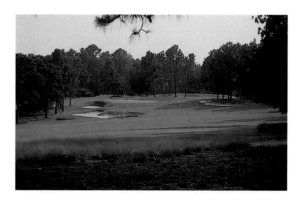

Pine Valley Golf Club ✦ 13

LOCATION: CLEMENTON, NEW JERSEY
ARCHITECTS: GEORGE CRUMP/H. S. COLT
LENGTH: 448 YARDS · PAR 4

No course in the world chips a golfer's ego down to size like Pine Valley. Its thirteenth hole is what architects like to call a par 4½, which is a nice way of saying it's well-nigh impossible for all but a straight, fearless long-hitter to reach the green in regulation and match par on this terrifying two-shotter. The bold, confident expert unconcerned about the dire consequences for a failed effort can throw caution to the wind and play a "death or glory" shot to the green. • This hole is showcased on pages 38–41.

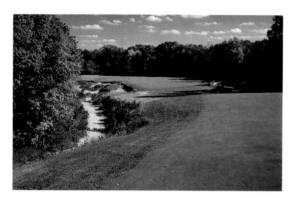

Pittsburgh Field Club ✦ 12

LOCATION: PITTSBURGH, PENNSYLVANIA
ARCHITECTS: ALEX FINDLEY, A. W. TILLINGHAST,
 ROBERT TRENT JONES, SR.
LENGTH: 459 YARDS · PAR 4

Before the 1937 PGA Championship, this hole was changed from a medium-length par 5 to a splendid par 4. The view from the tee ranges from the fairway winding its way artfully between two bunkers (the shorter one on the left catches plenty of tee shots) to the sloping green. Shots missing the green to the left must contend with a ten-foot-deep bunker and steep fall-off; two gentler bunkers on the right provide the only bailout.

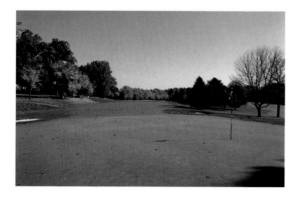

Plainfield Country Club ✦ 2

LOCATION: PLAINFIELD, NEW JERSEY

ARCHITECT: DONALD ROSS

LENGTH: 450 YARDS · PAR 4

Straight and long, with all the hazards visible, this hole can easily lull players into a false sense of security. Fact is, a drive of at least 250 yards is necessary to gain a reasonably flat lie, as the fairway slopes sharply from right to left. And this is not the type of green you'd want to approach from a hook lie—it is crowned, elevated, and quick. A bunker short and right catches many weak approaches, while gnarly rough and a steep slope behind ensure other misses will be duly punished.

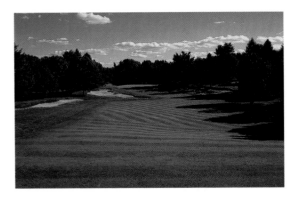

Prairie Dunes Country Club ✦ 8

LOCATION: HUTCHINSON, KANSAS

ARCHITECT: PERRY MAXWELL

LENGTH: 430 YARDS · PAR 4

When architect Perry Maxwell set out to build Prairie Dunes, he admired the rugged beauty of the windblown and sunbaked land. Its par-4 eighth rises from the tee over and around four sand dunes that traverse the fairway. Each successive dune becomes higher than the last, rising more than forty feet 140 yards from the green. • This hole is showcased on pages 170–171.

Pumpkin Ridge Golf Club (Witch Hollow) ✦ 6

LOCATION: NORTH PLAINS, OREGON

ARCHITECTS: BOB CUPP/JOHN FOUGHT

LENGTH: 453 YARDS · PAR 4

Presenting a fine example of a water hazard being used to its maximum potential, this hole offers all golfers a chance to navigate around the trouble if they choose the right strategy. The ideal drive is left-center of the fairway, thereby avoiding having to hit the second shot on a parallel line to the creek. Ample fairway short and right of the green gives shorter hitters an escape option, but the narrowness of the green will still require a solid approach.

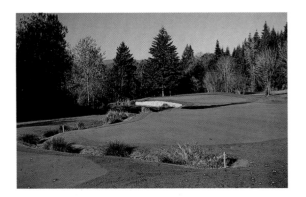

Quaker Ridge Golf Club ✦ 6

LOCATION: SCARSDALE, NEW YORK

ARCHITECT: A. W. TILLINGHAST

LENGTH: 446 YARDS · PAR 4

At 446 yards, Quaker Ridge's sixth is the narrowest and longest par 4 on a course known for two things: its long par 4s and its demand for accurate driving. The fairway is just twenty-two paces wide, pitches from right to left, and bends from left to right. The plateau fairway requires longer players to club down to assure finding the fairway off the tee and the best spot from which to advance the ball to the small green. • This hole is showcased on pages 174–175.

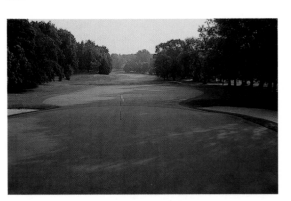

Quaker Ridge Golf Club ✦ 11

LOCATION: SCARSDALE, NEW YORK

ARCHITECT: A. W. TILLINGHAST

LENGTH: 387 YARDS · PAR 4

On a tight layout known as "Tillie's Treasure," the wide fairway of the eleventh often looks inviting. But ask people who have played it repeatedly, and they'll say it's one of the toughest holes on the course to par. A perfectly placed fairway bunker on the right catches plenty of tee shots, mainly because hitting to the left side of the fairway results in an awful approach angle into the small, well-guarded green.

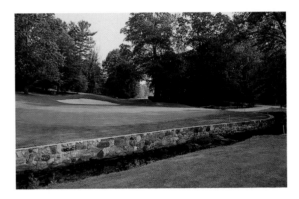

Ridgewood Country Club (Center) ✦ 6

LOCATION: RIDGEWOOD, NEW JERSEY

ARCHITECT: A. W. TILLINGHAST

LENGTH: 289 YARDS · PAR 4

"The Five and Dime" hole, as it is known to members, got its name because "If you don't make a 5, you'll make a 10." Truer words were never spoken. This hole represents Tillinghast's artistry, with its plateaued green surrounded by six troublesome bunkers. There's little benefit to trying to drive the green—the fairway ends about fifty yards short of the green, with thick rough and a large bunker standing guard.

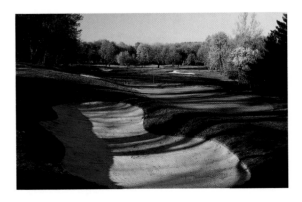

Riviera Country Club ✦ 10

LOCATION: PACIFIC PALISADES, CALIFORNIA

ARCHITECT: GEORGE C. THOMAS

LENGTH: 311 YARDS · PAR 4

The short par-4 tenth at Rivera Country Club accentuates the intricacy of architect George Thomas's creative mind. At just 311 yards, it tempts the player to drive the green—but the risk is substantial. The fairway is split by two bunkers while the green is inhospitable to receiving a drive and slopes severely from right to left. • This hole is showcased on pages 176–177.

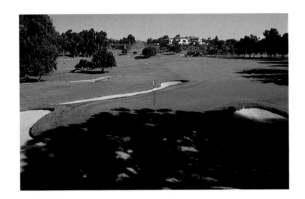

Riviera Country Club ✦ 18

LOCATION: PACIFIC PALISADES, CALIFORNIA

ARCHITECT: GEORGE C. THOMAS

LENGTH: 451 YARDS · PAR 4

Other holes at Riviera might be more architecturally innovative, but few holes in golf produce such a thrilling climax on tournament Sundays than this one. The stern uphill hole demands a blind drive to a plateau fairway that falls off to the right, with overhanging trees affecting approach shots. The grassy embankment around the bunkerless green is a spectator's dream, but a player's nightmare if they have to get up and down.

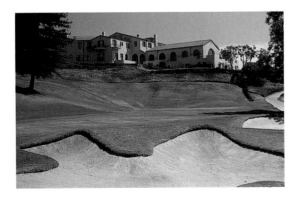

Royal Oaks Golf Club ✦ 13

LOCATION: DALLAS, TEXAS

ARCHITECTS: DON JANUARY/BILLY MARTINDALE

LENGTH: 467 YARDS · PAR 4

Majestic, large-canopied oaks dictate the character of this difficult hole. Hitting the green in regulation is virtually impossible without a drive of at least 240 yards, as the trees form a wall around the corner of the dogleg right. The green is protected like a fortress, with White Rock Creek flowing in front, grass bunkering to the left, and a large bunker back right. Approach shots must carry all the way to the green, or the slope will cause the ball to roll back into the creek.

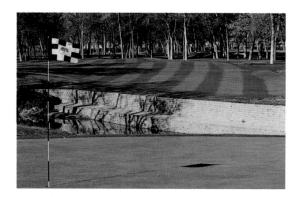

Salem Country Club ✦ 13

LOCATION: PEABODY, MASSACHUSETTS

ARCHITECT: DONALD ROSS

LENGTH: 342 YARDS · PAR 4

Not all short holes are birdie opportunities. When it was played as the sixteenth, this had the highest stroke average at the 1984 U.S. Women's Open. The drive is usually played with a long iron or fairway wood to a hollow in the dogleg-right fairway, and from here things get very interesting. The uphill approach must find a green that Ross once called "among the finest I've ever designed," where trouble comes in threes: Three greenside bunkers guard the three-tiered putting surface, which causes plenty of three-putts.

Sand Hills Club ✦ 7

LOCATION: MULLEN, NEBRASKA

ARCHITECTS: BEN CRENSHAW/BILL COORE

LENGTH: 283 YARDS · PAR 4

Sand Hills is a natural wonder; only two thousand cubic yards of earth were moved in its construction, and very little on this, the shortest par 4 of the world's best. A vast patch of high, unkept grass separates the tee from the broad, uphill fairway. Sand stands both left and right, demanding a well-placed shot with any club other than driver. The approach is just as tricky, requiring exact distance to carry the front-left bunker and stay on the green, which slants front to back. • This hole is showcased on pages 192–193.

Sankaty Head Golf Club ✦ 10

LOCATION: SIASCONSET, MASSACHUSETTS

ARCHITECTS: H. EMERSON ARMSTRONG, SKIP WOGAN, A. W. TILLINGHAST

LENGTH: 431 YARDS · PAR 4

No trees interrupt the expanse from knee-high rough and sandy dunes to the small, elevated green, with deep bunkers left and rear. It's the prevailing wind that is the primary obstacle to getting there, in summer turning this into a par 5 everywhere but on the scorecard. A valley fifty yards short of the green is a collection area for weak approaches—and a daunting place from which to play a tricky third shot to the sharp, right-to-left sloping green.

Saucon Valley Country Club (Old) ✦ 2

LOCATION: BETHLEHEM, PENNSYLVANIA

ARCHITECT: HERBERT STRONG

LENGTH: 434 YARDS · PAR 4

Challenges on golf holes come in different forms—some subtle, some in-your-face. This hole happens to have both, making it doubly fearsome. The drive is played to a tree-lined, plateau fairway that suddenly drops off, "revealing" a gnarly, hundred-yard-long chasm that must be carried on the approach. From here, the green looks relatively benign, but on closer inspection, its wild undulations become visible. Three-putts are common, making this hole play as the second-toughest on the course during the 1992 U.S. Senior Open.

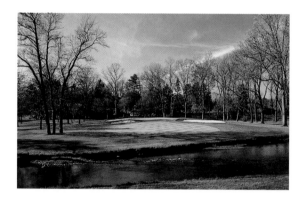

Scioto Country Club ✦ 2

LOCATION: COLUMBUS, OHIO

ARCHITECT: DONALD ROSS

LENGTH: 436 YARDS · PAR 4

This is classic Ross hole, whose enduring look and challenge makes it just as relevant nearly ninety years after its original design. The temptation off the tee is to sneak the drive close to the right corner to shave off some distance. But two bunkers, sitting at the crest of the hill, are perfectly placed to snag overly aggressive shots. The small, rounded green sits between two front bunkers, allowing the pin to be safely tucked in front to preserve par.

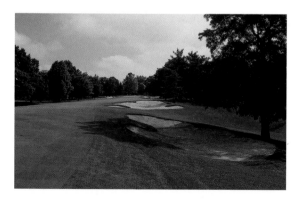

Seminole Golf Club ✦ 6

LOCATION: NORTH PALM BEACH, FLORIDA

ARCHITECT: DONALD ROSS

LENGTH: 383 YARDS · PAR 4

Ben Hogan used Seminole for his preseason warm-ups, so he knew what he was saying when he called this "the best par four in the world." He was referring to the precision needed to tame it: The best angle into the green is from the left side, but bunkers there push many a shot to the right. The resulting approach isn't all that long, but hard to judge due to the elevated green tucked behind four bunkers short and right. • This hole is showcased on pages 194–195.

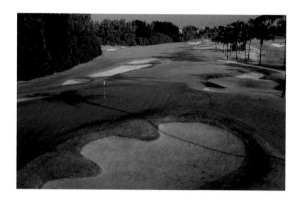

Seminole Golf Club ✦ 18

LOCATION: NORTH PALM BEACH, FLORIDA

ARCHITECT: DONALD ROSS

LENGTH: 417 YARDS · PAR 4

Paraphrasing words made famous by Frank Sinatra, Ben Hogan once said of Seminole, "If you can play well there, you can play well anywhere." This statement is embodied by the brilliantly beautiful eighteenth, where Ross's genius is on full display. True to Seminole's links character, the dune-top tee box is less than fifty yards from the crashing waves of the Atlantic, and the tee shot is played through a chute of trees to a dogleg-left fairway guarded by two bunkers.

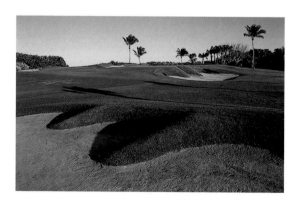

Shinnecock Hills Golf Club ✦ 14

LOCATION: SOUTHAMPTON, NEW YORK

ARCHITECTS: WILLIE DAVIS, WILLIAM S. FLYNN/HOWARD TOOMEY

LENGTH: 447 YARDS · PAR 4

For the truly accomplished shotmaker, Shinnecock Hills is the most complete test of golf in America. One of its many superb holes, the fourteenth, has everything a golfer could want. It's called "Thom's Elbow," after Charlie Thom, a Scottish professional who arrived in Southampton in 1906 and retired in 1961, after fifty-five years on the job. From its elevated tee, players launch drives over a formidable stretch of prickly scrub to reach an islandlike fairway nestled in a narrow valley. • This hole is showcased on pages 54–57.

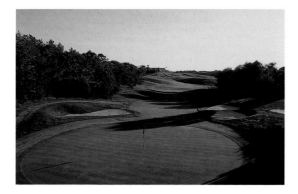

Shoal Creek Golf Club ✦ 18

LOCATION: BIRMINGHAM, ALABAMA

ARCHITECT: JACK NICKLAUS

LENGTH: 446 YARDS · PAR 4

After emerging from the forest-enclosed tee box, players are presented with a dangerous approach shot—water to the left, sand on all sides, and a raised green that falls off to a grass collection area. This hole was ranked as the toughest during the 1990 PGA Championship, a far cry from when Shoal Creek hosted the event in 1984. That year, Lee Trevino birdied the eighteenth to become the first player to win the PGA by breaking 70 in all four rounds.

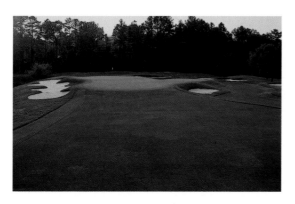

Shoreacres Golf Club ✦ 11

LOCATION: LAKE BLUFF, ILLINOIS

ARCHITECT: SETH RAYNOR

LENGTH: 352 YARDS · PAR 4

This hole uses the property's many ravines to perfection. The first carry comes on the tee shot, where longer hitters normally hit long iron or fairway wood to both carry the first ravine and avoid driving through the fairway to the next one. Mid- to high handicappers will likely need a driver, but for everyone, it's the second carry that's truly frightening. The twenty-yard-wide ravine butts up to the front edge of the small green, gobbling up any shots that fall short.

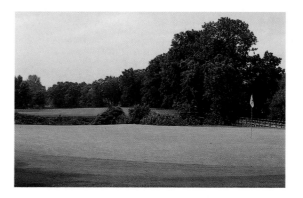

Somerset Hills Country Club ✦ 15

LOCATION: BERNARDSVILLE, NEW JERSEY

ARCHITECT: A. W. TILLINGHAST

LENGTH: 394 YARDS · PAR 4

This is the most memorable hole on a course that is a true hidden jewel compared with other Tillinghast tracks. The fifteenth is enveloped by trees, creating both scenic privacy and added challenge. The fairway slopes downhill and doglegs right to the largest green on the course. Here, players must contend not with Tillinghast's familiar flash-faced bunkers, but with a troublesome creek, which becomes a small waterfall just five feet off the putting surface.

Southern Hills Country Club ✦ 12

LOCATION: TULSA, OKLAHOMA

ARCHITECT: PERRY MAXWELL

LENGTH: 445 YARDS · PAR 4

Southern Hills is perhaps a misnomer—except for the steep inclines at the ninth and eighteenth holes, there are no hills. Its twelfth is a natural-born wrecker. The sweeping right-to-left dogleg calls for a long, accurate drive to a landing area narrowed by leafy trees and thick rough. The view from the second shot was described by Robert Trent Jones, Sr., as "spectacular and frightening at the same time"—to a green that is very slick and tilted from back to front. • This hole is showcased on pages 58–61.

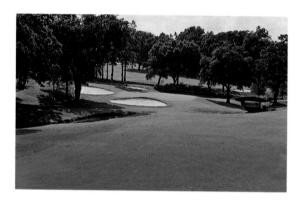

Southern Hills Country Club ✦ 18

LOCATION: TULSA, OKLAHOMA

ARCHITECT: PERRY MAXWELL

LENGTH: 430 YARDS · PAR 4

The eighteenth can be particularly frightening when a tournament is on the line. The driving area is pinched by two long, narrow ponds, as well as two fairway bunkers beyond them. Even a safely played tee shot can end up on a downhill lie, with the approach played to an elevated green. In the final round of the 1982 PGA Championship, eventual champion Raymond Floyd had a chance to break the tournament scoring record, but hit his 3-iron second shot into heavy rough and made bogey.

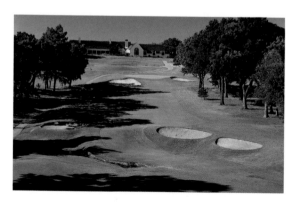

Spyglass Hill Golf Club ✦ 2

LOCATION: PEBBLE BEACH, CALIFORNIA

ARCHITECT: ROBERT TRENT JONES, SR.

LENGTH: 351 YARDS · PAR 4

There aren't many 350-yard holes where the average score for PGA Tour pros is above par, but there also aren't many holes like the second at Spyglass. Perched on a windswept ridge, and surrounded by sand dunes and the famous rubbery ice plant, the hole gives players fits during the Pebble Beach National Pro-Am. The narrow green, which Johnny Miller calls "one of the hardest on the Monterey Peninsula," becomes virtually impossible to hit during breezy conditions.

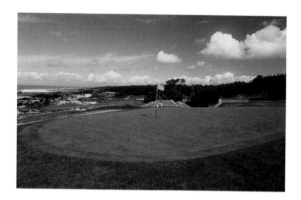

Spyglass Hill Golf Club ✦ 4

LOCATION: PEBBLE BEACH, CALIFORNIA

ARCHITECT: ROBERT TRENT JONES, SR.

LENGTH: 365 YARDS · PAR 4

Like Maidstone's ninth, the fourth at Spyglass Hill is as sincere and effective an interpretation of natural linksland golf as can be found in America. A short dogleg of 365 yards, the hole falls naturally downhill as the fairway tilts away from the higher ground to its right toward the center of the ocean. Its green is magnificent, with a long and shallow surface that angles away from the player and toward the ocean dunes. • This hole is showcased on pages 196–197.

Torrey Pines Golf Club (South) ✦ 12

LOCATION: LA JOLLA, CALIFORNIA

ARCHITECT: WILLIAM F. BELL

LENGTH: 468 YARDS · PAR 4

It may not look like much at first glance, but during the annual Buick Invitational, this is a hole where the pros simply want to take their par and walk away. Straight and true, the hole is toughened mainly by the onshore breeze, which often blows drives into the thick rough, and approach shots into one of two tricky greenside bunkers. Once past this hole, the final six holes offer ample chances for birdies, often producing a dramatic finish.

Tournament Players Club at Sawgrass (Stadium) ✦ 18

LOCATION: PONTE VEDRA BEACH, FLORIDA

ARCHITECT: PETE DYE

LENGTH: 440 YARDS · PAR 4

The TPC Sawgrass reaches its crescendo at the seventeenth, but it is on the eighteenth that players must maintain their composure, channel their adrenaline flow, and strike one last series of bold strokes. The graceful par 4 hugs a lake to the left, and many better players opt to hit a fairway wood to the narrow corner of the dogleg-left. Grassy mounds and pot bunkers surround the green, representing a minefield of short-game tests. • This hole is showcased on pages 200–201.

Tournament Players Club at The Woodlands ✦ 17

LOCATION: THE WOODLANDS, TEXAS

ARCHITECTS: ROBERT VON HAGGE/BRUCE DEVLIN

LENGTH: 382 YARDS · PAR 4

Proving that not all par 4s have to be long to be tough, the seventeenth routinely boasts an over-par scoring average during the Houston Open. Two design elements—one obvious, the other more subtle—give this hole its teeth. A large lake extends into the fairway landing area, catching drives hit too far left. But more important, the green is extremely shallow, and backed by a wide bunker, demanding pinpoint accuracy with the approach shot.

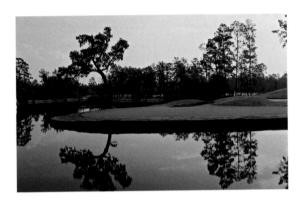

Troon Golf and Country Club ✦ 12

LOCATION: SCOTTSDALE, ARIZONA

ARCHITECTS: TOM WEISKOPF/JAY MORRISH

LENGTH: 400 YARDS · PAR 4

The jagged McDowell Mountains loom tall to the right, creating a stunning high-desert environment for Troon's back nine. The drive on this hole is normally played with a fairway wood or a long iron to a steady rise in the fairway, with rows of cacti lining both sides. Any drive that runs too far will settle in a downhill lie—a tough situation from which to handle the precise approach. Although it is wide, the green is less than ten paces deep, and is protected by three deep bunkers.

Troon North Golf Club (Monument) ✦ 18

LOCATION: SCOTTSDALE, ARIZONA

ARCHITECTS: TOM WEISKOPF/JAY MORRISH

LENGTH: 444 YARDS · PAR 4

When architects and players speak of their fondness for "classic finishing holes," they're talking about designs like this one. Though some might say that a wide swath of green carved into a rugged desert is anything but traditional, the fact is that this hole lays it all out in front of you and demands two long, accurate shots to have a chance at par. The sleek clubhouse and shapely ridge peaks provide a backdrop that silhouettes against the setting sun.

The Vintage Club (Mountain) ✦ 16

LOCATION: INDIAN WELLS, CALIFORNIA

ARCHITECT: TOM FAZIO

LENGTH: 406 YARDS · PAR 4

This hole winds through a tentacle of green extending into the belly of Mount Eisenhower. The first of three lakes must be carried from the championship tee; a long fairway bunker straddles the ridge that crosses the landing area. The wide but narrow green is fronted by the uppermost lake, whose waters cascade down a rocky falls to the middle lake, and so on. The contrast between man-made and natural features is evident from tee to green.

Westchester Country Club (West) ✦ 2

LOCATION: RYE, NEW YORK

ARCHITECT: WALTER TRAVIS

LENGTH: 442 YARDS · PAR 4

Westchester's nines are reversed during the annual Buick Classic, meaning this hole plays as number 11 for the Tour pros. It's a good thing, too, because they could get psyched out if faced with the prospect of making par here so early in the round. The hole always ranks among the top ten hardest holes on Tour, but the elevated tee at least gives big hitters a chance to boom a drive to the corner of the right-to-left dogleg.

Wild Dunes Golf Links ✦ 17

LOCATION: ISLE OF PALMS, SOUTH CAROLINA

ARCHITECT: TOM FAZIO

LENGTH: 405 YARDS · PAR 4

After sixteen holes of links character but no oceanfront views, the seventeenth beckons as the first of two glorious finishing holes along the Atlantic. There are no bunkers, no water in play, and no hidden tricks. This hole is all about the wind, long grass, and unpredictable bumps in the fairway. After a wide landing area, things get progressively narrower close to the green, which is separated from the beach on the left by only ten yards of rough.

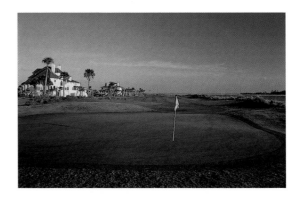

Wilshire Country Club ✦ 18

LOCATION: LOS ANGELES, CALIFORNIA

ARCHITECT: NORMAN MACBETH

LENGTH: 439 YARDS · PAR 4

A truly memorable finishing hole, designed in the spirit of British heathland courses. The dogleg-right fairway is crowned, and drives heading too far left will have to contend with trees. To the right is the hole's dominant feature— a twenty-foot-wide burn that follows the right side of the fairway, then crosses the fairway and curls around the entire back portion of the green. The green is long and narrow, and there are no bunkers to be found, as the burn creeps in close to the left side of the putting surface.

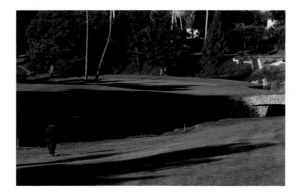

Winged Foot Golf Club (West) ✦ 18

LOCATION: MAMARONECK, NEW YORK

ARCHITECT: A. W. TILLINGHAST

LENGTH: 448 YARDS · PAR 4

This prototypical finishing hole—long, narrow, and requiring an exacting approach to an undulating green—will forever be remembered for a very famous rainbow. The 1997 PGA Championship was Davis Love III's crowning career achievement, and he ended it in style. He could have taken two putts on the eighteenth green and still won, but when the famous rainbow appeared, he thought of his late father, and drained it.

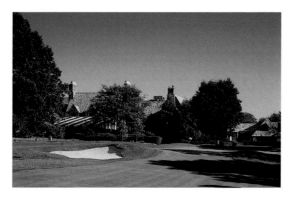

World Woods Golf Club (Pine Barrens) ✦ 15

LOCATION: BROOKSVILLE, FLORIDA

ARCHITECT: TOM FAZIO

LENGTH: 330 YARDS · PAR 4

Is this the best risk-reward par 4 in American public golf? Yes, and in fact it rivals some of the greatest short par 4s in all of golf. The right side of the split fairway is kept firm and fast, so a tee shot that manages to carry the lake will have a chance of rolling onto the green. It takes a big drive, but is far more dramatic than playing safely out to the left.

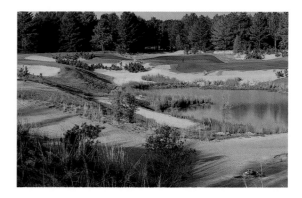

Yale University Golf Course ✦ 4

LOCATION: NEW HAVEN, CONNECTICUT

ARCHITECTS: CHARLES BLAIR MACDONALD/SETH RAYNOR

LENGTH: 443 YARDS · PAR 4

Few inland holes use a water hazard as perfectly as this stern two-shotter. Players can choose to challenge or shy away from the marsh on the right, which yields various angles of approach to the elevated, well-bunkered green. The ideal line for aggressive players is toward the corner of the dogleg-right, leaving the shortest and most direct line of attack. Playing left with a 3-wood may be safer, but the approach will be longer and bothered by overhanging trees. • This hole is showcased on pages 204–205.

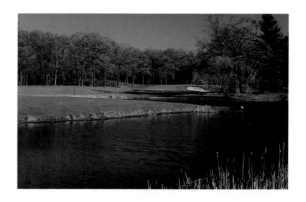

Atlanta Country Club ✦ 18

LOCATION: MARIETTA, GEORGIA
ARCHITECTS: WILLARD BYRD, JACK NICKLAUS
LENGTH: 509 YARDS · PAR 5

With a natural amphitheater and a lake down the left, this hole saw its share of fantastic finishes during thirty years of BellSouth Classics. In 1994, John Daly arrived at the tee 1 stroke out of the lead. After a huge drive, his 8-iron approach found the back-left bunker, and the ensuing up-and-down gave Daly the victory over David Peoples.

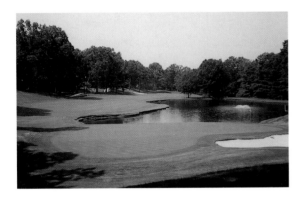

Augusta National Golf Club ✦ 13

LOCATION: AUGUSTA, GEORGIA
ARCHITECTS: ALISTER MACKENZIE/ROBERT TYRE JONES
LENGTH: 485 YARDS · PAR 5

The most representative hole on Augusta National, America's dreamiest inland course, is the thirteenth. Nestled under towering Georgia pines that frame the green are hundreds of azaleas that normally burst into bloom the week of the Masters. This par 5 can be reached in two if the golfer puts together two excellent shots—but golfers need to weigh carefully risk versus reward on this seductive, hairpin-shaped and water-crossed hole, because only two well-executed shots will find the mark. • This hole is showcased on pages 62–65.

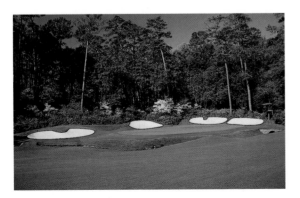

Baltimore Country Club (Five Farms East) ✦ 14

LOCATION: TIMONIUM, MARYLAND
ARCHITECT: A. W. TILLINGHAST
LENGTH: 603 YARDS · PAR 5

Rolling countryside provides a perfect setting for "Hell's Half Acre," the name of both the hole and its main feature. Two long shots, the second over the namesake bunker complex at the top of a hill, will get many players to the bottom of a gulley. From there, the uphill approach is about 80 yards to a green encircled by four bunkers. In the 1965 Walker Cup, American Downing Gray scored a pivotal birdie here on his way to a 1-up victory over Great Britain's Peter Townsend, and the matches ended in a thrilling 11-11 deadlock.

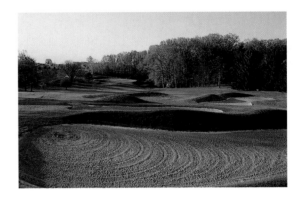

Baltusrol Golf Club (Lower) ✦ 17

LOCATION: SPRINGFIELD, NEW JERSEY
ARCHITECTS: A. W. TILLINGHAST, ROBERT TRENT JONES, SR.
LENGTH: 630 YARDS · PAR 5

Baltusrol's seventeenth on the Lower Course is the longest hole in U.S. Open competition. It requires an accurately placed drive to have any chance of the second carrying the cross bunkers—sometimes referred to as "the Sahara Desert"—at the 400-yard mark. Most players can only dream of carrying the bunkers with their lay-up, but in the 1993 U.S. Open, John Daly did it with a 1-iron second shot that flew all the way to the green, making him the first person ever to reach it in two shots. • This hole is showcased on pages 208–209.

Baltusrol Golf Club (Upper) ✦ 11

LOCATION: SPRINGFIELD, NEW JERSEY

ARCHITECTS: A. W. TILLINGHAST, REES JONES

LENGTH: 602 YARDS · PAR 5

After falling from use in the 1950s, the 602-yard championship tee was reborn under a revision by Jones. No matter which tee is being used, there is one common enemy to golfers: the one-hundred-yard swath of sand and gnarly grass that reduces the fairway's width by more than half at the corner of the dogleg-left. Assuming the second shot avoids that peril, the raised green is relatively large and accessible, though surrounded by five bunkers.

Bay Harbor Golf Club (Links) ✦ 7

LOCATION: PETOSKEY, MICHIGAN

ARCHITECT: ARTHUR HILLS

LENGTH: 500 YARDS · PAR 5

Hills calls this "perhaps the finest hole I've ever designed," which just adds to the long list of superlatives given to Bay Harbor since its 1997 opening. The first half of the hole is a relatively benign fairway that winds along Lake Michigan. After that, it's uphill to a green perched atop a windswept ridge. There are no greenside bunkers, but instead, sharp fall-offs on both sides send errant shots into either tall grass on the left or the lake on the right.

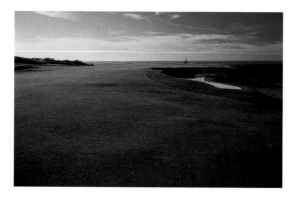

Bel-Air Country Club ✦ 14

LOCATION: LOS ANGELES, CALIFORNIA

ARCHITECTS: GEORGE C. THOMAS/JACK NEVILLE

LENGTH: 590 YARDS · PAR 5

The view from this tee—the highest point on the golf course—is tremendous. Golfers can see the creek running down the left side, trees and out of bounds to the right, and a deceptive cross bunker 40 yards short of the green. Three more bunkers sit greenside, and the green tilts sharply from front to back, courtesy of the Santa Monica Mountains. In a 1991 charity event, fifteen-year-old prodigy Tiger Woods went for this green in two during a rare downwind day, and hit a 3-iron into one of the greenside bunkers.

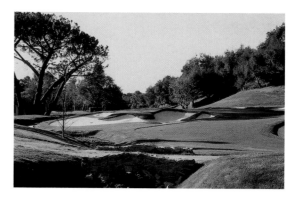

Bethpage State Park Golf Club (Black) ✦ 4

LOCATION: FARMINGDALE, NEW YORK

ARCHITECTS: A. W. TILLINGHAST, REES JONES

LENGTH: 522 YARDS · PAR 5

The fourth hole on the Black Course is one of the most gorgeous of all inland par 5s. Due in large part to the massive, sculptured bunkering, it stretches before you at the tee properly proportioned, aesthetically balanced, and strategically questioning. The green is obscured by a final giant bunker in front, making approaches to the sloping putting surface that much more difficult. • This hole is showcased on pages 210–211.

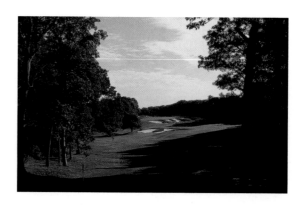

Black Diamond Ranch Golf and Country Club (Quarry) ✦ 14

LOCATION: LECANTO, FLORIDA
ARCHITECT: TOM FAZIO
LENGTH: 529 YARDS · PAR 5

This "Cape" hole fits perfectly into a stretch of land along the rim of a quarry. To the left is golf ball oblivion, but those who bite off part of the carry and hug the left side have the shortest route to the green. The drive and second-shot landing areas are guarded by bunkers to the right, though there is ample room to play safely. The greensite, mounted on a brilliant plateau with a sheer drop-off on the front left, calls for a downhill approach.

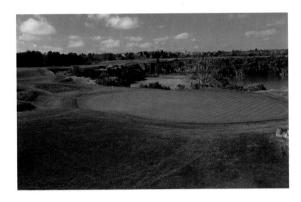

Blackwolf Run (River) ✦ 1

LOCATION: KOHLER, WISCONSIN
ARCHITECT: PETE DYE
LENGTH: 564 YARDS · PAR 5

Pete Dye wanted this to be a true three-shot par 5, which it is in all but the most favorable wind conditions. He placed the various hazards at just the right places from tee to green, ensuring that, like a dominating center in basketball, the hole will allow no shot to go uncontested. The drive must find its way between a gaping fairway bunker to the right and the Sheboygan River to the left, while four more bunkers guard the landing areas for the second shot.

The Boulders (South) ✦ 5

LOCATION: CAREFREE, ARIZONA
ARCHITECT: JAY MORRISH
LENGTH: 529 YARDS · PAR 5

A classic example of a risk-reward par 5—with a desert twist. A dry creek bed crossing the fairway serves as the hazard on this hole. Either the tee shot can be played short of the trouble, or, with a 230-yard carry, the player can attempt to reach a narrow patch of fairway up the left side. From there, the green can be reached with the second shot, but the inhospitable desert terrain makes double bogey a real possibility.

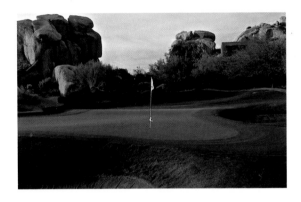

The Broadmoor Golf Club (West) ✦ 18

LOCATION: COLORADO SPRINGS, COLORADO
ARCHITECTS: DONALD ROSS, ROBERT TRENT JONES, SR.
LENGTH: 556 YARDS · PAR 5

This hole was lengthened in advance of the 1998 PGA Cup matches, a Ryder Cup–style event for club pros that saw one European player answer his opponent's birdie with a long eagle putt here to halve the match. The elevated tee looks down over a landing area pinched on both sides by bunkers and native heather grass, with tall ponderosa pines standing beyond the traps. From that point, it's uphill to a two-tiered green surrounded by three fairway bunkers and backed by the historic Broadmoor Hotel.

Canterbury Golf Club ✦ 16

LOCATION: CLEVELAND, OHIO

ARCHITECTS: HERBERT STRONG, GEOFFREY CORNISH

LENGTH: 605 YARDS · PAR 5

Some holes favor a more cautious approach, where if a birdie putt happens to fall, it's a big bonus rather than the expected outcome. Such is this sixteenth hole, where all a golfer is really trying to do is hit three straight shots, reach the green, and two-putt. The tight, tree-lined fairway rises to a plateau where many second shots land, revealing a final dogleg-right and a small green guarded by three traps. En route to victory in the 1973 PGA Championship, Jack Nicklaus made four straight pars here, while others in the field stumbled.

Champions Golf Club (Cypress Creek) ✦ 13

LOCATION: HOUSTON, TEXAS

ARCHITECT: RALPH PLUMMER

LENGTH: 530 YARDS · PAR 5

When the Ryder Cup and U.S. Open were played here in the late 1960s, this hole was a true three-shotter, the green guarded in front by four gaping bunkers. Today, the green is reachable in two by most professionals, but that doesn't make it play any easier. As the last par 5 on the course, the risk-reward decision can be pivotal. In the 1997 Tour Championship, David Duval hit a driver and 3-iron, then holed a 50-foot eagle putt to surge to victory.

Cherry Hills Country Club ✦ 17

LOCATION: ENGLEWOOD, COLORADO

ARCHITECT: WILLIAM S. FLYNN

LENGTH: 548 YARDS · PAR 5

The seventeenth at Cherry Hills is easily one of the most exciting par 5s in major championship history. It is reachable in two, but the tree-lined island green often convinces players to lay up. Though considered a birdie hole, it has doled out its share of heartbreak. Ben Hogan saw his chance to win the 1960 U.S. Open die a watery death at the seventeenth when, after a good second shot in the fairway, he tried to finesse his third shot to a tight pin position, and found the water instead.

Country Club of Detroit ✦ 10

LOCATION: GROSSE POINTE FARMS, MICHIGAN

ARCHITECTS: H. S. COLT/CHARLES ALISON

LENGTH: 569 YARDS · PAR 5

The defining feature of this hole is a close approximation of Oakmont's famous Church Pews bunker, from which a 9-iron or wedge is the only means of escape. Even with a perfect drive, this is a three-shot hole, as threading a shot through the trees on the dogleg-right is not recommended. A well-positioned second shot will allow an aggressive approach to a large green set at an angle away from the fairway. A beautiful, high-lipped bunker fronts the green, while more sand guards the left side.

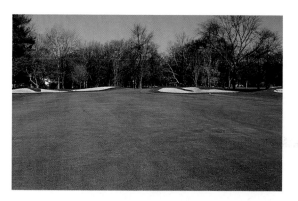

Crown Colony Country Club ✦ 3

LOCATION: LUFKIN, TEXAS
ARCHITECTS: BRUCE DEVLIN/ROBERT VON HAGGE
LENGTH: 565 YARDS · PAR 5

Beginning with a 225-yard carry from a tree-shrouded tee box, this hole starts off hard and keeps getting harder. The drive must carry a lake that continues up the left side to the green, while at the same time flirting with that left side in order to find a flatter lie. Truly long hitters might reach the green in two, but the preferred route up the slanted fairway leaves a short approach over the lake. The L-shaped green is bordered on the left and rear by water, and a large bunker guards its inside corner.

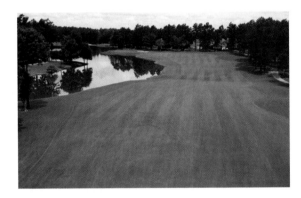

Crystal Downs Country Club ✦ 8

LOCATION: FRANKFORT, MICHIGAN
ARCHITECT: ALISTER MACKENZIE
LENGTH: 550 YARDS · PAR 5

A true three-shot par 5, the eighth at Crystal Downs derives its distinguishing characteristics from the abnormalities of its undulations and the increased precision it demands as you draw closer to the green. It is fascinating to see how golf's great architects go to the other end of the spectrum to make perilous strategic demands using almost no hazards. • This hole is showcased on pages 212–213.

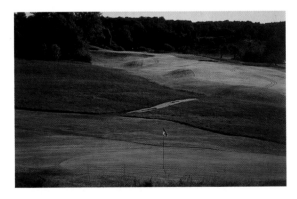

Desert Forest Golf Club ✦ 16

LOCATION: CAREFREE, ARIZONA
ARCHITECT: RED LAWRENCE
LENGTH: 523 YARDS · PAR 5

The magnificent view of Black Mountain inspires many players to go for glory on this reachable par 5. It's a tempting but risky move, as the crowned landing area is narrow, difficult to hold, and lined with desert. The second shot must cut the corner and avoid a thirty-five-foot-tall mesquite tree in the fairway to reach the green. Hitting a long iron off the tee produces a wider target, but the tree has been known to block the lay-up shot.

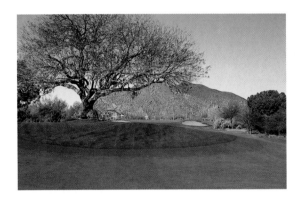

Desert Highlands Golf Club ✦ 17

LOCATION: SCOTTSDALE, ARIZONA
ARCHITECT: JACK NICKLAUS
LENGTH: 570 YARDS · PAR 5

Even on downhill terrain, this green is reachable in two only with a rocket launcher. Tension mounts as the drive heads toward numerous sets of pot bunkers, placed about 220 yards from each tee box. After surviving this minefield, laying up short of the nasty arroyo crossing the fairway is the prudent play. The wide, shallow green is fronted by three more bunkers. Depending on the pin placement, it plays like two separate targets, with the higher left-hand side sloping down to a much lower right side.

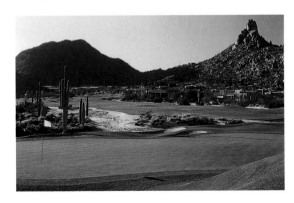

Desert Mountain Golf Club (Cochise) ✦ 15

LOCATION: SCOTTSDALE, ARIZONA

ARCHITECT: JACK NICKLAUS

LENGTH: 548 YARDS · PAR 5

Coming shortly after the relatively easy par-5 twelfth, this hole ensures that when playing in The Tradition each year, the Senior PGA Tour's best have a challenging three-shotter coming down the stretch. Theoretically, this green could be reached in two, but it would be quite a gamble. The drive must clear a yawning fairway bunker in the middle of the fairway, while the narrow, figure-eight-shaped green is virtually surrounded by water. The smart play is to lay up in front of the water, leaving a 100-yard approach.

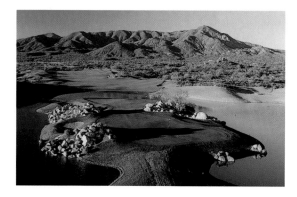

The Dunes Club ✦ 13

LOCATION: MYRTLE BEACH, SOUTH CAROLINA

ARCHITECT: ROBERT TRENT JONES, SR.

LENGTH: 590 YARDS · PAR 5

Trent Jones is famous for heroic holes, and this was one of his first, fashioned half a century ago. A long par 5 curling to the right around a large lake, the thirteenth offers a variety of tees that set up a choice of approaches—across or around the water—to tempt the better player while accommodating the lesser. • This hole is showcased on pages 216–217.

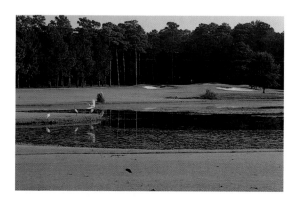

Edgewood Tahoe Golf Club ✦ 18

LOCATION: STATELINE, NEVADA

ARCHITECT: GEORGE FAZIO

LENGTH: 591 YARDS · PAR 5

This course is the site of the annual Isuzu Celebrity Golf Championship, and through the years the pond in front of the eighteenth hole has factored in several exciting finishes. In 1991, former Detroit Piston Bill "Bad Boy" Laimbeer was in good position to win, sitting 75 yards from the eighteenth green in two. He proceeded to chuck three balls in the pond, handing the title to baseball nice guy Rick Rhoden.

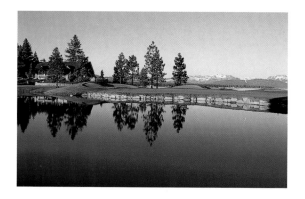

Ekwanok Country Club ✦ 7

LOCATION: MANCHESTER, VERMONT

ARCHITECT: WALTER TRAVIS

LENGTH: 597 YARDS · PAR 5

This course celebrated its centennial in 1999, and still no player had reached this green in two. The reason? "Saddleback," which is both the hole's name and the approximate shape of the massive hill that is its defining feature. From the elevated tee, the hill looms ominously, its steep slope covered with tall fescue grass. Second shots that manage to clear the crest will find two bunkers guarding the landing area on the left, while the green is set between a bunker and a wooded hillside.

Essex Country Club ✦ 3

LOCATION: MANCHESTER-BY-THE-SEA, MASSACHUSETTS
ARCHITECT: DONALD ROSS
LENGTH: 638 YARDS · PAR 5

This hole is nearly as long as the sum of the two par 4s that precede it, and was routed over a reclaimed tidal flood plain. Players must first avoid a "transition area" filled with sand, pebbles, and vegetation 260 yards from the tee, then contend with a brook on the left and a massive bunker on the right. The green is said to be the oldest in continuous use in North America, dating back to 1893. Along with a devious pot bunker on the back right, it is notable for its "bathtub," a three-foot-deep swale on the front left side.

Firestone Country Club (South) ✦ 16

LOCATION: AKRON, OHIO
ARCHITECTS: W. H. WAY, ROBERT TRENT JONES, SR.
LENGTH: 625 YARDS · PAR 5

There really is only one way to play this hole: with a succession of long, straight shots. Though much of the hole is downhill, its colossal length intimidates. As does its signature feature, a large pond fronting the green. For a reasonable chance at par, a strong drive must be followed by a second shot played from a downhill lie, to a fairway landing area guarded by a bunker. Tangling with the trees or rough lining the hole will almost certainly lead to a bogey, or worse. • This hole is showcased on pages 220–221.

The Gallery at Dove Mountain ✦ 9

LOCATION: MARANA, ARIZONA
ARCHITECTS: TOM LEHMAN/JOHN FOUGHT
LENGTH: 723 YARDS · PAR 5

No, the yardage is not a misprint. According to co-designer Tom Lehman, the reasoning behind this monstrous par 5 is simply "to make a legitimate three-shot hole." Mission accomplished. However, with a hundred-foot drop in elevation from tee to green, firm, fast fairways, and a prevailing downwind, the hole isn't quite as daunting as its yardage suggests. Still, the rock-strewn gully sitting 40 yards short of the green provides yet another hazard on a hole where the phrase "good bogey" might not be all that unpleasant.

The Golf Club ✦ 14

LOCATION: NEW ALBANY, OHIO
ARCHITECT: PETE DYE
LENGTH: 618 YARDS · PAR 5

Dye says of this winding hole, "It takes up more damn land than any hole I've seen." He used most of it in the hundred-yard-wide landing area for the tee shot, but was not quite as generous on the next target area. The second shot must be placed between a lake on the left and a half-acre sand pit on the right. Attacking the pin on the third shot can only be done from the right side, as a huge, two-hundred-year-old white oak tree guards the left of the green, which is ringed by deep and difficult pot bunkers.

Golf Club of Georgia (Lakeside) ✦ 11

LOCATION: ALPHARETTA, GEORGIA
ARCHITECT: ARTHUR HILLS
LENGTH: 607 YARDS · PAR 5

A lone tree in the right rough is the preferred aiming point for the drive on this splendid inland beauty. The second shot must be threaded between a row of three more trees on the left, and three fairway bunkers on the right. The final 150 yards or so are downhill, making it difficult to judge distance. The real trick, however, is to avoid being distracted by the sunlit waters of Lake Windward, which creep in closely around the well-bunkered green.

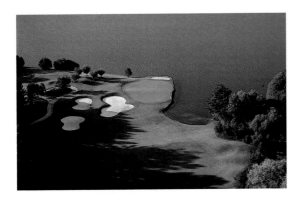

Haig Point Golf Club (Calibogue) ✦ 14

LOCATION: DAUFUSKIE ISLAND, SOUTH CAROLINA
ARCHITECT: REES JONES
LENGTH: 563 YARDS · PAR 5

Lowcountry topography and a fresh sea breeze combine to make this hole a true three-shotter, and an intimidating one at that. Though the drive is played to a generous fairway, tall pines and a solitary bunker greatly restrict the landing area on the second shot. The fairway then doglegs left to reveal a green complex that is pinched on both sides by Calibogue Sound marshland. Anything too far right or left is in the hazard, and the correct club can vary wildly depending on the wind.

Harbour Town Golf Links ✦ 15

LOCATION: HILTON HEAD ISLAND, SOUTH CAROLINA
ARCHITECTS: PETE DYE/JACK NICKLAUS
LENGTH: 575 YARDS · PAR 5

Back in the late 1970s, Lee Trevino said of this hole, "Even King Kong couldn't get on that green in two." Of course, that was back when woods were made of wood, nobody had heard of a Tour fitness trainer, and this green was the smallest on the Tour. Today, professional players do occasionally hit the fifteenth in two, but many still lay up, thanks to the lake, tall pines, and large bunkers that guard the green.

Hollywood Golf Club ✦ 7

LOCATION: DEAL, NEW JERSEY
ARCHITECTS: ISAAC MACKIE, WALTER TRAVIS, A. W. TILLINGHAST, DICK WILSON
LENGTH: 548 YARDS · PAR 5

Parkland holes bereft of water often fall short of being stern challenges, but not this one, which belies its otherwise ordinary terrain. The winding, narrowing fairway is lined with trouble from tee to green. Several strategically placed, high-lipped bunkers are the most obvious hazards, but not far off are the bushy, low-hanging trees that prevent any but the most timid recovery shots. The four-tiered green is surrounded by three massive bunkers.

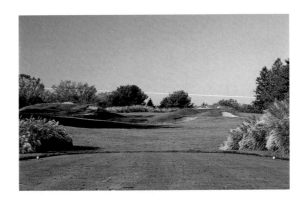

Interlachen Country Club ✦ 12

LOCATION: EDINA, MINNESOTA

ARCHITECTS: WILLIE WATSON, DONALD ROSS

LENGTH: 541 YARDS · PAR 5

This crescent-shaped, right-to-left hole is infamous for its ability to delude first-time players into thinking they can cut the corner. Don't fall for it—those trees are much denser than they look. A right-hand bunker guards the second landing area; the closer a ball is to the bunker, the better the angle to the green. And with this green, every little bit helps. It sits on a thirty-five-foot-high ridge lined with matted rough and three bunkers, and its sharply crowned surface can kick approach shots in any direction.

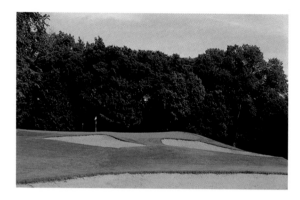

Kapalua Golf Club (Plantation) ✦ 5

LOCATION: KAPALUA, MAUI, HAWAII

ARCHITECTS: BEN CRENSHAW/BILL COORE

LENGTH: 532 YARDS · PAR 5

Though most versions of "Cape" holes are par 4s, this one is a par 5, which only adds to the excitement. Many big hitters will feel they can get to the green in two after a good drive, but they'll have to settle their nerves first. With a fairway that slopes left to right, most drives will end up close to the chasm of tropical vegetation that runs down the right side. The green is tucked into an "arm" of the hole, with all kinds of trouble lurking.

Lake Nona Golf Club ✦ 15

LOCATION: ORLANDO, FLORIDA

ARCHITECT: TOM FAZIO

LENGTH: 578 YARDS · PAR 5

For players putting together a good round, this hole represents a major hurdle on the way to the finish. Any shot too far left is a goner, but Fazio tempts players to flirt with that left side in order to reward themselves on the approach. The fairway curves left around a 175-yard-long bunker, with marsh and the Course's namesake lake farther out. The green is shaped like a lowercase letter "r," with the deeper left portion allowing more room for error.

Links at Spanish Bay ✦ 14

LOCATION: PEBBLE BEACH, CALIFORNIA

ARCHITECTS: ROBERT TRENT JONES, JR., SANDY TATUM, TOM WATSON

LENGTH: 571 YARDS · PAR 5

After a stretch of four inland holes, the course returns to the seaside with this tumbling par 5. The fairway narrows within 200 yards of the green, and four large bunkers are positioned to catch errant lay-up shots. Producing winds that make the hole play longer, the Pacific Ocean backdrops a green that is receptive to a bump-and-run, but is crowned to kick imprecise approaches off-line.

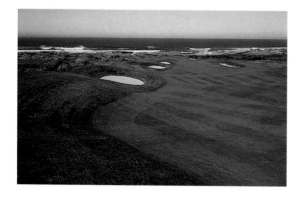

Monterey Peninsula Country Club (Dunes) ✦ 9

LOCATION: PEBBLE BEACH, CALIFORNIA

ARCHITECTS: SETH RAYNOR/CHARLES BANKS, REES JONES

LENGTH: 479 YARDS · PAR 5

Thoughts of birdies dance through many players' heads while they stand on this tee. But success will depend largely on a rumpled sand dune that, like a smaller version of Prestwick's "Alps," crosses in front (and partially obscures) the punch bowl green. If the drive is reasonably long, the second shot might be played with as little as a mid-iron, increasing the chance of carrying the dune. Approaches missing to the left will likely catch a bunker, which actually saves many shots from a worse fate in a small water hazard.

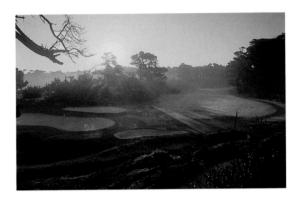

Nantucket Golf Club ✦ 18

LOCATION: SIASCONSET, MASSACHUSETTS

ARCHITECT: REES JONES

LENGTH: 590 YARDS · PAR 5

Upon seeing the course for the first time, New England native Brad Faxon remarked how impressed he was that he knew exactly where to hit his tee shot. The eighteenth reflects this design philosophy: From the tee, the view is of a twisting, heaving fairway that very clearly shows the favored route to the well-bunkered green. The site is made even more natural by its routing, adjacent to a breathtaking tract of land protected by the National Audubon Society.

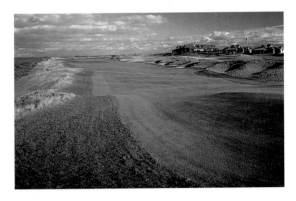

NCR Country Club ✦ 6

LOCATION: DAYTON, OHIO

ARCHITECT: DICK WILSON

LENGTH: 548 YARDS · PAR 5

Arnold Palmer, during the first round of the 1969 PGA Championship, reinjured his troubled hip while trying to reach this green in two with a vicious 1-iron. He limped to an 82, and withdrew. The odds are similarly against anyone trying to emulate that swing, as Wilson deliberately designed this green complex to be nearly unhittable with a longer club. The narrow green is an island in a sea of deep bunkers, requiring a high trajectory and soft landing to hold the surface.

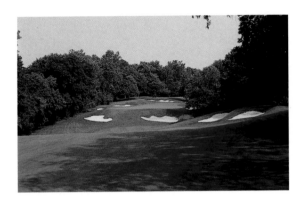

Oak Hill Country Club (East) ✦ 13

LOCATION: ROCHESTER, NEW YORK

ARCHITECTS: DONALD ROSS, ROBERT TRENT JONES, SR.,
GEORGE AND TOM FAZIO

LENGTH: 596 YARDS · PAR 5

Unlike some of the long, notable par 5s that play downhill, this is a full, three-shot hole playing nearly 600 yards uphill with a single dogleg to the right. And architect Robert Trent Jones, Sr., made sure to penalize those who are only strong and not cautious. The club's magnificent oak trees form a scenic backdrop. • This hole is showcased on pages 232–233.

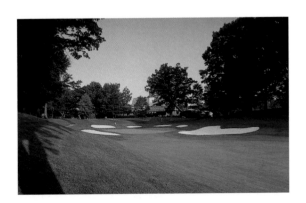

Oakmont Country Club ✦ 4

LOCATION: OAKMONT, PENNSYLVANIA

ARCHITECTS: HENRY AND WILLIAM FOWNES

LENGTH: 564 YARDS · PAR 5

Not content for a competitor to have but one encounter with the infamous "Church Pews" bunker, this three-shot hole returns one to it again along the left side. And again as the third balance is achieved with a cluster of five severe bunkers opposite the driving area. A century ago, Oakmont counted 350 bunkers; today, "only" 180—16 at this hole—including the vast one that stays in the golfer's mind long after leaving this cathedral. • This hole is showcased on pages 234-235.

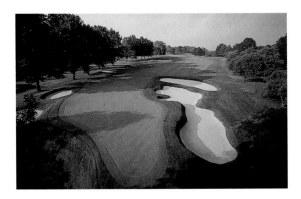

Oak Tree Golf Club ✦ 16

LOCATION: EDMOND, OKLAHOMA

ARCHITECT: PETE DYE

LENGTH: 479 YARDS · PAR 5

Sitting defiantly in the middle of the left greenside bunker is "the Hanging Tree," so named for the noose hanging from one of its branches. This hints at the penal nature of the course, while the sixteenth itself is more of an enigma. During the 1988 PGA Championship, Jack Nicklaus took a 9 here in the second round, but the rest of the field had it easier: Nine eagles were made on the hole during the first two days of the tournament.

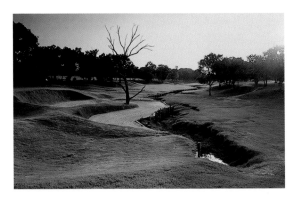

Peachtree Golf Club ✦ 2

LOCATION: ATLANTA, GEORGIA

ARCHITECT: ROBERT TRENT JONES, SR.

LENGTH: 534 YARDS · PAR 5

You won't see many bunkerless par 5s, but this is one where sand might only detract from the hole's architectural genius. Long hitters can get home in two here, but they'll have to contend with a lake and creek running in front and up the right side of the green. For others, the decision lies in where to place the second shot. Lay up short of the pond, and the third shot is nearly 150 yards. There's also a narrow strip of fairway to the left, but it brings the water directly into play. Myriad possibilities for a superbly strategic hole.

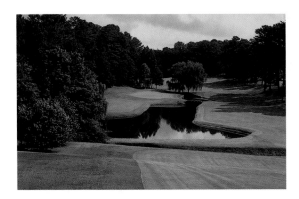

Pebble Beach Golf Links ✦ 18

LOCATION: PEBBLE BEACH, CALIFORNIA

ARCHITECTS: JACK NEVILLE/DOUGLAS GRANT, H. CHANDLER EGAN

LENGTH: 548 YARDS · PAR 5

Pebble Beach features the most spectacular finishing hole in the game, set along the curved shore of Carmel Bay. It runs along the ocean's edge a mere eight feet above the high-tide mark. Avoiding this distraction on the left is essential to reaching the green, as all three shots are tested by wind and the crash of the waves. The eighteenth is a perfect entwining of beauty and challenge. • This hole is showcased on pages 74-77.

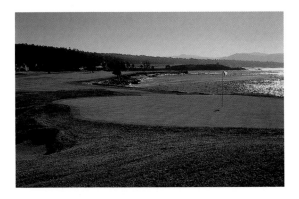

Pelican Hill Golf Club (North) ✦ 17

LOCATION: NEWPORT COAST, CALIFORNIA

ARCHITECT: TOM FAZIO

LENGTH: 543 YARDS · PAR 5

"Gut Check" is an appropriate moniker for this dogleg-right, where your swing tends to get shakier the closer you get to the green. The final 250 yards are equal parts stifling and exhilarating, as you try to maneuver your ball through a narrow fairway to an elevated green that seems to blend in with the Pacific horizon. Deep bunkers and thick scrub brush guard the right side, awaiting nervous slices.

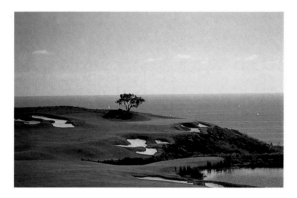

PGA West (Stadium) ✦ 16

LOCATION: LA QUINTA, CALIFORNIA

ARCHITECT: PETE DYE

LENGTH: 566 YARDS · PAR 5

One might be excited upon reaching the sixteenth tee to find a hole at PGA West in which water doesn't come into play. However, replacing the H_2O, like a desert mirage, is "the San Andreas Fault," the nineteen-foot-deep bunker along the left side of the green for which the hole is named. Players have been known to spend the better part of their day trying to escape. A long waste bunker also guards the left side of the hole around the dogleg.

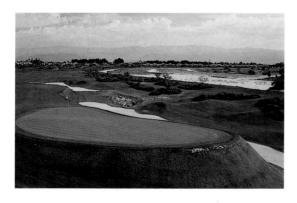

Pinehurst Country Club (No. 2) ✦ 10

LOCATION: PINEHURST, NORTH CAROLINA

ARCHITECT: DONALD ROSS

LENGTH: 613 YARDS · PAR 5

A par 5 that actually plays like one? They're rare for the world's best players these days, but during the 1999 U.S. Open, no one reached this green in two shots. It isn't just the length—though at 613 yards uphill, it's a big consideration—but more the angle to the green. The hole doglegs slightly left at the top of the hill, meaning anyone trying for it in two will have to flirt with the trees on the left side.

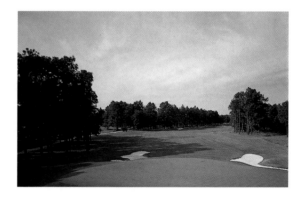

Pine Valley Golf Club ✦ 15

LOCATION: CLEMENTON, NEW JERSEY

ARCHITECTS: GEORGE CRUMP/H. S. COLT

LENGTH: 591 YARDS · PAR 5

Remarkably, this hole offers the only continuous fairway on the course. No sand pits in the middle, no ribbons of rough to contend with. However, don't think that it plays easy—it's the longest hole at Pine Valley. After a healthy carry from the tee over a lake, the fairway runs uphill to the green, narrowing gradually until it is virtually engulfed by pines, making the hole nearly impossible to hit in two.

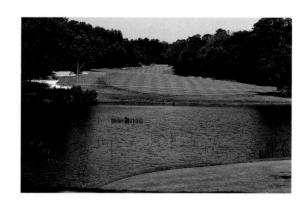

Plainfield Country Club ✦ 12

LOCATION: PLAINFIELD, NEW JERSEY
ARCHITECT: DONALD ROSS
LENGTH: 585 YARDS · PAR 5

Ross's penchant for designing subtly challenging green complexes is shown here. He has taken a 585-yard hole and made the difference between success and failure hinge on one swing with a short iron. Sure, two big shots are needed to get into position to hit the green, but they'll be useless if the player can't hit a precise 85–120-yard shot to a raised, semiblind green surrounded by deep grass and sand bunkers, and guarded on the front left by a lone pine tree.

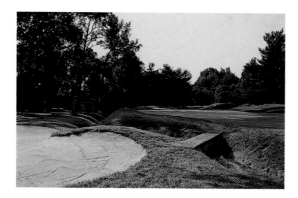

Princeville Resort Golf Club (Prince) ✦ 15

LOCATION: PRINCEVILLE, KAUAI, HAWAII
ARCHITECT: ROBERT TRENT JONES, JR.
LENGTH: 576 YARDS · PAR 5

Though golf architects often tend toward hyperbole when describing their creations, Jones's assessment of the fifteenth might be more correct than we realize: "It may be the finest par 5 I've ever built." Why? Jaw-dropping beauty for starters, but more than that are the dramatic risk-reward opportunities given to players. Deep ravines line nearly all sides of the wide landing areas (there are no fairway sand traps), and after a ravine for the second shot is carried, the green is well protected by a front pot bunker.

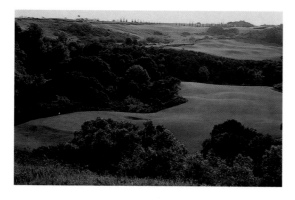

Pumpkin Ridge Golf Club (Witch Hollow) ✦ 14

LOCATION: NORTH PLAINS, OREGON
ARCHITECTS: BOB CUPP/JOHN FOUGHT
LENGTH: 470 YARDS · PAR 5

Despite the pond in front of the green, this par 5 yields more than its fair share of eagle putts. After a good drive to the corner of the dogleg, many players find themselves within reach of the green with an iron—and sometimes not even a long iron. In the semifinals of the 1996 U.S. Amateur, Tiger Woods hit a pitching wedge to this green, setting up a 12-foot eagle putt that enabled him to take his first lead over opponent Joel Kribel.

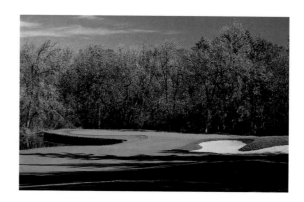

San Francisco Golf Club ✦ 9

LOCATION: SAN FRANCISCO, CALIFORNIA
ARCHITECT: A. W. TILLINGHAST
LENGTH: 570 YARDS · PAR 5

After giving players a fairly generous driving area, Tillinghast created a series of nasty, high-lipped bunkers on the right side of the second-shot landing area. This is where third shots come to die, as there is almost no chance of hitting the green. The last 30 yards are uphill to a quick, mounded green with three bunkers on the left. While Tiger Woods was a student at Stanford, he hit driver-driver 10 yards short of the green, a feat seen about as often as a 90-degree day in San Francisco.

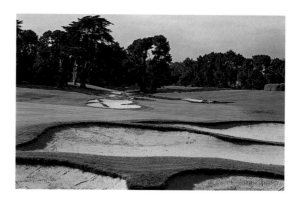

Saucon Valley Country Club (Old) ✦ 6

LOCATION: BETHLEHEM, PENNSYLVANIA
ARCHITECT: HERBERT STRONG
LENGTH: 582 YARDS · PAR 5

Saucon Valley is universally admired for the variety of its three courses, and the sixth hole is a microcosm of the property's enviable terrain. The hole is lined by a healthy portion of the Old Course's ten thousand trees, framing a right-bending dogleg. After that, the second shot must find its way over a Pine Valley-esque complex of sand and scrub brush, while favoring the left side of the fairway to avoid being blocked out by trees on the approach.

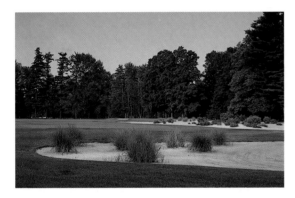

Scioto Country Club ✦ 8

LOCATION: COLUMBUS, OHIO
ARCHITECT: DONALD ROSS
LENGTH: 505 YARDS · PAR 5

Few other par 5s challenge a player's mental toughness more than the eighth. After a good drive, the inviting strip of fairway off to the right of a large lake is the next logical step—three shots to the green and a good chance for birdie. But ironically, the very fact that the fairway option exists causes more players to go for the green in two than probably should, as they shun the meeker option for one with more flash. Victory, Ross.

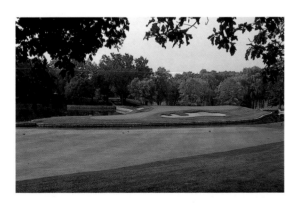

Shadow Creek Golf Club ✦ 18

LOCATION: NORTH LAS VEGAS, NEVADA
ARCHITECT: TOM FAZIO
LENGTH: 527 YARDS · PAR 5

To succeed in Vegas, you need a dramatic finish, and this one doesn't disappoint. The tee is perched high above the fairway on a ridge, while water runs continuously from green to tee through three lakes separated by waterfalls. Players choosing to go for the green in two will have to carry the water on both shots. The safer route is to the left, but even then the third shot must contend with the final lake in front of the long, narrow green.

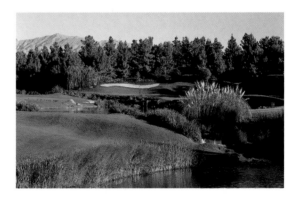

Shinnecock Hills Golf Club ✦ 16

LOCATION: SOUTHAMPTON, NEW YORK
ARCHITECTS: WILLIE DAVIS, WILLIAM S. FLYNN/HOWARD TOOMEY
LENGTH: 542 YARDS · PAR 5

It may be short compared to other notable par 5s, but Shinnecock's sixteenth boasts the qualities that make a great golf hole—strategy, beauty, and historical importance. It also has wind, bunkers, and heavy rough to compensate for any lack of length. Bunkers and long fescue grass guard each turn of the S-shaped fairway. There also are five bunkers at the entrance to the front-to-back-sloping green, which sits in the shadow of America's first clubhouse.
• This hole is showcased on pages 236–237.

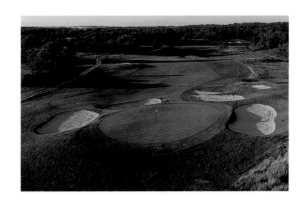

Spyglass Hill Golf Club ✦ 1

LOCATION: PEBBLE BEACH, CALIFORNIA
ARCHITECT: ROBERT TRENT JONES, SR.
LENGTH: 600 YARDS · PAR 5

Signaling the delights of the course to follow, this hole is among the best openers in golf. "Majestic" would most aptly describe its shape and style, as it tumbles downhill after a semiblind tee shot shrouded by Monterey pines. It is here that the hole's grandiosity becomes apparent. Approach shots are ideally played from a narrow swatch of level fairway to an expansive plateau green surrounded by a massive bunker. Beyond, the Pacific Ocean provides a stirring backdrop. • This hole is showcased on pages 242–243.

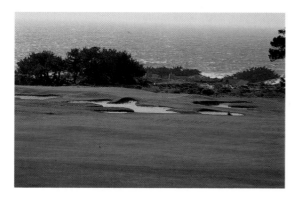

The Stanwich Club ✦ 17

LOCATION: GREENWICH, CONNECTICUT
ARCHITECT: WILLIAM GORDON
LENGTH: 568 YARDS · PAR 5

Stanwich is famous for, among other things, incredibly fast, difficult greens and tight, tree-lined fairways. The serene seventeenth hole embodies all these characteristics. A babbling brook first lurks behind trees to the left, then expands to a lake that must be carried to reach the green. The slippery putting surface slopes severely downward between two greenside bunkers, requiring players to keep the ball below the hole to avoid three-putts.

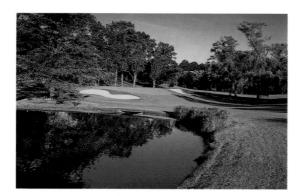

Tournament Players Club at Sawgrass (Stadium) ✦ 16

LOCATION: PONTE VEDRA BEACH, FLORIDA
ARCHITECT: PETE DYE
LENGTH: 497 YARDS · PAR 5

A fearsome par 5, despite the fact that many top players have the distance to hit it in two. The tree that sits eighty yards short of the green can affect incoming shots, while water looms close on the right. In the 1994 U.S. Amateur Championship, Tiger Woods got up and down for birdie from 60 yards on this, the thirty-fourth hole of the match, to pull even with Trip Kuehne and set the table for his historic victory.

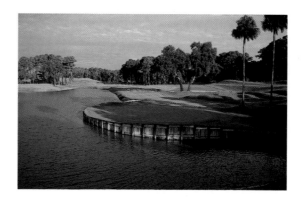

Troon North Golf Club (Monument) ✦ 3

LOCATION: SCOTTSDALE, ARIZONA
ARCHITECTS: TOM WEISKOPF/JAY MORRISH
LENGTH: 564 YARDS · PAR 5

This is the hole that named the course. The Monument actually is a giant boulder sitting on the right side of the fairway about 275 yards from the back tee. During construction, Weiskopf wanted it moved for liability purposes, but the city of Scottsdale thought it should stay, and released the course from any lawsuits. It makes it a better hole, with players having the option of the smart drive to the left or the risky one to the right.

Wade Hampton Golf Club ✦ 18

LOCATION: CASHIERS, NORTH CAROLINA

ARCHITECT: TOM FAZIO

LENGTH: 555 YARDS · PAR 5

The towering peak of Chimney Top Mountain casts a shadow from behind the eighteenth tee, adding a feeling of power to this exquisite finishing hole. A row of eight bunkers extends all the way up the right rough, while a creek beckons on the left. The creek later crosses in front of the green, upping the ante on the approach shot. Even with a short iron, it's a tough task, as the green is tucked into a hillside and circled by four bunkers.

Walden on Lake Conroe Golf and Country Club ✦ 11

LOCATION: MONTGOMERY, TEXAS

ARCHITECTS: BRUCE DEVLIN/ROBERT VON HAGGE

LENGTH: 589 YARDS · PAR 5

A pure three-shot hole, the eleventh is a double dogleg that causes more than its share of double-digit scores. Bunkers on the right and a cluster of pines on the left frame the landing area for the drive, while another row of bunkers affects the second shot. It is here that Lake Conroe creeps in on the right, setting up an approach to a peninsula green bordered by the lake and three bunkers. So begins Walden's "Bermuda Triangle," where golf balls are often lost and rarely found.

Wild Dunes Golf Links ✦ 18

LOCATION: ISLE OF PALMS, SOUTH CAROLINA

ARCHITECT: TOM FAZIO

LENGTH: 501 YARDS · PAR 5

Tom Fazio has said of Wild Dunes, "The holes looked like they had been there forever." The eighteenth almost has. It was the site of America's first southern victory during the Revolutionary War. It's also one of the most exciting finishing holes in golf. For those who unsuccessfully attempt to reach this green in two, deep front bunkers and closely encroaching tall grass make the penalty severe.

World Woods Golf Club (Pine Barrens) ✦ 14

LOCATION: BROOKSVILLE, FLORIDA

ARCHITECT: TOM FAZIO

LENGTH: 547 YARDS · PAR 5

The second half of this hole is uphill, so not many people will be going for the green in two. Still, Fazio constructed the green complex to encourage strategy on the second and third shots. The topsy-turvy green is flanked by deep bunkers in front that curve around the right side. Lay up too far to the right, and the approach shot will have to carry those bunkers. But if the lay-up is too far left, the shallow green becomes a very narrow target.

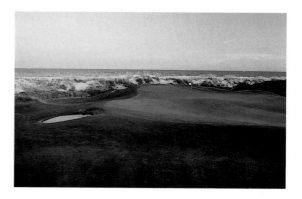

PAR 3

Cabo del Sol Golf Club ✦ 17

LOCATION: LOS CABOS, MEXICO
ARCHITECT: JACK NICKLAUS
LENGTH: 178 YARDS · PAR 3

This hole presents the same blend of beauty and strategy that is at the sixteenth at Cypress Point. Whatever the tee placement, from 115 to 178 yards, the Bay of Whales is always in play. The seventeenth is a strong example of seaside golf in a desert climate. Its designer called this the best golf property he's ever seen. • This hole is showcased on page 88-89.

Casa de Campo Golf Club (Teeth of the Dog) ✦ 7

LOCATION: LA ROMANA, DOMINICAN REPUBLIC
ARCHITECT: PETE DYE
LENGTH: 225 YARDS · PAR 3

The short seventh is an oceanside jewel cut and set within a Dominican masterpiece that is as much a testament to Pete Dye's will as it is to his imagination. The hole consists of little more than the tee perched at the ocean's edge and the green surrounded by a white sand beach. The wind, and a player's nerves, are the primary obstacles to overcome. • This hole is showcased on pages 90-91.

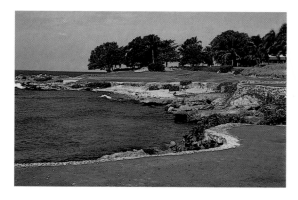

Casa de Campo Golf Club (Teeth of the Dog) ✦ 16

LOCATION: LA ROMANA, DOMINICAN REPUBLIC
ARCHITECT: PETE DYE
LENGTH: 185 YARDS · PAR 3

Pete Dye knew that players on this tee would do almost anything to avoid hitting into the ocean to the right. So what did he do? He built four bunkers on the left, ensuring that the space available for a bailout shot could fit neatly in the living room of one of the resort's casitas. To make matters worse, this hole plays into a prevailing left-to-right crosswind, meaning shots headed for the ocean usually stay there.

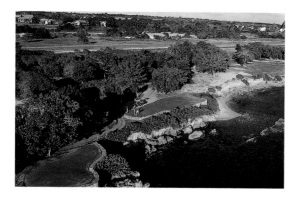

El Rincon ✦ 7

LOCATION: BOGOTÁ, COLOMBIA
ARCHITECT: ROBERT TRENT JONES, SR.
LENGTH: 179 YARDS · PAR 3

Before El Rincon's hosting the 1980 World Cup, Trent Jones reinforced this testy par 3, adding the lake to be carried to reach the green. It's not a long carry—especially at the course's 1½-mile altitude—but the consequences facing errant shots are penal. Three high-lipped bunkers flank the rear of the green; though you're technically on safe ground, the lake is not yet conquered. Explosion shots must be hit down the sloping putting surface, with the water looming beyond. • This hole is showcased on pages 94–95.

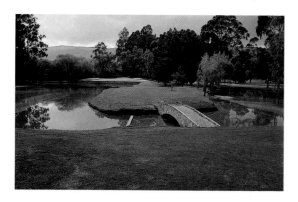

The Jockey Club (Red) ✦ 17

LOCATION: SAN ISIDRO, ARGENTINA

ARCHITECT: ALISTER MACKENZIE

LENGTH: 180 YARDS · PAR 3

This hole provides a wonderful example of Mackenzie's strategic genius. Two bunkers, each set at a slight angle to the tee, guard the left side of this long, narrow green. The hole's degree of difficulty varies wildly with the pin position: If it's cut short or right, the player has less green to work with but the bunkers are farther out of play; place the pin back or left and the bunkers are poised to swallow all but the most precise shots.

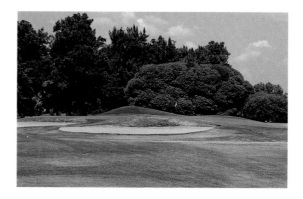

Mid Ocean Club ✦ 17

LOCATION: TUCKER'S TOWN, BERMUDA

ARCHITECT: CHARLES BLAIR MACDONALD

LENGTH: 220 YARDS · PAR 3

Unlike the original Redan hole—the fifteenth at North Berwick—Mid Ocean's rendition extends downhill to a rectangular green circled by small bunkers. With the ocean off to the left, the tee shot plays into the prevailing wind and away from the palatial clubhouse, a reminder that you only have to wait one more hole before sipping a cocktail on the porch.

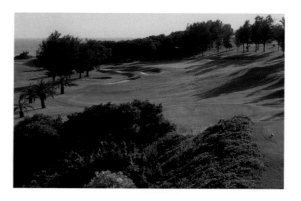

Port Royal Golf Club ✦ 16

LOCATION: SOUTHAMPTON, BERMUDA
ARCHITECT: ROBERT TRENT JONES, SR.
LENGTH: 176 YARDS · PAR 3

One can only imagine the joy Jones must have felt when he laid eyes on this piece of land, allowing him to build one of the most spectacular par 3s east of Cypress Point. The Atlantic Ocean stands guard to the left and behind the small, rounded green, exposing the hole to the ocean winds. A shallow, semi-circular bunker curves around the rear of the green, while three others catch shots heading left or right.

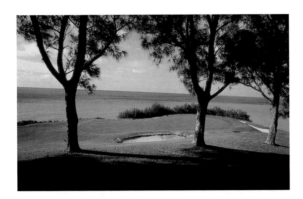

Cabo del Sol Golf Club ✦ 5

LOCATION: LOS CABOS, MEXICO
ARCHITECT: JACK NICKLAUS
LENGTH: 458 YARDS · PAR 4

The fifth hole represents the course's transition from high desert to the ocean coastline, and has elements of classic architecture woven in with its modern touches. A slight fade is favored off the tee, as the fairway runs away at an angle toward the green. With the ocean behind, the green sits dangerously close to two bunkers on the right and rugged terrain beyond them. Nearly 30 yards of fairway run parallel to the green on the left, leaving room for an alternate route but resulting in a delicate pitch.

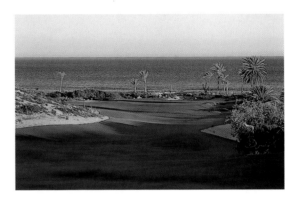

PAR 4

Buenos Aires Golf Club (Yellow) ✦ 9

LOCATION: BUENOS AIRES, ARGENTINA
ARCHITECT: KELLY BLAKE MORAN
LENGTH: 456 YARDS · PAR 4

This rigid par 4 is played as the finishing hole during the Argentina Open. A player must hit a booming drive to the uneven fairway, carefully avoiding the lake on the left. Though the course is only seven years old, the green complex looks like an early twentieth-century classic, with artful bunkers buffeting the crowned green.

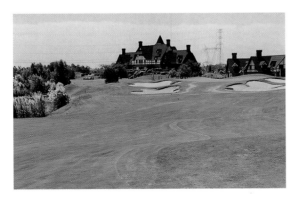

Cabo Reál Golf Club ✦ 5

LOCATION: LOS CABOS, MEXICO
ARCHITECT: ROBERT TRENT JONES, JR.
LENGTH: 454 YARDS · PAR 4

Though golfers are helped by onshore breezes that make this hole play slightly shorter, a par will be well earned. Tee shots reaching the deep fairway bunker on the right will cost at least one shot, and the fingers of fairway on both sides are bordered by cacti and desert. The wide, shallow green is fronted by a nasty arroyo, that must be carried to get close to left-hand pin placements. Those playing to the center of the green still have to carry a front bunker, and surrounding grass areas test the short game.

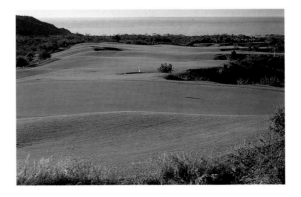

Casa de Campo Golf Club (Teeth of the Dog) ✦ 15

LOCATION: LA ROMANA, DOMINICAN REPUBLIC

ARCHITECT: PETE DYE

LENGTH: 384 YARDS · PAR 4

The first of the four holes dubbed "Reload Alley," the fifteenth marks the course's return to the sea, and offers a brush with the world of high fashion. The back tee box, buffeted by waves on one side, is adjacent to the home of native son Oscar de la Renta, who designed the resort's interior furnishings. While he must surely get a kick out of some of the golf outfits that pass his way, those who manage par on this oceanfront beauty deserve respect no matter what they're wearing.

Castle Harbour Golf Club ✦ 2

LOCATION: TUCKER'S TOWN, BERMUDA

ARCHITECT: CHARLES BANKS

LENGTH: 390 YARDS · PAR 4

Just a few miles from Charles Blair Macdonald's stunning Cape hole at Mid Ocean (one of the world's top eighteen), Banks—a Macdonald protégé—created one of his own, with an arguably tougher approach shot. The fairway is separated from the ocean on the left by thick vegetation and a rocky coastline. An inlet of water cuts in again just in front of the green, an added element of danger to a green complex that also includes two very deep bunkers on the left and another one on the right.

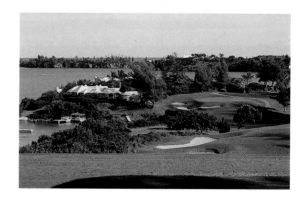

Golf Club de Uruguay ✦ 16

LOCATION: PUNTA CARRETAS, URUGUAY
ARCHITECT: ALISTER MACKENZIE
LENGTH: 310 YARDS · PAR 4

The skyline of Montevideo becomes more and more visible as this hilltop fairway climbs from tee to green. Despite playing longer due to the terrain, this hole lulls players into trying to drive the green, however minimal the chances of success. Dense vegetation lines the fairway and contrasts with the steel and concrete below, ensuring a stiff penalty for a wayward drive. For those playing more cautiously, Mackenzie's multilevel, undulating green and deep front bunkers provide a test to even the shortest of approach shots.

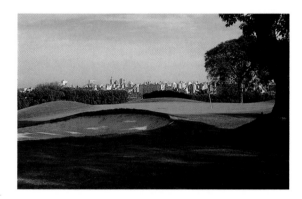

Mid Ocean Club ✦ 5

LOCATION: TUCKER'S TOWN, BERMUDA
ARCHITECT: CHARLES BLAIR MACDONALD
LENGTH: 433 YARDS · PAR 4

With eight golf courses distributed among its twenty-one square miles, Bermuda has more courses per capita than any other place on earth. Mid Ocean is its most prestigious layout, and this its most formidable hole. The fifth hole is in Macdonald's Cape style—a sharp dogleg over water, inviting the golfer to bite off as much as she dares—and is far grander and more dramatic than his first Cape, at The National Golf Links in Southampton. • This hole is showcased on pages 34–37.

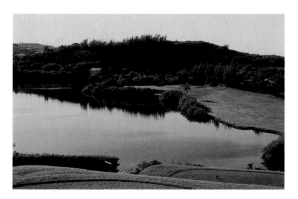

Olivos Golf Course ✦ 15

LOCATION: BUENOS AIRES, ARGENTINA
ARCHITECTS: LUTHER KOONTZ, EMILIO SERRA
LENGTH: 480 YARDS · PAR 4

It is easy to be beguiled by the beauty of Olivos's fifteenth, a short, dogleg-right par 4. From the first shot to the last, this hole is a demanding mistress. Tall deciduous trees define both sides of the fairway, eliminating a direct line across the dogleg. • This hole is showcased on pages 162–163.

PAR 5

Cabo Reál Golf Club ✦ 10

LOCATION: LOS CABOS, MEXICO
ARCHITECT: ROBERT TRENT JONES, JR.
LENGTH: 535 YARDS · PAR 5

This luscious hole plunges down a green ribbon of fairway surrounded by desert arroyos and cacti. Though the hole plays short, trying to get home in two is a big risk, as the small green is neatly perched among the crowd of bunkers. Downhill lies are almost unavoidable, and the deep blue horizon makes judging distances that much harder.

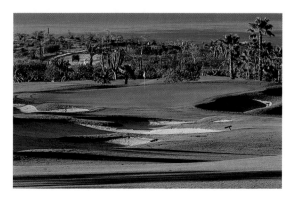

Dorado Beach Hotel and Golf Club (East) ✦ 13

LOCATION: DORADO, PUERTO RICO

ARCHITECT: ROBERT TRENT JONES, SR.

LENGTH: 540 YARDS · PAR 5

The thirteenth at Dorado Beach is designed in a style called a zigzag hole or double dogleg. It works its way around two water hazards found on opposite sides of the fairway. An accomplished player can choose to carry both of the water hazards and shorten the distance to the elevated green by nearly one hundred yards. • This hole is showcased on pages 214–215.

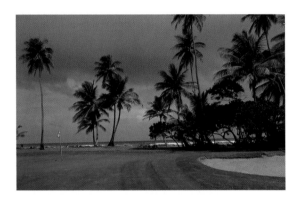

Los Leones Golf Club ✦ 4

LOCATION: SANTIAGO, CHILE

ARCHITECT: ALISTAIR MACDONALD

LENGTH: 560 YARDS · PAR 5

Los Leones is a peaceful oasis in the midst of a bustling metropolis. Similarly, the fourth stands out as a hole low on visual trickery, but one that also demands precision. Though trees, a lateral water hazard, and out of bounds encroach on the right, the first two shots have ample room to maneuver. The approach is where positioning and strategy come into play, as a perfectly placed tree shields the front left of the green, while a large bunker catches shots drifting right. • This hole is showcased on pages 228–229.

CANADA

Banff Springs Golf Course ✦ 4

LOCATION: BANFF, ALBERTA
ARCHITECT: STANLEY THOMPSON
LENGTH: 171 YARDS · PAR 3

A 1927 avalanche created a small glacial lake on the fourth. Though its icy waters are completely still, the lake gives the impression of a boiling pot, giving the fourth the name "Devil's Cauldron." The many bunkers create optical illusions, making the target appear closer or farther, depending on the where the pin sits. • This hole is showcased on pages 6–9.

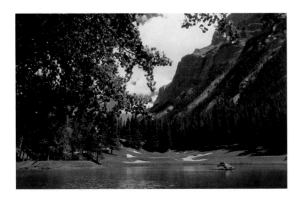

Devil's Paintbrush Golf Club ✦ 13

LOCATION: CALEDON, ONTARIO
ARCHITECT: MICHAEL HURDZAN
LENGTH: 226 YARDS · PAR 3

On a course that prides itself on offering firm ground and links-style features for low-running shots, this is a hole where you simply have to bomb away with a long club and hope it holds the green. To the right of the green are the woods and stone wall that denote the end of the property, while a lone tree guards the left. This ranks as the toughest tee shot on the course, and easily one of the most testing par 3s north of the border.

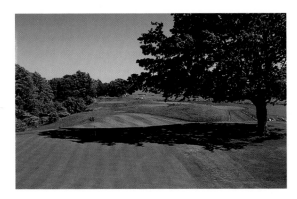

Kananaskis Country Golf Course (Mount Kidd) ✦ 4

LOCATION: KANANASKIS, ALBERTA
ARCHITECT: ROBERT TRENT JONES, SR.
LENGTH: 197 YARDS · PAR 3

Trent Jones called the Kananaskis development "the finest location I have ever seen for a golf course." While it's assumed he was talking about the mountains, the fourth hole expertly takes advantage of another local feature: befuddling valley winds. Who wants to stand on the fourth tee, wind whipping from behind the tee, and try to gauge how far the ball will fly in the thin air? Jones made it even tougher by creating a peninsula green for the fourth, bringing water into play for a shot that flies too far.

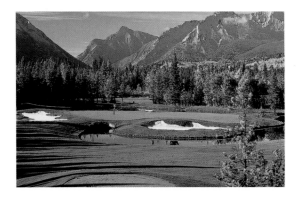

Uplands Golf and Country Club ✦ 8

LOCATION: THORNHILL, ONTARIO
ARCHITECT: STANLEY THOMPSON
LENGTH: 232 YARDS · PAR 3

This hole dates back to 1922, when it was played as the seventeenth before nine holes of this lovely track were lost to a housing development. Even with today's modern equipment, the tee shot is downright frightening. It is played almost entirely across a valley stream, to a target that is perfectly visible, yet seemingly inaccessible—a small green embedded in a wooded hillside. The margin for error is so slight that this hole can be rightly described as the inland equivalent to Cypress Point's sixteenth, which it predates by six years.

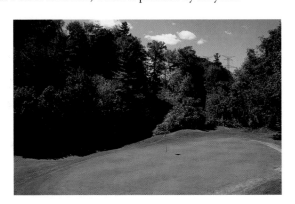

Glen Abbey Golf Club ✦ 14

LOCATION: OAKVILLE, ONTARIO

ARCHITECT: JACK NICKLAUS

LENGTH: 426 YARDS · PAR 4

The last of the four strong holes that wind along Sixteen Mile Creek, the fourteenth is routinely the most difficult hole during the annual Canadian Open. For the pros, it's not so much clearing the creek off the tee. It's the green that gives the players fits: A long hollow cuts across its middle, making putting a distinct challenge.

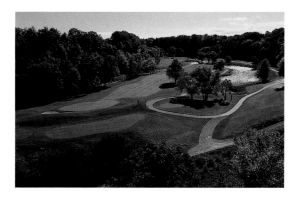

Hamilton Golf and Country Club (South) ✦ 2

LOCATION: ANCASTER, ONTARIO

ARCHITECTS: H. S. COLT, C. E. ROBINSON

LENGTH: 442 YARDS · PAR 4

Since many rounds at Hamilton begin on the West nine and proceed to the South, this is often played as the eleventh hole, which is just as well—you certainly want to be warmed up for this tee shot. The drive must travel at least 240 yards to clear the dogleg, and then it's uphill to an elevated green. Advice from the head pro: "I tell most people to play up short of the green on their second shot and play it as a par five; it saves them a lot of grief."

Highlands Links Golf Club ✦ 2

LOCATION: INGONISH, NOVA SCOTIA

ARCHITECT: STANLEY THOMPSON

LENGTH: 447 YARDS · PAR 4

The embodiment of Thompson's faithful devotion to old-style architecture, this hole looks right at home in the rugged and beautiful Cape Breton Highlands National Park. With a tee shot that sets up for a fade and a narrow, downhill fairway leading to a bunkerless green, this hole's lack of flash is what makes it so endearing.

St. George's Golf and Country Club ✦ 7

LOCATION: TORONTO, ONTARIO

ARCHITECT: STANLEY THOMPSON

LENGTH: 440 YARDS · PAR 4

Having hosted four Canadian Opens and five Du Maurier Classics, St. George's often gets the chance to show off its superb finishing holes. But before players reach those holes, they have to get through the seventh, the number one stroke hole. One has to wonder if Thompson didn't intend for this to be a par 5—its prodigious length is made even tougher by its uphill position, and the green is among the most severely undulating on the course.

Glen Abbey Golf Club ✦ 18

LOCATION: OAKVILLE, ONTARIO
ARCHITECT: JACK NICKLAUS
LENGTH: 508 YARDS · PAR 5

Three of the last six holes at Glen Abbey are par 5s. Fans love the thrilling finishes this hole often provides, though the architect himself would like to see it turned into a long par 4. Downwind, many long hitters can hit it in two with a mid-iron, making eagle a very real possibility. Of course, the lake fronting the green brings double bogey into play as well.

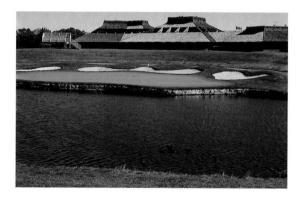

Gorge Vale Golf Club ✦ 15

LOCATION: VICTORIA, BRITISH COLUMBIA
ARCHITECTS: A. VERNON MACAN, NORMAN WOODS
LENGTH: 541 YARDS · PAR 5

On a hole named "Tipperary," the commanding view from the elevated tee often conjures up heroic thoughts of birdies and eagles, though as the song says, "It's a long way to go." For Canadian Tour player Matt Cole, those thoughts became reality as he made a 2 on this hole during the final round of the 1988 Shell Payless Open. To duplicate this feat, players will have to safely reach the narrow landing area at the corner of the dogleg-left. The green is the smallest on the course, and guarded by a large left bunker.

Highlands Links Golf Club ✦ 6

LOCATION: INGONISH, NOVA SCOTIA
ARCHITECT: STANLEY THOMPSON
LENGTH: 537 YARDS · PAR 5

Architect Stanley Thompson referred to Highlands Links as his "mountain and ocean course." This rugged, natural course features a sixth hole that reflects Thompson's instinct for the strategic elements of good course design. From the elevated tee, the task is clear: Avoid the marsh on the right side to safely find the fairway, then traverse the rough-hewn mounds that divide hole, while finally reaching the green guarded by six bunkers. • This hole is showcased on pages 222–223.

The National Golf Club ✦ 4

LOCATION: WOODBRIDGE, ONTARIO
ARCHITECTS: TOM AND GEORGE FAZIO
LENGTH: 581 YARDS · PAR 5

Lee Trevino won the 1979 Canadian PGA Championship at The National with a winning score of 1 over par, and afterward called it "one of my favorite courses in the world." Its difficulty and allure are highlighted at the fourth, where the Fazios present golfers with a classic risk-reward situation. A creek meanders down the right side and crosses the fairway 150 yards short of the green, daring players to clear it in two shots for an easier approach.

GREAT BRITAIN AND IRELAND

No matter their nationality, anyone who speaks the language of golf knows that, in a sense, the British Isles are their ancestral home. The game's birthplace boasts an endless collection of stunning, wind-blown links, from the famous to the obscure. Each has its own character and flavor, but all have one thing in common: They represent golf in its purest, most beautiful form.

In addition to the seaside links, gentle heathland courses also abound. Whether carved through the forests of southern England, like Sunningdale, or the rolling terrain of the Scottish Highlands, like Loch Lomond, these inland layouts are inspiring counterparts to their coastal brethren.

Not only is the Old Course at St. Andrews considered the game's first eighteen-hole layout, it also was the touchstone for early architects such as Old Tom Morris, Allan Robertson, and Willie Dunn, who continued to build courses throughout the British Isles. Their brilliant designs still challenge and delight golfers from every corner of the globe, proof of golf's ability to unite generations of enthusiasts.

PAR 3

Blairgowrie Golf Club (Rosemount) ✦ 17
LOCATION: ROSEMOUNT, PERTHSHIRE, SCOTLAND
ARCHITECTS: OLD TOM MORRIS, ALISTER MACKENZIE, JAMES BRAID
LENGTH: 165 YARDS · PAR 3

Though minor alterations have been made, this hole's superior tranquility and apparent simplicity were deemed too valuable to change. While the competitive course record on Rosemount stands at 64, the seventeenth was the last in a stretch of 10 consecutive birdies made by Scottish pro Lionel Platts in a practice round for a local tournament.

Carnoustie Golf Links (Championship) ✦ 16
LOCATION: CARNOUSTIE, ANGUS, SCOTLAND
ARCHITECTS: ALLAN ROBERTSON, WILLIE PARK, JR., JAMES BRAID
LENGTH: 250 YARDS · PAR 3

This is a par 3 in name only; players are often thrilled with making a 4. The second of the four most punishing finishing holes in golf, the long sixteenth is made even more difficult by its narrow bunker-surrounded green, which from the tee looks the size of a tabletop. In the 1975 British Open, Tom Watson failed to make par here five times—including the playoff—and still won.

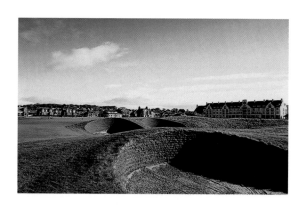

Cruden Bay Golf Club ✦ 4

LOCATION: CRUDEN BAY, ABERDEENSHIRE, SCOTLAND
ARCHITECTS: HERBERT FOWLER/TOM SIMPSON
LENGTH: 193 YARDS · PAR 3

Cruden Bay's routing takes golfers to many gorgeous expanses of dunes, but the elevated fourth tee is often cited as the prettiest spot on the course. It offers the first true glimpse of the North Sea, with the old Port Erroll fishing cottages standing guard to the left. Crossing the white footbridge on the way to the green, one can smell the salt air, an enticing foreshadowing of the seven seaside holes to come.

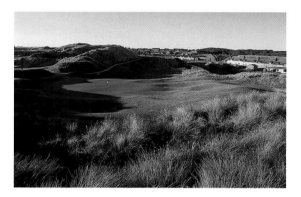

The European Club ✦ 14

LOCATION: BRITTAS BAY, COUNTY WICKLOW, IRELAND
ARCHITECT: PAT RUDDY
LENGTH: 165 YARDS · PAR 3

While many golf journalists think they know how to build great golf courses, Irish scribe Pat Ruddy actually went out and did it. After two holes that are fully exposed to the winds of the Irish Sea, the fourteenth on Ruddy's magnificent new links offers partial seclusion in the form of large dunes. However, hitting the shelflike green is still not a bargain, even on the rare days when the air is calm.

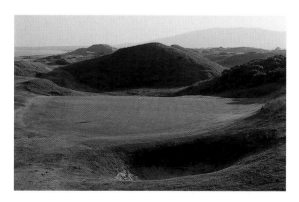

Lindrick Golf Club ✦ 18

LOCATION: NOTTS, YORKSHIRE, ENGLAND
ARCHITECTS: TOM DUNN, F. W. HAWTREE
LENGTH: 210 YARDS · PAR 3

This hole is more famous for what didn't happen on it than for what did. Lindrick was the site of the 1957 Ryder Cup, the last year that a team made up solely of British and Irish players would beat the mighty Americans. Many were anticipating the drama that would unfold during matches that came down to the par-3 final hole. Instead, only one match reached the eighteenth—Dick Mayer of the United States halved with Harry Bradshaw of Great Britain and Ireland—but by that time, the home team's celebration had already begun.

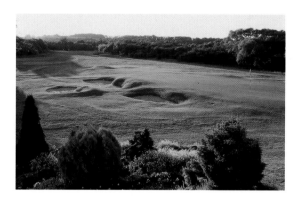

Loch Lomond Golf Club ✦ 5

LOCATION: LUSS, DUMBARTONSHIRE, SCOTLAND
ARCHITECTS: TOM WEISKOPF/JAY MORRISH
LENGTH: 190 YARDS · PAR 3

Upon seeing Loch Lomond for the first time, no less an authority than Nick Faldo said, "Would that all new courses were like this." It's likely that thought occurred to him while standing on the fifth tee, with the loch and distant mountains looming behind a narrow green ringed by bunkers. The sand on the left is particularly foreboding, forcing even the world's best players to scramble for par.

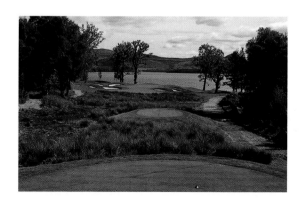

Muirfield (Honourable Company of Edinburgh Golfers) ✦ 13

LOCATION: GULLANE, EAST LOTHIAN, SCOTLAND

ARCHITECTS: OLD TOM MORRIS, H. S. COLT/TOM SIMPSON

LENGTH: 159 YARDS · PAR 3

Muirfield's thirteenth runs 180 degrees away from the twelfth and fourteenth, a change that requires a focused recalculation of the prevailing conditions and considerations. Uphill 159 yards to a long, narrow, contoured green, the thirteenth is nestled "in a basket of dunes." The green also is jealously guarded by three deep bunkers to the right and two to the left. • This hole is showcased on pages 98–99.

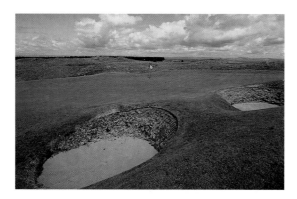

North Berwick Golf Links (West) ✦ 15

LOCATION: NORTH BERWICK, EAST LOTHIAN, SCOTLAND

ARCHITECT: DAVID STRATH

LENGTH: 190 YARDS · PAR 3

Generally regarded as the most copied hole in the world, North Berwick's Redan was perhaps the first to present a specific formula of defense against a player making par. The green is set at a forty-five degree angle, with the back left angled away and set behind a deep bunker. Except for the bunker, its elements of defense are largely invisible from the tee and are obscured by a ridge about 40 yards short of the green. • This hole is showcased on pages 102–103.

Royal Birkdale Golf Club ✦ 12

LOCATION: SOUTHPORT, MERSEYSIDE, ENGLAND

ARCHITECTS: GEORGE LOWE, F. W. HAWTREE/J. H. TAYLOR

LENGTH: 181 YARDS · PAR 3

Over the past thirty years, no club has hosted more major events. It is a "man-size course but not a monster," in the words of five-time British Open champion Peter Thomson. From the tee of the twelfth, which is situated in the hills, the shot must carry across a narrow valley to the green up in the next row of hills. Even from this relatively short distance, the green appears narrow and small. The rough is a colorful combination of creeping blackberry, willow scrub, and a yellow evening primrose. • This hole is showcased on pages 108–109.

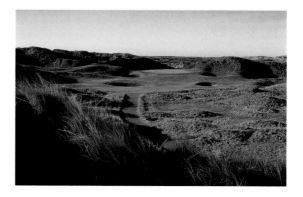

Royal County Down Golf Club ✦ 4

LOCATION: NEWCASTLE, COUNTY DOWN, NORTHERN IRELAND

ARCHITECTS: OLD TOM MORRIS, HARRY VARDON

LENGTH: 212 YARDS · PAR 3

Innumerable gorse bushes, ten bunkers, three mountain peaks, and one hotel spire equal the most magnificent view in British golf, granted from the hillside back tee of the fourth. It only requires a mid-iron from the middle tees, but when you're perched far back and with the salt breeze coming on off the sea, it can be one of the most daunting—and inspiring—shots in golf.

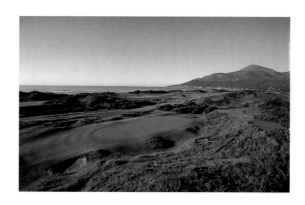

Royal Dornoch Golf Club ✦ 6

LOCATION: DORNOCH, SUTHERLAND, SCOTLAND
ARCHITECTS: OLD TOM MORRIS, JOHN SUTHERLAND,
GEORGE DUNCAN
LENGTH: 165 YARDS · PAR 3

Named "Whinny Brae," this hole signifies the transition of the Dornoch layout from the gentle valley of the third through fifth holes to the exposed ridge holes that give hints of the formidable linksland to come. Set in a sea of gorse bushes, the short but tricky sixth demands a precise tee shot, and a par here tends to energize players as they begin the long uphill climb to the seventh tee.

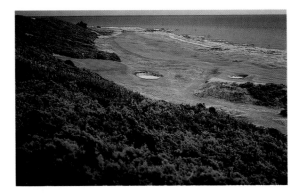

Royal Lytham and St. Annes Golf Club ✦ 1

LOCATION: ST. ANNES-ON-SEA, LANCASHIRE, ENGLAND
ARCHITECT: GEORGE LOWE
LENGTH: 206 YARDS · PAR 3

The only opening par 3 in championship golf, the first hole at Lytham is as distinctly quirky as the British Open itself. Some love it (Seve Ballesteros, who won the Open at Lytham in 1979 and 1988), and others hate it (Tony Jacklin, who called starting on a par 3 "a terrible strain"). Whatever your viewpoint, it's a fitting start to a front nine that includes some of the most intimidating tee shots in Open play.

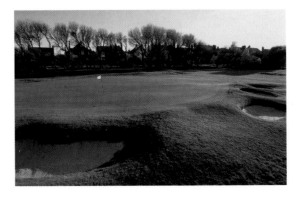

Royal Portrush Golf Club (Dunluce) ✦ 14

LOCATION: PORTRUSH, COUNTY ANTRIM, NORTHERN IRELAND
ARCHITECTS: OLD TOM MORRIS, H. S. COLT
LENGTH: 210 YARDS · PAR 3

The magnificence of Royal Portrush's architecture is nearly overwhelmed by its setting. It is the fourth oldest golf club in Ireland, and fifty important championships have been held on its links. "Calamity Corner," abbreviated to "Calamity," is the appropriate name given to the short fourteenth. With a violent seventy-five-foot chasm to the right of the green and defining hillocks along the left, only an exact shot will find safety. • This hole is showcased on pages 114–115.

Royal Troon Golf Club (Old) ✦ 8

LOCATION: TROON, AYRSHIRE, SCOTLAND
ARCHITECTS: WILLIE FERNIE, JAMES BRAID
LENGTH: 123 YARDS · PAR 3

"The hardest stamp in the world to lick." So it has been said about Royal Troon's short eighth, known to one and all as the Postage Stamp. It can be described as a deceptively simple, organic hole, nothing more than a short shot from the top of one dune to another. With its green measuring just twenty-five feet in width, its small size and the invisible wind are the Postage Stamp's strongest defenses. • This hole is showcased on pages 116–117.

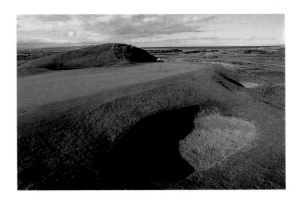

Royal Worlington Golf Club ✦ 5

LOCATION: WORLINGTON, SUFFOLK, ENGLAND
ARCHITECT: CAPTAIN A. M. ROSS
LENGTH: 157 YARDS · PAR 3

An acclaimed nine-hole course tucked onto a small parcel of land, Royal Worlington has many routing quirks, two of which are evident on the ingenious fifth. The hole runs perpendicular to the fourth and sixth holes, so that the tee shot must carry over the fairways of both holes. The narrow, bunkerless green is difficult to hit in the varying wind conditions, which are made even tougher by the sheltering stand of trees behind the green.

St. Andrews (Old) ✦ 11

LOCATION: ST. ANDREWS, FIFE, SCOTLAND
ARCHITECT: UNKNOWN
LENGTH: 172 YARDS · PAR 3

The Old Course's eleventh is one of the most copied short holes in the world because of the diabolical perplexity of its surrounding charms—the deep Hill bunker, the estuary of the Eden River, and a severely tilted putting surface that must be deciphered once reached. Alister Mackenzie considers it the greatest of all short holes because it requires a greater variety of shots under different conditions of wind and changes in position of the flag than any other. • This hole is showcased on pages 118–119.

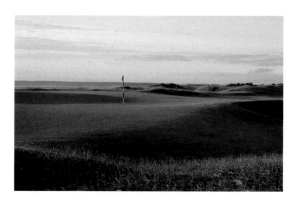

Southport & Ainsdale Golf Club ✦ 8

LOCATION: SOUTHPORT, MERSEYSIDE, ENGLAND
ARCHITECT: JAMES BRAID
LENGTH: 157 YARDS · PAR 3

Though this course is one of the few sites that witnessed a Great Britain and Ireland victory in the Ryder Cup, it remains overshadowed by its neighbor Royal Birkdale. That's a shame, because the front nine is superb, with the eighth hole being one of the jewels. Braid took a page out of Donald Ross's book in designing the green, which sits on a plateau and requires a deft touch for those looking to get up and down.

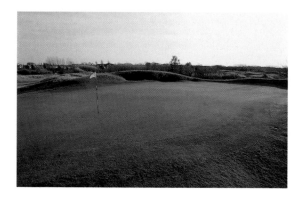

Sunningdale Golf Club (Old) ✦ 15

LOCATION: SUNNINGDALE, SURREY, ENGLAND
ARCHITECTS: WILLIE PARK, JR., H. S. COLT
LENGTH: 226 YARDS · PAR 3

The finest par 3 on the finest heathland course in Great Britain, the fifteenth is the beginning of a final four-hole stretch that goes a long way toward explaining Sunningdale's popularity. The tee shot is made tougher by the prevailing crosswind, which tends to steer the ball toward the left greenside bunkers. Bobby Jones said in 1926, "I wish I could take this course home with me," a sentiment that has been echoed by many others since then.

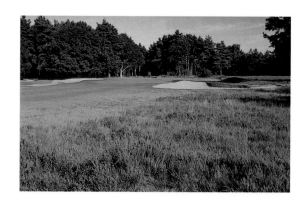

Turnberry Golf Club (Ailsa) ✦ 15

LOCATION: TURNBERRY, AYRSHIRE, SCOTLAND
ARCHITECTS: WILLIE FERNIE, P. M. ROSS
LENGTH: 209 YARDS · PAR 3

Though number 15 is referred to as a "short hole" in many golf books, nothing could be further from the truth. Into the prevailing wind, good players routinely hit 3-woods and drivers and still finish short of the green. In his famous 1977 British Open final-round duel with Jack Nicklaus, Tom Watson struck a mighty blow here, holing a 60-foot birdie putt from the light greenside rough to pull even with the Golden Bear, whom he would beat by round's end.

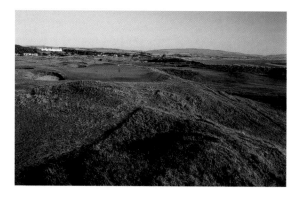

Waterville Golf Links ✦ 17

LOCATION: WATERVILLE, COUNTY KERRY, IRELAND
ARCHITECT: EDDIE HACKETT
LENGTH: 196 YARDS · PAR 3

The hole is named "Mulcahy's Peak," after club founder John Mulcahy. His favorite spot on the course was the magnificent twenty-foot-high back tee of the seventeenth, which, at his request, also became his final resting place after his death at age eighty-eight. Don't be surprised if your tee shot flies straight and true to the green—it's probably ol' John watching out for his guests.

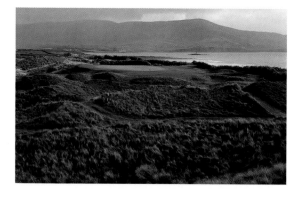

Wentworth Golf Club (West) ✦ 2

LOCATION: VIRGINIA WATER, SURREY, ENGLAND
ARCHITECTS: H. S. COLT/CHARLES ALISON
LENGTH: 155 YARDS · PAR 3

The World Match Play Championship has been held here since 1964, and if during a telecast you see the second hole and think, "There doesn't look like much room to miss," you're right. Affectionately dubbed "the Burma Road" because of its difficulty, this hole has a large Spanish oak sitting between the two right bunkers. If the green looks hard on TV, the tree makes the shallow green look even more inaccessible in person.

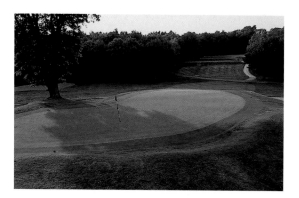

Woburn Golf and Country Club (Dukes) ✦ 3

LOCATION: MILTON KEYNES, BUCKINGHAMSHIRE, ENGLAND
ARCHITECTS: J.J.F. PENNINK, CHARLES LAWRIE
LENGTH: 134 YARDS · PAR 3

At this delicate par 3, the hundred-foot drop from tee to green is filled with a sea of rhododendrons, but it's the green that causes worries to bloom. It tilts severely from back to front—shots with too much backspin often roll off the front edge. After narrowly missing a 1-foot downhill birdie putt during the British Masters, Australian Brett Ogle found himself left with a 25-footer back up the hill for par. He drained it.

Ballybunion Golf Club (Old) ✦ 2

LOCATION: BALLYBUNION, COUNTY KERRY, IRELAND

ARCHITECTS: PATRICK MURPHY, TOM SIMPSON/MOLLY GOURLAY

LENGTH: 445 YARDS · PAR 4

Ballybunion's second tee offers a good amount of eye candy: the green of the par-3 third hole to the right, the fairway of the par-5 thirteenth to the left, and a small gap between the dunes ahead, through which the flagstick beckons from the top of a ridge. The same ridge will send an approach shot rolling back about fifty yards should it land short of the green.

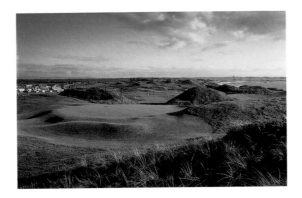

Ballybunion Golf Club (Old) ✦ 7

LOCATION: BALLYBUNION, COUNTY KERRY, IRELAND

ARCHITECTS: PATRICK MURPHY, TOM SIMPSON/MOLLY GOURLAY

LENGTH: 432 YARDS · PAR 4

This is why golfers travel to Ireland. With a tee and green set precariously close to the water's edge, the seventh provides the first true shot of adrenaline after the beginning inland holes. The fairway was once the victim of coastal erosion, and was afterward moved slightly away from the cliffside. Still, the sea is very much in play, and a par here will likely feel like a birdie.

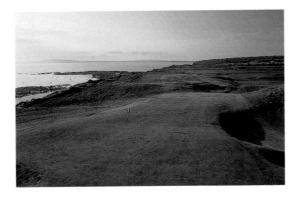

Ballybunion Golf Club (Old) ✦ 11

LOCATION: BALLYBUNION, COUNTY KERRY, IRELAND

ARCHITECTS: PATRICK MURPHY, TOM SIMPSON/MOLLY GOURLAY

LENGTH: 453 YARDS · PAR 4

Ballybunion was described by Herbert Warren Wind in 1971 as "nothing less than the finest seaside course I have ever seen." Its spectacular eleventh hole offers a clifftop tee that clings to flattened dune seventy feet above beach and the mouth of the Shannon. To succeed on the eleventh, one cannot advance the ball meekly down the fairway. It must be played as the Irish do, with abandon, holding nothing back. • This hole is showcased on pages 22–25.

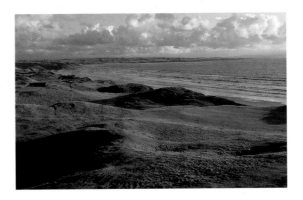

The Belfry (Brabazon) ✦ 18

LOCATION: SUTTON COLDFIELD, WARWICKSHIRE, ENGLAND

ARCHITECTS: PETER ALLISS/DAVID THOMAS

LENGTH: 474 YARDS · PAR 4

The Belfry will host its fourth Ryder Cup in 2001, and there is no question that the eighteenth is one of the most entertaining match-play holes in golf. It has been the scene of crushing disappointments and jubilant triumphs, none more impressive than that of Christy O'Connor, Jr., in the 1989 Ryder Cup. With teammate Tony Jacklin in the fairway whispering, "Hit this one for Ireland," O'Connor striped a 2-iron to within 3 feet of the flag, winning his match over Fred Couples 1-up and helping Europe retain the Cup.

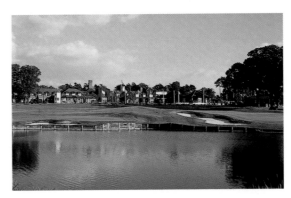

The Berkshire Golf Club (Red) ✦ 6

LOCATION: ASCOT, BERKSHIRE, ENGLAND

ARCHITECT: HERBERT FOWLER

LENGTH: 360 YARDS · PAR 4

Before the trees at the corner of this sharp dogleg-right grew in completely, the green could be reached by long hitters with a daring tee shot of about 290 yards. Today, the result is a hole that plays as it was designed—with a tee shot that must be long and straight enough to clear a ditch and get past the edge of the right-hand tree line. The approach is almost always into the wind, and is played to a raised green set closely in between two bunkers.

Carnoustie Golf Links (Championship) ✦ 17

LOCATION: CARNOUSTIE, ANGUS, SCOTLAND

ARCHITECTS: ALLAN ROBERTSON, WILLIE PARK, JR., JAMES BRAID

LENGTH: 459 YARDS · PAR 4

After the 1999 British Open, it's safe to say that Barry Burn stands second only to Rae's Creek in the ranks of championship-golf water hazards. It's actually on this hole that Barry Burn shows its fiercest teeth. Its serpentine shape turns this into a three-shot hole when the play is into the wind, as competitors are forced to play their tee shots in between the burn's two fairway crossings. This leaves a lengthy, and often impossible, approach to the gorse- and bunker-lined green.• This hole is showcased on pages 128–129.

Elie, The Golf House Club ✦ 13

LOCATION: ELIE, FIFE, SCOTLAND

ARCHITECTS: OLD TOM MORRIS, JAMES BRAID

LENGTH: 380 YARDS · PAR 4

Take it from Elie's favorite son, James Braid: "The thirteenth is the finest hole in all the country." Hometown pride, to be sure, but he wasn't that far off. The hole winds its way along the shores of the Firth of Forth, with MacDuff's cave visible in a distant cliff. Though the green is large, the ever-present winds make the second shot the most difficult on the course.

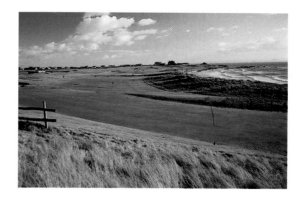

The European Club ✦ 7

LOCATION: BRITTAS BAY, COUNTY WICKLOW, IRELAND

ARCHITECT: PAT RUDDY

LENGTH: 470 YARDS · PAR 4

At the European Club's seventh, architect Pat Ruddy used the most effective visual devices borrowed from the best holes in the world. Length, danger, and green size are visually exaggerated, while, in fact, the hole offers generous landing zones and ample room to bail out. What Ruddy refers to as the "reverse view telescope effect" is employed at the tee to make everything seem more distant. • This hole is showcased on pages 140–141.

Ganton Golf Club ✦ 4

LOCATION: GANTON, YORKSHIRE, ENGLAND
ARCHITECTS: TOM CHISHOLM, HARRY VARDON, H. S. COLT,
HERBERT FOWLER, JAMES BRAID
LENGTH: 406 YARDS · PAR 4

Championships have highlighted Ganton's competitive history, but it's the beauty of the Yorkshire countryside that is the true allure of the course. That, and the fourth hole. After giving players some room off the tee, the hole tightens to reveal a superbly situated greensite. The approach must be fired over a shallow diagonal gulley, leading to a difficult plateau green with a steep fall-off on the left and a well-placed bunker on the right.

Lahinch Golf Club ✦ 4

LOCATION: LAHINCH, COUNTY CLARE, IRELAND
ARCHITECT: OLD TOM MORRIS
LENGTH: 428 YARDS · PAR 4

It's unusual for a hole that can almost be defined as "target-style" to get such acclaim in the land of the bump-and-run, but the magnificent fourth scores major points for its setting and visual complexity. The island fairway is not visible from the tee, and falls off sharply at about 275 yards. The green is partially obscured by a hill on the right, but through it all the sea beckons to the left, lifting the spirits of those searching for balls in the grass-covered dunes.

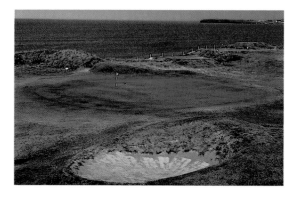

Loch Lomond Golf Club ✦ 10

LOCATION: LUSS, DUMBARTONSHIRE, SCOTLAND
ARCHITECTS: TOM WEISKOPF/JAY MORRISH
LENGTH: 455 YARDS · PAR 4

Loch Lomond, one of the country's most beautiful courses, was the first of Scotland's courses to be designed by American architects. At its tenth, backdrops of water, mountains, and forest are artfully balanced to enhance the course's strategic elements. "I consider Loch Lomond to be my lasting memorial to golf," said architect Tom Weiskopf. • This hole is showcased on pages 146–147.

Machrihanish Golf Club ✦ 1

LOCATION: CAMPBELLTOWN, ARGYLL, SCOTLAND
ARCHITECT: OLD TOM MORRIS
LENGTH: 423 YARDS · PAR 4

The sign to beachgoers reads DANGER, FIRST TEE ABOVE. PLEASE MOVE FARTHER ALONG THE BEACH. And so they do, allowing golfers the thrill of the most tantalizing opening tee shot in the game. Bite off as much of the dogleg as you dare, but remember, the beach is in bounds. A pull or hook could result in having to hit a recovery shot alongside a villager walking his Lab.

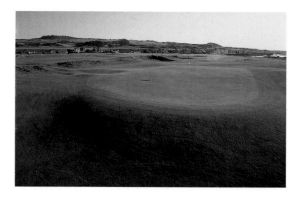

Muirfield (Honourable Company of Edinburgh Golfers) ✦ 18

LOCATION: GULLANE, EAST LOTHIAN, SCOTLAND
ARCHITECTS: OLD TOM MORRIS, H. S. COLT/TOM SIMPSON
LENGTH: 448 YARDS · PAR 4

When Nick Faldo struck a perfect 5-iron second shot to win in the 1987 British Open, he beat not only Paul Azinger but also one of the toughest finishing holes in golf. The hole favors a draw off the tee to a tight landing area, with three small bunkers on the left often causing players to shove their drives into the right rough. The deep but narrow green, with a ridge running through its center to create two tiers, is flanked closely by a large bunker on each side.

North Berwick Golf Links (West) ✦ 7

LOCATION: NORTH BERWICK, EAST LOTHIAN, SCOTLAND
ARCHITECT: DAVID STRATH
LENGTH: 354 YARDS · PAR 4

Though not long, the seventh is one of those holes that ends up playing much tougher than it appears when glancing at the scorecard. The snaking Eil Burn crosses the fairway just short of the green, making what should be a routine approach shot anything but. Take too little club and the prevailing wind will knock the ball down and into the wee stream. Overcompensate with too much club and face a tricky pitch from the high grass.

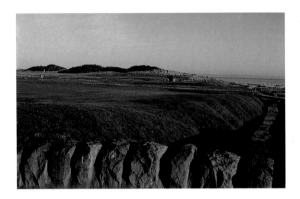

Nairn Golf Club ✦ 4

LOCATION: NAIRNSHIRE, SCOTLAND
ARCHITECTS: ARCHIE SIMPSON, OLD TOM MORRIS, JAMES BRAID
LENGTH: 378 YARDS · PAR 4

James Braid, after making some small alterations to Nairn, said in a report to the club, "The texture of the turf and character of the greens are unrivalled." He easily could have added, "Now, good luck on number four." The drive on the seaside par 4 must elude "Braid's bunker," which he added in a renovation. He also moved the green to the top of a plateau, adding a degree of difficulty to the approach shot.

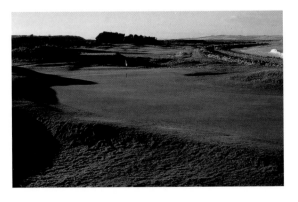

The Oxfordshire Golf Club ✦ 8

LOCATION: MILTON COMMON, OXFORDSHIRE, ENGLAND
ARCHITECT: REES JONES
LENGTH: 390 YARDS · PAR 4

Short but dangerous, this is a hole where the pros are happy to escape with par during the annual Benson and Hedges International. The landing area narrows progressively, making a long iron the popular club for tee shots. The hole doglegs sharply right around a lake, which then wraps behind the green to form a windswept peninsula. A huge oak tree marks the peninsula's edge, while the green, sloping from back to front, can be a putting adventure.

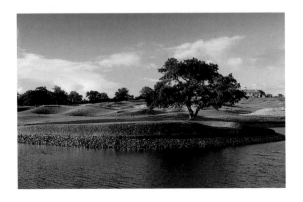

Portmarnock Golf Club ✦ 14

LOCATION: PORTMARNOCK, COUNTY DUBLIN, IRELAND

ARCHITECTS: GEORGE ROSS, W. C. PICKEMAN

LENGTH: 385 YARDS · PAR 4

This is one of the most beloved par 4s in golf. The narrow, elevated green demands a precise second shot if par is to be made, or in Joe Carr's case, a precise first shot. Local legend has it that the celebrated Irish amateur drove this green in one, his ball somehow avoiding the greenside bunkers. While that story is unverifiable, Henry Cotton once recorded a 7 here en route to losing his lead in the Irish Open.

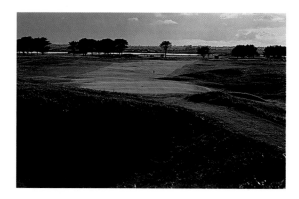

Prestwick Golf Club (Old) ✦ 1

LOCATION: PRESTWICK, AYRSHIRE, SCOTLAND

ARCHITECT: OLD TOM MORRIS

LENGTH: 346 YARDS · PAR 4

On the scorecard, this looks to be a benign hole. But a card cannot convey the nervousness that players feel on this, the Railway hole. At this first shot of the round, the dire consequences of a hooked or sliced tee shot are enough to make the mouth run dry. To the left are rough-covered mounds, to the right the tracks of the Glasgow-to-Ayr rail line. On the assumption that the tee shot will land safely, the approach is played to a small green directly behind a tall bunker. • This hole is showcased on pages 172–173.

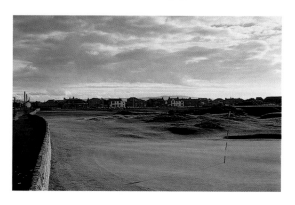

Royal Birkdale Golf Club ✦ 18

LOCATION: SOUTHPORT, MERSEYSIDE, ENGLAND

ARCHITECTS: GEORGE LOWE, F. W. HAWTREE/J. H. TAYLOR

LENGTH: 476 YARDS · PAR 4

In former days, four of the last six holes at Royal Birkdale could be played as par 5s. For the Open Championship, however, the thirteenth and eighteenth are configured as long 4s. At 476 yards, and well bunkered and bordered by two small ridges on either side of the fairway, the eighteenth requires two exacting shots to reach the green. • This hole is showcased on pages 180–181.

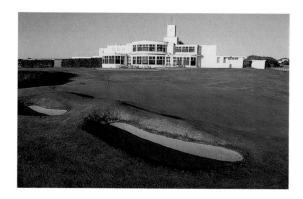

Royal County Down Golf Club ✦ 9

LOCATION: NEWCASTLE, COUNTY DOWN, NORTHERN IRELAND

ARCHITECTS: OLD TOM MORRIS, HARRY VARDON

LENGTH: 486 YARDS · PAR 4

The hand of man is barely detectable in the wild, wind-tossed terrain of Royal County Down. It is arranged in two loops of returning nines, with the outgoing nine, routed closer to the sea among haystack-shaped dunes rising to forty feet the more impressive. Capping this stretch is the most inspiring spot on the course, the "viewing hill" at the ninth. The view of the town and the mountains in the distance is the reason golfers carry clubs to Newcastle. • This hole is showcased on pages 42–45.

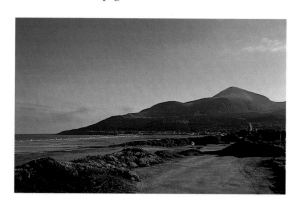

Royal Dornoch Golf Club ✦ 4

LOCATION: DORNOCH, SUTHERLAND, SCOTLAND
ARCHITECTS: OLD TOM MORRIS, JOHN SUTHERLAND,
GEORGE DUNCAN
LENGTH: 418 YARDS · PAR 4

The distinct bunkerless expanse of the fourteenth seems to attract more attention, but the third through fifth holes at Dornoch present as fine a stretch of par 4s as exists in golf. The aiming point for the tee shot on the fourth is the statue of the Duke of Sutherland atop a distant hill, but the hogback fairway ensures that even straight drives will need some good fortune to stay in the fairway.

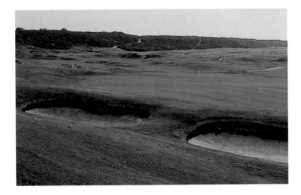

Royal Dornoch Golf Club ✦ 14

LOCATION: DORNOCH, SUTHERLAND, SCOTLAND
ARCHITECTS: OLD TOM MORRIS, JOHN SUTHERLAND,
GEORGE DUNCAN
LENGTH: 459 YARDS · PAR 4

Royal Dornoch's fourteenth carries the sobriquet "Foxy." It's the purest example of using the land to optimize golf strategy without artificial hazards or superficial shaping. The natural shape of the hummock of dune that runs along the right side of the hole and the hole's length make bunkers unnecessary. This may be the only one of the world's best holes to demand so much without the use of artificial hazards of any kind. • This hole is showcased on pages 182–183.

Royal Liverpool Golf Club (Hoylake) ✦ 1

LOCATION: HOYLAKE, CHESHIRE, ENGLAND
ARCHITECTS: ROBERT CHAMBERS, JR., GEORGE MORRIS
LENGTH: 429 YARDS · PAR 4

This was the first hole of the first Walker Cup matches, in 1921, between the best amateurs of the United States and Great Britain. That momentous occasion initiated a long—and often checkered—history. The fairway and green lie alongside the "cop," an artificial bank on the right that is also the out-of-bounds line bordering the practice range. Asked at the 1967 British Open what he thought of the hole, a brash Jack Nicklaus quipped, "It's not a particularly good opening hole." He would go on to finish second.

Royal Lytham and St. Annes Golf Club ✦ 17

LOCATION: ST. ANNES-ON-SEA, LANCASHIRE, ENGLAND
ARCHITECT: GEORGE LOWE
LENGTH: 462 YARDS · PAR 4

Very little is natural at Lytham, with the hazards placed by man to punish even the slightest miscue. A sea of bunkers is strategically positioned in the corner of this flat, tough dogleg-left, catching those who try to shorten the road home. There's also a plaque in the dogleg commemorating the play of Bob Jones in the 1926 British Open, when he hit his mashie shot from the sand and onto the green. Jones won the Open and proved that this hole can be tamed, but only by a master. • This hole is showcased on pages 184–185.

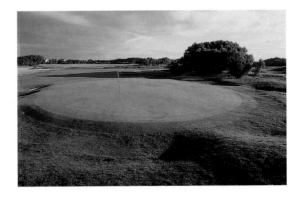

Royal Lytham and St. Annes Golf Club ✦ 18

LOCATION: ST. ANNES-ON-SEA, LANCASHIRE, ENGLAND

ARCHITECT: GEORGE LOWE

LENGTH: 412 YARDS · PAR 4

It's not the longest, most scenic, or the toughest finishing hole, but the eighteenth at Lytham has been the scene of several history-making moments over the years. These include Tony Jacklin's emotional win in the 1969 British Open (ending an eighteen-year victory drought by a "local"), Gary Player's left-handed recovery shot from the side of the clubhouse in 1974, Seve Ballesteros's fantastic up-and-down to salvage the 1988 Open, and Tom Lehman's 1996 triumph, making him the first American professional ever to win at Lytham.

Royal St. David's Golf Club ✦ 15

LOCATION: HARLECH, GWYNEDD, WALES

ARCHITECTS: HAROLD FINCH-HATTON, F. W. HAWTREE

LENGTH: 427 YARDS · PAR 4

There are no bunkers on this hole, but that doesn't mean there is no sand. The dogleg-right fairway is lined by rugged sand hills, which defend just as well against errant shots as any man-made hazard ever could. Additional challenges to scoring are provided by the wind and a deep hollow immediately in front of the green, which becomes a collecting ground for weak approaches. The majestic Mount Snowdon stands in the distance behind the green. • This hole is showcased on pages 186–187.

Royal St. George's Golf Club ✦ 4

LOCATION: SANDWICH, KENT, ENGLAND

ARCHITECTS: DR. LAIDLAW PURVES, ALISTER MACKENZIE, J.J.F. PENNINK

LENGTH: 470 YARDS · PAR 4

The 470-yard fourth exemplifies the reasons champion Harry Vardon considered it the best course in the world. An exact tee shot is demanded in order to achieve success. The name Elysian Fields is given to the landing area at the fourth and meant to reflect the peace a player feels having successfully negotiated the massive bunker on the right of the tee. • This hole is showcased on pages 188–189.

Royal St. George's Golf Club ✦ 15

LOCATION: SANDWICH, KENT, ENGLAND

ARCHITECTS: DR. LAIDLAW PURVES, ALISTER MACKENZIE, J.J.F. PENNINK

LENGTH: 467 YARDS · PAR 4

For architecture buffs, the fifteenth is one of the most visually striking par 4s in golf. Eleven fairway bunkers form a nearly perfect mirror image, and also provide opportunities for brilliance. In the 1922 British Open, Walter Hagen hit his second shot into a bunker 100 yards short of the green. After deciding against an explosion shot, he hit a 7-iron to a foot from the hole, saving par and going on to win by 1 stroke.

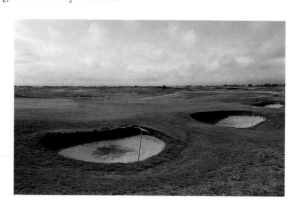

Royal Troon Golf Club (Old) ✦ 11

LOCATION: TROON, AYRSHIRE, SCOTLAND

ARCHITECTS: WILLIE FERNIE, JAMES BRAID

LENGTH: 481 YARDS · PAR 4

Playing adjacent to the Glasgow-to-Ayr rail line, this hole was converted from a par 5 to a par 4 for the 1997 British Open. It is undoubtedly a sterner test in its current form, playing to a 4.65 stroke average during the 1997 event. The first hurdle to cross is two hundred yards of gnarly gorse bush, which must be carried with the tee shot. The fairway then doglegs slightly right (toward the rail line), revealing a narrow green flanked by more gorse and a stone wall. • This hole is showcased on pages 190–191.

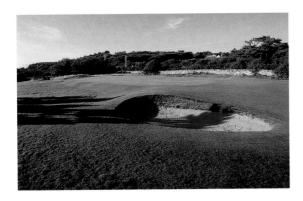

St. Andrews (New) ✦ 10

LOCATION: ST. ANDREWS, FIFE, SCOTLAND

ARCHITECT: OLD TOM MORRIS

LENGTH: 464 YARDS · PAR 4

It may be called "New," but this course was built in 1895 and boasts several sterling holes. The tenth is routed into the prevailing wind, and its challenges lie mainly in the terrain. The drive is made blind by a hill about 75 yards in front of the tee, and the sloping, S-shaped fairway is tough to hit. There are no bunkers in play, but that doesn't make the approach to the small, undulating green easy. It favors a high fade—just try hitting one of those with a gale coming off the North Sea.

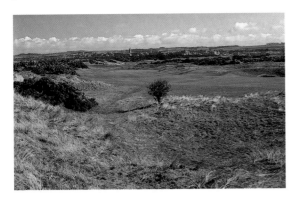

St. Andrews (Old) ✦ 17

LOCATION: ST. ANDREWS, FIFE, SCOTLAND

ARCHITECT: UNKNOWN

LENGTH: 461 YARDS · PAR 4

The Old Course at St. Andrews has upon its ancient, rumpled links many quirky holes, but none quite so special as this notorious par 4, "the Road" hole. The intimidation begins on the tee, where the player is encouraged to drive over the corner of a faux railway barn to cut off part of the dogleg-right. Farther up, short and left of the green, is the famed "Road" bunker. Its effect on play is tremendous, both due to its position and its fearsome reputation. • This hole is showcased on pages 50–53.

Sunningdale Golf Club (Old) ✦ 5

LOCATION: SUNNINGDALE, SURREY, ENGLAND

ARCHITECTS: WILLIE PARK, JR., H. S. COLT

LENGTH: 410 YARDS · PAR 4

From an elevated tee, the fifth is clearly defined. The fairway is bordered by heather, golden grass, and dark green forest. There are two fairway bunkers in the right half of the fairway; a small pond and four sentinel bunkers protect the green. Success calls for two pure shots—to the left in the fairway, avoiding the trouble at the green. Nothing is hidden, and nothing is more satisfying than negotiating the task at hand with intelligence and skill.• This hole is showcased on pages 198–199.

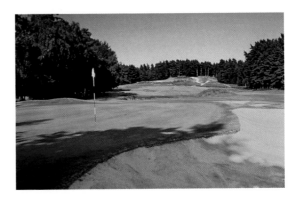

Tralee Golf Club ✦ 17

LOCATION: ARDFERT, COUNTY KERRY, IRELAND

ARCHITECTS: ARNOLD PALMER/ED SEAY

LENGTH: 353 YARDS · PAR 4

This hole overlooks the beach—called the Long Strand—on which scenes of the movie *Ryan's Daughter* were filmed. The forced-carry tee shot is played to a fairway that can only be called rugged, and even that is an understatement. Playing the hole into a strong headwind requires a Herculean effort, which will be long forgotten upon reaching the small, highly perched green.

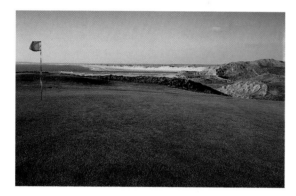

Turnberry Golf Club (Ailsa) ✦ 9

LOCATION: TURNBERRY, AYRSHIRE, SCOTLAND

ARCHITECTS: WILLIE FERNIE, P. M. ROSS

LENGTH: 455 YARDS · PAR 4

Its lighthouse and rocky outcroppings make Turnberry's ninth one of the most recognizable pieces of golf property in the world. This meeting of land and sea baffles description. The tee is perched above a rock peninsula that juts into the sea. The difficulty of the 200-yard carry necessary to find the safety of the fairway is emphasized by its hogbacked shape. • This hole is showcased on pages 202–203.

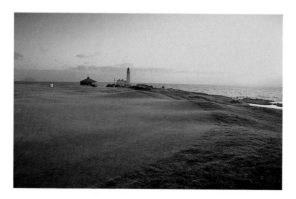

Turnberry Golf Club (Ailsa) ✦ 16

LOCATION: TURNBERRY, AYRSHIRE, SCOTLAND

ARCHITECTS: WILLIE FERNIE, P. M. ROSS

LENGTH: 409 YARDS · PAR 4

The hole is called "Wee Burn," and that says it all. This is the only hole on the course with water crossing the fairway, but without it, the sixteenth would be simply average. The steep banks leading down to the stream tend to play tricks on a player's mind, leaving this as one of the more memorable approaches at Turnberry. In 1986, Greg Norman sealed his victory in the British Open here with a superb second shot from the rough, which stopped 10 feet from the hole.

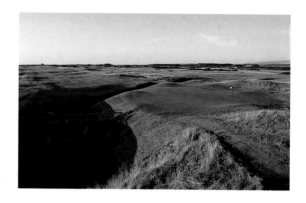

Walton Heath Golf Club (Old) ✦ 5

LOCATION: TADWORTH, SURREY, ENGLAND

ARCHITECT: HERBERT FOWLER

LENGTH: 395 YARDS · PAR 4

The final three holes at Walton Heath often get the most publicity, especially since they played key roles in the 1981 Ryder Cup matches. But the outward nine at Walton Heath is special in its own right, and the fifth is the best of the bunch. Thick heather envelops the fairway, and the green is enhanced by brilliant contouring and two well-placed bunkers.

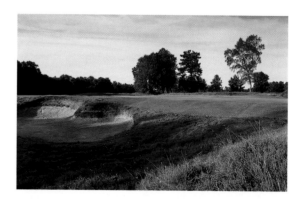

Wentworth Golf Club (West) ✦ 3

LOCATION: VIRGINIA WATER, SURREY, ENGLAND
ARCHITECTS: H. S. COLT/CHARLES ALISON
LENGTH: 452 YARDS · PAR 4

Recent softening of this hole's three-tiered green has been met with sighs of relief from players—instead of hoping for only a three-putt, they now have a fighting chance to get down in two! That is, if they have enough mental energy left once on the green. This hole would look at home as an eighteenth on a U.S. Open course—long and uphill, and more of a survival test than a reasonable chance at birdie.

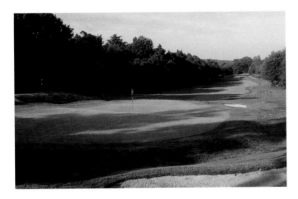

PAR 5

Alwoodley Golf Club ✦ 3

LOCATION: LEEDS, ENGLAND
ARCHITECTS: H. S. COLT, ALISTER MACKENZIE
LENGTH: 510 YARDS · PAR 5

At Alwoodley's third, it is the near absence of hazards that is disorienting to the player. The hole's one and only bunker 213 yards from the tee adds definition and depth to the landing area, as do the long-grass rough to the left and the heather along the right. • This hole is showcased on pages 206–207.

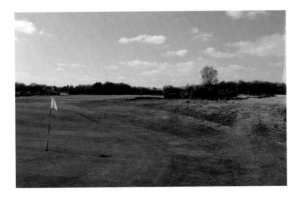

Carnoustie Golf Links (Championship) ✦ 6

LOCATION: CARNOUSTIE, ANGUS, SCOTLAND
ARCHITECTS: ALLAN ROBERTSON, WILLIE PARK, JR., JAMES BRAID
LENGTH: 578 YARDS · PAR 5

Carnoustie's strategic gem is the sixth, appropriately called "Long." The view from the tee is rather flat and featureless, but staring players in the face are a pair of cavernous bunkers, with a third lurking along the right side of the fairway. Golfers can fly the central bunkers to the safety of the fairway, tack safely to the right, or, like Ben Hogan in the 1953 British Open, flirt with out of bounds in hopes of finding the slim Elysian Fields on the left. • This hole is showcased on pages 66–69.

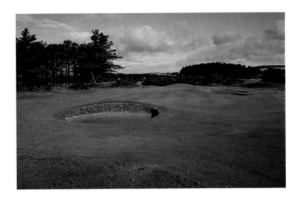

The European Club ✦ 13

LOCATION: BRITTAS BAY, COUNTY WICKLOW, IRELAND
ARCHITECT: PAT RUDDY
LENGTH: 596 YARDS · PAR 5

The thirteenth is one of the many great links holes that defies the notion of a hole having a "good place to miss it." On the left side are four menacing bunkers; on the right is the churning Irish Sea. Basically, you don't want to miss a shot at all on this hole. As the course's architect has been known to say, "Talk about being between the devil and the deep blue sea!"

Gullane Golf Club (No. 1) ✦ 3

LOCATION: GULLANE, EAST LOTHIAN, SCOTLAND
ARCHITECT: WILLIE PARK, JR.
LENGTH: 496 YARDS · PAR 5

Playing the first few holes at Gullane involves a huge amount of anticipation about reaching the top of Gullane Hill, with its tremendous view of the Firth of Forth. But along the way there are a few distinctive holes that should not be overlooked, the third in particular. A dozen bunkers dot the narrow fairway from tee to green, while the flatness of the terrain gives the hole its name: "Racecourse."

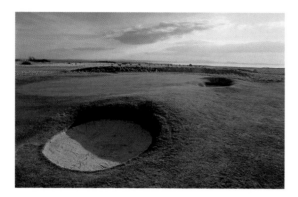

Hillside Golf Club ✦ 11

LOCATION: HILLSIDE, LANCASHIRE, ENGLAND
ARCHITECT: F. W. HAWTREE
LENGTH: 514 YARDS · PAR 5

For many years, Hillside paled in comparison with its more respected neighbors, Royal Birkdale and Southport & Ainsdale. But in the last thirty years, it has deservedly reaped its share of praise. The back nine was completely redesigned in 1967, and the eleventh hole was routed over the club's finest property. Gorse-covered dunes surround the tumbling, dogleg-left fairway, resulting in as fine a links experience as northwest England can offer.

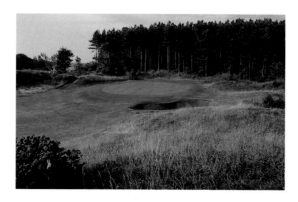

Loch Lomond Golf Club ✦ 6

LOCATION: LUSS, DUMBARTONSHIRE, SCOTLAND
ARCHITECTS: TOM WEISKOPF/JAY MORRISH
LENGTH: 625 YARDS · PAR 5

Loch Ness may have a monster in its waters, but Loch Lomond boasts a monster of its own—the longest hole in Scotland. Stretching along the shores of the namesake loch, the sixth forms the most splendid inland golf setting in Great Britain. The high peak of Ben Lomond rises to the north, while the gaping fairway bunker affects strategy for the second shot. Two mature trees frame the right-hand entrance to the raised green.

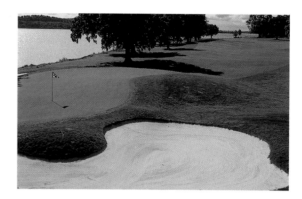

Muirfield (Honourable Company of Edinburgh Golfers) ✦ 9

LOCATION: GULLANE, EAST LOTHIAN, SCOTLAND
ARCHITECTS: OLD TOM MORRIS, H. S. COLT/TOM SIMPSON
LENGTH: 504 YARDS · PAR 5

This is one of the toughest tests on one of the great layouts. The fairway narrows sharply, hemmed in by long rough and, on the left, two bunkers and an out-of-bounds wall. Into the wind, the extra effort required often sends the ball hooking over the wall; downwind, the shrinking fairway takes its toll. Bunkers right and short of the green demand a strong approach, but too much sends the ball over the wall. • This hole is showcased on pages 230–231.

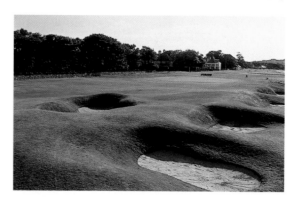

North Berwick Golf Links (West) ✦ 9

LOCATION: NORTH BERWICK, EAST LOTHIAN, SCOTLAND

ARCHITECT: DAVID STRATH

LENGTH: 510 YARDS · PAR 5

North Berwick is synonymous with the famous Redan hole, but the ninth actually presents the most demanding tee shot on the layout. An out-of-bounds wall bordering the left side of this dogleg-left fairway discourages trying to cut too much off of the corner. Some players balk at this and other quirks in the layout, but without them the course would lose much of its charm and unpredictability.

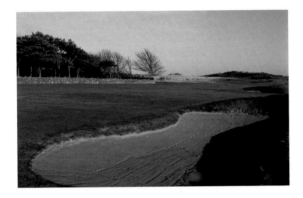

Old Head Golf Links ✦ 17

LOCATION: KINSALE, COUNTY CORK, IRELAND

ARCHITECTS: PADDY MERRIGAN, LIAM HIGGINS, JOE CARR

LENGTH: 628 YARDS · PAR 5

The majestic lighthouse in the background has seen plenty of crashes and burns in its 147 years (including the sinking of the *Lusitania,* which happened just a few miles offshore). But few of them compare with the sight of foursome after foursome trying desperately to keep their games together on this dramatic par 5. The fairway drops off at about 175 yards from the green, revealing a harrowing greensite guarded by bunkers and clinging to a two-hundred-foot-high cliffside.

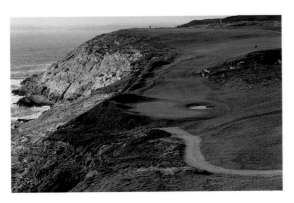

The Oxfordshire Golf Club ✦ 17

LOCATION: MILTON COMMON, OXFORDSHIRE, ENGLAND

ARCHITECT: REES JONES

LENGTH: 585 YARDS · PAR 5

The ingenious seventeenth presents golfers with three options, all visible from the elevated tee. Past the landing area, the fairway forms a wishbone, separated by a lake. A second shot to the right is safer, but will result in the longest approach to the green. Laying up to the left requires carrying the lake, as does going for the green in two, which Colin Montgomerie did on his way to birdie and victory in the 1999 Benson and Hedges. During the windswept 1996 event, every score from 3 to 13 was recorded on this hole—a professional record.

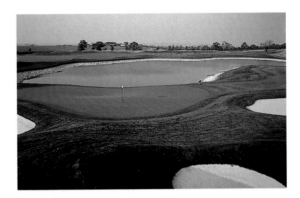

Prestwick Golf Club (Old) ✦ 3

LOCATION: PRESTWICK, AYRSHIRE, SCOTLAND

ARCHITECT: OLD TOM MORRIS

LENGTH: 482 YARDS · PAR 5

"The Cardinal" hole was only 436 yards in 1887, stretched to 505 for the 1987 British Amateur, but plays today at 482. They finally got it just right. With the Cardinal bunker looming in the distance, this hole does not need extra length to be a challenge. It's no wonder that, according to the club's records, no one has holed out for a double eagle in the long, long history of this hole.

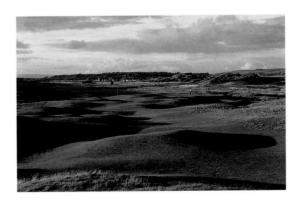

Royal Birkdale Golf Club ✦ 15

LOCATION: SOUTHPORT, MERSEYSIDE, ENGLAND

ARCHITECTS: GEORGE LOWE, F. W. HAWTREE/J. H. TAYLOR

LENGTH: 543 YARDS · PAR 5

Though history will show that Mark O'Meara won the 1998 British Open after a four-hole playoff with Brian Watts, in reality the victory was assured after this, the first playoff hole and the finest par 5 on the course. Both players hit superb third shots to the green, and it was O'Meara's turn to putt first. He made his 6-footer, while Watts missed, setting the tone for a playoff in which O'Meara calmly parred out to clinch victory.

Royal Liverpool Golf Club (Hoylake) ✦ 8

LOCATION: HOYLAKE, CHESHIRE, ENGLAND

ARCHITECTS: ROBERT CHAMBERS, JR., GEORGE MORRIS

LENGTH: 519 YARDS · PAR 5

Looking at the green at Hoylake's eighth, one can only wonder how he did it. How did Bobby Jones, who would go on to win the 1930 British Open for the second leg of the Grand Slam, take 5 strokes to get down from the fringe of the innocent-looking green in the final round? A rare case of nerves turned an easy birdie into a 7, and as he explained later, it happened "in the most reasonable manner possible."

Royal St. George's Golf Club ✦ 14

LOCATION: SANDWICH, KENT, ENGLAND

ARCHITECTS: DR. LAIDLAW PURVES, ALISTER MACKENZIE,
J.J.F. PENNINK

LENGTH: 508 YARDS · PAR 5

Named "the Suez Canal" for the troublesome burn crossing the fairway, the fourteenth presents one of the most intimidating tee shots on the course. Peter Jacobsen felt its wrath in the first round of the 1985 British Open, when he hooked his first drive and lost it in the dunes, then hit his second drive out of bounds to the right. He quipped afterward, "I never thought I'd be hitting my third tee shot on this hole until Saturday."

Royal Troon Golf Club (Old) ✦ 6

LOCATION: TROON, AYRSHIRE, SCOTLAND

ARCHITECTS: WILLIE FERNIE, JAMES BRAID

LENGTH: 577 YARDS · PAR 5

This was the longest hole in British Open championship golf until Carnoustie lengthened its sixth hole for the 1999 Open. It has actually been made harder in recent decades, with the green moved closer to the ocean dunes. If you ask Bobby Clampett, however, it was hard enough before. Cruising with a 7-stroke lead in the third round of the 1982 British Open, he shot into the bunker short and left of the green, en route to a triple-bogey 8. He hit into it again in the final round.

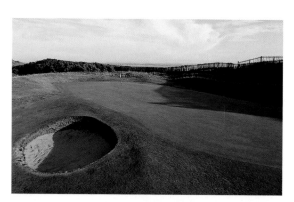

St. Andrews (Old) ✦ 14

LOCATION: ST. ANDREWS, FIFE, SCOTLAND
ARCHITECT: UNKNOWN
LENGTH: 567 YARDS · PAR 5

Jack Nicklaus can say he experienced the worst of hell, and lived to tell about it. During the first round of the 1995 British Open, Nicklaus hit his second shot into the infamous "Hell Bunker," which sits about 410 yards from the fourteenth tee. He took 4 shots to get out, en route to a 10. It's just one of the several incomparable features of this fearsome hole, which requires a well-placed drive in the vast Elysian Fields to have a chance for par.

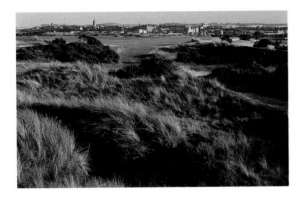

St. Enodoc Golf Club (Church) ✦ 16

LOCATION: ROCK, CORNWALL, ENGLAND
ARCHITECT: JAMES BRAID
LENGTH: 487 YARDS · PAR 5

Bernard Darwin once wrote of St. Enodoc, "I was not prepared for such mighty hills nor for quite so many of them." They are one of the many draws of this lovely spot, another of which is a scenic sixteenth hole, which begins an imposing finishing stretch. From the tee, the hole extends majestically through the dunes, while the waters of the Camel Estuary lie to the right.

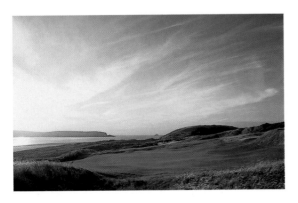

Southport & Ainsdale Golf Club ✦ 16

LOCATION: SOUTHPORT, MERSEYSIDE, ENGLAND
ARCHITECT: JAMES BRAID
LENGTH: 510 YARDS · PAR 5

Called "Grumbley's," Southport & Ainsdale's sixteenth contains as fine an example of a sleeper bunker as one could hope to find. The hole plays 510 yards directly into the prevailing winds, and the drive must be hit on a line between the tight fairway bunkers. • This hole is showcased on pages 238–239.

Waterville Golf Links ✦ 11

LOCATION: WATERVILLE, COUNTY KERRY, IRELAND
ARCHITECT: EDDIE HACKETT
LENGTH: 496 YARDS · PAR 5

It's been said that for nearly one hundred years before the current Waterville course was built in 1973, local laborers found natural holes to play among the dunes. If that is true, then it's very possible they were playing on the same ground the eleventh occupies today. The fairway hems and haws through stunning dunesland, and when the late-day shadows are just right, it feels about as close to heaven as golf gets.

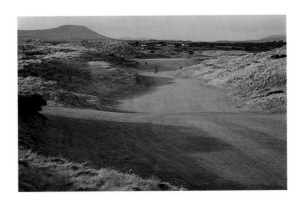

Wentworth Golf Club (West) ✦ 17

LOCATION: VIRGINIA WATER, SURREY, ENGLAND

ARCHITECTS: H. S. COLT/CHARLES ALISON

LENGTH: 571 YARDS · PAR 5

Wentworth's seventeenth is bordered on both sides by tall trees, often swept away by mist and fog, and offers a rough, natural sensation—in the midst of London's bustling outskirts. This par 5 has no bunkers, but definition is provided by trees and the bunkerlike undulations cut at the rear of the green.
• This hole is showcased on pages 246-247.

Western Gailes Golf Club ✦ 14

LOCATION: GAILES, AYRSHIRE, SCOTLAND

ARCHITECTS: WILLIE PARK, F. W. HAWTREE

LENGTH: 562 YARDS · PAR 5

Western Gailes was laid out on a narrow stretch of dunesland squeezed between the Ayrshire railway and the sea. After the last of the seaside holes, the fourteenth marks the inland return to the clubhouse, with commuter trains often whizzing by to the right. Often played downwind, it provides a big temptation for big hitters, but ten bunkers spread out through the final third of the hole's length often encourage a more prudent play.

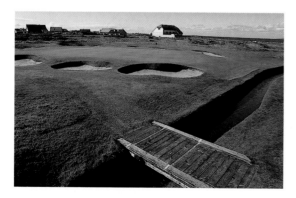

Worplesdon Golf Club ✦ 11

LOCATION: WOKING, SURREY, ENGLAND

ARCHITECTS: J. F. ABERCROMBY, WILLIE PARK, JR., H. S. COLT

LENGTH: 520 YARDS · PAR 5

Surrounded by brilliant heathland, this interesting hole has seen its challenges change with the times, but its supreme strategic character remains. A large bunker on the right can be carried by today's long hitters, but still comes into play for everyone else. A second large bunker sits near the lay-up area, and the fairway dips into a valley between the two. This often results in a downhill lie, giving pause to those trying to drive the green in two. The green, angled back from the fairway to the left, is guarded by three additional bunkers.

CONTINENTAL EUROPE

Golf's growth in continental Europe during the last thirty years has been remarkable. It used to be that the British Isles were the only true golf destination in Europe, but not anymore. The Costa del Sol in Spain and the Algarve in Portugal attract a steady flow of northern European "snowbirds" during the winter months, while France, Switzerland, and northern Italy are summertime golf hot spots.

The European PGA Tour has taken notice of the increased interest in golf: Tour events now are held in ten European countries, including the Czech Republic. They are played on courses young and old, reflecting Europe's unique balance of history and progress. While names such as Henry Cotton, H. S. Colt, and Javier Arana are associated with a few of the earlier courses, some of the game's best current designers are also eager to meet the demand, building high-quality courses to test the pros.

A healthy portion of such pros are natives of Sweden, most notably Annika Sørenstam, Jesper Parnevik, Gabriel Hjertstedt, and Liselotte Neumann. The country's golf image is disproportionately large considering its population of 8.8 million, and its many fine courses contribute nine holes to the world five hundred.

PAR 3

El Saler Golf Club ✦ 17
LOCATION: OLIVIA, VALENCIA, SPAIN
ARCHITECT: JAVIER ARANA
LENGTH: 215 YARDS · PAR 3

Take away the tropical sunshine and breezes, the beachfront skyscrapers rising in the distance, and the Spanish-speaking caddies, and this hole would blend in perfectly on a rugged Scottish links. Native sand dunes and steep-faced bunkers form a ring around a large, subtly sloping green that demands a precise tee shot. The crashing waves of the Mediterranean provide an ideal background.

Falsterbo Golf Club ✦ 11
LOCATION: FYRVÄGEN, FALSTERBO, SWEDEN
ARCHITECT: GUNNER BAUER
LENGTH: 160 YARDS · PAR 3

On a course set on a peninsula, it could be said that the eleventh hole is a microcosm of Falsterbo. The oval-shaped green complex is surrounded on three sides not by the Baltic Sea, but by one of the several lakes that dot the otherwise linksland property. Though the hole is short, it is certainly the most dramatic on the course, where the chances for par or double bogey are about equal.

Gardagolf Country Club ✦ 2

LOCATION: SOIANO DEL LAGO, LOMBARDIA, ITALY

ARCHITECT: DONALD STEEL

LENGTH: 159 YARDS · PAR 3

Especially coming so early in the round, this hole is an obstacle that must be reckoned with rather than attacked. Though it lacks the front and rear bunkers of its architectural inspiration, the twelfth at Augusta National, the greensite's position is nonetheless precarious. A slippery front bank normally spells watery doom for shots coming up short, while the rear hillside is a tricky place from which to chip. The green, shaped like a kidney bean, is shallow and slopes quickly down toward the creek.

Gut Laerchenhof Golf Club ✦ 8

LOCATION: PULHEIM, NORTH RHINE-WESTPHALIA, GERMANY

ARCHITECT: JACK NICKLAUS

LENGTH: 241 YARDS · PAR 3

One of the longest par 3s in professional golf played to a 3.08 scoring average during the 1998 Linde German Masters, and was a momentum-stopper for players who had gotten off to fast starts. Its green is relatively small, and very difficult to hold. The prevailing wind out of the right makes soft-landing fades tough to play. There's not much trouble around the green, but a large bunker 15 yards in front catches many shots that come up short.

Halmstad Golf Club (North) ✦ 16

LOCATION: HALMSTAD, SWEDEN

ARCHITECT: RAFAEL SUNDBLOM

LENGTH: 180 YARDS · PAR 3

This is the spot where good rounds on the North Course are most likely to come apart. The most feared hole at Halmstad, the sixteenth is aptly named "the Brook." A serpentine creek winds its way from the tee all the way up the right side of the green, which is angled and guarded by two bunkers. A prevailing sea breeze from the left carries all but the straight and true tee shots into the water.

Hubbelrath Golf Club (East) ✦ 7

LOCATION: DÜSSELDORF, NORTH RHINE-WESTPHALIA, GERMANY

ARCHITECT: BERNHARD VON LIMBURGER

LENGTH: 175 YARDS · PAR 3

After Vijay Singh torched the Hubbelrath layout during the 1992 German Open, setting a tournament record of 26-under-par 262, modifications were made to the course in the interest of toughening it up. The seventh, however, didn't need any alterations. The hole was carved out of thick forest, which encroaches closely on the left side. The tee shot must carry a pond, and the green is obscured by two front bunkers and thick vegetation.

Las Brisas Golf Club ✦ 11

LOCATION: MÁLAGA, SPAIN

ARCHITECT: ROBERT TRENT JONES, SR.

LENGTH: 210 YARDS · PAR 3

The majestic peak of La Concha towers over the course, and playing down its lower slopes is this sumptuously situated one-shotter. The tee box is encased by trees, sheltering players from the tricky valley wind. The broad stream that weaves through four other holes sits to the left of the green, and sneaks up in front to catch weak tee shots. Two deep bunkers also guard the front of the green, whose surface slopes away from the tee.

Moliets Golf Club ✦ 16

LOCATION: MOLIETS, FRANCE

ARCHITECT: ROBERT TRENT JONES, SR.

LENGTH: 146 YARDS · PAR 3

Representing the transition between the oceanside dunes to the more secluded holes within the Les Landes forest, this uphill par 3 plays much tougher than it appears. Winds that often swirl and gust wreak havoc with club selection, and this is not the type of green where a mis-clubbed shot will be generously forgiven. The surface is shallow and firm, and flanked by two long bunkers. Unyielding gorse grows behind, ensuring that long approaches may never be found, or, if found, not be hit without taking a drop.

Neguri Golf Club ✦ 14

LOCATION: ALGORTA, SPAIN

ARCHITECT: JAVIER ARANA

LENGTH: 211 YARDS · PAR 3

Fanning out across tree-lined clifftops overlooking the Bay of Biscay, this difficult par 3 is subject to the coastline's mutable winds, mist, and fog. Arana kept things simple in response to these conditions—the uphill hole is guarded by only one bunker. Its placement, however, is overpowering: a soaring face of sand sitting front and center before the crowned green. Standing on the tee, players see only a small sliver of green and land that drops off on three sides. It's enough to make them wish for the fog to come rolling back in.

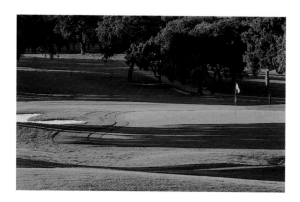

Örebrö Golf Club ✦ 3

LOCATION: ÖREBRÖ, VINTROSA, SWEDEN

ARCHITECT: NILS SKÖLD

LENGTH: 171 YARDS · PAR 3

Örebrö's waterways were once the exclusive domain of beavers, who concentrated much of their activity near this green. Aptly named "the Beaver" hole, the third requires the tee shot to carry two water hazards en route to the green—a pond just beyond the tee, and a snaking river that winds in front, to the left, and behind the green. Two large bunkers penalize shots flying over the green. In a 1969 tournament, Jack Nicklaus hit his tee shot stiff to the hole here, en route to equaling the course record.

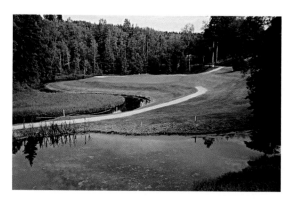

Penina Golf Club ✦ 13

LOCATION: PORTIMÃO, ALGARVE, PORTUGAL

ARCHITECT: HENRY COTTON

LENGTH: 229 YARDS · PAR 3

Henry Cotton is credited with starting the golf boom in the Algarve with his 1966 design of Penina, and the visionary's favorite hole was this one. The diagonal tee means the farther back one begins, the more water needs to be carried. Cotton used to take pleasure in manufacturing tee shots of different shapes with his driver, showing guests the various ways to hit the green.

Racing Club de France (La Vallée) ✦ 10

LOCATION: LA BOULIE, VERSAILLES, FRANCE

ARCHITECTS: WILFRID REID, SEYMOUR DUNN, WILLIE PARK, JR.

LENGTH: 213 YARDS · PAR 3

The gorgeous countryside of the French Racing Club near Versailles provides a splendid palette for this artistic hole. From a tee that sits nearly thirty feet above the green, the player is able to see a nearly uninterrupted forest of pine and oak trees, along with the large but well-guarded target. A phalanx of bunkers, their edges flowing upward to the fringe, surround the green almost completely. The slick putting surface slopes from back to front, ringed by fringe and rough reminiscent of U.S. Open courses.

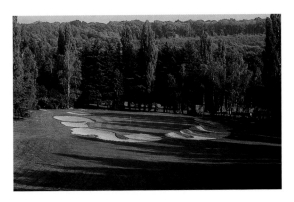

Töreboda Golf Club ✦ 10

LOCATION: TÖREBODA, SWEDEN

ARCHITECTS: THE CLUB MEMBERS

LENGTH: 132 YARDS · PAR 3

A short but tricky hole, especially since the short-iron tee shots are so vulnerable to the wind. The green is set on a peninsula sloping on all sides toward Månsarudssjön, the lake that comes into play on seven other holes at Töreboda. Club selection is crucial, as shots coming up short will either find the lake or the wide, shallow bunker fronting the green, while a thicket of trees stands behind. The horseshoe-shaped green offers many possibilities for tough pin placements.

Ullna Golf Club ✦ 3

LOCATION: ROSENKÄLLE, ÅKERSBERGA, SWEDEN

ARCHITECT: SVEN TUMBA

LENGTH: 160 YARDS · PAR 3

The Swedish architect of this course took a page out of Pete Dye's book, creating a stadium-style course that would provide good viewing and drama for spectators of the Scandinavian Enterprise Open. So it's no surprise that he also replicated Dye's most famous hole, making Ullna's third hole an island-green par 3 where the only two options are hitting the green or splashing your ball into scenic Ullna Lake.

Valderrama Golf Club ✦ 15

LOCATION: CÁDIZ, SPAIN

ARCHITECT: ROBERT TRENT JONES, SR.

LENGTH: 225 YARDS · PAR 3

Encroaching cork trees from the right, along with three well-placed bunkers around the green, put a premium on accuracy. The hole drops about seventy feet from tee to green, playing shorter but also susceptible to the area's gusty winds. During singles play at the 1997 Ryder Cup matches, with Nick Faldo's tee shot 3 feet from the cup, Jim Furyk holed out from a greenside bunker for a halve, then won the match on the next hole.

Vale do Lobo Golf Club (Yellow) ✦ 7

LOCATION: ALMANSIL, ALGARVE, PORTUGAL

ARCHITECT: HENRY COTTON

LENGTH: 196 YARDS · PAR 3

In all the world of golf, there is nothing like what lies before you on the seaside tee of the seventh. Serenely, the vast Atlantic washes onto the beach far below while the quiet violence of its erosive power blares from the vast cliff faces before you. A necklace of hazard stakes running the length of the hole is a reminder that, although on the tee, you are in effect in the hazard. • This hole is showcased on pages 120–121.

Aloha Golf Club ✦ 2

LOCATION: MARBELLA, SPAIN

ARCHITECT: JAVIER ARANA

LENGTH: 364 YARDS · PAR 4

The second is both a cerebral and physical challenge, as the view from the elevated tee shows a gently sloping fairway from left to right feeding down to a pond. The tendency is to err on the left side, but a cluster of thick trees blocks the path to the green if the tee shot strays too far.

Barsebacks Golf and Country Club (New) ✦ 17

LOCATION: LANDSKRONA, SWEDEN

ARCHITECTS: TURE BRUCE, DONALD STEEL

LENGTH: 440 YARDS · PAR 4

After a redesign by British architect Donald Steel was completed in 1989, this became the best hole on arguably the best course in Sweden. It is carved through forest, but the wind blowing off the Øresund (the body of water separating Sweden and Denmark) definitely has an effect, often making the green virtually unreachable in two shots. A large bunker to the left of the 58-yard-deep green adds to the challenge, and the hole ranked fourth in difficulty during the 1997 Volvo Scandinavian Masters.

Castelconturbia Golf Club (Yellow) ✦ 7

LOCATION: AGRATE, CONTURBIA, ITALY

ARCHITECT: ROBERT TRENT JONES, SR.

LENGTH: 383 YARDS · PAR 4

The welcoming, generous landing area on this dogleg-left is balanced by the demands of the approach shot. The island green, though wide, is fairly shallow, meaning a mistake in club selection has players staring double bogey in the face. When the course hosts the Italian Open, this hole is played as the sixteenth, increasing the chances for late-round heroics. Ian Woosnam hit a stellar approach in the 1991 event, but missed the 4-foot birdie try, while Craig Parry converted his birdie effort on his way to a 1-stroke victory.

Castelgandolfo Country Club ✦ 4

LOCATION: CASTELGANDOLFO, LAZIO, ITALY

ARCHITECT: ROBERT TRENT JONES, SR.

LENGTH: 411 YARDS · PAR 4

Warming up before a round at Castelgandolfo is always a good idea, as the hardest hole on the course comes early. The fourth starts off with a gradually narrowing landing strip, punctuated by three trees on the left. Water begins to creep in on the right, then farther up on the left, until the final 165 yards—bounded by two lakes—becomes a skinny peninsula in the shape of a reverse C. The shallow green, situated at the very tip of the peninsula, is guarded front and left by bunkers.

Club zur Vahr (Garlstedter Heide) ✦ 16

LOCATION: BREMEN, LOWER SAXONY, GERMANY

ARCHITECTS: AUGUST WEYHAUSEN, BERNHARD VON LIMBURGER

LENGTH: 434 YARDS · PAR 4

This course made quite a splash just a year after it opened, hosting the 1971 German Open and attracting players from twenty-three countries. The sixteenth hole is a fine example of the difficult driving conditions on the course. There are no bunkers to deal with, but a large tree blocks the right side of the fairway, meaning a fade off the tee is necessary to have the preferred angle into the green. Miss it left and it's an awkward approach.

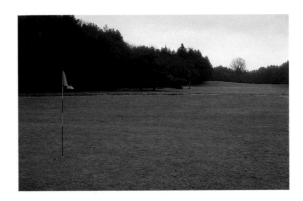

Crans-sur-Sierre Golf Club ✦ 7

LOCATION: CRANS-SUR-SIERRE, SWITZERLAND

ARCHITECT: SIR ARNOLD LUNN

LENGTH: 302 YARDS · PAR 4

The soaring peaks of the Swiss Alps provide a postcard setting for this exciting, if short, par 4 that plays among the easiest holes during the annual European Masters. However, while the hole is susceptible to birdies and eagles, they don't come without risk. The last 75 yards of the hole are uphill, and this section is peppered with five bunkers. In addition, players trying to drive the green often have to watch their balls roll down an embankment on the sides and rear of the green covered not with edelweiss, but knee-high rough.

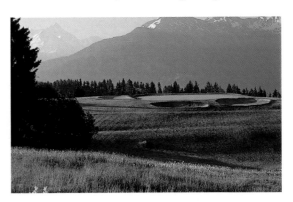

Dinard Golf Club ✦ 6

LOCATION: SAINT-BRIAC-SUR-MER, FRANCE

ARCHITECTS: TOM DUNN, WILLIE PARK, JR.

LENGTH: 349 YARDS · PAR 4

Englishman Dunn laid out this seaside beauty in 1887, well before earth-moving equipment was available. The hole's undulations are wild and untamed, as nature intended. The narrow fairway is the midpoint of a three-step elevation change, sweeping down to the ocean on the right. Mounds up to twenty feet tall can create some interesting stances for the approach, which is played to a steep-faced green surrounded by swales and native rough.

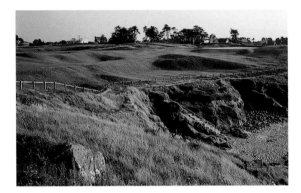

Frankfurter Golf Club ✦ 18

LOCATION: FRANKFURT, HESSEN, GERMANY

ARCHITECTS: H. S. COLT, CHARLES ALISON, J.S.F. MORRISON

LENGTH: 432 YARDS · PAR 4

The eighteenth might look innocuous, but its defenses are very much intact. From the tee, the landing area is fairly generous. It's the next shot that has shattered many a player's dream of winning the German Open. The traditional Sunday pin placement is cut close behind a deep front bunker, with the green sloping severely from back to front. There's little room to leave a flat birdie putt, as Mark James discovered during the 1989 event. After hitting his approach 20 feet above the hole, he three-putted to lose in a playoff to Craig Parry.

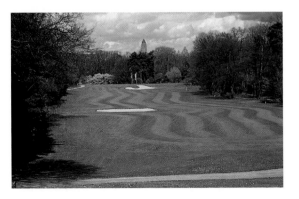

Frösakers Golf Club ✦ 18

LOCATION: FRÖSAKER, VÄSTERAS, SWEDEN

ARCHITECT: SUNE LINDE

LENGTH: 418 YARDS · PAR 4

The mantra for this hole is "Short out, long in; or long out, short in." It describes the choice posed to golfers—either take a long iron and lay up safely to the plateau on the right half of the fairway, leaving a longer shot to the green, or pull out driver and try to wing the ball down the hill, past the tree at the corner of the dogleg. The latter brings the water into play off the tee, but results in a shorter carry over the pond to the three-tiered green.

Golf Club del Sur (North) ✦ 3

LOCATION: TENERIFE, CANARY ISLANDS, SPAIN

ARCHITECT: JOSÉ "PEPE" GANCEDO

LENGTH: 457 YARDS · PAR 4

The barren ravine and lava wasteland to the right contrast starkly with this lush and long hole, which is a golf ball graveyard for slicers. It's a very thin line between safety and danger, especially when the wind blows across the open hillside. Palm trees dot the left boundary of the hole, but it's the surface beneath them that offers the true intimidation. Mean-looking, black sand bunkers surround the bases of the trees and extend up the entire left side of the deep, narrow green.

Kennemer Golf and Country Club ✦ 1

LOCATION: ZANDVOORT, HOLLAND

ARCHITECTS: H. S. COLT/J.S.F. MORRISON

LENGTH: 452 YARDS · PAR 4

English-born H. S. Colt brought his considerable architectural talent and love of links golf to Kennemer. Fairness is a big part of his philosophy, demonstrated on the first hole. Despite its ample length, this hole provides players a good opportunity for an early-round boost of confidence. The dunes lining the fairway slope gently toward its middle, but beware the second shot, as the green is surrounded by thick gorse bushes.

Le Golf National (Albatros) ✦ 15

LOCATION: GUYANCOURT, FRANCE

ARCHITECTS: ROBERT VON HAGGE/HUBERT CHESNEAU/
PIERRE THEVENIN

LENGTH: 423 YARDS · PAR 4

The dogleg-right fairway wraps around a lake from tee to green—drives to the left are safer, but result in a longer shot to the three-tiered peninsula green. During the 1994 World Amateur Team Championship, Scotland's Gordon Sherry took a cumulative 19 strokes on the hole over three days, while Englishman Martin Gates found the water in the final round of the 1997 Peugeot Open de France, en route to a bogey and a tie for third place.

Le Robinie Golf Club ✦ 4

LOCATION: OLONA, LOMBARDIA, ITALY

ARCHITECT: JACK NICKLAUS

LENGTH: 381 YARDS · PAR 4

As this hole suggests, the Golden Bear brought 1980s-style golf course architecture to the Lombardy countryside with Le Robinie. The mounded fairway slopes down to a retention pond, outlining a clear objective: Drive the ball as far as possible down the left side, thereby leaving a short iron into this shallow, plateau green. However, players whose approaches find their way into the multilevel bunker complex short and right of the green might be reaching for a glass of Chianti at the turn.

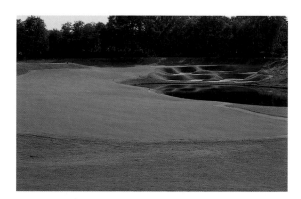

Morfontaine Golf Club ✦ 7

LOCATION: SENLIS, FRANCE

ARCHITECT: TOM SIMPSON

LENGTH: 430 YARDS / PAR 4

The terrain dictates the challenge on this hole, as boulder-strewn tall grass gives way to an uneven fairway lined by white birch trees. First up is a semi-blind tee shot, played over a rise that slopes from left to right. On a hole that doglegs left, this toughens the drive considerably, as drives are often kicked into the right rough. Though the green is large, its undulating surface leaves few safe places for an approach. A deep bunker guards the left side, and a false front sloping back to fairway must be carried.

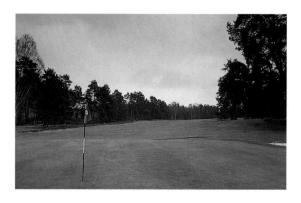

Noordwijkse Golf Club ✦ 8

LOCATION: NOORDWIJK, HOLLAND
ARCHITECT: J.J.F. PENNINK
LENGTH: 406 YARDS · PAR 4

After a five-hole stretch that winds through a lovely forest, the course emerges back into rugged dunesland at the eighth. For this reason alone, the hole often produces a feeling of excitement and anticipation among visitors, but there is more to it. The twisting, narrow fairway lined with blond heather grass is a feast for the eyes, while the greensite is enhanced by pot bunkers tucked into the dunes.

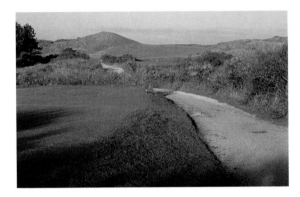

Royal Antwerp Golf Club ✦ 6

LOCATION: KAPELLENBOS, BELGIUM
ARCHITECT: TOM SIMPSON
LENGTH: 424 YARDS · PAR 4

On a former army training ground, Royal Antwerp's heavily wooded property does not boast any notable changes in elevation or much in the way of topography. But architect Tom Simpson used the trees to perfection in the creation of several fine dogleg fairways, including the sixth. The fairway forms an hourglass shape in the landing area, putting a premium on accuracy, not distance, off the tee.

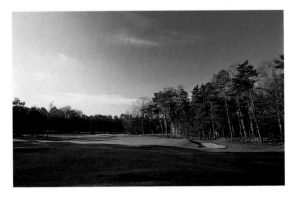

St. Eurach Golf Club ✦ 9

LOCATION: IFFELDORF, BAVARIA, GERMANY
ARCHITECT: DONALD HARRADINE
LENGTH: 390 YARDS · PAR 4

The ninth plays much tougher than the yardage suggests. In fact, it is used as the eighteenth hole when the course hosts the European Tour's BMW Open, and has been the scene of several round-ending bogeys. The view of the Alps from the green is breathtaking, but getting to that scenic plateau first requires driving the ball on the left side of the fairway. If the ball does not land there, the approach will be stymied by the tall, overhanging trees on the right. The second shot is sharply uphill to a deep green, often requiring two extra clubs.

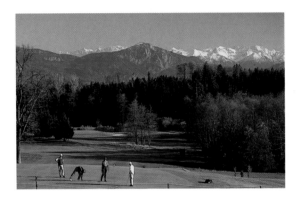

St. Germaine Golf Club ✦ 14

LOCATION: SAINT-GERMAIN-EN-LAYE, FRANCE
ARCHITECTS: H.S. COLT/CHARLES ALISON
LENGTH: 444 YARDS / PAR 4

Like many of the 1920s-era courses around Paris, Saint Germain's character reflects the many stages of its life. At this hole, despite decades of tree growth that now leave the hole a private wooded enclave, vestiges of a more open, linkslike design remain. Mounded, closely sculpted fairway bunkers that pinch the tee shot landing area are covered with fescuelike long grass, while the crowned green is bunkerless in front and therefore receptive to a variety of mid-trajectory approaches.

St. Leon-Rot Golf Club ✦ 9

LOCATION: ST. LEON-ROT, BADEN-WÜRTTEMBERG, GERMANY

ARCHITECT: HANNES SCHREINER

LENGTH: 400 YARDS · PAR 4

The view from this elevated tee is both intimidating and inspiring. Four bunkers down the right side affect all parts of the landing area, while a lake borders the left side from the tee to the peninsula green. The undulating green is also guarded by a deep bunker on the right, a scary place to be with the water lurking just off the putting surface. In the second round of the 1999 Deutsche Bank SAP Open, Tiger Woods rolled in a snaking, 20-foot birdie putt here to take a lead that he would never relinquish.

San Lorenzo Golf Club ✦ 6

LOCATION: ALMANSIL, ALGARVE, PORTUGAL

ARCHITECTS: JOE LEE, ROCKY ROQUEMORE

LENGTH: 424 YARDS · PAR 4

The placid waters of the Ria Formosa form the right-hand boundary for this dogleg-left beauty, which begins a string of three superb holes. A draw is the ideal shot off the tee, placing the ball between the river on the right and the tree line on the left. The narrow, slick green is precariously close to the river's edge, and defended by two bunkers. These factors are all complicated further by the wind, which often blows hard across the exposed greensite.

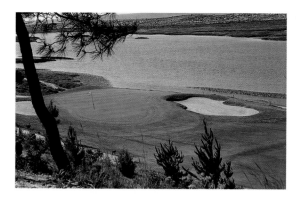

St. Nom La Bretèche Golf Club (Red) ✦ 6

LOCATION: ST. NOM LA BRETÈCHE, FRANCE

ARCHITECTS: F. W. HAWTREE, PIER MANCENELLI

LENGTH: 439 YARDS · PAR 4

European Tour officials reverse the two nines when the Trophée Lancôme is played here, making this hole part of a difficult stretch run. The key is to drive the ball into the right half of the fairway, avoiding both the bunker at the left corner and the bushy trees that extend all the way down to the green (it's possible to be on the left edge of the fairway and not see the pin). The greensite is a compendium of deep bunkers, pine trees, and deep rough, testing the short games of the world's best players.

Seignosse Golf Club ✦ 17

LOCATION: SEIGNOSSE, FRANCE

ARCHITECT: ROBERT VON HAGGE

LENGTH: 401 YARDS · PAR 4

This is the only par 4 on the course without a bunker, and it doesn't need one—the pond along the left side provides ample defense. Off the tee, the left side of the fairway is preferable, but placing a drive there is tougher due to the pond pinching the landing area. The long, narrow, kidney-shaped green is expertly situated along the banks of the pond, with trees overhanging on the right. It is most receptive to a draw on the approach, but draws that unexpectedly turn hooks will find a watery grave.

Sotogrande Golf Club (Old) ✦ 7

LOCATION: CÁDIZ, SPAIN
ARCHITECT: ROBERT TRENT JONES, SR.
LENGTH: 422 YARDS · PAR 4

Trent Jones did not mince words when preparing the plans for his first European design: "The players attack the course, and it's the architect's job to defend it." He could easily have been describing the seventh hole. The mid-iron second shot, played to a narrow green surrounded by four bunkers and sloping down to a small pond, has befuddled more than its fair share of players throughout the history of the Spanish Open.

Valderrama Golf Club ✦ 18

LOCATION: CÁDIZ, SPAIN
ARCHITECT: ROBERT TRENT JONES, SR.
LENGTH: 454 YARDS · PAR 4

One of the most claustrophobic tee boxes in golf sets the tone for this ultra-tight finisher. Players coming to the tee with less than full confidence in their swings will likely find the rough and the cork trees, and will find it nearly impossible to hit the green. This happened twice to Miguel Angel Martín in the 1999 American Express Championship; he bogeyed this hole in the final round of regulation and in the sudden-death playoff to lose to Tiger Woods.

Villa d'Este Golf Club ✦ 15

LOCATION: COMO, LOMBARDIA, ITALY
ARCHITECT: PETER GANNON
LENGTH: 454 YARDS · PAR 4

The only thing outwardly tricky about this hole is its considerable length. But after you watch your tee shot roll suspiciously to the left, it becomes clear what the next challenge is: an approach, often played with a long iron or fairway wood, that must be hit from a hook lie due to the leftward-sloping fairway. Not coincidentally, the trees and underbrush encroach closely on the left side of the green, which is also fronted by two deep bunkers.

PAR 5

Åtvidaberg Golf Club ✦ 11

LOCATION: ÅTVIDABERG, SWEDEN
ARCHITECT: DOUGLAS BRASIER
LENGTH: 517 YARDS · PAR 5

Water extends down the entire left side of "Long Lake," and surrounds the intimidating back tee box. Second shots that snuggle up close to the water on the left have the best angle to the three-tiered green, which is guarded by a front bunker, a large oak tree to the right, and water behind.

Barsebacks Golf & Country Club (Old) ✦ 12

LOCATION: LANDSKRONA, SWEDEN
ARCHITECT: TURE BRUCE
LENGTH: 561 YARDS · PAR 5

This windswept, linksland par 5 plays as the 465-yard, par-4 ninth during the Volvo Scandinavian Masters. Either in that form or as an everyday par 5, it forces players to pick their poison off the tee—to the left is the shoreline of Øresund, with Denmark visible across the water in the distance, and to the right are three fairway bunkers. The green is sheltered between two stands of trees, making back-right pin positions virtually inaccessible. Two bunkers, one on each side, guard the front half.

Chantilly Golf Club (Vineuil) ✦ 18

LOCATION: CHANTILLY, OISE, FRANCE
ARCHITECT: TOM SIMPSON
LENGTH: 596 YARDS · PAR 5

An attractive hole with a history of drama, the eighteenth is the most talked about championship finishing hole in continental Europe. Several times during the final round of the French Open, players have come to this tee needing to preserve their leads—not an easy task. In 1989, Nick Faldo arrived at 18 tied with three other players. The defending champion ground out a birdie, avoiding a playoff and claiming victory.

Domaine Imperial Golf Club ✦ 4

LOCATION: GLAND, SWITZERLAND
ARCHITECT: PETE DYE
LENGTH: 589 YARDS · PAR 5

Unlike Switzerland, its home country, this unyielding par 5 is anything but neutral, as it confronts golfers with a host of hazards. Having a shape similar to an hourglass, the hole's corner dogleg-right is its narrowest section, no more than 15 yards across. Out of bounds and a solitary bunker cut in closely on the left, while tall heather grass challenges on the right. The second shot must contend with a 80-yard-long bunker, which gives way to an assortment of smaller pot bunkers and dense trees that surround the green.

El Saler Golf Club ✦ 3

LOCATION: OLIVIA, VALENCIA, SPAIN
ARCHITECT: JAVIER ARANA
LENGTH: 543 YARDS · PAR 5

The sandy soil terrain characterizing El Saler is delightfully diverse, with both links and coastal forest features. This hole runs through dense woodlands, requiring accuracy and forethought if the long hitter is to attempt reaching the green in two. In order for it to happen, the drive must favor the left side, sneaking past the corner of the dogleg while avoiding the bunkers on the right. There is only a narrow avenue through which to reach the oblong green, which is guarded on both sides by bunkers.

Hamburger Golf Club (Falkenstein) ✦ 17

LOCATION: HAMBURG, GERMANY

ARCHITECTS: H. S. COLT, CHARLES ALISON, J.S.F. MORRISON

LENGTH: 480 YARDS · PAR 5

Heide is the German version of Scottish gorse, and its presence on this excit-ing hole creates some agonizing decision making. The bunker guarding the corner of this dogleg-left also marks the crest of a hill. Drives coming to rest here are only about 210 yards from the green, but a 100-yard-long field of heide must be carried to get there. It's either gamble and try for an eagle putt, or pull out the pitching wedge for an unsatisfying short lay-up.

Las Brisas Golf Club ✦ 8

LOCATION: MÁLAGA, SPAIN

ARCHITECT: ROBERT TRENT JONES, SR.

LENGTH: 507 YARDS · PAR 5

Players of varying abilities are tempted by the heroic opportunities at this hole, which can yield either an eagle putt or a quick-striking double bogey. The drive is played across a broad stream up the right side of the fairway. A strong tee shot brings a major decision: To try for the green, which sits allur-ingly back across the stream, behind a stand of trees, or play safely across the water and leave a short third. Either way, failure brings a long round of second-guessing. • This hole is showcased on pages 226–227.

Le Querce Golf Club ✦ 1

LOCATION: SAN MARTINO, LAZIO, ITALY

ARCHITECTS: GEORGE AND JIM FAZIO

LENGTH: 595 YARDS · PAR 5

Rambling across a scenic valley north of Rome, this hole provides a demand-ing start. A large bunker on the right side of the landing area can prevent tee shots from trundling into the woodlands, but it's just another reason to favor the more open left side. This is where it gets very interesting: The pond on the left and trees on the right make the lay-up shot a testy one, with slim mar-gin for error. Approaches missing the elevated green often roll down the shaved sides into any of three bunkers.

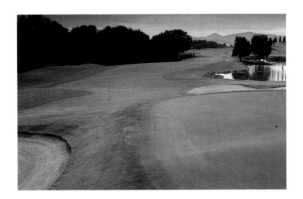

Los Naranjos Golf Club ✦ 18

LOCATION: MARBELLA, SPAIN

ARCHITECT: ROBERT TRENT JONES, SR.

LENGTH: 576 YARDS · PAR 5

Jones put only three bunkers on this exciting finishing hole, but their posi-tions ensure maximum impact on play. The first comes at the outside corner of the dogleg-left, encouraging long hitters to try cutting the corner with their tee shots. Some players may try to clear the twenty-foot-wide stream crossing the fairway about thirty yards short of the green; for those who lay up short, another large bunker guards the landing area, while the green is fronted by a third that all but eliminates going for most front pin positions.

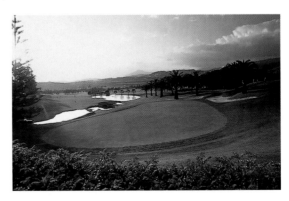

Penha Longa Golf Club ✦ 6

LOCATION: SINTRA, LISBOA, PORTUGAL
ARCHITECT: ROBERT TRENT JONES, JR.
LENGTH: 520 YARDS · PAR 5

The green of this stunning double-dogleg hole is reachable in two for longer hitters, but they'll have to contend with hazards both modern and ancient. After a well-placed drive that manages to avoid two bunkers at the corner of the dogleg, it's decision time. A long second shot to the green would have to carry a pond on the left, a series of four deep bunkers short, or the remains of a fourteenth-century stone aqueduct to the right.

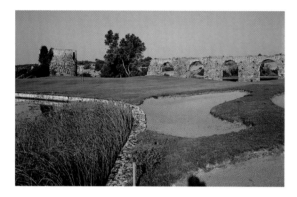

Pevero Golf Club ✦ 15

LOCATION: COSTA SMERALDA, SARDINIA, ITALY
ARCHITECT: ROBERT TRENT JONES, SR.
LENGTH: 480 YARDS · PAR 5

Though it's hard to concentrate on golf amid the postcard scenery, this hole demands attention. It's short but uphill, so few players try for the green in two. If they do, accuracy is a must, as the fairway is lined on both sides by impenetrable bushes and trees that seem to have been brought in on the last plane from Scotland. Another factor going against an aggressive play is the small, crowned green, which is not too accepting of longer shots and is buttressed by four bunkers.

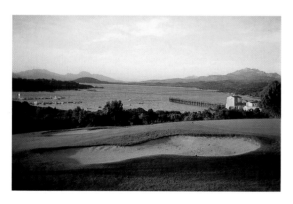

Pléneuf-Val-André Golf Club ✦ 11

LOCATION: PLÉNEUF-VAL-ANDRÉ, FRANCE
ARCHITECT: ALAIN PRAT
LENGTH: 535 YARDS · PAR 5

Tracing splendid coastal headlands, this hole offers a feast for the eyes. The tee boxes are staggered on a hillside encrusted with gorselike bushes. To the left is a lone tree and small stone house, followed by a long dune of mangled rough and sand that extends all the way to the green. The ocean and its influences—namely, the wind—are never far away. The straight, wide fairway offers a chance to get home in two, but the butterfly-shaped green is closely watched by three bunkers.

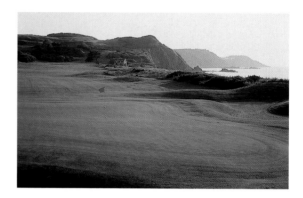

Quinta do Lago ✦ 17

LOCATION: ALMANSIL, ALGARVE, PORTUGAL
ARCHITECT: WILLIAM F. MITCHELL
LENGTH: 561 YARDS · PAR 5

Also known as the eighth hole on the "C" nine (the club's B/C rota forms the championship course), this beautiful par 5 offers a last look at the ocean before tackling the bruising par-4 eighteenth. The serenity may be short-lived, however, as the prevailing wind and uphill terrain conspire to make this seem like a par 6. There isn't much trouble until the greensite, which sits on a promontory and features a narrow, slick putting surface flanked by two bunkers. A tip to remember: All putts break toward the Strait of Gibraltar.

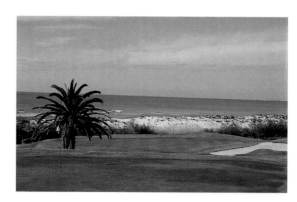

Sotogrande Golf Club (Old) ✦ 12

LOCATION: CÁDIZ, SPAIN

ARCHITECT: ROBERT TRENT JONES, SR.

LENGTH: 582 YARDS · PAR 5

With its ample water supply and healthy turf, Sotogrande was a perfect laboratory for Trent Jones's early experiments with water hazards. He routed the twelfth hole with a lake down the right side, and the angled green is set to the right of the fairway, with a narrow inlet of water just short. Anyone going for it in two will have plenty to think about, while even those who lay up will face a tricky third shot.

Sperone Golf Club ✦ 16

LOCATION: BONIFACIO, CORSICA, FRANCE

ARCHITECT: ROBERT TRENT JONES, SR.

LENGTH: 580 YARDS · PAR 5

At the southern tip of Corsica, Sperone overlooks the Strait of Bonifacio. Its sixteenth is bordered by the sea and one-hundred-foot cliffs for the entirety of its left side. Jones has often stated that every hole should be a hard par but an easy bogey. Such is the case at Sperone's sixteenth. • This hole is showcased on pages 240–241.

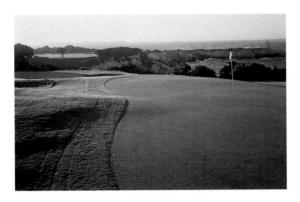

Sporting Club Berlin (Faldo) ✦ 11

LOCATION: BAD SAAROW, BRANDENBURG, GERMANY

ARCHITECT: NICK FALDO

LENGTH: 538 YARDS · PAR 5

This design brings a taste of Faldo's native soil to the central German countryside. Looking out from the tee at the fearsome gauntlet of deep, stacked-sod bunkers running all the way to the green, players can easily transport themselves to just about any British links. Wispy, knee-length heather grass lining the hole sharpens the picture. It is completed upon reaching the large, undulating green, where the solitary sand pit guarding the front-right side must be carried to fire at certain pin positions.

Valderrama Golf Club ✦ 4

LOCATION: CÁDIZ, SPAIN

ARCHITECT: ROBERT TRENT JONES, SR.

LENGTH: 535 YARDS · PAR 5

This relatively new course has hosted many important events—most notably the 1997 Ryder Cup matches—and this hole has always held its own. The tee is elevated, making the golfer see the risk and reward options ahead. The landing area is wide open, but any chance for birdie demands a shot along the left side, close to bunkers. The long, two-tiered green has water right and back, with sand on the left. There is little room to run a shot in, so this is almost always a three-shot hole. • This hole is showcased on pages 244–245.

AFRICA
AND SOUTH AFRICA

In Africa, the game's presence stretches from northern Morocco to Zimbabwe and South Africa, the last two boasting the continent's highest concentration of heralded courses. Not surprisingly, this wealth of superb golf in often spectacular settings has produced its share of star players, among them Gary Player and Ernie Els from South Africa, and Nick Price from Zimbabwe (formerly Rhodesia).

A handful of the region's most revered layouts are the arenas for several high-profile professional events, including the 2002 Presidents Cup, the World Cup of Golf, and the Sun City Million Dollar Challenge. Rugged coastlines and lush, mountainous regions offer superior scenery, and yet another frontier for the traveling golfer to explore.

Golf in Africa's northern reaches is mostly limited to Morocco and Tunisia in the west, and Egypt in the east. Of these, only Morocco's Royal Dar-es-Salaam ranks as a world-class facility.

PAR 3

Durban Country Club ✦ 2
LOCATION: DURBAN, NATAL, SOUTH AFRICA
ARCHITECTS: GEORGE WATERMAN/LAURIE WATERS
LENGTH: 188 YARDS · PAR 3

The Indian Ocean coastline, just two hundred yards away from this tricky par 3, has a large hand in what happens here. The hole was expertly crafted across two separate ridges making up the property's highest point, and the correct club for the tee shot is highly dependent on the varying wind conditions. Four bunkers flank the small green, and a hill acts as a backstop to the rear. Shots hit left often end up at the bottom of the valley, looking up at nothing but grass and sky.

George Golf Club ✦ 17
LOCATION: GEORGE, SOUTH AFRICA
ARCHITECTS: HENDRICK J. RAUBENHEIMER, DR. C. M. MURRAY
LENGTH: 182 YARDS · PAR 3

It's not hard to see why this course is part of South Africa's "Garden Route"—its property is marked by fertile valleys and the Outeniqua Mountains. It is also home to the well-known George heather, a gnarly bush that lines this attractive par 3. Cascading down from an elevated tee, the hole demands a well-judged tee shot to find the green, angled away from left to right. A creek extends dangerously up the right side of the green, while two pot bunkers sit on the left.

Royal Dar-es-Salaam (Red) ✦ 9

LOCATION: RABAT, MOROCCO

ARCHITECT: ROBERT TRENT JONES, SR.

LENGTH: 199 YARDS · PAR 3

The Red at Royal Dar-es-Salaam is literally fit for a king, having been designed for the late King Hassan II. At this long "short" hole, the carry is entirely over water to a green set on a crescent–shaped plot of land. Ducks, geese, and flamingos add to the effect. Leading to either side of the green are two hump-backed wooden bridges, creating a scene that has been described as taken from a piece of willowware china. • This hole is showcased on pages 110–111.

Wild Coast Country Club ✦ 13

LOCATION: PORT EDWARD, SOUTH AFRICA

ARCHITECT: ROBERT TRENT JONES, JR.

LENGTH: 146 YARDS · PAR 3

The 1997 Wild Coast Challenge, a South African PGA event, saw how fickle winds can render this hole's seemingly innocuous yardage meaningless. Players hit anything from punch 5-irons to three-quarter wedges on this hole to adapt to the changing conditions, knowing that shots missing this green can land in all sorts of trouble. The "jungle" is the most obvious hazard, but a rear bunker, giving way to another cluster of knotted vegetation, can be nearly as distressing.

Chapman Golf Club ✦ 6

LOCATION: HARARE, ZIMBABWE

ARCHITECTS: SALISBURY RAYTON ATHLETIC CLUB MEMBERS, PETER MATKOVICH

LENGTH: 459 YARDS · PAR 4

Chapman's original 1930 layout was redesigned to create more water hazards. One of those was the lake that now fronts the sixth green, turning the second shot into a long carry over the water. The drive should ideally sit on the right side of the fairway, aiming away from the lake.

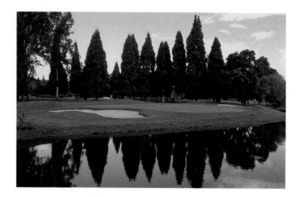

Durban Country Club ✦ 5

LOCATION: DURBAN, NATAL, SOUTH AFRICA

ARCHITECTS: GEORGE WATERMAN/LAURIE WATERS

LENGTH: 461 YARDS · PAR 4

The fifth is the longest par 4 on the course, and one that sports a different look than its hillier counterparts. Tree-lined and less exposed to the winds, the fifth presents no major trouble off the tee other than a narrow, topsy-turvy fairway. The green complex is subtle yet smart, with two perfectly placed bunkers guarding the narrow surface. Both come into play when the pin is cut short or in the middle, while the right bunker must be carried for the more difficult back-right placement.

Fancourt Country Club (Montagu) ✦ 6

LOCATION: BLANCO, SOUTH AFRICA

ARCHITECT: GARY PLAYER

LENGTH: 435 YARDS · PAR 4

Weaving through a splendid corner of the valley property, the smartly designed sixth hole is buffeted on the left by thick trees and a winding creek. That creek crosses the fairway after a steep fall-off about 275 yards from the tee, meaning some players can easily drive into it if their shots roll too far. A turn to the left reveals a heart-shaped green with four large bunkers behind and to the right, making the back-right pin position one of the hardest on the course.

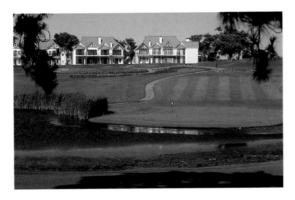

Gary Player Country Club ✦ 18

LOCATION: SUN CITY, SOUTH AFRICA

ARCHITECT: GARY PLAYER

LENGTH: 442 YARDS · PAR 4

This testy finisher doglegs nearly 90 degrees to the left, putting an emphasis on driving the ball far enough to clear the tree-lined corner, but not too far. Still more trees and rough punish drives hit through the dogleg, while a pond catches balls that are hit too far left. The resulting approach presents more trouble, with a small green bookended by two tricky bunkers, but it's mainly the tee shot that causes players' palms to sweat here.

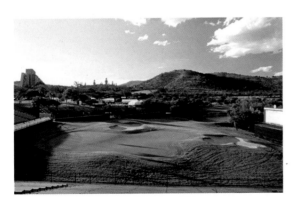

Glendower Golf Club ✦ 10

LOCATION: EDENVALE, SOUTH AFRICA

ARCHITECT: CHARLES ALISON

LENGTH: 468 YARDS · PAR 4

In addition to its splendid parkland setting, where it seems nearly every species of tree exists, this is also one of the toughest par 4s in the Johannesburg area. It played as such during the 1997 South African Open, resulting in plenty of bogeys despite the overall low scoring. The main culprit is the long, nervous approach over a broad pond, which comes right up to the green. Along with the two bunkers bookending each side of the green, this water feature makes front pin positions particularly dangerous.

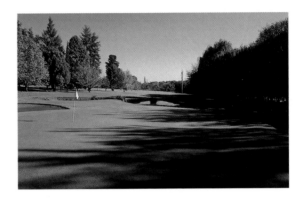

Humewood Golf Club ✦ 13

LOCATION: PORT ELIZABETH, HUMEWOOD, SOUTH AFRICA

ARCHITECTS: S. V. HOTCHKIN, DONALD STEEL

LENGTH: 449 YARDS · PAR 4

South African golf professional Hendrik Buhrman once took 14 strokes on this hole in a local tournament, still a competitive record. The gentle dogleg-right is the most demanding hole on the course, playing into the prevailing wind and featuring a host of trouble. The undulating fairway leads to an elevated green tucked behind a sand dune. A deep bunker guards the left side, while a scrub area of sand and rough lies to the right. Any approaches going long are virtually unrecoverable, as they will certainly land in the gorselike bushes.

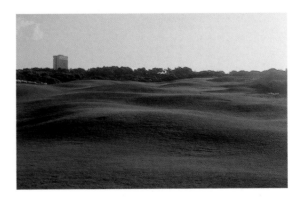

Mowbray Golf Club ✦ 15

LOCATION: CAPE TOWN, SOUTH AFRICA
ARCHITECTS: S. V. HOTCHKIN, ROBERT GRIMSDELL
LENGTH: 438 YARDS · PAR 4

This hole is an understated yet stern challenge. The undulating fairway and tricky crosswinds make the fairway tough to hold, while a pond on the left and out of bounds on the right further emphasize accuracy off the tee. The green is very narrow in front but gets wider as it curves closely around a deep left-hand bunker, with grass swales and mounds to contend with on all other sides. Towering trees and the distant cliffs of the Cape Peninsula Mountains provide a postcard backdrop to the green.

Royal Johannesburg Golf Club (East) ✦ 11

LOCATION: JOHANNESBURG, TRANSVAAL, SOUTH AFRICA
ARCHITECTS: ROBERT GRIMSDELL, CHARLES ALISON
LENGTH: 467 YARDS · PAR 4

With no fairway bunkers, the commanding feature of this lovely dogleg-right hole is the huge willow tree in the left rough, just before the creek that crosses in front of the green. Drive in the left rough, and a shot to the green is almost completely blocked by the tree. However, faced with this predicament in the 1974 South African Open, Bobby Cole hit a soaring 4-wood from 220 yards in the rough, barely clearing the tree and reaching the green. He made par, and went on to win.

Durban Country Club ✦ 3

LOCATION: DURBAN, NATAL, SOUTH AFRICA
ARCHITECTS: GEORGE WATERMAN/LAURIE WATERS
LENGTH: 513 YARDS · PAR 5

At the tee at the most famous hole on the most highly regarded layout in South Africa, you see the gaping bunker eating into the fairway on the left, the narrow gap to the right. The raised green is unkind to run-up shots—it is not often hit and held in two. Even a short third must be exact or be swallowed by impenetrable brush. •This hole is showcased on pages 70–73.

Gary Player Country Club ✦ 9

LOCATION: SUN CITY, SOUTH AFRICA
ARCHITECT: GARY PLAYER
LENGTH: 545 YARDS · PAR 5

Only the truly daring would attempt to confront this hole's many risks for the chance at eagle, even though it's technically reachable in two by the professionals who come each year for the Million Dollar Challenge. For starters, the fairway is tree-lined, narrow, and guarded by a large bunker on the right, making it tough to swing away with the driver. That's nothing compared with the island green, however, which is elevated and sits on the upper tier of a two-level lake.

AUSTRALASIA

This region is a study in contrasts. Throughout Asia, and especially Japan, golf is so popular yet available land so scarce that playing the game is, for some, a once-in-a-lifetime chance. Still, several magnificent courses have been built over the years. Elsewhere, countries such as the Philippines, South Korea—even Vietnam and China—are catching the golf craze. Though not every Asian golf fan may get to play on world-class courses, the enthusiasm and love for the game in Asia is unquestioned.

To the south, Australia and New Zealand are a very different world. Golf is plentiful, often moderately priced, and played quickly. British traditions ensure that the best courses in each country are at least partially accessible to visitors, with terrain ranging from the sandy soil of Melbourne to the Southern Alps in New Zealand's South Island.

ASIA

PAR 3

Blue Canyon Country Club (Canyon) ✦ **17**

LOCATION: PHUKET, THAILAND
ARCHITECT: YOSHIKAZU KATO
LENGTH: 221 YARDS · PAR 3

This hole has been known to make or break a round. In the final round of the 1998 Johnnie Walker Classic, Ernie Els bogeyed to fall one stroke behind Tiger Woods, who eventually won in a playoff after a remarkable 8-stroke comeback. The longest par 3 in Thailand is dangerous and demanding, as the tee shot must carry a canyon to reach the banana-shaped green. Three large bunkers, and one larger lake, are ready to penalize errant shots.

Kasumigaseki Country Club (East) ✦ **10**

LOCATION: SAITAMA, JAPAN
ARCHITECTS: KINYA FUJITA, CHARLES ALISON
LENGTH: 177 YARDS · PAR 3

This hole should count twice, thanks to the vagaries of the Japanese climate. Two greens—one made of Bermuda grass, and one of rye and bent grasses—along with two tees, two lakes, and two bunker complexes, separated by a line of trees, keep the hole green and lush throughout the year. During his redesign, Alison added a deep-faced bunker in front of the green, which Japanese to this day refer to as an "Arison."

Kau Sai Chau Golf Course (North) ✦ 14

LOCATION: HONG KONG, CHINA
ARCHITECT: GARY PLAYER
LENGTH: 205 YARDS · PAR 3

This is certainly one of the most astonishing sites for a public-course par 3 in all of golf. The view from the back tee looks straight down the barrel of a fjordlike inlet that frames the cliffside greensite. The tee shot is all carry over water, and bailout room is minimal. In setting this hole where he did, Gary Player set the golfer up for either a glittering triumph or a truly spectacular splash-and-burn.

Nagoya Golf Club (Wago) ✦ 17

LOCATION: AICHI, JAPAN
ARCHITECT: M. OTANI
LENGTH: 171 YARDS · PAR 3

Jumbo Ozaki emerged from a close third-round battle with Greg Norman and Brian Watts after curling in a 15-foot, left-to-right birdie putt on this green, propelling him to victory in the 1997 Chunichi Crowns tournament. The tee shot can be a tense one even for the pros, as it must clear a lake and also avoid any of six bunkers, spread around two greens used at different times of the season. The densely wooded hillside that forms a backdrop for the green is not a hospitable ending for those missing long.

Ocean Dunes Golf Club ✦ 9

LOCATION: PHAN THIET, VIETNAM
ARCHITECT: NICK FALDO
LENGTH: 148 YARDS · PAR 3

The name of the course says it all, as Faldo created a hole that would feel at home on any links course in Great Britain. From the tee to the green, the natural rise of the terrain is subtle, but it must be factored into club selection. The deep, narrow green sits on a breezy plateau between two sand dunes, just steps from the beach. Keeping the ball below the hole is critical, as the green slopes sharply from back to front.

Puerto Azul Golf and Beach Club ✦ 17

LOCATION: PASAY CITY, PHILIPPINES
ARCHITECT: GARY PLAYER
LENGTH: 234 YARDS · PAR 3

This is a magnificent hole, where pars will be hard-earned. After you take a minute to gaze over the South China Sea to Corregidor Island, it's time for the daunting task at hand: a long-iron or fairway-wood tee shot that must carry over the coastline and find land near the windswept, two-tiered green. Two bunkers on the right are often the safest place to hide, but even then players will be faced with a scary, downhill bunker shot played toward the sea.

Rajapruek Golf Club ✦ 4

LOCATION: BANGKOK, THAILAND

ARCHITECT: J. MICHAEL POELLOT

LENGTH: 214 YARDS · PAR 3

The pathway from the third green to the fourth tee, crossing a waterfall and surrounded by flora, is a harbinger of things to come. This hole is situated amid a lake, large mounds, and several species of trees. All of these contribute to the hole's difficulty, as the tee shot must carry the lake and find the wide, sloping green, ensconced in a lush amphitheater. A deep bunker guards the left side of the green, while several grass swales catch shots missing to the right.

Thai Country Club ✦ 6

LOCATION: CHACHEONGSAO, THAILAND

ARCHITECT: DENNIS GRIFFITHS

LENGTH: 218 YARDS · PAR 3

With the prevailing wind directing tee shots toward water on the right, this can be a frightening hole. The green juts out into the water and is set away from the tee at an angle. One large bunker short of the green and two smaller ones behind leave little room for misjudging the distance. But it's the lake that looms large in players' minds: During the final round of the 1997 Asian Honda Classic (won by Tiger Woods), this hole played to a 3.38 stroke average, ranking first in difficulty.

Yomiuri Country Club ✦ 18

LOCATION: TOKYO, JAPAN

ARCHITECT: SEICHI INOUE

LENGTH: 224 YARDS · PAR 3

Like many courses in Japan, Yomiuri provides two greens for each hole that rotate according to the time of year. In the case of the eighteenth hole, either green presents a formidable challenge, thanks to a ring of five bunkers that is always in season. The primary green is set behind all five, stretching the hole to its maximum yardage but also taking the two shortest bunkers virtually out of play. The secondary green is nearly 40 yards closer but surrounded by sand, completing an exciting finisher with dual personalities.

Agile Golf and Country Club (South) ✦ 8

LOCATION: ZHUHAI, GUANGDONG, CHINA

ARCHITECT: J. MICHAEL POELLOT

LENGTH: 472 YARDS · PAR 4

This hole offers two routes to the green. The safer choice off the tee is to the right of five fairway bunkers. A stream down the left comes into play for the riskier left-fairway option, but from that point the approach is shorter and more straightforward.

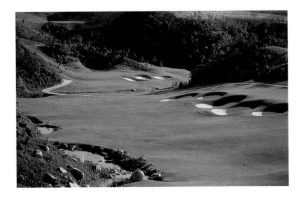

Bali Golf and Country Club ✦ 16

LOCATION: NUSA DUA, BALI, INDONESIA

ARCHITECTS: ROBIN NELSON/NEIL HAWORTH

LENGTH: 460 YARDS · PAR 4

The sparsely planted rows of tall, skinny palm trees lining the corner of this dogleg-left seem innocent, but they have foiled many attempts to bite some distance off the hole. It's not a secret why players try—the elevated green, which juts out as a peninsula into a sea of sand on the right, is very tough to hit with anything longer than a mid-iron. Those who play the safer shot off the tee often find themselves laying up to the left, rather than trying the low-percentage shot to the green.

Chung Shan Hot Springs Golf Club (Palmer) ✦ 3

LOCATION: ZHONGSAN CITY, CHINA

ARCHITECT: ARNOLD PALMER

LENGTH: 405 YARDS · PAR 4

An attractive dogleg-left par 4, the third is where the course heats up after a comparably trouble-free start. The green is not visible from the tee—a flower bed, planted to resemble the club's logo, is a good target. The approach to the elevated green carries a host of challenges. A creek crosses the fairway just in front of a deep greenside bunker, while out of bounds lurks closely to the left. Hit it O.B., and you'll likely see your ball being resold in the pro shop the following week—at a bargain price, of course.

Clearwater Bay Golf and Country Club ✦ 14

LOCATION: HONG KONG, CHINA

ARCHITECTS: J. MICHAEL POELLOT/BRAD BENZ

LENGTH: 345 YARDS · PAR 4

Slightly resembling the Cape hole design made famous by Charles Blair Macdonald, this seaside stunner allows players to bite off as much of the dogleg-right as they can. The wind plays a major role in the decision, and the rocky cliffside on the right leads to a watery grave for shots that are overly bold. The approach from the fairway is riddled with trouble, as the South China Sea stands guard on the right of the green and bunkers await on the left.

Hong Kong Golf Club (Eden) ✦ 18

LOCATION: HONG KONG, CHINA

ARCHITECTS: MICHAEL WOLVERIDGE, JOHN HARRIS

LENGTH: 417 YARDS · PAR 4

A haunted finishing hole? This one might qualify. Numerous grave sites were unearthed during construction, and moved to other parts of the property. The hole begins from an elevated tee and continues down to a landing area pinched between three bunkers. The approach must carry a large pond to reach the crowned green, resulting in plenty of bogeys. A tough hole, to be sure, but "the revenge of the dead" might also have something to do with it.

Kawana Golf Links (Fuji) ✦ 13

LOCATION: SHIZOUKA, JAPAN

ARCHITECT: CHARLES ALISON

LENGTH: 395 YARDS · PAR 4

Immediately after completing two of Kawana's cliffside ocean holes, many players expect a lull in the action at this conventional-looking par 4. Instead, it is a perplexing challenge. A huge cross bunker is the first obstacle—drive in it and the green is all but unreachable; lay up too short and the tough approach will be that much longer. The green's two main defenses are its slope, which falls away from front to back, and its korai grass, which is several times coarser and grainier than even the strongest Bermuda grass.

Klub Golf Rimba Irian ✦ 14

LOCATION: IRIAN JAYA, INDONESIA

ARCHITECT: BEN CRENSHAW

LENGTH: 383 YARDS · PAR 4

This is a fascinating hole, carved out of deep rain forest and ominously named "Boelen's Python." A sharp dogleg-left allows players to cut a bit of the corner off the tee, though danger awaits. A winding, steeply banked stream down the left side makes the margin for error small, while a lone fairway bunker in the landing area catches more than its fair share of "safe" shots. Only the front of the green is unguarded, as the stream runs down the left and rear and bunkers protect the right.

Laguna National Golf Club (Classic) ✦ 13

LOCATION: SINGAPORE

ARCHITECTS: PETE AND ANDY DYE

LENGTH: 457 YARDS · PAR 4

This demanding, long par 4 requires two strong shots to reach the green, but also presents players with an option to gamble a bit off the tee to improve their position. The fairway doglegs right, and at the inside corner is a gaping bunker. Though there is ample landing room to the left, the angle of approach to the green becomes easier the closer the drive is to the bunker. Hit in the bunker, though, and the green—well guarded by a canal and long bunker on the right—becomes almost unreachable.

Lakeside Country Club (West) ✦ 18

LOCATION: KYUNGKI DO, SEOUL, SOUTH KOREA
ARCHITECTS: NAKANO RYU/IKSUNG YOON
LENGTH: 410 YARDS · PAR 4

A large tree extends into the fairway from the right rough on this birdieable finisher, blocking the angle to the green from that side of the fairway. Well, one green, at least. There are two greens of different grasses on this hole: The one to the right prevails during much of the year, and is fronted by a deep pot bunker. In the final round of the 1997 Samsung World Championship of Women's Golf, Juli Inkster rolled in a 12-foot birdie putt here to claim victory over Kelly Robbins and Helen Alfredsson in a sudden-death playoff.

Manila Southwoods Golf and Country Club (Masters) ✦ 10

LOCATION: CAVITE, MANILA, PHILIPPINES
ARCHITECT: JACK NICKLAUS
LENGTH: 429 YARDS · PAR 4

Nicklaus encourages players to work the ball in both directions here, as the tee shot favors a slight draw to follow the dogleg-left fairway. Slight, because a fifteen-foot-wide stream frames the left edge of the fairway, catching any drives that stray too far left. The stream empties into a pond just short of the green, which is elevated, firm, and angled away from the fairway. These factors require a faded approach shot to carry the pond and hold the green.

Naruo Golf Club ✦ 10

LOCATION: HYOGO, JAPAN
ARCHITECT: H. C. CRANE
LENGTH: 480 YARDS · PAR 4

This hole tumbles downhill and plays slightly shorter than the yardage indicates, but two well-placed shots are still necessary to give players a good chance at par. Tee shots finding the fairway bunker sitting atop the hillside on the right will be left with virtually no chance to reach the green. The deep, washboardlike trough just short of the green gobbles up any shot coming up short, and the green complex is marked by four stunning, high-lipped sand traps.

Navatanee Country Club ✦ 6

LOCATION: BANGKOK, THAILAND
ARCHITECT: ROBERT TRENT JONES, SR.
LENGTH: 457 YARDS · PAR 4

It stands to reason that a course built on former rice paddies and swampland should feature water so prominently, but it doesn't make it any less intimidating. The sixth hole is the most demanding of the course's water holes, mostly due to its length. A narrow stream runs up the entire left side, then expands into a large pond as it crosses the hole in front of the green. The approach is usually a mid-iron at least, making the carry feel even longer than it already is.

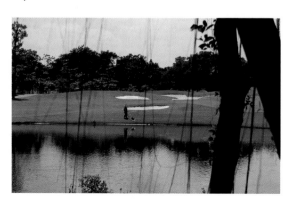

New St. Andrews Golf Club ✦ 18

LOCATION: TOCHIGI, JAPAN

ARCHITECT: JACK NICKLAUS

LENGTH: 428 YARDS · PAR 4

Judgment and restraint will win over brute length at the final hole of Jack Nicklaus's first design in Japan. From the tee, the bunkers are not visible as the plateau landing area blocks them from view. There is a lurking feeling, however, that something treacherous might lie just out of view. • This hole is showcased on pages 154–155.

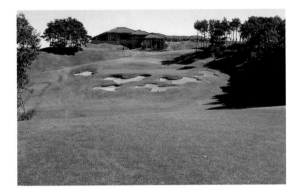

Shan Shui Golf Club ✦ 15

LOCATION: TAWAU, SABAH, MALAYSIA

ARCHITECTS: ROBIN NELSON/NEIL HAWORTH

LENGTH: 422 YARDS · PAR 4

"Jungle Love" would be an appropriate moniker for this treacherous dogleg-right par 4, where the fairway weaves its way through dense vegetation that must be carried twice. The landing area is fairly wide and slopes from right to left, giving players a good chance to find the best approach angle on the left side of the fairway. The long green sits precariously close to a ravine on the right, while the bunker on the left sees plenty of activity as players try to bail out.

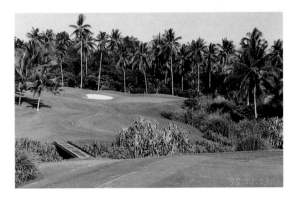

Singapore Island Country Club (Bukit) ✦ 11

LOCATION: SINGAPORE

ARCHITECTS: JAMES BRAID, J.J.F. PENNINK

LENGTH: 426 YARDS · PAR 4

The course is situated around two large reservoirs, which contribute cooling, and often confusing, breezes to toughen an already arduous hole. The eleventh bends gently to the right after emerging from a tee box sheltered by large trees. A line of trees along a service road runs down the left side, and is brought into play by the right-to-left slope of the fairway. The green is fairly large, but made of a clay base that firms up quickly. A deep, peanut-shaped bunker guards the front left.

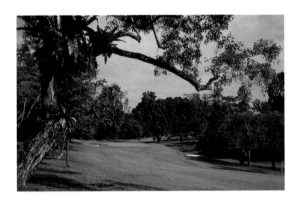

Spring City Golf Resort (Mountain) ✦ 18

LOCATION: KUNMING, CHINA

ARCHITECT: JACK NICKLAUS

LENGTH: 472 YARDS · PAR 4

With the chance to give golfers a demanding finish over dramatic terrain, Nicklaus didn't disappoint. A line of bunkers down the right must be avoided off the tee; if not, reaching the green on the next shot will require a Golden Bear–like effort. The reason? A rugged, deep ravine crossing the fairway just short of the wide green. Balls that go in seldom see the light of day again. Not enough? Two bunkers—one in front and one behind—also guard the green.

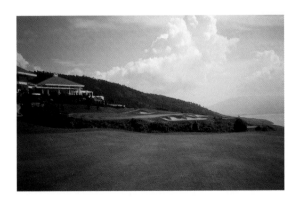

Tong Hwa Golf and Country Club ✦ 7

LOCATION: LIN KOU, TAIPEI, TAIWAN
ARCHITECT: SATO TAKESHI
LENGTH: 444 YARDS · PAR 4

Tumbling downhill over an undulating fairway, this long hole demands that players steer their drives toward the left to avoid fairway bunkers and a thick forest on the right. Those who drive too far past the bunkers will likely be playing their second shots from a downhill lie, a troubling situation when confronted with the green complex. A large lake and a long, serpentine bunker border the left and front of the green, and the approach is best played with a high trajectory to both carry the trouble and hold the green.

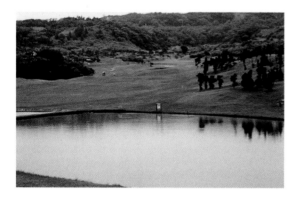

PAR 5

Bangkok Golf Club ✦ 18

LOCATION: PATHUMTHANI, THAILAND
ARCHITECT: ARNOLD PALMER
LENGTH: 552 YARDS · PAR 5

The landing area is wedged between a lake on the left and two bunkers on the right. To go for the green in two, big hitters will have to carry the second lake on the right, where three more bunkers circle the green.

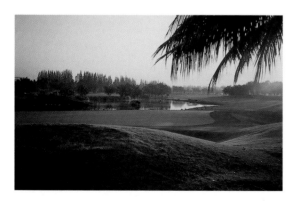

Bukit Pelangi, Rainbow Hills Golf Club ✦ 4

LOCATION: BOGOR, INDONESIA
ARCHITECT: J. MICHAEL POELLOT
LENGTH: 538 YARDS · PAR 5

Inspiring mountain views frame this strategic hole from the elevated tee. The landing area is fairly wide, though a series of bunkers can be reached by the longest hitters. From there, the upper fairway to the right provides a wider target for the second shot, but leaves a longer approach to the green. The lower fairway is narrower, but provides a shorter route. It's an important decision, as the ridge-top green is guarded by a large left bunker and has a false front that makes it tough to gauge the correct distance.

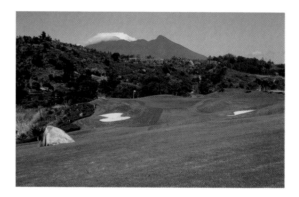

Fujioka Country Club ✦ 16

LOCATION: MAGOYA, JAPAN
ARCHITECTS: PETER THOMSON, T. YAMADA
LENGTH: 605 YARDS · PAR 5

The longest par 5 in Japan is played from the back tees only in professional competitions, as it might warrant a par 6 for members. The tee shot plays uphill to a narrow V-shaped fairway. Despite the difficulty, sliced drives are aided by a tall bank on the right that kicks shots back into the fairway. It's a hole that Jumbo Ozaki himself has never eagled.

Hirono Golf Club ✦ 15

LOCATION: KOBE, JAPAN

ARCHITECT: CHARLES ALISON

LENGTH: 565 YARDS · PAR 5

The pristine fifteenth was designed as a three-shot hole, and it took thirty years before a young pro named Jack Nicklaus hit the green in two. A gargantuan Kuromatsu (black pine) tree stands guard on the left of the fairway, foiling attempts to cut the corner of the dogleg. Alison's wonderful cross bunkers—a feature he perfected on his English heathland courses—here immediately follow the first of two fairway ravines that must be carried on the way to the green. • This hole is showcased on pages 224–225.

Mission Hills Golf Club (World Cup) ✦ 7

LOCATION: SHENZEN, CHINA

ARCHITECT: JACK NICKLAUS

LENGTH: 523 YARDS · PAR 5

The tee on the seventh looks out over a landscape that is lush and colorful, but also intimidating. The hole is bisected by water—first a wide stream that must be carried off the tee, then a vast lake. It can be a gambler's delight, as a well-positioned drive down the left side of the fairway presents a tough decision: carry the lake immediately to reach the green in two, or lay up and wait till the third shot. Either way, a wide, undulating green, backed by two large bunkers, awaits on the other side.

Mount Malarayat Golf and Country Club (Makulot) ✦ 7

LOCATION: LIPA CITY, BATANGAS, PHILIPPINES

ARCHITECT: J. MICHAEL POELLOT

LENGTH: 519 YARDS · PAR 5

The first of several decisions on this hole comes on the tee, when players will have to gauge how aggressively to play their drives. The corner of the dogleg-right is guarded by a bunker, and carrying it is the only chance to hit the green in two. Even playing conservatively down the left involves strategy, as the short approach is to a peninsula green surrounded by four deep sand traps. Pin positions cut on the right are particularly risky, as the green narrows and begins to slope down toward the lake.

Taiheiyo Club Gotemba (East) ✦ 18

LOCATION: GOTEMBA, SHIZUOKA, JAPAN

ARCHITECT: SHUNSUKE KATO

LENGTH: 517 YARDS · PAR 5

Snowcapped Mount Fuji stands majestically in the distance behind this dramatic finisher, which can be reached in two by those who have the courage. The two-tiered green is tucked closely between a large pond in front and three rear bunkers, and misjudged shots often roll back into the water. This happened to Lee Westwood during the first round of the 1998 Sumitomo VISA Taiheiyo Masters. Half the ball was still visible, so he climbed into the pond, hit a lob wedge to within 2 feet, made birdie, and went on to win.

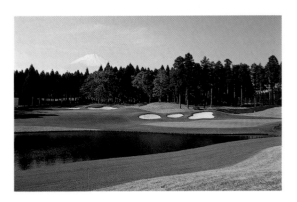

Christchurch Golf Club ✦ 11

LOCATION: SHIRLEY, CHRISTCHURCH, NEW ZEALAND
ARCHITECTS: DES SOUTAR, PETER THOMSON
LENGTH: 141 YARDS · PAR 3

From the secluded tee box within a stand of trees, players are screened from determining the wind conditions. The prevailing breeze is slightly into the player from the right to the left; this, and out of bounds on the right, direct many players' tee shots toward the deep left bunker. This hole made golf history in May 1936: It was halved with aces—the first time in a four-ball match.

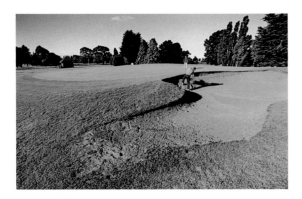

The National Golf Club ✦ 2

LOCATION: CAPE SCHANCK, VICTORIA, AUSTRALIA
ARCHITECT: ROBERT TRENT JONES, JR.
LENGTH: 152 YARDS · PAR 3

Perhaps taking a cue from Cypress Point, Trent Jones made the signature hole at this ultra-exclusive club an ocean-view par 3, but with a different personality. Instead of being close enough to smell the crashing waves, the second is built on a cliffside three hundred feet up from the sea. It's hit the green or else—between tee and green is nothing but unrecoverable forest vegetation. Though it's a manageable carry, the hole's position so early in the round can add tension to the swing.

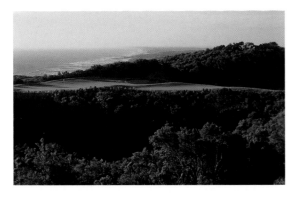

New South Wales Golf Club ✦ 6

LOCATION: LA PEROUSE, SYDNEY, AUSTRALIA
ARCHITECTS: ALISTER MACKENZIE/ERIC APPERLY
LENGTH: 193 YARDS · PAR 3

To reach the sixth, you must cross a bridge to the reef where the back tee is located. It's tempting to try to avoid the pounding ocean to its left, but the right-to-left pitch of the green makes recovery from the right extremely difficult. • This hole is showcased on pages 100–101.

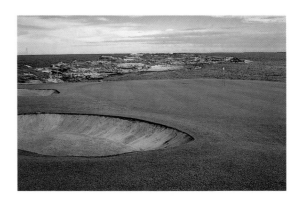

Royal Melbourne Golf Club (West) ✦ 5

LOCATION: MELBOURNE, AUSTRALIA
ARCHITECTS: ALISTER MACKENZIE/ALEX RUSSELL
LENGTH: 176 YARDS · PAR 3

Royal Melbourne has tested world champions and continually pleases its members. The fifth employs one of Mackenzie's most common devises at a short hole, a sharp down slope at the front of the green so that a ball landing short will roll back toward the golfer and off the putting surface. The shot from the tee requires a 170-yard carry across a small valley to a green surrounded by sand, heather, and bracken. • This hole is showcased on pages 112–113.

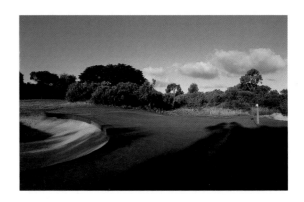

Kingston Heath Golf Club ✦ 6

LOCATION: CHELTENHAM, MELBOURNE, AUSTRALIA

ARCHITECTS: DES SOUTAR, ALISTER MACKENZIE

LENGTH: 431 YARDS · PAR 4

There are few non–water holes where a slice will hurt a golfer more than here, a hole with three separate clusters of bunkers along its right side. Two of those clusters affect the tee shot, as the hole has four bunkers of its own and also shares five more with the parallel first hole.

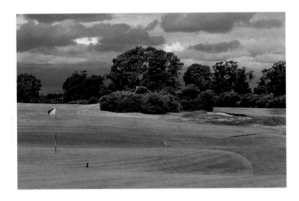

Metropolitan Golf Club ✦ 15

LOCATION: SOUTH OAKLEIGH, MELBOURNE, AUSTRALIA

ARCHITECTS: J. B. MACKENZIE, DICK WILSON

LENGTH: 467 YARDS · PAR 4

Metropolitan's character relies on deep bunkers and lightning-fast greens; both are on this course's toughest par 4. Beware the 44-yard-long fairway bunker, whose high lip all but prevents a full-length recovery. It's better to play left, as overhanging branches and a greenside bunker challenge the approach from the right. And the green? Its severe slope is infamous. In the 1997 Australian Open, Greg Norman missed it but pitched to 3 feet, in good shape to save par. Instead, he three-putted for a double bogey 6.

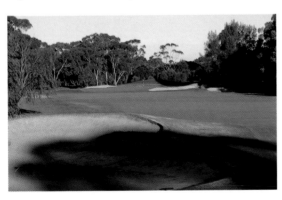

Newcastle Golf Club ✦ 6

LOCATION: FERN BAY, STOCKTON, AUSTRALIA

ARCHITECTS: FRED POPPLEWELL/A. A. FRANKLIN, ERIC APPERLY

LENGTH: 400 YARDS · PAR 4

Two natural elements challenge the tee shot on this artful par 4: thick native scrub bush and a hill sloping down across the landing area. The hole doglegs slightly left—in the direction opposite to the hill—so the trick is to start the tee shot down the left side and let it roll to the fairway's right edge. If it bounds too far, however, it will be lost in the bush; should it stay on top of the hill, the result will be an awkward lie. The slick putting surface is nestled cozily among trees and three-deep bunkers.

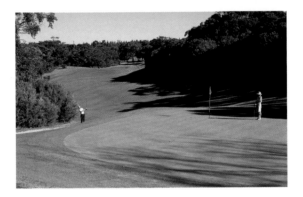

Paraparaumu Beach Golf Club ✦ 17

LOCATION: WELLINGTON, NEW ZEALAND

ARCHITECT: ALEX RUSSELL

LENGTH: 442 YARDS · PAR 4

New Zealand's Paraparaumu Beach is on the North Island of New Zealand overlooking the Cook Strait and Tasman Sea. Its seventeenth is a par 4 of notable length, which, when played into the wind, presents difficulties of distance, when played downwind, difficulties of accuracy. Furthermore, its demands are made much more diabolical by a split fairway. • This hole is showcased on pages 164–165.

Royal Adelaide Golf Club ✦ 3

LOCATION: SEATON, ADELAIDE, AUSTRALIA
ARCHITECT: ALISTER MACKENZIE
LENGTH: 301 YARDS · PAR 4

A hole whose merits and faults have been debated fervently, the third is an important part of the charm of Royal Adelaide. The tee shot is completely blind, rising up the hill to a narrowing fairway surrounded by thick marram grass. Big hitters often pull out the driver to go for the green, but a large amount of luck is required to actually reach it. More often than not, an aggressive play ends up in the long grass, resulting in bogey or worse.

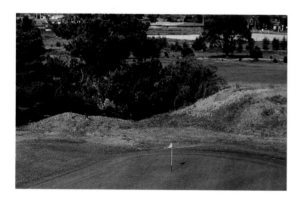

Royal Adelaide Golf Club ✦ 14

LOCATION: SEATON, ADELAIDE, AUSTRALIA
ARCHITECT: ALISTER MACKENZIE
LENGTH: 447 YARDS · PAR 4

Taking its main defenses from the wind and the impervious marram grass lining the fairways, this hole defies its elementary appearance to present a tough resistance to par. Three bunkers sit in a row at the inside corner of the dogleg-right, and the plateau landing area is elusive and tough to hold. Two clusters of trees mark the entrance to the narrow green, which is further surrounded by rough and three more bunkers. • This hole is showcased on pages 178–179.

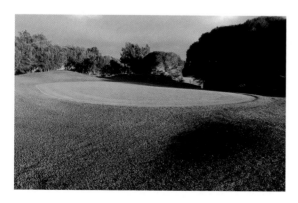

Royal Melbourne Golf Club (West) ✦ 6

LOCATION: BLACK ROCK, MELBOURNE, AUSTRALIA
ARCHITECTS: ALISTER MACKENZIE/ALEX RUSSELL
LENGTH: 450 YARDS · PAR 4

Near the shores of Port Phillip Bay is a geological anomaly known as the Sand Belt, a twenty-five-square-mile area marked by undulating terrain, native scrub, and fine grasses. It is the perfect medium in which to create naturalistic, linkslike golf courses. The sixth is the stand-out two-shotter in the Southern Hemisphere. Its elevated tee is set in a grove of tea trees. Its tiered green is severely sloped from back to front and can be lightning quick, a feature of many of Royal Melbourne's holes. • This hole is showcased on pages 46–49.

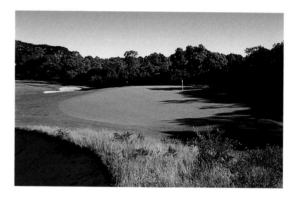

Yarra Yarra Golf Club ✦ 5

LOCATION: BENTLEIGH EAST, MELBOURNE, AUSTRALIA
ARCHITECTS: ALEX RUSSELL/ALISTER MACKENZIE
LENGTH: 440 YARDS · PAR 4

Though Yarra Yarra lacks the championship length of nearby Royal Melbourne, this par 4 could easily fit on that more famous Sand Belt layout. The drive must clear a moderate rise in the fairway, finding a generous but sheltered hollow. The green sits at the top of another gentle climb, while along the way are four sand traps about 30 yards short of the green, and another large one guarding its left edge.

Gulf Harbour Golf & Country Club ✦ 17

LOCATION: WHANGAPARAOA, AUCKLAND, NEW ZEALAND
ARCHITECT: ROBERT TRENT JONES, JR.
LENGTH: 648 YARDS · PAR 5

There were nearly twice as many bogeys as birdies on this hole during the 1998 World Cup of Golf. From a promontory tee box, the drive is played to a crest in the fairway. What remains is a fairway that snakes between two batches of bunkers before finally leading to an elevated, multitiered green.

The Lakes Golf Club ✦ 11

LOCATION: ROSEBURY, SYDNEY, AUSTRALIA
ARCHITECTS: ROBERT VON HAGGE/BRUCE DEVLIN
LENGTH: 578 YARDS · PAR 5

Appropriate for Down Under, this beastly par 5 is shaped like a boomerang, curling around one of the course's numerous lakes. This one was once the Sydney water supply, presumably before it became riddled with wayward golf balls. Three fairway bunkers—one to the right off the tee, then one on each side affecting the lay-up—must be avoided. But it's the testy third shot that usually accounts for high scores, as players must carry one final inlet of water to a green deceptively closer than it appears.

New South Wales Golf Club ✦ 5

LOCATION: LA PEROUSE, SYDNEY, AUSTRALIA
ARCHITECTS: ALISTER MACKENZIE/ERIC APPERLY
LENGTH: 512 YARDS · PAR 5

In much the same way as Pebble Beach's par-5 sixth hole offers a worthy prelude to the par-3 seventh, this hole is a prologue to New South Wales's beloved par-3 sixth. First rising to a plateau 225 yards out from the tee, the fairway then dives downhill to the hole's climax—an exalted cliffside green setting, just a stone's throw from the Pacific. The stunning sixth is clearly visible off to the right, and it was near this spot that Captain James Cook first landed in Australia in 1770, naming the inlet Botany Bay.

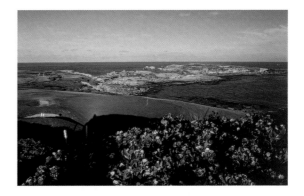

Palm Meadows Golf Club ✦ 18

LOCATION: CARRARA, GOLD COAST, AUSTRALIA
ARCHITECTS: ROBIN NELSON/GRAHAM MARSH
LENGTH: 572 YARDS · PAR 5

Water, wind, and sand offer the ideal stage for this theatrical finishing hole. It forms a semicircle around a lake, allowing players to take the safer route along the left side, or tempt fate along the right. The water's edge curves back and forth along the fairway, ending in a fifty-yard inlet that guards the green complex like a moat guards a castle. In the 1990 Daikyo Palm Meadow Cup, Aussie Rodger Davis twice gambled and hit this green in 2, making eagle the second time to beat Curtis Strange in a playoff.

Royal Adelaide Golf Club ✦ 15

LOCATION: SEATON, ADELAIDE, AUSTRALIA

ARCHITECT: ALISTER MACKENZIE

LENGTH: 499 YARDS · PAR 5

The challenges at the fifteenth hole begin the moment the golfer reaches the tee. The path to the double-dogleg fairway (first left, then right) begins through a narrow chute of trees, and from the sheltered tee box it is virtually impossible to gauge how the wind will affect the ball. Wispy rough lines the fairway to make the green unreachable from anywhere but the fairway, and two large bunkers sixty yards short of the green on the right side must be carried to reach the green in 2.

Victoria Golf Club ✦ 9

LOCATION: CHELTENHAM, MELBOURNE, AUSTRALIA

ARCHITECTS: ALISTER MACKENZIE/ALEX RUSSELL,
PETER THOMSON, MICHAEL WOLVERIDGE

LENGTH: 585 YARDS · PAR 5

A good tee shot here will fly over a sharply rising crest and then down a fairway incline, marking this sweeping finish to the outward nine. Native gum trees line the hole, sometimes swallowing golf balls in their branches. (This happened to Arnold Palmer in the 1961 Australian Open—he proceeded to climb the tree, knock the ball out, and save par.) Second shots hit over another rise to a plateau set up the short approach, to a large green with sand at all corners.

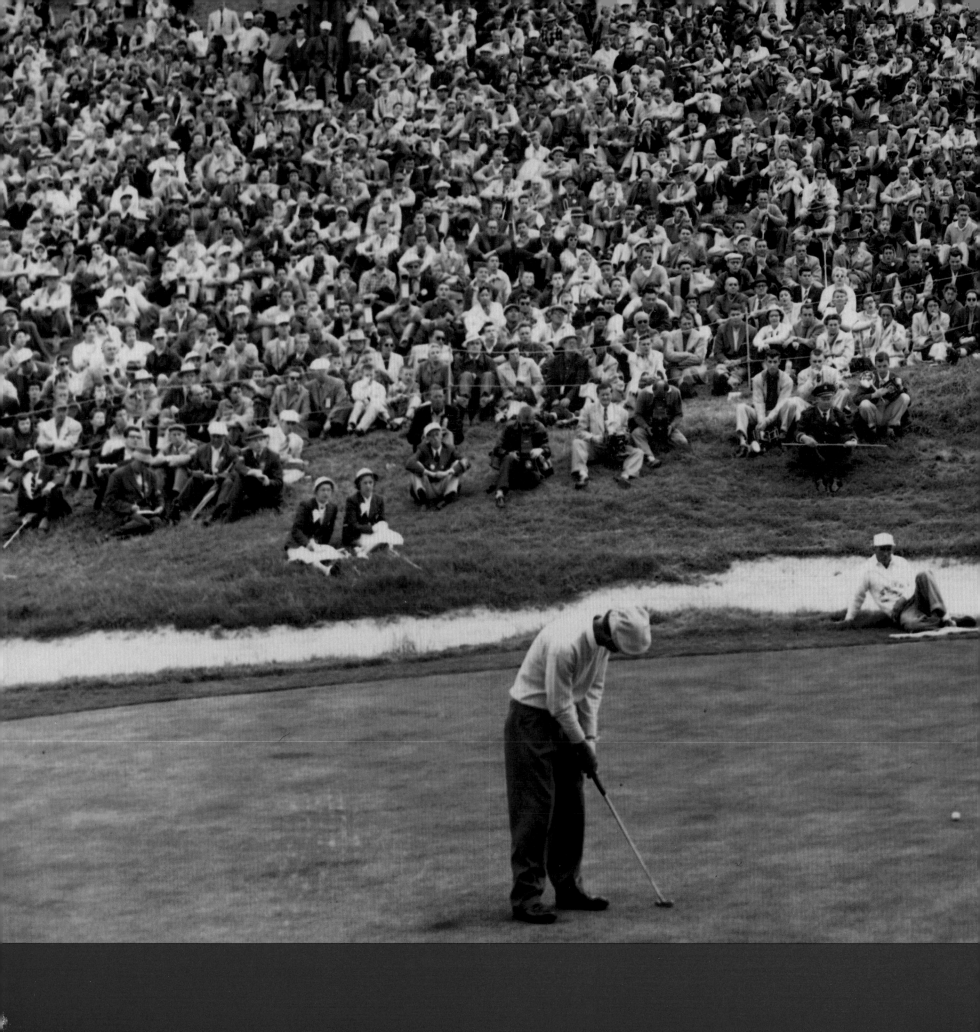

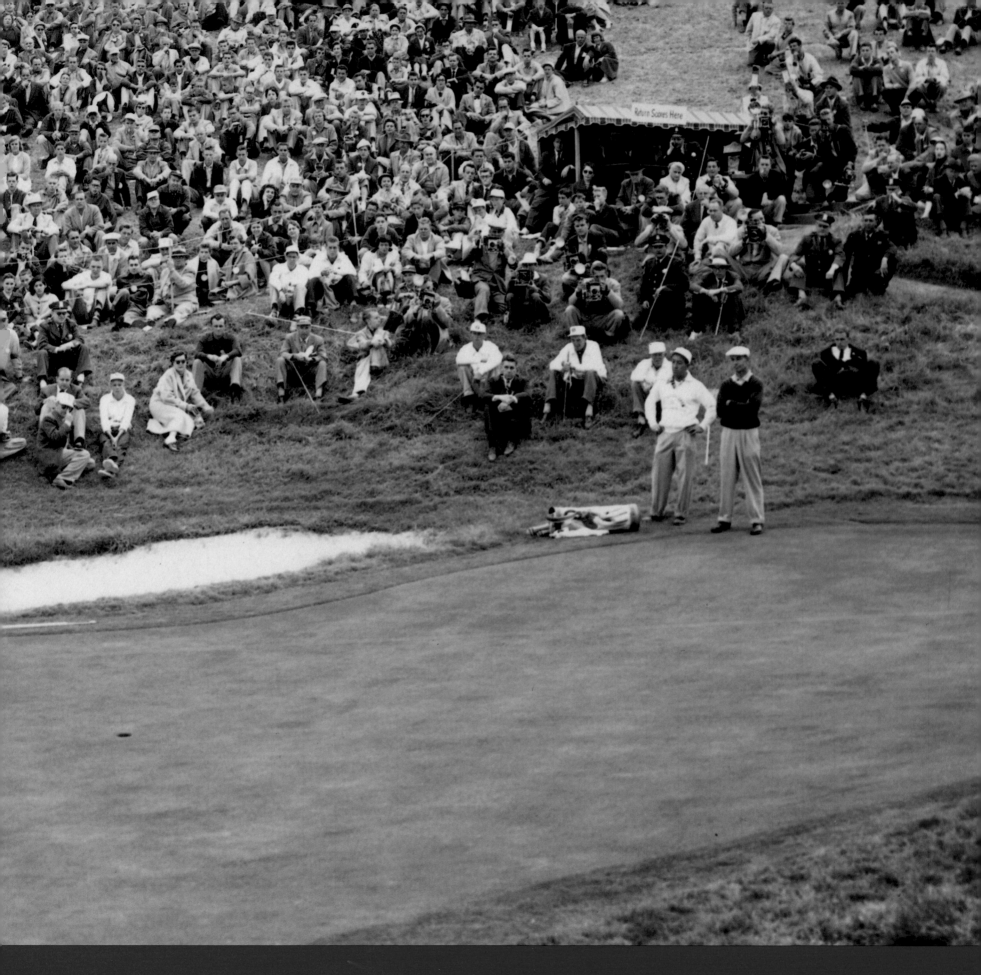

THE BEST OF THE BEST

Everybody loves lists. Best-seller lists. Top-ten lists. Best-dressed lists. Lists help us organize, quantify, plan, and compare. They cut to the chase.

Golfers love lists, too, and for another reason. Like a flagstick stuck in the middle of a green, lists give the golfer a target, something to shoot at. Read the list of the best new courses and you immediately look for the ones nearest you and begin planning a road trip. Scan the list of the best putters on Tour and you compare your personal stats with theirs. And then there's golf's most-quoted list, the money list, which sends every amateur into a fit of "If only I'd started playing the game sooner . . ."

Starting with a list of five hundred golf holes means there are countless ways to subdivide that landscape. Golf holes may be nearly as unique as snowflakes, but there are countless ways to correlate and consolidate them: by location, by designer, by beauty, by difficulty, by size, by accessibility, by age, by the experience they provide and by the toll that they take.

Each list is a mini course of its own, an eighteen-hole layout of distinction. And you're walking to the first tee.

PRECEDING PAGES: Jack Fleck putting on the eighteenth at Olympic Club (page 288) to win the playoff against Ben Hogan at the 1955 U.S. Open. LEFT: Valderrama's fourth hole (pages 244–245).

THE SINGLE BEST HOLES BY NUMBER

We've established the best eighteen holes in the world (pages 1–77), but the purpose of the list here is to recognize the single best opening hole in the world, the single best hole number 2, hole number 3, and so on.

Inevitably, there's some overlap. For instance, number 18 at Pebble Beach was the only closing hole to make our top eighteen in the world, so it automatically became the best eighteenth hole in the world—no contest. Similarly, unchallenged titles went to eight other holes from the all-world list: number 3 at Royal Durban, 6 at Carnoustie, 9 at Royal County Down, 11 at Ballybunion, 12 at Southern Hills, 14 at Shinnecock Hills, 15 at Cypress Point, and 16 at Merion.

Then the selections became tricky. Consider that eight of the other nine holes on our all-world eighteen list consisted of four "pairs": two

Number 7 at Casa de Campo (pages 90–91)

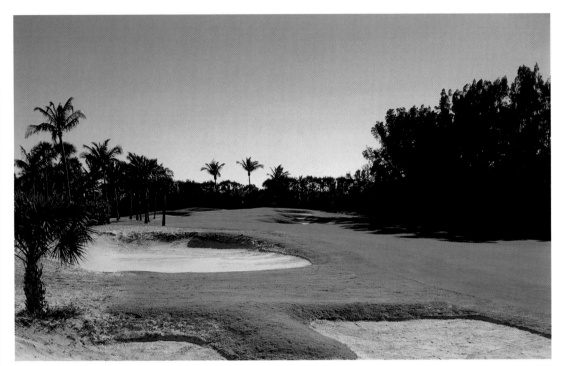

Seminole's sixth hole (pages 194–195)

number 4s, two 5s, two 13s, and two 17s. How to choose among them? Rightly or wrongly, a desire for geographic ecumenism took over, and so our choices were Banff, Royal Melbourne, Augusta National, and St. Andrews.

Ah, but that left a final challenge. The all-world eighteen had provided no candidates at all for holes number 1, 2, 7, 8, and 10. So the search area widened to include the other eighty-two holes in the top hundred in the world. The toughest decision may have been the last of those, number 10, where the top choices were the back-nine openers at Bel-Air, Pine Valley, Riviera, and Winged Foot. Ultimately, we had no trouble justifying our pick—perhaps the most famous hole on the course that *Golf Magazine* has consistently ranked number one in the world. That alone makes it a perfect 10.

No attempt was made to create a "golf course" out of this procession of preeminence, but in the end it worked out to a very playable par 70 of 6,640 yards.

Machrihanish ◆ 1
423 YARDS, PAR 4

Prairie Dunes ◆ 2
161 YARDS, PAR 3

Durban ◆ 3
513 YARDS, PAR 5

Banff Springs ◆ 4
171 YARDS, PAR 3

Royal Melbourne (West) ◆ 5
176 YARDS, PAR 3

Seminole ◆ 6
383 YARDS, PAR 4

Casa de Campo (Teeth of the Dog) ◆ 7
225 YARDS, PAR 3

Crystal Downs ◆ 8
550 YARDS, PAR 5

Royal County Down ◆ 9
486 YARDS, PAR 4

Pine Valley ◆ 10
146 YARDS, PAR 3

Ballybunion (Old) ◆ 11
453 YARDS, PAR 4

Southern Hills ◆ 12
445 YARDS, PAR 4

Augusta National ◆ 13
485 YARDS, PAR 5

Shinnecock Hills ◆ 14
447 YARDS, PAR 4

Cypress Point ◆ 15
139 YARDS, PAR 3

Merion (East) ◆ 16
428 YARDS, PAR 4

St. Andrews (Old) ◆ 17
461 YARDS, PAR 4

Pebble Beach ◆ 18
548 YARDS, PAR 5

THE
MOST
SCENIC
HOLES

One of the most appealing things about golf is its propensity to bring us in touch with spectacular natural beauty. Nature's grandeur always makes the spirit soar, and that can be of great comfort—sometimes the *only* comfort—to golfers struggling with their game. Here, then, are eighteen wonderful holes on which to play badly.

The variety of scenic splendor reflects the diversity of playgrounds for golf, from mountains to deserts, parklands to forests, hillsides to tidal marshes. A few holes also play near the ocean, although not with the intimacy of those on pages 402–403. Here the sea is largely a backdrop, never a hazard.

Interestingly, only one par 5 made this list. That's likely because the true postcard holes present a single magnificent view that can be enjoyed from tee to green. For the same reason, many of these holes play steeply

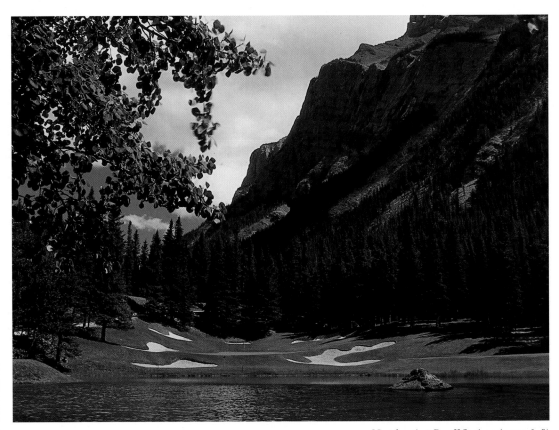

Number 4 at Banff Springs (pages 6–9)

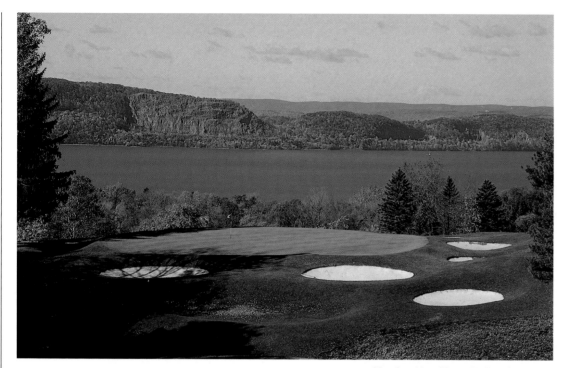

Number 16 at Sleepy Hollow (page 262)

downhill, with little curvature in the fairway—everything is right there in front of you, to be enjoyed and attacked.

But these are more than eighteen pretty faces. In each case, the visual elements enhance the design of the hole. (After all, a picturesque pond quickly loses its charm when the architect positions it in the center of the tee shot landing area.) However, the designers of these holes have taken a light hand, heeding the admonition of A. W. Tillinghast that "spectacular holes may be sadly overdone." Here, the only overpowering element is the view. Indeed, on these eighteen holes, keeping one's head down can be a true act of will.

Augusta National ✦ 10
485 YARDS, PAR 4

Bandon Dunes ✦ 4
415 YARDS, PAR 4

Banff Springs ✦ 4
171 YARDS, PAR 3

Castle Pines ✦ 10
485 YARDS, PAR 4

Crans-sur-Sierre ✦ 7
302 YARDS, PAR 4

Cruden Bay ✦ 4
193 YARDS, PAR 3

Desert Highlands ✦ 1
356 YARDS, PAR 4

Forest Highlands ✦ 9
478 YARDS, PAR 4

Harbour Town ✦ 18
478 YARDS, PAR 4

Kau Sai Chau (North) ✦ 14
205 YARDS, PAR 3

Loch Lomond ✦ 10
455 YARDS, PAR 4

The National ✦ 2
152 YARDS, PAR 3

Pelican Hill (North) ✦ 17
543 YARDS, PAR 5

Royal Antwerp ✦ 6
424 YARDS, PAR 4

Royal County Down ✦ 4
212 YARDS, PAR 3

Sleepy Hollow ✦ 16
150 YARDS, PAR 3

Tralee ✦ 17
353 YARDS, PAR 4

Whistling Straits ✦ 12
166 YARDS, PAR 3

THE
MOST
DIFFICULT
HOLES

"The majority of golfers are agreed, I think, that an ideal hole should be a difficult one."

There is no arguing with Dr. Alister Mackenzie that a hole must be difficult to be good. But what, exactly, does one mean by "difficult"? Perhaps the best way to define "hard" is by example, specifically that of the holes below. Take the famous Road hole, the seventeenth at St. Andrews. Every shot poses an element of difficulty—the drive over the outbuildings, the approach to the well-defended green, the putt whether from on or in front of that green, and every possible recovery shot (and there are many, be they from the deep bunker, the long rough, or the eponymous road). However, those very same shots can prove successful if played with a little smarts, a little skill, and a little luck.

What about the short tenth at Pine Valley? How hard can it be at

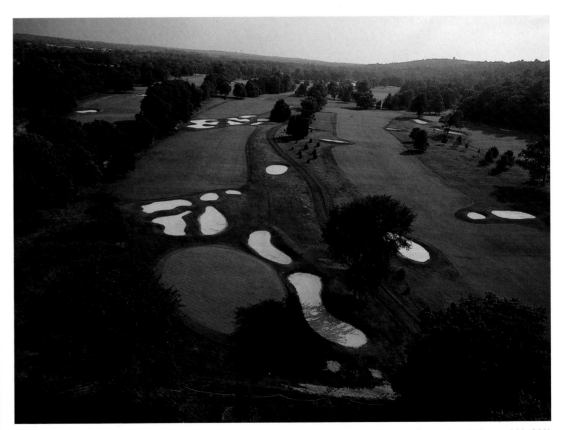

Baltusrol's number 17 (pages 208–209)

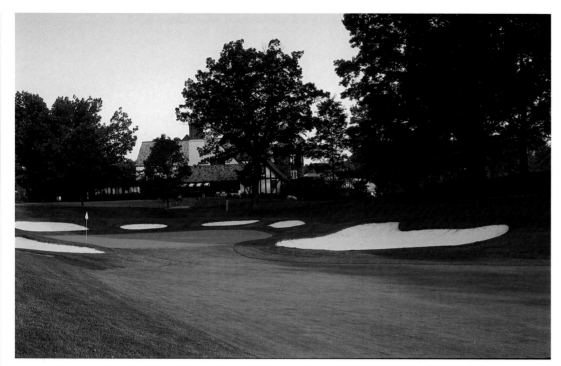

Number 13 at Oak Hill (East) (pages 232–233)

only 146 yards? It doesn't take much of a mistake to find out. Miss the small green and your ball could be consigned to the surrounding sand pit or worse, the diabolical (called "the Devil's Asshole") pot bunker in front. Even hitting the green offers no guarantee, as the surface undulates, requiring a graduate degree in reading to master it.

Much the same can be said for the other sixteen holes. They test the golfer's every swing, every fiber. With a famously hard hole, its reputation precedes it, so it becomes all the more difficult for the golfer standing on the tee, wondering what to do. This is often the same golfer who, walking off the green, curses the hole. "It does not by any means follow that when a player condemns a hole in particularly vigorous language he really dislikes it," said Dr. Mackenzie. "It may be a source of pleasure to his subconscious mind. Although condemning it, he may be longing to play it again so as to conquer its difficulties."

So add this to the definition of "hard": hard to resist.

Baltusrol (Lower) ✦ 17
630 YARDS, PAR 5

Bay Hill ✦ 18
441 YARDS, PAR 4

Blackwolf Run (River) ✦ 1
564 YARDS, PAR 5

Butler National ✦ 18
466 YARDS, PAR 4

Carnoustie (Championship) ✦ 16
250 YARDS, PAR 3

Colonial ✦ 5
466 YARDS, PAR 4

Cypress Point ✦ 16
233 YARDS, PAR 3

Firestone (South) ✦ 16
625 YARDS, PAR 5

Muirfield ✦ 9
504 YARDS, PAR 5

Oak Hill (East) ✦ 13
596 YARDS, PAR 5

Pebble Beach ✦ 8
431 YARDS, PAR 4

Pinehurst (No. 2) ✦ 5
482 YARDS, PAR 4

Pine Valley ✦ 10
146 YARDS, PAR 3

Quaker Ridge ✦ 6
446 YARDS, PAR 4

Royal Adelaide ✦ 14
447 YARDS, PAR 4

Royal Lytham and St. Annes ✦ 17
462 YARDS, PAR 4

Royal Troon (Old) ✦ 11
481 YARDS, PAR 4

St. Andrews (Old) ✦ 17
461 YARDS, PAR 4

THE MOST STRATEGIC HOLES

"The strategy of the golf course is the soul of the game. The spirit of golf is to dare a hazard, and by negotiating it reap a reward, while he who fears or declines the issue of the carry, has a longer or harder shot for his second . . . yet the player who avoids the unwise effort gains advantage over one who tries for more than in him lies, or who fails under the test."

Thank George C. Thomas—designer of Riviera, Bel-Air, and Los Angeles North—for an unassailable definition of strategy. Then reread his thoughts replacing "golf" and "golf course" with "golf hole" and you understand the list maker's dilemma.

Every hole on the list of the top five hundred in the world exhibits elements of strategy. Think about it: It is impossible for a hole to be great if it allows the golfer to hit the ball without wondering, worrying, and

The seventeenth at The National (pages 152–153))

Number 11 at St. Andrews (Old) (pages 118–119)

working to place it in a special location. It cannot be a great hole if there isn't an element of dare and negotiation, a chance to play for an advantage, the possibility of failing the test. It is the one trait all five hundred holes hold in common.

Now take that thought a step further: The qualities that make the holes on the following list great are what make golf great. Each hole, like the game itself, is an examination. How golfers study for and handle themselves in this crucible is the basis of golf's eternal attraction. Many have said that this game is special because it is the individual against the course. It is these holes that prove how good the course can be.

Leave it to Donald Ross to capture the gist of strategy—and, yes, the gist of the game—with the same economy and spirit he exhibited on his best designs: "A course that continually offers problems—one with fight in it, if you please—is the one that keeps the player keen for the game."

Augusta National ✦ 13
485 YARDS, PAR 5

Carnoustie (Championship) ✦ 17
459 YARDS, PAR 4

Crystal Downs ✦ 5
353 YARDS, PAR 4

Dorado Beach (East) ✦ 13
540 YARDS, PAR 5

The National ✦ 17
368 YARDS, PAR 4

New South Wales ✦ 6
193 YARDS, PAR 3

Oak Hill (East) ✦ 7
432 YARDS, PAR 4

Oxfordshire ✦ 17
585 YARDS, PAR 5

Quaker Ridge ✦ 6
446 YARDS, PAR 4

Riviera ✦ 10
311 YARDS, PAR 4

Royal Dornoch ✦ 14
459 YARDS, PAR 4

Royal St. George's ✦ 4
470 YARDS, PAR 4

St. Andrews (Old) ✦ 11
172 YARDS, PAR 3

Seminole ✦ 6
383 YARDS, PAR 4

Sperone ✦ 16
580 YARDS, PAR 5

Valderrama ✦ 4
535 YARDS, PAR 5

Wentworth (West) ✦ 17
571 YARDS, PAR 5

Yale ✦ 4
443 YARDS, PAR 4

THE
MOST
HEROIC
HOLES

Although heroic holes have been a part of the golf landscape since the very first designs, it was Robert Trent Jones, Sr., circa 1950, who first classified them as an architectural genre. Heroic refers to the kind of hole that gives a clear advantage to the player who can attempt and pull off a shot of significant length and boldness. Usually, this involves a drive (or second shot on a par 5) over a hazard or other peril, and ideally that hazard sits on a diagonal to the play, so that each player has the thrill of biting off his or her own chunk of challenge.

The ultimate such hole may be number 13 at the much beloved Augusta National. Its sharply leftward bending fairway cries out for an aggressive hook around the corner, the reward for which is a still-lengthy approach to a green, fronted by scenic water—another call for heroism. If either of these shots is misplayed, the penalty can be severe, but if both

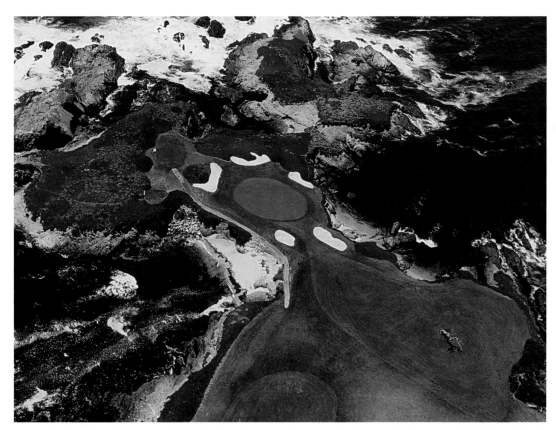

Cypress Point's sixteenth hole (pages 92–93)

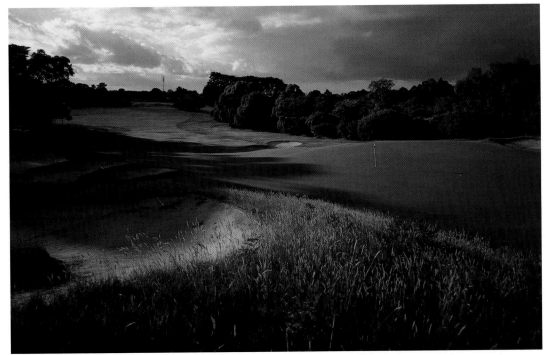

Royal Melbourne's sixth hole (pages 46–49)

are struck extremely well, the prize is a putt for an eagle or a birdie.

The good news on heroic holes is that there is always another route, a safer play for those of weaker heart (or stronger self-control). For instance, those who are unable or unwilling to risk the 220 or so liquid yards required by the tee shot at the par-3 sixteenth at Cypress Point may bail out with a short- or mid-iron to a strip of fairway well short and left of the green. The next shot may be a full wedge or more, but at least there will be a next shot, as opposed to a penalty stroke.

The heroic hole is golf's quintessential gut check—a simultaneous test of competence and confidence. As such, these eighteen may be the most exhilarating holes of all.

Augusta National ✦ 13
485 YARDS, PAR 5

Cherry Hills ✦ 17
548 YARDS, PAR 5

Cypress Point ✦ 16
233 YARDS, PAR 3

Doral (Blue) ✦ 18
443 YARDS, PAR 4

The Dunes ✦ 13
590 YARDS, PAR 5

Glen Abbey ✦ 14
426 YARDS, PAR 4

Kapalua (Plantation) ✦ 5
532 YARDS, PAR 5

Las Brisas ✦ 8
507 YARDS, PAR 5

Machrihanish ✦ 1
423 YARDS, PAR 4

Mauna Kea ✦ 3
210 YARDS, PAR 3

Mid Ocean ✦ 5
433 YARDS, PAR 4

Pebble Beach ✦ 18
548 YARDS, PAR 5

PGA West (Stadium) ✦ 9
452 YARDS, PAR 4

Royal Melbourne (West) ✦ 6
450 YARDS, PAR 4

St. Andrews (Old) ✦ 17
461 YARDS, PAR 4

TPC at Sawgrass (Stadium) ✦ 18
440 YARDS, PAR 4

World Woods (Pine Barrens) ✦ 15
330 YARDS, PAR 4

Yale ✦ 4
443 YARDS, PAR 4

THE
MOST
PENAL
HOLES

It's easy to understand how someone could confuse the "most diffi-cult" holes with the "most penal." But there is a difference, and, we'd argue, it isn't all that subtle. A difficult hole is tough on every shot, yet usually affords a recovery. Penal is hard, it's true (brutally so, in most cases), but the chances for a recovery after a mistake are slim and none. That helps explain why the list is heavy with par 3s (you have only one shot, so make it a good one) and par 5s (where distance is tempered by at least one do-or-die attempt).

Many times, a penal hole is dictated by its geography. Take a look at the list here and you see that missing by just a little bit at some of these will result in your ball finding a fairly impressive list of watery graves: Lake Michigan, the Pacific Ocean, the Irish Sea, the Atlantic Ocean, the Strait of Bonifacio, the Celtic Sea. The other holes may present less

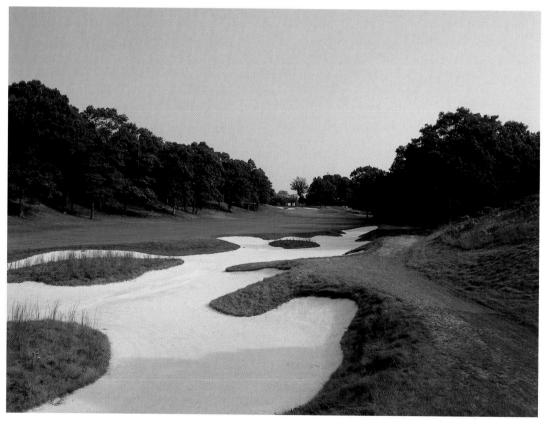

The fifth at Bethpage (Black) (pages 26–29)

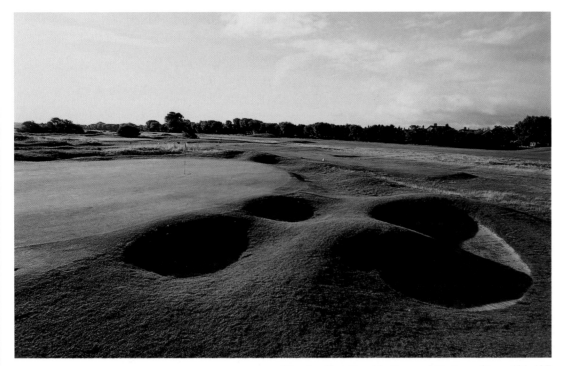
Number 17 at Royal Lytham and St. Annes (pages 184–185)

romantic-sounding points of no return, but there is no love in trying to find (let alone hit) your ball from Oakmont's Church Pews bunker, a Tillinghast cross bunker, two sets of Scottish railroad tracks, or any manner of sand-filled hazard brought into play by Pete Dye or his nineteenth-century predecessors.

And we dare not forget another creation by Mr. Dye (is it something about his name?), the unnamed pond that surrounds the island-green seventeenth hole at the TPC at Sawgrass.

These are the holes that bring real meaning to the word "hazard." Some are natural, showing off a raw beauty of rugged cliffs and crashing surf. Others have been stuck there by man. Man-made or a natural wonder, each of these holes stands up straight, gets in your face, and double-dares you. They all have chutzpah, *cojones,* gall. They stand toe-to-toe and all but scream, "Take your best shot!" And you'd better.

Hate these holes if you like, but give them their due. For they are very often what people remember best—often for making them play their worst.

Bay Harbor (Links) ✦ 7
500 YARDS, PAR 5

Bay Hill ✦ 17
223 YARDS, PAR 3

Bethpage (Black) ✦ 4
522 YARDS, PAR 5

Cypress Point ✦ 16
233 YARDS, PAR 3

Fishers Island ✦ 4
397 YARDS, PAR 4

Kiawah (Ocean) ✦ 4
432 YARDS, PAR 4

The National ✦ 2
152 YARDS, PAR 3

Oakmont ✦ 3
425 YARDS, PAR 4

Old Head ✦ 17
628 YARDS, PAR 5

PGA West (Stadium) ✦ 16
566 YARDS, PAR 5

Prestwick (Old) ✦ 1
346 YARDS, PAR 4

Royal County Down ✦ 4
212 YARDS, PAR 3

Royal Lytham and St. Annes ✦ 17
462 YARDS, PAR 4

Royal Portrush (Dunluce) ✦ 14
210 YARDS, PAR 3

Royal Troon (Old) ✦ 11
481 YARDS, PAR 4

Sperone ✦ 16
580 YARDS, PAR 5

TPC at Sawgrass (Stadium) ✦ 17
132 YARDS, PAR 3

Vale do Lobo (Yellow) ✦ 7
196 YARDS, PAR 3

THE
LONGEST
HOLES

Depending on your definition of "longest," the following holes may or may not be the mean eighteen. If, however, you consider pure yardage as the sole criterion, then these are unequivocally the right ones: the four longest par 5s, ten longest par 4s, and four longest par 3s among our famed five hundred.

Of course, other factors can contribute mightily to the "playing yardage" of a hole. Elevation change from tee to green and prevailing wind are the two most common, while sufficient altitude above sea level can shorten a hole up to 15 percent. However, since the calibration of such factors is an inexact science, we chose to go with the safety in numbers.

At 723 yards—yes, 723 yards—the longest hole on the list belongs to a club with one of the longest names—The Gallery at Dove Mountain.

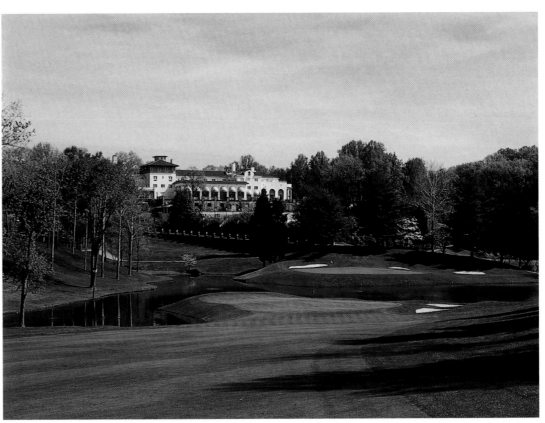

Number 17 at Congressional (Blue) (pages 132–133)

Royal Troon's eleventh hole (pages 190–191)

Thankfully, it does play downhill from an elevated tee to a dry, hard fairway, and the high and dry air of Tucson surely adds a bit to the ball's flight. Still, this is one par 5 that does not yield putts for eagle.

The longest par 4 among the five hundred comes from our elite top eighteen—number 9 at Royal County Down. For years this beauty, played from an elevated tee to a valley amid two lines of sand hills, had been played largely as a par 5, with only the front tee used as a 4. Now it's one tough and wonderful 4, no matter where you put your peg.

Surely the single sternest demand comes from the sixteenth at Carnoustie, a par 3 of 250 yards—and that's over dead flat terrain at sea level. The prevailing breeze is mercifully helpful, for in a stiff headwind not even Tiger Woods could find this green. When Tom Watson won the first of his five British Opens here, in 1975, he never scored better than a bogey at 16, in five attempts including the playoff.

Par for these eighteen holes is 72—the distance: 8,401 yards.

The Gallery at Dove Mountain ✦ 9
723 YARDS, PAR 5

Gulf Harbour ✦ 17
648 YARDS, PAR 5

Baltusrol (Lower) ✦ 17
630 YARDS, PAR 5

Old Head ✦ 17
628 YARDS, PAR 5

Royal County Down ✦ 9
486 YARDS, PAR 4

Augusta National ✦ 10
485 YARDS, PAR 4

Royal Troon (Old) ✦ 11
481 YARDS, PAR 4

Cherry Hills ✦ 14
480 YARDS, PAR 4

Congressional (Blue) ✦ 17
480 YARDS, PAR 4

Hamburger (Falkenstein) ✦ 17
480 YARDS, PAR 4

Naruo ✦ 10
480 YARDS, PAR 4

Olivos ✦ 15
480 YARDS, PAR 4

Forest Highlands ✦ 9
478 YARDS, PAR 4

Harbour Town ✦ 18
478 YARDS, PAR 4

Carnoustie (Championship) ✦ 16
250 YARDS, PAR 3

Los Angeles (North) ✦ 3
244 YARDS, PAR 3

Riviera ✦ 3
236 YARDS, PAR 3

Puerto Azul ✦ 17
234 YARDS, PAR 3

THE
BEST
SHORT
PAR 4s

Enumerating the "essential features of an ideal golf course," Alister Mackenzie insisted upon "two or three drive-and-pitch holes." Typically, the short par 4, usually running between 250 and 375 yards, is inserted as a "breather," the chance for golfers to catch their breath and pencil in a good score. But that's not what Dr. Mackenzie had in mind. Nor did we when compiling this list.

The best of the short two-shotters put a premium on artfulness, accuracy, and acumen. Driver is rarely the smart play off the tee, because the landing area for even a mediocre tee shot is usually narrow or non-existent. So the question becomes, Which club should be hit to find the perfect landing area (a spot, usually small, that is safe, flat, and offers a view of the flag), while leaving the best approach to a green that is often a well-guarded minefield of undulations, slopes, and secrets?

Number 1 at Prestwick (pages 172–173)

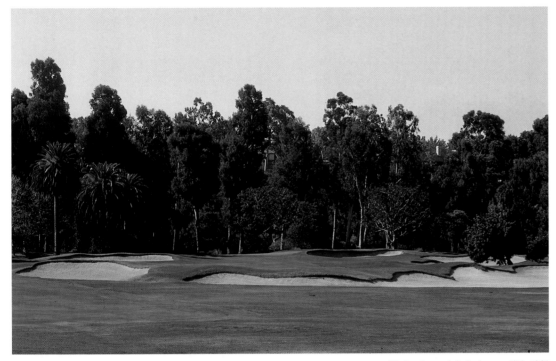

Riviera's tenth hole (pages 176–177)

Note two qualities of our short-listed short holes. First, while most are of classic vintage, a few (including Muirfield Village, Mauna Kea, Sand Hills, Clearwater Bay) have been built in the modern era, proving that the concept endures. Second, the average length of the holes on this list is only 332 yards, a distance increasingly coming into the range of the new breed of long hitters. However, rarely will even the bombers "go for the green" off the tee of one of these little devils. And if they do, it will only be after giving the matter much thought.

Indeed, it is the need to ruminate before every swing that gives these short holes their lengthy reputations.

Clearwater Bay ✦ 14
345 YARDS

The Country Club (Open) ✦ 4
334 YARDS

Crans-sur-Sierre ✦ 7
302 YARDS

Crystal Downs ✦ 5
353 YARDS

Dinard ✦ 5
349 YARDS

Double Eagle ✦ 17
355 YARDS

GC de Uruguay ✦ 16
310 YARDS

Mauna Kea ✦ 6
344 YARDS

Milwaukee ✦ 9
332 YARDS

Muirfield Village ✦ 14
363 YARDS

North Berwick (West) ✦ F 7
354 YARDS

Prestwick (Old) ✦ 1
346 YARDS

Ridgewood (Center) ✦ 6
289 YARDS

Riviera ✦ 10
311 YARDS

Royal Adelaide ✦ F 3
301 YARDS

Sand Hills ✦ 7
283 YARDS

Shoreacres ✦ 11
352 YARDS

Tralee ✦ 17
353 YARDS

THE
BEST
MOUNTAIN
HOLES

The first question should be: "Are there eighteen great mountain holes in the world?" Yes, but only if you indulge us some expansion of the definition.

As should be obvious, mountains are not very conducive to the construction of golf courses. While architects like to play with elevation, mountains take such changes to a sometimes unplayable extreme. Playing on a mountain forces the creation of more blind holes and uphill and downhill lies than even the most sadistic designer desires. From a more practical (and liability) standpoint, there are the problems of scaling an alpine course with clubs on one's back (or the back of a golf cart), to be followed by descending safely, particularly down severely pitched cart paths or long grass coated in mountain dew.

Then there's the effect of altitude on distance. At Castle Pines, for

The fifteenth at Troon (page 263)

Number 9 at Royal County Down (pages 42–45)

example, which rises nearly seven thousand feet high in the Colorado Rockies, the par-4 tenth hole (485 yards when the PGA Tour is in town for the International; 420 yards for the rest of us) can play as much as 10 to 15 percent shorter thanks to the thinned air. Players should be wary of nosebleeds!

All that said, there are a number of courses built if not on, then around and through, significant hills. We also included layouts that offer breathtaking views of mountains, bringing into play the American Southwest—where holes cozy up against jagged red peaks—New England, and some great holes in Europe. For example, the tee of the magnificent ninth at Royal County Down looks down the fairway and straight up at the Mountains of Mourne; the fifteenth at Royal St. David's in Wales sits in the shadows of the hills of Snowdonia; Vermont's historic Green Mountains surround the seventh at Ekwanok; and the seventh at Crans-sur-Sierre is in Switzerland—enough said.

However, we did not include either the fifth or seventeenth hole at Prestwick despite their names, Himalayas and Alps. Even we couldn't elevate the rules that far.

Banff Springs ✦ 4
171 YARDS, PAR 3

Cascades ✦ 12
476 YARDS, PAR 4

Castle Pines ✦ 10
485 YARDS, PAR 4

Crans-sur-Sierre ✦ 7
302 YARDS, PAR 4

Edgewood Tahoe ✦ 18
591 YARDS, PAR 5

Ekwanok ✦ 7
597 YARDS, PAR 5

The Gallery at Dove Mountain ✦ 9
723 YARDS, PAR 5

Highland Links ✦ 6
537 YARDS, PAR 5

Kananaskis (Mount Kidd) ✦ 4
197 YARDS, PAR 3

La Quinta (Mountain) ✦ 16
168 YARDS, PAR 3

Las Brisas ✦ 8
507 YARDS, PAR 5

Linville ✦ 3
455 YARDS, PAR 4

Loch Lomond ✦ 6
625 YARDS, PAR 5

Royal County Down ✦ 9
486 YARDS, PAR 4

Royal St. David's ✦ 15
486 YARDS, PAR 4

Troon ✦ 15
139 YARDS, PAR 3

Villa d'Este ✦ 15
454 YARDS, PAR 4

Wade Hampton ✦ 18
555 YARDS, PAR 5

THE
BEST
OCEAN
HOLES

Golf was born at the edge of the sea, and for half a millennium the ocean has been the game's most breathtaking hazard. Today, only a handful of the world's twenty-five thousand courses are sited along the coast, but most of those so blessed are world-renowned, from Pebble Beach to Turnberry, Casa de Campo to New South Wales.

The holes listed here combine spectacular scenery with unrelenting challenge. Two of them come from ancient links—Machrihanish and Ballybunion—but the majority are modern holes, put into play after 1970. Some of them wind precariously along the brink of the sea while others—such as number 16 at Cypress Point—tackle the ocean head on. Ten of the holes here are par 3s, calling for a single death-defying shot across the sea, while the par 4s and 5s tend to taunt the players, testing not only their length and accuracy but their discretion and valor as well.

The sixth at New South Wales (pages 100–101)

Number 17 at Wild Dunes (page 299)

Above all, these holes reflect Plato's observation that the artistry of man cannot match that of nature. Architectural guile is generally absent from this list. In each case, the designer's chief contribution was to "find" the hole and then restrain himself, allowing the elements to reign. Thus, other holes may be more strategically inventive than those on this list, but it is these holes, above all, that exemplify the architect's central mission, a goal best expressed by Cypress Point's designer Alister Mackenzie: "to give the player as much pleasurable excitement as possible."

Ballybunion (Old) (Atlantic Ocean) ✦ 11
453 YARDS, PAR 4

Cabo del Sol (Pacific Ocean) ✦ 17
178 YARDS, PAR 3

Casa de Campo (Teeth of the Dog) (Caribbean Sea) ✦ 15
384 YARDS, PAR 4

The Challenge at Manele (Pacific Ocean) ✦ 12
202 YARDS, PAR 3

Cypress Point (Pacific Ocean) ✦ 16
233 YARDS, PAR 3

El Saler (Mediterranean Sea) ✦ 17
215 YARDS, PAR 3

The European Club (Irish Sea) ✦ 13
596 YARDS, PAR 5

Machrihanish (where the Sound of Jura meets the Irish Sea) ✦ 1
423 YARDS, PAR 4

Mauna Kea (Pacific Ocean) ✦ 3
210 YARDS, PAR 3

Mauna Lani (South) (Pacific Ocean) ✦ 15
196 YARDS, PAR 3

New South Wales (Botany Bay) ✦ 6
193 YARDS, PAR 3

Old Head (Celtic Sea) ✦ 17
628 YARDS, PAR 5

Pebble Beach (Pacific Ocean) ✦ 7
107 YARDS, PAR 3

Port Royal (Atlantic Ocean) ✦ 16
176 YARDS, PAR 3

Sperone (Mediterranean Sea) ✦ 16
580 YARDS, PAR 5

Turnberry (Ailsa) (Irish Sea) ✦ 9
455 YARDS, PAR 4

Vale do Lobo (Yellow) (Atlantic Ocean) ✦ 7
196 YARDS, PAR 3

Wild Dunes (Atlantic Ocean) ✦ 17
405 YARDS, PAR 4

THE BEST WATER HOLES (NON-OCEAN)

The most famous water holes are those that incorporate the ocean—found in another list in this section. They are almost always described as "dramatic." But a number of inland water holes are similarly dramatic productions. The "island-green" seventeenth hole at the TPC at Sawgrass, the fourth at Baltusrol, and the fourth at Banff Springs—all demanding forced carries over expansive ponds—are as throat-tightening as any transatlantic or transpacific excursion.

As for most of the rest of the top water holes? They are less about drama and more about mystery. How should they be played? How close can one stay near the water (which is usually the most advantageous line) without taking a bath? How can one win without getting wet?

The liquid assets in question are ponds, streams, creeks, rivers, lakes, even waterfalls sometimes placed parallel to the line of play, some-

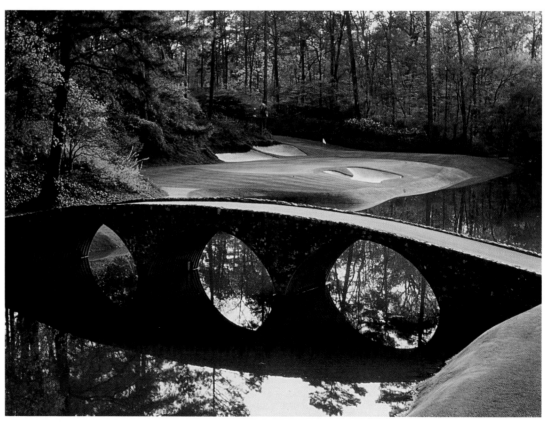

Augusta National's twelfth hole (pages 84–85)

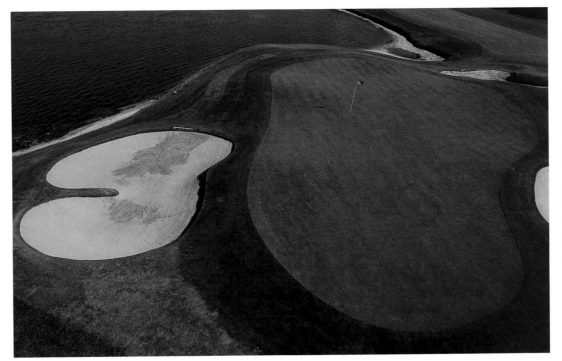

Number 11 at The Lakes (page 378)

times crossing, sometimes both. Perhaps the game's most famous body of water is Rae's Creek, which runs through Amen Corner at Augusta National, a course Mackenzie designed with Bobby Jones. Only a few feet wide, it plays a starring role at holes 12 and 13: Crossing in front of the green at the par-3 twelfth, it forces an exact lofted shot to a narrow surface backed by sand and woods. At the thirteenth, it runs along the left side of the fairway, then cuts in front of the green, so it can come into play twice—when the drive on the right-to-left hole has too much draw and again when players go for the green in two on the short par 5. This meandering brook, which also flows into play on the eleventh hole, makes the back nine at Augusta among the greatest stretches of golf in the world.

Augusta National ✦ 12
155 YARDS, PAR 3

Augusta National ✦ 13
485 YARDS, PAR 5

Baltusrol (Lower) ✦ 4
194 YARDS, PAR 3

Banff Springs ✦ 4
171 YARDS, PAR 3

Bay Hill ✦ 18
441 YARDS, PAR 4

Carnoustie (Championship) ✦ 17
459 YARDS, PAR 4

Chapman ✦ 6
459 YARDS, PAR 4

Congressional (Blue) ✦ 17
480 YARDS, PAR 4

The Creek ✦ 11
195 YARDS, PAR 3

Doral (Blue) ✦ 18
443 YARDS, PAR 4

The Dunes ✦ 13
590 YARDS, PAR 5

Falsterbo ✦ 11
160 YARDS, PAR 3

The Lakes ✦ 11
578 YARDS, PAR 5

Navatanee ✦ 6
457 YARDS, PAR 4

Oakland Hills (South) ✦ 16
405 YARDS, PAR 4

TPC at Sawgrass (Stadium) ✦ 17
132 YARDS, PAR 3

Whistling Straits (Straits) ✦ 12
166 YARDS, PAR 3

Yale ✦ 4
443 YARDS, PAR 4

THE
BEST
HOLES
WITH
BUNKERS

Not every great hole has a bunker, but the majority do. So is the presence of sand a prerequisite to greatness? No. But a bunker, perhaps more than any other hazard, can turn an everyday hole into an extraordinary one.

Ironically, bunkers, which most golfers seek protection from, began as a form of protection. The first were created by the sheep that grazed on the scruffy linksland that separated the arable upland from the beach. Trying to escape the winds that buffeted the shore, the sheep burrowed into hillsides, eventually wearing away the vegetation and exposing the sand beneath. The golfers who played on the early "links" incorporated these burrows into their games, quickly learning that it took special skill (and, for many, special equipment) to escape them.

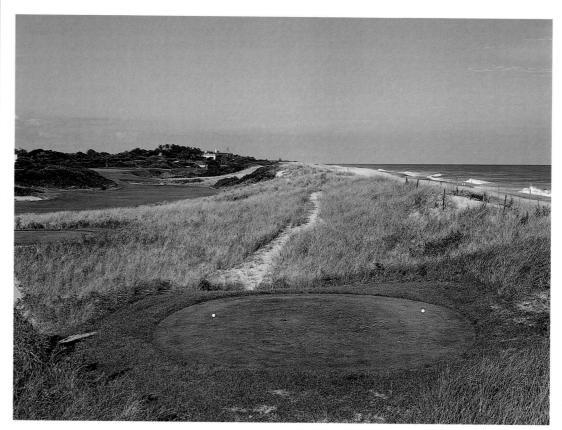

Maidstone's ninth hole (pages 148–149)

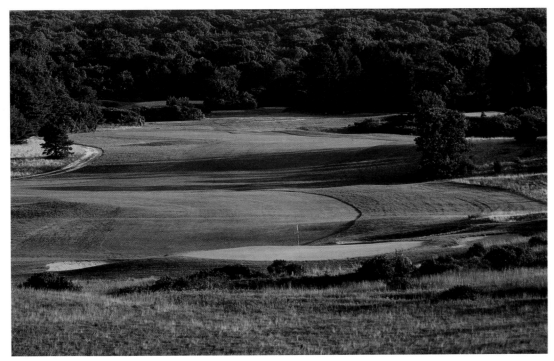

The sixteenth at Shinnecock Hills (pages 236–237)

The human course designers who followed borrowed the concept of burrows from the ovine architects, realizing that cleverly sited, they could force players to hit over, around, or away from them. So bunkers became one of the first strategic elements used by man in what had been, for hundreds of years, a game of natural occurrences.

The key to good bunkering is location, location, location. Although he was speaking of all hazards, Alister Mackenzie definitely was thinking about bunkers when he wrote, "Hazards should be placed with an object in mind, and not one should be made which has not some influence on the line of play to the hole." Donald Ross was more succinct, if less charitable, when he said, "Regardless of where a bunker may be, it is the business of the player to avoid it."

The holes on this list should not be avoided: Their bunkering is as good as it gets. And their bunkers are not only those positioned greenside, but also ones that cross and line fairways. Their unifying principle is strategy, as they all force the player, as Ross directed, to stay as far away as possible—but not so far as to leave one's ball out of position or, worse, find another hazard.

Baltusrol (Lower) ✦ 17
630 YARDS, PAR 5

Bethpage (Black) ✦ 4
522 YARDS, PAR 5

Canterbury ✦ 18
438 YARDS, PAR 4

Carnoustie (Championship) ✦ 6
578 YARDS, PAR 5

Kawana ✦ 13
395 YARDS, PAR 4

Maidstone ✦ 9
402 YARDS, PAR 4

Muirfield ✦ 13
159 YARDS, PAR 3

Oakmont ✦ 3
425 YARDS, PAR 4

Old Warson ✦ 14
360 YARDS, PAR 4

Pine Valley ✦ 10
146 YARDS, PAR 3

Prairie Dunes ✦ 8
430 YARDS, PAR 4

Royal Birkdale ✦ 18
472 YARDS, PAR 4

Royal St. George's ✦ 15
467 YARDS, PAR 4

St. Andrews (Old) ✦ 17
461 YARDS, PAR 4

Shinnecock Hills ✦ 16
542 YARDS, PAR 5

Southport & Ainsdale ✦ 16
510 YARDS, PAR 5

Winged Foot (West) ✦ 10
190 YARDS, PAR 3

Yomiuri ✦ 18
224 YARDS, PAR 3

THE HARDEST-TO-PUTT GREENS

If, as architect Charles Blair Macdonald opined, "Putting greens are to golf courses what faces are to portraits," then what follows is a rogues' gallery of the game's meanest mugs. On these surfaces, three-putting is not a possibility; it's an achievement.

Each has a face as captivating as the Mona Lisa's. But along with the art comes artifice—these greens that command our close attention, whether the assignment is to attack from 200 yards or two-putt from 20 feet.

Essentially, the difficulty of any putting green depends on two elements—speed and contour, and these surfaces have both in abundance. Most of them were constructed before the age of the power mower, when even the fastest greens were perhaps half the speed of the fastest today. So golf course architects felt free to design surfaces with severe slopes. With

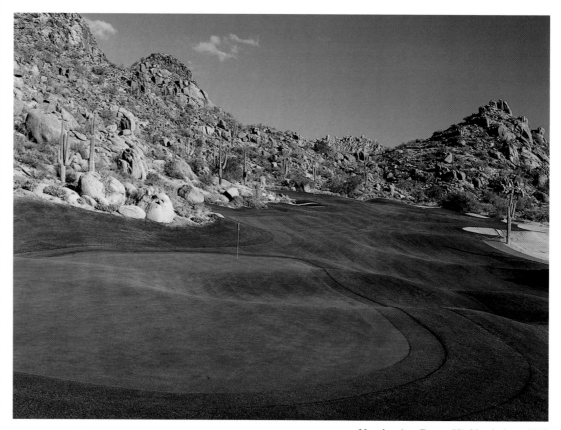

Number 1 at Desert Highlands (page 275)

The fifth at Pinehurst (No. 2) (pages 168–169)

the advent of modern greenkeeping equipment, however, those slopes became treacherous. On these greens, distance from the hole can be less important than angle of attack—your prospects on a 30-footer from the safe side are invariably better than on a 5-footer from the panic zone.

It's not coincidental that the holes on this list come from some of the best-known courses in the world. Clubs such as Augusta National, Pine Valley, and Oakmont are justifiably famed not only for the challenge and charm of their courses, but for the decades of care they've bestowed on their turf. These greens may be nasty to putt, but they're never in poor condition.

Augusta National ✦ 13
485 YARDS, PAR 5

The Creek ✦ 6
453 YARDS, PAR 4

Desert Highlands ✦ 1
356 YARDS, PAR 4

The Dunes ✦ 13
590 YARDS, PAR 5

Kingston Heath ✦ 6
431 YARDS, PAR 4

Myopia Hunt ✦ 4
392 YARDS, PAR 4

Oakmont ✦ 18
453 YARDS, PAR 4

Olympic (Lake) ✦ 18
338 YARDS, PAR 4

Pebble Beach ✦ 8
431 YARDS, PAR 4

Pinehurst (No. 2) ✦ 5
482 YARDS, PAR 4

Pine Valley ✦ 13
448 YARDS, PAR 4

Royal Troon (Old) ✦ 8
129 YARDS, PAR 3

St. Andrews (Old) ✦ 11
172 YARDS, PAR 3

St. Louis ✦ 3
203 YARDS, PAR 3

Shinnecock Hills ✦ 11
158 YARDS, PAR 3

Stanwich ✦ 17
568 YARDS, PAR 5

Winged Foot (West) ✦ 10
190 YARDS, PAR 3

Yale ✦ 9
211 YARDS, PAR 3

THE
BEST
GREENSITES
IN THE
WORLD

Be careful when reading the title of this list. Note that it is not the best greens in the world, but rather the best "green*sites.*" The difference is neither subtle nor unimportant.

The green—the putting surface—is a tabletop that has been made difficult by the clever application of speed, size, slope, and undulation. Indeed, the other relevant listing in this section is for "hardest-to-put-greens," with hardness a mostly subjective estimate of the golfer's potential success rolling the ball on that surface to the hole.

The greensite—or "green complex"—is not only the putting surface but also its surroundings, the room in which the table is located. But the room plays a role almost as important (some say more) than the table itself: When the architect has done his job well, the surrounding area exerts a powerful influence on how you approach the green.

The fourth at Valderrama (pages 244–245)

Number 13 at Salem (page 294)

The architect can draw on many disparate elements in creating a greensite. One of the most telling is the location: For example, a green cut into the top of a mound (like the eighth at Royal Troon) presents a different challenge from one set in a bowl (the thirteenth at Oak Hill). Then there is the use and placement of greenside hazards—bunkers, water, mounds, trees and other plantings (consider the azaleas and other flowering shrubs behind holes 12 and 13 at Augusta National, which often come into play). Slopes around a green can have a notable effect on the choice of approach shots and how they are accepted or repelled: Good examples include Ross's crowned greens at Pinehurst, the Redan design first seen at North Berwick (and copied on many other courses), and Mackenzie's ramp down the front of the tenth at Winged Foot. Then there is the threat of trouble, such as the Pacific Ocean behind the seventh at Pebble Beach and the Atlantic Ocean along the left side of the fifth at Mid Ocean: Neither water hazard should come into play, but just knowing they're there (and how can one not?) works on a player's mind.

Take nothing away from the greens themselves, but in the examples listed, it is the chocolate around the cream filling that is the treat.

Augusta National ✦ 12
155 YARDS, PAR 3

Augusta National ✦ 13
485 YARDS, PAR 5

Congressional (Blue) ✦ 17
480 YARDS, PAR 4

The Honors Course ✦ 15
443 YARDS, PAR 4

Kittansett ✦ 3
165 YARDS, PAR 3

Mid Ocean ✦ 5
433 YARDS, PAR 4

Muirfield ✦ 13
159 YARDS, PAR 3

North Berwick (West) ✦ 15
192 YARDS, PAR 3

Oak Hill (East) ✦ 13
596 YARDS, PAR 5

Pasatiempo ✦ 16
395 YARDS, PAR 4

Pebble Beach ✦ 7
107 YARDS, PAR 3

Pinehurst (No. 2) ✦ 5
482 YARDS, PAR 4

Plainfield ✦ 12
585 YARDS, PAR 5

Royal Troon (Old) ✦ 8
129 YARDS, PAR 3

St. Andrews (Old) ✦ 11
172 YARDS, PAR 3

Salem ✦ 13
342 YARDS, PAR 4

Valderrama ✦ 4
535 YARDS, PAR 5

Winged Foot (West) ✦ 10
190 YARDS, PAR 3

THE
BEST
HOLES
IN
AMERICA

Since 266 holes on the top 500 are from the United States, the task of selecting the best 18 was daunting. Fortunately, half the job was done, as 10 holes from the all-world list are American-made. For help on the back 8, we polled the American members of *Golf Magazine*'s top hundred courses in the world panel, then applied the criterion that holds for all of the top-eighteen lists: a maximum of 1 hole per course.

Not surprisingly, the classic designs predominated. Only one hole on this list—the seventeenth at the Tournament Players Club at Sawgrass— was designed after 1966, and all but four appeared before 1950, with Charles Blair Macdonald's Redan hole, number 4 at The National Golf Links (1911), the eldest of the eighteen holes. Architect Alister Mackenzie leads the way with three holes on the list, followed by A. W. Tillinghast and Robert Trent Jones, Sr., with two each.

Number 16 at Merion (pages 30–33)

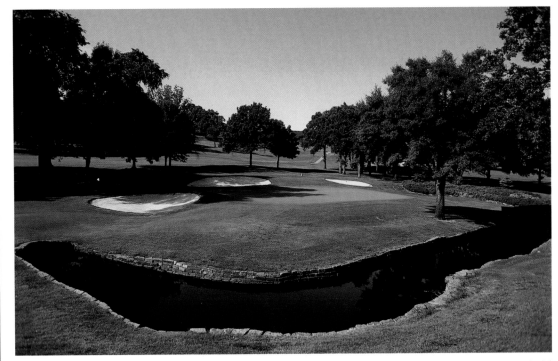

Number 12 at Southern Hills (pages 58–61)

Our composite course is big and brawny—a par 72 of 7,235 yards—reflecting the bold and expansive American mien. The ten par 4s here average a bruising 437 yards, while one of the 5s weighs in at 590.

Geographically, the eighteen holes are reasonably well dispersed, with seven holes in the Northeast, five in the South, three in the middle of the country, and three on the West Coast. Interestingly, although fourteen of the holes come from coastal states, the ocean comes into play only twice. However, lakes or streams lurk on another half dozen, along with a host of dehydrated perils, from church pew–like bunkers to knee-deep fescue to a fifty-foot-deep quarry.

Augusta National ✦ 13
485 YARDS, PAR 5

Bethpage (Black) ✦ 5
455 YARDS, PAR 4

Colonial ✦ 5
466 YARDS, PAR 4

Crystal Downs ✦ 8
550 YARDS, PAR 5

Cypress Point ✦ 15
139 YARDS, PAR 3

Doral (Blue) ✦ 18
443 YARDS, PAR 4

The Dunes ✦ 13
590 YARDS, PAR 5

Merion (East) ✦ 16
428 YARDS, PAR 4

The National ✦ 4
197 YARDS, PAR 3

Oakmont ✦ 3
425 YARDS, PAR 4

Pebble Beach ✦ 18
548 YARDS, PAR 5

Pinehurst (No. 2) ✦ 5
482 YARDS, PAR 4

Pine Valley ✦ 13
448 YARDS, PAR 4

Shinnecock Hills ✦ 14
447 YARDS, PAR 4

Southern Hills ✦ 12
445 YARDS, PAR 4

Spyglass Hill ✦ 4
365 YARDS, PAR 4

TPC at Sawgrass (Stadium) ✦ 17
132 YARDS, PAR 3

Winged Foot (West) ✦ 10
190 YARDS, PAR 3

THE
BEST
HOLES
IN
EUROPE

Nine different countries are represented among these eighteen holes, in an array of architectural primacy that is as diverse as Europe itself—from the Atlantic Ocean to the Alps, links to moorland, palm groves to pine forests. Spain and Portugal lead the way with four holes apiece, followed by France with three. Sweden claims two holes while Belgium, Germany, Holland, Italy, and Switzerland check in with one hole each.

Several of these courses have played host to European Tour events, including, most prominently, Valderrama, also site of the 1997 Ryder Cup matches, and its neighbor on the Costa del Sol, Las Brisas, which hosted the World Cup in 1973 and 1989.

Golf was played in pockets of Europe well over a century ago, but only among the wealthy. It didn't begin to catch on with the general

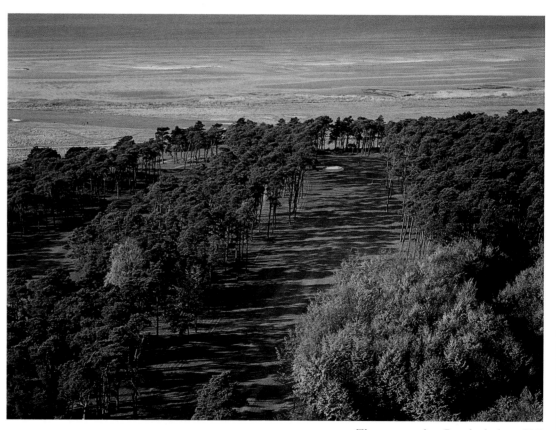

The seventeenth at Barsebacks (page 351)

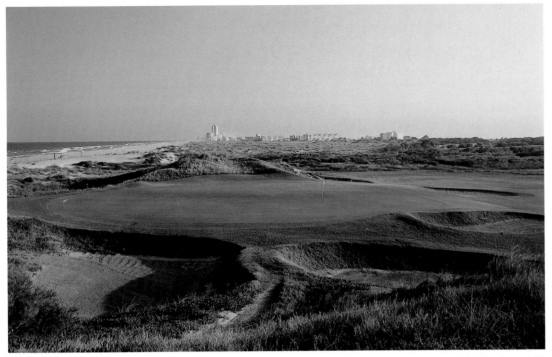

The seventeenth at El Saler (page 347)

public the way it did in America and the British Isles until the 1980s.

Thus, like Europe itself, this is a mixture of traditional and modern. The holes at Chantilly, Frankfurter, Kennemer, and Royal Antwerp date back more than half a century, while Crans-sur-Sierre came from the modern drawing board of Jack Nicklaus. In between, Robert Trent Jones, Sr., was active, designing a third of the holes on this list.

Most of the top European courses are private, but with a bit of ingenuity and a good travel agent, access can be gained to all of the holes listed here.

Barsebacks (New), Sweden ✦ 17
440 YARDS, PAR 4

Castelconturbia (Yellow), Italy ✦ 7
383 YARDS, PAR 4

Chantilly (Vineuil), France ✦ 18
596 YARDS, PAR 5

Crans-sur-Sierre, Switzerland ✦ 7
302 YARDS, PAR 4

El Saler, Spain ✦ 17
215 YARDS, PAR 3

Falsterbo, Sweden ✦ 11
160 YARDS, PAR 3

Frankfurter, Germany ✦ 18
432 YARDS, PAR 4

Kennemer, Holland ✦ 1
452 YARDS, PAR 4

Las Brisas, Spain ✦ 8
507 YARDS, PAR 5

Morfontaine, France ✦ 7
430 YARDS, PAR 4

Penha Longa, Portugal ✦ 6
520 YARDS, PAR 5

Penina, Portugal ✦ 13
229 YARDS, PAR 3

Royal Antwerp, Belgium ✦ 6
424 YARDS, PAR 4

San Lorenzo, Portugal ✦ 6
424 YARDS, PAR 4

Sotogrande, Spain ✦ 7
422 YARDS, PAR 4

Sperone, France ✦ 16
580 YARDS, PAR 5

Valderrama, Spain ✦ 4
535 YARDS, PAR 5

Vale do Lobo (Yellow), Portugal ✦ 7
196 YARDS, PAR 3

THE BEST HOLES IN AUSTRALASIA AND JAPAN

Although a stick-and-ball game called *suigan* was played during the Ming Dynasty, golf did not take hold in most of the Far East until nearly the twentieth century. Oh, there were a few outposts—in India the British colonials got the game under way when they established the Royal Calcutta Golf Club in 1829—but in most countries courses did not begin to take root until the 1880s, the same time golf began in the United States.

However, while golf in America grew steadily, and at times rapidly, the game was slow to expand in the Far East, as a combination of political, economic, and geographic factors conspired to thwart most efforts. In Japan, the pivotal moment came in 1957 when two Japanese players scored an upset victory in the Canada Cup (now the World Cup) and ignited national interest in the game. Today, Japan leads all Far Eastern

Number 6 at Kingston Heath (page 376)

Kasumigaseki's tenth hole (page 366)

countries both in the number of courses and in the zeal with which its people have embraced golf. Although nearly 15 million Japanese call themselves golfers, only a small fraction of them ever set foot on a fairway, as the lack of suitable land, and thus the cost of course construction, makes the game prohibitively expensive. So for most, golf means an occasional visit to one of the nation's more than four thousand driving ranges.

Without question the best courses in this half of the world are in Australia, particularly in the sand belt area a half hour or so outside of Melbourne. Royal Melbourne, ranked fifth in the world by *Golf Magazine,* heads the list, but half a dozen superb courses are within a short drive. The other center is Sydney, with a collection of outstanding seaside and parkland courses led by New South Wales.

Blue Canyon (Canyon), Thailand ✦ 17
221 YARDS, PAR 3

Hirono, Japan ✦ 15
565 YARDS, PAR 5

Kasumigaseki (East), Japan ✦ 10
177 YARDS, PAR 3

Kawana, Japan ✦ 13
395 YARDS, PAR 4

Kingston Heath, Australia ✦ 6
431 YARDS, PAR 4

The Lakes, Australia ✦ 11
578 YARDS, PAR 5

The Metropolitan, Australia ✦ 15
467 YARDS, PAR 4

Naruo, Japan ✦ 10
480 YARDS, PAR 4

The National, Australia ✦ 2
152 YARDS, PAR 3

Navatanee, Thailand ✦ 6
457 YARDS, PAR 4

Newcastle, Australia ✦ 6
400 YARDS, PAR 4

New South Wales, Australia ✦ 6
193 YARDS, PAR 3

Paraparaumu Beach, New Zealand ✦ 17
442 YARDS, PAR 4

Royal Adelaide, Australia ✦ 15
499 YARDS, PAR 5

Royal Melbourne (West), Australia ✦ 6
450 YARDS, PAR 4

Taiheiyo Club Gotemba (East), Japan ✦ 18
517 YARDS, PAR 5

Victoria, Australia ✦ 9
585 YARDS, PAR 5

Yarra Yarra, Australia ✦ 5
440 YARDS, PAR 4

THE
BEST
LINKS
HOLES

Golf as we know it was first played across narrow strips of sandy, windswept turf along the eastern coast of Scotland. These areas, formed when the seas receded after the last ice age, were essentially useless, serving no real purpose except to link the beaches with the more fertile land above—hence the name "links."

The grandfather of all links is the Old Course at St. Andrews, which most historians date to the sixteenth century. No one designed it—architectural credit is shared by God, Mother Nature, and several generations of grazing sheep—and the same is true of several of the early links courses. Not until the late nineteenth century did the game move inland, when the term "golf course" was coined to describe playing grounds without salt air and sand hills.

Today, less than a fifth of the courses in Scotland and only a handful

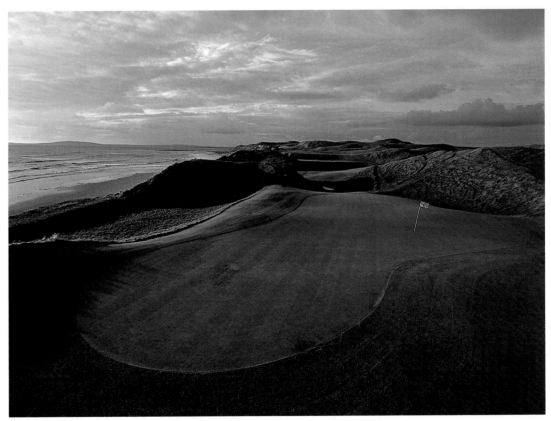

Ballybunion(Old)'s eleventh hole (pages 22–25)

The sixth at Carnoustie (Championship) (pages 66–69)

Ballybunion (Old) ✦ 11
453 YARDS, PAR 4

Carnoustie (Championship) ✦ 6
575 YARDS, PAR 5

El Saler ✦ 3
534 YARDS, PAR 5

Falsterbo ✦ 11
160 YARDS, PAR 3

Kennemer ✦ 1
452 YARDS, PAR 4

Maidstone ✦ 9
402 YARDS, PAR 4

Muirfield ✦ 9
504 YARDS, PAR 5

North Berwick (West) ✦ 15
192 YARDS, PAR 3

Paraparaumu Beach ✦ 17
442 YARDS, PAR 4

Prestwick (Old) ✦ 3
482 YARDS, PAR 5

Royal Birkdale ✦ 12
181 YARDS, PAR 3

Royal County Down ✦ 9
486 YARDS, PAR 4

Royal Dornoch ✦ 14
459 YARDS, PAR 4

Royal Lytham and St. Annes ✦ 17
462 YARDS, PAR 4

Royal Portrush (Dunluce) ✦ 14
210 YARDS, PAR 3

Royal St. George's ✦ 15
467 YARDS, PAR 4

Royal Troon (Old) ✦ 8
129 YARDS, PAR 3

St. Andrews (Old) ✦ 17
461 YARDS, PAR 4

of those outside the British Isles are considered to be true links. But the best of the links—led by St. Andrews—remain in the top ranks of the world's courses. The first twelve British Opens were contested over the links of Prestwick, and for nearly a century and a half the world's oldest championship has been played exclusively on links courses. Today, it rotates among five sites in Scotland—St. Andrews, Carnoustie, Muirfield, Royal Troon, Turnberry—and three in England—Royal Birkdale, Royal Lytham and St. Annes, and Royal St. George's. Each of those venues is represented here.

Linksland calls for a specific type of golf—a ground game in which the tee shots are kept under the wind, the iron shots are punched, and the short game consists largely of bump-and-runs. Level lies are rare, as most of the fairways are full of humps and hummocks, and the greens nestle within dunes. The stepping-off and calculation of yardage is usually useless, as the seaside wind is all but constant and often strong. This is golf as it was meant to be. Forget mechanics and measurements: Bring your imagination instead.

THE BEST HOLES DESIGNED SINCE 1970

The first of the great modern courses is generally agreed to be Pete Dye's Harbour Town Golf Links (1969), a compact, cozy, shot-maker's showcase that broke abruptly with the expansive ways of the Robert Trent Jones, Sr., era. Target golf became the architectural byword, as narrow fairways and well-guarded greens forced players to take an aerial attack rather than bouncing their shots to the hole.

One of Dye's biggest fans was then–PGA Tour commissioner Deane Beman, and together the two of them gave birth to a new genre: the stadium course. Built and owned by the PGA Tour, its purpose was to present a stern challenge for the game's best players and no challenge for those who came to watch them. The first such specimen, the TPC at Sawgrass, introduced huge "spectator mounds" beside the fairways and greens—good viewing and natural seating for thousands. Today, more

Number 17 at Cabo del Sol (pages 88–89)

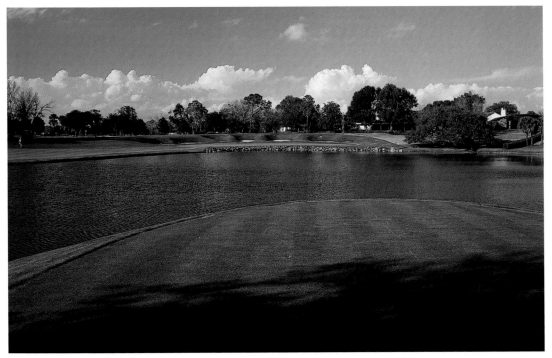

Number 18 at Bay Hill (pages 126–127)

than thirty such courses are in play, including several overseas.

The 1980s and 1990s thus were marked by a spate of contrived, artificial, and borderline unplayable courses, with greens that were hard to hit, hard to hold, and hard to putt. Inevitably, a backlash ensued with a return to more natural and traditional courses; its chief architects were Tom Fazio, and Rees and Robert Trent Jones, Jr.

Another by-product of the stadium course phenomenon was the enlistment of tour pros as design consultants. The dominant is Jack Nicklaus, who has designed nearly two hundred courses worldwide.

Bandon Dunes ✦ 4
415 YARDS, PAR 4

Bay Hill ✦ 18
441 YARDS, PAR 4

Black Diamond (Quarry) ✦ 15
371 YARDS, PAR 4

Cabo del Sol ✦ 17
178 YARDS, PAR 3

Casa de Campo (Teeth of the Dog) ✦ 7
225 YARDS, PAR 3

The Challenge at Manele ✦ 12
202 YARDS, PAR 3

The European Club ✦ 7
470 YARDS, PAR 4

Loch Lomond ✦ 10
455 YARDS, PAR 4

Muirfield Village ✦ 14
363 YARDS, PAR 4

Navatanee ✦ 6
457 YARDS, PAR 4

Pumpkin Ridge (Witch Hollow) ✦ 6
453 YARDS, PAR 4

Royal Dar-es-Salaam (Red) ✦ 9
199 YARDS, PAR 3

Sand Hills ✦ 7
283 YARDS, PAR 4

Sperone ✦ 16
580 YARDS, PAR 5

TPC at Sawgrass (Stadium) ✦ 17
132 YARDS, PAR 3

Troon ✦ 15
139 YARDS, PAR 3

Whistling Straits ✦ 12
166 YARDS, PAR 3

Wild Dunes ✦ 18
501 YARDS, PAR 5

THE BEST HOLES DESIGNED BY DONALD ROSS

Donald Ross is credited with hundreds of courses, although there's no doubt he "designed" more than a few without leaving his office, working from photographs and maps. Yet even without trodding the land, these mail-order courses usually possess some greatness, such was his considerable talent.

A son of Scotland, Ross was raised in the town of Dornoch. In his teens he moved to St. Andrews, where he learned about club making from David Forgan and playing the game from Old Tom Morris. At twenty-one, he returned to his hometown as greenkeeper of the burg's famous links, where he gained a deep knowledge and appreciation of agronomy and course maintenance. More important, his familiarity and infatuation with the town's course influenced all his work to follow.

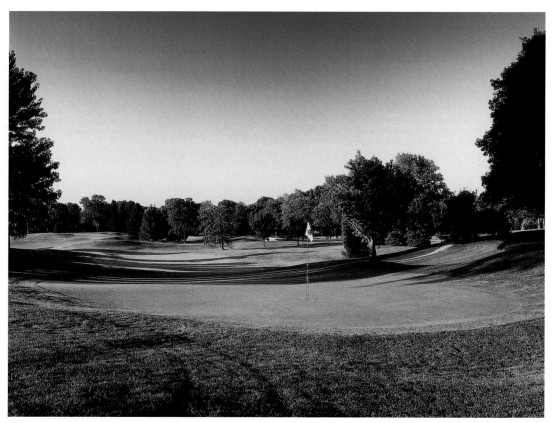

The eleventh at Oakland Hills (South) (page 286)

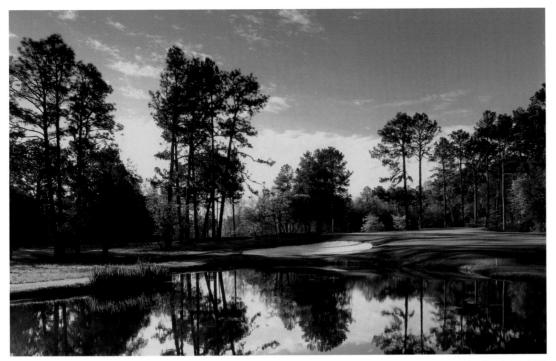

The third at Pine Needles (page 259)

Ross emigrated to the United States as the twentieth century dawned and was soon head pro and course designer at a fledgling resort called Pinehurst in the North Carolina sand hills. As golf caught on, so did Ross, and he became the most sought-after architect of his day. From his five hundred–plus courses, many rank among the best in the world, including Pinehurst No. 2, Seminole, Oakland Hills, and Oak Hill. Most of his courses, and the best of his holes, share common characteristics: routing along the natural flow of the land; numerous options off the tee; and greensites featuring dramatic contouring, which puts an emphasis on short-game recovery. All are features found at his beloved Dornoch.

As the 1999 U.S. Open at Pinehurst proved, we are still being thrilled by his genius half a century after his death.

Aronimink ✦ 1
432 YARDS, PAR 4

Broadmoor (West) ✦ 18
556 YARDS, PAR 5

Inverness ✦ 7
452 YARDS, PAR 4

Metacomet ✦ 14
459 YARDS, PAR 4

Oak Hill (East) ✦ 7
432 YARDS, PAR 4

Oak Hill (East) ✦ 13
596 YARDS, PAR 5

Oakland Hills (South) ✦ 11
431 YARDS, PAR 4

Oakland Hills (South) ✦ 16
405 YARDS, PAR 4

Pinehurst (No. 2) ✦ 2
441 YARDS, PAR 4

Pinehurst (No. 2) ✦ 5
482 YARDS, PAR 4

Pinehurst (No. 2) ✦ 10
613 YARDS, PAR 5

Pine Needles ✦ 3
134 YARDS, PAR 3

Plainfield ✦ 12
585 YARDS, PAR 5

Salem ✦ 13
342 YARDS, PAR 4

Scioto ✦ 2
436 YARDS, PAR 4

Scioto ✦ 8
505 YARDS, PAR 5

Seminole ✦ 6
383 YARDS, PAR 4

Wannamoisett ✦ 3
136 YARDS, PAR 3

THE
BEST HOLES
DESIGNED
BY
ALISTER
MACKENZIE

Alister Mackenzie was arguably golf's first world-famous architect. Although he was born in England, his heart was in the Highlands, where as a youth he spent long summer holidays at his family's ancestral home. Today, most of his best-known courses are American, but his work spans four continents.

Golf architecture was the furthest thing from young Alister's mind when he graduated from Cambridge in 1887. Instead, he trained as a doctor, following in the footsteps of his father. After various hospital appointments, he became attached to the British infantry and was posted to South Africa as a surgeon in the Boer War. He later transferred from the Royal Medical Corps to the Royal Engineers, where he became an expert on the use of camouflage.

It was not until 1907 that Mackenzie began dabbling in golf course

Number 5 at Crystal Downs (pages 136–137)

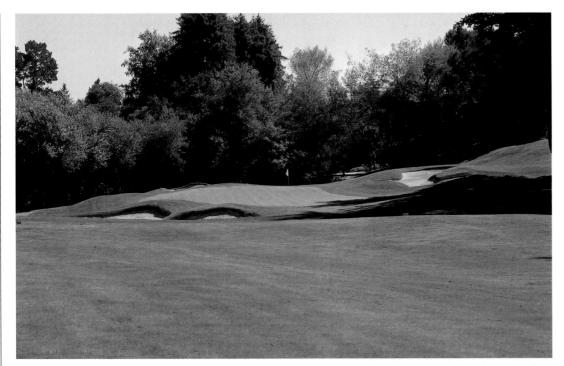

Pasatiempo's second hole (pages 166–167)

design, assisting H. S. Colt on alterations to Alwoodley Golf Club in England. Nearly twenty years would pass before he tried his hand outside the United Kingdom, but with the appearance of Cypress Point (1928), Royal Melbourne (1931), Crystal Downs (1933), and Augusta National (1933), Mackenzie became the undisputed doyen of golf architects.

Mackenzie's best golf holes are superbly strategic, allowing players of varying abilities to chart different paths to the green. He believed in letting the natural beauty of a course's site shine through with as little alteration as possible. Variety was also important to him, both in the character of the holes and in the shots they summoned a player to hit. "A really great course," he wrote, "must be a constant source of pleasure to the greatest possible number of players."

Alwoodley ◆ 3
510 YARDS, PAR 5

Augusta National ◆ 12
155 YARDS, PAR 3

Augusta National ◆ 13
485 YARDS, PAR 5

Crystal Downs ◆ 5
353 YARDS, PAR 4

Crystal Downs ◆ 8
550 YARDS, PAR 5

Cypress Point ◆ 15
139 YARDS, PAR 3

Cypress Point ◆ 16
233 YARDS, PAR 3

The Jockey Club (Red) ◆ 17
180 YARDS, PAR 3

Kingston Heath ◆ 6
431 YARDS, PAR 4

New South Wales ◆ 6
193 YARDS, PAR 3

Pasatiempo ◆ 2
442 YARDS, PAR 4

Pasatiempo ◆ 16
395 YARDS, PAR 4

Royal Adelaide ◆ 3
301 YARDS, PAR 4

Royal Adelaide ◆ 14
447 YARDS, PAR 4

Royal Melbourne (West) ◆ 5
176 YARDS, PAR 3

Royal Melbourne (West) ◆ 6
450 YARDS, PAR 4

The Valley Club of Montecito ◆ 8
154 YARDS, PAR 3

Yarra Yarra ◆ 5
440 YARDS, PAR 4

THE BEST HOLES DESIGNED BY A. W. TILLINGHAST

In the course of his sixty-eight years, Albert Warren Tillinghast was, in no particular order, a playboy, artist, photographer, antiques dealer, writer, musician, and sportsman. Born wealthy and spoiled rotten (his nickname, "Tillie the Terror," spoke to his childhood temper), he had the money to indulge many different interests. It wasn't until he was in his thirties that he found one that stuck (and in which he showed great talent), that of golf course designer.

As a teenager, Tillinghast had taken his first golf lesson from Old Tom Morris at St. Andrews, Scotland. He qualified for the U.S. Amateur three times, and finished twenty-fifth in the 1910 U.S. Open, held in his hometown of Philadelphia. A family friend offered him the opportunity to try his hand at course design for the resort at Shawnee-on-the-Delaware. Tillinghast threw himself into the task with a zeal he'd never

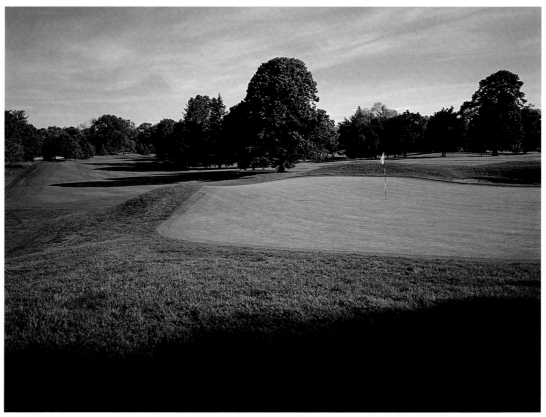

The eighteenth at Winged Foot (page 300)

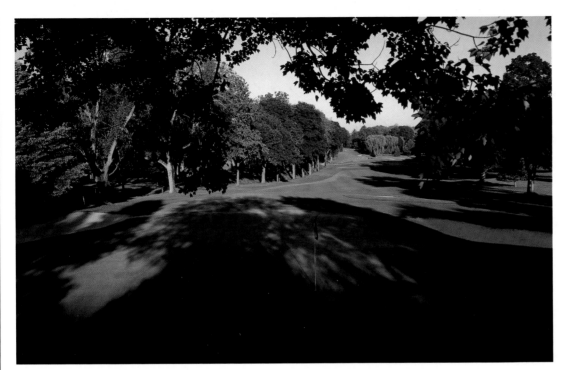
Philadelphia Cricket Club's ninth hole (page 290)

before shown for honest work. Shortly after Shawnee opened in 1907, he hung out his shingle as a full-time architect. By the early 1920s, he was one of the busiest and best.

Among his notable courses are San Francisco, Baltusrol, Somerset Hills, Baltimore, Quaker Ridge, Ridgewood, and Winged Foot. Finding a common thread in those creations is difficult. His only theme was individuality; he sculpted the best course to fit the natural flow of the land. Some of his layouts are long, others short. At different times, he used both sand-faced and grass-faced bunkers. As a rule, his greens are neither small nor large, and some were severely sloped while others rolled like waves. But none of his courses could be overpowered: A good score would only follow smart, strategic play.

"A round of golf should provide 18 inspirations," Tillinghast wrote, "not necessarily thrills, for spectacular holes may be sadly overdone. Every hole may be constructed to provide charm without being obtrusive with it." The holes below certainly are eighteen inspirations, designed by one of the most inspirational, and creative, minds the game has ever seen.

Baltimore (Five Farms East) ✦ 14
603 YARDS, PAR 5

Baltusrol (Lower) ✦ 4
194 YARDS, PAR 3

Baltusrol (Lower) ✦ 17
630 YARDS, PAR 5

Baltusrol (Upper) ✦ 11
602 YARDS, PAR 5

Baltusrol (Upper) ✦ 16
435 YARDS, PAR 4

Bethpage (Black) ✦ 4
522 YARDS, PAR 5

Bethpage (Black) ✦ 5
455 YARDS, PAR 4

Brook Hollow ✦ 16
220 YARDS, PAR 3

Philadelphia Cricket ✦ 9
472 YARDS, PAR 4

Quaker Ridge ✦ 6
446 YARDS, PAR 4

Ridgewood (Center) ✦ 6
289 YARDS, PAR 4

San Francisco ✦ 7
190 YARDS, PAR 3

San Francisco ✦ 9
570 YARDS, PAR 5

Somerset Hills ✦ 12
144 YARDS, PAR 3

Somerset Hills ✦ 15
394 YARDS, PAR 4

Winged Foot (East) ✦ 6
194 YARDS, PAR 3

Winged Foot (West) ✦ 10
190 YARDS, PAR 3

Winged Foot (West) ✦ 18
448 YARDS, PAR 4

THE BEST HOLES DESIGNED BY ROBERT TRENT JONES, SR.

No one designed more courses for more years in more parts of the world than Robert Trent Jones, Sr., the dean of golf course architects for the entire second half of the twentieth century.

He was born in England in 1906 but grew up near Rochester, New York, where as an avid young golfer he once caddied for Walter Hagen. At Cornell University he devised his own curriculum, combining agronomy, engineering, and landscape architecture to create the first degree in golf course architecture. Jones took his early training under Canada's leading architect, Stanley Thompson, but by the 1950s he had set out on his own.

He first drew widespread attention with his renovation of Oakland Hills for the 1953 U.S. Open, lengthening and stiffening its holes to the point that that year's champion, Ben Hogan, dubbed it "a monster." Jones

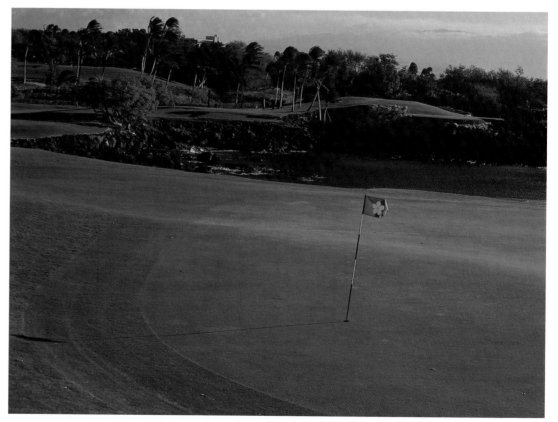

Number 3 at Mauna Kea (pages 96–97)

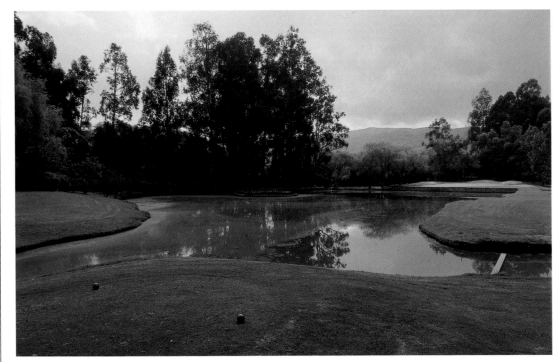

The seventh at El Rincon (pages 94–95)

soon became known as "the Open Doctor" and went on to update several more U.S. Open venues while also becoming a prolific designer on his own. By the end of the century, he had built more than five hundred courses in two dozen countries and nearly every state in the Union, while traveling three hundred thousand miles a year. There was no keeping up with this Jones. Today, his sons, Robert Trent, Jr., and Rees, both have made their marks as two of the game's preeminent architects.

Jones's design philosophy was simple: "Each hole should be a difficult par but an easy bogey." On the list that follows, all but two of the holes have a par of either 3 or 5. This would not have surprised Jones. In his book *Golf's Magnificent Challenge,* he wrote: "It is relatively easy to design striking par-three and par-five holes and put them in balance with the golf course. Designing par-four holes is the toughest task an architect faces."

Dorado Beach (East) ✦ 13
540 YARDS, PAR 5

The Dunes ✦ 13
590 YARDS, PAR 5

El Rincon ✦ 7
179 YARDS, PAR 3

Firestone (South) ✦ 16
625 YARDS, PAR 5

Kananaskis (Mt. Kidd) ✦ 4
197 YARDS, PAR 3

Las Brisas ✦ 8
507 YARDS, PAR 5

Mauna Kea ✦ 3
210 YARDS, PAR 3

Old Warson ✦ 14
360 YARDS, PAR 4

Peachtree ✦ 2
534 YARDS, PAR 5

Pevero ✦ 15
480 YARDS, PAR 5

Point O'Woods ✦ 9
197 YARDS, PAR 3

Port Royal ✦ 16
176 YARDS, PAR 3

Royal Dar-es-Salaam (Red) ✦ 9
199 YARDS, PAR 3

Sotogrande (Old) ✦ 12
582 YARDS, PAR 5

Sperone ✦ 16
580 YARDS, PAR 5

Spyglass Hill ✦ 1
600 YARDS, PAR 5

Spyglass Hill ✦ 4
365 YARDS, PAR 4

Valderrama ✦ 4
535 YARDS, PAR 5

THE HOLES MOST NEARLY IMPOSSIBLE TO GET ON

For many golfers, the greatness of a hole is directly proportional to the trouble one must go through to play it. For such status-seeking swingers, this is the list to drool over.

It is a fact that many wonderful golf holes, particularly (but not solely) in the United States, are at clubs harder to get on than a runaway train. Exclusivity has been part of the American golf scene since its earliest days, when "country clubs" were built so city-dwellers could escape the crowds and heat of Gotham for the cool comfort provided by the great outdoors and the social safety of their "own kind."

Another feature common to the clubs on this list is wealth. Many were founded by individuals for whom money truly was no object. That certainly helped when the architect (usually one of the greats) was told to spare no expense.

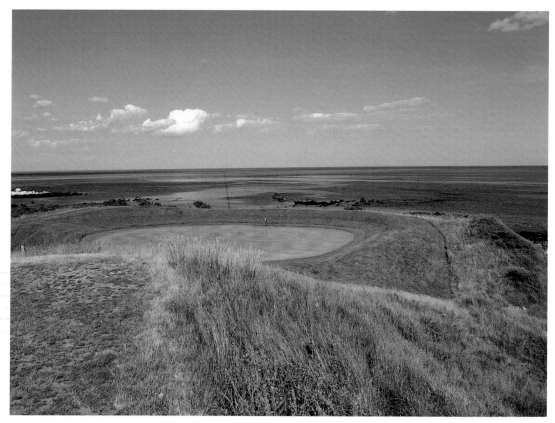

Number 4 at Fishers Island (page 276)

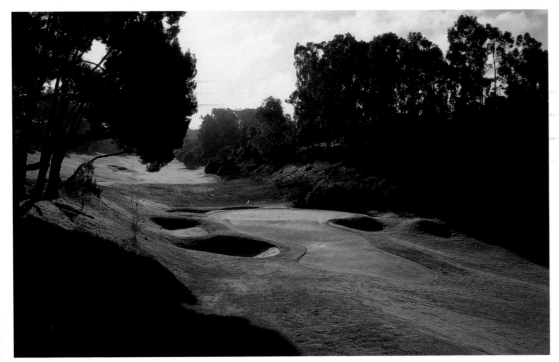
The seventh at San Francisco (page 261)

Today, the well-to-do are still well represented, but money alone isn't enough to get in to most of these clubs. Just ask a certain software billionaire whose subtle inquiries about a locker at Augusta National were not so subtly booted. (In the old days, if a person of wealth was turned away from one of the great clubs, he'd build his own—which might then find its way onto a list like this. In fact, at least one or two of the courses here began after someone swore, "I'll show them!")

As the game grows and reaches out to people regardless of wealth or background, the public's chances to play some of these gems may improve. In the meantime, as you try to figure out how to get invited to one of these ultraprivate playgrounds, take solace in Bob Hope's classic line about one of the most select: "Cypress Point had a very successful membership drive last month," Hope reported. "They drove out forty members."

Augusta National ✦ 13
485 YARDS, PAR 5

Camargo ✦ 12
415 YARDS, PAR 4

Crystal Downs ✦ 5
353 YARDS, PAR 4

Cypress Point ✦ 15
139 YARDS, PAR 3

Devil's Paintbrush ✦ 13
226 YARDS, PAR 3

Double Eagle ✦ 17
355 YARDS, PAR 4

Fishers Island ✦ 4
397 YARDS, PAR 4

Hirono ✦ 15
565 YARDS, PAR 5

Loch Lomond ✦ 10
455 YARDS, PAR 4

Los Angeles (North) ✦ 16
433 YARDS, PAR 4

Merion (East) ✦ 16
428 YARDS, PAR 4

The Nantucket ✦ 18
590 YARDS, PAR 5

The National ✦ 4
197 YARDS, PAR 3

Ocean Forest ✦ 16
394 YARDS, PAR 4

Pine Valley ✦ 13
448 YARDS, PAR 4

San Francisco ✦ 7
190 YARDS, PAR 3

Seminole ✦ 6
383 YARDS, PAR 4

Shinnecock Hills ✦ 14
447 YARDS, PAR 4

THE BEST HOLES YOU CAN PLAY

Public access to the best golf holes is a long-standing tradition, going back to the beginning of the game. Like most early layouts, the Old Course at St. Andrews tumbled across town land. That meant golfers had to share the links with strolling families, grazing sheep, and hearty souls seeking beach access to the North Sea. It also meant that anyone with a club and a ball could take a shot—or several—at the fabled layout.

How "public" was such access? Until the end of the nineteenth century, there was no greens fee. The Old Course was free of charge.

More than five centuries later, pedestrians still have the right of way, but more important, the Old Course (as well as the others at St. Andrews) is still owned and operated by the municipality, which means it is open to one and all. And one and all want to come and play: Tee times are hard to come by, despite there now being a cost in excess of $150.

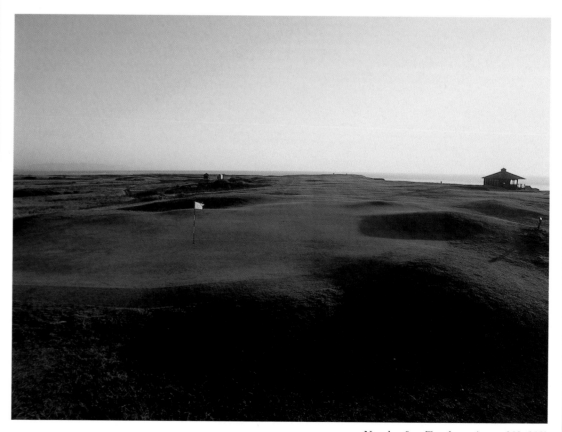

Number 9 at Turnberry (pages 202–203)

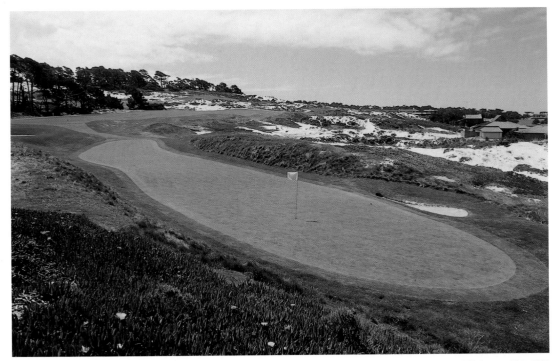

The fourth at Spyglass Hill (pages 196–197)

Most of the other great British courses also welcome guests—on certain days of the week and only if a game has been arranged well in advance. Such a policy exists in a good part of the world. The notable exceptions are the United States and Japan, where "private" usually means just that.

That's not to say that Americans can't test themselves against many wonderful homegrown holes. The ranks of top-notch public, municipal, semiprivate, and resort courses are growing at a rapid pace. And with the game becoming more and more popular (and politically correct), the incentives are there to build better courses that everyone can play.

As the following—and the many other public-access holes in the top-five-hundred list—show, there is great variety in open-to-all golf. From the originals at St. Andrews and Pinehurst to modern classics at Cabo del Sol and World Woods, the great holes accessible to all men and women provide some of the best the game has to offer. And they offer themselves to you.

Ballybunion (Old) ◆ 11
453 YARDS, PAR 4

Banff Springs ◆ 4
171 YARDS, PAR 3

Bethpage (Black) ◆ 5
455 YARDS, PAR 4

Cabo del Sol ◆ 17
178 YARDS, PAR 3

Carnoustie (Championship) ◆ 6
578 YARDS, PAR 5

**Casa de Campo
(Teeth of the Dog) ◆ 7**
225 YARDS, PAR 3

The Dunes ◆ 13
590 YARDS, PAR 5

Harbour Town ◆ 18
478 YARDS, PAR 4

Highlands Links ◆ 6
537 YARDS, PAR 5

Mauna Kea ◆ 3
210 YARDS, PAR 3

Mid Ocean ◆ 5
433 YARDS, PAR 4

Muirfield ◆ 9
504 YARDS, PAR 5

Pebble Beach ◆ 18
548 YARDS, PAR 5

Pinehurst (No. 2) ◆ 5
482 YARDS, PAR 4

St. Andrews (Old) ◆ 17
461 YARDS, PAR 4

Spyglass Hill ◆ 4
365 YARDS, PAR 4

TPC at Sawgrass (Stadium) ◆ 17
132 YARDS, PAR 3

Turnberry (Ailsa) ◆ 9
455 YARDS, PAR 4

THE
HOLES
THAT
HAVE
PRODUCED
GREAT
MOMENTS

Augusta National ♦ 10

Ben Crenshaw sinks a twisting 60-foot birdie putt en route to victory in the 1984 Masters.

Bay Hill ♦ 18

Robert Gamez holes out a 7-iron from 176 yards for eagle to edge Greg Norman for the 1990 Bay Hill Classic title.

Congressional (Blue) ♦ 17

In 1964, when this played as the eighteenth hole, Ken Venturi two-putts for par to cap the most emotional U.S. Open victory ever.

The Country Club (Open) ♦ 18

In a playoff for the 1913 U.S. Open, nineteen-year-old Francis Ouimet stuns British titans Harry Vardon and Ted Ray and becomes America's first golf hero.

Inverness ♦ 18

Bob Tway holes his greenside bunker shot for birdie and a 1-stroke win over Greg Norman in the 1986 PGA Championship.

Merion (East) ♦ 18

A year after his auto accident, Ben Hogan returns, striking a 1-iron to this green to set up the closing par he needs to reach a playoff with George Fazio and Lloyd Mangrum, whom he beats the next day.

Oakland Hills (South) ♦ 16

South African Gary Player hits a death-defying 9-iron over a willow tree to within 3 feet for birdie to set up his victory in the 1972 PGA Championship.

Oakmont ♦ 18

In 1962, twenty-two-year-old Jack Nicklaus caps off victory in his first professional major championship, beating hometown hero Arnold Palmer in an eighteen-hole playoff.

Olympic (Lake) ♦ 18

With a closing birdie, Jack Fleck shocks the world of golf by tying Ben Hogan's total for the 1955 U.S. Open, then beats Hogan in an eighteen-hole playoff.

Pebble Beach ♦ 7

In near gale-force winds on the final day of the 1992 U.S. Open, Tom Kite chips in for birdie en route to his only major championship victory.

Riviera ♦ 18

Hale Irwin sinks a 20-foot birdie putt to win the 1998 U.S. Senior Open by a stroke; Ben Hogan wins two Los Angeles Opens and a U.S. Open between 1947 and 1948.

Royal Birkdale ♦ 18

In 1969, when Jack Nicklaus concedes Tony Jacklin a 3-foot putt, the United States and Great Britain halve the Ryder Cup for the first time.

Royal Lytham and St. Annes ✦ 17

Bobby Jones rips a daring 4-iron from a fairway bunker onto the green, and goes on to edge out Al Watrous for the 1926 British Open.

Royal St. George's ✦ 18

With a par in 1993, Greg Norman posts 267, the lowest seventy-two-hole total ever in a major championship.

St. Andrews (Old) ✦ 11

In the 1921 British Amateur, young Bobby Jones finds the Hill Bunker and despite repeated swings, never gets out. He tears up his card and walks off the course.

Shinnecock Hills ✦ 16

Ray Floyd's brilliant punched 8-iron sets up the birdie that separates him from a large pack of contenders to take the 1986 U.S. Open.

Valderrama ✦ 18

Colin Montgomerie halves his match with Scott Hoch to secure the deciding point in Europe's upset victory over Team U.S.A. in the 1997 Ryder Cup.

Winged Foot (West) ✦ 18

In 1929, Bobby Jones sinks a twisting 12-footer to reach a U.S. Open playoff with Al Espinosa, whom he trounces the next day.

Ben Crenshaw celebrating his birdie at Augusta's tenth (page 265) at the 1984 Masters

INDEX

A

Abercromby, J. F., 346
Agile Golf and Country Club (South), 369
Ainsley, Ray, 270
Alfredsson, Helen, 371
Alison, Charles, 220, 224, 246, 273, 284, 304, 331, 341, 346, 353, 355, 359, 364, 365, 366, 370, 374
Alliss, Peter, 332
Aloha Golf Club, 351
Alwoodley Golf Club, 206–7, 246, 341, 425
American Cricketer, 33
American Express Championship, 357
Anderson, Dave, 208
Apperly, Eric, 100, 375, 376, 378
Arana, Javier, 218, 347, 349, 351, 358
Architectural Side of Golf, The
 (Wethered and Simpson), xi
Argentine Open, 162, 319
Armour, Tommy, 128, 130, 235
Armstrong, H. Emerson, 294
Aronimink, 265, 423
Asian Honda Classic, 368
Atlanta Country Club, 301
Åtvidaberg National Golf Club, 357
Augusta National Golf Club, xi–xii, 48, 49, 130, 166, 170
 8th hole of, 212
 10th hole of 265, 387, 397, 434
 11th hole of, 94, 405
 12th (Golden Bell) hole of, 84–85, 250, 257, 348, 405, 411, 425
 13th hole of, x, 62–65, 301, 385, 391, 392, 393, 405, 409, 411, 413, 425, 431
 16th hole of, 94, 262
 18th hole of, 279
Australian Open:
 of 1924, 46, 112, 164
 0f 1962, 178
 of 1997, 376
Azinger, Paul, 258, 335

B

Bali Golf and Country Club, 369
Ballesteros, Seve, 184, 265, 329, 338
Ballybunion Golf Club (Old), 23–25, 192, 197, 202, 332, 384, 385, 402, 403, 419, 433
Baltimore Country Club (Five Farms East), 208, 301, 427
Baltusrol Golf Club (Lower), 26, 235
 3rd hole of, 265
 4th hole of, 94, 250, 404, 405, 427
 17th hole of, 208–9, 301, 389, 397, 407, 427
Baltusrol Golf Club (Upper), 208, 267
 11th hole of, 302, 427
 16th hole of, 266, 427
Bandon Dunes Golf Club, 266, 387, 421
Banff Springs Golf Club, 6–9, 222, 323, 385, 387, 401, 404, 405, 433

Bangkok Golf Club, 373
Banks, Charles, 253, 284, 310, 320
Barsebacks Golf and Country Club
 (New), 351, 415
Barsebacks Golf and Country Club (Old), 358
Barton Creek Country Club (Fazio), 266
Bauer, Gunner, 347
Bayer, George, 271
Bay Habor Golf Club (Links), 302, 395
Bay Hill Club, 126–27, 138, 251, 266, 389, 395, 405, 421, 434
Bel-Air Country Club, 86–88, 106, 251, 267, 302, 385
Belfrey, The (Brabazon), 332
Bell, Alphonzo, 86
Bell, William P., 256, 261, 282, 298
BellSouth Classic, 301
Beman, Deane, 188, 200, 420
Bendelow, Tom, 253, 257
Benson and Hedges International, 335, 343
Benz, Brad, 369
Berkshire Golf Club (Red), 224, 333
Bethpage State Park Golf Club (Black), 208
 4th hole of, 210–11, 302, 395, 407, 427
 5th hole of, 26–29, 267, 413, 427, 433
 10th hole of, 267
Biarritz hole, 125, 264
Black Diamond Ranch Golf and Country
 Club (Quarry), 267, 303, 421
Blackwolf Run Golf Club (Meadow
 Valleys), 268
Blackwolf Run Golf Club (River), 268, 303, 389
Blairgowrie Golf Club (Rosemount), 326
Blasted Heaths and Blessed Greens
 (Finegan), 52
Blue Canyon Country Club (Canyon), 366, 417
BMW Open, 355
Bolt, Tommy, 60
Boros, Julius, 134
Boulders, The (South), 303
Bradshaw, Harry, 327
Braid, James, 66, 117, 128, 190, 238, 326, 329, 330, 333, 334, 335, 339, 341, 344, 345, 372
Brasier, Douglas, 357
Bredemus, John, 130, 271
British Amateur Championship, 109
 of 1921, 435
 of 1960, 114
 of 1970, 44
 of 1987, 343
 of 1999, 44
British Ladies Amateur Championship, 44–45, 109, 114
British Masters, 331
British Open, 49, 178, 188, 202, 336, 419
 of 1921, 118
 of 1922, 338
 of 1923, 117
 of 1926, 184, 199, 435

of 1929, 99
of 1930, 344
of 1934, 120
of 1937, 120
of 1940, 109
of 1947, 114
of 1948, 120
of 1951, 114
of 1953, 68, 341
of 1954, 109, 180
of 1955, 52
of 1959, 230
of 1961, 126
of 1962, 190
of 1966, 99
of 1968, 68
of 1969, 338
of 1971, 109
of 1973, 117
of 1974, 338
of 1975, 326, 397
of 1977, 331
of 1978, 50
of 1979, 329
of 1980, 99
of 1982, 344
of 1983, 180
of 1984, 52
of 1985, 344
of 1986, 340
of 1987, 335
of 1988, 329, 338
of 1995, 208, 345
of 1996, 184, 338
of 1998, 344
of 1999, x, 66
Broadmoor Golf Club (West), 303, 423
Brook Hollow Golf Club, 208, 251, 427
Brown, Cal, 40
Bruce, Ture, 351, 358
Buenos Aires Golf Club (Yellow), 319
Buhrman, Hendrik, 364
Buick Classic, 299
Buick Invitational, 298
Bukit Pelangi, Rainbow Hills Golf Club, 373
bunkers, 406–7
Burke, Jackie, Jr., 264
Butler National Golf Club, 268, 389
Byrd, William, 301
Byron Nelson Classic, 276

C

Cabo del Sol Golf Club, 89, 317, 319, 403, 421, 433
Cabo Reál Golf Club, 319, 321
California Amateur, 86
Camargo Club, 268, 431
Campbell, Bill, 232
Campbell, Willie, 134, 272, 273
Canada Cup, 416–17
 of 1959, 46, 48
Canadian Open, 324
Canadian Pacific Railway, 8
Canterbury Golf Club, 269, 304, 407

Cape hole, 34–36, 309, 320, 321, 369
Carey family, 170
Carnoustie Golf Links (Championship), 178, 218
 6th hole of, 66–69, 341, 384, 407, 419, 433
 16th hole of, 326, 389, 397
 17th hole of, 128–29, 333, 391, 405
Carr, Joe, 114, 336, 343
Casa de Campo Golf Club (Teeth of the Dog), 402
 7th hole of, 90–91, 317, 385, 421, 433
 8th hole of, 240
 15th hole of, 320, 403
 16th hole of, 317
Cascades Golf Club, 269, 401
Castelconturbia Golf Club (Yellow), 352, 415
Castelgandolfo Country Club, 352
Castle Harbour Golf Club, 320
Castle Pines Golf Club, 269, 387, 401
Challenge at Manele, 89, 251, 403, 421
Chambers, Robert, Jr., 337, 344
Champions Golf Club (Cypress Creek), 252, 270, 304
Chantilly Golf Club (Vineuil), 358, 415
Chapman Golf Club, 363, 405
Charles, Bob, 184
Chen, T. C., 258
Cherry Hills Country Club, 270, 304, 393, 397
Chesneau, Hubert, 354
Chicago Golf Club, 270, 271
Chisholm, Tom, 334
Christchurch Golf Club, 375
Chung Shan Hot Springs Golf Club (Palmer), 369
Chunichi Crowns tournament, 367
Churchill, Winston, 102
Church Pews bunkers, 160, 235, 395
Cincinnati Golf Club, 125
Clampett, Bobby, 344
Clearwater Bay Golf and Country Club, 369, 399
Club zur Vahr (Garlstedter Heide), 352
Cobb, George, 132, 142, 253, 272
Cog Hill Golf Club (Dubsdread), 271
Cole, Bobby, 365
Cole, Matt, 325
Collett, Glenna, 166
Colonial Country Club, 130–31, 170, 271, 389, 413
Colt, H. S., 39, 73, 99, 106, 112, 114, 199, 206, 220, 225, 230, 246, 259, 273, 284, 291, 304, 312, 324, 328, 329, 331, 334, 335, 339, 341, 342, 346, 347, 353, 354, 355, 359, 425
Congressional Country Club (Blue), 132–33, 272, 397, 405, 411, 434
Cooke, Alistair, 3
Cooper, Harry, 266
Coore, Bill, 192, 251, 261, 294, 309
Cornish, Geoffrey, 134, 269, 285, 304
Cotton, Henry, 120, 128, 188, 336, 347, 350, 351

Country Club (Open), 134–35, 272, 273, 399, 434
Country Club of Detroit, 220, 246, 273, 304
Couples, Fred, 64, 84, 332
Crane, H. C., 371
Crans-sur-Sierre Golf Club, 352, 387, 399, 401, 415
Creek Club, 252, 273, 405, 409
Crenshaw, Ben, 192, 251, 261, 276, 294, 309, 370, 434
Crooked Stick Golf Club, 252, 273
Crown Colony Country Club, 305
Cruden Bay Golf Club, 134, 327, 387
Crump, George, 39, 86, 106, 255, 259, 291, 312
Crystal Downs Country Club, 130, 170, 274, 385
 5th hole of, 136–37, 274, 391, 425, 431
 8th hole of, 212–13, 305, 413, 425
Cupp, John, 292, 313
Curtis Cup, 44
Cypress Point Club, 62, 100, 106, 166, 202, 212, 375
 15th hole of, 10–13, 252, 384, 385, 413, 425, 431
 16th hole of, 86, 89, 92–93, 253, 323, 389, 393, 395, 402, 403, 425
 17th hole of, 274

D
Daikyo Palm Meadow Cup, 378
Dallas Open, 251
Daly, Fred, 114
Daly, John, 208, 252, 273, 288, 301
Darwin, Bernard, 40, 45, 81, 114, 152, 173, 184, 199, 345
Davis, Rodger, 378
Davis, William F. "Willie," 55, 237, 258, 262, 285, 296, 314
de la Renta, Oscar, 320
Demaret, Jimmy, 174
Desert Forest Golf Club, 274, 305
Desert Highlands Golf Club, 275, 305, 387, 409
Desert Mountain Golf Club (Cochise), 306
Desert Mountain Golf Club (Geronimo), 253
Detroit Golf Club, 220
Deutsche Bank SAP Open, 356
De Vicenzo, Roberto, 162
Devil's Paintbrush Golf Club, 323, 431
Devlin, Bruce, 298, 305, 316, 378
Dey, Joe, 232
Dickinson, Patric, 50
Dinard Golf Club, 353, 399
Doak, Tom, 30, 55, 68, 72, 265
Dobereiner, Peter, 39, 45, 200
Domaine Imperial Golf Club, 358
Donald Ross Society, 263
Dorado Beach Hotel and Golf Club (East), 214–16, 226, 322, 391, 429
Doral Resort and Country Club (Blue), 138–40, 275, 393, 405, 413
Double Eagle Golf Club, 275, 399, 431

Down the Fairway (Jones), 118
Down the Nineteenth Fairway (Dobereiner), 39
Duane, Frank, 278
Du Maurier Classic, 324
Duncan, George, 183, 329, 337
Dunes Club, 94, 217, 226, 306, 393, 405, 409, 413, 429, 433
Dunn, Seymour, 350
Dunn, Tom, 327, 353
Dunn, Willie, 125, 220, 326
Durban Country Club, 70–73, 362, 363, 365, 384, 385
Dutra, Olin, 238
Duval, David, 20, 304
Dye, Alice, 20
Dye, Andy, 370
Dye, Pete, xiii, 18–20, 30, 90, 142, 200, 252, 254, 255, 256, 258, 263, 264, 268, 273, 279, 281, 282, 290, 298, 303, 307, 308, 311, 312, 315, 317, 320, 350, 358, 370, 395, 420
 on Merion Golf Club, 32–33

E
Earthquake Corner, 259
East Lake Golf Club, 253
Eden at St. Andrews, 246
Edgewood Tahoe Golf Club, 306, 401
Egan, H. Chandler, 74, 104, 259, 289, 311
Eisenhower, Dwight D., 232
Ekwanok Country Club, 306, 401
Elie, The Golf House Club, 333
Elkington, Steve, 200, 270
El Rincon Golf Club, 94–95, 317, 429
Els, Ernie, 70, 132, 235, 362, 366
El Saler Golf Club, 218–19, 347, 358, 403, 415, 419
Emerald Fairways and Foam-Flecked Seas (Finegan), 24
Emmet, Devereux, 132, 254, 272, 277
Espinosa, Al, 435
Essex Country Club, 307
Essex County Country Club, 253
Estancia Club, 275
European Club, 141, 327, 333, 341, 403, 421
European PGA Tour, 146, 347, 355, 414

F
Faldo, Nick, 50–52, 64, 265, 273, 327, 335, 351, 358, 361, 367
Falsterbo Golf Club, 347, 405, 415, 419
Fancourt Country Club (Montagu), 364
Faulkner, Max, 114, 190
Faxon, Brad, 310
Fazio, George, 157, 232, 255, 268, 280, 286, 306, 310, 325, 359, 434
Fazio, Jim, 359
Fazio, Tom, xiii, 157, 232, 261, 266, 267, 268, 275, 277, 280, 281, 286, 289, 299, 300, 303, 309, 310, 312, 314, 316, 325, 421
Fernie, Willie, 117, 190, 202, 329, 331, 339, 340, 344

Finch-Hatton, Harold, 186, 338
Findley, Alex, 291
Finegan, Jim, 24, 52
Firestone, Harvey, 220
Firestone Country Club (South), 220–21, 242, 307, 389, 429
Fischer, Bob, 144
Fishers Island Club, 276, 395, 431
Fleck, Jack, 259, 288, 434
Floyd, Raymond, 57, 262, 297, 435
Flynn, William S., 39, 55, 56, 126, 134, 138, 237, 256, 262, 269, 270, 272, 273, 280, 290, 296, 304, 314
Forest Highlands Golf Club, 276, 387, 397
Forgan, David, 422
Fought, John, 292, 307, 313
Four Seasons Resort and Club (TPC at Las Colinas), 276
Fowler, Herbert, 327, 333, 334, 340
Fownes, Henry C., 160, 235, 286, 287, 311
Fownes, William C., 160, 235, 286, 287, 311
Fox Chapel Golf Club, 254
Frankfurter Golf Club, 353, 415
Franklin, A. A., 376
French Open, 358
Frösakers Golf Club, 353
Frost, David, 70
Fujioka Country Club, 373
Fujita, Kinya, 366
Furyk, Jim, 351

G
Gallery at Dove Mountain, 307, 396–97, 401
Galloway National Golf Club, 277
Gamez, Robert, 126, 266, 434
Gancedo, Jose "Pepe," 353
Gannon, Peter, 357
Ganton Golf Club, 334
Gardagolf Country Club, 348
Garden City Golf Club, 254, 277
Gary Player Country Club, 364, 365
Gates, Martin, 354
Geiberger, Al, 130
George Golf Club, 362
German, Open:
 of 1971, 352
 of 1989, 353
 of 1992, 348
Glen Abbey Golf Club, 324, 325, 393
Glendower Golf Club, 364
Golden Horseshoe Golf Club (Gold), 110, 254, 277
Golf Club, 254, 307
Golf Club del Sur (North), 353
Golf Club de Uruguay, 321, 399
Golf Club of Georgia (Lakeside), 308
Golf Club of Oklahoma, 277
Golf de Biarritz, 125
Golf Journal, 33
Golf Magazine, ix–x, 46, 70, 130, 248, 385, 412, 417
Golf's Magnificent Challenge (Jones), 429
Gordon, William, 315

Gorge Vale Golf Club, 325
Gourlay, Molly, 23, 332
Grand Cypress Resort (North), 278
Grant, Douglas, 74, 104, 259, 289, 311
Graves, Robert Muir, 256, 260, 282
Gray, Dowing, 301
Greenbrier, 125, 138, 278
 Old White course of, 278
greensite, 410–11
Griffiths, Dennis, 368
Grimsdell, Robert, 73, 365
Gulf Harbour Golf & Country Club, 378, 397
Gulf Stream Golf Course, 138
Gullane Golf Club (No. 1), 342
Gulph Mills, 170
Gut Laerchenhof Golf Club, 348

H
Haas, Jay, 157, 286
Hackett, Eddie, 331, 345
Hagen, Walter, 99, 117, 188, 232, 338, 428
Hagge, Robert von, 138, 298, 305, 316, 354, 356, 378
Haig Point Golf Club (Calibogue), 308
Half Moon Bay Golf Club (Links), 278
Halmstad Golf Club (North), 348
Hamburger Golf Club (Falkenstein), 359, 397
Hamilton Golf and Country Club (South), 324
Harbour Town Golf Links, 142–43, 255, 279, 308, 387, 397, 420, 433
Harradine, Donald, 355
Harris, John, 370
Hassan II, king of Morocco, 110, 363
Havers, Arthur, 238
Haworth, Neil, 369, 372
Hawtree, F. W., 109, 180, 186, 327, 328, 336, 338, 342, 344, 346, 356
Hazeltine National Golf Club, 94, 144–45, 279
Higgins, Liam, 343
Highlands Links Golf Club, 222–23, 324, 325, 401, 433
Hills, Arthur, 302, 308
Hillside Golf Club, 342
Hills of Lakeway Golf Course, 255
Hilton, Harold, 186, 188
Hirono Golf Club, 224–25, 374, 417, 431
Hjertstedt, Gabriel, 347
Hoch, Scott, 435
Hoch, Steve, 265
Hockady, Ray, 170
Hogan, Ben, 32, 58, 60, 68, 99, 128, 157, 176, 235, 246, 251, 260, 267, 283, 288, 341, 428–29, 434
 Colonial assessed by, 130, 271
 in 1955 U.S. Open, 259
 6th hole of Seminole admired by, 194, 295
 10th hole of Winged Foot described by, 122
Hollins, Marion, 86, 92, 166
Hollywood Golf Club, 308

Hong Kong Golf Club (Eden), 370
Honolulu Golf Club, 125
Honors Course, 279, 411
Honourable Company of Edinburgh
 Golfers, *see* Muirfield
Hood, Fred, 256
Hope, Bob, 431
Hotchkin, S. V., 73, 364, 365
Houston Open, 298
Hubbelrath Golf Club (East), 348
Humewood Golf Club, 364
Hunter, Robert, 74, 263
Huntingdon Valley Country Club, 280
Huntsville Golf Club, 280
Hurdzan, Michael, 323
Hutchinson, H. G., 188

I

Inkster, Juli, 371
Inoue, Seichi, 368
Interlachen Country Club, 309
Inverness Club, 280, 423, 434
Irish Open, 114, 336
Irwin, Hale, 434
island green, 110
Isuzu Celebrity Golf Championship, 306
Italian Open, 352

J

Jacklin, Tony, 144, 180, 184, 188, 329, 332,
 338, 434
Jacobsen, Peter, 344
James, Mark, 353
Jamieson, Jim, 158
January, Don, 294
Japanese Amateur Championship, 224
Jasper Park, 222
Jockey Club (Red), 318, 425
Johnnie Walker Classic, 366
Jones, Rees, xiii, 26, 28, 130, 134, 144, 174,
 253, 262, 266, 267, 272, 273, 279, 280,
 282, 284, 287, 302, 308, 310, 335, 343,
 421, 429
 on 4th hole of Bethpage, 210
 on 9th hole of Maidstone, 148
Jones, Robert Trent, Jr., 36, 313, 319, 375,
 378, 421, 429
Jones, Robert Trent, Sr., xi, 58–60, 94, 96,
 110, 132, 144, 157, 158, 197, 208, 214,
 217, 220, 227, 232, 240, 242, 245, 250,
 254, 257, 258, 259, 260, 265, 272, 277,
 279, 283, 284, 286, 288, 291, 297, 301,
 303, 306, 307, 309, 310, 311, 315, 317,
 319, 321, 322, 323, 349, 351, 352, 357,
 360, 361, 363, 371, 392, 413, 415
 best holes designed by, 428–29
 design philosophy of, 429
 13th hole of Augusta described by,
 62–64
Jones, Robert Tyre "Bobby," xi–xii, xiii,
 32, 62, 84, 166, 199, 206, 232, 250,
 253, 265, 301, 330, 344, 405, 435
 "Old Equaliser" of, 184
 in withdrawal from 1921 British Open,
 118

Jones, Steve, 258
Jupiter Hills Club (Hills), 255

K

Kananaskis Country Golf Course (Mount
 Kidd), 323, 401, 429
Kapalua Golf Club (Plantation), 309,
 393
Kasumigaseki Country Club (East),
 366, 417
Kato, Shunsuke, 374
Kato, Yoshikazu, 366
Kau Sai Chau Golf Course (North),
 367, 387
Kawana Golf Links (Fuji), 370, 407, 417
Kemper Lakes Golf Club, 255
Kennemer Golf and Country Club, 354,
 415, 419
Kiawah Island Resort (Ocean), 281, 395
Kidd, David McLay, 266
Killian, Ken, 255
Kingston Heath Golf Club, 46, 376, 409,
 417, 425
Kite, Tom, 434
Kittansett Club, 256, 411
Klub Golf Rimba Irian, 370
Koch, Gary, 90
Koontz, Luther, 162, 321
Kribel, Joel, 313
Kuehne, Trip, 315

L

La Cerda, John, 222
Lacoste, Catherine, 114
Laguna National Golf Club (Classic),
 370
Lahinch Golf Club, 334
Laimbeer, Bill "Bad Boy," 306
Lake Nona Golf Club, 281, 309
Lakes Golf Club, 378, 405, 417
Lakeside Country Club (West), 371
Lancaster, Neal, 57
La Quinta Resort and Club (Mountain),
 256, 401
Las Brisas Golf Club, 226–27, 349, 359,
 393, 401, 414, 415, 429
Laurel Valley Golf Club, 281
Lawrence, Red, 274, 305
Lawrie, Charles, 331
Lawrie, Paul, 66, 128
Lee, Joe, 271, 356
Leeds, H. C., 285
Le Golf National (Albatros), 354
Lehman, Tom, 132, 146, 184, 307, 338
Leonard, Justin, 66
Le Querce Golf Club, 359
Le Robinie Golf Club, 354
Lietzke, Bruce, 252
Limburger, Bernhard von, 348, 352
Linde, Sune, 353
Linde German Masters, 348
Lindrick Golf Club, 327
Links, The (Hunter), 74–76
Links at Spanish Bay, 309
Linville Golf Course, 281, 401

Loch Lomond Golf Club, xii, 146–47, 327,
 334, 342, 387, 401, 421, 431
Locke, Bobby, 70, 184, 188
Long Cove Club, 282
Longhurst, Henry, 32
Los Angeles Country Club (North), 86,
 106, 228, 256, 282, 397, 431
Los Angeles Open, 434
Los Leones Golf Club, 228–29, 322
Los Naranjos Golf Club, 359
Love, Davis, III, 258, 300
Lowe, George, 109, 180, 184, 328, 336, 337,
 338, 344
Lunn, Arnold, 352
Lyle, Sandy, 68, 188

M

Macan, A. Vernon, 325
Macbeth, Norman, 300
Macdonald, Alister, 228, 322
Macdonald, Charles Blair, 14–16, 34, 36,
 102, 125, 152, 202, 220, 252, 258, 261,
 262, 264, 270, 271, 273, 275, 285, 300,
 318, 320, 321, 369, 408, 412
Machrihanish Golf Club, 334, 385, 393,
 402, 403
Mackenzie, Alister, x, 10, 12, 42, 49, 50,
 62, 64, 81, 84, 100, 130, 164, 170,
 178, 188, 212, 246, 248, 252, 253,
 263, 265, 274, 289, 301, 305, 318,
 321, 326, 330, 338, 341, 344, 375,
 376, 377, 378, 379, 388, 389, 398,
 403, 405, 411, 412–13
 background and influence of, 206
 best holes designed by, 424–25
 on designing interesting holes, 102, 217
 on golf course design, 136
 on hazards, 407
 on Pine Valley, 106
 on playing a first-class hole, 89
 on playing the 11th hole of St.
 Andrews, 118
 on 16th hole of Cypress Point, 92
 on 16th hole of Pasatiempo, 166
 on 17th hole of National Golf Links,
 152
Mackenzie, J. B., 376
MacKenzie, Reed, 144
Mackie, Isaac, 308
Mahaffey, John, 20
Maidstone Club, 134, 148–49, 170, 197,
 256, 282, 297, 407, 419
Mancenelli, Pier, 356
Manero, Tony, 266
Mangrum, Lloyd, 434
Manila Southwoods Golf and Country
 Club (Masters), 371
Marsh, Graham, 378
Martin, Miguel Angel, 357
Martindale, Billy, 294
Mashburn, Bruce, 90
Masters, 48, 62, 138, 162, 250, 301
 of 1984, 434
 of 1987, 265
 of 1989, 265

of 1996, 64
 of 1998, 64
Matkovich, Peter, 363
Mattiace, Len, 20
Mauna Kea Golf Club, 89, 94, 96–98, 257,
 283, 393, 399, 403, 429, 433
Mauna Lani Resort (South), 257, 403
Maxwell, Perry, xii, 58, 130, 170, 260, 271,
 292, 297
Mayer, Dick, 327
Mayfield Country Club, 220
MCI Classic, 255
Medinah Country Club (No. 3), 257
Meister, Ed, 273
Merion Cricket Club, 30
Merion Golf Club (East), 86, 170, 413,
 431, 434
 Dye on, 32–33
 16th hole of, 30–33, 283, 384, 385
Merion Golf Club (West), 126
Merrigan, Paddy, 343
Metacomet Golf Club, 283, 423
Metropolis Country Club, 284
Metropolitan Golf Club, 46, 376, 417
Middlecoff, Cary, 130
Mid Ocean Club, 34–38, 125, 318, 320,
 321, 393, 411, 433
Miller, Johnny, 235, 287, 297
Million Dollar Challenge, 365
Milwaukee Country Club, 284, 399
Mission Hills Golf Club (World Cup),
 374
Mitchell, Abe, 238
Mitchell, William F., 360
Mize, Larry, 265
Moliets Golf Club, 349
Monterey Peninsula Country Club
 (Dunes), 284, 310
Montgomerie, Colin, 68, 132, 343, 435
Moran, Kelly Blake, 319
Morcom, Mick, 46
Morfontaine Golf Club, 354, 415
Morris, George, 337, 344
Morris, Old Tom, 42, 70, 99, 114, 148, 173,
 183, 230, 326, 327, 329, 333, 334, 335,
 336, 337, 339, 342, 343, 422, 426
Morrish, Jay, 146, 263, 275, 276, 298, 299,
 303, 315, 328, 334, 342
Morrison, J.S.F., 353, 354, 359
Morrissett, John, 100
Morrissett, Ran, 100
Morse, Samuel F. B., 10
Mount Malarayat Golf and Country Club
 (Makulot), 374
Mowbray Golf Club, 365
Mucklemouth Meg, 222
Muirfield (Honourable Company of
 Edinburgh Golfers), 99, 230–31,
 328, 335, 342, 389, 407, 411, 419, 433
Muirfield Village Golf Club, 150–51, 257,
 284, 399, 421
Muirhead, Desmond, 150, 257, 284
Mulcahy, John, 331
Murphy, Patrick, 23, 332
Murphy's Irish Open, 24

Murray, C. M., 362
Myopia Hunt Club, 285, 409

N

Nagoya Golf Club (Wago), 367
Nairn Golf Club, 335
Nakajima, Tommy, 50
Nantucket Golf Club, 310, 431
Naruo Golf Club, 371, 397, 417
National Golf Club, 325, 375, 417
National Golf Links of America, 36, 125,
 130, 170, 204, 218, 265, 321, 387
 2nd hole of, 395
 3rd hole of, 285
 4th hole of, 14–17, 102, 258, 412, 413, 431
 14th hole of, 152
 17th hole of, 152–53, 285, 391
Navatanee Country Club, 371, 405, 417, 421
NCR Country Club, 310
Neguri Golf Club, 349
Nelson, Byron, 269, 290
Nelson, Robin, 257, 369, 372, 378
Nestlé International, 266
Nestlé Invitational, 126
Neumann, Liselotte, 347
Neville, Jack, xii, 74, 86, 104, 251, 259, 267,
 296, 302, 311
Newcastle Golf Club, 376, 417
Newport Country Club, 125, 258, 285
New St. Andrews, 154–56, 339, 372
New South Wales Golf Club, 46, 100–101,
 152, 375, 378, 391, 402, 403, 417, 425
New York Times, The, 208
Nicklaus, Jack, xiii, 32, 68, 84, 89, 99, 142,
 150, 154, 180, 190, 224, 232, 235, 251,
 253, 255, 257, 269, 270, 275, 278, 279,
 280, 284, 296, 301, 304, 305, 306, 308,
 311, 317, 319, 324, 325, 331, 345, 348,
 349, 354, 371, 372, 374, 415, 421, 434
Nissan Open, 260
Noordwijkse Golf Club, 355
Norman, Greg, 46, 49, 57, 64, 84, 126, 188,
 265, 266, 280, 340, 367, 376, 434, 435
North Berwick Golf Links (West), 14, 16,
 102–3, 122, 176, 254, 258, 318, 328,
 335, 343, 399, 411, 419
Nugent, Dick, 255

O

Oak Hill Country Club (East):
 7th hole of, 146, 157, 286, 391, 423
 13th hole of, 226, 232–34, 310, 389, 411,
 423
Oakland Hills Country Club (South),
 158–59, 258, 286, 405, 423, 428, 434
Oakmont Country Club, 160–61, 235–36,
 286, 287, 304, 311, 395, 407, 409, 413,
 434
Oak Tree Golf Club, 258, 311
Ocean Dunes Golf Club, 367
Ocean Forest Golf Club, 287, 431
O'Connor, Christy, Jr., 332
Ogle, Brett, 331
Ojai Valley Inn Golf Club, 86, 287
Old Head Golf Links, 343, 395, 397, 403

Old Memorial Golf Club, 287
Old Warson Country Club, 288, 407, 429
Olivos Golf Course, 162–63, 321, 397
Olmsted, Frederick Law, 148, 166
Olympia Fields Country Club (North), 288
Olympic Club (Lake), 259, 288, 409, 434
O'Meara, Mark, 64, 344
O'Neil, George, 278
Örebrö Golf Club, 349
Otani, M., 367
Ouimet, Francis, 134, 434
Oxfordshire Golf Club, 335, 343, 391
Ozaki, Jumbo, 367, 373

P

Pablo Creek Club, 289
Packard, Roger, 257
Palmer, Arnold, 126, 184, 190, 220, 230,
 232, 251, 266, 273, 278, 287, 310, 340,
 369, 373, 434
Palm Meadows Golf Club, 378
Paraparaumu Beach Golf Club, 164–65,
 376, 417, 419
Park, John, 148, 256, 282
Park, Willie, 148, 256, 282
Park, Willie, Jr., 66, 128, 199, 288, 326,
 330, 333, 339, 341, 342, 346, 350, 353
Parks, Sam, 235
Parnevik, Jesper, 347
Parry, Craig, 352, 353
Pasatiempo Golf Club, 166–67, 289, 411,
 425
Pate, Jerry, 200
"Pavilion on the Links" (Stevenson), 230
Pavin, Corey, 57
Peachtree Golf Club, 311, 429
Pebble Beach Golf Links, xii, 86, 125, 166,
 202, 378
 7th hole of, xiii, 104–5, 259, 402, 403,
 411, 434
 8th hole of, xiii, 289, 389, 409
 18th hole of, xiii, 74–78, 228, 240, 311,
 384, 393, 413, 433
Pebble Beach National Pro-Am, 274, 297
Pelican Hill Golf Club (North), 312, 387
Penha Longa Golf Club, 360, 415
Penina Golf Club, 350, 415
Pennink, J.J.F., 188, 331, 338, 344, 355, 373
Peoples, David, 301
Pete Dye Golf Club, 290
Peugeot Open de France, 354
Pevero Golf Club, 360, 429
PGA Canadian Championship, 325
PGA Championship, 174, 246
 of 1937, 291
 of 1960, 220, 310
 of 1970, 60
 of 1972, 158, 434
 of 1973, 304
 of 1980, 232
 of 1982, 60, 297
 of 1984, 296
 of 1986, 280, 434
 of 1988, 258, 311
 of 1989, 255

 of 1990, 296
 of 1991, 208, 252, 273
 of 1997, 300
 of 1998, 253, 260
 of 1999, 257
PGA Cup, 303
PGA Tour, 18, 20, 130, 138, 200, 252, 260,
 268, 271, 275, 276, 401, 420
PGA West (Stadium), 256, 290, 312, 393,
 395
Philadelphia Country Club, 290
Philadelphia Cricket Club, 290, 427
Pickeman, W. C., 336
Pickford, Mary, 166
Pinehurst Country Club (No. 2), 168–69,
 291, 312, 389, 409, 411, 413, 423, 433
Pine Needles Lodge and Golf Club, 259,
 423
Pine Valley Golf Club, xi, 86, 130, 160,
 170, 210, 212, 255, 312, 413, 431
 10th hole of, 106–8, 112, 259, 385, 389,
 407
 13th hole of, 39–41, 291, 409
 Thomas on playing at, 106
Pittsburgh Field Club, 291
Plainfield Country Club, 292, 313, 411, 423
Platts, Lionel, 326
Player, Gary, 68, 70, 73, 99, 128, 158, 178,
 184, 232, 338, 362, 364, 365, 367, 434
Players Championship, 18, 20, 130, 200, 263
Pléneuf-Val-André Golf Club, 360
Plummer, Ralph, 252, 270, 304
Poellot, J. Michael, 368, 369, 373, 374
Point O'Woods Golf and Country Club,
 260, 429
Popplewell, Fred, 376
Portmarnock Golf Club, 141, 336
Port Royal Golf Club, 319, 403, 429
Prairie Dunes Country Club, 192, 260, 385
 8th hole of, xii, 170–72, 292, 403
Prat, Alain, 360
Presidents Cup, 46, 49
Prestwick Golf Club (Old), 14, 173, 285,
 310, 336, 343, 395, 399, 401, 419
Price, Charles, 36, 62
Price, Nick, 46, 176, 362
Princeville Resort Golf Club (Prince), 313
Puerto Azul Golf and Beach Club, 367, 397
Pumpkin Ridge Golf Club (Witch
 Hollow), 292, 313, 421
Purves, Laidlaw, 188, 338, 344

Q

Quaker Ridge Golf Club, 174–75, 292,
 293, 389, 391, 427
Quinta do Lago, 360

R

Racing Club de France (La Vallée), 350
Rajapruek Golf Club, 368
Raubenheimer, Hendrick J., 362
Ray, Ted, 434
Raynor, Seth, 92, 125, 204, 252, 253, 254,
 261, 262, 264, 265, 268, 270, 271, 273,
 276, 278, 284, 296, 300, 310

Rebholz, Warren, 144
Redan hole, 14, 16, 102, 122, 176, 254, 256,
 258, 265, 318, 328, 343, 411, 412
Reid, Mike "Radar," 255
Reid, Wilfrid, 350
Rhoden, Rick, 306
Ridgewood Country Club (Center), 208,
 293, 399, 427
Riviera Country Club, xi, 86, 106, 176–77,
 260, 293, 385, 391, 397, 399, 434
Robbins, Kelly, 371
Robertson, Allan, 66, 128, 326, 333, 341
Robinson, Cabell, 110, 245
Robinson, C. E., 324
Robinson, Ted, 260
Rockefeller, John D., 220
Rockefeller, Laurance, 96, 283
Rogers, Will, 166
Roquemore, Rocky, 120, 356
Ross, A. M., 330
Ross, Donald, xi, 86, 90, 138, 146, 150, 154,
 157, 158, 183, 194, 220, 232, 248, 253,
 258, 259, 263, 265, 280, 281, 283, 285,
 286, 291, 292, 294, 295, 303, 307, 309,
 310, 312, 313, 314, 330, 337, 391, 407,
 411
 best holes designed by, 422–23
 on water hazards, 158
Ross, George, 336
Ross, P. M., 202, 331, 340
Royal Adelaide Golf Club, 46, 178–79,
 377, 379, 389, 399, 417, 425
Royal Antwerp Golf Club, 355, 387, 415
Royal Ashdown Forest, 110
Royal Birkdale Golf Club, 109, 126,
 180–82, 328, 330, 336, 342, 344, 407,
 419, 434
Royal Calcutta Golf Club, 416
Royal County Down Golf Club, 42–45,
 228, 328, 336, 384, 385, 387, 395, 397,
 401, 419
Royal Dar-es-Salaam (Red), 110–11, 363,
 421, 429
Royal Dornoch Golf Club, 134, 183, 184,
 187, 329, 337, 391, 419, 423
Royal Johannesburg Golf Club (East),
 365
Royal Liverpool Golf Club (Hoylake),
 218, 337, 344
Royal Lytham and St. Annes Golf Club,
 184–85, 329, 337, 338, 389, 395, 419,
 435
Royal Melbourne Golf Club (East), 46, 62,
 100
Royal Melbourne Golf Club (West),
 46–49, 112–13, 164, 212, 375, 377,
 385, 393, 417, 425
Royal Oaks Golf Club, 294
Royal Portrush Golf Club (Dunluce),
 114–16, 329, 395, 419
Royal St. David's Golf Club, 186–87, 338,
 401
Royal St. George's Golf Club, 180, 188–89,
 338, 344, 391, 407, 419, 435
Royal Sydney Golf Club, 46

Royal Troon Golf Club (Old), 117, 190–91, 256, 329, 339, 344, 389, 395, 397, 409, 411, 419
Royal Worlington Golf Club, 330
Ruddy, Pat, 141, 327, 333, 341
Rulewich, Roger, 257
Russell, Alex, 46, 112, 164, 375, 376, 377, 379
Ruth, Babe, 36
Ryder, Samuel, 238
Ryder Cup, 109, 245, 252, 304, 330
 of 1933, 238
 of 1937, 238
 of 1953, 238, 246
 of 1957, 327
 of 1961, 184
 of 1969, 180, 434
 of 1977, 184
 of 1979, 278
 of 1981, 340
 of 1989, 332
 of 1995, 157, 232, 286
 of 1997, 245, 351, 414, 435
 of 1999, 134, 272
Ryu, Nakano, 371

S

Sahalee Country Club, 260
St. Andrews (Old), xi, 66, 70, 89, 125, 134, 141, 183, 208, 212, 228, 326, 345, 406, 418, 422, 426, 432–33
 11th hole of, 118–19, 330, 391, 409, 411
 Sand Hills Club and, 192
 17th (Road) hole of, 50–54, 270, 339, 385, 388, 389, 393, 407, 419
St. Enodoc Golf Club (Church), 345
St. Eurach Golf Club, 355
St. George's Golf and Country Club, 324
St. Germaine Golf Club, 355
St. Leon-Rot Golf Club, 356
St. Louis Country Club, 261, 409
St. Nom La Bretèche Golf Club (Red), 356
Salem Country Club, 294, 411, 423
Samsung World Championship of Women's Golf, 371
Sand Hills Club:
 7th hole of, 192–93, 294, 399, 421
 17th hole of, xii, 261
San Francisco Golf Club, 208, 261, 313, 427, 431
Sankaty Head Golf Club, 294
San Lorenzo Golf Club, 356, 415
Sarazen, Gene, 99, 117, 118, 157
Saturday Evening Post, The, 222
Saucon Valley Country Club (Old), 170, 295, 314
Sayers, Ben, 16
Scandinavian Enterprise Open, 350
Schreiner, Hannes, 356
Scioto Country Club, 295, 314, 423
Scott, Jack, 178
Seay, Ed, 340
Seignosse Golf Club, 356
Seminole Golf Club, 194–96, 212, 218, 295, 385, 391, 423, 431

Senior PGA Tour, 306
Senior Skins Game, 257
Serra, Emilio, 162, 321
Shadow Creek Golf Club, xii, 261, 314
Shan Shui Golf Club, 372
Shell Payless Open, 325
Sherry, Gordon, 354
Shinnecock Hills Golf Club, 138, 220
 11th hole of, 262, 409
 14th hole of, 55–57, 296, 384, 385, 413, 431
 16th hole of, 237, 314, 407, 435
Shoal Creek Golf Club, 296
Shoreacres Golf Club, 125, 262, 296, 399
Shute, Denny, 238
Sigel, Jay, 251
Silva, Brian, 285
Simpson, Archie, 335
Simpson, Scott, 144
Simpson, Tom, ix, 23, 99, 230, 327, 328, 332, 335, 342, 354, 355, 358
Singapore Island Country Club (Bukit), 372
Singh, Vijay, 253, 260, 348
Sköld, Nils, 349
Sleepy Hollow Country Club, 125, 262, 387
Smyers, Steve, 287
Snead, Sam, 26, 48, 104, 157
Somerset Hills Country Club, 262, 296, 427
Sorenstam, Annika, 347
Sotogrande Golf Club (Old), 245, 357, 361, 415, 429
Soutar, Des, 178, 375, 376
South African Open, 70
 of 1956, 73
 of 1969, 73
 of 1974, 365
 of 1997, 364
Southern Hills Country Club, 58–61, 218, 297, 384, 385, 413
Southport & Ainsdale Golf Club, 238–39, 330, 342, 345, 407
Spanish Open, 357
Sperone Golf Club, 240–41, 361, 391, 395, 403, 415, 421, 429
Spirit of St. Andrews, The (Mackenzie), 50, 166
Sporting Club Berlin (Faldo), 361
Spring City Golf Resort (Mountain), 372
Sprint International, 269
Spyglass Hill Golf Club, 197–99, 242–44, 297, 314, 413, 429, 433
Stanwich Club, 315, 409
Steel, Donald, 348, 351, 364
Stevenson, Robert Louis, 230
Stewart, Payne, 57, 144, 255
Stockton, Dave, 60, 130
Strange, Curtis, 84, 134, 157, 232, 273, 286, 378
Strath, David, 102, 328, 335, 343
Stricker, Steve, 260
Strong, Herbert, 269, 284, 295, 304, 314
Sumitomo VISA Taiheiyo Masters, 374
Sundblom, Rafael, 348
Sunningdale Golf Club (Old), 199, 206, 225, 326, 330, 339

Sutherland, John, 183, 329, 337
Sutton, Hal, 253

T

Taiheiyo Club Gotemba (East), 374, 417
Takeshi, Sato, 373
Tatum, Sandy, 309
Taylor, J. H., 109, 180, 328, 336, 344
Thai Country Club, 368
Thevenin, Pierre, 354
Thom, Charlie, 56, 296
Thomas, David, 332
Thomas, George C., xi, 39, 40, 251, 256, 260, 267, 282, 287, 293, 302
 on golf strategy, 176, 390
 on playing at Pine Valley, 106
 on playing golf, 82
Thompson, Stanley, 6, 8, 222, 248, 323, 324, 325, 428
Thomson, Peter, 49, 52, 109, 178, 180, 184, 230, 328, 373, 375, 379
Tillinghast, A. W., 5, 26–28, 33, 39, 81, 86, 122, 174, 208, 210, 250, 251, 253, 258, 261, 262, 264, 265, 266, 267, 284, 285, 290, 291, 292, 293, 294, 296, 300, 301, 302, 308, 313, 387, 413
 best holes designed by, 426–27
Times-Union Open, 157
Tolley, Cyril, 166
Tong Hwa Golf and Country Club, 373
Toomey, Howard, 55, 56, 126, 138, 237, 262, 280, 290, 296, 314
Töreboda Golf Club, 350
Torrey Pines Golf Club (South), 298
Tournament Players Club at Sawgrass (Stadium), 160, 254, 315
 17th hole of, 18–22, 263, 395, 404, 405, 412, 413, 421, 433
 18th hole of, 200–201, 298, 393
Tournament Players Club at The Woodlands, 298
Townsend, Peter, 301
Tralee Golf Club, 340, 387, 399
Trans-Mississippi Cup, 251
Travis, Walter, 188, 254, 277, 299, 306, 308
Trevino, Lee, 32, 57, 296, 308, 325
Troon Golf and Country Club, 263, 298, 401, 421
Troon North Golf Club (Monument), 299, 315
Trophée Lancôme, 356
Tucker, William H., 148, 256, 282
Tumba, Sven, 350
Turnberry Golf Club (Ailsa), 202–3, 331, 340, 402, 403, 419, 433
Tway, Bob, 280, 434

U

Ullna Golf Club, 350
Uplands Golf and Country Club, 323
U.S. Amateur, 74, 166, 426
 of 1896, 237
 of 1910, 160
 of 1916, 32
 of 1930, 32

of 1954, 273
of 1994, 315
of 1996, 313
USGA, x, xi, 60, 130, 144, 160
U.S. Mid-Amateur, 251
U.S. Open, 26, 70, 174, 176, 188, 235, 252, 277, 304, 341, 429
 of 1896, 55, 237
 of 1905, 285
 of 1910, 426
 of 1913, 134, 434
 of 1929, 435
 of 1936, 266
 of 1938, 270
 of 1939, 290
 of 1941, 130
 of 1946, 269
 of 1948, 260
 of 1950, 32, 283
 of 1951, 158
 of 1953, 428
 of 1954, 250
 of 1955, 259, 288, 434
 of 1958, 58, 60
 of 1963, 134, 273, 304
 of 1964, 272, 434
 of 1970, 144
 of 1971, 32
 of 1973, 287
 of 1976, 200
 of 1977, 60
 of 1980, 265
 of 1985, 258
 of 1986, 55, 57, 237, 262, 435
 of 1988, 134, 273
 of 1989, 232
 of 1991, 144, 200, 291
 of 1992, 434
 of 1993, 208, 265, 301
 of 1995, 55, 57, 237
 of 1996, 258
 of 1997, 132
 of 1998, 288
 of 1999, 168, 312, 423
 of 2001, 60
 of 2002, 26, 210, 267
 of 2003, 288
 of 2004, 55, 237
U.S. Senior Amateur, 237
U.S. Senior Open, 295, 434
U.S. Women's Amateur Championship, 92
 of 1900, 237
 of 1969, 114
U.S. Women's Open, 294

V

Valderrama Golf Club, 218, 245, 351, 357, 361, 391, 411, 414, 415, 429, 435
Vale do Lobo Golf Club (Yellow), 120–21, 351, 395, 403, 415
Valley Club of Montecito, 263, 425
Van de Velde, Jean, 66
Vardon, Harry, 42, 188, 328, 334, 336, 338, 434
 on playing at Royal St. George's, 188

Venturi, Ken, 76, 132, 272, 434
Victoria Golf Club, 46, 379, 417
Villa d'Este Golf Club, 357, 401
Vintage Club (Mountain), 299
Volvo Masters, 245
Volvo Scandinavian Masters, 351, 358

W

Wade Hampton Golf Club, 316, 401
Walden on Lake Conroe Golf and
 Country Club, 316
Wales, prince of (King Edward VII), 114,
 186
Walker Cup, 109
 of 1922, 160
 of 1965, 301
 of 1969, 284
 of 1977, 237
 of 1997, 174
 of 2001, 287
Walton Heath Golf Club (Old), 340
Wannamoisett Golf Club, 263, 423
Waterman, George, 70, 362, 363, 365
Waters, Laurie, 70, 362, 363, 365
Waterville Golf Links, 331, 345
Watrous, Al, 184, 435
Watson, Tom, 23, 24, 52, 99, 128, 180, 309,
 326, 331, 397
Watson, Willie, 259, 288, 309
Watts, Brian, 344, 367
Way, W. H. "Bert," 220
Weiskopf, Tom, 146, 263, 275, 276, 298,
 299, 315, 327, 334, 342
 on playing at New St. Andrews, 154
Wentworth Golf Club (West), 246–47,
 346, 391
Westchester Country Club (West), 299,
 331, 341
Western Gailes Golf Club, 346
Western Open, 268, 271
West Links, Scotland, 14
Westner, Wayne, 258
Westwood, Lee, 374
Wethered, H. N., xi
Wethered, Joyce, 166
Weyhausen, August, 352
WGC American Express Championship,
 245
Whistling Straits Golf Club (Straits),
 264, 387, 405, 421
White, Stanford, 237
Whiting, Sam, 259, 288
Wild Coast Challenge, 363
Wild Coast Country Club, 363
Wild Dunes Golf Links, 299, 316, 403,
 421
Wilshire Country Club, 300
Wilson, Alan, 39
Wilson, Dick, 126, 138, 251, 266, 271, 275,
 280, 281, 308, 310, 376
Wilson, Hugh, 33, 39, 86, 256, 283
Wind, Herbert Warren, 23, 24, 62, 332
Winged Foot Golf Club, 26, 122–24, 208,
 264, 267, 300, 385, 407, 409, 411,
 413, 427, 435

Woburn Golf and Country Club (Dukes),
 331
Wogan, Skip, 294
Wolveridge, Michael, 370, 379
Wood, Craig, 130, 290
Woods, Norman, 325
Woods, Tiger, 20, 28, 76, 302, 313, 315,
 356, 366, 368, 397
Woosnam, Ian, 352
World Amateur Team Championship:
 of 1974, 90
 of 1994, 354
 of 1998, 228
World Cup, 46, 416–17
 of 1973, 414
 of 1980, 94
 of 1989, 414
 of 1998, 378
World Match Play Championship, 331
World Woods Golf Club (Pine Barrens),
 300, 316, 393, 433
Worplesdon Golf Club, 224, 346
Wright, Rodney, 257

Y

Yale University Golf Course, 125, 204–5,
 252, 264, 391, 393, 405, 409
Yamada, T., 373
Yarra Yarra Golf Club, 48, 377, 417, 425
Yeamans Hall Club, 265
Yomiuri Country Club, 368, 407
Yoon, Iksung, 371

Z

Zaharias, Babe Didrikson, 166, 232
Zoeller, Fuzzy, 200

PHOTO CREDITS

**Aloha Golf Club, photograph courtesy of
the club:** *p. 351, upper right*
AP/Wide World Photos: *p. 380*
Claudio Alvarez/Liaison Agency: *p. 349,
upper right*
**Atlanta Country Club, photograph
courtesy of the club:** *p. 301, upper left*
**Åtvidaberg Golf Club, photograph
courtesy of the club:** *p. 357, lower right*
Doug Ball: *p. 323, lower left; p. 323, lower
right; p. 324, upper right; p. 324, lower left;
p. 324, lower right; p. 325, upper left; p. 325,
upper right; p. 325, lower right*
**Banff Springs Golf Course, photograph
courtesy of the club:** *p. 9*
Clive Barber/Golf Shots: *p. 324, upper left*
Dr. David C. Bell: *p. 268, lower right; p. 304,
upper left*
Bettmann/Corbis: *p. 78*

**The Broadmoor Golf Club, photograph
courtesy of the club:** *p. 303, lower right*
**Brook Hollow Golf Club, photograph
courtesy of the club:** *p. 251, upper right*
Howard Burditt/Liaison Agency: *p. 363,
upper right*
Didier Chicot: *p. 349, lower left; p. 354,
lower right*
**Christchurch Golf Club, photograph
courtesy of the club:** *p. 375, upper left*
**Chung Shan Hot Springs Golf Club,
photograph courtesy of the club:** *p. 369,
upper right*
**Clearwater Bay Golf and Country Club,
photograph courtesy of the club:** *p. 369,
lower right*
**Country Club of Detroit, photograph
courtesy of the club:** *p. 273, lower left; p. 304,
lower right*
**Crown Colony Country Club, photograph
courtesy of the club:** *p. 305, upper left*
J. D. Cuban/Allsport: *p. 87; p. 251, lower left*
John Davis: *p. 223*
Peter Dazeley: *p. 219; p. 358, lower right*
John DeMello: *p. 257, lower left*
Mike DeVries/DeVries Design: *p. 137;
p. 274, lower left; p. 305, lower left; p. 380;
p. 424; p. 425*
Tom Doak/Renaissance Golf Design:
*p. 83; p. 213; p. 225; p. 260, upper left; p. 262,
lower left; p. 269, lower left; p. 269, upper
right; p. 277, lower left; p. 277, lower right;
p. 283, lower right; p. 285, upper left; p. 288,
upper left; p. 290, upper right; p. 296, upper
right; p. 306, lower right; p. 310, upper left;
p. 321, upper left; p. 364, lower right; p. 365,
lower left; p. 367, lower left; p. 374, upper
left; p. 417*
Joann Dost/Golf Editions: *p. 75; p. 259,
lower left; p. 278, lower right; p. 284, upper
right; p. 309, lower right*
**Dick Durrance/Drinker Durrance
Graphics:** *p. 193; p. 261, lower left; p. 268,
lower left; p. 303, upper right; p. 323, upper
right*
Chris Duthie: *p. 7; p. 323, upper left; p. 386*
**Patrick Eagar/The Phil Sheldon Picture
Library:** *p. 121; p. 351, lower left*
**Falsterbo Golf Club, photograph courtesy
of the club:** *p. 347, lower right*
Ross D. Franklin: *p. 215; p. 277, upper right;
p. 322, upper left*
**Carl Furuta/Wilshire Country Club,
photograph courtesy of the club:** *p. 300,
upper left*
Rich Gagnon: *p. 294, lower left*
**Gary Player Country Club, photograph
courtesy of the club:** *p. 364, lower left*
**Gorge Vale Golf Club, photograph
courtesy of the club:** *p. 325, lower left*
**Sam Greenwood/The Golf Magazine
Picture Collection:** *p. 289, upper left*
Anders Greidmark: *p. 353, upper right*
Jeff Gross/Allsport: *p. 263, upper right;
p. 267, upper left; p. 302, upper right*

Nico ter Haak/Wiz Art Golf Design:
p. 355, upper left
**Halmstad Golf Club, photograph courtesy
of the club:** *p. 348, upper right*
Matthew Harris/Golf Picture Library:
*p. 113; p. 115; p. 207; p. 247; p. 309, upper
left; p. 329, upper right; p. 331, lower right;
p. 335, upper right; p. 341, lower left; p. 343,
upper left; p. 346, upper right; p. 360, lower
right; p. 362, lower right; p. 363, upper left;
p. 364, lower left; p. 373, lower right; p. 375,
lower right; p. 376, upper left; p. 378, lower
left; p. 378, lower right; p. 398; p. 402; p. 405*
Jeannine Henebry/Henebry Photography:
*p. 167; p. 256, upper right; p. 266, lower left;
p. 275, lower right; p. 277, upper left; p. 282,
lower left; p. 285, lower left; p. 294, upper
right; p. 316, upper left; p. 316, lower right*
Eric Hepworth: *p. 25; p. 53, lower right;
p. 69, lower right; p. 69, lower left; p. 108;
p. 129; p. 181; p. 182; p. 327, upper left; p. 327,
upper right; p. 328, lower right; p. 329, lower
left; p. 329, upper right; p. 331, upper right;
p. 332, upper right; p. 333, lower left; p. 334,
upper left; p. 334, lower right; p. 335, upper
left; p. 336, upper right; p. 337, lower left;
p. 337, lower right; p. 339, upper left; p. 340,
upper right; p. 342, lower left; p. 344, upper
right; p. 344, lower right; p. 345, lower left;
p. 346, lower left; p. 395; p. 397; p. 418; p. 432*
**Hills of Lakeway Golf Course, photograph
courtesy of the club:** *p. 255, lower left*
Hidehisa Hosoda: *p. 366, lower right;
p. 368, upper right; p. 371, upper right*
**Huntingdon Valley Country Club,
photograph courtesy of the club:** *p. 280,
upper left*
Mark Huphries: *p. 276, lower right*
Daniel Husted: *p. 253, lower right*
Phil Inglis: *p. 227; p. 348, upper left; p. 352,
lower left; p. 353, upper right; p. 355, lower
left; p. 357, upper right; p. 359, lower right;
p. 359, lower right*
JMP Golf Design Group: *p. 369, upper left;
p. 373, upper right*
Chris John/PDI: *p. 133; p. 201; p. 244; p. 253,
lower left; p. 259, upper right; p. 266, upper
right; p. 278, upper left; p. 279, upper left;
p. 291, lower right; p. 299, lower left; p. 299,
upper left; p. 301, upper left; p. 306, upper
right; p. 332, upper left; p. 349, upper left;
p. 396*
**John R. Johnson/Johnson Design
Photographics:** *p. 169; p. 221; p. 233; p. 253,
upper left; p. 254, upper right; p. 261, lower
right; p. 262, upper right; p. 265, upper left;
p. 269, upper left; p. 275, lower left; p. 283,
upper right; p. 288, lower left; p. 291, lower
left; p. 292, upper left; p. 292, lower left;
p. 293, lower left; p. 293, upper left; p. 297,
lower left; p. 298, upper left; p. 299, upper
left; p. 307, lower left; p. 309, lower left;
p. 310, upper right; p. 313, upper right;
p. 314, upper right; p. 339, lower left; p. 399*
M. Joppen: *p. 353, lower left*

Leonard Kamsler: *p. 18; p. 127; p. 145; p. 209; p. 255, upper left; p. 258, upper right; p. 264, lower left; p. 266, upper left; p. 270, lower left; p. 279, lower left; p. 302, upper left; p. 312, lower right; p. 388; p. 411; p. 435*

Ronny Karlsson: *p. 351, lower right; p. 414*

Kau Sai Chau Golf Course (North), photograph courtesy of the club: *p. 367, upper left*

Russell Kirk/GolfLinks: *p. 49; p. 66; p. 101; p. 116; p. 123; p. 159; p. 198; p. 254, lower left; p. 259, upper left; p. 265, lower left; p. 267, lower right; p. 272, lower left; p. 272, upper left; p. 291, upper left; p. 300, lower left; p. 300, upper right; p. 310, lower right; p. 311, upper right; p. 313, upper left; p. 314, upper left; p. 326, lower right; p. 328, upper right; p. 330, lower left; p. 330, lower right; p. 332, upper left; p. 335, lower right; p. 339, lower right; p. 339, upper right; p. 340, upper left; p. 340, lower right; p. 346, upper left; p. 351, upper left; p. 357, lower right; p. 361, lower right; p. 375, upper right; p. 377, upper right; p. 378, upper left; p. 382; p. 389; p. 391; p. 410; p. 422; p. 423*

Mike Klemme/Golfoto: *p. 2; p. 4; p. 97; p. 161; p. 171; p. 243; p. 250, lower left; p. 252, upper left; p. 258, lower right; p. 260, lower left; p. 260, upper right; p. 261, upper right; p. 264, upper left; p. 268, upper left; p. 269, lower right; p. 270, upper right; p. 271, lower right; p. 273, lower right; p. 275, upper left; p. 276, upper right; p. 280, upper right; p. 287, upper left; p. 287, upper right; p. 289, lower left; p. 292, lower left; p. 296, lower left; p. 297, lower right; p. 298, lower left; p. 298, lower right; p. 303, lower left; p. 304, lower left; p. 304, upper right; p. 308, upper left; p. 313, lower right; p. 315, lower right; p. 315, upper left; p. 350, upper left; p. 352, lower right; p. 400; p. 425; p. 428; p. 431*

James Krajicek: *p. 293, lower right; p. 308, lower right*

Lakeside Country Club, photograph courtesy of the club: *p. 371, upper left*

L. C. Lambrecht: *p. 13; p. 14; p. 15; p. 27; p. 29; p. 30; p. 31; p. 33; p. 38; p. 41; p. 43; p. 45; p. 70; p. 71; p. 73; p. 93; p. 107; p. 124; p. 149; p. 153; p. 195; p. 205; p. 211; p. 251, upper left; p. 252, lower left; p. 253, upper right; p. 255, upper right; p. 256, lower right; p. 256, lower right; p. 258, lower left; p. 259, lower right; p. 263, lower right; p. 264, upper right; p. 264, lower right; p. 267, lower left; p. 267, upper right; p. 270, lower right; p. 271, upper left; p. 272, lower right; p. 273, upper right; p. 274, upper right; p. 276, upper left; p. 280, lower left; p. 282, upper right; p. 282, lower right; p. 285, upper right; p. 285, lower right; p. 287, lower left; p. 290, lower right; p. 291, upper right; p. 292, upper left; p. 295, lower right; p. 295, upper left; p. 295, upper right; p. 300, lower left; p. 302, lower left; p. 302, lower right; p. 303, upper right; p. 307, upper left; p. 308, lower left; p. 309, upper*

right; *p. 310, lower left; p. 315, lower left; p. 315, upper right; p. 332, lower left; p. 336, upper left; p. 336, lower right; p. 362, lower left; p. 365, upper right; p. 385; p. 390; p. 394; p. 401, lower left; p. 406; p. 412; p. 421; p. 427; p. 430*

Laurel Valley Golf Club, photograph courtesy of the club: *p. 281, upper right*

J. F. LeFevre: *p. 241; p. 350, lower left; p. 353, upper left; p. 354, lower left; p. 355, lower right; p. 356, lower left; p. 356, lower right; p. 358, upper right; p. 360, lower left; p. 360, lower left; p. 361, lower left*

Tony Lewis: *p. 377, lower left; p. 379, upper left*

Keith Liljegren: *p. 294, lower right*

Patrick Lim: *p. 367, upper right; p. 368, lower left; p. 368, upper left; p. 372, lower right; p. 372, upper right; p. 373, lower right*

David Mackintosh: *p. 318, upper right*

Ken May/Rolling Greens Photography: *p. 252, upper right; p. 282, upper left; p. 307, lower right; p. 308, upper right*

Metropolitan Golf Club, photograph courtesy of the club: *p. 376, lower left*

Hector Millozzi: *p. 163; p. 319, lower left; p. 321, upper right*

Milwaukee Country Club, photograph courtesy of the club: *p. 284, lower left*

Mission Hills Golf Club, photograph courtesy of the club: *p. 374, lower left*

Taku Miyamoto: *p. 289, upper right; p. 321, lower right; p. 357, upper left; p. 361, upper left; p. 370, lower left*

Brian Morgan/Golf Photography Limited: *p. 21; p. 45; p. 59; p. 61; p. 63; p. 77; p. 85; p. 139; p. 140; p. 147; p. 172; p. 175; p. 187 p. 216; p. 231; p. 234; p. 236; p. 239; p. 251, lower right; p. 252, lower left; p. 254, lower right; p. 262, upper left; p. 262, lower right; p. 263, lower left; p. 265, upper right; p. 266, lower left; p. 268, upper right; p. 271, upper right; p. 274, upper left; p. 276, lower left; p. 278, lower left; p. 279, lower right; p. 279, upper right; p. 280, lower right; p. 281, lower right; p. 283, lower left; p. 283, upper left; p. 286, lower right; p. 290, lower left; p. 290, upper left; p. 295, lower left; p. 296, lower right; p. 297, upper left; p. 297, upper right; p. 298, lower right; p. 305, lower right; p. 306, upper left; p. 306, lower left; p. 311, lower left; p. 314, lower left; p. 316, upper right; p. 317, upper left; p. 319, upper left; p. 320, lower right; p. 321, lower left; p. 326, lower left; p. 327, lower left; p. 327, lower right; p. 328, lower left; p. 331, upper left; p. 333, lower left; p. 334, lower left; p. 334, upper right; p. 336, lower left; p. 337, upper left; p. 337, upper left; p. 338, lower left; p. 341, upper left; p. 341, lower right; p. 342, upper right; p. 342, lower right; p. 343, lower right; p. 345, upper right; p. 348, lower right; p. 352, upper right; p. 354, upper right; p. 354, upper right; p. 356, upper right; p. 358, lower left; p. 359, upper left; p. 364, upper left; p. 365, upper left; p. 365, lower right; p. 366,*

lower left; *p. 369, lower left; p. 378, upper right; p. 384; p. 403; p. 408; p. 415; p. 433*

Jim Moriarty: *p. 143*

Robin Moyer: *p. 367, lower right; p. 370, upper left; p. 370, upper right; p. 370, lower right; p. 371, lower left; p. 374, upper right*

Navatanee Country Club, photograph courtesy of the club: *p. 371, lower right*

New St. Andrews Golf Club, photograph courtesy of the club: *p. 155; p. 372, upper left*

Newcastle Golf Club, photograph courtesy of the club: *p. 376, upper right*

Mark Newcombe/Visions in Golf: *p. 330, upper right; p. 333, upper left; p. 342, upper left; p. 344, lower left*

Old Memorial Golf Club, photograph courtesy of the club: *p. 287, lower right*

Karl Olson: *p. 17; p. 258, upper left*

Orebro Golf Club, photograph courtesy of the club: *p. 349, lower right;*

Paraparaumu Beach Golf Club, photograph courtesy of the club: *p. 165; p. 376, lower right*

Pelican Hill Golf Club, photograph courtesy of the club: *p. 312, upper left*

Hy Peskin/Life Magazine©Time, Inc.: *p. xiv*

Piero Pomponi/Liaison Agency: *p. 95; p. 317, lower right; p. 429*

Dennis Roberson: *p. 131*

Tony Roberts/The Golf Magazine Picture Collection: *p. v; p. vi; p. 22; p. 23; p. 51; p. 53, top; p. 88; p. 111; p. 177; p. 255, lower right; p. 271, lower left; p. 281, upper left; p. 293, upper right; p. 299, lower right; p. 317, upper left; p. 319, upper right; p. 319, lower right; p. 329, upper left; p. 331, lower left; p. 343, lower left; p. 345, upper left; p. 345, lower right; p. 420*

Royal Oaks Golf Club, photograph courtesy of the club: *p. 294, upper left*

Keiichi Sato/K1 Photograph: *p. ii; p. viii; p. 19; p. 65, bottom; p. 74; p. 263, upper left*

Keiichi Sato/The Golf Magazine Picture Collection: *p. 274, lower right; p. 305, upper right; p. 307, upper right*

Claudio Scaccini: *p. 352, upper left*

Evan Schiller: *p. 11; p. 80; p. 91; p. 105; p. 196; p. 256, lower left; p. 257, upper left; p. 273, upper left; p. 278, upper right; p. 284, upper left; p. 301, lower left; p. 311, lower right; p. 313, lower left; p. 317, lower left; p. 318, lower right; p. 320, upper right; p. 387; p. 388*

Paul Severn: *p. 330, upper left*

Shan Shui, photograph courtesy of the club: *p. 372, lower left*

Phil Sheldon/The Phil Sheldon Picture Library: *p. xiii p. 103; p. 156; p. 179; p. 189; p. 250, lower right; p. 257, upper right; p. 265, lower right; p. 270, upper left; p. 281, lower left; p. 284, lower right; p. 286, upper left; p. 288, upper right; p. 288, lower right; p. 289, lower right; p. 293, upper right; p. 301, lower right; p. 338, upper left; p. 338, upper right; p. 343, upper right; p. 347, lower left; p. 363,*

lower left; *p. 363, lower right; p. 375, lower left; p. 377, upper left; p. 377, lower left; p. 392; p. 404; p. 407; p. 419*

Enrique Siques/Liaison Agency: *p. 229; p. 322, upper right*

Julia Sullivan: *p. 379, upper right*

Taiheiyo Club Gotemba, photograph courtesy of the club: *p. 374, lower right*

Tong Hwa Golf and Country Club, photograph courtesy of the club: *p. 373, upper left*

Toreboda Golf Club, photograph courtesy of the club: *p. 350, upper right*

Tom Travis/Rolling Green Photography: *p. 312, lower left*

Ullna Golf Club, photograph courtesy of the club: *p. 350, lower right*

United States Golf Association: *p. 248*

Stefan Von Stengel: *p. 34; p. 35; p. 37; p. 348, lower left; p. 355, upper right; p. 356, upper left; p. 358, upper left; p. 359, upper left; p. 361, upper left*

Fred Vuich/The Golf Magazine Picture Collection: *p. 10; p. 47; p. 53, lower left; p. 54; p. 55; p. 57; p. 65, top; p. 67; p. 69, top; p. 98; p. 119; p. 135; p. 151; p. 185; p. 191; p. 203; p. 254, upper left; p. 257, lower right; p. 260, lower right; p. 261, upper left; p. 272, upper right; p. 275, upper right; p. 286, lower left; p. 286, upper right; p. 296, upper left; p. 311, upper left; p. 312, upper right; p. 314, lower right; p. 328, upper left; p. 338, lower left; p. 338, lower right; p. 340, lower left; p. 341, upper right; p. 344, upper left; p. 360, upper left; p. 393; p. 409; p. 413; p. 416; p. 426*

Walden on Lake Conroe Golf and Country Club, photograph courtesy of the club: *p. 316, lower left*

David J. Whyte/The Scottish Photo Golf Library: *p. 333, upper right; p. 335, lower left*